March 21, 2004

Dear Connie,

Happy, happy Birthday

Love
Yiota

Gift 8/13

Renaissance Rivals

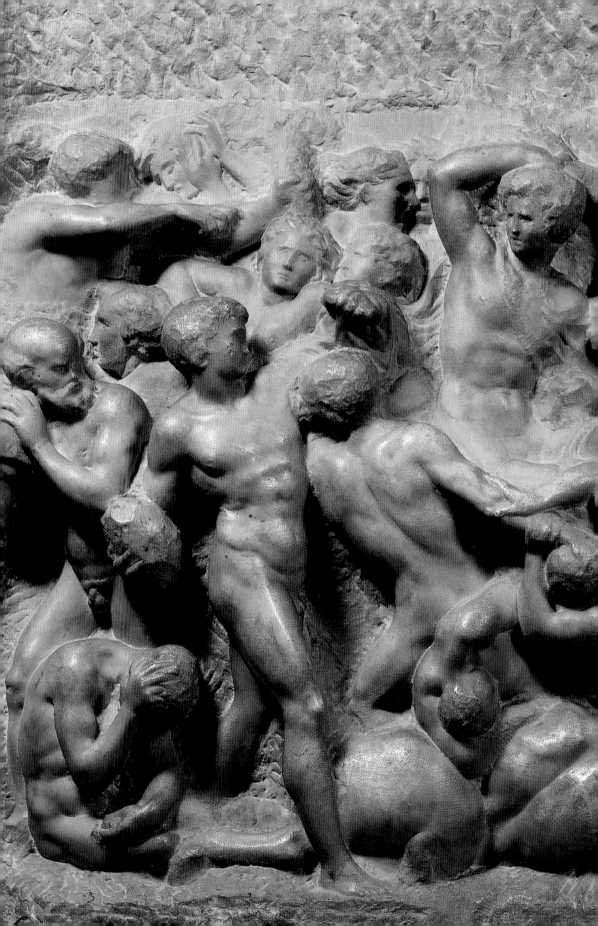

Renaissance Rivals

Michelangelo, Leonardo, Raphael, Titian

Rona Goffen

Yale University Press

New Haven & London

PUBLISHED WITH THE ASSISTANCE OF
THE GETTY GRANT PROGRAM

Designed by Gillian Malpass

Printed in Singapore

Library of Congress Cataloging-in-Publication Data

Goffen, Rona
Renaissance rivals: Michelangelo, Leonardo, Raphael, Titian / by Rona Goffen.
p. cm.
Includes bibliographical references and index.
ISBN 0-300-09434-5
1. Art, Renaissance – Italy. 2. Competition (Psychology). 3. Michelangelo
Buonarroti, 1475–1564. I. Title.
N6915 .G54 2002
709'.45'09024 – dc21 2002001026

A catalogue record for this book is available from
The British Library

Frontispiece Michelangelo, *Battle of the Centaurs and Lapiths* (detail of Fig. 31)

Contents

Preface and Acknowledgments

History is necessary, not only to make life agreeable, but also to
endow it with a moral significance.

Marsilio Ficino[1]

MOST IF NOT ALL of the works discussed in this book are familiar and their makers famous. I have tried to see them anew, however – or rather, the way their contemporaries saw them five hundred years ago, and that is through the prism of rivalry. This is not my idea but theirs, as they tell us repeatedly in various writings. Their idea, too, is my focus on Michelangelo as protagonist. Everyone else – Leonardo, Raphael, Titian, and others – is seen in relation to him, as his antagonist.

Rivalry may not always be primary or even dominant in every Renaissance discourse about the arts or in every relationship between artists. Rivalry is, however, always there, one way or another, sometimes (often) overt, other times, implicit or metaphoric. Indeed, rivalry defines the period commonly described as "Renaissance" – a term as convenient as it is amorphous.

Renaissance Rivals is not a compendium of every famous painting and sculpture produced in sixteenth-century Italy, and it is not an anthology of mini-monographs on the masters named in the title. Rather, the book is a selective history of Renaissance art determined by the response of the first knowledge-able observers of that art: its makers, their patrons, and their friends. Leonardo and Michelangelo, for example, knew and probably disliked each other even before their compatriots provided a public venue for their rivalry, commissioning frescoes by each master on opposite walls in the Sala del Gran Consiglio of the Palazzo della Repubblica in Florence (1503–05). Raphael had moved to Florence by 1504, quickly establishing himself as another admirer of Leonardo – and another competitive irritant for Michelangelo. Their rivalry moved with them to Rome. By 1508 Michelangelo and Raphael were at work in the Vatican Palace under the watchful eye of Raphael's kinsman Bramante, Michelangelo in the Sistine Chapel, Raphael in the Stanza della Segnatura – a stone's throw from each other.

Three years later, in 1511, the Venetian Sebastiano del Piombo also moved to Rome and joined the rivalrous fray. Sebastiano's first Roman commission set

him against Raphael. Their competition soon included Michelangelo – or he included Sebastiano in his own competition, making the Venetian a cat's paw in his rivalry with Raphael.

Meanwhile, Sebastiano maintained close ties with friends in Venice, including Titian. Sebastiano was almost certainly one of Titian's early sources for information about Michelangelo's work in Rome. Titian and Michelangelo themselves might have met in Venice during the Florentine's visit there in 1529, though there is no contemporary record of that meeting. In any case, Michelangelo was able to see Titian's works there and elsewhere, and soon became aware of Titian as a competitor. Contemporaries celebrated the agon between them.

Both Titian and Michelangelo faced challenges from other competitors as well. In Venice, after the death of Giorgione in 1510, Sebastiano's move to Rome the following year, and Giovanni Bellini's demise in 1516, Titian had remained unrivaled until Pordenone's arrival in 1528. The newcomer managed to win commissions from Titian's otherwise faithful patron, Doge Andrea Gritti. Pordenone died in 1539, and thereafter Titian's artistic hegemony continued without challenge until mid-century when two younger masters, Tintoretto and Veronese, came on the scene. (Among Tintoretto's earliest works, not coincidentally, are drawings after casts of sculptures by Michelangelo.) By that time, however, Titian's reputation was worldwide, and his list of patrons a sixteenth-century Debrett's Peerage.

Michelangelo had a more troublesome time with both his rivals and his patrons. In 1525 the commission for a pendant for Michelangelo's *David* was awarded to Baccio Bandinelli. This fact in itself greatly displeased Michelangelo, but, to make matters worse, Bandinelli had been trained by Giovanni Francesco Rustici, a close friend of Leonardo. From Michelangelo's point of view, to commission a pendant for his *David* – his first public work in Florence – by Bandinelli, of all people, was to add insult to injury. Their rivalry was exacerbated by their political differences: Michelangelo was a supporter of the Florentine Republic, and Bandinelli of Pope Clement VII de' Medici, who laid siege to the city in 1529. The eventual result of the commission was Bandinelli's *Hercules and Cacus*, unveiled in 1534. Later that year Michelangelo moved definitively to Rome, thereby ceding Florence to his opponent. Duke Cosimo I de' Medici made Bandinelli in effect his court sculptor, and the artist enjoyed over ten years of *de facto* monopoly in the Florentine sculpture market. His happy state ended in 1545, when Benvenuto Cellini returned to Florence from his successes at the court of François I.

Cellini and Bandinelli were not only rivals: they were bitter enemies. Their hatred is recorded in Cellini's *Autobiography*, and their rivalry visualized in their portrait busts of Duke Cosimo, the purpose of the dual commissions (finagled by Bandinelli) being precisely to allow a direct confrontation of their works. Even while battling each other, Cellini and Bandinelli attempted to rival Michelangelo. And even after Michelangelo's death, Titian honored him – and challenged him.

* * *

My subject is rivalry, but I never found a trace of it in working on the book, only generosity and collegiality. At the Institute for Advanced Study in Princeton, where I began writing the book as a Visitor in 1999–2000, I enjoyed discussions with Irving Lavin of the School of Historical Studies and his colleagues, especially Oleg Grabar and Marilyn Aronberg Lavin; and with the Fellows, especially Christiane Andersson and Bette Talvacchia. I am also most grateful to Marcia Tucker and her extraordinary colleagues at the Institute's Library of Historical Studies and Social Science.

A number of knowledgeable friends and colleagues outside the Institute were most generous in responding to questions, including Sylvie Béguin, Renate Blumenfeld-Kosinski, Francis Fletcher, Michael Hirst, Charles Hope, Antoni Kosinski, Yogesh Laluria, David Rosand, James Saslow, William Wallace, Laura S. White, Diane Finiello Zervas, and especially Giovanna Nepi Scirè and Louis Alexander Waldman, who also kindly lent difficult-to-obtain photographs, as did Charles E. Cohen and Patricia Meilman. Some of the most elusive illustrations were hunted down by Sabine Eiche. Jonathan and Sandra Brown advised me to make the book "dishy," perhaps because we were having dinner at the time. I've tried to follow their advice by letting the subjects speak for themselves as much as possible. I also want to acknowledge my gratitude to my smart, indefatigable research assistants at Rutgers, Wendy Streule and Kirsten Tranter.

I am profoundly grateful to Paul Joannides, Fred Licht, and Bridget Gellert Lyons, who read my manuscript with great attention and who offered specific suggestions and emendations as well as more general conceptual criticisms and encouragement.

At Yale University Press, Judy Metro gave first approval and early encouragement to the idea for this book. When she left the Press for the National Gallery of Art in Washington, both the book and the author were inherited by Gillian Malpass in London. Sandy Chapman was enormously helpful in obtaining photographs and permissions to publish them, a loathsome task that she handled with aplomb. Ruth Thackeray edited the manuscript with exemplary attention to substance and detail. Finally, as everyone who has had the privilege of working with Gillian Malpass already knows, as an editor, designer, and friend, she is unrivalled.

I
Preamble

I

Imitatio and Renovatio

A dispute also arose among them, which of them was to be regarded
as the greatest. And he said to them, "[. . .] For which is the greater,
one who sits at table, or one who serves? Is it not the one who sits at
table?"

Luke 22 : 24–27

He is a poor disciple who does not excel his master.

Leonardo da Vinci[1]

THE RENAISSANCE BEGAN WITH A COMPETITION. But, one may ask, what is
the Renaissance? And which competition? The quickest answer to the first
vast question is found in the conception, or ideal, of *renovatio*: the revival of
classical letters – in a word, Humanism – followed thereafter by the visual arts.
As Thomas Greene has brilliantly shown, *imitatio* is central and pervasive in
Italian Renaissance culture.[2] The same can be argued for rivalry. Perhaps rivalry
is inherent in *imitatio*; certainly *imitatio* is inherent in rivalry. Once poetry and
the ancient works it may describe are taken as models to be imitated, they
become challenges to be surpassed.

The Renaissance revival of antiquity is bound to the classical (and
unChristian) agon, an opposition or confrontation to surpass one's rival. At
once psychological and cultural, the Renaissance agon is as central to the period
as the revival of Ciceronian Latin and classical conceptions of beauty and pro-
portion. And central to the Renaissance agon is Michelangelo, the great pro-
tagonist of his time. Giorgio Vasari expressed the idea in a nutshell: "Force
yourself to imitate Michelangelo in everything."[3] Everyone else might be
perceived – and was perceived by Michelangelo – either as his antagonist or as
his acolyte. For everyone else, he was *the* referent. Even Lodovico Dolce, one
of Titian's greatest champions, described Leonardo, Raphael, and Titian himself
as Michelangelo's rivals.[4] For Michelangelo himself, the only acknowledged
points of reference were nature and classical antiquity.

The intention to surpass one's rivals, past and present, distinguishes the
Renaissance from earlier periods of rebirth. In his seminal book on the
subject, Erwin Panofsky argued that the fundamental distinction between

Detail of Fig. 6.

"Renaissance" and "renascences" was that only in the fifteenth century did the ancient gods reassume their original appearance: Christ may continue to resemble Apollo, but now Apollo himself reappears as himself, with his ancient attributes and his classical demeanor.[5] Panofsky's observation, though incontrovertible, is incomplete. The Renaissance revival of antiquity is concerned not only with archaeological awareness – in itself, a conscious and self-conscious concern – but also, perhaps subconsciously, with psychological emulation. Earlier generations may have imitated ancient motifs, but now artists and authors announced the intention to transcend them. "In Renaissance rhetorical and educational theory," as Wayne Rebhorn explains, "emulation is classified as a form of imitation, an identification with one's model at the same time that one attempts to surpass it. [. . .] On the one hand, then, emulation means *identification* with another person, a model, or an ideal. [. . .] On the other hand, it simultaneously means *rivalry*; it is a competitive urge that necessarily involves struggle, but which can also [. . .] entail feelings of hatred and envy."[6] So if one's rival is not necessarily one's enemy, neither is rivalry an entirely innocuous emotion. Giovanni Pisano's rivalrous inscription on the Pistoia Pulpit, for example, can be read almost as a metaphoric patricide: "Giovanni carved it who performed no empty work, born of Nicolà but blessed with greater skill, Pisa gave him birth, endowed with learning in all things visual." Ignoring fourteenth-century beliefs about nature and nurture, Giovanni suggests that his talent owes little if anything to his father but rather to Pisa, the city of his birth, while implying with the adjective *beatus* that his gift is a blessing bestowed by God.[7]

At its most extreme, rivalry may devolve into hatred and even bloodshed, as described in Benvenuto Cellini's autobiographical accounts of his own acts of violence (some of them invented – presumably wishful thinking).[8] More often, however, though Hatfields and McCoys may kill each other, Titians and Michelangelos sublimate their antagonism in artistic endeavor.

To repeat, then, and to answer the second question posed at the beginning of this discussion: the Renaissance was an inherently rivalrous age that began with a competition. Rivalry was institutionalized in the competition for the bronze doors of the Florence Baptistery at the turn of the fifteenth century. Announced by the Arte dei Mercanti di Calimala (the Merchants' Guild) during winter 1400–1401, the competition for the Baptistery doors may not have been the first such contest to determine a major public commission, but it was probably the most conspicuous, and for Florence, the most prestigious, involving the city's most venerable building (Figs. 1, 2, 3). Its venerability derived from remarkable and perhaps willful historical amnesia: built between 1059 and 1150, since Dante's day the Baptistery had been identified as an ancient Roman structure. The timing of the contest to coincide with the beginning of the new century may have been happenstance and yet not entirely a matter of indifference. The commission for the Baptistery doors was bound to hopes for the new era.[9] At the same time, the competition announced – and encouraged – rivalry as a motif of the times. Perhaps Lorenzo Ghiberti and Filippo Brunelleschi, the

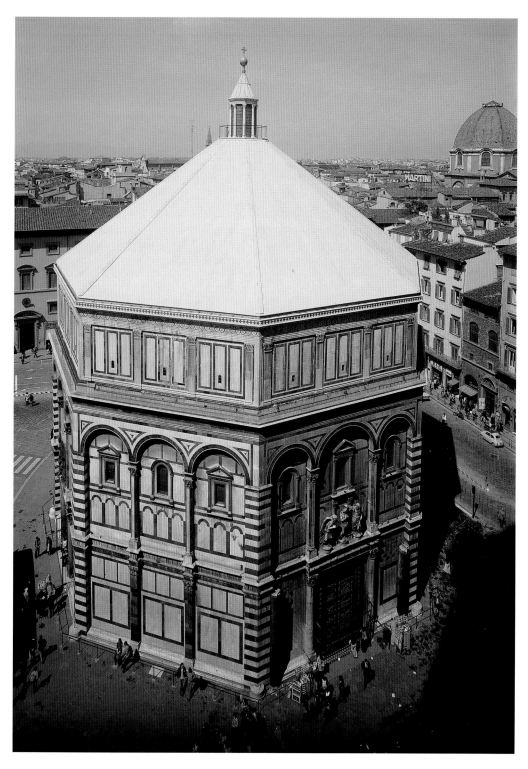

1 Florence, Baptistery.

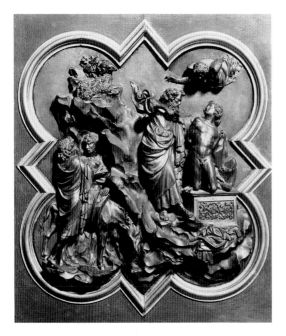 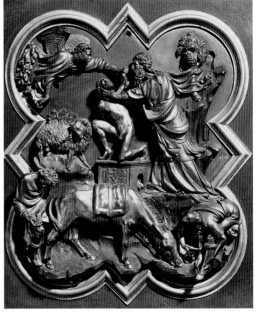

2 Lorenzeo Ghiberti. *Sacrifice of Isaac* (competition panel). Gilded bronze. Florence, Museo Nazionale del Bargello.

3 Filippo Brunelleschi. *Sacrifice of Isaac* (competition panel). Gilded bronze. Florence, Museo Nazionale del Bargello.

leading competitors for the Baptistery commission, would have disliked each other in any case, but the contest became the flashpoint for their bitter and life-long rivalry and a prototype for competition among artists.

Renaissance rivalry implies parity or near-parity, which is to say, one's rival is essentially one's peer: one does not duel with an inferior. This equality implies in turn an appreciation of an artist's status that was characteristic of the Renaissance. Patrons had always had preferences, but since the fourteenth century in Italy, beginning with such masters as Giotto and Simone Martini and such enlightened patrons as Petrarch and Robert of Anjou, the *individual* genius of artists had been vaunted. An artist may have a peer or peers – though the rhetoric of praise characteristically denies that fact – but one great master is not *interchangeable* with another.

The result of the Florentine competition of 1400–1401 was to be the second set of doors for the Baptistery. The first set, executed by Andrea Pisano between 1329 and 1336, was also the result of a competition – not among artists, however, but among cities.[10] Essentially political and often bellicose, these civic rivalries, interlaced with local pride or *campanilismo*, were given nonviolent expression in the construction of such public monuments. (The cathedral *campanile* or bell tower was one of the most conspicuous monuments in any

medieval or Renaissance Italian city and almost certainly the tallest: hence *campanilismo*.) The Florentine decision to commission the first set of doors for the Baptistery, for example, had been encouraged by the bronze doors of Pisa cathedral, made by Bonanus of Pisa in 1186 (and remade after the fire of 1595). The Florentines dispatched the goldsmith Piero di Jacopo to Pisa in 1329 to record those rival doors two months before Andrea Pisano set to work.[11] Having determined that their Baptistery doors were to be "as beautiful as possible," the Calimala charged Piero to "go to Pisa to see those doors that are in said city and to portray them," literally, to make their "portrait."[12]

The Florentines were not the only ambitious Italians. The construction of a new Florence cathedral beginning in 1296 had prompted Siena to rebuild their own Duomo, intended to be larger and in every way grander than the Florentine colossus.[13] The unfinished foundations of this abandoned building campaign stand next to the apse, testimony to Siena's thwarted ambition in the rivalry with Florence.

In the fifteenth century and thereafter, rivalry of patronage on the city-state level became increasingly personalized, involving both individual and corporate patrons. The Calimala, for example, were inspired to proceed with plans for the Baptistery doors because, beginning in the 1390s, a rival guild, the Arte della Lana (Wool Manufacturers), had been financing – and completing – decoration of the cathedral's Porta della Mandorla. Focusing on this local target in the civic arena, the Calimala transcended the ancient enmity between Florence and Siena, inviting two Sienese contestants to participate in the Baptistery competition. In Richard Krautheimer's words, "Florentine *campanilismo* must have winced."[14]

The Baptistery competition was later described by the winner, Lorenzo Ghiberti: "To me was conceded the palm of victory. [. . .] To me the glory was conceded unanimously, without any exception."[15] Other sources, including Brunelleschi's biography, confirm the gist of his account.[16] In the autobiographical *Commentarii*, Ghiberti reported that six artists competed in addition to himself, each being required by the contest rules to create a bronze plaque of the same subject, the *Sacrifice of Isaac*. Among the *combattitori*, as he called the contestants, only Brunelleschi and Ghiberti himself were native-born citizens of Florence.[17] Their works were judged by a committee of thirty-four who prepared a written report for the guild, but this document has been lost. The committee's decision was surely influenced by the fact that Ghiberti's panel weighed 7 kilos less than Brunelleschi's, savings in bronze that signified considerable savings of money.[18] And whether the contest was rigged (as Brunelleschi's supporters charged) or honest (as Ghiberti maintained), the Baptistery competition set a precedent for similar procedures in relation to other public commissions, including that of the Shrine of Saint Zenobius in 1432, also won by Ghiberti.[19]

Whatever Vasari might have known about the practical considerations involved in the competition or the acrimony between Ghiberti and Brunelleschi, he described the comportment of the principals as exemplary, in stark contrast

with the destructive invidiousness of his contemporaries. The story is told in the first edition of Vasari's *Lives of the Most Excellent Painters, Sculptors and Architects* in 1550 and repeated in 1568, and the heroes are Brunelleschi and Donatello, who is wrongly described as one of the contestants. Judging themselves and the others, they eliminated all but two of the competition panels for various reasons. Even Donatello's (fictitious) submission, "well designed and badly wrought," was dismissed. Ghiberti's was the best, in their opinion. "Neither was Brunelleschi's narrative much inferior, however." But viewing all the entrants, Donatello and Brunelleschi agreed that Ghiberti's panel was superior:

> And thus they persuaded the consuls with good reasons that the commission be given to Ghiberti, showing that public and private spheres would be better served thereby. And this was truly true goodness of friends and virtue without envy and a healthy judgment in knowing themselves, for which they deserved more praise than if they themselves had brought the work to perfection. Happy spirits who, while helping each other, delighted in praising another's labors, how unhappy are now our own spirits, [. . .] dying of envy in biting others.[20]

"Virtue without envy" may have been Vasari's ideal, but certainly not his reality, as he himself lamented. Of course neither was it fifteenth-century reality, a time characterized by a pattern of rivalries among artists, their patrons, their champions, and their styles. These various kinds of competition are visualized in another Florentine edifice, the guild church of Orsanmichele.[21] Constructed as a grain loggia in 1336–37, the building was venerated as the site of a miraculous image of the Virgin Mary. (Unhappily, its miracles did not include self-preservation, and the panel was replaced by Bernardo Daddi's *Madonna and Child Enthroned*, commissioned in 1347 and enframed by Andrea Orcagna's magnificent tabernacle, signed and dated 1359.) Each of the guilds was expected to contribute a statue of its patron saint to decorate the exterior piers of Orsanmichele. Most of the guilds proved delinquent, however, and in 1406 the Signoria sought to jolt them into action by imposing a ten-year deadline for the completion of the statues and their enframing niches. A guild's failure to do so was to be punished by forfeiture of the pier and its assignment to another guild – a very public and *permanent* humiliation.[22] Despite these admonitions, the enterprise took more than twenty years to complete, but the result was twelve sculptures: three each by Ghiberti, Donatello, and Nanni di Banco; one by Niccolò di Pietro Lamberti; and one attributed to Bernardo Ciuffagni but possibly designed by Brunelleschi.[23]

At Orsanmichele, rivalry among the patrons is inherent in the juxtaposition of their commissions: seen in immediate proximity, the statues invite comparison by the beholder. Moreover, none of these commissions is anonymous: each statue was labeled by its patron with the guild coat of arms. On at least one occasion, the guilds' rivalry was mandated by a contractual clause imposing competition on the artist, requiring the sculptor-signatory to outdo the

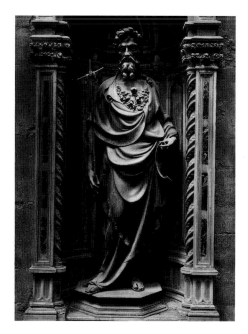

4 Lorenzo Ghiberti. *Saint John the Baptist*. Bronze. Florence, Orsanmichele.

others and indeed himself, in satisfying his patron. When it was installed in 1416, the Calimala's *Saint John the Baptist* by Ghiberti (Fig. 4) was the largest bronze statue of its time (the Calimala was also his employer for the Baptistery doors). Consequently, when the Arte del Cambio (Bankers) hired Ghiberti to execute their *Saint Matthew* for Orsanmichele, they stipulated that he must "make the said figure of Saint Matthew of fine bronze [. . .] at least as big as the Calimala's figure of Saint John the Baptist, or bigger, however would be best in the judgment of the said Lorenzo Ghiberti."[24] "Bigger" means *better*.

The fact that several masters were engaged in the Orsanmichele program was surely related to the number of patrons involved and to the timetable for completion of the work imposed by the Signoria. Elsewhere, cycles of sculpture for architectural monuments were more commonly assigned to an individual artist and his shop. Had history not interfered with their good intentions, for example, the Calimala would have proceeded to commission a second set of bronze doors from Andrea Pisano, who had completed the first set in 1336. A century later, when Ghiberti's doors were finally done, the Calimala turned to him again, for the final, third set of Baptistery doors, the Gates of Paradise. (This epithet is a pun, credited to Michelangelo, referring both to the beauty of the work as worthy of the celestial Gates of Paradise and to the space between the Baptistery and cathedral, called the *Paradiso*.[25]) Commissions for painted cycles were likewise usually awarded to individual artists and their shops – Giotto in the Scrovegni Chapel in Padua, for example – or to artist-partners, such as Masaccio and Masolino in the Brancacci Chapel in Florence.

The idea was not juxtaposition of styles but rather accommodation. In 1476, concerned that too many cooks would spoil his broth, the Duke of Milan, Galeazzo Maria Sforza, admonished the three artists decorating San Giacomo in Pavia, Bonifacio Bembo of Cremona, Vincenzo Foppa, and Jacomino Zaynario. They were to complete the frescoes according to their contracts, avoiding the use of "many hands" lest the results seem "deformed": "we wish that you observe your obligations, painting the paintings so that they not seem to be badly executed, as a result of being painted by many hands, as you seem to be doing; but one of you must do the work, being obligated to do so, and do it as soon as possible."[26] A similar desire for homogeneity prompted the Piccolomini to add a clause to the contracts with Michelangelo regarding his contributions to their altar in Siena cathedral, begun by Andrea Bregno and including work by several other masters as well. In these documents of 1501 and again in 1504, Michelangelo was asked "for his honor and courtesy and humanity" to finish the draperies and head of the *Saint Francis*, left incomplete by his enemy Pietro Torrigiani (perhaps this fact explains the appeal to his better nature), "so that it not reveal a master and different hand, [. . .] so that everyone who may see it will say that it was his work," that is, entirely Michelangelo's.[27]

Such patrons as the Piccolomini and Sforza meant to suppress anything (including over-reliance on assistants) that might threaten the harmonious appearance of their projects. By implication this meant to suppress artistic rivalry, or at least artistic individuality. The ideal of stylistic homogenization also found expression in the common contractual stipulation that the artist-signatory execute his commission "with his own hand," *a sua mano*. Of course, artists did not customarily work alone, and patrons were well aware of the fact – and aware too that the requirement was probably unenforceable in practice. The clause may be understood less as a legality than as a reflection of a patron's practical concerns – disparities of style would mar the results – and also his (or, occasionally, her) understanding of disparate artistic abilities.[28] At its simplest, that understanding is predicated on the assumption that assistants are not so good as their masters. The patron is paying for the master's work, not the pupil's. Such pragmatic concerns were increasingly subjugated to a belief in the inimitability of artistic genius. *His* hand becomes the hand of Raphael, of Michelangelo, of Titian, and no other will do.

In *Purgatory* (xi.91–96), Dante declared that the public perception of greatness is fickle: "O empty glory of human powers! [. . .] Cimabue thought to hold the field in painting, and now Giotto has the cry, so that the other's fame is dim." No one, certainly not Cimabue or even Giotto, can expect his achievements to win immortality. Implicit in Dante's account of ephemeral, hence meaningless, worldly success is the idea of confrontation of styles, and the triumph of one over the other: Giotto's manner displaces Cimabue's. Whereas Dante implied that Giotto, too, would be surpassed, his great fifteenth-century commentator thought otherwise. Discussing artists in his *Apologia di Dante* published in 1481, Cristoforo Landino praised Giotto as Cimabue's "noble

successor. [. . .] He was so perfect [. . .] that since his time, many others have been exhausting themselves having wished to outdo him."[29]

By Landino's day, a time more sanguine than Dante's about the worth of human accomplishments, individual style had come to be of fundamental importance in the appreciation of art. This new way of thinking is exemplified – not to say embodied – by Isabella d'Este Gonzaga, Marchesa of Mantua, in her protracted dealings with Giovanni Bellini. In November 1496 the marchesa opened negotiations with Bellini for a secular subject, to be displayed in her Studiolo in the Castello Gonzaga at Mantua, and at first Bellini expressed willingness to comply.[30] It is not known what subject Isabella had in mind, but it must have been akin to the first *fantasia* produced for the Studiolo, the *Parnassus* (*Mars and Venus*), by Andrea Mantegna, Bellini's brother-in-law and the Gonzaga court painter.[31] Isabella had been discussing Mantegna's possible commissions for the Studiolo with him as early as 1492, even before the room was complete. *Parnassus* was probably begun in 1496 and installed by 3 July 1497.[32] The chronology of the sequence of Isabella's dealings with the painters is suggestive. In 1496, with Mantegna's *Parnassus* presumably in progress, Isabella was already planning a second work for the Studiolo by Bellini. Judging from her later correspondence about portraits by Bellini and Leonardo da Vinci, one would not be putting words in Isabella's mouth to say that she wished to see works by Bellini and Mantegna *al parangone*, as she spelled the word.[33] (The situation recalls the confrontation of the *Cantorie* by Luca della Robbia and Donatello in Florence cathedral, a *paragone* intended by the patrons.[34]) Bellini was the first foreign master she sought for her Studiolo, after or perhaps at the same time as she began her project with her own court painter.

Isabella was still waiting five years later. According to her agent Michele Vianello, writing from Venice on 2 March 1501, Bellini's explanation for the delay was that he "was constrained by the Venetian government to continue the work begun in the Palazzo Ducale," in the Sala del Maggior Consiglio, "and he couldn't leave at any time."[35] Notwithstanding his obligations from dawn to dusk, however, Bellini would do the painting for Isabella, "when he could. About the price, he asked me for 150 ducats, but he'll come down to 100."[36]

A month later (1 April) Vianello informed Isabella that Bellini required the measurements for her painting – and an initial payment of 25 ducats.[37] The ducats were sent, and also instructions for an *istoria* or narrative.[38] Unfortunately, these instructions have been lost, but whatever Isabella wanted, it must have been high-minded and mythological, a suitable companion piece for the *Parnassus* and for the other "fantasies" that eventually decorated the room.[39]

Having received Isabella's 25 ducats, Bellini began to express reluctance about her narrative and the rivalrous juxtaposition of his work with Mantegna's. Vianello reported Bellini's doubts in a letter dated 25 June 1501:

> regarding that *istoria* which Your Ladyship has given him, one cannot say
> how very unwillingly he would do it, because he knows the judgment of Your

Ladyship and then [because] it is going to the comparison [*va al parangone*] with those works by Messer Andrea [Mantegna] and, notwithstanding, in this work he wishes to do as much as he will know how to do, and he says that in this *istoria* he cannot do the things that would fit well, nor does it have anything good in it, and he would do it most very unwillingly as much as one can say, so that I doubt that he would serve Your Excellency as she would desire. So that, if it appears to Your Excellency to *give him the liberty to do what he pleases*, I am most certain that Your Ladyship will be much better served.[40]

Whatever his doubts about the subject or himself, Bellini's refusal to "va al parangone" with Mantegna may also have been reluctance to undermine his brother-in-law, who had never been able to take Isabella's favor for granted.[41] And whatever Vianello's doubts about Bellini, his advice to Isabella is extraordinary: "give him liberty," *darlli libertade*. More remarkable still, Isabella accepted this recommendation, asking only that Bellini paint a classical theme: "If Giovanni Bellini would do this *istoria* so very unwillingly, [. . .] we shall be content to *submit to his judgment*, provided that he paint some ancient narrative or fable of his own invention or pretending to be one that represents something ancient."[42]

Isabella's tempered response to the artist's caviling suggests that she may have learned from her husband, Marchese Francesco II Gonzaga, that submitting to Bellini's judgment was the only way to get him to cooperate. In October 1497 – one year after the beginning of Isabella's negotiations with the painter – Gonzaga had been forced to this conclusion, writing to Bellini that he would "defer to your judgment regarding what should be painted" on a picture in the marchese's collection. Gonzaga had wanted Bellini to "paint the city of Paris" but accepted Bellini's explanation for rejecting this idea, "because I have never seen it."[43] Surely the marchese knew as well as Bellini did that artists commonly paint what they have never seen: his gracious acceptance of what he must have recognized as a lame excuse means that Gonzaga wanted something by Bellini's hand more than he wanted to "see" Paris on his picture. Bellini in turn acknowledged the marchese's flexibility in a letter that is at once appropriately sycophantic, in the traditional fashion of a Renaissance painter addressing his noble patron, and assertive, in the artist's declaration of his intellectual independence:

I have learned from Your Lordship's letter that Your Lordship has changed his mind about my adding a view of the city of Paris to the painting that I have [in hand]. And this because I have never seen it. Your Most Excellent Lordship for his humanity and benignity yields to my judgment that I paint on said painting what seems appropriate to me. [. . .] thus I shall fortify myself with my little talent [*ingegno*] to do that which would be pleasing to Your Excellency.

Again that with a more secure soul I shall have served you, having understood something of your fantasy [*fantaxia*], but I shall not cease, as I have

said, from using my every diligence in order to content Your Most
Illustrious Lordship.[44]

Clearly, both the Marchese and the Marchesa of Mantua desired to possess
works by Bellini, and the artist was evidently much discussed at their court
(more on their discussions presently). While Isabella pursued Bellini, Bellini
continued his Fabian tactics, adding injury to insult when he completed a *Saint
Dominic* for her brother, Alfonso d'Este, Duke of Ferrara. Rubbing salt in the
wound, Isabella's agent Lorenzo da Pavia informed her about the painting in
a letter offering *pro forma* reassurance about the work Bellini was supposedly
doing for her: "Regarding the [marchesa's] painting by Giovanni Bellini, he is
being pressed with all diligence. Now he has completed a half-figure of Saint
Dominic on a small panel, which is very beautiful, and it was done for Lord
Alfonso."[45]

Isabella persisted, and Bellini reassured her that he would paint "a fantasy
in his own way."[46] By now, however, her patience was wearing thin, and
Isabella changed her mind. Instead of the secular narrative for her study, which
Bellini had not yet produced, she would like a *Presepio*, that is, a *Nativity*, for
a bedroom: "we don't care anymore about said picture [the fantasy] and if,
instead of that work, he would like to do a *Nativity*, we shall remain very
content. [. . .] In this *Nativity*, we shall want to have the Madonna and Our
Lord God, Saint Joseph, a Saint John the Baptist, and the beasts."[47]

Bellini seemed to agree to this commission, though Isabella rejected his
suggestion that he use the canvas he had already prepared for the abandoned
Studiolo picture: the *Nativity* was meant for a bedroom, Isabella said, and not
her study. She required different dimensions, therefore – and offered a differ-
ent fee, also because the *Nativity* entailed fewer figures than the secular
subject.[48] Perhaps Isabella felt she was pressing her luck by insisting too much,
however, because in a subsequent letter she offered an olive branch, or a loop-
hole: "We are content that Master Giovanni Bellini do the *Nativity* in place of
the *historia. If for some reason he shows himself inclined to abandon the
'Nativity' and to do some other of his new inventions of the Madonna, we shall
be content that he do so*: [but] the truth is that we shall be more content with
the *Nativity.*"[49]

Bellini's answer to this was that the presence of Saint John the Baptist at the
Nativity was "inappropriate" – *fuori de proproxito*. Instead of the *Nativity*,
therefore, he proposed to do "a *Madonna and Child*, with the Baptist and some
distant vistas [*luntani*] and other fantasies" – and all this for a bargain price
of 50 ducats.[50] At first, Isabella was willing to accept such a painting, provided
that the *Madonna* include Saint Jerome as well as the Baptist, "*with the other
inventions that will then seem appropriate*" to Bellini.[51] But ten days after dis-
patching these instructions to her agent, on 22 November 1502, she declared
that she had changed her mind. She wanted a *Nativity* after all, though she
would leave the choice of canvas or panel to Bellini, and – more importantly
– she agreed that he might

indeed make the *Nativity* without Saint John the Baptist, since he will still
be satisfied about it, because the change that we made [in requesting a
Madonna] was made because of the concern that he unwillingly accepted the
commission of the *Nativity*, the painting of which [subject] we desire more
than any other because we don't have one; and on that account we implore
you that he begin the painting and *that he do it in his own way so that it be
beautiful and correspond to the fame of the painter.*[52]

The subject mattered, but the beauty of the work as an example of Bellini's art
mattered even more.

The painting was nearing completion by next fall, but Isabella's correspon-
dent would not be allowed to see it: "it will not be possible for me to see the
picture that Giovanni Bellini is painting because *he never shows anyone
anything of his that is not finished.*"[53] (The insistence on working in secrecy
also characterized Michelangelo, at this same date finishing his *David* behind
walls that he had had constructed to assure his privacy.)

Still waiting for her *Nativity* in April 1504, Isabella lost patience. Writing to
the Venetian nobleman Alvise Marcello, the marchesa explained that she
wanted her 25 ducats back from the artist, even if it became necessary to "say
a word about it to the Serene Prince," that is, the doge, "or to another magis-
trate." It was the principle of the thing that prompted Isabella's request for
Marcello's intervention, "not so much for the recovery of the cash, as not to
endure the injury received from Bellini."[54] The threat, or perhaps her address-
ing Bellini through a patrician intermediary, worked. Bellini himself replied to
Isabella with a letter expressing his contrition, "kneeling to beg her pardon
[. . .] praying to Our Lord God that if in the course of time he has not so sat-
isfied the aforesaid Your Ladyship [. . .] in this work she remain content," refer-
ring to the picture that he was at long last completing for the marchesa.[55] There
is a three-month gap, however, between Isabella's complaint to Marcello, dated
10 April 1504, and Bellini's letter of apology to Isabella, dated 2 July, the impli-
cation being, in those days of rapid communication by messenger, that the
painter may have been apologetic, but he was not in any hurry to say so.
Bellini's delay in replying belies the abject tone of the letter. Isabella accepted
his apology, however, writing to the artist within the week (9 July): "If the
painting of the picture that you have made in our name corresponds to your
fame, as we hope, we shall remain satisfied with you."[56]

Isabella had already received some encouraging news about the work.
Lorenzo da Pavia had been able to reassure her in a letter of 6 July 1504 that
Bellini's painting "truly is a beautiful thing, he has done better than I believed.
I know that it will please Your Excellency. And in this painting he has really
done his utmost, mostly for respect of Messer Andrea Mantegna" – not for his
patron, that is, but for his kinsman and rival.[57] Evidently Bellini continued to
see himself, or his work, in precisely the kind of *paragone* he reportedly had
wished to avoid in shirking Isabella's first commission for a *fantasia*. Lorenzo
certainly understood the situation in this way and thought that the sense of

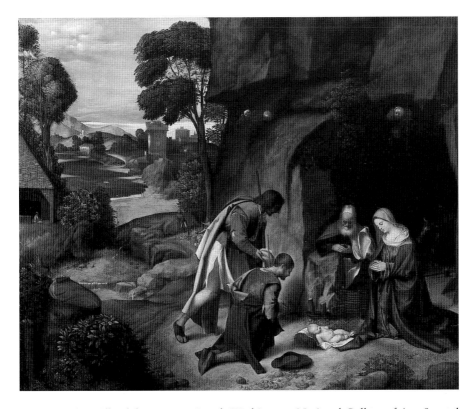

5 Giorgione. Allendale *Nativity*. Panel. Washington, National Gallery of Art, Samuel H. Kress Collection.

rivalry had inspired Bellini to honor both himself and his brother-in-law by making a work of exceptional beauty, "Even though it's true that in invention he can't approach the most excellent Messer Andrea. So that I pray Your Ladyship deign to take the painting for her honor and also for the effect of the work."[58] In a letter of 16 July, while repeating that the *Nativity* "really is a very beautiful thing," Lorenzo reiterated his criticism of the figures but now added praise for Bellini's colorism: "I would have wished the figures larger. As I wrote in my other letter, in invention no one can approach Messer Andrea Mantegna, [. . .] but in coloring, Giovanni Bellini is excellent."[59] A third letter, written after the marchesa had received the painting, implies that Isabella may have shared Lorenzo's reservation that "the figures are small."[60] Lorenzo's reference to the figures' "reduced" scale has often been interpreted as an indication that Bellini's painting, which has been lost, resembled Giorgione's Allendale *Nativity* (Fig. 5). The critical opinion of Lorenzo and perhaps of Isabella herself regarding the "small figures" is a matter of taste: whereas Bellini and other Venetian masters painted landscapes – including, we may assume, Isabella's *Nativity* – in which figures are indeed small in comparison with their

setting, Mantegna emphasized the figures, who dominate their world. The manner in which Bellini privileged the landscape, which seemed inept to Lorenzo, may have seemed *modern* to other viewers.

This criticism notwithstanding, Lorenzo advised the marchesa to buy the painting without fail: "and all the more so, [Bellini's] being very old and getting worse."[61] In other words, this might be Isabella's only chance to get a painting by Bellini, and moreover, Lorenzo added, it seemed that the painter might have another client interested in the picture. Isabella bought the *Nativity* and was so pleased with it that she reopened negotiations with Bellini for a *fantasia* for the Studiolo. This time, however, Isabella asked Pietro Bembo to intervene with Bellini on her behalf. The Venetian humanist, poet, and prelate was himself a patron of Bellini's, and on friendly terms with him.

Like Isabella's own correspondence, Bembo's letters document a reversal of the traditional patron–painter relationship, describing Bellini's willfulness and advising Isabella to cajole him, if she wants him to satisfy her request. Bellini would paint her narrative, Bembo assured Isabella in a letter dated 1 January 1506, "as soon as the measurements or canvas is sent." But, he warned, Isabella would be constrained to forgo the invention she had in mind, about which she had previously written to Bembo, and submit herself to the artist's will: "Bellini [. . .] is most well-disposed to serve Your Excellency whenever he has the painting's measurements or the canvas. It will be necessary that the invention that Your Ladyship wrote to me, which I find on the drawing" – that is, for Bembo to transmit to Bellini – "be accommodated to the fantasy of him who has to paint it [. . .] very precise terms do not suit his style, *accustomed as he says always to roam at his will in paintings.*"[62]

Perhaps because Bembo's letter has been much cited, one forgets how extraordinary is his description of Bellini's artistic imagination and creative freedom – subjects that he and Bembo had evidently discussed. But the letter must also be read in the context of Isabella's dealings with other masters at the same time, notably Mantegna and Pietro Perugino. Like most patrons, Isabella was flexible about certain particulars and had fixed ideas about others. In any event, Perugino did essentially what he was told to do; adjustments to the original program of his *Triumph of Chastity* were authorized or suggested by Isabella herself.[63] Mantegna, as the Gonzaga court painter, was expected to satisfy Isabella's requests. He was not always so accommodating, however, when dealing with outsiders, including Bona of Savoy, Duchess of Milan. She had written to Marchese Federigo (Isabella's father-in-law) with the request that Mantegna produce a painting based on "certain drawings" which she included with her letter of 9 June 1480. Federigo showed the *disegni* to "my painter Andrea Mantegna," the marchese informed the duchess in his reply of 20 June. But Mantegna was uninterested: "he tells me that it would be a job more for a miniaturist." Federigo tried unsuccessfully to persuade him, "but usually these excellent masters have [a quality] of fantasy, and it's better to take from them what one can get" – in this case, apparently nothing.[64] The marchese's explanation anticipates Bembo's letter to Isabella some twenty-five years later, but

with this critical difference. Seeking to placate the Duchess of Milan, Federigo Gonzaga provided Mantegna with the "artistic temperament" defense, which may be seen in part as the marchese's offering a more gracious motive for the artist's refusal than Mantegna had provided for himself. The painter's suggesting a larger commission might be seen as venal; the marchese's suggesting that "recognized masters have something of the fanciful" is high-minded. All of this is Federigo's explanation, not Mantegna's. Bembo's letter, on the contrary, quotes Bellini himself, informing Isabella moreover that the painter is "accustomed" to his artistic freedom. Equally (or more) remarkable, Bembo's letter documents the fact that Bellini's imagination was a subject of discussion between the painter and noble humanist.

Only Bellini was capable of resisting the marchesa's "assaults," like the fortress to which Bembo compared him in a letter of 27 August 1505. In this letter, Bembo reassured Isabella, "I have not forgotten that I promised Your Ladyship to do everything in my power to see that Giovanni Bellini accept the commission of a painting for Your Ladyship's Studiolo. [. . .] In sum, we have waged such a battle against him that I believe the fortress will surrender. To achieve which end it would be most helpful if Your Ladyship wrote him a warm letter about it, urging him to please her, and send it by my hand, as I am certain that the letter would not be written in vain."[65] Bembo's offer to deliver Isabella's letter confirms his close relationship with Bellini and his commitment to her project.

Isabella listened to her Venetian adviser, and the saga ends with a letter to Bellini that is tantamount to a subjugation of her will to his. The marchesa even excused herself to the painter for not having written earlier:

> Messer Giovanni. However much our desire may have been to have a picture painted with a narrative from your hand to place in our studio near those of your brother-in-law Mantegna, you have easily let the agreed times pass so that we have not had the narrative done promptly, but on account of your many obligations, you have not been able to do it; and [. . .] we have accepted the *Nativity* in place of the narrative [*historia*] that you initially promised to do, which greatly pleases us, holding it as dear as any painting that we have. [. . .] we have been vexed with a fever so that we have not been able to attend to such matters, but now that we are in better health, it has come to us to write this present letter of ours, praying you that you will be agreeable to painting another picture, and *we leave to you the responsibility of conceiving the poetic invention*, when you do not doubt that we desire it, that beyond the courteous and honorable payment for it, we shall feel eternal gratitude.[66]

This is the kind of artistic license that Leonardo and even Michelangelo perhaps dreamed of but rarely achieved in commissioned works – and which Titian was able to claim for himself only by sending *un*commissioned paintings to King Philip II of Spain for which the painter hoped eventually to be paid. Titian, like Bellini, took "responsibility for conceiving the poetic invention";

6 Andrea Mantegna. *Cult of Cybele*. Canvas. London, National Gallery.

but, unlike Bellini (and in at least one instance, Michelangelo), he had no assurance of payment, there being no contractual agreement with his royal patron for these works.[67]

Bellini's refusal to paint a narrative for Isabella's Studiolo is usually interpreted as an expression, or confession, of insecurity – a concern that his efforts might not equal Mantegna's achievement. But there is another way of interpreting Bellini's response to Isabella, namely as an assertion of his status and the uniqueness of his art: "not to be compared," *non andare al paragone*, may imply "incomparable," without paragon. Isabella herself confirmed Bellini's self-regard by her wrangling to obtain work by him, ultimately accepting whatever he was willing to offer, as indeed her husband had been, in accepting Bellini's reluctance to paint the city of Paris. Bembo's letters to Isabella confirm this interpretation of the master's artistic autonomy: no one can tell Bellini, Bembo told Isabella, what to do. Earlier artists may have felt the same way about avoiding comparison or dictating to their patrons, but we have no contemporaneous record of their feelings – in part, presumably, because no one considered them worth recording.[68]

In Bembo's letter to Isabella of 1 January 1506, urging her to let Bellini roam at his will, the writer also asked a favor of Isabella, that she intervene with Mantegna on behalf of Francesco Corner (Cornaro), Bembo's friend and kinsman. The previous spring, Corner had commissioned Mantegna to paint a frieze in grisaille representing the life of Scipio Africanus, the ancestor of the Corner, according to the family's mythologized genealogy. "Now he tells me," Bembo wrote, "that this Messer Andrea doesn't want to do the work anymore for the agreed price, and he's asking for a lot more. [. . .] For which reason, I pray and supplicate Your Ladyship [. . .] that Your Ladyship persuade Messer Andrea to honor the commitment given to Messer Francesco. [. . .] I promise you that all that Your Ladyship does with Messer Andrea to help resolve the matter of Messer Francesco's paintings, the said Messer Francesco will repay from here to be of use in expediting Your Ladyship's affairs with Giovanni Bellini."[69]

Unfortunately, as Isabella explained in her reply, Mantegna was gravely ill.[70] Indeed, he died shortly thereafter, having finished only the *Cult of Cybele* (Fig. 6).[71] And now Bellini agreed to complete the cycle for the Corner though

7 Giovanni Bellini and assistants. *Countenance of Scipio*. Canvas. Washington, National Gallery of Art, Samuel H. Kress Collection.

delegating the greater part of the execution of the work, representing the *Countenance of Scipio*, to assistants (Fig. 7). In this case, it seems that a direct confrontation with (or against?) Mantegna did not disturb Bellini, and neither did the fact that he was the patron's *second* choice.[72] Although Mantegna was now dead, this was not, and is not, relevant to the *paragone* of his art with Bellini's – a *paragone* inevitably more directly in the Corner studio than anything Isabella might have conceived, given the theme of the life of Scipio Africanus and the use of grisaille. One may wonder too that Bellini should have assigned so much of the Corner commission to assistants. Was he uninterested in the subject or in painting fictive reliefs in grisaille?

Whatever Bellini's motivations, it was the painter, not the patron, who controlled their dealings and determined the outcome because something fundamental had changed in the conception of art and its acquisition. Isabella wanted something by Bellini's hand more than she wanted a painting of a particular subject. The patron's primary concern was the acquisition of a work – *any* work – by a certain master. Now we may speak of "a Leonardo, a Raphael, a Titian, a Michelangelo," thus making the artist's name synonymous with his art, and indeed, in some cases, more significant than the particular work. This decidedly modern conception of art and artists began with such collectors as Isabella and such masters as Bellini. As for the artist himself, here too one recognizes a sea change in self-perception, as Bellini, his contemporaries and successors become more professionally self-aware than their predecessors, and in consequence, more rivalrous.

Isabella's brother Alfonso d'Este, Duke of Ferrara, was similarly concerned with matters of individual style. After the death of Raphael in 1520, for example, the duke was unwilling to accept a work by the artists' heirs in fulfillment of the master's contract for a *Hunt of Meleager*, intended for the duke's Camerino d'Alabastro. Alfonso's decision was predicated on the distinction between idea and execution. Raphael had already conceived the composition, so his heirs Giulio Romano and Gianfrancesco Penni would have been following the master's directions in completing what he had begun. Alfonso wanted not only Raphael's conception, however; he wanted Raphael's facture. In the context of the painting's intended site, the Camerino, this was particularly important. The work had to be autograph because it was to be displayed with

other works by other masters. (Dante's reference to Cimabue and Giotto in *Purgatory* anticipates this kind of confrontation between great masters, though the poet's primary concern in naming them was to illustrate the vainglory of human powers.) Unlike Galeazzo Maria Sforza in Milan or the Piccolomini in Siena, who wanted homogeneity in individual cycles or monuments, Alfonso purposefully sought artistic difference for his Camerino.

The idea had a classical pedigree. Philostratus the Elder had extolled the juxtaposition of works by different masters as a demonstration of the patron's abilities as collector and connoisseur. The fictional villa of the *Imagines* is "particularly splendid," Philostratus explained, "by reason of the panel-paintings set in the walls, paintings which I thought had been collected with real judgment, for they exhibited the skill of very many painters."[73] With this text in hand, Alfonso planned to decorate his study with works by various masters, stylistic variety being the spice of the collection.[74] Isabella – whose copy of Philostratus Alfonso had borrowed – did the same in her Studiolo in Mantua. Predicated on the juxtaposition of works by different masters, such arrangements necessarily involve competition among makers and their collectors. When Isabella decorated her Studiolo or Alfonso his Camerino, they did so with the express purpose of comparison: works by the greatest masters were meant to be seen together. Competing in the acquisition and display of their collections, such patrons as the covetous Este siblings inevitably stirred competition among artists whose works they displayed together. Ancient and contemporary art, sculpture, and painting, works by Venetians, Romans, Florentines, and Northerners, confronted each other in intimate spaces that invited the viewer's engagement in games of connoisseurship and interpretation. Rivalry was inherent in the very concept of a study, therefore, as patrons themselves inform us when they require that each master's work is to be worthy of display with its predecessors – a variant on the familiar contractual clause stipulating that works equal or surpass similar works done for other patrons. In the case of a study, precisely because the patron and the site were the same, the artist was compelled to confront his competitors directly: their works were made to be compared not in the viewer's memory but in the act of beholding. Rivalry among collectors is thus interwoven with rivalry among the artists they patronized – Titian competing with Giovanni Bellini in Alfonso's Camerino, for example, or Bellini refusing to compete with Mantegna in Isabella's Studiolo. Rivalry among artists was similarly bound to confrontational patterns of patronage at Orsanmichele. Yet the most conspicuous instance of authorial multiplicity in the execution of a Renaissance cycle, and the most prestigious, involved only one patron: Pope Sixtus IV della Rovere and his Sistine Chapel.

Constructed between 1475 and 1481, the chapel was decorated during the following two years with papal portraits and cycles of Moses and Christ by Sandro Botticelli, Domenico Ghirlandaio, Cosimo Rosselli, Perugino, Bernardino Pinturicchio, and Luca Signorelli (Figs. 8, 9, 10).[75] The pope's choices reflect his taste. In the chapel and elsewhere, Sixtus favored Central

8 Vatican, Sistine Chapel.

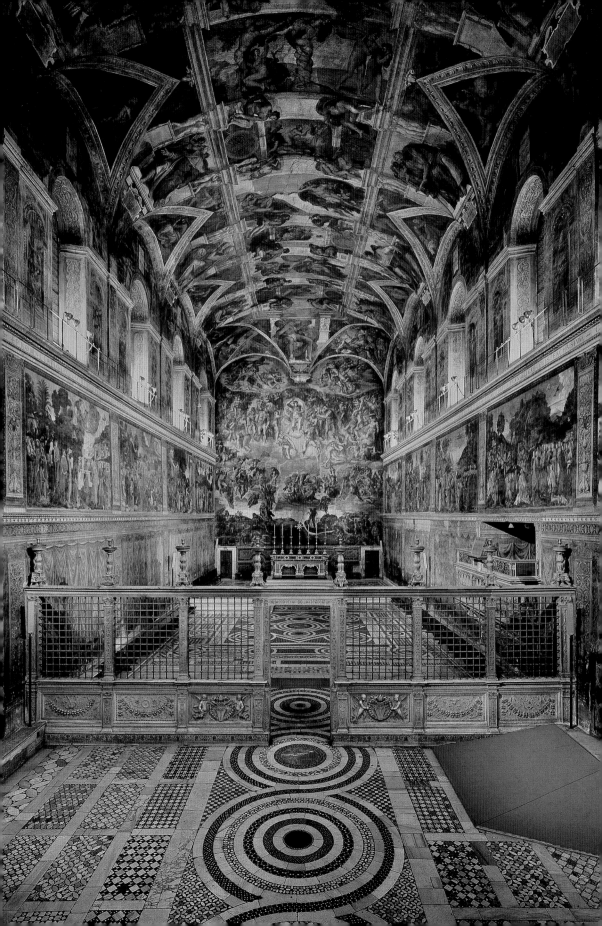

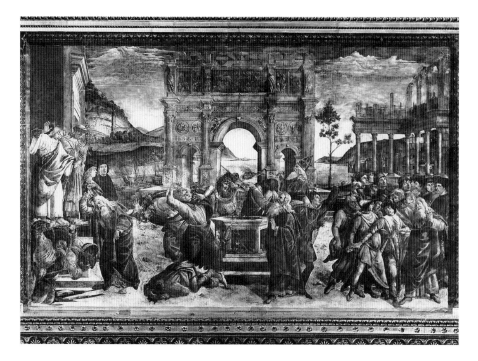

9 Sandro Botticelli. *Punishment of Korah*. Fresco. Vatican, Sistine Chapel.

Italians and Tuscans in particular. North Italians are entirely absent from his roster, and, most remarkably, one great Florentine master is conspicuous by his absence: Leonardo da Vinci, who moved to Milan just as the chapel decoration was getting under way. The omission is all the more significant given the fact that three of Sixtus's artists – Botticelli, Ghirlandaio, and Perugino – had been associated with Leonardo's own master, Andrea del Verrocchio.[76]

Nothing in the historical record tells us what the painters or their patron thought about the division of labor in the Sistine Chapel, that is, whether Sixtus intended to inspire competition among his artists. The situation was inherently rivalrous, however, as in the Sala del Maggior Consiglio in Venice, where Bellini and Vivarini were similarly set to work together, according to Vasari, "so that competition would make everyone work better."[77] Similarly, there was an implicit rivalry among painters (and perhaps between patrons) in Lorenzo il Magnifico's employing three of Sixtus's artists, Botticelli, Perugino, and Ghirlandaio, together with Filippino Lippi, for the decoration of the Medici villa at Spedaletto near Volterra, c. 1490.[78] Perhaps Sixtus merely hoped that by hiring a number of masters, he would see his chapel completed sooner rather than later.[79] In any case, he had undeniably created an extraordinary situation, introducing artistic rivalry to one of the most conspicuous sites in Christendom. Even (especially?) in this sacred setting, neither the protagonists nor

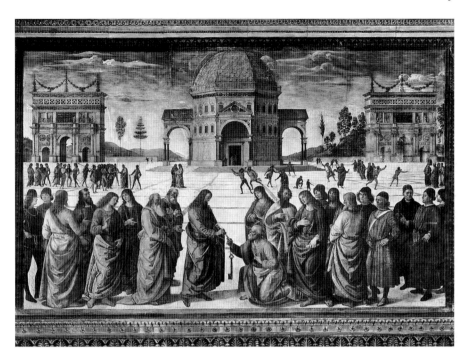

10 Pietro Perugino. *Christ Giving the Keys to Saint Peter*. Fresco. Vatican, Sistine Chapel.

their contemporary viewers can have been indifferent to the competitiveness inherent in their joint endeavor. The painters themselves cannot have ignored the fact that their works would be seen together, each praised or found wanting in comparison to the others, with the agon focused on elements of style precisely because all the narratives were required to adhere to certain unifying compositional principles. Similarly, whatever pious or political thoughts may have occurred to the chapel's more discerning Renaissance viewers, they would also have noticed the differences between Botticelli's *Punishment of Korah*, for example, and Perugino's *Christ Giving the Keys to Saint Peter*. Rivalry now had the papal imprimatur.

When Sixtus's nephew and eventual successor, Pope Julius II della Rovere, decided to repaint the Sistine ceiling and to redecorate the Vatican Apartments, he also brought together a disparate group, Raphael and Michelangelo among them. Their rivalry was so acrimonious, at least on Michelangelo's part, that contemporaries took note of it. Indeed, Julius himself was inevitably aware of it and of his fundamental role in their competition. At the same time, Julius was motivated in part by his own competitiveness, casting himself as the rival of his despised predecessor, Alexander VI Borgia, whose decoration of the residential quarters known as the Borgia Apartments the della Rovere pope sought to outdo in magnificence.

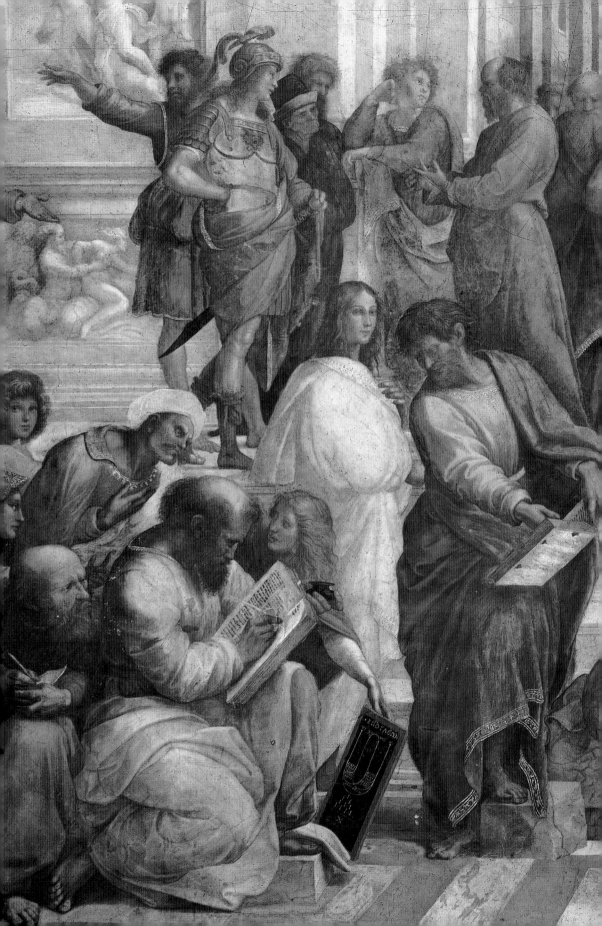

2

Agon

I F SIXTEENTH-CENTURY ITALIANS were to come back to life today, they would discover that history has vindicated their judgment. We still venerate the same masters as they did, notably Leonardo, Raphael, Titian, and Michelangelo. We still rely on the same source for much of our information, namely, Vasari's *Lives*. And we still call their era by the name that they themselves used: Renaissance, *Rinascità* in Italian, that is, "rebirth," alluding to the rebirth of classical civilization.[1]

In the early fourteenth century, Petrarch had written of his hopes for the rebirth of the glories of ancient Italy, by which he meant both the political and the cultural achievements of the Roman Empire, achievements that would bring light to the world after centuries of darkness: "For who can doubt that Rome herself would rise again instantly if she began to know herself."[2] He did not think that he would live to see this rebirth, Petrarch lamented, but he profoundly hoped that future generations would do so. Thus Petrarch articulated two interrelated conceptions of history that Vasari later incorporated into his *Lives*: periods of light opposed to periods of darkness; and the biological cycle of birth, death, and rebirth.[3] *What* was reborn, and where, Petrarch has already explained: ancient Roman civilization, to flourish again in Italy. *When* the rebirth took place is recounted by later authors, who, unlike Petrarch, felt themselves to be present at the blessed event. Rather than "rebirth," however, one should speak of "rebirths," because the arts did not arrive, or revive, in tandem. Men of letters led the way. Such fifteenth-century humanists as Flavio Biondo credited Petrarch himself with the revival of classical literary standards.[4] But Italian literary humanism already existed before Petrarch, notably in the work of Albertino Mussato and Lovato dei Lovati.[5] In Padua in 1315, Mussato became the first humanist to be publicly crowned with laurel – a consummation devoutly wished by Dante and Petrarch but achieved by them only some years later.[6] Surely Petrarch, despite his protests (perhaps not entirely disinterested), must have recognized that the renaissance of letters was well under way. As for the visual arts, Giovanni Boccaccio was among the first to announce their rebirth, crediting Giotto with having revived the dead art of painting.

Detail of Fig. 119.

Rivalry is endemic in this cyclical scheme, implicit or explicit as each age succeeds the other, as each master surpasses his predecessors in the sequence of birth, death, and regeneration. By the fifteenth century, artists and their patrons seem to have acknowledged and sometimes to have encouraged rivalry among themselves. They were aided and abetted in this agon by the examples of classical antiquity provided by Pliny the Elder, whose *Natural History* was more widely available than ever before, with the first printed editions appearing c. 1470 and Cristoforo Landino's edition published in 1476. By the end of the century, personal, sometimes deeply felt rivalries among the greatest masters were so powerful that they could become a subject of discourse.

The art history of the High Renaissance as sixteenth-century Italians described it was one of reputations being made, patrons wooed, arguments debated – and rivals surpassed. For Vasari, the development of the "modern style" – the style now commonly called the High Renaissance – was propelled by rivalry among the leading masters of his time, as artists responded to each other's work.[7] Of course Vasari did not "invent" competition, but the theme so permeates the *Lives* as to have encouraged rivalry among his readers, patrons as well as artists.

Artists have always borrowed from each other. Borrowing or reiteration of a prototype was frequently required by contractual stipulation or by sacrosanct traditions regarding the appearance of sacred beings, from the colors they wear to their demeanor when they participate in certain events. Saints are meant to be recognizable, whoever represents them. What is different about the sixteenth century is that the great masters knew each other's work (or knew it better than their predecessors, in part thanks to print media); they often knew each other's major patrons; and they knew each other, sometimes as friends and colleagues, sometimes as enemies – but always as rivals.[8] Their lives and art were bound together perhaps more than in any preceding generation. For sixteenth-century artists, the borrowing or repetition of motifs was not merely quotation or the observance of tradition: it was dialog or dialectic, sometimes combative (as when Titian revises Michelangelo), sometimes a pacific declaration of admiration (when Raphael emulates Leonardo), sometimes hostile (when Cellini confronts Bandinelli). In each case, the response was rivalrous, its intent being to surpass the referent. The sense of rivalry was pervasive, involving past and present, both living competitors in the marketplace and past heroes, dead for centuries but worthy competitors nonetheless. Competition with the classical past included surviving monuments and those known only through laudatory *ekphrases* or descriptions, involving in turn the rivalry or *paragone* between the sister arts, painting and poetry. (For Lodovico Dolce, they were not sisters but "almost brothers."[9]) By definition, the *paragone* is a rivalry that only one art (or artist) can win.

Renaissance rivalry thus embraced the dead as well as the living. And the most ardent rivalry was reserved for the living. Renaissance rivalries, then, were sometimes personal, sometimes a matter of theory or philosophy: they might concern conflicting personalities or contradictory ideas. Artists competed

with each other, sometimes for the immediate and pragmatic advantages of patronage, sometimes in the expectation of immortal fame. These kinds of individual rivalry were often accompanied by regional rivalries, as each republic or commune vaunted the superiority of its own style. *Campanilismo* permeates every facet of Vasari's *Lives*. His preference for Tuscan masters is based on taste, of course, but taste predetermined by his patriotism. Vasari was not alone in allowing "love of the fatherland" to cloud his judgment. Lodovico Ariosto was found guilty of the same error in including Battista and Dosso Dossi in his list of "illustrious painters" in *Orlando furioso*, according to Dolce's "Aretino" (who forgives the great poet this peccadillo).[10] Venetians, of course, were not immune to such patriotic clouding. Even when Sebastiano del Piombo was living and working in Rome, his compositions and his style now thoroughly Michelangelesque, Venetians continued to describe him as "ours," *nostro*. But anywhere in Italy is better than anywhere else: if only Albrecht Dürer "had been born in Italy [. . .] he would not have been inferior to anyone."[11] Interwoven with such personal, regional, and national rivalries are the rivalries of competing theories or doctrines: the *paragone*, notably the rivalry of painting and poetry, painting and sculpture; and the gendered rivalries of style, that is, masculine *disegno* (drawing) and feminine *colorito* (the expressive use of color).

Men of letters debated yet another kind of stylistic rivalry concerning the emulation of models in writing, a discourse with implications for artists as well. Should an author – or an artist – imitate one model or many? The Florentine Giovanni Francesco Pico della Mirandola endorsed the imitation of numerous models in a letter to Pietro Bembo dated September 1512: "I say that one must imitate all the good writers, not only one, and not in everything."[12] Such multiple imitation is explicitly bound to the hope, or expectation, of eclipsing one's predecessors. "You may emulate and also surpass in every argument the invention transmitted by others," Pico declared; "you may compose better, also discusss [the invention] with greater elegance."[13] Replying to Pico on 1 January 1513, Bembo agreed that one should of course strive to outdo one's exemplar but warned against such blatant eclecticism: "It would be as though you thought it possible, in constructing a single palace, to reproduce textually many models of conception and diverse execution."[14] The author should imitate only one model and embrace him completely: "we should imitate the one who is best of all" – namely Cicero – and "Who wishes to deserve the name of imitator [. . .] must reproduce the totality of the style of his model."[15]

Michelangelo may be seen as the "Ciceronian" model for the visual arts of his time, as Giotto had been for an earlier age.[16] From early in his career, Michelangelo had cast himself in this central role, manipulating public perception of himself as the great master of his age. He achieved this desideratum by means that seem modern, a kind of public relations campaign, sometimes embellishing the truth and sometimes bending it. Michelangelo was certainly bending (or breaking) the truth, for example, when he denied practical knowledge of painting before the Sistine ceiling. In reality, he had completed at least one panel (the Doni *Madonna*) and had trained in the Ghirlandaio shop for

approximately two years – a fact Michelangelo ignored in his own writings (including a sonnet written while he was at work on the ceiling) and eventually sought to deny through his authorized biography by Ascanio Condivi, published in 1553. Similarly disingenuous were assertions that Michelangelo worked alone.[17] And Michelangelo's contemporaries colluded with him by acknowledging, tacitly or explicitly, his genius and his primacy. But the fundamental reason for the success of his propaganda campaign was that, for all his machinations, Michelangelo was utterly truthful about one thing, the fundamental thing: his great teachers were nature and classical antiquity. Throughout his career, he remained indebted principally to them – and to himself. More than any of his contemporaries in a remarkably self-aware generation, Michelangelo remained self-referential.

The self-consciousness of sixteenth-century artists and patrons seems unprecedented even by their own recent past, finding an antecedent in fabled antiquity, notably in the figures of Apelles and his patron, Alexander the Great. These great personages were seen as prototypes and rivals to be surpassed by present-day artists and patrons. Fourteenth- and fifteenth-century masters might be extolled as "New Apelles," including Fra Angelico in the Latin epitaph of his tomb in Santa Maria sopra Minerva in Rome: "Let me not be given praises because I have been like another Apelles but because I gave all my earnings, O Christ, to thine."[18] But later masters hope to *excel* Apelles, and Bellini, for one, was said to have done so. Had they been contemporaries, Alexander would have chosen "not Apelles but Bellini," according to the poet Nicolò Liburnio, writing in 1502.[19] Vasari made an even greater assertion for Michelangelo, declaring that no work, past or present, ever exceeded Michelangelo's in painting and sculpture. And Cellini claimed the laurels for himself, informing readers of his *Autobiography* that his various works have no equal, ancient or modern – and moreover, he had François I, Duke Cosimo de' Medici, and even Michelangelo say as much: "Who was this master who has portrayed you so well and with such a beautiful style [*con sì bella maniera*]?" Cellini's Michelangelo inquires of Bindo Altoviti. "And know that this head pleases me as much and better than anything that the ancients did; and to be sure, there are some beautiful things of theirs to be seen."[20] (Michelangelo then advises Altoviti on how better to display his bust given the room's ambient lighting.) Whether Michelangelo admired Cellini's work in precisely these words is beside the point. Favorable comparison with antiquity had become the "classic" encomium, a trope perhaps all the more significant for its repetition. And Michelangelo's judgment had become gospel.

By the mid-sixteenth century, when Cellini was writing his *Autobiography*, such authors as Vasari and Dolce began to write new kinds of literature on art. Cellini's life was not printed until 1728, but Vasari, Dolce, and others wrote for publication, and their works were readily available to artists and their patrons. Writing of rivalries, these texts engaged in rivalries of their own: in 1548 Paolo Pino rushed his *Dialogo di pittura* into print, prompted in part by competition with Benedetto Varchi's *Due lezzioni*, presented in 1547 (though

not published until 1550), and in part by the desire to "scoop" Vasari's first
edition.[21] Condivi's biography of Michelangelo was intended to emend and
supplant Vasari's first Life of the master; Vasari's second edition in 1568
responded to this challenge and also, in a more general way, to Dolce's
Dialogue on Painting (the *Aretino*), published in 1557, that is, to the rivalries
of style and of *disegno* as opposed to *colorito*. (Not coincidentally, the second
edition of Vasari's *Lives* includes his autobiography.) Cellini's *Autobiography*
records his triumphs over hated rivals; Varchi's *Lezzioni* reiterate the rivalries
of the *paragone* of painting and sculpture; in their poetry, Pietro Aretino,
Michelangelo, and Agnolo Bronzino, among others, address the *paragone* of
literature and the visual arts.

Giving voice to the rivalries of men and ideas that characterized the art of
their time, such authors made rivalry a Leitmotif of writing about art, its
making, and its acquisition. The subjects of Vasari's *Lives*, for example, find
rivalry everywhere, sometimes recognizing it even where it did not exist, or at
least not to such a degree as the author would have his readers believe. In one
notorious case, he exaggerated its force to deadly extremes, falsely accusing
a murderously jealous Andrea del Castagno of slaying Domenico Veneziano.[22]
Yet Vasari also extolled nonviolent artistic rivalry as a bloodless revolution
culminating in the triumph of his hero, Michelangelo. From now on, Vasari
proclaimed, any artist should learn from two masters: nature and art –
preferably the art of Michelangelo. In Dolce's *Dialogue on Painting*, proxies
for the Venetian and Central Italian schools acclaim the achievements of
Raphael, Michelangelo, and Titian, ultimately asserting Titian's superiority.
Like many other Renaissance dialogues – and indeed like Plato's – Dolce's dia-
logue is agonistic.[23] The Venetian advocate in the *Dialogue* is Aretino himself,
recently deceased but well known as one of Titian's closest friends and his great-
est publicist, in several volumes of letters and poetry.[24] (Aretino was also a
former admirer of Michelangelo, who had become one of his most acerbic
critics.) Vasari recognized Aretino's extraordinary role in Titian's career,
describing in his Life of the artist how "Aretino, the very celebrated poet of
our times, became the greatest friend [. . . and] was of great honor and use
to Titian, because he made him known as far as the reach of his pen, and
especially to princes of importance."[25]

Renaissance patrons similarly became rivals in sacred and public arenas. In
the domestic sphere, competitiveness was reified in the studiolo or camerino, a
retreat where a collector might enjoy his or her collection and vaunt its treas-
ures to visitors. And like their guild, civic, and ecclesiastical counterparts, such
patrons invested not only money but gave considerable thought to their acqui-
sitions. In 1502, for example, Isabella d'Este and Francesco Gonzaga, con-
templating the purchase of one or two vases from the collection of Lorenzo
de' Medici, exchanged at least ten letters with their agent in Florence, had
drawings made to supplement his descriptions of the vases, and then remade
to scale and in color, and had him consult Leonardo da Vinci regarding their
possible acquisition (did Leonardo also provide the second set of drawings?).

Leonardo preferred the jasper vase, Isabella the crystal, and sure of her own judgment, this was the one she offered to buy with a payment in woolen textiles. The deal collapsed, however, when the sellers rejected her valuation of these goods.[26]

These various Renaissance rivalries among patrons, collectors, artists, and authors culminate in the persons of Michelangelo and Titian, Michelangelo's last and most enduring rival. Acting with them in this drama are Leonardo, Giorgione, Raphael, Sebastiano, Cellini, and Bandinelli, among others. Patrons too play their parts: Julius II della Rovere and the Medici popes Leo x and Clement VII, and private collectors such as the Este. Reporting these rivalries, while engaging in their own, are such authors as Aretino, Condivi, and Vasari. But always at the center is Michelangelo, the protagonist whose art makes its maker "more than angel, divine."[27]

3

Paragoni

I do not wish to approach the *paragone*, so as to avoid comparisons which are always odious.

Lodovico Dolce[1]

I can execute sculpture in marble, in bronze, and in terracotta, likewise in painting, whatever can be done, in a *paragone* with every one.

Leonardo da Vinci[2]

THE LIFE OF LEONARDO DA VINCI introduces Vasari's third, modern age of the arts. Born illegitimate on 15 April 1452, Leonardo evidently entered Andrea del Verrocchio's shop in 1469. Given his age in 1469, Leonardo must have had previous training, though his experience with Verrocchio proved decisive. His companions there included Lorenzo di Credi and three associates who were later favored by Sixtus IV: Botticelli, Ghirlandaio, and Perugino. Rivalry is inherent in the structure of a Renaissance studio, involving a group of young men seeking to please their master, thereby competing with each other and, eventually, with the master himself. The environment of Verrocchio's studio was perhaps more rivalrous than most precisely because of the remarkable constellation of young artists working there. Vasari's description of the relationship among three of them epitomizes the studio psychology of camaraderie, imitation, and rivalry. Lorenzo di Credi had joined Verrocchio's studio, and "under him, having for his companions and friends Pietro Perugino and Leonardo da Vinci, even though they were rivals, devoted all diligence to painting. And because the style [*maniera*] of Leonardo was enormously pleasing to Lorenzo, and he knew how to imitate so well that there was no one who, in the clarity and finish of the work, diligently imitated Leonardo better than Lorenzo did."[3] The rivalries of Verrocchio's studio were passed on to the next generation: Ghirlandaio became the master of Michelangelo, Leonardo's greatest competitor; and Perugino, the teacher of Raphael, Leonardo's greatest "follower."

No other Renaissance shop in Central Italy seems to have employed a more extraordinary cohort than Verrocchio – not Antonio del Pollaiuolo,

Verrocchio's own principal competitor in Florence; not Leonardo, despite his vast influence on the younger generation; not Raphael, whose large studio produced only one great successor, namely Giulio Romano; and certainly not Michelangelo, famously, or infamously, without students of any distinction. (The closest parallel with Verrocchio's shop is found in Venice, in Giovanni Bellini's studio, a vast enterprise and the training ground for Giorgione and Titian, among others.)

Enrolled in the Florentine Compagnia di San Luca (the painters' guild) in 1472, and therefore an independent master at age twenty, Leonardo was still living in Verrocchio's house in 1476 – a fact documented by anonymous accusations of sodomy against him. (The sodomy charges were later dismissed, evidently an indication of Leonardo's having friends in high places, among them Lorenzo de' Medici.) Leonardo's earliest documented independent commission dates from two years later, an altarpiece for the Chapel of Saint Bernard in the Palazzo della Repubblica, for which he received his first payment in March 1478.[4] Despite the prestige of the commission, Leonardo never fulfilled his contract.

In March 1481, undeterred by Leonardo's apparent failure to satisfy the Signoria, the monastic church of San Donato a Scopeto (outside Florence) turned to him for their high altarpiece, to represent the Adoration of the Magi. Leonardo received partial payment for the San Donato commission in September of that year. He eventually reneged on this contract as well, producing only the underpainting (Fig. 15). Although the *Adoration of the Magi* remained unfinished, it has always been admired for its "many beautiful things," in Vasari's words.[5] Its influence is incalculable, and indeed to a large degree due precisely to its being incomplete. Had Leonardo finished it, using the palette of his approximately contemporary paintings such as the *Madonna of the Carnation* or *Madonna with a Vase of Flowers* (Fig. 16), his colors would have masked some of the *Adoration*'s more original compositional and psychological elements. To put the matter another way, which the painting's first viewers would also have understood: without color, the *Adoration* is all the more remarkable than it would have been with color, because one sees its unfamiliar qualities unmediated by Leonardo's chromaticism, still for the most part traditional in 1482.

The painting's stylistic innovations are bound to its technique. Elsewhere, Leonardo used cartoons and *spolvero* to transfer compositions from paper to panel; traces of the dots from this process are visible in the portrait of *Ginevra de' Benci*, for example, painted c. 1474–76, and the *Cecilia Gallerani* or *Lady with the Ermine*, c. 1488–90 (Figs. 11, 12).[6] There are no such indications in the *Adoration*, however, though one might expect that the complexity of the composition would have required a cartoon. Leonardo made sketches of individual figures and elements of the scene, a number of which survive. But the composition itself was painted, and repainted, directly on the panel: *pentimenti* testify to the freedom and confidence of Leonardo's technique.[7]

For present-day viewers, one sign of the *Adoration*'s modernity is the absence of obvious supernatural markers, such as haloes or adoring angels – elements that other masters, including Bellini and Michelangelo, were unwilling to relinquish. (The omission of haloes is not a matter of the painting's being incomplete; haloes are also absent from Leonardo's other sacred works.) However "advanced" Leonardo's exclusion may now seem, one must remember that contemporaries and successors did not always follow his example in this regard. In any case, in the *Adoration*, the primary indication of the identity of Mary and Christ is of course precisely the fact of their being adored – adored, moreover, by perhaps the most psychologically and physically varied company of worshipers ever represented in Christian art. These are the heads that Vasari particularly admired. In the *Adoration*, each character's inner life is expressed in his appearance, demeanor, and action – that is, in Renaissance terms, each personage embodies the principle of decorum.

Leonardo himself defined his purpose and his achievement in his notebooks, explaining that the best figures are those whose actions clearly express their emotions so that the beholder can understand them: "Painted figures must be done in such a way that the spectators are able with ease to recognize through their attitudes the thoughts of their minds (*il concetto dell'anima*)."[8] The psychological sophistication and physiognomical variety of the *Adoration* makes the emotional sameness of most other late fifteenth-century works look like a failure of imagination.[9]

The acuity of Leonardo's psychological observation is one of his greatest accomplishments and characteristic of his work from the beginning (his angel in Verrocchio's *Baptism of Christ* is identifiable as Leonardo's as much by one's sense of the angel's personality as by the style in which he is painted). More important than symbolic devices or the narrative situation is Leonardo's visualization of the sanctity of Mother and Child in their faces and demeanor. In her maternal emotion, she recalls but transcends her predecessors in works by Verrocchio and by Desiderio da Settignano. Surpassing his models, Leonardo individualizes Mary and Christ in ways that may have seemed startling to contemporaries and still surprise beholders today. In the Benois *Madonna*, evidently begun in 1478, Leonardo adapts elements of the Infant's pose from a relief by Desiderio, but now shows the Virgin laughing at her Child's awkward attempts to grasp the flowers, symbolic of his Passion (Figs. 13, 14). Is her laughter simple amusement at his clumsy action, or an expression of her joy in its inherent promise of redemption for humankind?[10]

It is this psychology or spirituality that distinguishes Leonardo's Mary from those by Desiderio and Verrocchio, whom she otherwise resembles in her facial type, coiffure, and drapery patterns of her garments. At the same time, Leonardo provided his own sculptural models for his paintings, making figurines which he clothed in fabric dampened with gesso and molded into volumetric patterns. His painted figures simulate the three-dimensionality of these models. The *paragone* of painting and sculpture was thus in Leonardo's

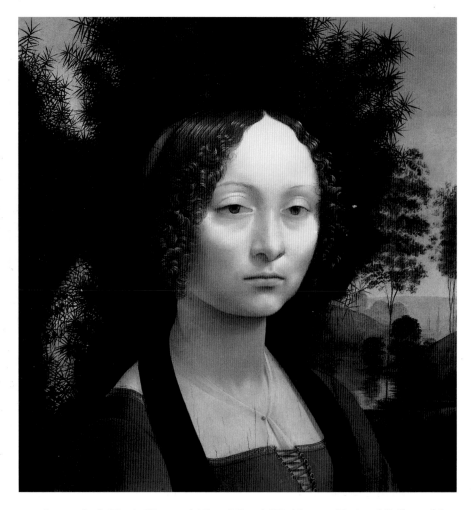

11 Leonardo da Vinci. *Ginevra de' Benci*. Panel. Washington, National Gallery of Art, Ailsa Mellon Bruce Fund.

practice and his thoughts, if not yet in his vocabulary, from the beginning of his career as a painter.[11]

 That the painter Leonardo should have borrowed figure types from sculptors in conceiving his early Madonna paintings is not surprising, given his association with Verrocchio's shop. Yet the debt is noteworthy as the first appearance of a Leitmotif in Leonardo's art and thought, namely his concern with the mimetic qualities of painting which allow the simulation of the volumetric qualities of sculpture, what he later termed *rilievo*. Precisely this sense of volume distinguishes his early Madonnas from their marble prototypes: remarkably, the paintings seem more plastic than the sculptures that inspired them. What seems to have begun as Leonardo's borrowing of sculptural

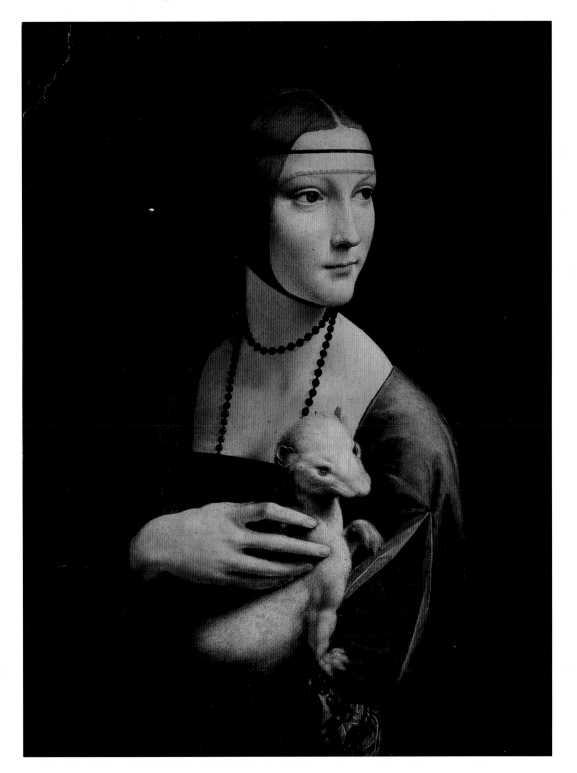

12 Leonardo da Vinci. *Cecilia Gallerani* (*Lady with the Ermine*). Panel. Kraków, Czartoryski Collection.

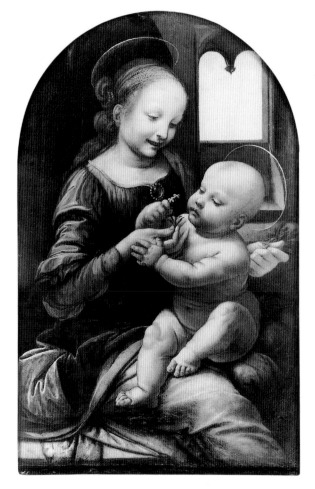

13 Leonardo da Vinci.
Benois *Madonna*. Panel
transferred to canvas.
Saint Petersburg,
Hermitage Museum.

motifs led to his invention of a new style of painting that rivals the three-dimensionality of sculpture. Theory quickly followed practice, as Leonardo began to articulate his conception of *rilievo* in his notebooks of the 1480s, identifying the simulation of three-dimensional relief as the painter's primary concern. "*Rilievo*," he declared, "is [. . .] the soul of painting"; it can be achieved by subordinating light and ultimately color to shadow: "Shadow is of greater power than light, in that it can impede and entirely deprive bodies of light."[12] Depriving bodies of light, shadow can therefore also deprive them of color. The eventual result was the subjugation of local color by a unifying system of modeling in which all darkest shadows become black, and all lightest highlights white – in a word, *chiaroscuro*.

By virtue of being a monochromatic underpainting, the *Adoration* anticipates the treatment of color, light, and shadow in Leonardo's later thought and works. If the effect is accidental or coincidental in this unfinished work, in other

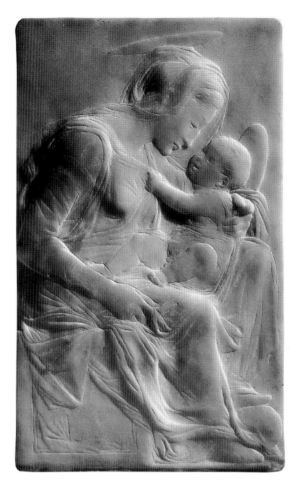

14 Desiderio da
Settignano. *Madonna and
Child*. Marble. London,
Victoria and Albert
Museum.

respects, Leonardo's revolutionary intentions in the *Adoration* are clear. First,
he simplified, hence monumentalized, Mary's figure: he abandoned both her
elaborately braided coiffure and the complicated pattern of drapery folds
employed in the first Madonna paintings, which now look fussy by comparison.
Mary's round face in the *Madonna of the Carnation* becomes oval in the
Adoration and seems more mature, less girlish, especially compared with the
childlike Mother of the Benois *Madonna*.

The Christ in the *Adoration*, looking very much like the same Infant though
somewhat less robust, is more adult in his gestures, blessing with the right hand,
reaching purposefully to accept the oldest Magus's gift with the left. As in the
Madonna paintings, here too Leonardo asserts a gendered psychological
and intellectual hierarchy that privileges Christ: he responds to the present sit-
uation, she responds only to him. The cognitive differentiation of Mary and
Christ in the Madonna paintings is the prelude for Leonardo's distinction of

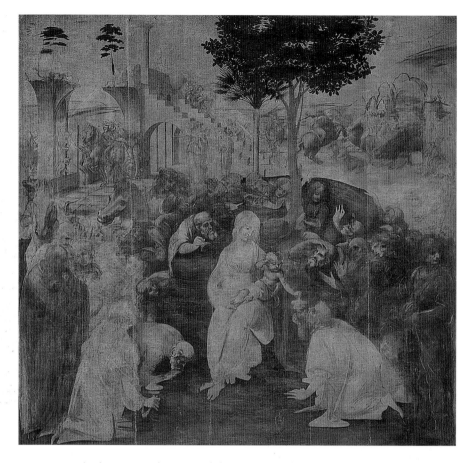

15 Leonardo da Vinci. *Adoration of the Magi*. Panel. Florence, Galleria degli Uffizi.

personalities and psychologies in the large cast of characters who populate the *Adoration*.

The *Adoration* is organized according to geometrical principles, Mary and Christ forming a pyramid flanked by the circular formation of worshipers. The pyramidal composition was not Leonardo's invention, as Meyer Schapiro explained; but "Compared with old types, the novelty of Leonardo's form, later carried further by Michelangelo and Raphael, lies rather in the fact that within the conventional pyramid of three or four figures, each has a complex asymmetry of contrasted forms in depth, [. . .] and each person responds actively to another." In addition, Schapiro continued, Leonardo's "great originality as a painter" is seen in the "new fullness and subtlety of modelling, a palpable atmosphere, a mysterious light and shadow [. . .], and the infinitely extended landscape background as a lyrical revelation of mood in counterpoint to the figures."[13]

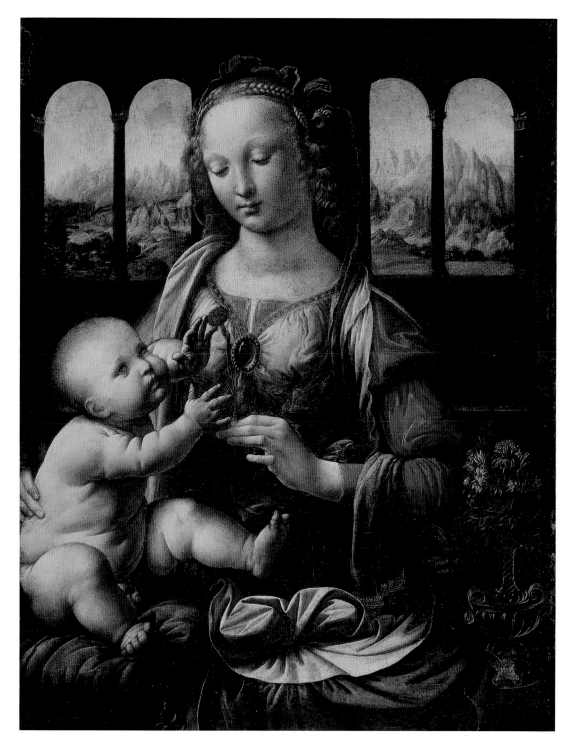

16 Leonardo da Vinci. *Madonna of the Carnation* (*Madonna with a Vase of Flowers*). Panel. Munich, Alte Pinakothek.

Perhaps no painting – and certainly no unfinished work – had ever exerted greater influence than Leonardo's *Adoration*. Other compositions had been greatly admired and much copied, such as the Doryphoros of Polykleitos, the statue that established the Canon of classical proportions for the heroic male nude, or the Venus Pudica of Praxiteles, which established a canonical posture or action for the beautiful female nude. Similarly, certain sacred, presumably miraculous, images were frequently replicated, including Madonnas attributed to Saint Luke and images of the *Veronica* (meaning "true image," *vera icon*), the veil imprinted with the face of Jesus. But Leonardo's *Adoration* was influential not only, and not principally, for individual facial types and expressions or its composition or its particular motifs – the way in which a horse rears, for example, or the way one man turns to address another. Its great impact was less precise and more profound, changing the ways in which artists and their audiences thought about the conception of individuals, their interrelationships in compositions, their enactment of narrative – even when the individuals do not look like Leonardo's personages, when they are deployed differently and engaged in different actions. In this broader sense, the *Adoration* is central to the history of Renaissance art. Like his classical predecessors, Leonardo established a canon influencing High Renaissance ideas of characterization, composition, and narrative. Seeing the *Adoration*, no artist – and equally important, no discerning patron – would be satisfied in future by an undifferentiated cast of characters, however attractive; or by a rigid composition, however well ordered; or by a mechanistic narrative, however coherent.[14] Artists were now challenged to create, and the beholder to expect, an unfolding drama enacted by completely realized individuals who engage one's interest and invite an empathetic response. Leonardo himself must have been aware of his revolutionary achievement. Yet he abandoned both the *Adoration of the Magi* and the altarpiece for the Chapel of Saint Bernard to go north to Milan just as his compatriots were traveling south to Rome.

Leonardo left for Milan in late 1481 or early 1482.[15] The ostensible purpose of the trip was to deliver a *lira da braccio* to Lodovico il Moro, a gift from his Medici friend and ally, Lorenzo il Magnifico.[16] Lorenzo had already befriended Leonardo, permitting him to study the antiquities displayed in the Medici Palace gardens (where ten years later Michelangelo enjoyed similar privileges). Dispatching Leonardo to Milan with the *lira*, perhaps Lorenzo was responding to a request by Leonardo himself for an elegant entrée to the Sforza court.[17]

Leaving little if anything to chance, Leonardo also invited himself, or asked to be invited, advertising his ingenuity in a letter to il Moro, citing various abilities from arms to sculpture – and mentioning painting almost in passing. Undated and unsigned, and with several corrections and emendations, the text preseved in Leonardo's Codex Atlanticus is evidently a draft of the letter; its orthography and abbreviations are unusual for him; and written left to right, it does not resemble his customary handwriting, written right to left. Even so, the draft reflects Leonardo's thoughts: no matter who wrote it, its contents are

authentic.[18] This was not the first letter addressed by an artist to a possible patron. In 1438, for example, Domenico Veneziano had written to Piero de' Medici (Lorenzo il Magnifico's father), similarly seeking employment.[19] But Leonardo's letter is arguably the most wide-ranging and least formulaic of such missives.

Referring to Lodovico's primary concerns as Leonardo understood them, the letter begins with the artist's skills in constructing instruments of war quite unlike those commonly in use. He can design portable bridges, convenient for pursuit of the enemy – and for flight, if necessary; he can drain trenches, destroy fortresses, and in general make himself useful in times of war. In times of peace, too, Leonardo can give the greatest satisfaction, comparable with – *al paragone di* – every other master of architecture and hydraulics. He can make sculpture in marble, bronze, and clay. And finally, Leonardo can also paint as well as any rival: he "can do everything in the art of painting that can be done, in comparison with – *a paragone di* – everyone and anyone else."[20]

The word "paragone" appears in these two sequential paragraphs in the letter, about peace-time architecture and about sculpture and painting. Thus repeating "paragone," Leonardo signaled his readiness to compare himself, favorably – not to say, victoriously – with others. This use of "paragone," meaning comparison, with rivals named or, as in this instance, unnamed, was familiar to fifteenth-century Italians. (Isabella d'Este and Giovanni Bellini used it in much the same way.) When Leonardo and his contemporaries used the word "paragone," they meant it in this sense of rivalrous comparison of *artists* or their works; only later did the term come to refer primarily to the rivalrous comparison of the *arts*. Even so, it is not wishful thinking, or reading, to see in Leonardo's use of "paragone" in his letter an anticipation of this later usage; at the very least, the word announces his competitive ambitions.

Leonardo's only mention of painting is the last part of the sentence about his knowledge of *sculpture* in various media. In the context of expansive boastfulness about his every other skill, such reticence about painting seems inexplicable, unless we understand that by using the word "paragone," Leonardo says everything that needs to be said about his gifts as a painter. Given the self-confident tone of the letter, and his detailed enumeration of his other skills, Leonardo's terseness about painting may also reflect his belief that he had already proved himself in that arena.

If Leonardo's reticence about his experience in painting may be seen as an understatement expressing self-assurance, his description of his other talents is tinged with braggadocio. His assertion of experience with bronze casting cannot be dismissed as false advertising, however. Having apprenticed in Verrocchio's shop, Leonardo would have witnessed, and presumably participated in, the making of sculpture in stone and in bronze.[21] Among the works he took with him to Milan, Leonardo listed "a narrative of the Passion made in relief," *fatta in forma*, perhaps an example of his own efforts in sculpture.[22] Even so, Leonardo's characterizations of his abilities seem to be in inverse proportion to his actual experience.

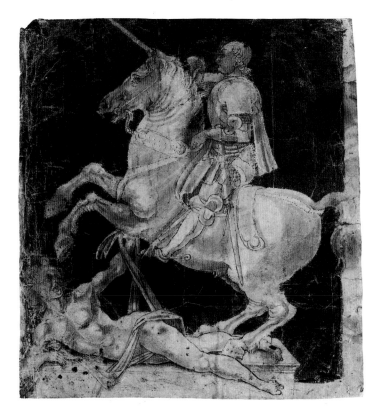

Leonardo had a particular purpose in mind in vaunting his abilities as a sculptor: he wanted the commission for the bronze equestrian monument being planned for Lodovico's late father, Duke Francesco. The Sforza equestrian monument might be safely entrusted to him, Leonardo assured Lodovico: "one could undertake the bronze horse which will be immortal glory and eternal honor of the happy memory of the lord your father and of the illustrious house of Sforza."

Knowing of the monument, Leonardo was perforce aware that the Sforza had already discussed the commission with other artists. In 1472 Lodovico's elder brother, Duke Galeazzo Maria, had hired the Mantegazza brothers Cristoforo and Antonio to design the statue and in the following year had begun searching for a bronze caster. Lodovico abandoned this design, however, and evidently discussed the project with the Florentine painter-sculptor Antonio del Pollaiuolo.[23] Milanese interest in Pollaiuolo may have been particularly galling to Verrocchio, who had produced the decorations for Galeazzo's triumphal entry into Florence in 1471, possibly assisted by Leonardo. Pollaiuolo's study for the Sforza monument is dated c. 1481, that is, at the time of Leonardo's move to Milan (Fig. 17). Clearly the commission was not Leonardo's "for the asking," no matter how assertive the request; but once in Milan, he began to

17 (*facing page*)
Antonio del Pollaiuolo.
Study for the Sforza
monument. Pen and
brown ink with brown
wash. New York, The
Metropolitan Museum
of Art, Robert Lehman
Collection.

18 Andrea del
Verrocchio. *Colleoni*.
Bronze. Venice, Campo
di Santi Giovanni e
Paolo.

produce drawings for the statue, while no more was heard, or seen, of Pollaiuolo's project. Lodovico was presumably discussing the monument with Leonardo in the early 1480s, then, though the first written reference to his actually working on it comes only in 1489.[24]

Meanwhile, if Verrocchio had indeed been passed over by the Sforza, he had been successful in a similar enterprise, or very nearly so, completing before his death in summer 1488 the model for the equestrian monument of Bartolomeo Colleoni in Venice. Recalling the contest for the Florentine Baptistery doors, the commission was the result of a formal competition open to *forestieri* as well as citizens of the Venetian Republic. A decree of the Senate dated 30 July 1479 documents the contest, naming three *operai* to fulfill Colleoni's testamentary bequest for his monument (Fig. 18).[25] By summer 1481 their competition had led to the production of at least one of three documented entries, a lifesize model of the horse evidently made with fabric stiffened with gesso.[26] Another entry was done in terracotta, its maker now also unknown. Verrocchio's winning model was made of wax.[27] His likely competitors may have included two fellow Florentines: his longstanding rival, Pollaiuolo; and Leonardo himself, who was already intellectually engaged in a comparable commission for the Sforza monument, if not yet under contract.

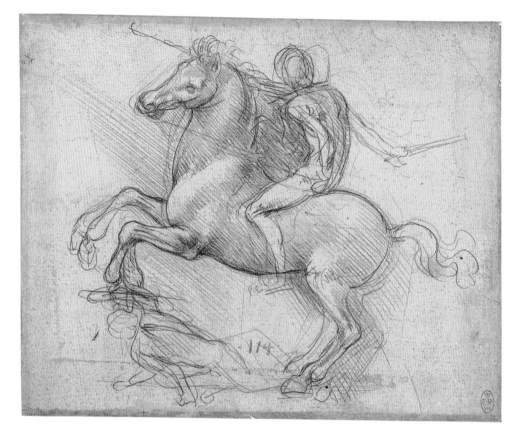

The public contest for the *Colleoni* and the private competition for the Sforza monument, involving at least the Mantegazza brothers and then Pollaiuolo, provide the context for Leonardo's maneuverings to win the Milanese commission. The self-assured tone of Leonardo's letter to Lodovico was determined as much by his appreciation of the practical realities of this highly competitive situation as by his awareness – or embrace – of the agon with his rivals. His work for the Sforza monument, and later, his equally abortive attempt to execute the equestrian monument of Gian Giacomo Trivulzio (1511), obsessed Leonardo for much of his career, much as Michelangelo's failure to complete his tomb for Julius II was to obsess *him*. Like Michelangelo, who was characteristically more voluble in explaining his motivations and frustrations, Leonardo conceived the Sforza monument (and later the Trivulzio) as commemorations of his own genius as much or more as commemorations of their ostensible subjects (Fig. 19).[28] In itself, this represents a stunning reversal of centuries, perhaps millennia, of thinking about works of art, and in particular, funerary and other commemorative monuments. When Michelangelo later described the aborted plans for the tomb of Julius II as a "tragedy," he meant *his* tragedy, not the pope's.[29] Leonardo did not record his eventual disappoint-

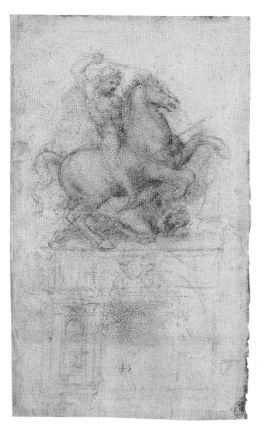

19 (facing page)
Leonardo da Vinci. Study
for the Sforza monument.
Silverpoint. Windsor, Royal
Library 12358r, Her Majesty
Queen Elizabeth II.

20 Leonardo da Vinci.
Study for the Sforza
monument. (?)Black chalk.
Windsor, Royal Library
12354, Her Majesty Queen
Elizabeth II.

ments with the Sforza and Trivulzio equestrian monuments, but he can hardly
have been indifferent about them, and certainly contemporaries saw these more
as losses for Leonardo and indeed for Italian art than for their subjects.

As articulate as any written source, Leonardo's drawings and models trace
the development of his conception of the Sforza monument.[30] The artist's ideas
were endorsed by his patron, or perhaps merely tolerated, if the Florentine
ambassador's report of Lodovico's views is to be believed. Writing to Lorenzo
de' Medici about Leonardo's work on the project in 1489, the ambassador
claimed that Lodovico "is not confident that he will succeed."[31] It was evidently
as much or more Leonardo's intention than his patron's that the Sforza monu-
ment outdo all its competitors, ancient and modern; Leonardo's ambitions,
even more than Lodovico's dynastic dreams, that determined the conception of
the monument. The kinds of desiderata that earlier patrons might require of
their artists Leonardo now imposed on *himself*. Not only was the statue to be
bigger, hence better, than other equestrian monuments: the horse was to rear
on its hindlegs, with the forelegs resting on air. The classical bronze horses that
everyone knew in late fifteenth-century Italy bent one foreleg to lift the hoof
off the ground: thus in Rome, the mount of Marcus Aurelius (mistakenly

identified as Constantine); in Venice, the Quadriga of four horses taken from Constantinople to adorn the façade of San Marco; and in Pavia, the so-called *Regisole* (which Leonardo saw during a visit to Pavia in 1490, traveling with Francesco di Giorgio). But the horse of Donatello's *Gattamelata* in Padua, installed in 1453, rested its raised hoof on a small globe. Fifteenth-century masters had been able to replicate the ancient prancing pose only in media other than bronze, in fresco, for example, or in wood.[32] The technical difficulties seemed insurmountable, but Pollaiuolo's drawing for the Sforza monument indicates that he planned to tackle the problem by providing a fallen enemy to support the rearing horse (Fig. 17). Whether Leonardo saw this sheet is unknown, though presumably the Sforza would have informed him of Pollaiuolo's ideas. In any case, Leonardo's drawings document his ever-increasing aspirations for the monument. First the horse props its rearing forelegs on a vanquished foe, as in Pollaiuolo's design; but then the supporting figure is moved, and the horse almost rears in air (Figs. 19, 20). That this cannot be easily done in bronze did not preclude Leonardo's wanting to do it. On the contrary, it was precisely the difficulty of the task that engaged him. Honoring Francesco Sforza, Leonardo would honor himself, with a conspicuous demonstration of his superiority to other sculptors. The full-scale clay horse that Leonardo completed in winter 1492–93 was displayed in Milan cathedral on the occasion of the marriage of Bianca Maria Sforza to Emperor Maximilian I. The model became enormously famous, admired by such men of letters as Paolo Giovio – but not, unfortunately, by the French soldiers who occupied Milan in 1499. Seeing in Leonardo's clay model a convenient target, Gascon archers reduced the horse to rubble.[33]

The Sforza horse assured Leonardo's fame. Perugino, his contemporary, was already far more prolific than Leonardo, but Giovanni Santi (Raphael's father) paired them as equals in his rhyming *Chronicle* written in the early 1490s, and called Leonardo "divine."[34] With hindsight, Santi's encomium seems entirely justified, though Leonardo had done comparatively little to explain such appreciation by that date, and what little he had done was known to a comparatively small audience. The early 1490s means *before* the *Last Supper*, completed in Milan between 1494 and 1496; and *before* the great works of the second Florentine period: versions of the *Madonna and Child and Saint Anne*, *La Gioconda*, and the cartoon for the *Battle of Anghiari*.

A perspicacious critic but not clairvoyant, Santi could have based his opinion of Leonardo on the *Adoration* underpainting, the first version of the *Madonna of the Rocks*, the terracotta *Horse* for the Sforza monument, and such extravagant ephemera as the inventions for the Sforza-Aragon wedding in 1490, with seven rotating planets.[35] Had Santi actually seen any of these works or had he merely heard of them? Had he seen any of Leonardo's drawings? He cannot have read anything by Leonardo: though Leonardo planned to write several treatises, he never succeeded in completing any of them.[36]

The mystery of Leonardo's early celebrity is greater than the mystery of Gioconda's smile. One thing is certain, however: Leonardo himself was largely

responsible for this manipulation of public opinion. As practiced by Leonardo and thereafter, such manipulation could take the form of published letters, chronicles, and treatises, as well as unpublished correspondence and discourse among patrons and *cognoscenti*. Such conversations are imagined (or remembered) in Baldassare Castiglione's *Book of the Courtier*; and such correspondence is exemplified by Isabella d'Este's *carteggi*. Writing to Fra Pietro da Novellara in Florence on 27 March 1501, for example, the marchesa expressed her interest in Leonardo's latest doings and her desire to have a work by him. Learning from her dealings with Bellini, Isabella was willing to leave the choice of subject to Leonardo, though she suggested a theme appropriate to his style:

> If Leonardo the Florentine painter is now there in Florence, we pray [you] wish to inform yourself what his life is, that is, whether he has begun some work, because some report of it has been made, and what work this is, and if you believe that he must remain there for some time, then sounding him out about whether he would undertake the business of making a painting in our studio which, when he be content to do so, we shall defer to him about the subject [*inventione*] and the timing, but when you find him reluctant, see at least about inducing him to do a little picture of the Madonna, holy and sweet as is his natural manner [*suo naturale*]. Then you will beg him to wish to send another sketch [*schizo*] of our portrait because our Illustrious Lord and consort has given away the one that he left here.[37]

Replying to the marchesa's breathless letter on 3 April 1501, Fra Pietro reported that Leonardo was at work on a painting of the *Anna Metterza*, that is, the *Madonna and Child and Saint Anne*, which the friar then described to her.[38]

Isabella's knowing about the cartoon from her correspondent, and Novellara's knowing the work itself, having seen it in Leonardo's studio, help explain the artist's fame among his contemporaries: Leonardo was generous. He made his ideas readily available, even ideas about works in progress (including the *Saint Anne*), so that their impact was immediate, often – as in this case – preceding their completion. Vasari confirms what Novellara's letter implies about Leonardo's open-door policy: "he made a cartoon with Our Lady and a Saint Anne with Christ, which not only amazed all the craftsmen [*artefici*] but, for two days after it was finished, men and women kept coming to see it, the young and the old, as one goes to solemn feasts, to see the marvels of Leonardo, which amazed all those people."[39] Similarly, *La Gioconda* was displayed though still unfinished in 1504–06, and in consequence changed the conception of portraiture for Raphael and other masters. Clearly, Leonardo followed his own advice to welcome visitors, and their suggestions: "while a man is painting he should not refuse anyone's judgement [but] be eager to lend a patient ear to the opinions of others."[40] This openness meant that such "amazed" visitors as Lorenzo da Pavia, Isabella's agent in Venice, might become Leonardo's publicists.[41] It meant that even those who had never seen his works seem to have known of Leonardo and to have understood that his achievement

was somehow extraordinary. (The paradigm here is Apelles, Zeuxis, or the other fabled masters of antiquity – famous even in the absence of their works.) Leonardo's fame made him an exemplar for other masters but also a natural rival. And we have seen that Leonardo himself had anticipated, or invited, this kind of rivalrous confrontation, describing himself in his letter to il Moro "*a paragone* of everyone else." Perhaps it was more than coincidence, then, that Leonardo found himself in a competition staged by Lodovico's sister-in-law, Isabella d'Este, using very nearly that same turn of phrase.

In 1498, two years after Isabella's initial request to Giovanni Bellini and while she continued her negotiations with him, the marchesa staged a competition of his portraits with Leonardo's. More precisely, she wanted to confront Leonardo's portrait of Cecilia Gallerani with works by Bellini that she had just now been able to examine (Fig. 12).[42] Portrait *paragoni* were an Este family tradition, starting with Marchese Lionello's competition between Pisanello and Jacopo Bellini in 1441.[43] Isabella's choice of Leonardo and Bellini as contestants may seem obvious but in fact requires explanation. Bellini had been painting portraits for at least a quarter of a century when Isabella sought to juxtapose his portraiture with Leonardo's. Indeed, Bellini was the portraitist that Alexander himself would have chosen over Apelles, had they been contemporaries, as Nicolò Liburnio's sonnet announced.[44] Elsewhere, Liburnio praised Bellini as "among the other masters worthy of immortality" in a poem included in *Le selvette*, published in Venice in 1513 with a dedication to Isabella d'Este.[45] Another humanist poet, Baccio Ziliotto, also made the comparison between Bellini and Apelles as portraitists.[46] Compared with Bellini, however, Leonardo was a portrait novice in 1498. The only portrait universally attributed to Leonardo which precedes the *Cecilia* is *Ginevra de' Benci*, c. 1474. Leonardo's *Gioconda*, probably the most famous portrait ever painted, was not yet in existence; and the *Portrait of a Musician* in the Biblioteca Ambrosiana of Milan, a work of the late 1480s or early 1490s, would have been an unlikely or unsuitable example of his portraiture for Isabella's purposes, given the gender and the social class of the subject, and the way in which he presents his music for the beholder's information and approbation.[47] The marchesa might have found *La Belle Ferronière* of more interest as a more recent example of Leonardo's work, c. 1496, assuming that she knew of it (Fig. 21). The sitter has been tentatively identified as Lucrezia Crivelli, one of Lodovico's paramours whose portrait Leonardo is known to have painted.[48] There is no evidence that Isabella knew any of these works, however, and in any case, it was the *Cecilia Gallerani* that particularly interested her. Gallerani (1473–1536) was another of Lodovico's former mistresses, but this amorous past did not interfere with Isabella's asking a favor of her.[49]

Whatever combination of perspicacity, avarice, or obsession with portraiture (and especially portraits of herself) may have inspired Isabella's interest in Leonardo as a portraitist and her curiosity regarding the *Cecilia*, the marchesa was not satisfied with having heard descriptions of the portrait: Isabella wanted to see it (again?) for herself. In a letter dated 26 April 1498 Isabella requested Cecilia to lend her portrait by Leonardo:

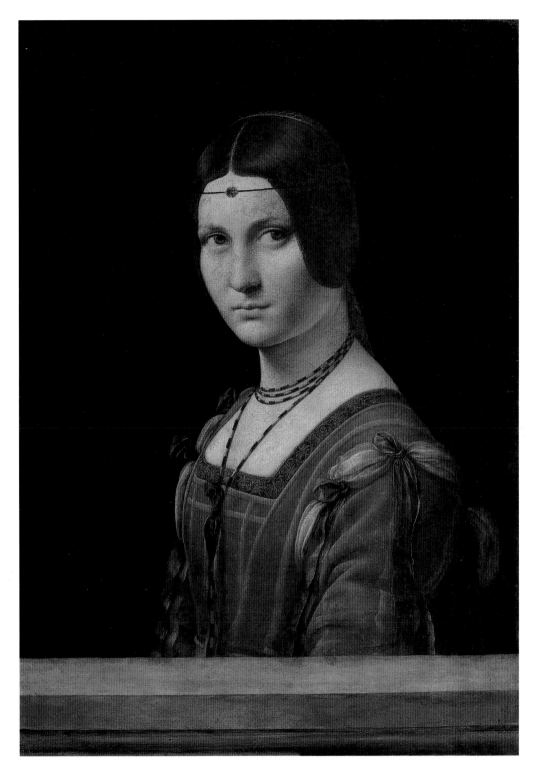

21 Leonardo da Vinci. *La Belle Ferronière*. Panel. Paris, Musée du Louvre.

Having happened today to have seen certain beautiful portraits by the hand of Giovanni Bellini, we have entered into discourse about the works of Leonardo, with the desire to see them *al paragone* with those that we have, and recalling that he has portrayed you from the life, we pray you [. . .] that you be so kind as to send this your portrait [. . .] so that in addition to its giving satisfaction in the *paragone*, we shall also most willingly see your face.[50]

It is possible that Isabella had seen Leonardo's portrait during a visit to Milan in 1495, but nothing in the letter confirms this. In any case, she now wanted to see it in *paragone* with Bellini's portraits. In her letter Isabella alluded to the common suppositions that a portrait is a likeness of its subject and that such a likeness may function as the proxy for that subject. And she repeated the idea, inherent in the Renaissance concepts of *imitatio* and rivalry, that works of art must be seen in juxtaposition, that is, *al paragone*. Such comparisons were in the air.[51] Recalling Isabella's juxtaposition of Bellini and Leonardo, for example, Ambrogio Calepino compares the two masters in his definition of *Pingo* in his *Dictionarium*, first published in 1502. Mantegna is also mentioned, again (presumably unintentionally) echoing Isabella in her desire to compare him with Bellini.[52] Cecilia's portrait was lent, and Isabella returned it a month later.[53]

Lodovico's marriage to Beatrice d'Este, Isabella's sister, in January 1491 had been followed by the marriage of Cecilia and Ludovico Visconti Bergamini in the following year – a marriage arranged by il Moro, after Cecilia had given birth to il Moro's son, Cesare, on 3 May 1491. Cecilia's portrait antedates this protracted "double wedding" by one or two years, dating between 1488 and 1490, when Beatrice was still a shadow on the horizon. It has frequently been noted that the prehensile ermine embraced by Cecilia in her portrait is a pun on the name Gallerani in Greek, which also suggests "white," the color of the creature (*gal* means "milk"). As everyone knew – including Leonardo, who recorded the fact in one of his notebooks and in a drawing – the ermine prefers (in Leonardo's words) "to be captured by hunters rather than take refuge in a muddy lair, in order not to stain its purity."[54] Leonardo was echoing the motto of the noble Neapolitan Order of the Ermine, of which il Moro had been named a knight in 1488, MALO MORI QUAM FOEDARI (better to die than to be sullied). Cecilia's portrait commemorates this honor as much as their dishonorable liaison. In the portrait, therefore, the ermine refers not only to the name Gallerani but also to her beloved, and the heraldic pose of the beast confirms this association of ideas. But the chaste sentiment of the knightly motto is contradicted by the animal's phallic appearance and by Cecilia's intense expression, which eroticize her image. Embracing the ermine, Cecilia embraces her beloved.

Cecilia Gallerani is the one portrait by Leonardo that Isabella certainly knew before commissioning her own portrait by him in 1500 (Fig. 22). Whether Isabella's commission implies that she preferred Leonardo's manner of portraiture to Bellini's, as scholars have argued, is moot; and she remained keenly

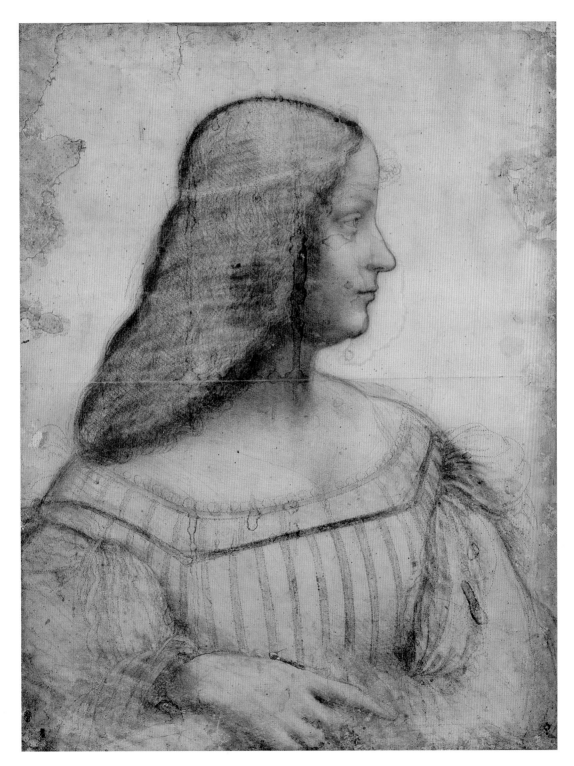

22 Leonardo da Vinci. *Isabella d'Este*. Black chalk and sanguine cartoon. Paris, Musée du Louvre.

interested in obtaining works by the Venetian. While Bellini proved elusive, however, Leonardo willingly went to Isabella's court, or rather was brought there by momentous events. In October 1499 the French had occupied Milan, and the Sforza were expelled. Although Leonardo was later to enter the service of French allies and eventually of the French king, at that date, perhaps sensing that he was too closely associated with the vanquished duke, Leonardo sought patronage elsewhere. Traveling with the mathematician Luca Pacioli, in December 1499 Leonardo left Milan for Venice, stopping at Mantua en route. Leonardo's *Isabella d'Este* never advanced beyond the cartoon which Leonardo executed during the three months (or less) of his residence in Mantua, from December 1499 or January 1500 until March 1500, when he arrived in Venice.[55] Whatever Isabella may have thought about Cecilia's portrait, she rejected anything similar when it came to Leonardo's interpretation of herself. Leonardo's *Isabella* can be understood in a sense not only as an "anti-*Cecilia*," but as an anti-Leonardo portrait. The *Cecilia* is a narrative portrait in which the subject turns to respond, not to the observer, whom she ignores, but to someone else, not seen by us – that is, to Duke Lodovico. In this way, the observer becomes a voyeur, an intruder on this intimate scene. Leonardo helped popularize this conception, which derives from such portraits as Andrea del Verrocchio's marble bust of the *Lady with a Bouquet of Flowers*, dating from c. 1475 (Fig. 23). Here too the hands are included – an inclusion that was still a novelty in Italian portraiture at this date – and the woman's pose suggests a narrative situation in which she seems to respond, either to us or to an unseen interlocutor. This implicit narrative situation – the subject's evident awareness of her being seen, though not necessarily seen by the beholder – distinguishes Verrocchio's *Lady* and Leonardo's *Cecilia* from other female subjects, including Leonardo's *Ginevra de' Benci*. Ginevra's expression suggests a self-aware and self-absorbed hauteur that is oblivious to any beholder, including the viewer before her image. Her beauty, the back of the panel tells us, adorns her virtue: *Virtutem forma decorat*.[56] Perhaps her evident unawareness of being seen is intended as an assertion or concomitant of this virtue. Leonardo's portrait encourages us to forget that Ginevra posed for him. We may see her, he tells us, but she is not complicit in our looking. Cecilia is also removed from us emotionally, but now her indifference has an explanation, her only physical and psychological point of reference being her unseen companion.

Isabella would have nothing of the sort for herself, rejecting the frontality of Leonardo's other portraits in favor of a half-length profile, self-contained in the pyschological and narrative, or rather, non-narrative, sense. The profile makes no reference to another person, offers no acknowledgment of the beholder. Ephemera of movement and of expression of emotions are subjugated to the eternal stasis of posture and visage. Surely it was Isabella who opted for the profile format, given her well-documented control over her image in every medium.

Antithetical to the art of Leonardo, the psychological qualities of the *Isabella d'Este* are characteristic of Bellini's portraiture, exemplified by the *Portrait of*

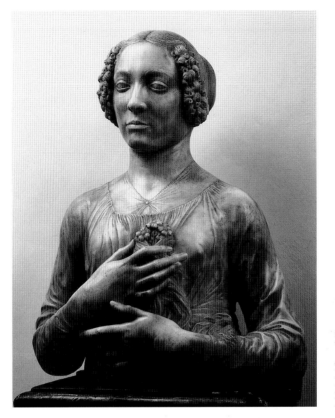

23 Andrea del Verrocchio. *Lady with a Bouquet of Flowers.* Marble. Florence, Museo Nazionale del Bargello.

a Man ("Pietro Bembo"), painted c. 1500 (Fig. 24).[57] Bellini's *un*expression in portraiture is quite distinct from the emotionalism of some of his sacred characters, for example, the Virgin Mary in the *Pietà* (Fig. 25), c. 1500–05, to cite an example close in date to the portrait.[58] In this work and others describing the grief of the Virgin Mother and other sacred beings, Bellini shows himself to be a sublime poet of the most profound emotions. Clearly, Bellini's suppression of emotion in portraiture is purposeful. Moreover, this emotional passivity must have been amenable to his subjects, members of the Venetian ruling classes. Indeed, for Venetian patricians and original citizens (*cittadini originari*), the expression of emotion was deemed inappropriate, as they themselves explained and as Bellini's portraits show. (Not coincidentally, the Bellini themselves were *cittadini originari*.) Public display or revelation of one's feelings is to be avoided: it is for lesser mortals – or sometimes for more exalted beings, as in the *Pietà.* The tranquil social mask of Bellini's portraits is the patrician's *true* face, or at least the face that he wishes to commemorate (*he* because few Venetian ladies were portrayed). And in Leonardo's portrait, Isabella adopted that mask for herself. Posing for Leonardo, she acted as though she were posing for Bellini, preferring his veil to Leonardo's scrutiny.

25 (*facing page*) Giovanni Bellini. *Pietà*. Panel. Venice, Gallerie dell'Accademia.

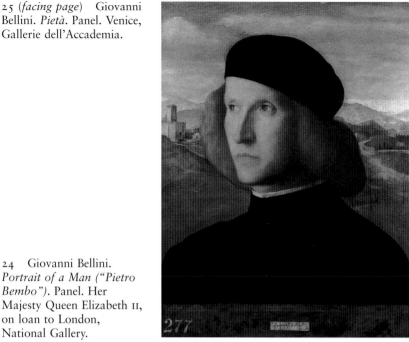

24 Giovanni Bellini. *Portrait of a Man ("Pietro Bembo")*. Panel. Her Majesty Queen Elizabeth II, on loan to London, National Gallery.

It is not difficult to imagine that Isabella may have shown Leonardo some examples of Bellini's portraiture to consult as prototypes for her portrait. But what portraits might she have known by Bellini to place *al paragone* with Leonardo's *Cecilia*? None of Bellini's portraits of women has survived, and his only documented female subject was Pietro Bembo's beloved. This portrait exists only in two laudatory sonnets by Bembo (XIX and XX), inspired by Petrarch's two sonnets on the portrait of Laura painted by Simone Martini: "O my image, celestial and pure," and "Are these those beautiful eyes in which, gazing with no defense to make, I lose myself?"[59]

The Petrarchan derivation of Bembo's sonnets on Bellini's portrait was recognized by Vasari, who cited Petrarch's sonnet in discussing the portrait of Bembo's *innamorata*. Certainly Bembo was profoundly knowledgeable about Petrarch, publishing an edition of Petrarch's poems with Aldus Manutius in Venice in 1501. The first edition of the *Rime* by Bembo himself was not published until 1530 (Venice, da Sabbio), but it includes poems written many years earlier – among them, these two sonnets. As for the portrait, while there is no certainty regarding its date or the identity of this unnamed beloved, circumstantial evidence (including Bembo's *Carteggio d'amore*) suggests that she was Maria Savorgnan, the object of Bembo's desire during his residence in Venice in 1500 and 1501, that is, precisely when he was completing his edition of Petrarch, the inspiration for his own sonnets and for his commission of the portrait by Bellini.[60] Given that the portrait of Bembo's beloved pre-existed the

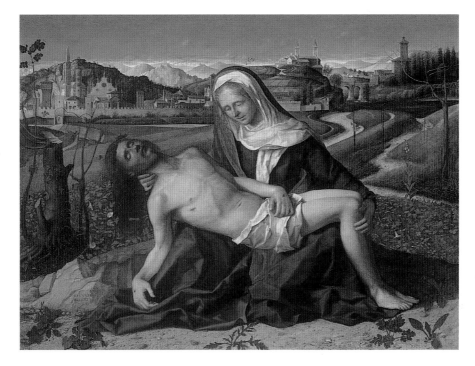

sonnets that it inspired, Bellini must have completed the work by 1501. If it were painted as early as 1498, it is tempting to imagine, though impossible to prove, that Isabella compared this portrait with Leonardo's *Cecilia Gallerani*, also the portrait of a beloved mistress.

Whether Isabella knew Bellini's portrait, most of Bembo's contemporaries could know the work (his very private possession) only through his sonnets. These verses invoke the venerable *paragone* between painting and poetry in the depiction of beauty, with a nod toward the *paragone* of painting and sculpture: Bellini's "celestial and pure image" is like the one Bembo has "sculpted in my heart with greater care." The poems leave almost no cliché unturned. But literary tradition aside, the portrait existed, and other painters and patrons surely knew of it. What did it look like?

That it was beautiful goes without saying: the beautiful women of such works as Bellini's *Madonna and Child with Two Female Saints*, painted at the end of the fifteenth century, bear testimony to the fact (Fig. 26).[61] Like most of Bellini's works, the portrait was painted on panel, a fact confirmed by Bembo's wording of sonnet XIX in the first edition of the *Rime* (though not the second): "a mere picture on wood." In sonnet XX, Bembo praises his mistress's beautiful eyes, her beautiful lashes, her face itself ("O volto"), and her brow. These phrases may be clues, and not merely an itemization of the qualities shared by all Petrarchan beauties. Bembo's references to his beloved's visage, eyes, and

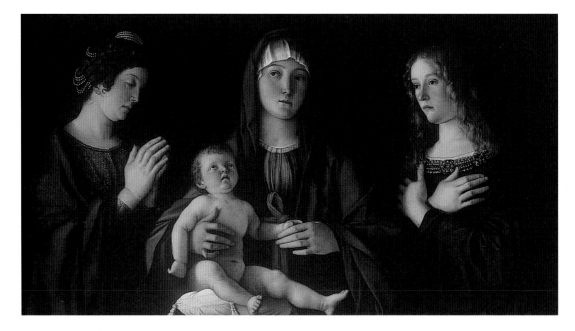

eyelashes suggest that Bellini's portrait was frontal or perhaps three-quarter view, indeed, like all his surviving portraits.

Bembo's allusion to his beloved's beautiful hair seems to be another clue about the lost portrait. The implication is that Bellini portrayed her with her hair unbound, suggesting a degree of informality in her image. It seems strange that such a highly praised work should have left no *visual* trace and that it should survive only in the words of its principal viewer. Perhaps Bellini's lost portrait was the mother, so to speak, of all those anonymous beautiful women of early sixteenth-century Venetian art shown with their hair unbound in works by Titian, Palma il Vecchio, and others.[62] And perhaps Bellini's portrait of Bembo's mistress was also, if not the mother, the godmother of Leonardo's *Isabella*, likewise depicted with her hair unbound. In all her other portraits, including the "fictional" portrait that Titian completed in 1536, Isabella wears the type of elaborate turban that contemporaries recognized as one of her particular fashion statements.[63] Admittedly, in her portrait medal by Gian Cristoforo Romano of c. 1495–98, Isabella's hair is uncovered, but it is tied in a kind of pony-tail *all'antica*. Only in Leonardo's portrait of her is Isabella's hair both unbound and without a turban, veil, or other covering. Did Isabella have Bellini's portrait in mind when she posed for Leonardo?

This may seem a tenuous reference to Bellini's lost portrait of Bembo's mistress – an argument that hangs by a hair – but the resemblance becomes stronger when we restore the missing parapet to Leonardo's *Isabella* with the aid of a follower's contemporary copy of the cartoon (Fig. 27). The copy shows that Isabella's arms and her book rest on a ledge, which almost certainly repro-

26 (*facing page*) Giovanni Bellini. *Madonna and Child with Two Female Saints*. Panel. Venice, Gallerie dell'Accademia.

27 After Leonardo. *Isabella d'Este*. Black chalk. Oxford, Ashmolean Museum.

duces what Leonardo originally represented, though the bottom of the cartoon has been damaged and this part of his composition lost. Isabella's hands are crossed at the waist, with the right index finger pointing toward a closed book, visible only in its pricked contours and more legible in the copy. (The pricking may have been done to enable the making of another drawing of Isabella, which Leonardo is known to have done.[64]) Leonardo used the parapet in one other portrait, the *Belle Ferronière*, close in date to the *Isabella*. In the *Ferronière*, however, he conceals the hands behind the illusionistic ledge. Only in the *Isabella* did Leonardo combine the motifs of hands and parapet. But parapets are *de rigueur* in Bellini's portraits, with the subject's hands concealed behind this ledge (hands appear only in his latest portraits, starting with the *Doge Leonardo Loredan and His Counsellors*, dated 1507 in Berlin, Staatliche Museen). Leonardo's concealment of hands behind the parapet in the *Ferronière* seems a counter-intuitive choice for him, which Daniel Arasse has characterized as "retardataire."[65] Was this concealment a conscious echo of Bellini's fifteenth-century portraiture? Leonardo included the sitter's hands in other portraits, including the *Cecilia Gallerani* and the *Ginevra de' Benci* in its original state, exploiting the expressive power of gesture, as he himself explained (echoing Leon Battista Alberti), in order to illustrate movements of the soul in movements of the body. Indeed, Cecilia's hands express perhaps too much of her soul for propriety's sake.

Apparently preferring Leonardo's portraiture to Bellini's, Isabella commissioned the kind of portrait associated more with the Venetian master than with the Florentine. She rejected the psychological revelation and narrative

conception of Leonardo's *Cecilia Gallerani*, in which the subject "turns and reacts" to the beholder.[66] Leonardo's *Isabella*, on the contrary, turns and *ignores* the beholder. Perhaps this requirement did not sit well with Leonardo and may explain why he did not finish her portrait (though he seems never to have needed an excuse not to complete a commission). If the psychological conception of Leonardo's *Isabella* and some aspects of its composition may fairly be called Bellinesque, one conservative element that is *not* Bellinesque is the profile, arguably the portrait's most retardataire feature.

But *why* the profile? And especially why a profile portrait by Leonardo? As Isabella herself recognized, one of Leonardo's great achievements was the expression of emotion, which is precisely what a profile inhibits, if it does not prohibit it altogether. In March 1501, in a letter quoted above, while waiting for her portrait or even a copy of the cartoon that Leonardo had taken to Venice, Isabella asked her agent to commission a painting for her Studiolo, and if that did not appeal to Leonardo, she hoped he might be persuaded to do a "sweet" Madonna. Three years later, writing to Leonardo himself in Florence on 14 May 1504, she reminded him of her longstanding hope to have something "by your hand" and recalled how he had promised to do her portrait having made the cartoon. "But because this would be almost impossible" – given his other commitments, he would not be able to go to Mantua – "we pray that desiring to satisfy the obligation of faith that you have with us that you wish to convert our portrait into another figure, which would be even more welcome, that is, to make a young Christ of about twelve years old, which would be the age he was when he disputed in the Temple, and made with that sweetness and suaveness (*dulceza et suavita*) of expressions that you have for your particular art *par excellence*."[67] She reiterated her request in another letter to Leonardo, dated 31 October of that year.[68] Admiring this psychological quality in his work and indeed soliciting it, why was Isabella willing to subjugate expression in a profile? The profile was still being used in portrait medals, including Isabella's by Gian Cristoforo Romano, but had been abandoned in painted portraiture some twenty or twenty-five years before. Her choice of the profile must have seemed *passé* in 1500. Perhaps Isabella chose the format precisely because it mitigates or suppresses the expression of emotion, but were this her only aim, certainly Leonardo was capable of achieving it in a frontal portrait, as indeed was Bellini. Although Leonardo made numerous drawings of heads in profile, however, none of his painted portraits uses the format. Similarly, none of Bellini's surviving portraits is a profile, and neither was his portrait of Bembo's mistress, if the wording of the sonnets may be taken as descriptive. Simone's portrait of Laura, on the contrary, *must* have been a profile, like other fourteenth-century portraits. Bembo's poems about the portrait of his beloved specifically evoke the Petrarchan commission, but there is no reason to think that Bellini's painting referred to its *visual* model (presumably already lost). The relation to Simone's work is indirect and literary, and perhaps even extraneous to Bellini's conception, applied *ex post facto* by Bembo. Arguably most if not all Renaissance pictures of beautiful women may

be considered Petrarchan to a greater or lesser degree. Perhaps Leonardo and Isabella intended her profile portrait to recall the great Petrarchan prototype in a more direct and visual manner?

Petrarchan or not, from Isabella's point of view, the profile had the advantage of preserving her from precisely the kind of psychological inquest in which Leonardo excelled. (Later, Isabella achieved this self-protective desideratum by refusing to pose for her portraits, engineering portraits that conceal – sometimes by adopting another persona, as in Titian's *Isabella*, painted in her absence.) That Isabella would wish to evade Leonardo's scrutiny is suggested by her behavior a few years earlier in relation to yet another portrait commission. She had posed for Mantegna in early 1493, and had found the portrait unsatisfactory, claiming that it did not resemble her at all, whereas surviving portraits by him suggest that it probably resembled her all too well. In any case, Isabella had then turned to Giovanni Santi.[69] Although Santi's portrait is lost, surviving works suggest that the face must have been rather bland, quite unlike Mantegna's precise visages. Of course Bellini is not bland – but he does shield his subjects, whereas Leonardo makes them accessible, perhaps even vulnerable. And Isabella did not want vulnerability for her self-image.

The circumstances of the commission may seem extraordinary: its determination by a contest without the active cooperation of the contestants. But Isabella's machinations regarding her portrait by Leonardo were not so different from what other patrons were doing and thinking. The difference was more a matter of degree, involving an exceptionally controlling and knowledgeable patron and two erstwhile rivals who were also two of the greatest painters of their time. Whatever considerations motivated Isabella, however, the matter was decided once she had Leonardo in hand in Mantua. As she posed for Leonardo, perhaps she showed him a portrait or portraits by Bellini or perhaps described them to him. For his part, Leonardo was more amenable to such a confrontation than Bellini may have been.

Leonardo's letter of introduction to Lodovico documents the artist's competitiveness – he is *"al paragone di"* every other master in various arenas. In one of his notebooks, he advised painters to practice drawing in company with others for two explicitly agonistic reasons: "first [. . .] you will be ashamed to be counted among draughtsmen if your work is inadequate, and this disgrace must motivate you to profitable study. Secondly a healthy envy will stimulate you to become one of those who are more praised than yourself, for the praises of others will spur you on."[70] (*Unhealthy* envy, however, leads to infamy and cannot "stand in *paragone*," according to a notation on a drawing Leonardo made about 1494.[71]) And in 1498, while Isabella was orchestrating her confrontation of Leonardo's *Cecilia Gallerani* and Bellini's portraiture, Leonardo was participating in a *paragone* debate at the Sforza court in Milan.

Such debates on various subjects – the favored theme was love – were a popular form of courtly entertainment. Claire Farago cites the example of a week-long poetry contest at the Sforza court in 1423 involving the recitation of eclogues on love; and Castiglione's protagonists engaged in a disputation on the *paragone* of painting and sculpture, reiterating many of Leonardo's ideas.[72]

Their fictional exchange may echo the tone and content of the actual debate at the Sforza court in 1498. With Duke Lodovico in attendance, Leonardo discoursed on various matters with theologians, men of science, and other artists.[73] These kinds of intellectual sparring matches are ultimately descended from the Greek *agones*, including competitions in the recitation of poetry, such as that won by Hesiod, and also musical contests and painting competitions, as well as political, philosophical, and other rivalries.[74] The ancients provided numerous examples of competitions among artists, but the agon between Apelles and Protogenes, recounted by Pliny among others – including Ghiberti – became the archetype for such battles of wit and skill.[75]

Whether Isabella had such venerable precedents in mind when she set out to compare portraits by Leonardo and Bellini, or whether her interests were entirely pragmatic – who should paint her next portrait, and in what manner? – Leonardo must have been aware of her borrowing his work to compare with the Venetian's. The warmth with which Cecilia refers to Leonardo in her reply to Isabella suggests that they were on friendly terms. Do not blame Leonardo, Cecilia writes, if the portrait no longer looks like me, some twelve years after it was painted. One does not find anyone equal to him (*non se ne truova allui un paro*).[76] But even had Leonardo been ignorant of the contest staged by Isabella between his portraiture and Bellini's, the fact remains that the *Isabella* evokes Bellini in certain regards. Moreover, Bellinesque elements in the slightly earlier *Belle Ferronière* suggest that Leonardo was confronting his rival even before Isabella staged her competition.

Leonardo's awareness of Bellini's work need not depend on a possible visit to Venice before his documented sojourn there in spring 1500: Bellini's portraits circulated. In any case, an earlier visit to Venice is likely, given Verrocchio's residence there from 1482 until his death in 1488, and the presence of several of Leonardo's former companions from Verrocchio's shop who remained to complete the *Colleoni*, unveiled on 21 March 1496.[77] Leonardo cannot have been indifferent to the production of this great equestrian monument while he continued to struggle with his own Sforza monument in another paragonistic confrontation with past and present masters.

Did Leonardo meet Bellini? An encounter seems likely, given what is known of Bellini's openness to at least two other foreign visitors, Dürer and – more to the point – the sculptor Cristoforo Solari, a colleague of Leonardo in Milan.[78] Added to this coincidental evidence is the certainty that Bellini and Leonardo knew of each other and likely also knew of Isabella's *paragone* of their portraits. Leonardo had the *Isabella* cartoon with him in Venice. Characteristically generous about showing his work to others, including his drawings, Leonardo might well have shown this one to Bellini. Indeed, Leonardo's displaying the cartoon in Venice is mentioned by at least one contemporary, Lorenzo da Pavia.[79] It is easy to imagine that Bellini would have gone to see it. And possibly Leonardo also had some contact with Giorgione, who is described as having debated with the sculptors who had worked on the *Colleoni*, some or all of whom Leonardo had known from his years in Verrocchio's shop.[80]

The disputation concerned the relative merits of painting and sculpture. Unless the Verrocchio équipe remained in Venice long after the completion of the *Colleoni* in 1496, the debate must have taken place in that year if not earlier. But not very much earlier: Giorgione was born around 1476, and even if precocious, was not likely before age twenty or so to have been both sophisticated enough to engage in such discussions and mature enough as an artist to produce the winning (visual) argument.[81] Giorgione's painted riposte to the Florentine sculptors is described as *Saint George in Armor* by the Veneto Paolo Pino, as a male nude by the Tuscan Vasari. Whatever the subject, some historians have doubted the existence of Giorgione's *paragone*; they suspect that the lost work may have been a fiction perhaps invented by Pino (and varied by Vasari) to illustrate his argument about the superiority of painting over sculpture.[82]

Assuming for the sake of argument that Giorgione's painting existed, was the subject a nude, as Vasari wrote, or Saint George, as Pino claimed? Pino's description of Giorgione's subject as the painter's onomastic saint may be seen as confirmation of the painting's existence precisely because it is so wonderfully apposite: defending his art, Giorgione is defending himself. "I will silence those who seek to defend sculpture," boasts Lauro, Pino's Venetian interlocutor,

> just as they were confounded with different means by Giorgione da Castelfranco, our most celebrated painter, no less worthy of honor than the ancients. To the perpetual confusion of sculptors, he painted a picture of an armed Saint George, standing and leaning on the shaft of a spear, with his feet at the very edge of a limpid and clear pool in which the entire figure was reflected, foreshortened as far as the crown of the head, [and] he had feigned a mirror leaning against a tree trunk, in which the entire figure was reflected from the back and one side. He feigned a second mirror opposite this, in which one saw the entire other side of Saint George, wishing to demonstrate that a painter can make visible an entire figure at a single glance, which a sculptor cannot do, and this work was (as a creation of Giorgione's) perfectly conceived in all the three parts of painting, that is, design, invention and color, *disegno, invenzione, e colorire*.[83]

Vasari considered Giorgione's painted *paragone* so important as to warrant his mentioning it twice in the 1568 edition (though not at all in 1550), describing the subject as a nude, perhaps thinking unconsciously of Michelangelo's preferred subject. In the *Proemio di tutta l'opera*, in the context of a discussion of the *paragone* of painting and sculpture, Vasari explained that

> whereas the sculptors make two or three figures together at most from a single block of marble, they [painters] make many of them in one single panel, with those very many and varied views that they [sculptors] say that a single statue has, [painters] compensating with the variety of their poses, foreshortening, and attitudes, for the ability to see the works of sculptors from all around; even as Giorgione da Castelfranco has already done in one

of his pictures, which had a figure turning the shoulders, and having two
mirrors, one on each side, and a pool of water at the feet, showing the figure's
back in the painting, the front in the pool, and the sides in the mirrors – a
thing that sculpture has never been able to do.[84]

Vasari returned to the subject in his Life of Giorgione, this time offering a more
explicit description of the lost work and explaining its genesis in the context
of the painter's debate with Verrocchio's colleagues. "It is said" – words sug-
gesting that the anecdote was a familiar one –

> that Giorgione, arguing with several sculptors at the time when Andrea
> Verrocchio was making his bronze horse [for the *Colleoni*], who held that
> because sculpture showed in one single figure different poses and views as
> one moved around it, that for this reason it surpassed painting, which showed
> only a single view of a figure. Giorgione [. . .] was of the opinion that in a
> painted narrative one could show, without the need to walk around, but in
> a single glance, all the kinds of views that one man can make in many ges-
> tures, a thing that sculpture cannot do without changing the site and point
> of view, so that [in painting] there is not one but many points of view. He
> further proposed that with one single painted figure, he wanted to show the
> front, the back and the two profiles from the sides. [. . .] And he did it this
> way. He painted a nude man who turned his shoulders and had in the ground
> a pool of the most limpid water in which he made the front part by reflec-
> tion; on one of the sides there was a burnished cuirass that the man had
> removed, in which was the missing profile, because everything was seen in
> the polished surface of that armor; on the other side was a mirror, within
> which was reflected the other side of the nude: which was a thing of the most
> beautiful whim and caprice, he wishing to demonstrate that in effect paint-
> ing leads with greater *virtù* and effort, and shows in one single view of the
> living figure more than does sculpture. Which work was most greatly praised
> and admired as something ingenious and beautiful.[85]

The reliability of these sixteenth-century literary sources (and Pino in par-
ticular) is confirmed indirectly by visual evidence of paintings that seem to have
been influenced by Giorgione's lost work. Titian's *Saint George*, datable to
c. 1516, may recall the spiraling stance of Giorgione's lost figure, though the
reflecting motifs have been abandoned, and with them, the point of the exer-
cise.[86] Closer to Giorgione's polemical purpose is Giovanni Girolamo Savoldo's
Man in Armor, possibly a self-portrait (Fig. 28). Pino was Savoldo's devoted
follower, and some scholars have suspected that he may have had this portrait
or similar work in mind when he recounted the story of Giorgione's *paragone*.[87]
And yet Pino's dedication to his master may suggest precisely the contrary: were
Savoldo, and not Giorgione, the painter of the definitive paragonistic work,
presumably the author would have said so. In any case, there is of course no
pool of water in Savoldo's portrait because his subject is seen in an indoor
setting; but Giorgione's two mirrors are at home here, evoking Pino's descrip-

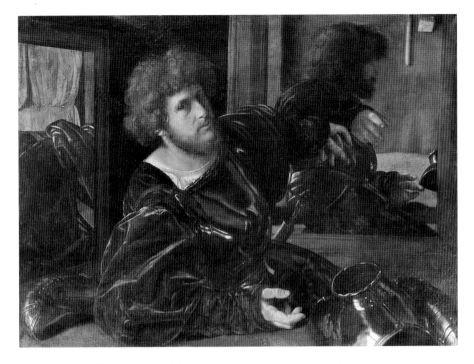

28 Giovanni Girolamo Savoldo. *Man in Armor*. Canvas. Paris, Musée du Louvre.

tion. Savoldo exploited one of these mirrors to display his signature, written on a *cartellino* or fictive label visible only as a reflection in the mirror behind the subject. The *cartellino* is affixed to a wall that we understand to be in front of the man, by implication in the beholder's space, that is, in the real world reflected in the image by virtue of the artist's skill.[88] The conspicuous foreshortening of the left arm and the forward tilt of the torso, which becomes backward in the mirror reflection, may also derive from the lost Giorgione: both Pino and Vasari allude to foreshortened limbs.

Whatever Giorgione's subject – nude or saint – its meaning, or the anecdote's meaning, was clear for both Pino and Vasari. The painter can represent multiple views of a figure by means of reflections in such surfaces as water, glass, or metal, something the sculptor cannot do. In addition, those views need not all be from the same vantage point: in one of Giorgione's reflections, the figure is foreshortened. Giorgione's choice of mirror and water as reflecting surfaces was not coincidental. The reflecting spring is the mirror's natural counterpart, evoking the pool where Narcissus, beholding himself, invented painting. Pino remembered the myth, and purposefully echoed Alberti's explication of its significance for painting.[89] Painters, Pino declares, should "become liquid, and resolve themselves, like Narcissus, in the image of his beauty."[90]

A statue can obviously be viewed from front, back, and sides; but the sculptor depends perforce on the beholder's movement around the work. Moreover,

the beholder can see these views only sequentially, not simultaneously, as the painter enables one to do. Indeed, the fact that a statue has these various points of view is no credit to the sculptor: it is a function of the medium itself, as Leonardo explained: "There is no comparison between the innate talent, skill and learning within painting and within sculpture, inasmuch as spatial definition in sculpture arises from the nature of the medium and not from the artifice of the maker."[91] Leonardo's words about the *paragone* of painting and sculpture express Giorgione's ideas, or at least the ideas imputed to him by Pino and Vasari. Leonardo's texts may be read as an explication of Giorgione's lost painting – or the painting seen as the illustration of Leonardo's texts.

Vasari's account of Giorgione's *paragone* is introduced as a report of something he had "heard about," *dicesi*, suggesting that the event was still being discussed some six decades later. If Venetians were still talking, and theorists writing, about Giorgione's *paragone* in the mid-sixteenth century, Leonardo probably heard of it when he came to the city in 1499, when it was newer news on the Rialto. In any case, if Leonardo needed encouragement to think more about the *paragone*, he could find it in Venice. And that the *paragone* was already on Leonardo's mind at the end of the century is certain, given his participation in the debate at the Milanese court in 1498, Isabella's portraiture contest of the same year, and Leonardo's own writings.

As early as 1492, Leonardo had begun to compile notes for a projected treatise on painting, including a discussion of the *paragone* of the arts. These notes, identified as the *Parte prima, Libro di pittura* in the Codex Vaticanus Urbinas Latinus, can be dated to that time (the latest parts of the manuscript are datable c. 1508–10).[92] Giorgione's exploitation of mirror reflections would have been of particular interest to him, because for Leonardo, painting and mirror are equivalents – or should be. Thus he advised the painter to "be like a mirror which is transformed into as many colours as are placed before it, and, doing this, he will seem to be a second nature."[93] Later in the same codex, and also in the Ashburnham manuscript, Leonardo expanded the simile, advising the painter to "take the mirror as your master [. . .] make your picture [. . .] look like something from nature seen in a large mirror."[94] Most of the *Parte prima* of the Vatican codex is concerned, however, with Leonardo's "Paragone," in particular the demonstration of painting's status as a science and the rivalrous comparisons of painting and poetry, painting and sculpture – with painting found to be superior in each case. Painting and poetry may be compared "because poetry puts its subjects [*cose*] into the imagination with letters, and painting represents things that are in reality outside the eye, so that the eye receives the likenesses [*similitudini*] as though they were natural."[95] Although comparable, however, painting and poetry are not equal: "Painting acts through a more worthy [*degno*] sense than poetry," sight being more noble than hearing because the eyes are the windows of the soul.

> And the painter [. . .] goes directly to the imitation of those works of nature. [. . .] With this [painted imitation], lovers are moved by the likenesses of the

beloved [*cosa amata*] to speak with imitative pictures. With this, people are moved [. . .] to seek the simulacra of the gods, and not a look at the works of poets which figure the same gods with words. With this, animals are deceived. Once I saw a painting that deceived a dog so that he most joyfully greeted the likeness of his master.[96]

A "painting lacks only the soul" (a variation of the ancient trope that a great likeness lacks only the voice).[97] And the clincher: "If you claim that painting [is] mute poetry, then the painter could say that poetry [is] blind painting. [. . .] Place the name of God in writing in a place, and if you set up his figure opposite this, you will see which is the more revered. [. . .] Take a poet who describes the beauties of a lady to her lover, and take a painter who figures her, you will see where nature will lead the enamoured judge."[98] Leonardo invokes King Matthias of Hungary to prove the point. The king had been reading a poem in his honor but closed the book when "presented [. . .] with a portrait of his beloved." When the poet called upon him to continue reading, Matthias responded "Silence, O poet. [. . .] Give me something I can see and touch and not only hear."[99]

Having trounced poetry, Leonardo turns to the *paragone* of painting and sculpture with even more vehement and indeed *personal* arguments. It could hardly have been otherwise because, unlike the comparison of painting and poetry, whose rivalrous sisterhood dates from classical antiquity, the *paragone* of painting and sculpture lacked a comparable literary tradition.[100] But Leonardo adapts various sources to this new purpose. "Sculpture is not science but a most mechanical art, because it generates sweat and bodily fatigue in the worker," he declares, referring to stone carving (as opposed to modeling or casting techniques).[101] "The only difference I find between painting and sculpture," he continues, hammering home the point,

> is that the sculptor conducts his works with greater physical effort than the painter, and the painter conducts his works with greater mental effort. You can prove that this is true because when the sculptor makes his work he consumes the marble [. . .] by effort of his arm and by percussion, which is a highly mechanical exercise, often accompanied by great amounts of sweat composed of dust and coverted into mud, with his face coated and all dusty with marble dust so that he looks like a baker, and covered with minute flakes so that he seems to have been covered with snow; and his house is filthy and full of chips and stone dust. Just the opposite happens to the painter (speaking of excellent sculptors and painters), because the painter sits in front of his work at great ease, well dressed, and wielding the lightest brush with charming colors. His clothing is ornamented according to his pleasure, and his house is filled with charming paintings, and clean, and he is often accompanied by music or readers of varied and beautiful works that are heard with great pleasure without the uproar compounded of hammers and other noises.[102]

The opposing point of view – sculpture is superior to painting – was perhaps best articulated not in any text but in a wax relief representing *Ugolino and his Sons* by Pierino da Vinci, Leonardo's nephew.[103] But Bronzino, among others, echoed Leonardo's arguments in a letter written for Varchi's *Due lezzioni*: "the physical effort of chiseling [. . .] does not make their [sculptors'] art nobler, but rather it diminishes its dignity, because the more the arts are exercised with manual and physical exertion, the closer they are to the mechanical crafts. [. . .] But if one means mental effort, the painters say that painting is not only equal but surpasses sculpture by far" – and this from one who, unlike Leonardo, venerated Michelangelo.[104]

The physical exertion entailed in sculpture was not its only fault, however, as Leonardo had explained. If a sculptor seeks to defend his art by claiming that once he has cut away the marble, he cannot "add on" as the painter can do, Leonardo would reply that if the sculptor's "art were perfect [. . .] he would have taken away only what was enough," and nothing more. Besides, the sculptor does not have to cope with shadow and light, "because nature itself generates them in his sculptures. There is nothing [in sculpture] about color, and if the sculptor is moderately concerned with distance or nearness in his work, he will merely adopt linear perspective but not that [aerial perspective] of colors. [. . .] Therefore, sculpture has less discourse and, consequently, a lesser effort of imagination compared with painting."[105] In other words, "sculpture is not other than what it appears to be."[106] And finally, if a sculptor argues that sculpure is "more eternal" than painting, he should realize that "this permanence is born from the material and not from the artificer." Besides, a painter can achieve comparable longevity by using enamels on metal or terracotta.[107]

The discourse may seem puerile, even risible, today. But for Renaissance participants in the debate, the *paragone* of painting and sculpture was very serious indeed, because it concerned the fundamental purpose of art, which is the imitation of nature. And this painting can do better than any other art, according to Leonardo and Giorgione.

The *paragone* was more than theory to Leonardo and his contemporaries: it was real life, bound to competition with other masters. Leonardo had moved to Milan in 1481–82, perhaps in search of a safer haven for his genius after some unknown difficulty in Florence or because of his disappointment at being excluded from the Sistine Chapel. Leonardo brought competition with him, or rather a rivalrous mentality, as his letter of introduction to Duke Lodovico shows. At the end of his Milanese residence, Leonardo and Bellini had confronted each other in a *paragone* by proxy, engineered by Isabella d'Este. Visiting her court in Mantua, Leonardo would have seen her Studiolo while still a work in progress, though with its agonistic conception already implicit if not completely articulated. During his sojourn in Venice, he would have seen works by Bellini, his erstwhile competitor in Isabella's contest, and perhaps met with him and other Venetian masters, including Giorgione. And finally returning to Florence after nearly a quarter of a century's absence, Leonardo was compelled to face another rival, younger and far more confrontational.

II

Protagonist

29 Michelangelo. After Giotto, *Ascension of Saint John*. Ink. Paris, Musée du Louvre.

4

Michelangelo

He was never jealous of the efforts of others, even in his own art,
more for the goodness of his nature than because of the opinion that
he had of himself. Indeed, he has always universally praised everyone,
even Raphael of Urbino, between whom and himself there were a few
painting contests.

<div align="right">Ascanio Condivi[1]</div>

O wonder of nature, Angel elect [. . .] you are perfect in both
wisdom and goodness.

<div align="right">Agnolo Bronzino[2]</div>

TODAY, LEONARDO IS COMMONLY PERCEIVED as the universal great genius,
the Renaissance man, in large part because of works not known, or not
widely known, to his contemporaries, namely his notebooks and drawings. He
completed few works, and of those, two of the most important were lost or in
poor repair even during his lifetime: the Sforza horse had been destroyed by
1500, when the *Last Supper* was already showing signs of deterioration. In the
new century, it was Michelangelo who predominated. Indeed, in Vasari's
hagiography, Leonardo was cast as the Precursor to Michelangelo's Redeemer
of the arts. Michelangelo's stature derives in great part from the undeniable fact
of his extraordinary achievements in all three arts, painting, sculpture, and
architecture: the scope of his oeuvre and its quality are unsurpassed. But
sixteenth-century Michelangelo-centricity was also promoted by Michelangelo
himself, a master of a fourth art now known as spin control.

Michelangelo has been famous since his lifetime for such works as the
Vatican *Pietà*, the *David*, and the Sistine Chapel frescoes. No less enduring
than any of these monuments was Michelangelo's creation of himself as the
paradigm of artistic genius. Accounts of his youth provided by his principal
biographers, Giorgio Vasari and Ascanio Condivi, suggest that Michelangelo
began this process of self-creation at the start of his career. Vasari and Condivi
were writing half a century or more after these first critical steps toward
Michelangelo's self-creation, and much of what they describe is exaggerated or
sometimes invented, as their readers have long realized. Their purpose was

not necessarily to record facts about Michelangelo, however, but to abet his process of self-definition as protagonist of their time. Doing so, they cast everyone else as antagonists in his drama. Toward the end of his life, like all great masters, Michelangelo came to confront himself in a series of profoundly self-referential masterpieces. Thus he fulfilled the implicit challenge of his biographers' encomia: only Michelangelo can surpass Michelangelo.[3]

In his life-long process of self-invention, Michelangelo told many half-truths and not a few lies. But about one thing, the central thing, he was truthful: the art of his contemporaries was of little interest to him. His teachers were long dead. They were the ancients, of course, and three great progenitors of earlier Tuscan Renaissance art, namely Giotto, Masaccio, and Donatello (it is significant that two of these exemplars were painters). Michelangelo's audience recognized the debts. While exalting Michelangelo – he has surpassed all the moderns and equalled the ancients in painting, sculpture, and architecture – Giovanni Battista Gelli acknowledged the profundity of Michelangelo's debt to Giotto. In Giotto's paintings, Gelli explained,

> it seems that all his figures do what is appropriate to them: those who have sorrow appear depressed, the happy seem cheerful, and those who have fear seem to be frightened; which quality until our times no one has seemed to have observed better than Michelangelo Buonarroti, as is evident from the *Last Judgment* he painted in Rome in the time of Pope Paul, in which the blessed seem most content and show the greatest joy, the damned on the contrary show in their faces a marvelous grief, which quality he has perhaps taken from the aforementioned Giotto, whose works he very frequently went to see when he was in Florence, and in particular he was seen to remain for three and four hours at a time in the chapel adjacent to the high altar of Santa Croce [Giotto's Bardi Chapel] where there are [depicted] certain friars who weep for the death of St. Francis.[4]

Gelli's reference to Giotto's weeping friars suggests that Michelangelo made a drawing or drawings after the *Death of Saint Francis*, now lost. A surviving drawing after two witnesses of Giotto's *Ascension of Saint John the Evangelist* in the Peruzzi Chapel, adjacent to the Bardi, documents Michelangelo's study (Fig. 29).[5]

Vasari was also aware of Michelangelo's relationship to earlier masters – his Life echoes parts of Gelli's text – though not so interested as his predecessor in the debt to Giotto. Both the 1550 and 1568 editions begin with invocations of Giotto, but only as the exemplary antecedent destined to be eclipsed by Michelangelo.[6] Vasari's "Letter to Craftsmen and Readers," which closes the *Lives*, reiterates this point: praised by contemporaries, Giotto would not have been so appreciated had he lived in Michelangelo's time.[7] (Here and elsewhere, Vasari consistently used the word *artefici*, "craftsmen" or "artisans," not *artisti*, "artists.") Vasari was more interested in Michelangelo's study of Masaccio, described in both editions of the *Lives* as an implicitly agonistic imitation. Michelangelo's drawings of Masaccio's Brancacci Chapel frescoes were so

splendid that they "stupefied craftsmen and other men, in such a way that envy of Michelangelo grew together with his name."[8] Indeed, Pietro Torrigiani became so envious that, "moved by envy in seeing him more honored than himself and more talented in art, with much pride punched him in the nose," breaking it badly and marking Michelangelo for life.[9]

Condivi's biography includes the anecdote of the broken nose, emphasizing Torrigiano's perfidy and exulting in his bad end, but omitting mention of Michelangelo's drawings after Masaccio as the proximate cause of Torrigiani's pique.[10] While vaunting Michelangelo's debts to Nature and to the ancients, Condivi remained silent about his study of earlier Italian masters, ignoring Giotto as well as Masaccio, and alluding to Donatello only to (mis)quote Michelangelo's criticism of him. Similarly, Benedetto Varchi in his *Orazione funerale* avowed that as a boy "Michelangelo was very capricious, and did not deign to learn from others except from Nature. [. . .] he painted without having had, I do not say, anyone before him, having had God, the Heavens and Nature [. . .] as example and as Masters, but without anyone's having told him either the rules or lessons."[11] Michelangelo's works themselves tell a different story, illustrating his profound debts to his predecessors, starting with his early drawings after Giotto and Masaccio.

The first works that Vasari attributed to the young artist are also drawings made while Michelangelo was in Domenico Ghirlandaio's shop. Condivi denied this association in his volume, accommodating Michelangelo's wish to present himself as an autodidact in the art of painting, or at least to deny Ghirlandaio any credit for his training. Vasari's response to this in the second edition of his *Lives* was to document Michelangelo's apprenticeship by publishing a contract that Ghirlandaio's heirs had shown him: the agreement between Michelangelo's father, Lodovico, and Domenico and Davide Ghirlandaio, dated 1 April 1488.[12] Although this document has been lost, a payment record of 28 June 1487 confirms that Michelangelo was in fact in Ghirlandaio's shop even a year earlier than Vasari believed.[13]

According to Vasari in 1568, Michelangelo's earliest drawing was a sheet that had come into Vasari's possession by 1550, presumably too late to be included in the first edition. This was a pen sketch by one of the other Ghirlandaio *garzoni* after the master's depictions of draped women:

> Michelangelo took that paper and with a thicker pen re-outlined one of those women with new contours, in the style [*maniera*] that it should have had to be done perfectly: it is a marvelous thing to see the difference between the two styles, and the goodness and judgement of a youth so brave and proud that he had spirit enough to correct the works of his master. This sheet is today in my possession, kept as a relic, which I got from Granacci to include in my book of drawings with others by him [Michelangelo], received from Michelangelo; and in the year 1550, when he was in Rome, Giorgio [Vasari] showed it to Michelangelo, who recognized it and was happy to see it again, saying with modesty that he knew more about this art when he was a boy than now that he was old.[14]

The second work by Michelangelo that Vasari mentioned in 1568 (the first in the 1550 edition) is a sketch, in effect a genre scene, depicting the scaffolding and some trays, with all the materials (*masserizie*) of the art, and "some of those youths who were working" in the Tornabuoni Chapel, that is, the chancel of Santa Maria Novella, where Ghirlandaio's shop was employed between 1486 and 1490. This drawing so amazed Ghirlandaio, according to Vasari, that the master declared, " 'This one' " – Michelangelo – " 'knows more about it than I do'; and he remained flabbergasted by the boy's new style."[15] The thirteen-year-old pupil had already exceeded his ostensible master, and Ghirlandaio himself acknowledged as much. Of course, like much else in Vasari's *Lives* and other Renaissance sources, these episodes may not have happened precisely as the author recounts. The master surpassed by his brilliant pupil is a trope in the *Lives*; for example, Leonardo's Angel in Verrocchio's painting of the *Baptism of Christ* "was the reason that Andrea never again wanted to touch colors, outraged that a boy should know more than he."[16] Regardless of their historical accuracy, such anecdotes are psychologically truthful in describing the way in which Michelangelo's contemporaries perceived him and the way in which he perceived himself.

Condivi did not mention these drawings: they raise the specter of Michelangelo's association with Ghirlandaio's shop. The official biographer began instead with Michelangelo's copy of Martin Schongauer's *Temptation of Saint Anthony*, discussed also in both editions of Vasari and remembered as Michelangelo's first work by Benedetto Varchi in his funeral oration for the artist in 1564.[17] It was common practice for young artists to learn by making copies – including teenage Michelangelo and other boys copying Giotto and Masaccio – but quite uncommon for a biographer to privilege such copies as Michelangelo's lives did, introducing the oeuvre of this most original master with the descriptions of works that are unoriginal by definition. One likely reason for, and certainly the result of, the biographers' choice (and a reason also for Michelangelo's having advertised this youthful effort to them) was to establish an agonistic frame of reference for his achievements. Michelangelo is announced as the triumphant protagonist of a series of rivalrous confrontations with competitors, past and present.

Schongauer's engraving of the *Temptation of Saint Anthony* was one of the German's first works, dating from the early 1470s (Fig. 30). Michelangelo's choice of this source is as unexpected as his biographers' privileging the copy: a German work, not Italian and not classical, and recent too – Vasari specified that the print had just arrived in Florence when Michelangelo laid hands on it. Given the evidence provided by Vasari and by Condivi, this must have been around 1487 or 1488, when Michelangelo had already become friendly with Francesco Granacci, and when both of them were in the Ghirlandaio shop. According to Condivi, it was Granacci who gave Michelangelo the print. Born in 1475, Michelangelo was therefore about twelve or thirteen when he copied Schongauer's *Temptation of Saint Anthony*. Whatever artistic or psychological considerations may have led him to this work, his choice seems suggestive.

30 Martin Schongauer. *Temptation of Saint Anthony*. Engraving.

Perhaps he was attracted by the monstrous elements of the composition, a first sign of a taste for the grotesque that was later restricted to decorative details or banished altogether? Parts of the story recall Leonardo's early *Medusa*: perhaps great masters are supposed to have such youthful encounters with the unnatural?[18]

Michelangelo did not intend only to copy the engraving; he meant to transform it. Redoing Schongauer, he would *outdo* him. Michelangelo's ambitions are implicit, first of all, in his choice of medium. Not satisfied with a mere drawing – the most likely and easiest means of copying an engraving – Michelangelo made a pen drawing which he then colored, thereby transforming the print into a painting. According to Vasari in 1550, his drawing technique was in itself unique, "in a style that was not known" (no wonder Ghirlandaio was nonplussed).[19] According to Condivi, the copy was on panel, a more durable medium than paper, revealing Michelangelo's ambition and seriousness of purpose. Yet painting was so new to Michelangelo, Condivi claimed, that he did not have his own pigments or brushes: like the print, these were supplied to him by his pal Granacci.[20]

Second, and more importantly, Michelangelo embellished his model, as both Condivi and Vasari described. In order to depict the demons that beset the saint,

Michelangelo consulted not the black and white of Schongauer but the colors provided by Nature. And so Michelangelo went to the fish market (according to Condivi), perhaps actually buying some (according to Vasari). Copying from Nature, Michelangelo endowed Anthony's demons with bizarre colors (Vasari) and fishy eyes (Condivi), to remarkable effect. For this skillful counterfeiting of demons, Michelangelo "acquired credit and fame," according to Vasari.[21] Condivi added that the painting "not only gave amazement to whoever saw it, but also envy – as some wished – to Domenico," that is, to Ghirlandaio, introduced here as *Granacci's* esteemed master. Underscoring the point, Condivi concluded that Michelangelo's painting led to "admiration in the world and, as I have said, some envy in Ghirlandaio."[22] Condivi's only references to Ghirlandaio are thus in relation to his jealousy of Michelangelo. In any case, the gist of both biographies is that Michelangelo exhibited his *Saint Anthony* and that its first audience admired the painting as a demonstration of his abilities. So Michelangelo launched his career with a copy that surpassed its original and with drawings that surpassed his (unacknowledged) master.

Immediately following the accounts of the emended Schongauer, both Condivi and Vasari reported on Michelangelo's forgery of "old masters," intended to equal and then transcend their creators. Condivi did not specify the medium or media of these imitations, though Vasari implied that some at least were drawings: Michelangelo "counterfeited [. . .] sheets by the hand of various Old Masters, so similar that they were unrecognizable [as copies], tinting them and aging them with smoke and various things [. . .] he soiled them so that they appeared old; and comparing them (*paragonatole*) with the original, one could not know one from the other." But his purpose was not venal. On the contrary, "He used to do this for no other reason but to have originals from the hand of those [. . .] whom he admired for the excellence of the art and was seeking to surpass in the execution: from which he acquired a very great name."[23]

Michelangelo's adolescent frauds were rewarded by the invitation to study in the sculpture garden of Lorenzo de' Medici, il Magnifico.[24] Michelangelo later described his years with Lorenzo's household – he lived in the palace until il Magnifico's death in 1492 – as the happiest time of his life.[25] But it was also there and then that Michelangelo engaged in his first face-to-face competition with a contemporary. The custodian of the sculpture garden was Donatello's former associate Bertoldo di Giovanni (c. 1420–91); and, according to Vasari in 1568, he had given Torrigiani, another pupil, some clay figures to model.[26] Michelangelo's response to Torrigiani's modeling of the figures was to make some of his own figures "in emulation," and his efforts were rewarded by Lorenzo's approbation. This emulation of Torrigiani's labors was in effect a competition that of course Michelangelo won. (If Vasari's sequence is correct, this was before Torrigiani broke Michelangelo's nose, suggesting that their rivalry was not a "one-shot" affair.) Again according to Vasari, Lorenzo's encouragement led Michelangelo to make his first sculpture in stone, the *Head of a Faun*; according to Condivi, who omitted the *sculpture* competition with

Torrigiani, Michelangelo did not depend on Lorenzo's approval but was self-motivated, inspired by the beauty of the antiquities in the garden.[27] In other words, having learned from Nature (the fish), now Michelangelo learned from the ancients. The classical *Head* showed the faun "old, bearded, and with a laughing face," as Condivi explained, "though because of the head's antiquity, one could barely see the mouth or tell what it was."[28] Obtaining marble and tools from stonemasons employed by Lorenzo, Michelangelo finished his copy "in a few days, supplying from his imagination everything that the ancient work lacked." Even in this first imitation of antiquity Michelangelo was able to surpass his model. And he did this, according to Vasari in 1568, "though he had never before touched either marble or chisels." Lorenzo was "stupefied."[29]

The *Head of a Faun* was, then, Michelangelo's first marble sculpture (assuming his biographers are correct and that none of the earlier works in unspecified media was carved in stone); and also his first certain copy of an antiquity. But as with the copy after Schongauer, here too Michelangelo altered his source, and so doing, eclipsed it. This triumph is implicit in Condivi's description of the original, to which Michelangelo supplied what was missing, namely, the mouth; and explicit in his account of what happened when Lorenzo saw the work. "Oh, you have made this *Faun* old and left him all his teeth," Lorenzo joked; "Don't you know that there are always some teeth missing in old men of that age?"[30] Opening the faun's mouth, Michelangelo presumably wished to rival the Greek painter and sculptor Polygnotos, whose fundamental contribution to the art of painting, according to Pliny, was precisely to open "the mouth, showing the teeth."[31] Michelangelo himself need not have read the Latin author to be aware of this text. Pliny was a Medici household name: Landino, whose edition of Pliny's *Natural History* was published in 1476, had been il Magnifico's tutor.[32] The ancient example would have seemed particularly apposite to Michelangelo because, like himself, Polygnotos was both a painter and a sculptor. (Architecture came later.)

Lorenzo's teasing response to the open mouth of the *Faun* inspired Michelangelo to remove one of the upper teeth, drilling into the gum. Lorenzo had a good laugh, but then, "considering the perfection of the thing and the age of [the boy, . . .] he determined to help him and to favor such ingenuity and to take him into his house."[33] Michelangelo was given a room in the Medici palace and dined with the family and their distinguished guests.[34] One would give a great deal to be (for a while) a fly on that dining-room wall.

Condivi also took note of Michelangelo's study of antiquity. Once Michelangelo had "tasted the beauty" of the ancient works in the Medici sculpture garden, Condivi wrote, "he never again went to Domenico's shop but stayed there all day, as in the best school of that faculty [of sculpture], always doing something."[35] (This passing mention of Ghirlandaio may be tacit admission of Michelangelo's apprenticeship: one cannot cease going to a shop that one has never frequented.) Thus the ancients became Michelangelo's second teacher, after Nature.

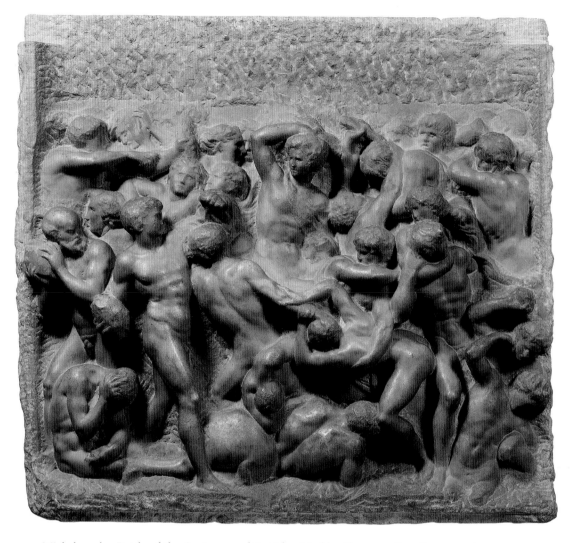

31 Michelangelo. *Battle of the Centaurs and Lapiths*. Marble. Florence, Casa Buonarroti.

From this first copy of an antiquity, Michelangelo immediately progressed to making his own antiquity, that is, to create an ancient work *ab ovo*. Both the subject and the marble itself were provided by the humanist Angelo Poliziano (Politian), tutor of Lorenzo's sons and "a most learned and sharp-minded man, as everyone knows": the *Battle of the Centaurs and Lapiths* (Fig. 31).[36] According-ing to Condivi, the *Centaurs* relief was completed just before il Magnifico's death on 8 April 1492. If this chronology is correct, Michelangelo was no more than seventeen when he did the work.

Condivi reported that the relief was "still" in Michelangelo's house in 1553, that is, when the *Life* was published, suggesting that the work had always been

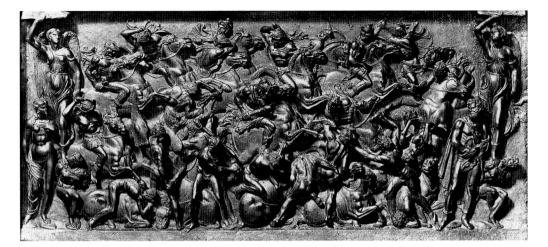

32 Bertoldo di Giovanni. *Battle*. Bronze. Florence, Museo Nazionale del Bargello.

in the artist's possession (it remains in Casa Buonarroti, its provenance unin-terrupted), and that Poliziano had relinquished whatever claim he may have had to the work, having provided both the idea and the material. Vasari also considered the relief important. Although he omitted the *Battle* from his first edition, evidently because he was ignorant of it, he added it to the second, reit-erating the information provided by Condivi, though identifying the subject dif-ferently (Condivi called it the *Rape of Deianira*, Vasari the *Battle of Hercules and the Centaurs*).[37] Both authors seem to have been mistaken about the subject, however. The only certainty is that Michelangelo represented men bat-tling Centaurs in a composition notable for its narrative obfuscations. Chaos is undeniably characteristic of battle, but it was probably not Michelangelo's intention to depict pandemonium without narrative. His subject seems to be the story of the Centaurs and Lapiths, as most scholars believe.

Homer, Ovid, and Boccaccio, among others, recounted how the Lapiths, a Greek tribe, had invited the Centaurs to attend the wedding of Perithous and Hippodamia. The Centaurs drank far too much. Intoxicated, they lost their heads (or minds), reverting to their bestial natures – embodied, literally, in the lower parts of their anatomy – and attempted to carry off the bride herself. The Lapiths and their human guests, including Theseus, the groom's close friend, defended the bride and drove off the miscreants. The meaning of the text is clear: one's animal nature, that is, one's behavior, must be ruled by intellect. By nature half-man and half-beast, the Centaurs became entirely bestial when ine-briated. Such bestiality must be controlled and will be vanquished, as Theseus and the Lapiths defeated the centaurs in this Centauromachy.

Whatever Poliziano might have told Michelangelo to do, he seems to have interpreted his source in his own way, an idiosyncratic interpretation char-acteristic of his thinking, as later works confirm. The narrative clarity that

distinguishes written or verbal accounts of the episode – presumably including that provided by Poliziano – is confused in the relief. Here physical or visual ambiguity is imbricated with moral ambiguity, and legibility of narrative sequence is sacrificed to dramatic uncertainty. Some of this illegibility may be due to the visual model consulted by Michelangelo, though not credited by either Condivi or Vasari: Bertoldo di Giovanni's bronze *Battle* relief, c. 1479, originally installed in the Medici palace (Fig. 32).[38] Bertoldo's relief copies a late second-century Roman battle sarcophagus in the Camposanto of Pisa. Michelangelo may have known the original as well as the copy – but it was the copy that was more important for his conception of a battle. The Roman sarcophagus is in poor condition, and Bertoldo had to "restore" it in producing his own *Battle* relief with Hercules the protagonist. A concomitant of his refashioning was the elimination of armor: Bertoldo's combatants are mostly nude.[39] Michelangelo needed little if any encouragement to represent his actors the same way, and in any case, the conception of struggling nudes had already been popularized by Antonio del Pollaiuolo's engraving of the *Battle of the Nudes*.[40] Like the print, the relief was also conceived as a demonstration piece. But the particular debt to Bertoldo's composition is confirmed by the central figure of Michelangelo's relief. Frontal with his head turned to his right and his right arm raised to strike a foe, this figure is adapted from the horseman in the upper center of Bertoldo's work. Michelangelo fused the soldier with his mount, however, transforming him into a Centaur, a fact that is not evident at first glance. Exacerbating the frenzy inherent in any ancient Roman battle relief – and in Bertoldo's bronze – Michelangelo masks the differentiation of species. Only three figures can be identified as Centaurs with any certainty, this one and two fallen companions: one in the immediate center foreground, with his rump facing the beholder; and the other in the lower right corner, with only the beginnings of his forelegs indicated to identify him. Similarly unclear is the differentiation of gender. The viewer cannot be certain whether Hippodamia is represented here, though she has been identified as the figure seen from the back to right of center. One thing is indisputable, however: this is a particularly brutal fight. Where Bertoldo's soldiers use clubs, Michelangelo's Lapiths use very large rocks, rough-hewn and massive. It is tempting to see these stones as signs – in both senses, as symbols and as omens – as the young Michelangelo's precocious recognition of the centrality of stone in his life.

Two men at the left prepare to hurl their stone missals at the enemy (presumably the central figure); and another uses his rock to strike the fallen Centaur in the right corner. It is as though Michelangelo wished to say that such battles turn not only Centaurs but all men to beasts. At the same time, creating a composition that consists *entirely* of figures, he announces his lifelong obsession with the body, especially the male nude. Pollaiuolo had provided a background screen of trees for his *Nude Men*; and even Bertoldo gave some indication of setting, providing little plots of ground for some foreground figures and enclosing the scene between two standing Victories who support arch-like forms. But Michelangelo represents figures only, renouncing environ-

mental and anecdotal elements altogether. In this way, the *Battle* anticipates not only his later vocabulary of poses and his concern with the male nude, but also his minimalist settings.[41]

Michelangelo was justifiably proud of this youthful achievement. It was so successful, according to Condivi, "that when he" – Michelangelo – "sees it again, he knows what a great wrong he committed against nature, not to follow the art of sculpture at once."[42] The lament implies regret for what little time he had spent painting in Ghirlandaio's shop and for the years later spent in the Sistine and Pauline chapels. This impression is confirmed in a *postilla* or marginal note in a copy of the biography belonging to Michelangelo himself or to his young friend, the Florentine sculptor-architect Tiberio Calcagni: "In fact he says that his art is sculpture; the others he does and has done to please princes," that is, his patrons. Michelangelo had been living in Rome since 1534, so had not seen this early work for some twenty years when he spoke of it to Condivi and later to Calcagni; but he continued, "Of the narrative, that when he saw it, he recognized the difficulties of the art to be most insubstantial for one who loves it."[43] (There are twenty-four such notes in Calcagni's hand recording Michelangelo's comments about the text, apart from the last notation, which refers to the master's death.)

The *Battle of the Centaurs* clearly had great significance for Michelangelo, then, and may be described as a work that he made for himself (whatever Poliziano's role in its genesis), as its Casa Buonarroti provenance indicates. The *Madonna of the Stairs* has the same provenance and also seems to have been made for himself (Fig. 34). Whereas the *Battle* is Michelangelo's depiction of an ancient subject carved in the manner of an ancient relief (Condivi described it as *mezzo-rilievo*), the *Madonna* is an essay in Donatello's manner of *rilievo schiacciato* or flattened relief.[44] Thus with these two early works – the earliest sculptures known by him – Michelangelo demonstrated his mastery of the two principal kinds of relief carving and the two principal kinds of subject, pagan and Christian. In this sense, the two reliefs are pendants, despite their differences in theme and handling. But while recalling his pride in the *Battle* when he spoke with Condivi nearly six decades after carving it, Michelangelo evidently kept silent about the *Madonna*.

Datable between 1489 and 1492, the *Madonna* was unique in Michelangelo's oeuvre, a technical dead-end as his only exploration of *rilievo schiacciato*.[45] Decades later, writing to Benedetto Varchi about the *paragone* in 1547, he expressed disdain for this kind of sculpture because it approximates painting. In reply to Varchi's questions about his own views, Michelangelo answered that he had refined his thinking having received and read a manuscript copy of Varchi's *Due lezzioni* (published three years later):

I say that the picture seems to me to be considered better the more it approaches the relief, and the relief the worse the more it approaches the picture: for to me it used to seem that the sculpture was the lantern of the picture, and that between the one and the other there was the same

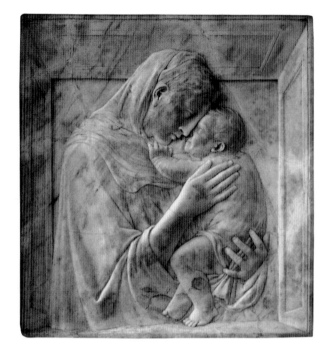

33 Donatello. Pazzi
Madonna. Marble.
Berlin, Staatliche
Museen.

difference as between the sun and the moon. Now, after having read in your
Book where you say that, speaking philosophically, those things that have
an identical purpose are the same thing, I have changed my mind, and I say
that, if greater judgment and difficulty, obstacle and hard work do not make
for greater nobility, then the picture and the sculpture are the same thing. I
mean by "sculpture" that which one makes by dint of removing [material];
that which one makes by means of adding is similar to the picture. It is suf-
ficient that, coming one and the other from the same intelligence, that is,
sculpture and picture, one can make a good peace between them and forgo
so many disputes; because that [argument] takes more time than making the
figures. He who wrote that the picture is more noble than the sculpture,
[. . .] my house girls could have written better.[46]

Michelangelo's practice had anticipated this enunciation of his views: not
only did he never repeat his early experiment with Donatello's technique,
he also abandoned independent relief sculpture altogether early in the new
century, using reliefs (or planning them) only for decorative embellishment.
Michelangelo's devotion to the ancients, however, never left him. The *Battle of
the Centaurs and Lapiths* had a future in his art, or foretold his future, in a
way that the *Madonna of the Stairs* did not, so Michelangelo crowed to Condivi
about the former and presumably said nothing about the latter.

The Donatellesque *Madonna* represents an intimate interpretation of an inti-
mate subject. Two years after Michelangelo's death, in 1566, his nephew and

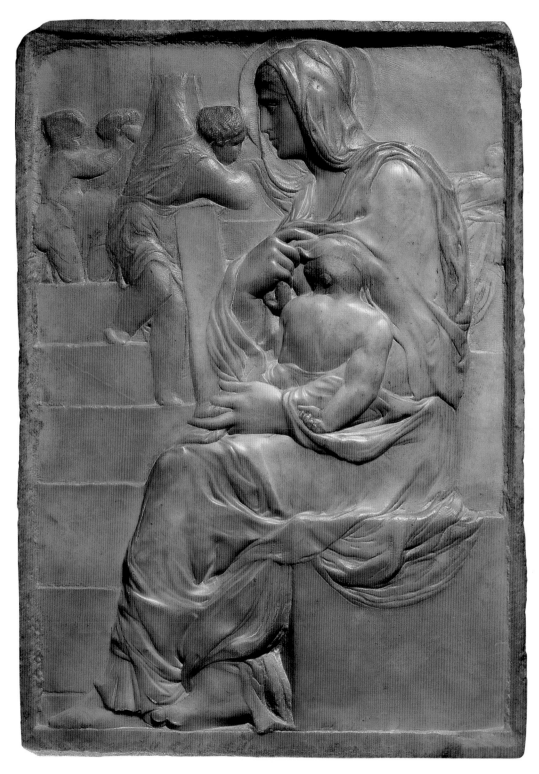

34 Michelangelo. *Madonna of the Stairs*. Marble. Florence, Casa Buonarroti.

heir, Lionardo, presented the *Madonna* to Duke Cosimo de' Medici: the gift is confirmation of the work's importance.[47] Yet during Michelangelo's lifetime and apparently in accordance with his instructions, the relief was kept hidden from view. Writing to his father from Rome on 31 January 1507, Michelangelo asked that "Our Lady of marble" be brought home from his shop and that "you not let anybody see it."[48] Michelangelo was characteristically secretive about his work, but in this instance secretiveness may have been exacerbated by other factors. Assuming that he was referring to the *Madonna of the Stairs*, perhaps Michelangelo was embarrassed by the relief's imitation of Donatello? Perhaps it was made as a forgery?[49] Or perhaps Michelangelo wished to conceal it because it was too personal.

Condivi, as always, excluded anything that might interfere with his portrait of the young artist indebted only to Nature (his first teacher) and to Antiquity (which he surpassed). Discussion of Michelangelo's Donatellesque *Madonna*, an overtly derivative work, would compel acknowledgment of another master. Condivi's omission of the relief may thus be understood as a function of his interpretation of Michelangelo's privileged artistic education. But the story may be more complicated, or more personal, than that.

As Michelangelo later told both Condivi and Vasari, he had been sent to a wetnurse, the wife of a stone cutter.[50] Inordinately proud of a family that was in reality rather modest – claiming descent from the counts of Canossa – Michelangelo evidently felt some need to explain his profession. The Buonarroti were comparatively undistinguished and unmonied (before Michelangelo made his family rich) but had ties of blood kinship with two great Florentine clans, the Rucellai and Del Sera, and were distantly related to the Medici by bonds of matrimony. Relationship with the counts of Canossa was fanciful, but contemporaries believed it, and in 1520 Count Alessandro himself was pleased to acknowledge his kinship with Michelangelo.[51] In the normal course of events, given this background, Michelangelo should perhaps have become a notary like his father. But his nurse's milk exposed him to other influences.

The fact that Michelangelo repeated the anecdote about his wetnurse to his biographers, understanding that the information would be published, implies that he considered the story to be significant. Every contemporary father who could afford a wetnurse for his child was likely to employ one; Leonardo da Vinci had a wetnurse too, having been taken from his unwed mother to live in his father's household. But none of this changes the self-evident importance of Michelangelo's nurse for him. His recollections about her, the fact that one of his earliest surviving sculptures, the *Madonna of the Stairs*, is a nursing Madonna evidently made for himself or his family, and his treatment of the nursing theme in this and other works indicate that the subject was meaningful to him. His own writings – letters and poetry – confirm Michelangelo's introspection and self-reference as texts or subtexts of his art. In this case, his silence and the concealment of the *Madonna* are eloquent, confirming the work's personal significance for him.

By 1568, Vasari had seen the *Madonna of the Stairs* in the Medici collections. Recognizing Michelangelo's debt to Donatello, Vasari also perceived his hero's transcendence of mere *imitatio*. "Michelangelo [. . .] still a young man and wanting to counterfeit (*contrafare*) Donatello's style, did it so well that the *Madonna* seems to be by Donatello's hand, except that here one sees more grace and more design."[52] Michelangelo's emulation of Donatello is presented as an agonistic triumph.

Donatellesque in technique, Michelangelo's *Madonna* also recalls a particular composition by the earlier master, the Pazzi *Madonna*, dated c. 1433 (Fig. 33). Donatello's *Madonna* was much copied in stucco, and Michelangelo was likely to have known either the original or a replica, though he may also have consulted ancient prototypes for the treatment of the Virgin's head.[53] Her features are grand rather than delicate, with broad cheeks and a prominent nose, its straight bridge rising to the forehead. The Pazzi *Madonna* is Donatello's most classicizing profile, but it seems softer and more feminine compared with Michelangelo's Mary. Where the face of Donatello's Virgin is round, Michelangelo's is linear. This is in part a result of the way in which Michelangelo arranges her veil to bisect her face, in part the way in which he straightens the curves of her jaw and cheeks. Michelangelo's Madonna more closely resembles the sculpted goddesses and matrons of classical antiquity, a stern model made gentle by Donatello.

While "correcting" Donatello, Michelangelo also revised the Dudley *Madonna and Child*, a Donatellesque composition attributed to a more recent predecessor, Desiderio da Settignano, in the 1470s, and much reproduced in marble and in stucco (Fig. 14).[54] The differences are both visual and psychological. Desiderio allowed Mary's figure to overlap the borders at the sides and bottom, projecting her into the beholder's space, but kept her head well below the upper edge. Michelangelo reversed all of these spatial relations, keeping Mary within the frame except at the top. Desiderio foreshortened the haloes, establishing but not specifying the depth of the spatial realm behind the figures. Michelangelo blocked recession with the stairs; made the Virgin's halo parallel to the plane, except where it bends to overlap the upper border of the scene; and omitted Christ's halo. Desiderio seated the Madonna on a block but almost concealed its form with her drapery. Michelangelo clarified and privileged the block's geometry. Desiderio allowed the Mother to embrace her Child, bending her head to his as he tugs at the neck of her garment, presumably wanting to nurse. Although her head is in profile, and his in three-quarter view, both turn their torsos toward the beholder, unlike Michelangelo's beings whose postures imply rejection: Mary in profile and Christ with his back to us. Finally, Michelangelo's relief is more than twice the size of Desiderio's (55.5 × 40 cm. versus 27.2 × 16.5 cm.), a difference in dimensions that affects the viewer's response to the image. Michelangelo renounced intimacy. There is nothing sweet in his vision of Mother and Child, nothing joyous in their relationship, and nothing of Desiderio's (or Donatello's) solace offered to the worshiper. Michelangelo disdained this kind of human, informal characterization,

35 Giovanni Bellini.
San Giobbe altarpiece.
Panel. Venice, Gallerie
dell'Accademia.

preferring a more restrained, or constrained, demeanor for the Madonna. In its subdued spirituality, Michelangelo's first Madonna resembles those of Giovanni Bellini; the young artist's own proclivities predisposed him to the influence of the older master even before his first Venetian sojourn in 1494 (Figs. 26, 35).

Bellini never represented a nursing Madonna, however. Popular in Italian art of the fourteenth and early fifteenth centuries, the subject had become *démodé* by the time Michelangelo carved his first Virgin and Child. Michelangelo all but conceals the fact of Mary's nursing, covering her breast with her right hand,

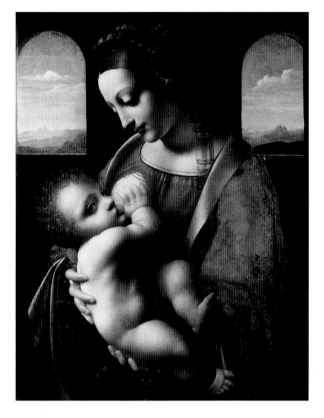

36 Leonardo and
assistants. *Madonna
Litta*. Panel transferred
to canvas. Saint
Petersburg, Hermitage
Museum.

her mantle, and the Child's head. The breast is so minimized and desexed that
it becomes a sign of nurturance rather than an integral and potentially erotic
member, as in the *Madonna Litta*, c. 1490, attributed to Leonardo with assis-
tance (Fig. 36).[55] Leonardo's Christ Child suckles vigorously. In Michelangelo's
relief, the Infant is no longer nursing but has fallen asleep, slumping uncom-
fortably in his mother's arms, with his back to us. Offering a natural explana-
tion for this position – the Infant has turned away from us because he
sleeps – Michelangelo lulls the beholder into accepting a pose that breaks with
artistic tradition and, more importantly, that implies Christ's turning away not
only physically but spiritually. Before the *Madonna of the Stairs*, Christ had
rarely turned his back on the worshiper, and he rarely did so again. The motif
reappears most notably in two other works by Michelangelo himself, the
Madonna and Child (1521–34) carved for the altar of the Medici Chapel in
San Lorenzo and the *Pietà* made for his own tomb (Fig. 196).[56]
 In the *Madonna of the Stairs* as in other depictions of the Virgin with the
sleeping Child, his sleep anticipates his death. His head is partially covered by
her mantle, suggesting the way he will be shrouded by the winding cloth, and
his left arm falls over hers, with the shoulder pronated, recalling many depic-
tions of the Crucified Christ, including the Vatican *Pietà* (Fig. 55). Mary

understands this or foresees it; unlike Leonardo's Madonnas, she looks *away* from the Child and away from us, with a pensive expression. She sees the future internally, or rather she sees it literally before her, in elements of the setting that reiterate the theme of Christ's Passion, adumbrated in his sleep. The children in the background are wingless: not putti, therefore, but the Innocents slain by Herod, the first martyrs for Christ. The cloth that two of them hold behind Mother and Child is folded to suggest the winding cloth, anticipating the motif of Mary's enshrouding mantle. The way in which one Innocent seems to struggle with the balustrade of the staircase suggests the raising of the Cross on Golgotha.[57] Mary does not react to their action, however, any more than she responds to her Child or to the beholder. Like the stairway itself, the reification of her identity as *Scala coeli*, she is present, yet passive: it is the worshiper who wishes to reach salvation through her who must act.[58] The Stairway is available to us; and entirely ours, the responsibility, or burden, of climbing to salvation.

The square block on which Mary sits is also symbolic. Michelangelo freed it from Desiderio's obstructing drapery, enlarging and clarifying the form in the process. The cube was "an old symbol of constancy," as Rudolf Wittkower explained. By a logical process of association, the cube was adopted by Renaissance Platonists as an appropriate Throne of Wisdom: Sapientia is thus enthroned on the title page of Petrarch's *De remediis*, published in Paris in 1523 with the inscription SEDES VIRTUTIS QUADRATA.[59] In the sacred context of Michelangelo's *Madonna*, Mary herself is the *Sedes Sapientiae*, the equivalent of the symbolic form on which she sits. Given the relief's allusions to the Passion, the block may also evoke the Stone of Unction, the stone with which the Savior's tomb will be sealed.[60] In addition to this traditional imagery, the block becomes a trope – or a totem – in Michelangelo's oeuvre, a referent both to the block of stone from which he releases his figures (or in painting, imagines their being released) and to his deepest understanding of structure. The block evidently represented something visceral for him, and no doubt Michelangelo would have made it his icon in any case. There is always a "first," however, and for Michelangelo, the first encounter with this conceit may have come through his teacher, Ghirlandaio. In 1487, the year when Michelangelo entered Ghirlandaio's shop, the master dated his *Adoration of the Magi* in Roman numerals incised on a neatly carved rectangular block of stone in the foreground, its edges slightly chipped to suggest age (Fig. 37).[61] Ghirlandaio's block may have only a coincidental relation to his pupil's, but it serves nonetheless as the sign of a kinship and a debt that Michelangelo sought to deny.

Similarly, in the *Madonna of the Stairs*, Michelangelo sought to avoid any debt to Leonardo. Michelangelo had been only seven when Leonardo left Florence for Milan in 1481 or 1482, but as a young artist, he surely knew some if not all of the works that the older master had left behind: the unfinished *Adoration of the Magi*, then in the possession of Amerigo Benci; the *Annunciation*, then displayed at San Bartolomeo di Monteoliveti, near Florence; the *Madonna of the Carnation* and the Benois *Madonna* (though their

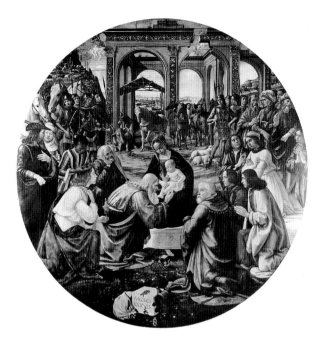

37 Domenico
Ghirlandaio. *Adoration
of the Magi.* Panel
tondo. Florence,
Galleria degli Uffizi.

Renaissance provenance is undocumented, these works were probably painted
for Florentine or Tuscan clients); and one portrait, the *Ginevra de' Benci* (Figs.
15, 16, 13, 11).[62] The portrait may have held little attraction for Michelangelo,
who later expressed a lack of interest in that genre. Leonardo's sacred works,
however, he studied closely – not to emulate but to reject them, that is, to posit
an alternative vision, a visual dialectic of thesis and antithesis.[63] Except for the
remarkably muscular Infant she holds, Michelangelo's Madonna has little in
common with Madonnas by Leonardo. On the contrary, Michelangelo's relief
suggests that he purposefully denied the emotional relationship between
Mother and Child that was fundamental to Leonardo's conception of the
theme. Michelangelo experimented with pyschologically comparable composi-
tions in his drawings but suppressed such tenderness from finished works.
Where there was intimacy, now there is separation, if not alienation. When we
remember how famous Leonardo had become by the turn of the century, and
how greatly esteemed, we realize how courageous was Michelangelo's rejection
of his example.

In the *Madonna*, as in the *Battle of Centaurs and Lapiths*, Michelangelo's
choice of subject was no less a historical reference than the manner in which
he interpreted it. With these two early works, he confronted his predecessors
and claimed his own place in (art) history, a history he intended to rewrite for
himself. The *Madonna* is important in the reconstruction of Michelangelo's
early career and as the beginning of his agon; but, as it remained in his family's
possession until two years after his death and was unnoticed by men of letters
until Vasari's first mention of it in 1568, it had little if anything to do with

public perception of the master before that date. Michelangelo's growing reputation depended on his extravagant emendation of Schongauer's *Saint Anthony*, his classicizing works produced during his years in the Medici household (namely the *Head of a Faun* and the *Battle* relief), and sculptures completed shortly after Lorenzo's death in 1492. The most ambitious of these works was the marble *Hercules*, Michelangelo's first freestanding statue and over-lifesize (4 *braccia*, according to Condivi, i.e., approximately 2.33 meters). Dispatched to France perhaps as early as 1529 – much to Michelangelo's displeasure – and lost in the eighteenth century, it is variously and confusingly identified with different depictions of the hero.[64] Most likely Michelangelo's *Hercules* resembled the Capitoline type, standing in *contrapposto* with his club in the right hand and the apples of the Hesperides in the left (Fig. 38). The ancient bronze *Hercules* measures 2.40 meters, nearly identical in size with Michelangelo's lost work (if Condivi may be trusted), but more to the point, it had been famous since its discovery in 1471, during the pontificate of Sixtus IV, and could easily have been known to the young sculptor from copies (he had not yet been to Rome). The Michelangelesque wax model of a male nude echoes the pose of the ancient colossus and has been seen as a reflection of the lost *Hercules* (Fig. 39).[65]

The loss of any work by Michelangelo is cause for mourning, but this loss is particularly frustrating because the *Hercules* was so important to him. According to Condivi, the sculptor had made the *Hercules* when he emerged from his depression over Lorenzo's death; carving the statue may have helped him deal with this loss. The implication is that the colossus was made for himself and at his own expense. In reality, Michelangelo would have had a patron for such a large-scale and costly work: it was made for Piero de' Medici, il Magnifico's son and successor, whose expulsion from Florence in 1494 made association with him an embarrassing liability for Michelangelo.[66] This would account for Condivi's misstatement, presumably repeating what the sculptor had told him. The Strozzi family most likely acquired the *Hercules* from Piero in 1494 and in 1506 installed it in their newly completed palace in Florence.[67]

Michelangelo was willing to acknowledge Piero's patronage of another work, conspicuously insignificant in comparison with the monumental *Hercules* supposedly made to honor Lorenzo: an enormous snowman commissioned by Piero after the blizzard of 20–21 January 1494 (1493, according to the Florentine calendar). Both Condivi and Vasari record this ephemeron, introducing it immediately after the account of the *Hercules*, thus commemorating two works that neither had been able to see.[68] The pointed juxtaposition of the two colossi – a marble hero, a snow giant – implies not only Michelangelo's range but the egregious distinction between his Medici patrons, Lorenzo il Magnifico, whom he loved, and Lorenzo's unsuccessful son, whom Michelangelo despised.

Although *Hercules* had been sent to France, the statue was remembered in Florence. Most importantly, those who entrusted the *David* to Michelangelo in

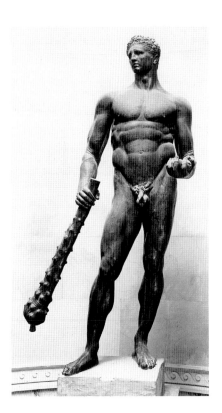

38 Anonymous Roman (after
?Lysippos). *Hercules* (*Hercules
of the Forum Boarium*). Gilded
bronze. Rome, Musei Capitolini
(Palazzo dei Conservatori).

39 ?Michelangelo. *Male Nude*. Wax.
Florence, Casa Buonarroti.

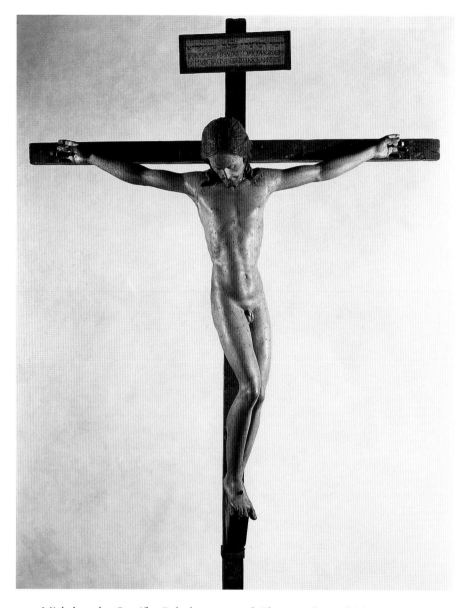

40 Michelangelo. Crucifix. Polychrome wood. Florence, Santo Spirito.

1501 had seen the *Hercules*: as a colossal, freestanding male nude, it was the immediate predecessor of *David* in Michelangelo's oeuvre. His success with the first enabled him to win the commission for the second.

While working on the *Hercules*, Michelangelo completed another male nude, but this time pathetic rather than heroic. Michelangelo's only sculpture in wood, the Crucifix, was made as a gift for the prior of Santo Spirito (Fig. 40).

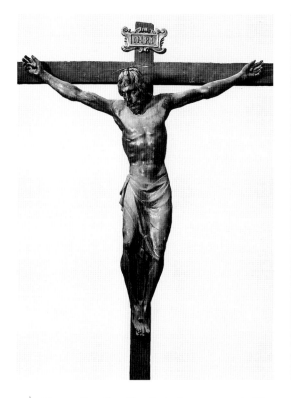 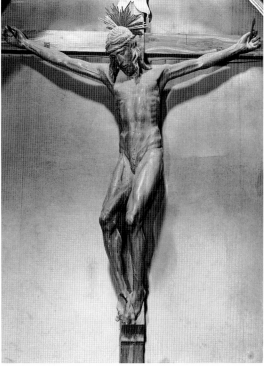

41 Donatello. Crucifix. Polychrome wood. Florence, Santa Croce.

42 Filippo Brunelleschi. Crucifix. Polychrome wood. Florence, Santa Maria Novella.

Like most (if not all) wood sculpture of that date, the Crucifix was also polychromed; and like all nude figures of the Crucified Christ, this one would have been provided with a loincloth and a crown of thorns.[69] Inevitably, Michelangelo knew many precedents – but two in particular were likely in his mind's eye as he carved his own Christ Crucified: those by Donatello and Brunelleschi (Figs. 41, 42). According to Vasari, Brunelleschi's Crucifix in the Dominican church of Santa Maria Novella was made in competition with Donatello's for the Franciscan church of Santa Croce – and Donatello acknowledged defeat in the contest. Seeing Brunelleschi's work for the first time, Donatello dropped the eggs and other provisions he had brought for their breakfast and declared, "to you it is given to make Christs and to me the peasants [*contadini*]."[70] Whether these two masters actually competed in this way, whether the story was already known to Michelangelo, or whether Vasari entered them in competition because it seemed appropriate that they should be rivals is not the issue here. What matters is that Michelangelo surely knew these works as two of the greatest examples of the Crucified Christ in Florence, by two of his greatest predecessors, but just as surely rejected them as prototypes for his own Crucifix, except for one important detail. Like Brunelleschi's Christ,

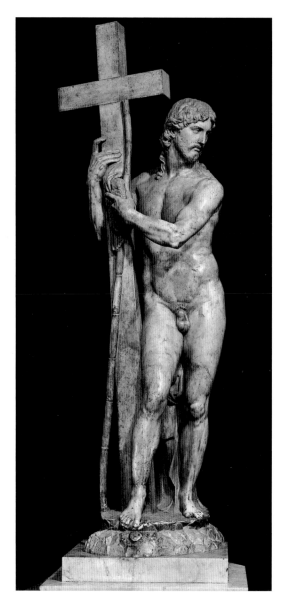

43 Michelangelo. *Risen
Christ*. Marble. Rome,
Santa Maria sopra
Minerva.

Michelangelo's is represented as a male nude "complete in all his parts," and
in this regard anticipates his *Risen Christ* in the Roman church of Santa Maria
sopra Minerva (Fig. 43).[71] Donatello's Christ has a wooden loincloth which can
be removed; beneath this, the figure has no genitalia. Like most images of the
adult Christ, he was never meant to be seen naked.

The Crucifix was displayed on the high altar according to Francesco
Albertini's *Memoriale* of 1510, and it was "still" there in 1550, when Vasari
described the work in passing. But Condivi recounted how it came to be made:

Michelangelo carved the Crucifix in gratitude to Giovanni di Lapo Bicchiellini, the prior of Santo Spirito, who had allowed him to do dissections.[72] This explanation may be seen as an *ex post facto* response to Leonardo's achievements in the study of anatomy and also as a way of emphasizing Michelangelo's knowledge of nature. But in the *postilla* to this passage, Michelangelo confirmed that he made dissections "as occasion arose."[73] For Michelangelo and Condivi, the Crucifix thus commemorated the artist's first opportunity to study the human body, anticipating his plans for two books, one a volume by himself on the body, and the other, a treatise on anatomy by his physician friend Realdo Colombo, for which Michelangelo was to provide the illustrations. Neither plan reached fruition, and by the time Condivi mentioned these projects in 1553, when Michelangelo was already an old man, it must have been clear that they would never be completed.[74] But the biographer *did* mention them, in part to stake a claim to territory associated with Leonardo (who had also failed to complete his anticipated publication on anatomy) and even more, by mid-century, with Andreas Vesalius, whose splendid *De fabrica* had been published in Basel in 1543 with illustrations ascribed to Titian.[75]

Although Condivi and presumably Michelangelo saw the Crucified Christ in relation to the artist's interest in anatomy – he could have thanked the prior with a *Madonna*, for example – its originality is less a matter of physiological precision than its composition and psychology. Posed so that "no part of the body is presented in a strictly frontal view," Michelangelo's Crucified turns, gently spiraling, though fixed to the cross.[76] While his posture recalls his struggle, his slender proportions and mild expression suggest acquiescence. In this way, Michelangelo's interpretation evokes the physical and emotional arc of Christ's experience on the cross, from protest to acceptance.

Nothing is known of how the prior of Santo Spirito displayed his Crucifix before 1510: whether it was in his residence, hence *in clausura*; or in the church, easily seen by any church-goer. Similarly, there is no certainty regarding where or how the *Hercules* was displayed in the early years of the century, at least not before 1506, when the Strozzi installed it in their new palace. Michelangelo's only documented *public* work was the "very beautiful" but ephemeral snowman for Piero de' Medici.[77] It was not until Michelangelo left Florence that he really began to make a name for himself. Fleeing the city when the Medici were expelled in 1494, he went first to Venice, where he apparently made nothing but learned a great deal (that he looked closely at Giovanni Bellini and other Venetian masters is evident in his works made after this sojourn). Then settling in Bologna, Michelangelo enjoyed the hospitality and friendship of Gianfrancesco Aldovrandi. Together they read Dante, Petrarch, or Boccaccio, "until he fell asleep," as Condivi wrote of Michelangelo. It was Aldovrandi who arranged his commission for three statues needed to complete the tomb of Saint Dominic, begun by Nicolà Pisano and still incomplete in 1494, when his successor, Niccolò dell'Arca, died: an *Angel*, which would serve as a figural candlestick, and the pendant of the *Angel* completed by Niccolò; *Saint Petronius*; and *Saint Proclus* (Figs. 44, 45).[78] Half a century after the fact,

44 Niccolò dell'Arca. *Angel.* Marble. Tomb of Saint Dominic. Bologna, San Domenico.

Condivi described the commission as a double rivalry. Michelangelo had per-force to compete with Pisano and Niccolò dell'Arca, as his benefactor made clear when he asked the young sculptor whether "he had spirit enough" to complete the tomb.[79] Chameleon-like, Michelangelo produced three figures that easily coexist with their predecessors, subjugating his own style to the exigen-cies of the situation.[80] His achievement aroused the envy of at least one local

45 Michelangelo. *Angel*. Marble. Tomb of Saint Dominic. Bologna, San Domenico.

sculptor, according to Condivi; and with that rival "threatening to do him some unpleasantness," Michelangelo left Bologna to return home.

Back in Florence in 1495, Michelangelo made his most notorious fake. Discussing the works of Praxiteles, Pliny had praised two interpretations of *Cupid*, both sculpted in marble and both famous for inspiring ardent devotion. One of these, which Pliny knew in Octavia's collection, had also been mentioned by

46 Anonymous Roman. *Sleeping Cupid*. Marble. Florence, Galleria degli Uffizi.

Cicero as "the famous Cupid for the sake of which men visited Thespiae"; and the other *Cupid*, "naked, at Parium [. . .] matches the Venus of Cnidus in its renown, as well as in the outrageous treatment which it suffered. For [. . .] a man from Rhodes [. . .] fell in love with it and left upon it a similar mark of his passion."[81] In addition to these literary sources, Michelangelo would have known at least one ancient sculpture of a *Sleeping Cupid*, a gift from King Ferdinand I to Lorenzo il Magnifico, which had been installed in the sculpture garden in 1488.[82] With these texts and at least one visual example in mind, Michelangelo made his own *Cupid*, intended to evoke Praxiteles and perhaps to recreate one of these fabled lost works (Fig. 46).

Michelangelo's *Sleeping Cupid* was so fine, Lorenzo di Pierfrancesco de' Medici told him, that it could easily be sold as an antique. All Michelangelo had to do was age the thing (something he knew how to do, as his earlier exploits with forgery testify), and then Lorenzo would help him sell it in Rome for a hefty price. In other words, according to the official version of the escapade, all the art was Michelangelo's, all the fraud Lorenzo's. They were defrauded in turn by their accomplice in Rome, Baldassarre del Milanese: he kept the greater part of their lucre. But the deceit was soon discovered by their client, Raffaelo Riario, Cardinal San Giorgio and vice-chancellor of the Papal Curia.[83] Riario dispatched his banker, Jacopo Galli (or Gallo), to Florence to confront Michelangelo; Michelangelo confessed; and the banker took the sculptor with him to Rome.[84]

Although he rejected the forgery, Riario forgave the forger. Inviting Michelangelo to his residence, Riario asked him what he thought of "the things I had seen," as he reported in a letter to Lorenzo di Pierfrancesco dated 2 July 1496. Michelangelo answered that there were indeed "many beautiful things."

Riario then asked whether Michelangelo had "enough spirit" to make something beautiful for him. (The question recalls Aldovrandi's whether Michelangelo had the spirit, *anima*, to complete the tomb of Saint Dominic: it was an idiomatic phrase, its frequency expressing the competitive mood of the age. Whatever words these benefactors may have said to him, Michelangelo remembered their questions as challenges.) Michelangelo modestly replied that "I would not make such great things" as the cardinal possessed, "but that he would see what I would do." When Michelangelo wrote his letter, he had already purchased "a piece of marble for a lifesize figure" for the cardinal and planned to begin work on the following Monday (4 July). This "piece of marble" became the *Bacchus* (Fig. 49).[85] As for the *Cupid*, nine years after its rejection as a fake antiquity by Riario, it was embraced by Isabella d'Este as a genuine Michelangelo.[86]

Michelangelo's first (aborted) Roman sale had been a forged antique. His first honest Roman commission was to be an ancient subject presumably to be represented *all'antica*. Riario had a taste for such things, and Michelangelo had already demonstrated his predilection for classical subjects and style. One assumes that the cardinal expected a *Bacchus* as convincingly ancient as the *Cupid* but without the taint of fraud. What Michelangelo produced was a *Bacchus* that does not recreate the ancient subject but reinvents it, ignoring familiar prototypes for the depiction of the god. Probably no patron could have expected the work of extraordinary originality that Michelangelo created. Certainly Riario failed to do so and rejected the *Bacchus*. Patrons rarely declined works they had commissioned, and this rejection must have humiliated Michelangelo, especially following the cardinal's repudiation of the *Cupid*. Thus wounded, Michelangelo evidently misled his biographers about the patronage of the *Bacchus*, mentioning Riario only to denigrate him.[87]

Refused by the cardinal, the *Bacchus* was acquired by Galli. The figure's serpentine posture indicates that it was conceived to be freestanding, and Galli displayed it this way in his garden (where Maarten van Heemskerck made a pen and ink drawing of it c. 1532–33), breaking the right arm to make the statue seem more authentically ancient. Michelangelo's god was the only modern work exhibited in the garden, inviting a *paragone* with the surrounding antiquities.[88] Galli's installation confirms that the *Bacchus* was understood an appropriate companion for its classical predecessors. Pairing Bacchus with a satyr, Michelangelo recalls ancient groups representing these beings side by side; and his close observation of antiquities is self-evident.[89] Yet the *Bacchus* is *un*antique in appearance. Indeed, the statue does not resemble classical depictions of this or any other deity. Instead, as Vasari recognized, Michelangelo's figure is doubly gendered, characterized by an admixture of masculine and feminine qualities, "a certain marvelous mixture of members, and particularly having given him the quickness of the youth of the male and the fleshiness and roundness of the female."[90] Perhaps Vasari was echoing Aretino's praise of Michelangelo's *Venus* for her similar combination of male and female qualities: "the body of the female, the muscles of the man, so that she is moved by virile

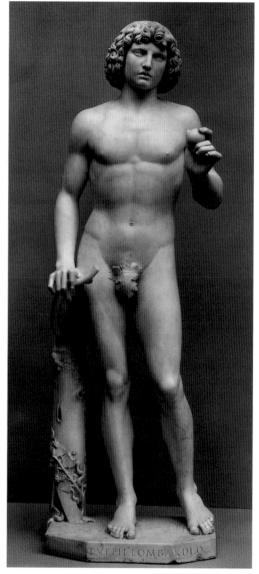

47 Anonymous Roman.
Antinous as Apollo. Marble.
Delphi, Museum.

48 (*right*) Tullio Lombardo.
Adam. Marble. New York, The
Metropolitan Museum of Art,
Fletcher Fund, 1936. (36.163).

and feminine feelings."[91] Dolce similarly extolled this kind of "mixed" nude in his *Dialogue on Painting*. The speaker is his imaginary Aretino, echoing the opinion of his namesake: "we can present [the nude] either as heavily muscled or as delicate: such delicacy is called by painters 'softness' [*dolcezza*]."[92] Explicating the difference between the two, Dolce's Aretino concludes "that a delicate body ought to take precedence over a muscular one." To his inter-locutor Fabrini's objection that delicate physiques are more typical of women than of men, Aretino replies that "one finds great numbers of delicate men,

such as noblemen for the most part, without being so excessively delicate that they look like a woman or like Ganymede."[93]

Michelangelo's bigendering – the feminized masculinity of the *Bacchus* and the masculinized femininity of later works – has little precedent in ancient art, not even where one might expect to find it, namely in the depiction of hermaphrodites. In keeping with the myth of Hermaphroditus, offspring of Hermes and Aphrodite, these figures show women's bodies with male genitalia. Aside from this critical and improbable appendage, however, nothing about the hermaphroditic body suggests masculinity. Rather, she/he is otherwise feminine in appearance, in physique, face, and coiffure.[94] The dual sexuality is mechanical, therefore, accomplished by the attachment of a male member to a female body. Michelangelo's bigendering is organic, a homogenized sexual *mélange* of male and female qualities.

Like Apollo and even Hercules, Bacchus might be feminized in images from the late fifth century and there-after, but none of them provides a precise prototype for Michelangelo's god.[95] Perhaps Hadrian's beloved Antinous (Fig. 47) provides the closest classical antecedent for Michelangelo's sensuous treatment of the flesh and the contrast of the soft face with the intri-cately carved mass of hair and garland (and, later, David's heavy head of hair).[96]

Michelangelo may also have a more recent precedent in mind: Tullio

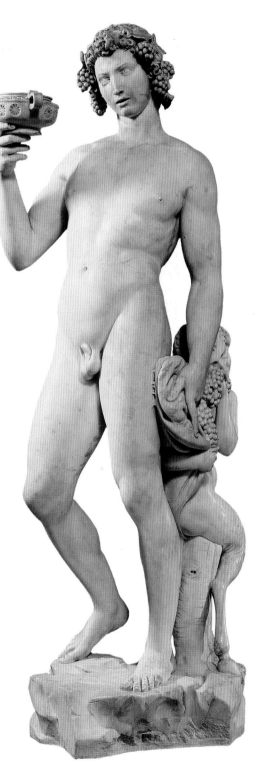

49 Michelangelo. *Bacchus*. Marble. Florence, Museo Nazionale del Bargello.

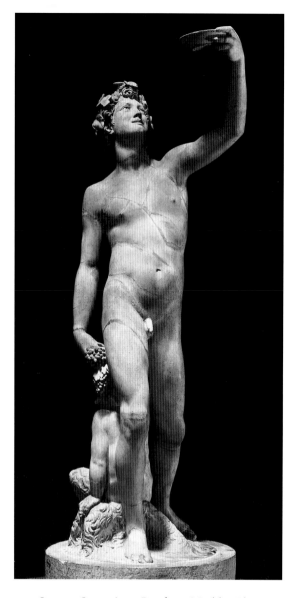

50 Jacopo Sansovino. *Bacchus*. Marble. Florence, Museo Nazionale del Bargello.

Lombardo's *Adam* (Fig. 48), completed in 1493, the year before the Florentine's arrival in Venice the following October.[97] Adam's heavy, almost wig-like hair and the contrast of texture between hair and flesh foreshadow Bacchus while recalling Antinous. Although Michelangelo did not need Tullio's work as an introduction to ancient prototypes, other elements of the Venetian's work suggest a direct relation between *Adam* and *Bacchus*. Adam's posture and gestures anticipate the god's, though Michelangelo reversed right and left (Adam raises the apple with his left hand, appropriately, whereas Bacchus raises his instrument of destruction, the cup, with the right; Adam rests his left hand on a branch, Bacchus holds the panther skin and grapes with his right). Their soft, unathletic body types are also similar. Adam's softness is explained in relation to his condition: he holds the forbidden fruit, which he rightly contemplates with a worried expression. He is physically soft because he has not yet experienced muscle-building toil, and also metaphorically soft, the unheroic victim of Eve's and Satan's wiles. Nothing about Tullio's *Adam* suggests a duplex sexuality; rather, his delicacy suggests that, like a "gentleman," he has not had to exert himself. Michelangelo's *Bacchus*, on the contrary, is not merely "delicate" but explicitly effete, his effeminacy the visualization of his moral failings.

Muscles there are, especially in the back and in the powerful arms, but they seem to become slack as Bacchus tilts and weaves. Only the satyr prevents his falling. The god's stance is a parodistic commentary on classical *contrapposto*: the pose that epitomizes perfect balance of stasis and potential movement has been transformed into a posture of precarious instability. With a head too small for his body, Bacchus is conceived as a heroic nude gone physically, intellectually, and morally awry. His open-mouthed expression confirms his already having drunk too much and his intention to drink again. It is as though

Michelangelo remembered and reinterpreted the moral of Poliziano's story of the Centaurs and Lapiths. Drink made the Centaurs brutish. Drink makes Bacchus ridiculous and effete.

Michelangelo's unorthodox interpretation seems to have been rejected by contemporaries even when his fame had made the *Bacchus* a worthy subject for admiration and rivalrous imitation. When Jacopo Sansovino alluded to Michelangelo in carving his own *Bacchus*, completed in 1512, he revised the original, changing not only the god's appearance but his psychology, correcting Michelangelo by restoring classical idealism to the deity (Fig. 50).[98] Sansovino normalized the proportions of Michelangelo's *Bacchus* – the god is no longer a pinhead – and made him slightly more slender. The cup, now in his left hand, is raised high: a gesture that suggests exaltation rather than his intention to drink. And his ecstatic expression confirms his exalted state. This is an act of worship or veneration, not debauchery. The pose and raised arm, if not the expression, recall ancient prototypes such as the Uffizi *Satyr*. Presumably recognizing the reference, Benedetto Varchi particularly admired Sansovino's bravura carving of the arm and cup: "truly to make an articulated or distinct member, as though it were an arm in the air, and all the more [remarkable] if the arm have something in the hand, as one sees in the most beautiful, indeed miraculous *Bacchus* by Messer Jacopo Sansovino."[99] Vasari echoed the praise in 1568, and Cellini paid Sansovino the compliment of imitating the motif in adapting *Bacchus*'s pose for his *Perseus* (Fig. 195).[100] With the exception of Vasari, perhaps no other artist so venerated Michelangelo as did Cellini; but even he rejected the *Bacchus*'s heresy in favor of Sansovino's more traditional sexuality. And, admiring the statue, Vasari nonetheless withheld the ultimate praise: *Bacchus* is "more excellent" than any other modern statue – but no claim is made of its *surpassing* the ancients, which is the ultimate accolade.[101] Yet this was precisely what Michelangelo had intended – to surpass the ancients with his modern *Bacchus* – and he may have felt that Vasari's account had missed the mark. Condivi's explication of the statue attempts to correct Vasari's misprision.

In the absence of precise classical visual models for his gender-bending *Bacchus*, Michelangelo might have invoked the authority of literary sources. At any rate, Condivi did this on his behalf, noting that the *Bacchus* "correspond[s] in every particular to the intention of the *writers* of antiquity." Michelangelo presumably read Pliny's *Natural History*, which he had encountered in the Medici household when Poliziano suggested the text for the *Centaurs and Lapiths*; he may have consulted it again as he faked his *Sleeping Cupid*, completed shortly before the *Bacchus*. Classical Cupids were readily available for emulation, however, and in making his own *Cupid*, Michelangelo had intended the work to be mistaken for an antiquity. (That Michelangelo's forgery was meant to evoke Praxiteles and perhaps even to recreate one of the fabled lost works described by Pliny is confirmed by Isabella d'Este's later display of his *Cupid* with one attributed to Praxiteles.) Now, with *Bacchus*, he would not imitate but rival his fabled predecessor by recreating a work known *only* from its descriptions.[102]

The *Bacchus* recalls Pliny's ekphrasis of a bronze by Praxiteles representing "a Father Liber or Dionysus, with a figure of Drunkenness and also the famous Satyr, known by the Greek title Periboëtos meaning 'Celebrated.'"[103] Michelangelo may also have been inspired by another ancient account of Praxiteles' work, namely Callistratus in the *Descriptions*, 8, praising the *Dionysus* for its lifelikeness, its "supple and relaxed" body, and noting that "a wreath of ivy encircled the head."[104] Recreating the ancient work, Michelangelo acknowledged his debt to the literary source while eschewing reliance on visual prototypes. His rivalrous *paragone* with antiquity is thus interlaced with the *paragone* of image and text.

Despite these ancient ekphrases and notwithstanding his classical identity, *Bacchus* is insistently unclassical, not to say, anti-classical, an ironic interpretation of the divinity's character and disrespectful of the heroic male nude, the classical theme *par excellence* – and Michelangelo's favorite subject. What is perhaps most unexpected about the *Bacchus* (and presumably what Riario found unacceptable) is that the god seems insalubrious and amoral. He is drunk – he has difficulty focusing on his wine cup – and is about to get drunker, lifting the cup to take another drink. The "drunken Bacchus existed in late antique sculpture," but Michelangelo's figure does not evoke his classical self so much as the drunken Silenus – a far less dignified antecedent.[105] Condivi sought to redeem *Bacchus* with a moralizing interpretation of the god's demeanor: "letting himself be so drawn by the senses and by the appetite for that fruit and its liquor, ultimately he leaves his life there."[106] The explanation (rationalization?) misses the irony of the situation, that the god of wine should be shown in the process of self-destruction by means of his own invention, normally perceived as a beneficent contribution to human well-being. In this regard, the *Bacchus* echoes the parodistic interpretations of contemporary Venetian authors and artists – and of one artist in particular, namely, Giovanni Bellini.

In Venice in fall 1494 Michelangelo had seen works by Bellini and had perhaps met the master himself, a possibility that seems likely given Bellini's openness toward foreign visitors. That Michelangelo studied the older painter closely is confirmed by his Bellinesque interpretation of the Virgin Mary in works done after this first Venetian sojourn, the Madonna of the Vatican *Pietà* and the Bruges *Madonna*.[107] Bellini's witty disrespect for antiquity (later epitomized in the *Feast of the Gods* of 1514) is illustrated by an allegorical painting of a plump Bacchus in a cart pulled by a scrawny soldier, so close to Michelangelo's unheroic conception of the god that it is tempting to postulate a relation between the two (Figs. 49, 51).[108] Whether Bellini's very small painting (32 × 22 cm.) influenced Michelangelo's lifesize statue, Michelangelo's *Bacchus* resembles Bellini's in his unathletic figure and unsteady stance, his flaccid body imaging his flabby morals.

Galli rescued Michelangelo after Riario's double rejection, buying the *Bacchus* for himself and also commissioning a second *Cupid*, now awake and armed with arrows.[109] With this work, Michelangelo revisited the subject of the notorious forgery once in Riario's possession, but now, for Galli, the statue

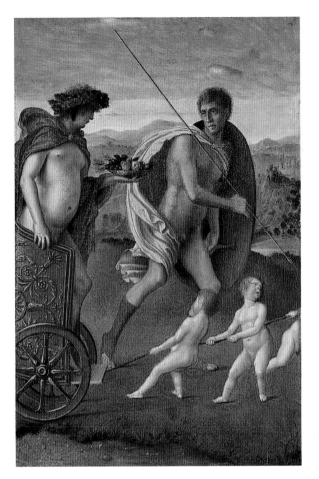

51 Giovanni Bellini.
Bacchus and a Soldier
(*Allegory*). Panel. Venice,
Gallerie dell'Accademia.

was made openly as "a Michelangelo." More important than the works Galli
bought for himself, however, was the commission he helped negotiate for
Michelangelo with the French ambassador to Rome, Cardinal Jean de Bilhères
Lagraulas: the *Pietà*, ordered before November 1497 and completed two years
later (Fig. 55).[110] Nearly seventy at the time of the commission, de Bilhères was
dead and buried by the time the *Pietà* was installed in his funerary chapel in
Santa Petronilla, attached to the south transept of Old Saint Peter's.[111]

At some date before 18 November 1497 the cardinal and Michelangelo had
come to an agreement "that he make a *Pietà* of marble, that is, a clothed Virgin
Mary with the dead Christ, nude in her arms, to be installed in a certain chapel
that we intend to establish in Saint Peter's in Rome, in the chapel of Santa
Petronilla."[112] In a letter of 7 April 1498 the cardinal referred to "our chapel
in Saint Peter's in Rome": he had acquired the chapel by that date.[113]

The final contract, written by Galli on 27 August 1498, annuls "all other
writings in my hand or in the hand of the said Michelangelo," and stipulates

that "Michelangelo, Florentine sculptor [. . .] must make a *Pietà* of marble [. . .], that is, a clothed Virgin Mary with the dead Christ in her arms, as large as a well-proportioned man (*homo iusto*) would be, for the price of 450 gold ducats [. . .] within one year." The cardinal made a down payment of 150 ducats and promised further payments of 100 ducats every four months while Michelangelo completed the work,

> in such a way that the 450 ducats [. . .] be paid within a year, if the said work be finished; and if the work be completed before then, His Most Reverend Lordship be obligated to pay the entire sum. And I, Jacopo Galli, promise the Most Reverend Monsignore that the said Michelangelo will complete the said work within a year and that it will be the most beautiful work of marble that exists in Rome today, and that no master today could do the work better. And vice versa, I promise to the said Michelangelo that the Most Reverend Cardinal will make payment.[114]

Galli's pledge that Michelangelo would complete the work within a year was not kept – it took two years. But even now, five hundred years later, many viewers would agree that Galli's second promise to the cardinal was indeed fulfilled: Michelangelo's *Pietà* is "the most beautiful work of marble that exists in Rome today." Michelangelo's interpretation of the traditional theme of Mary seated with her crucified Son on her lap was so successful that the work has become synonymous with the subject, changing the Renaissance usage of the word *pietà* in the process.

Brunetto Latini and Dante had defined *pietà* (Latin *pietas*) in the sense of "piety," that is, in Latini's words, "a virtue that makes us love and diligently serve God and our parents and our friends and our country."[115] The definition evokes Aeneas' rescue of his father, Anchises, from burning Troy, and that hero was traditionally considered to be the classical archetype of *pietà*. When Andrea Alciati and other emblematists visualized the concept, they depicted Aeneas carrying Anchises on his back.[116] The same image recurs with the same meaning of a child's *pietas* toward his parent–though now representing nameless individuals – in Raphael's *Fire in the Borgo* (Vatican, Stanza dell'Incendio). In another of Alciati's emblems, the parent–child roles are reversed, and men are replaced by birds as a parent pelican nurtures its offspring to signify *pietate*.[117] Although not so ancient as the figure of Aeneas, this image was equally venerable and had been adopted by Christian theologians.[118] Alciati's two emblems distinguish between the two definitions of *pietas*: whereas Aeneas' action exemplifies *piety*, the avian symbol reifies *pity*.[119]

Michelangelo's *Pietà* combines both of these meanings, piety and pity, as Condivi implied in his account of the work: "he made in *one piece of marble* that marvelous statue of Our Lady. [. . .] She is seated on the rock where the Cross was fixed, with the dead son in her lap; of great and such rare beauty, that no one who sees her is not stirred within himself to *pietà*."[120] That is, the *Pietà* is carved of a single block, "in un pezzo di marmo"; the statue represents the Madonna with Christ in her lap; she is *Maria super petram*, evoking not

only the site of the Crucifixion (perhaps made explicit by a cross behind her in the original installation) but also the rock or stone on which the Church is founded – a particularly apt image for a monument in Saint Peter's, built at that "rock's" own gravesite.[121] The eloquent gesture of Mary's left hand epitomizes the emotion and significance of the image, expressing her grief while addressing the worshiper and, as the most delicate form most fully liberated from the block, demonstrating the sculptor's skill.[122]

Condivi used *pietà* to characterize the beholder's response to the image. Other writers might use the word to identify an image itself. In the fifteenth century, if not before, the term described any composition representing the dead Christ mourned by Mary, John the Evangelist, or angels. Giovanni Bellini's *Dead Christ with Angels* (Fig. 53), for example, is identified as a "Pietà" by its first owner in his testament – with no explanation of precisely what is intended by this term, because the meaning was self-evident.[123] Conversely, in their contract with Michelangelo, de Bilhères and Galli had had to explain exactly what they meant by the word. After the unveiling of Michelangelo's *Pietà*, however, the term eventually came to refer only to compositions like his, in which the seated Virgin Mother supports the body of her dead Son in her lap. Although Condivi in 1553 called it simply "that marvelous statue of Our Lady," Vasari, in 1550 and again in 1568, *titled* Michelangelo's work the *Pietà*.[124] That today one takes the definition for granted is testimony to Michelangelo's triumph.

Like the word, Michelangelo's composition also had a long prehistory, and by the late thirteenth century, the type was particularly popular in Northern Europe, especially France and Germany. It is not coincidental, therefore, that Michelangelo's patron was a Frenchman – and that the French monarchy was particularly devoted to the subject of the Pietà.[125] Discussing the commission with Michelangelo, de Bilhères might have evoked the sculptural monuments of various French funerary chapels.[126] Similarly, the cardinal might have recalled such compositions as the Avignon *Pietà* and described how the body of Christ curved around his mother's lap (Fig. 52).[127] Michelangelo would have known at least one Italian example of the motif: Botticelli's *Pietà* or *Lamentation with Saints*, painted in the early 1490s for the Florentine church of San Paolino, of which Poliziano was prior (Fig. 54).[128] The Botticelli and the Avignon *Pietà* are large works, each around 1.4 meters high, and the figures almost lifesize, but most fifteenth-century Pietàs, including sculptures, are small-scale. These devotional images do not prepare us – and certainly did not prepare turn-of-the-sixteenth-century Italian viewers – for Michelangelo's *Pietà*. Monumentalizing the theme, he reinvented it.[129]

Of all Michelangelo's works, the *Pietà* comes closest to Leonardo's aesthetic – not the Leonardo whose early works Michelangelo would have known in Florence but the mature master of the *Madonna of the Rocks* and the *Last Supper* (Figs. 56, 57). Although Michelangelo had no firsthand knowledge of Leonardo's Milanese works, he had certainly heard about them and may well have seen drawings or copies. The resemblance of types – the conception of Mary's youthful loveliness, the narrative eloquence of gesture – has more

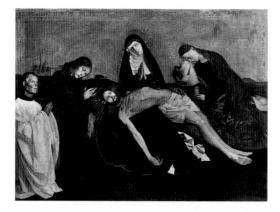

52 School of Avignon
(attr. Enguerrand
Quarton). Avignon
Pietà. Panel. Paris,
Musée du Louvre.

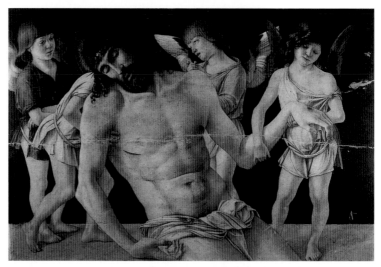

53 Giovanni Bellini.
Pietà (*Dead Christ with
Angels*). Panel. Rimini,
Musei Communali.

54 Sandro Botticelli.
Pietà (*Lamentation with
Saints*). Panel. Munich,
Alte Pinakothek.

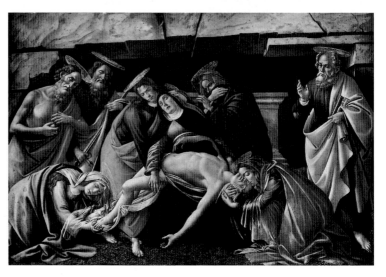

55 (*facing page*)
Michelangelo. *Pietà*.
Marble. Vatican, Saint
Peter's.

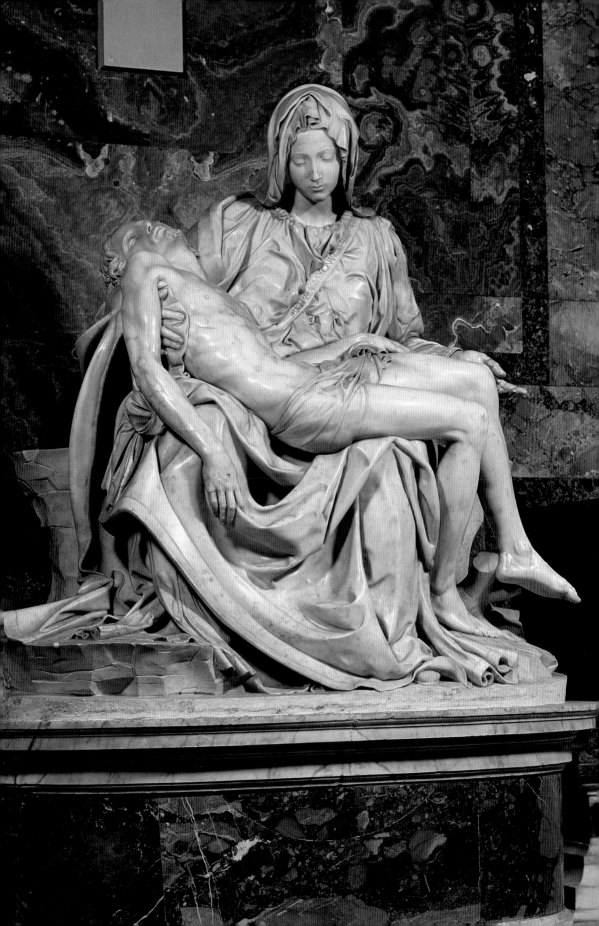

to do with the consonance of their interests and their common Tuscan heritage, however, than with any direct relation between their works.[130] Having purposefully shunned Leonardo in his own earliest compositions, now Michelangelo embraced not his rival's art *per se* but those elements that they shared. The geometric principles of composition are another generic link between them. Michelangelo composed the two figures of the *Pietà* in a pyramid that unifies their forms, giving them stability despite the precariousness of their situation (an adult man in the lap of a presumably smaller woman). Leonardo's *Adoration of the Magi* is the first monumental demonstration of this principle of design (Fig. 15). The pyramid itself was not Leonardo's invention: the conception goes back to Giotto, as Michelangelo (close student of the Trecento master) must have realized. Moreover, the pyramid is far grander in his *Pietà* than in Leonardo's work done nineteen years earlier. In any case, by the turn of the century, the compositional principle of the *Adoration* was familiar, and Leonardo's copyright had expired. Similarly, if Michelangelo's composition is comparable with that of Leonardo's lost *Saint Anne* cartoon, which was displayed in Florence in 1501, the resemblance is the result of their finding the same "classic solution" to similar problems.[131] The resemblance is not only compositional, however. Leonardo's style and technique in the cartoon and in contemporary drawings suggest that he was influenced by Michelangelo's "sculptural" drawing.[132] Learning from each other, each of them had become a High Renaissance artist.

In Michelangelo's case, this stylistic leap into a new era was achieved in part as a result of his close observation of Venetian art, notably the sculpture of Tullio Lombardo and the paintings of Giovanni Bellini. To recognize that, for their part, the Venetians themselves had been responsive to Leonardo's art is not to dismiss Lombardo and Bellini as mere filters of Leonardesque influence on Michelangelo. On the contrary, the correspondence between Michelangelo's art and that of the Venetians at the turn of the century is more direct than that with Leonardo's contemporary work. Not only did they provide Michelangelo with figural prototypes but with psychological interpretations amenable to his own proclivities for expressive bodies and restrained physiognomies.

The affinities between Michelangelo and Leonardo around 1500 are, again, primarily the result of their common interests and common heritage rather than a matter of imitation. There is one conspicuous exception, however, and that is Michelangelo's treatment of fabric in the *Pietà*, what Vasari called its "divine draperies."[133] The resemblance is not to contemporary works by Leonardo but rather to the painting and especially the drawings produced while he was still affiliated with Verrocchio's shop. In his mature works, including the *Madonna of the Rocks*, the *Last Supper*, and the *Madonna and Child and Saint Anne* (in its various incarnations), Leonardo "used folds as a means of modelling figures and of securing the continuity of interior lineament" (Figs. 56, 57, 74).[134] In the *Pietà*, conversely, and in other early sixteenth-century works, most notably the Bruges *Madonna*, Michelangelo carved "bunches of folds and cataracts of deep moulds [. . .] as centres of independent plastic life," in the manner of later

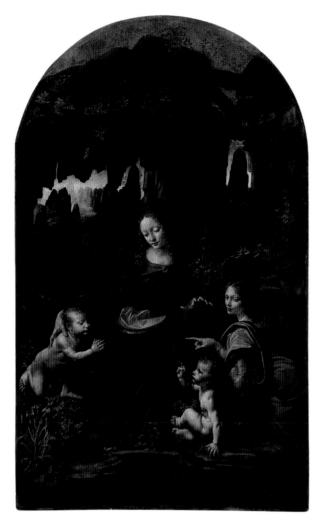

56 Leonardo da Vinci. *Madonna of the Rocks*. Panel transferred to canvas. Paris, Musée du Louvre.

fifteenth-century Florentine *marmorarii* (Fig. 59).[135] These kinds of study had been a specialty of Verrocchio and his associates, including the young Leonardo (Fig. 58). His sculptural treatment of fabric is based in fact on his drawings of plastic models.[136] In Leonardo's early works, including the drapery studies produced in Verrocchio's shop, the drapery is self-justified, sometimes responsive to the body beneath and sometimes independent, as though with a life or a purpose of its own. Even in the *Madonna of the Rocks*, Leonardo permitted himself volumetric patterns of drapery that are essentially decorative and independent of the body, like the yellow lining of Mary's mantle (Fig. 56). Michelangelo almost certainly knew at least one of Leonardo's drapery studies, a drawing used by the Ghirlandaio shop in the 1480s when Michelangelo was apprenticed there.[137] But Leonardo himself had since abandoned these kinds of

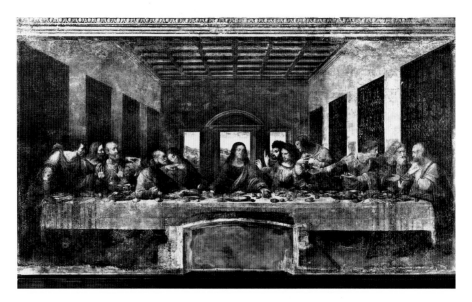

57 Leonardo da Vinci. *Last Supper* (before restoration). Milan, Santa Maria delle Grazie, Refectory.

58 Leonardo da Vinci. Drapery study for a kneeling figure. Bodycolor with white heightening applied with brush over traces of black chalk on linen. Paris, Musée du Louvre.

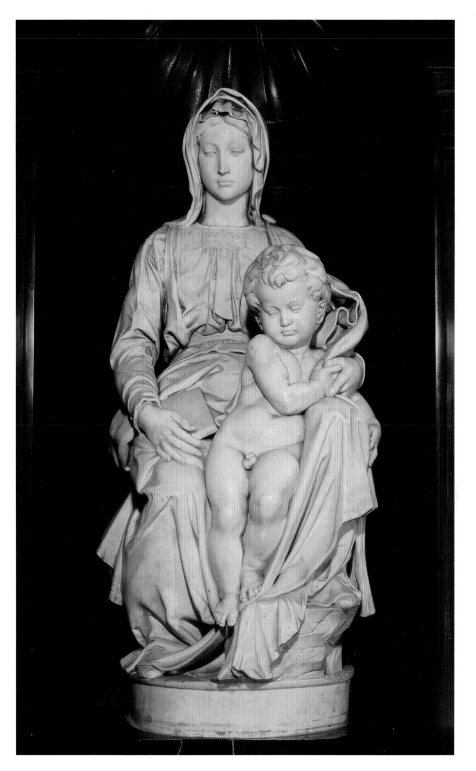

59 Michelangelo. Bruges *Madonna*. Marble. Bruges, Onze Lieve Vrouwkerk (Notre Dame).

deeply modeled drapery patterns. In the works done in Milan and during his second Florentine period, Leonardo's drapery is about the volume of the figures, not the fabric, and about their spatial relations, in short, the simulation of *rilievo*, as he characteristically described it.

The movements of Michelangelo's fabrics, on the contrary, are almost always determined by the figure, and when they are not, their independence is more than decorative exuberance: it is expressive of meaning. So Michelangelo's drapery is about volume but also about expression of emotion, deflected from the figures' visages to their garments. The deeply cut volute of drapery around the Child's head in the Bruges *Madonna*, for example, or the folds of Mary's mantle around her head, suggest a kind of psychic disturbance, like brain waves indicating awareness of their destiny. Similarly, in the *Pietà*, the abstract patterns of the Virgin's mantle and the neckline of her gown express her anguish, while the very deep cutting of the mantle between her knees under Christ's body and beneath her right hand and his torso suggest a psychological abyss, an unease between mass and void, volume and emptiness.

Despite a generic similarity between them, Michelangelo's Mary is unlike Leonardo's in physiognomy and in psychology. Leonardo reveled in her lovely hair, waves and braids implying movement like the currents of air and water that so intrigued him. In the only two images of Mary completed by Michelangelo before he encountered Leonardo in Florence, the *Madonna of the Stairs* and the *Pietà*, Mary's hair is concealed beneath her mantle and veil, low on her forehead. This archaizing Byzantinizing motif had also been employed by Giovanni Bellini, though he had himself abandoned it by the turn of the century.

Both Leonardo and Michelangelo made Mary beautiful, of course, but beautiful in different ways. Leonardo visualized her much as Verrocchio and other earlier Florentine masters had done: young (in the Benois *Madonna*, surprisingly so), blonde, with a round face (in the *Madonna of the Carnation*, almost circular), small features, and shaved or very thin brows. In Michelangelo's earliest images, the *Madonna of the Stairs* and the *Pietà*, the shape of the face is oval with a long jaw and pointed chin; her mouth is wider, less pursed and more sensuous than in Leonardo's works. The face of Michelangelo's Mary in the *Pietà* bears a striking resemblance to that of the Christ of the Santo Spirito Crucifix completed some six years earlier. Perhaps the same (male) model posed for both works, or perhaps Michelangelo conceived the same androgynous ideal to be appropriate for both Mary and Christ? Most remarkably, her eyebrows are well defined, despite female reality as enhanced by then-current fashion for thin or shaved eyebrows, as in Leonardo's Madonnas. The mood is different as well: Leonardo's Mary, like Verrocchio's, is gracious in demeanor, and she smiles more readily at her Child. In the *Madonna of the Stairs*, Mary ignores her Child even while she offers him her breast, and he ignores us, alseep with his back turned on the beholder. In the *Pietà*, conversely, Mary's mouth hints at a smile: the apparent inappropriateness of her expression can be explained only as an indication of her understanding that her dead Son will rise and redeem humankind with his suffering.

Thus Michelangelo rejected Leonardo's example of Mary's beauty and psy-
chology, and did so at a time when most if not all of his Florentine contem-
poraries continued to employ the familiar Leonardesque (or Verrocchian)
themes. Doing so, he set himself against, or apart from, everyone else active
in Florence at that date, including his former master, Ghirlandaio; his
friend, Botticelli (who died in 1510); Lorenzo di Credi (the leading painter in
Verrocchio's shop after Leonardo's departure); Perugino (who maintained a
studio in the city); and of course Leonardo himself – both the Leonardo of the
1470s and the Leonardo of the new century. At the same time, Michelangelo's
Pietà, his most conspicuous declaration of independence and his most impor-
tant commission to date, was also in some ways the most responsive to
Leonardo. Cognizant of that fact, Michelangelo signed the *Pietà*. It was to be
his only signature: MICHEL.A[N]GELVS.BVONAROTVS.FLORENT. FACIEBA[T], liter-
ally, "Michelangelo Buonarroti the Florentine was makin[g]."[138]

For previous generations, a signature might be a straightforward declaration
of authorship. By the fourteenth century, artists had become more voluble,
perhaps especially in Tuscany. Giovanni Pisano's boastful signature on the Pisa
pulpit may be the longest such inscription ever written and one of the most
personal, combining reproach of his critics with exultant self-approbation.[139]
In Siena, Duccio di Buoninsegna was pithy if equally personal in the verse
inscribed on the base of Mary's throne in the *Maestà* installed on the high altar
of Siena cathedral in 1312: MATER SANCTA DEI SIS CAUSA SENIS REQUIEI SIS
DUCIO VITA TE QUIA PINXIT ITA, "Holy Mother of God, be peace for Siena's
sake, be life for Duccio who has painted you thus."[140] Pride in creation is
expressed in this prayer to the Virgin whom we see thanks to Duccio's art – as
the text informs her and the viewer/reader. Although the identity of the speaker
is not explicit, the gist of the prayer is clear: in return for this image, Mary is
beseeched to grant peace to Siena and life to Duccio. Such signatures remained
exceptional, however. A more commonplace formula, one well known to
Michelangelo, is represented by the signature of the south doors of the
Florence Baptistery. The inscription ANDREAS:UGOLINI:NINI:DI:PISIS:ME:
FECIT:A D:M:CCC:XXX documents the authorship and date of Andrea Pisano's
work, addressing the beholder or reader directly with the words *me fecit*, "made
me."[141]

As was customary, Andrea specified his Pisan nationality in signing this work
made for another city-state. And perhaps precisely because he had signed as
"Andreas di Pisis," Lorenzo Ghiberti declared his own *Florentine* citizenship
in the inscription on his first set of doors for the Baptistery, vindicating national
pride while declaring his authorship. The sculptor divided his name between
the reliefs of the *Nativity* and the *Adoration of the Magi*: .OPVS.LAVREN and
TII.FLOREN TINI, inscribed at the top of the rectangular panels containing the
quatrefoils that frame the narratives.[142] Donatello signed as a Florentine some
Florentine works and, with one exception, all his foreign commissions, includ-
ing monuments known to Michelangelo, such as *Saint John the Baptist*,
Donatello's only dated work, inscribed MCCCCXXXVIII / OPVS / DONATI DE /
FLO RENTIA in the church of Santa Maria Gloriosa dei Frari in Venice.[143]

Like Andrea, Donatello, and Ghiberti, Michelangelo specified his nationality; and recalling some of their inscriptions, his too addresses the beholder. Unlike them, however, he did not sign on the periphery or border of his work but wrote his name across Mary's breast. And, again unlike his predecessors, indeed unlike any other artist since classical antiquity, Michelangelo used the imperfect tense of the verb, *faciebat*.[144]

As knowledgeable contemporaries recognized, Michelangelo's wording recalls Pliny's description of the way in which Apelles and Polyclitus signed their works. Pliny evoked their use of *faciebat* in the Preface to his *Natural History* as an example, or *apologia*, for himself:

> I should like to be accepted on the lines of those founders of painting and sculpture who [. . .] used to inscribe their finished works, even the masterpieces [. . .], with a provisional title such as *Faciebat Apelles* or *Polyclitus*, as though art was always a thing in process and not completed, so that when faced by the vagaries of criticism the artist might have left him[self] a line of retreat to indulgence, by implying that he intended, if not interrupted, to correct any defect noted. Hence it is exceedingly modest of them to have inscribed all their works in a manner suggesting that they were their latest, and as though they had been snatched away from each of them by fate. Not more than three [. . .] are recorded as having an inscription denoting completion – *Made by* [*Ille fecit*] so-and-so [. . .]; this made the artist appear to have assumed a supreme confidence in his art, and consequently all these works were very unpopular.[145]

Pliny suggests that an author – himself – can emulate artists in recognizing that their creations are always works in progress. The verb *faciebat* neatly announces this fact to the beholder while also implying that the master might, with time, have done even more, even better. The signature becomes at once a sign of the maker's becoming modesty, a disclaimer – self-defense against potential criticism – and an acknowledgement of the enormity of the task. Even though "art is *always* incomplete [*inchoata*] and unfinished or imperfect [*imperfecta*]," the great master knows when to stop. Protogenes apparently did not, and Pliny criticized him precisely for not recognizing "when to take his hand from the panel."[146]

Not wishing to emulate Protogenes but aspiring to be "Alter Polyclitus," Michelangelo revived the ancient formula for himself. He had almost certainly learned of it from Poliziano, his humanist mentor in the Medici household. Pliny's work had been readily available since the publication of Landino's edition in 1476, but it was Poliziano who brought particular attention to the passage regarding *faciebat* in his *Liber miscellaneorum*.[147] Describing his Roman sojourn in spring 1488, Poliziano recalled a Greek inscription in the atrium of the Mellini house in Piazza Navona, which he translated into Latin as "Seleucus rex, Lysippus faciebat." With him on this occasion, he added, was the Venetian apostolic secretary, Giovanni Lorenzi, who opined that the artist had signed *faciebat* rather than *fecit* with reason. Agreeing, Poliziano explained

by quoting the passage from Pliny's Preface to the *Natural History*, including Pliny's assertions that such signatures are modest and that no artist of any consequence uses *fecit*. Poliziano ended his discourse by repeating Giovanni Lorenzi's assertion that there are other such *faciebat* inscriptions to be found elsewhere in Rome. If Michelangelo saw some of these when he later went to Rome, he would have known how to interpret them thanks to Poliziano.

Michelangelo's signature is emblazoned on a band across Mary's breast, pressing so tightly that the fabric of her garment bulges around it, shadowing and sometimes partly concealing the letters. In itself, this conceit was not a new idea. Elsewhere, painters and sculptors had similarly made parts of inscriptions disappear for the sake of illusion. In Donatello's Pecci Tomb in Siena cathedral, for example, the bottom of the signature, OPVS DONATELLI, is sliced by the scroll with the dedicatory inscription and the date of the bishop's death, 1426.[148] And in the left pinnacle of Gentile da Fabriano's Strozzi *Adoration* (Florence, Uffizi), part of the text of the angelic salutation on Gabriel's scroll is concealed, the words subjugated to the curling movement of the parchment. Here, as indeed in the *Pietà*, any literate beholder would be able to fill in the gaps in the text. Unlike his predecessors, however, Michelangelo made his concealment of text not only verisimilar but meaningful. Omitting the final "t" of the verb, Michelangelo went the ancients one better: the word itself is incomplete. His signature is "a visual pun," the verb *faciebat[t]* truncated to illustrate its meaning literally, graphically.[149]

Admittedly, the quality of the lettering betrays Michelangelo's inexperience – the inscription is a strange hybrid of Latin capitals and (by 1500) old-fashioned manuscript abbreviations. Michelangelo was not interested in the Roman stylistic tradition of imitating classical letters.[150] But the band that carries these words has no practical function except that of providing a field for them. It is not a Marian fashion statement: neither the Virgin nor indeed any other woman in sacred art wears a band exactly like this. And it is not functional: it does not hold her mantle in place, though perhaps one is meant to think that it does so.[151] (Nearly forty years later, Parmigianino gave his Uffizi *Madonna of the Long Neck* a similar band, a homage to Mary of the *Pietà*, but now made of a sheer fabric, like the similar band of material around the Madonna's left sleeve.) Michelangelo himself provided the closest precedent for this device in the *Entombment*, left incomplete in 1500 or 1501 (Fig. 72). The woman seen from the back wears a similar horizontal band, knotted at her shoulder and wrapped around her waist. Indeed, such bands are a Leitmotif in this painting, including those around Christ's chest and beneath his legs, which his mourners use to support his body. Whereas these bands are fabric, the material of Mary's is uncertain, but its placement and the way it is carved deep among the folds on her breast indicate that it cannot have been a last-minute addition to the statue; Michelangelo must have conceived it sooner rather than later in the execution, presumably for the same purpose that it eventually served, namely, to carry his signature. The *Pietà* inscription is significant, then, for being the first Renaissance use of the ancient *faciebat*, and equally remarkable for the unorthodox placement of the text.

Michelangelo's signature is exceptional for yet another reason, usually forgotten: the inscription labels a funerary monument. Although it is impossible to know how the *Pietà* was originally installed, the statue was indisputably part of its patron's burial site. As such, the statue might have carried an inscription commemorating the deceased or those charged with executing his bequests there. Cardinal Giuliano della Rovere, later Pope Julius II, is honored as donor in the inscription of the tomb of his uncle Sixtus IV by Antonio del Pollaiuolo. Yet it is precisely in this monument, completed in 1493, and in the tomb of Innocent VIII Cibo where one finds the immediate precedents for Michelangelo's signature – not for the wording, but the fact of commemorating his accomplishment on his patron's funerary monument.[152]

Given the high finish of the *Pietà*, the signature's assertion of incompleteness seems immodest, a self-conscious and perhaps insincere disavowal of pride in the achievement. Vasari read the signature in this way in 1550. Having praised the sculpture's beauties, he concluded that "Michelangelo put so much love and effort together in this work, that here he did something that he never did again in any other work, he left his name written across a belt that ties around the breast of Our Lady, as of a thing in which he was both satisfied and pleased with himself."[153] Michelangelo had every reason to be pleased, and with his extravagant signature, as Kathleen Weil-Garris Brandt has noted, he "defined the *Pietà* beyond its function as a devotional image, specifically as a work of art."[154] At the same time, Michelangelo apparently defined the *Pietà* as an *altarpiece*.[155] Were it a funerary monument *tout court*, as has been suggested, the only inscription would have honored the patron, incorporating the artist's name in the epitaph, as Pollaiuolo and others had done in their signed tombs. But Pollaiuolo's signatures are not the only writings on his papal tombs: these monuments include other inscriptions and epitaphs honoring the deceased pontiffs and, in the case of the della Rovere pope, his nephew and patron of the monument, Cardinal Giuliano.

The *Pietà* has always been admired. Antonio Billi, writing c. 1530, declared that the "*Pietà* of marble stupefied all the intelligentsia."[156] Both Vasari and Condivi reported that the statue made Michelangelo's name. "From it he acquired greatest fame," Vasari wrote in 1550. And Condivi elaborated: "He acquired from this effort great fame and reputation, such that, in the opinion of the world, not only did he already far surpass anyone else of his time and of the time before him, but he even vied with the ancients."[157] *Of course* Michelangelo signed this work, his most important commission to date, and signed it most conspicuously, as though to inscribe his name on Mary's heart. When names appear on garments, they identify the persons who wear them, not the maker, and they are opportunistically incorporated into such parts of costumes as necklines, borders, or hems, which any dress will have, whether inscribed or not.[158] No less than Michelangelo's revival of the Plinian *faciebat*, its placement distinguishes his signature from others.

With hindsight, Michelangelo's self-advertisement might be interpreted as presumptuous or superfluous – or, worse, an expression of insecurity. Surely

the master's hand should be immediately recognizable to a knowledgeable viewer even without such documentation. Paolo Giovio thought this to be so, explaining that "just [. . .] by inspecting one of the better paintings we recognise at once the hand and brush of the artist."[159] Similarly, Vasari asserted that one craftsman, with "long practice" in looking, should be able to recognize another's work, "as a learned and experienced chancellor knows the diverse and varied writings of his peers, and everyone the handwriting of his closest familiars, friends and kinsmen."[160] (In the 1550 edition, Vasari specified that the craftsman's practice in looking should be achieved "without envy," advice deleted from the second edition perhaps because the injunction seemed futile.) One's *style* is one's signature, or should be, if the viewer is knowledgeable.

Decades after the *Pietà* had been unveiled, Michelangelo's only signature seemed to require explanation. (He also later signed at least one drawing – but that was a private work, and the writing addressed to himself; Fig. 67.) This Vasari provided in 1550, explaining the signature as the reification of Michelangelo's *pride* in his creation – not the maker's *modesty*, as Pliny would have it. Having praised the sculpture's beauties, Vasari concluded that Michelangelo signed the work because he was "satisfied and pleased with himself."[161] He then offered an explanation for Mary's youthfulness (virgins do not show signs of suffering or ageing), concluding that the work brought Michelangelo great fame. Three years later, Condivi repeated this explanation, now ascribed to Michelangelo himself, and also the assertion – no doubt correct – about Michelangelo's fame. But the biographer omitted mention of the signature: perhaps it had come to embarrass Michelangelo?

In 1568 Vasari revised his account of the signature. After repeating what he had said eighteen years before – Michelangelo's only signature records the love and effort he had invested in the work – Vasari deleted the unflattering reference to Michelangelo's unPlinian self-satisfaction as the explanation for his inscription. Instead, Vasari paraphrased an anecdote reported by an unknown correspondent, writing within a month of Michelangelo's death on 17 February 1564.[162] The writer knew Michelangelo, and his letter describes events at which he himself was present, with the critical exception of the story of the signature, with which his account begins, warning the reader "that from the thorns one plucks the rose, which will be the truth."

Discussing this anecdote, scholars have missed the most amazing fact about it: not whether it is true or false but that less than a month after Michelangelo's death and nearly sixty-five years after the unveiling of the *Pietà*, at least one person who knew him was repeating the story of the signature. The writer made clear, moreover, that it was not *his* story but one that he had heard, implying that people in Rome had talked about the signature and perhaps were still talking. Certainly Vasari's inclusion of the anecdote indicates his sense that the signature *requires* an explanation and that the *apologia* offered in 1550 was perhaps insufficient for such an extraordinary inscription. The signature came "into being because one day Michelangelo, entering the place where it [the *Pietà*] was installed, found a great number of Lombard strangers who were

praising it highly, one of whom asked another who had done it; he answered: 'Our Gobbo from Milan,'" referring to Cristoforo Solari. "Michelangelo stood silent, but it seemed somewhat strange to him that his efforts should be attributed to someone else. One night he shut himself in there and, with a little light, having brought his chisels, he carved his name there."[163] Vasari's narrative ends here, omitting the letter-writer's account of Michelangelo's being discovered by a nun who, once she was reassured about his purpose, made him a *frittata*.

Vasari included the anecdote not because he necessarily found it a *convincing* explanation for Michelangelo's signature but that he felt he needed a *satisfactory* explanation, or justification, one that could account for this unique inscription while not offending the master's memory with the taint of vainglory. And a principal reason for his feeling the need to explain the signature – in 1550 as in 1568 – may have been the fact that by then Michelangelo's works were so famously recognizable that a signature seemed extraneous. After all, Leonardo da Vinci, the Renaissance lion, had signed none of *his* works: "The lion can be recognized from his footprint," *ex ungue leonem*.[164] Like their contemporaries, we too can recognize Michelangelo from *his* footprint, though evidently those (fictional?) Lombards in 1500 failed to do so.

Bad enough that Solari should be credited with the work, but worse yet – and what Vasari omitted to say – is that Solari was better known than Michelangelo in early sixteenth-century Rome. Michelangelo's patrons, after his humiliating rejection by Riario, were his banker and a recently deceased French cardinal (de Bilhères had died in 1499); Solari's patron was the pope himself, Alexander VI. Equally annoying, and more to the point, Solari was associated with Leonardo, Michelangelo's arch-rival at the turn of the century.[165]

Admired by contemporaries for his ability to represent classical subjects in a classical style – exactly the forte of the young Michelangelo – Solari had been in Venice when Michelangelo was there in 1494 and was almost certainly in Rome in late 1499 and 1500, during Michelangelo's first Roman residency.[166] The two sculptors presumably knew each other. Nothing by Solari resembles the *Pietà*, however, so despite his fame in 1499, it seems strange that anyone should have thought of him in relation to that work – and stranger still in 1564, when Vasari's informant described the confusion. The Milanese sculptor had died in 1524, and even by then, he had been eclipsed by Michelangelo. Today, it is impossible to look at Michelangelo's *Pietà* without knowing that it is his. But what did those uninformed Lombards (if they existed) see in the monument that modern-day observers do not? Perhaps the most logical reason for Solari's being named in the anecdote about the misattribution of the *Pietà* is that there had indeed been some rivalry between him and Michelangelo. Or Solari might have been invoked as a surrogate for Leonardo, because of the Leonardesque elements in the *Pietà* – the pyramidal composition, the refined characterizations, and the draperies. Indeed, Vasari suggested that this was the case, albeit indirectly.

In both 1550 and 1568 Vasari praised Michelangelo's "divine draperies," his treatment of the dead Christ (one cannot conceive a more divine nude nor one that so convincingly represents a dead body), and Mary's youthful beauty.[167] But at the turn of the century Mary's beauty in general and divine draperies in particular might indeed have been perceived as Leonardesque elements in Michelangelo's *Pietà*. Michelangelo himself must have realized his debts to Leonardo in the statue, his most important commission to date. Michelangelo signed the *Pietà* precisely for this reason. That Vasari understood this explains his inclusion of the Lombard anecdote, psychologically true, whatever its factual status may be. Whether total fiction or garbled fact, the story remains historically valuable as a reflection of the changing ways in which mid-sixteenth-century viewers might see the *Pietà* and read its signature – an expression of pride in 1550, requiring explanation in 1568.

Michelangelo's success in Rome with the *Pietà* led directly to his triumph with the *David* in Florence (Figs. 60, 61, 63). His accomplishment was all the more remarkable, according to Vasari, because the block had been "maimed" (*storpiato*) by its first sculptors.[168] The principal culprit was Agostino di Duccio, who on 18 August 1464 had contracted with the Operai of the cathedral Office of Works in Florence to produce a giant (*gughante*) representing a prophet, for a cathedral buttress, intended as a marble pendant for his recently completed terracotta *Hercules*.[169] The sculptor "promised to make said figure of four pieces, that is, in one piece the head and neck, two pieces the arms, and the rest in a single piece, and he must make said figure in a manner and in perfection corresponding to the wax model by the said Agostino." Agostino evidently sketched the figure in *one* piece, however. On 20 December 1466 the Operai met again to deliberate the commission. Recalling their contractual stipulation that the sculptor make the *Giant* in four pieces, they noted "that the said Agostino is making the said marble figure of one piece."[170] This is the first mention of the idea that the *Giant* be made of one block, evoking the ancient tradition of the colossus carved *ex uno lapide*, including such fabled predecessors as the *Laocoön* as described by Pliny.[171] The record does not use that phrase – it refers to "unius petii" – but clearly the Operai understood that one piece was better than more, involving not only greater expertise but greater intellect, and so Agostino's fees were increased accordingly. Thus Agostino had effectively predetermined that the *Giant* would be carved of one stone, and his patrons had taken note of it. Wittingly or not, they had set the stage for Michelangelo's agon. Completing his *David*, Michelangelo commemorated his triumph in this contest by leaving an unfinished spot at the top of the statue to prove that the entire block had been used.[172]

Although the record implies that Agostino had completed the statue (*fecit*), later events indicate that at most he had succeeded – or rather failed – only in blocking out the stone, doing this job badly, according to those who inspected the marble in summer 1501.[173] Despite the damage to the block, in their meeting on 2 July the Operai reiterated their intentions of having the *Giant* made and installed "in its proper place." And now they identified the prophet it was

intended to represent as "David."[174] Leonardo da Vinci had returned to Florence by April the previous year, and he was considered for the commission, according to Vasari.[175] Condivi (naturally) omitted all mention of him, but Vasari was likely correct: Leonardo had been trained by the sculptor Verrocchio, and, more to the point, had recently completed the great *Horse* for the Sforza equestrian monument. Of course the Florentines would have thought of Leonardo for the *David*: how could they overlook him?

Michelangelo was first described as "divine" by Ariosto only in the final edition of *Orlando furioso* in 1532 (the same edition in which the poet first mentioned Titian): "Michel, più che mortale, Angel divino."[176] But Leonardo's "divinity" had already been recognized for decades, as witness Giovanni Santi's rhyming *Chronicle* of the early 1490s. Whereas Leonardo characteristically opened his studio to visitors and made works in progress readily available, Michelangelo locked his doors and hid his unfinished works from view. When carving the *David*, for example, he had walls constructed around the block so that he could "work continuously without anyone's seeing him," in Vasari's words.[177] Before leaving for Rome in 1506, he had packed his drawings in a sack: evidently, nothing was to be left lying around for curious eyes to see. Writing to his father from Rome on 31 January 1506 (modern 1507), Michelangelo asked that the drawings be sent to him (this is the same letter in which he expressed concern that no one be allowed to see "that Our Lady of marble").[178] Five years later, he remonstrated with his father who had not responded to his request that "my things, either drawings or other things" – possibly models or works in progress – "are not to be touched by anybody."[179]

Clearly Michelangelo did not wish his inventions to be made public until he was ready to unveil them, well aware that an artist's ideas may be published not only in his originals but in copies. Moreover, whereas contemporaneous copies of Leonardo's completed works were widely produced and circulated, copies of Michelangelo's creations were not generally available until the 1540s.[180] Even Leonardo's conspicuous failures, such as the unfinished Sforza monument, seemed only to add luster to his name. Indeed, the very fact that the terracotta *Horse* had been destroyed by the French made it the stuff of legend. In the memory of those who had seen it, and perhaps even more in the imaginations of those who had not, the *Horse* acquired mythical status.

Leonardo had been in Florence for about a year by the time Michelangelo arrived in May 1501. Friends had alerted Michelangelo to this "threat" and he returned to claim the *Giant* commission for himself, "however difficult it would be to carve an entire figure without pieces" – that is, *ex uno lapide* – "which, unlike him, the others did not have spirit enough to do without [separate] pieces," according to Vasari. And, he added, Michelangelo had long desired to undertake the task, and returned to Florence precisely to get it.[181] Judging from Fra Pietro's letter to Isabella, written the month before Michelangelo's return, the sculptor had come home to a city humming with excitement about Leonardo's latest invention, the *Saint Anne*. Once home, according to Condivi, Michelangelo encountered another rival, Andrea Sansovino. As in 1401, when

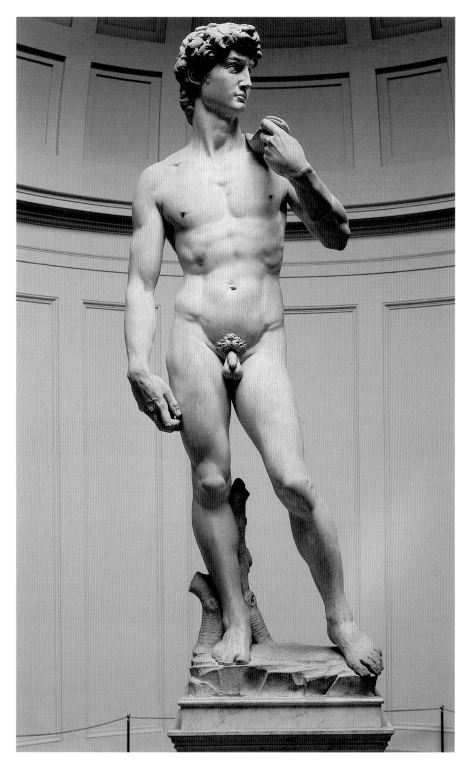

60 Michelangelo. *David*. Marble. Florence, Galleria dell'Accademia.

Ghiberti's economic use of bronze promised considerable savings, unlike Brunelleschi's profligacy with the material, again in 1501, the Florentine decision was influenced in part by Michelangelo's guarantee to complete the figure without requiring the expense of an additional block or blocks, as Sansovino thought necessary. On 16 August, little more than a month after determining to commission the *David*, the Operai, together with the consuls of the Arte della Lana (the Wool Workers' Guild, which financed much of the sculptural decoration of the cathedral) awarded the contract to Michelangelo to carve the *Giant*. A marginal note explains that on 9 September Michelangelo struck the block once or twice to remove a *nodus* on its breast.[182] On 13 September he began work in earnest. The rest is familiar history.

Now Michelangelo became truly famous – and acclaimed moreover for a heroic male nude, the theme thereafter most closely associated with his name. After the unveiling on 8 September 1504 the Florentine chronicler Giovanni Cambi recorded his opinion that Michelangelo was the greatest artist in Italy.[183] The first publication of his name appeared later that year in Pomponius Gauricus's treatise *De sculptura*, printed in Florence. Having invoked the names of great past masters, the author went on to cite distinguished sculptors of "our times," including "Michelangelo Buonarroti, a painter as well (*etiam pictor*)."[184] In 1504, then, Michelangelo was already known as both a painter and a sculptor, though he had apparently painted very little before that date. One wonders on what evidence Gauricus described Michelangelo as "pictor." Perhaps the lost copy after Schongauer's *Temptation of Saint Anthony*, apparently much admired by contemporaries, influenced his judgment.

David was not Michelangelo's first colossus. He had already produced *Hercules* some ten years earlier. But *Hercules* had not been half so large as *David*, which measures 4.10 meters (*Bacchus*, a mere 1.84 meters, is dwarfed by comparison). And size was what every contemporary noted about *David*. Both Vasari and Condivi pointedly recorded that the block itself measured 9 *braccia*.[185] For them and their contemporaries, it was not "David" but "the Giant," recalling (or preserving) the way in which their fifteenth-century predecessors had referred to the uncut stone and generally ignoring the fact that the block had acquired a name and an identity.[186] References to "the Giant" may also have been a joking allusion to David's identity as Giant-Slayer, but the title indicates that what first impressed its original audience was the size of the block and the size of the statue itself, and Michelangelo's extraordinary technical ability in having carved it, especially given the damaged condition of the stone. "It was certainly a miracle," as Vasari put it, "that of Michelangelo, to restore to life one who was dead."[187] Moreover, he concluded, this miracle surpassed "all ancient and modern statues, whether Greek or Latin, that have ever existed," an agonistic encomium that Vasari illustrated by reciting a list of ancient colossi known to him, all now dwarfed by Michelangelo's *Giant*.[188]

Neither Condivi nor Vasari wrote anything about the decision to place the statue in front of the Palazzo della Signoria, though this was not its original destination. The block had belonged to the Operai, and the statue was initially

planned as part of a group of giant prophets decorating the tribune buttresses. The program seems to have been conceived partly in competition with the giants decorating the exterior of Milan cathedral. Reviving the project at the turn of the century, the Operai may also have been rivaling their predecessors who had staged the competition of 1401 for the Baptistery doors.[189] Meeting on 2 July 1501, six weeks before awarding the contract to Michelangelo (16 August), the Operai had reiterated their intentions to place the new statue on a cathedral buttress.[190] But it must have become obvious as Michelangelo was working on *David* that this site would be difficult, if not impossible. The statues of Prophets made by Donatello and by Agostino di Duccio for the buttresses were not marble but terracotta, painted white to simulate stone. Barring costly and possibly unsightly adjustments to the cathedral, Michelangelo's marble *David* was likely to be too unwieldy for a buttress. Unlike his patrons, the sculptor would have been aware of the practical difficulties involved in such an installation.[191] If Michelangelo (and eventually his patrons) did not consider the *David* practicable as a buttress figure, did he have another site in mind as he worked? Saul Levine has argued that he did, that Michelangelo indeed conceived the *Giant* for the entrance of the Palazzo della Signoria, and that both the statue and its site were politically controversial. As interpreted by N. Randolph Parks, however, the sources indicate that the palace was selected only after protracted deliberations. His textual analysis seems to be correct, but words tell only part of the story, the part concerning the patrons and their advisory committee.[192] The *David* itself narrates another part, evidence of the maker's intentions. It is improbable if not impossible that Michelangelo could have completed his *Giant* without considering its placement. Doing so, he would be proceeding like any Renaissance master of stature working on any commission of consequence, whether in painting or in sculpture. The best evidence for Michelangelo's intention that the *David* occupy the site where it was eventually installed is not the silence of the documents regarding the Palazzo della Signoria before 1504, but the conception of the statue itself. Although conceived to be seen principally from the frontal view, the *David* was completed in the round, including the sling that establishes the Giant's identity as David, a detail that would be invisible were the figure on a buttress.[193] (The *Pietà*, conversely, is comparatively unfinished at the back; fig. 62.)

David was nearing completion by 16 June 1503, when the Operai decided to arrange a public viewing on June 23, that is, "the vigil of the feast of Saint John the Baptist," patron of Florence; the closed door of the enclosure where Michelangelo had been working in secrecy was "to be open all day" so that everyone who wanted to see the marble *Giant* might do so.[194] Then some six months after this viewing, on 25 January 1504, the consuls of the Arte della Lana convened a meeting to consider the matter of its site. Presumably the statue still belonged to the Operai, who, together with the consuls, had contracted with Michelangelo for the *Giant*. But now the Signoria intruded, and placement on a buttress or even elsewhere at the cathedral could no longer be taken for granted.[195] Accordingly, the consuls sought advice about the statue's

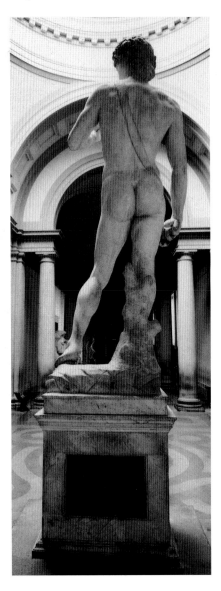

61 Michelangelo. Back view of *David* (Fig. 60).

placement from a group of thirty-two "masters and citizens." The record of the meeting clearly states their purpose: "Seeing that the statue of David is almost finished, and desiring to install it and to give it an appropriate and acceptable location [...] and because the installation must be *solid and structurally sound according to the instructions of Michelangelo*, master of the said Giant, and of the consuls of the Arte della Lana, [...] they decided to call together [...] competent masters, citizens, and architects."[196] The record is silent (perhaps naturally) about whatever political ramifications may have been involved in determining a site, but quite explicit about these practical concerns that the installation be "structurally sound." In this context, Michelangelo's instructions are assumed to be technical, whereas the opinions of the consuls may have more to do with intangible, though equally important, matters concerning the site. None of this discussion would have been necessary, however, had the consuls and Operai not finally realized what Michelangelo most likely already knew: the *David* was unsuitable for a buttress. And precisely because the practical concerns of determining a "solid" and appropriate placement were critical, the *ad hoc* committee was dominated by artists, architects or artisans, numbering twenty-nine of the thirty-two participants. Among them were Leonardo da Vinci; Michelangelo's boyhood friend Francesco Granacci and four newer friends, Botticelli, il Cronaca (Simone del Pollaiuolo), and Giuliano and Antonio da Sangallo (il Vecchio), who later made the machinery that carried the completed statue to its site; Davide Ghirlandaio, brother of Michelangelo's former master; Giovanni Cellini, father of Benvenuto, who became one of his greatest admirers; and Michelangelo di Viviani de' Bandini, father of Baccio Bandinelli, who became one of his principal challengers.[197]

Francesco Filarete, First Herald of the Signoria, was the first to speak, proposing that *David* replace Donatello's *Judith*. His suggestion may have been a foregone conclusion despite the committee's appearance of open discussion: Michelangelo and the Signoria (represented by the herald) may have already selected this site, as the chronicler Pietro Parenti attested in his records for 1504 and as Vasari later suggested.[198] In the deliberations, the herald argued that *Judith* should go: she is "an emblem of death, and is not fitting for the Republic – especially when our emblems are the cross and the lily – and I say it is not fitting that the woman should kill the man. And even more important, it [*Judith*] was erected under an evil star, for from that day to this, things have gone from bad to worse: for then we lost Pisa." (By the time the *David* was installed in *Judith*'s place, the Republic was planning a new campaign against the city.) Alternatively, the herald suggested, the *David* might also be situated within the palace courtyard, in place of Donatello's bronze *David*; but his preference was "for where the *Judith*

62 Michelangelo. Back view of *Pietà* (Fig. 55).

now is," in front of the palace. Other discussants demurred. Replying to the herald, the woodcarver Francesco Monciatto reminded the group that the statue had been made for the cathedral. Perhaps they might place it outside the church? Cosimo Rosselli agreed: "I had been thinking of putting it on the steps of the cathedral, on the right-hand side." This site seemed appropriate to Botticelli, but he objected to the asymmetry of such an arrangement. The *Giant* should be placed as Rosselli suggested, but "with a Judith at the other corner." Thus Botticelli reminded his colleagues that Judith (whom he himself had portrayed) and David were natural counterparts, and indirectly defended her reputation after the herald's attack.[199] Doing so, Botticelli implicitly asserted the ideal of symmetry as a fundamental principle of Renaissance design. The Signoria were also cognizant of this concern.

Some discussants objected to the cathedral site: the marble would suffer from exposure to the elements. Perhaps a more prudent location would be the Loggia dei Lanzi, where the statue would be sheltered. This was the recommendation of Giuliano and Antonio da Sangallo and Leonardo da Vinci, among others.

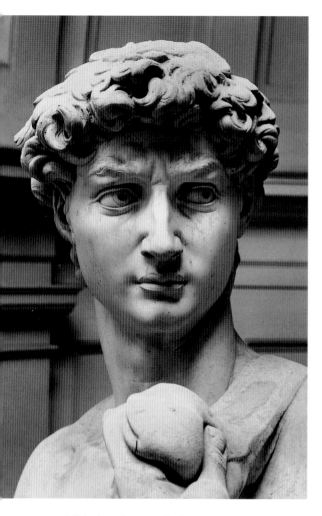

63 Michelangelo. Detail of Fig. 60.

Their concern about exposure may seem disingenuous: marble sculptures had long been made for display out of doors, and before modern times and modern pollution, exposure to the elements caused comparatively little damage. (The *David* itself, taken indoors to the Accademia delle Belle Arti only in 1873, is in good condition.) Were the *David* installed in the Loggia, as they suggested, the hero would be handsomely enframed by the central arch, transforming the structure into his realm – and his alone, because in 1504, there were no statues in the Loggia to compete for the beholder's attention. The Loggia's later transformation into a sculpture "museum" was prophesied and perhaps inspired by the proposals of Leonardo and the Sangallo. But the real motivation for proposing the Loggia may have been not aesthetic but political, that is, pro-Medicean, a way of mitigating *David*'s Republican associations, which the palace setting would make explicit.[200]

Aside from the herald's lament about Judith's complicity in the loss of Pisa, however, no one mentioned political concerns, at least according to the written record. The gemsmith Salvestro favored "the place outside the palace" for the statue; but this was a matter of taste, and his opinion was offered in deference to Michelangelo's judgment: "he who made it surely knows better than anyone the place best suited to the appearance and character of the figure." Filippino Lippi agreed: "I believe that the master-sculptor would know best." Asserting Michelangelo's rights, Salvestro and Lippi implied that all artists should have a voice in determining the fate of their creations. After further discussion of installing the *Giant* in the Loggia or in the courtyard of the Palazzo della Signoria, Piero di Cosimo returned to the theme of the maker's rights: "I would approve an opinion in agreement with him who made it, since he knows best where he wants it to be."

Certainly the Loggia setting would have been elegant and prestigious, and it may be that Michelangelo himself hoped to install his *Giant* there, as some scholars have argued.[201] The record of the meeting is unclear, however, and may

be read to imply that he preferred the façade of the palace, as others have inferred. David himself seems to offer contradictory testimony about his intended site, bearing witness with his glance, or rather, his scowl.

David's expression is perhaps his most idiosyncratic feature, all the more remarkable in relation to his *contrapposto* and heroic nudity, blazons of antiquity (Fig. 63). Whereas his body and his stance are those of a pagan hero or deity, his face is that of a modern man, the determined defender of his people. The ancient heroes whom the *David* resembles in form and posture do not allow their thoughts to disturb their features; such physiognomic distortions are far more likely to characterize monsters and villains. Aside from the *David*, few other works by Michelangelo exploit facial expression to convey a hero's state of mind, chief among them the *Moses*. Thereafter, until the frescoes of the Pauline Chapel, the visages of Michelangelo's heroes remain impassive; expressions so powerful that they may distort the features

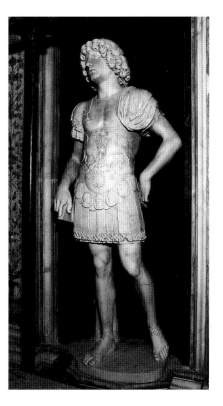

64 Tullio Lombardo. *Warrior*. Marble. Vendramin Tomb. Venice, Santi Giovanni e Paolo.

are seen most often in a negative context, notably in Adam and Eve after the Fall and among the Damned in the *Last Judgment*. The closest antecedent for the expressive visage of the *David*, and a work presumably known to Michelangelo, is that of Tullio Lombardo's *Warrior*, completed by 1493 (Fig. 64). The *Warrior*'s "deeply incised scowl and mood of tense, anxious watchfulness [. . .] was an important precedent" for Michelangelo, as was Tullio's characteristic treatment of the heavy mass of hair, almost wig-like, its intricately carved locks contrasting with the smooth planes of the face.[202] Whereas the Venetian *Warrior* expresses anxiety, however, the Florentine hero shows fearsome determination. Thus combining the athletic nudity and stance of classical heroes with the vehemence of their antagonists' faces, Michelangelo endows David's visage with Judeo-Christian morality and purpose.

David's scowl, which knots his brow and shadows the eyes almost to the point of distortion, is informed by contemporary and ancient beliefs about physiognomy. Pomponius Gauricus, for example, defined physiognomy as the means whereby the beholder perceives "qualities of the soul."[203] What the first beholders of *David* perceived in his visage, as the discussants of 1504 imply, is

65 Leonardo da Vinci. *Neptune*. After Michelan-
gelo, *David*. Pen, ink, and black chalk. Windsor, Royal
Library 12591. Her Majesty Queen Elizabeth II.

danger. It would be better placed in the Loggia, Andrea il Riccio opined, because passers-by would go to see the statue, "and not that the figure come to see us."[204] The *Giant*'s powerful gaze is to be avoided, then; at least it should not fall on the beholder before the beholder's eye sees it first. (Concern about the danger of the hero's gaze recalls Petrarch's conception of the perils of the beloved's gaze and anticipates Bronzino's praise of Cellini's *Medusa* whose gaze can transfix the unwary viewer.[205]) So *where* he looks is significant: like the glances of most if not all persons in Italian art since Giotto's day, David's gaze is directed. But where did Michelangelo intend the *David* to look? Standing in the Loggia dei Lanzi, the hero would glower to the west, toward Pisa. Standing in front of the palace, he would look south, toward Rome. Either direction made geopolitical sense in 1504. Florence had lost Pisa, as the herald lamented at the start of the proceedings; and plans for reconquest were likely already under discussion. In Rome Alexander VI (himself no friend to the Republic) had given refuge to Piero de' Medici, and the Medici were consolidating their power. Whether David was conceived to look south or west, then, is uncertain; the fact that either direction would have been appropriate may have exacerbated the difficulties of deciding its placement. Some five months after the meeting of January 1504, it was finally decided that *David* would face Rome, replacing Donatello's *Judith* at the left of the palace entrance, installed atop the *ringhiera* or ceremonial platform, since destroyed.[206]

As Michelangelo carved *David*'s face, in addition to physiognomical theories and works he had seen in Venice, he may have had in mind examples provided by Leonardo's studies and his conception of expressions that reflect the individual's spiritual or intellectual life. Whether Michelangelo intended to chal-

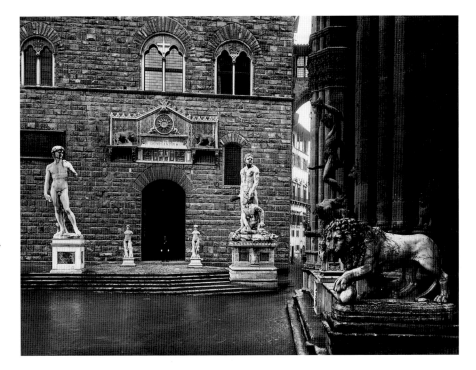

66 Florence, Piazza della Signoria, Palazzo Vecchio, and Loggia dei Lanzi.

lenge Leonardo in the depiction of emotion, contemporary viewers might well have thought of the older master's physiognomies as they looked at Michelangelo's *David* for the first time. And the statue may have reminded them of Leonardo in another regard as well. In the sixteenth century *David* was famous above all for its size: it was the *Giant*, and as such comparable with Leonardo's *Horse* for the unrealized Sforza monument. Whereas the *Horse* was terracotta, *David* is marble, a far less tractable medium. With the *David*, Michelangelo achieved his most conspicuous success, triumphant precisely where Leonardo had conspicuously failed, in the creation of a modern colossus. Perhaps in part for this reason, Leonardo's response to the *David* was not entirely enthusiastic, as implied by his sketch of the statue, aptly described as a "graphic critique." Given Leonardo's custom of freely showing his drawings, Michelangelo probably knew of this insult (Fig. 65).[207]

Brought to the piazza between 14 and 18 May 1504 (and stoned en route during the first night by pro-Medici vandals), the *David* was installed on 8 June, mounted on a high socle or base in the manner of an ancient statue. The diarist Luca Landucci recorded the events: "The marble giant was taken out of the *Opera* [. . .] ; it was brought out at [8:00 p.m.], and they had to break down the wall above the door so that it could come through. During the night stones were thrown at the giant to injure it. [. . .] It went very slowly, being bound in

an erect position, and suspended so that it did not touch the ground with its feet."[208] The hero was crowned with a golden wreath of victory, the sling and tree stump were gilded, and gilded too the grape leaves that (eventually) concealed his nudity.[209] Thus adorned, *David* was finally unveiled on 8 September, the feast of the Nativity of the Virgin, in the site now occupied by a replica (Fig. 66). The choice of the date was of course purposeful: Mary is a patron of Florence, and unveiling the *David* on her feastday underscored the political implications of the *Giant* as champion of the Republic. Its meaning was remembered even when the statue's original anti-Medici politics were forgotten, or denied. Vasari, who naturally wished to ignore its Republican origins, characterized *David* as the *insegna*, "the sign or emblem of the Palace." It was unnecessary to specify *which* palace: Vasari meant the Palazzo Vecchio, in the decade between 1540 and 1550 the residence of Cosimo de' Medici. But Vasari's omission conceals the fact that when *David* was installed there in 1504, the building then known as the Palazzo della Signoria had served as the seat of the *Republican* government.[210]

David is the archetypal defender of his people, but with the restoration of the Medici in September 1512, he himself might have been endangered. By then, however, the *Giant* and its maker were protected by their fame. The Medici found it more expedient to coopt both the statue and Michelangelo himself. As Vasari (a Medici client) described *David* both in 1550 and 1568, the hero had "defended his people and governed them with justice, as he who would govern this city must bravely defend it and justly rule it."[211] In 1504, however, "this city" was governed by the Republic. Standing guard at the Palazzo della Signoria, *David* silently declared his affiliation with that popular regime. Vasari and his Medici patrons may have chosen to ignore this fact, but Michelangelo surely remembered.

With the *Giant*'s unveiling, Michelangelo had supplanted Donatello, and yet at this moment of his first public triumph in Florence, he was compelled to copy his predecessor's bronze *David*, then displayed in the courtyard of the Palazzo della Signoria. This new bronze *David* was to be (merely) lifesize, with the head of Goliath at his feet. Michelangelo could not refuse: the request came from Piero Soderini, *gonfaloniere* in spring 1501 and thereafter (1 November 1502) appointed *gonfaloniere di giustizia a vita*, governor for life.[212] Acting in a semi-official capacity, Soderini was responding to the request of Pierre de Rohan, the Maréchal de Gié. Rohan had admired the Donatello during his residence in the palace in 1494, when the French forces occupied the city, and later expressed his desire for a cast of the work. On 12 August 1502, wishing to remain in good French graces, the Signoria determined to commission Michelangelo to produce a bronze *David* for Rohan, intended as a variant if not a replica of Donatello's. Soderini signed a contract with Michelangelo on the maréchal's behalf on that same day, requiring the artist to complete the work within six months. The work took rather longer – six years – and Rohan himself was out of favor by the time his *David* was completed in 1508 (it was cast after Michelangelo's departure for Rome and finished by Benedetto da

Rovezzano). The statue was presented instead to Florimund Robertet, French secretary of finance. It has been lost, but a wax figure in Casa Buonarroti may have been a *modello*.[213]

Condivi tried to put the matter in the best possible light: Michelangelo executed the bronze *David* precisely to demonstrate that "there was no material that fell under the art of statuary in which he did not place his hands."[214] (Is this an indirect, posthumous jibe aimed at Leonardo?) According to Varchi, Michelangelo made the *David* "not so much in imitation as in rivalry with that of Donatello."[215] Michelangelo's own testimony about the bronze *David* is not so positive.

In 1502, while he was still very much engaged in working on the marble *David*, Michelangelo made a drawing illustrating ideas germane to both statues (Fig. 67). One part of the sheet has David with the head of Goliath, as Donatello had represented him and as Michelangelo's own bronze was meant to do. Next to this figure is a sketch of the right arm and shoulder of the *Giant*. The two parts of the drawing are differently oriented: when the "bronze" figure is upright, the "marble" arm and shoulder are upside down. Written on the sheet are several lines in Michelangelo's hand:

> Davicte cholla Fromba
> e io chollarcho
> Michelagniolo
> (David with the sling, and I with the bow – Michelangelo);

and then, lower down on the sheet:

> Rocte lalta cholonna el verd . . .
> (Broken are the tall column and the green . . .).

This line alludes to the opening of Petrarch's sonnet 269: "Rotta l'alta colonna e 'l verde lauro."[216]

The "archo" (in modern Italian, *arco*) refers to Michelangelo's own weapons: the sculptor's running drill (*trapano*), worked by means of a bow; and the compass (*seste ad arco*), used, as Irving Lavin has explained, "in enlarging from a small-scale model or transferring dimensions from the full-scale model to the final work in stone. In fact, the bowed compass [. . .] is the sculptor's primary instrument of measure and proportion."[217] It is a tool involving brains, not brawn. So the meaning of the first two lines, followed by Michelangelo's signature, is clear: he saw himself as an *inventive* warrior, like David. Each is armed with his own wits and his own weapon or weapons in battle with a giant, that is, Goliath or the block. And perhaps too Michelangelo saw himself as a defender of his people, like David.[218]

The meaning of the Petrarchan misquotation is less straightforward. It might be related to Michelangelo's identification with David, in this instance with the hero as personification of courage and fortitude, sometimes symbolized by a broken column, and also with the column or block of marble from which the sculptor was fashioning his *Giant*. For Petrarch, "lauro" alluded as always to

Laura, and "colonna" to Cardinal Giovanni Colonna, the poet's patron who had died 3 July 1348.[219] For Michelangelo, "lauro" was similarly a pun on a name, in this case, the name of his first great patron, Lorenzo il Magnifico, and also an allusion to the familiar Medici emblem. The truncation of the reference to green laurel, "el verd," the words themselves cut as though to visualize their meaning, has been taken to refer to his death some ten years earlier, 8 April 1492.[220] (The symbolism recalls Michelangelo's truncated *facieba*... in the *Pietà* signature.) And yet these interpretations of Michelangelo's texts are incomplete because they do not take into account a fundamental fact about the inscriptions.

The texts are written with the same orientation as the sketch for the *bronze* statue, to be read as we look at that figure, though the words and their image are separated by the "upside down" and larger arm of the marble *David*. Referring to the stone carver's drill and compass as his weapons, the signed lines are a bellicose expression of Michelangelo's preference for marble, now well known but in 1502 not to be taken for granted. Michelangelo resented having to make this particular bronze, commissioned as a copy of another master's work. Comparing himself with David, identifying his weapons as those associated with stone carving, Michelangelo lamented his situation even while asserting his powers. His abbreviated quotation from Petrarch sanctions this reading. That single line can be understood only when the poem is read in its entirety – a poem Michelangelo probably knew from memory:

> Broken are the high Column and the green Laurel that gave
> shade to my weary cares; I have lost what I do not hope to find
> again, from Boreas to Auster or from the Indian to the Moorish
> Sea.
> You have taken from me, O Death, my double treasure that
> made me live glad and walk proudly; neither land nor empire
> can restore it, nor orient gem, nor the power of gold.
> But, since this is the intent of destiny, what can I do except have
> my soul sad, my eyes always wet, and my face bent down?
> Oh our life that is so beautiful to see, how easily it loses in one
> morning what has been acquired with great difficulty over many
> years![221]

In the context of the sheet on which Michelangelo wrote the first line of this sonnet, the "double treasure" may be understood to refer not to the deaths of persons dear to him (or at least not only to Lorenzo's death) but rather to the *Pietà* and the marble *David*. These achievements (the latter nearing completion in 1502) had made him "live glad and walk proudly," but now he weeps, having lost what he had "acquired with great difficulty over many years," namely his fame. He seems to have said to himself – and the study sheet was made for himself, the text addressed to himself – I am now beyond this kind of thing; and my patrons should realize it. Yet he was compelled to make a copy of a fifteenth-century work, in bronze (not his preferred medium), and

67 Michelangelo. Studies for the figure of David with verse fragments. Pen. Paris, Musée du Louvre 714r.

commissioned by Soderini, his "great friend" (as Condivi described him) and erstwhile champion, who presumably should have known better. Such a self-referential reading of the poem is consistent with what is known of Michelangelo's personality. He mourned Lorenzo no doubt; but ten years after Lorenzo's death, Michelangelo was thinking, and writing, primarily about himself.

This interpretation is indirectly confirmed by Condivi, quoting Michelangelo. Mentioning Donatello's *David*, but not the fact that it was the prescribed prototype of a work by Michelangelo, Condivi then described Michelangelo's opinion of his predecessor. Donatello was "an excellent man in that art [bronze sculpture] and much praised by Michelangelo, except for one thing, that he did not have patience in polishing his works, so that, succeeding wonderfully when seen from a distance, seen up close they lost credit."[222] This negative impression is emended in a *postilla*. Condivi got it wrong, Michelangelo said, referring to Donatello's bronze *David* and *Judith and Holofernes*: "when they are good, a lot of polishing is not needed."[223]

So Michelangelo balked at criticizing Donatello, at least in private. His admiration for his predecessor, implicit in his art, is confirmed by an anecdote recounted by Vasari at the end of the 1568 edition, quoting Michelangelo's praise of Donatello's *Saint Mark* as the image of an honest man.[224] Considering the unfinished or *non-finito* state of many of Michelangelo's own sculptures in 1553, when Condivi's life was published, the denunciation of Donatello's "rough" surfaces seems particularly inappropriate. (Was Michelangelo defending himself when he defended Donatello in his *postilla*?) Nonetheless, whether Condivi had misrepresented Michelangelo's criticism or whether Michelangelo had later come to regret it as ungenerous and untrue, the context of the report is telling. Discussing Michelangelo's bronze *David*, Condivi said nothing about its derivation from his predecessor's work, cited only as another – lesser – example of the same theme, a silence that seems purposeful precisely because the point of the criticism of Donatello is to (re)assert Michelangelo's superiority. Michelangelo, or Condivi on his behalf, was willing to publicize his having mastered bronze in 1502 but did not want to reveal his debt.

Michelangelo's plaintive citation of Petrarch in his signed drawing may also be read in relation to Vasari's anecdote about Soderini's response to the marble *David* and his commission of the bronze. Looking at the *Giant*, Soderini thought the nose too large; Michelangelo, high on the scaffold, sprinkled him with marble dust as though chiselling at the stone. The gonfaloniere was deceived: "I like it better." Michelangelo descended the scaffold, "with feelings of pity for those who wish to seem to understand matters of which they know nothing."[225] Michelangelo had every reason to be grateful to Soderini, and Condivi's account is surely accurate in describing him as the artist's friend. But Soderini had been a conspicuous political opponent of the Medici, and Vasari, a Medici client, would wish to disparage him for this reason alone. Certainly Vasari was capable of concocting the fable – which appears only in the second edition (published four years after Michelangelo's death) – and it is most likely an invention or a mean-spirited paraphrase of similar stories told by Pliny and

others about presumptuous critics.[226] Deprecating Soderini, however, the anec-
dote also serves the purpose of insulating the marble *David* from Republican
guilt by association with the gonfaloniere who could not appreciate it. Having
thus introduced and disparaged Soderini in 1568, Vasari then repeated infor-
mation about his commission of the bronze *David* which had been included in
the first edition. Now, having been told that Soderini was ignorant about art,
the reader credits the commission of this "most beautiful bronze" entirely to
"the fame that Michelangelo had acquired in sculpture" after the unveiling of
the marble *David*.[227] But, like Condivi, Vasari omitted the fundamental fact
about the bronze, namely that it was intended as a copy after Donatello.

The *David* – or the *Davids* – led to three new public commissions for
Michelangelo in Florence: a mural for the Sala del Maggior Consiglio of the
Palazzo della Signoria; a series of marble statues of the Twelve Apostles for the
cathedral; and a pendant for his *Giant*.[228]

When Botticelli had responded to Rosselli's proposal that Michelangelo's
statue be placed at one side of the cathedral with a suggestion that *David* be
accompanied by *Judith*, he was reminding his colleagues of symmetry as a
desideratum of design. While the installation of Donatello's *Judith* at the
entrance to the Palazzo della Signoria was exceptional, the concomitant asym-
metry was mitigated by scale, because the statue is under lifesize.[229] The
Signoria did not take Botticelli's advice about the *Giant*'s location – he had
favored the cathedral – but it did heed his concerns about the symmetry of the
arrangement. Once they had determined to place the *David* to one side of the
palace entrance, they almost certainly began to plan a second monumental
statue for the other side.[230] The *Giant*'s new companion was not to be another
Judith, however; perhaps she had been discredited for the reasons adduced by
the herald Filarete. In any case, the Florentines had someone else in mind, even
better suited to represent their civic and moral virtue than that heroine:
Hercules, renowned for his great strength and for his victories over various
nefarious enemies. Half-god and half-man, Hercules was traditionally com-
pared to Christ as mediator.[231] And Hercules had the further advantage of his
venerable association with Florence, dating from the thirteenth century (if not
earlier) when the hero was depicted on the city seal. The inscription on the
reverse explained his relevance: "The club of Hercules subdues the depravity
of Florence."[232] The block that had become *David* had originally been assigned
to Agostino di Duccio, who was to have carved a companion for his cathedral
Hercules, so in a sense the demigod had been destined to accompany
Michelangelo's *Giant* – a classical/biblical typology authorized by Dante.[233] The
two heroes had already been presented as examples of civic virtue within the
Palazzo Vecchio, Hercules perhaps as early as the late 1380s and David since
1416, when the Signoria "requested" that the cathedral workshop relinquish
Donatello's marble statue.[234]

Hercules is also represented in two reliefs on the façade of San Marco in
Venice, where he was venerated as a tribal forefather of the Republic. This fact
gained him further cachet with the Signoria of Florence, who found in the

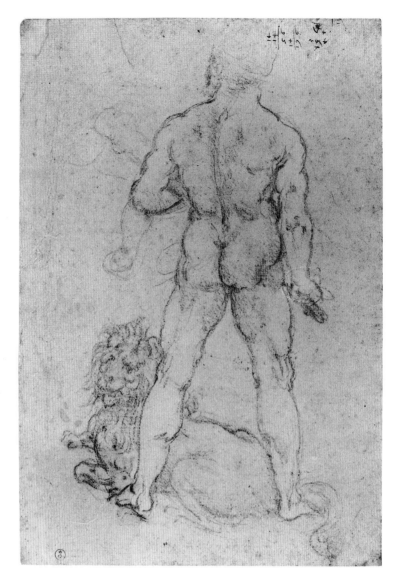

Serenissima an exemplar of governmental stability and prosperity. That the
Florentines were particularly responsive to the Venetian example at the begin-
ning of the sixteenth century is indicated by their actions, both pragmatic and
symbolic: naming Soderini *gonfaloniere a vita* in 1502, in emulation of
the Venetian doge's lifetime tenure; and planning a decorative scheme for the
Sala del Gran Consiglio, inspired by the Sala del Maggior Consiglio of the
Venetian Palazzo Ducale.

Eventually, Hercules did join David in front of the palace, when Baccio
Bandinelli's *Hercules and Cacus* was installed in 1534, thirty years after

68 (facing page)
Leonardo da Vinci.
Hercules and the
Nemean Lion. After
Michelangelo, David.
Charcoal or black
chalk. Turin, Biblioteca
Reale 15630.

69 Leonardo da Vinci.
Hercules. Charcoal or
black chalk, pen and
dark ink. New York,
The Metropolitan
Museum of Art.
Purchase, Florence B.
Seldon Bequest and
Rogers Fund, and
Promised Gift of Leon D.
and Debra R. Black,
2000. (2000.328 a, b
verso).

the unveiling of Michelangelo's colossus. But in 1504, in the period immediately following the completion of *David*, and for many years thereafter, Michelangelo had expected that the new commission would be his. The earliest visual evidence for a pendant for the *David* may be seen in drawings made by Leonardo c. 1504–08, that is, at the time of the statue's completion and shortly thereafter. In one drawing, Leonardo reinterpreted the *Giant* as *Neptune* (Fig. 65), giving him a more massive body and more active stance – altering Michelangelo in ways that anticipate Baccio.[235] In a sketch of *Hercules and the Nemean Lion*, Leonardo again critiqued Michelangelo by offering a hero both heavier and livelier than *David* (Fig. 68).[236] Finally, in a sheet dating c. 1506–08, Leonardo represented Hercules standing with legs apart, holding his club horizontally across his hips, seen frontally on the recto and from the back on the verso (Fig. 69).[237] Years later Daniele da Volterra modeled a terracotta *David Slaying Goliath*, which he then painted on both sides of a slate panel, as a demonstration piece in relation to the *paragone* debates. Michelangelo himself evidently provided drawings for the project.[238] And Bronzino painted a canvas with front and back views of the *Dwarf Morgante*, also alluding to the *paragone* (though in this case, with ribald intentions).[239] In the case of Leonardo's front/back drawing, however, the concern was more practical than theoretical: he was visualizing a figure meant to be seen in the round. Nor was this an entirely random exercise, because in 1508 – the approximate date of the drawing – Leonardo was thinking about depicting the Labors of Hercules for Pier Francesco Ginori.[240] But the Hercules of the drawing, though armed, is not "laboring," and neither is he resting from his labors. In this regard, he departs from classical and Renaissance precedents, as Carmen C. Bambach has

explained, noting that "This vigilant Hercules type is quite unclassical in mood."[241] While Hercules does not suggest earlier images of himself, however, Leonardo's hero does resemble Michelangelo's *David*. The characterization of Hercules suggests that Leonardo was thinking of his adversary. Might Leonardo also have been thinking of a sculpture to accompany, and rival, Michelangelo's *Giant*?[242] Although the Signoria was apparently already considering a companion piece, however, there is no indication (unless the drawing may be considered as such) that they discussed the commission with Leonardo. Competition between Leonardo and Michelangelo for the second "Giant" existed only in Leonardo's imagination and in his sketches: a letter from Soderini indicates that the Signoria already had Michelangelo in mind by summer 1506 if not earlier.

Writing to Alberigo Malaspina, Marchese of Massa, on 7 August 1506, Soderini asked that an enormous block of marble recently quarried at Carrara be held for the Florentine Republic.[243] Given the time involved in quarrying a block of this size, the work had almost certainly begun some three or four years earlier.[244] And given the rarity of blocks of these dimensions, the Signoria might already have been contemplating a pendant for the *Giant* as early as 1503 or 1504 – to be carved by Michelangelo. The plans are confirmed by another letter from Soderini to Malaspina on 21 August 1507, informing the marchese of Michelangelo's imminent arrival to examine the block. Meanwhile, Michelangelo continued to dream of colossi. In Carrara in 1505, looking over the seacoast, Michelangelo imagined carving an even greater colossus than his own *David*, one that would evoke and rival the Colossus of Rhodes. Remembering this daydream nearly fifty years later, he recounted it to Condivi, who included it in his biography: "the desire came to him to make a Colussus that would appear to seamen from the distance, being inspired mostly by the suitability of the stone [. . .] and by emulation of the ancients. [. . .] And surely he would have done it, if he had had time."[245] The anecdote strains credulity – until one reads the *postilla* that Michelangelo dictated to Calcagni while reading Condivi's account: "This was, he said, a craziness that came to me, so to say. But if I were sure of living four times as long as I have lived, I'd have gone there."[246] That is, he would have made his Colossus. What Michelangelo preferred not to remember was that while he was in Carrara in 1505 he must perforce have witnessed the quarrying of the block destined for the second Florentine Giant – the commission he expected, but eventually lost to Bandinelli.

While the Colossus of Carrara remained a dream, the other, for Florence, seemed about to become reality in 1508. Soderini confirmed the Signoria's plans for *David*'s companion in a letter to Malaspina dated 10 May of that year. He asked that the marchese continue to reserve the block for Michelangelo, now specifying that the marble was intended for a statue in the Piazza della Signoria.[247] The request was repeated in another letter, dated 4 September. Writing yet again to the marchese on 16 December 1508, Soderini was adamant that only Michelangelo be allowed to supervise the block's roughing out lest it

be ruined.[248] Evidently the sculptor already had a subject in mind, a two-figure group representing Hercules and an opponent, most likely Antaeus.[249] By then, however, Michelangelo was living in Rome, having been summoned by Julius II in March 1505 to design the pope's funerary monument.[250] The block that he and Soderini had planned to transform into a second giant statue for the Piazza remained in Carrara until 1525, eventually to become Bandinelli's *Hercules and Cacus*.

Of course, Bandinelli's commission was unforeseen and unforeseeable in 1504. After the installation of the *David*, Michelangelo could assume that the Signoria would want him to make this second Giant to accompany his first. The commission for the Twelve Apostles might also have been expected: Michelangelo had demonstrated his mastery of sculpture with the spectacular successes of the *Pietà* and, more to the Florentine point, the *David*, and it was natural that the Operai and the Arte della Lana turn to him for their projected series, to be displayed inside the cathedral. The commission for the Sala del Maggior Consiglio, however, was not to be taken for granted.

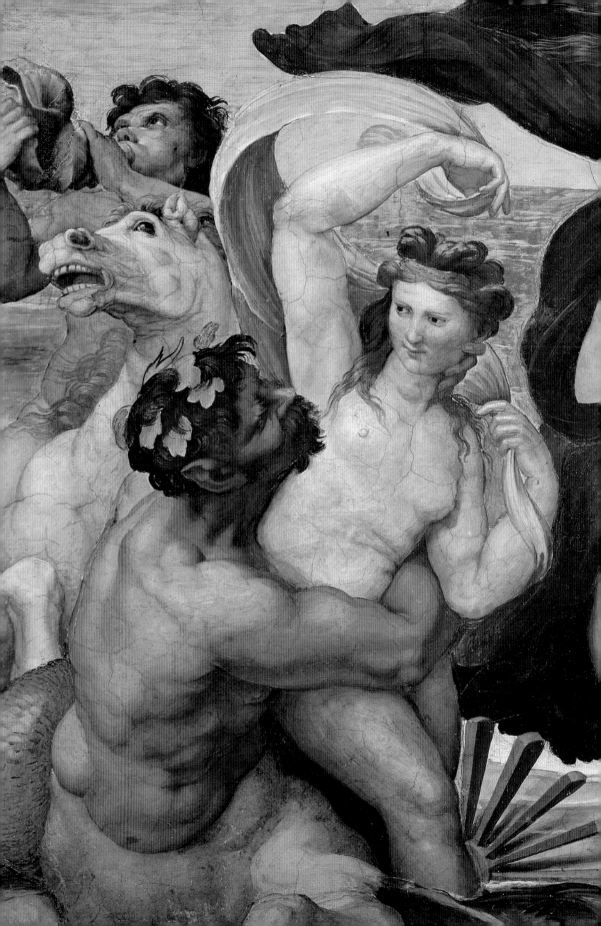

III

Antagonists

Detail of Fig. 128.

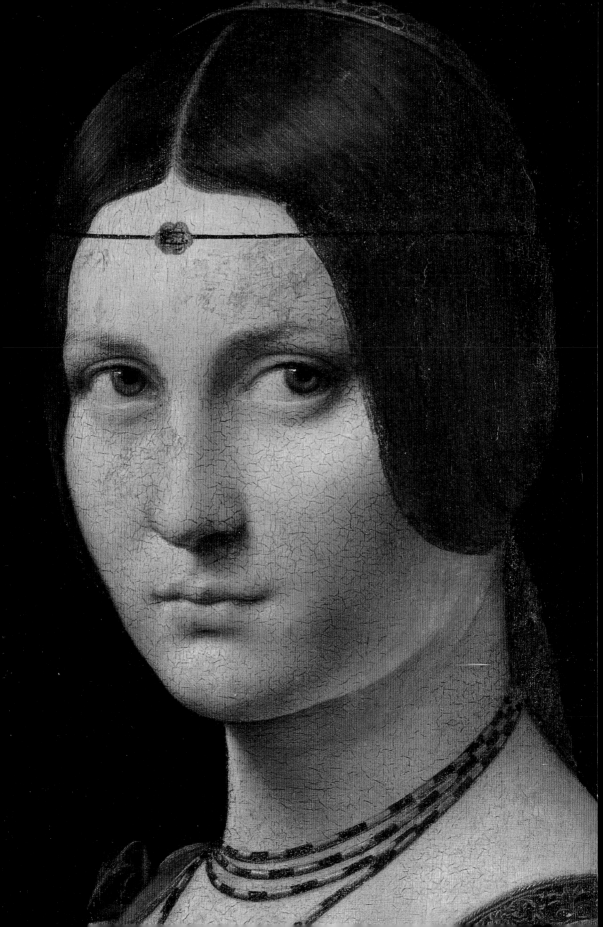

5

Leonardo

This cartoon was the first wonderful work in which Michelangelo
showed his magnificent genius, and he made it in competition with
another artist – Leonardo da Vinci.

Benvenuto Cellini[1]

COMMISSIONING LEONARDO's *Battle of Anghiari* for the Sala del Gran
Consiglio, the Signoria meant to commemorate the Florentine victory over
the Milanese on 29 June 1440 (Fig. 70).[2] Commissioning Michelangelo's *Battle
of Cascina* for the same room, the Signoria purposefully set Michelangelo
against Leonardo, stamping their rivalry with the seal of state approval
(Fig. 71). Benedetto Varchi underscored the point in his funeral oration:
"Gonfaloniere Soderini [. . .], to stage a competition [*per far concorrenza*] with
Leonardo, assigned Michelangelo that other wall: wherefore Michelangelo, to
conquer him [*per vincere colui*] [. . .] undertook to paint" his *Battle*.[3] The room
had been designed in 1495–96, modeled on the Sala del Maggior Consiglio in
Venice.[4] The Venetian Great Council met under an enormous mural, the
Coronation of the Virgin in Paradise. The Florentine council planned to meet
under the protection of Christ himself, who would have been present among
his councillors in the statue commissioned to Andrea Sansovino, "sculptor,
master and nobleman in sculpture," reminding beholders of the Republic's
foundation on 9 November 1494, the Feast of the Savior.[5]

Did Michelangelo court the commission? Did he seek the direct rivalry with
Leonardo? His having done so would help explain the Signoria's unlikely
decision in 1504: awarding a fresco commission to a sculptor with com-
paratively little experience in painting. Perhaps his Florentine contemporaries
remembered what Michelangelo later tried to deny: his training as a painter
in the Ghirlandaio shop. Whatever he may have learned there, however,
Michelangelo had done little painting on his own. The only completed paint-
ings that contemporaries ascribed to him before he began work on the *Cascina*
in 1504 were his fabled copy of Schongauer's *Saint Anthony* and a *Stigmati-
zation of Saint Francis*, formerly in the church of San Pietro in Montorio in
Rome. According to Vasari, Michelangelo provided a cartoon of that subject
to be painted in tempera by Cardinal Riario's barber, who knew his *colore* but

Detail of Fig. 21.

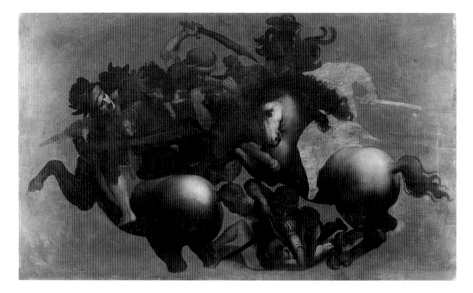

70 Anonymous Tuscan, sixteenth century. After Leonardo, *Battle of Anghiari*. Panel.
Florence, Galleria degli Uffizi.

not his *disegno*. Varchi's account is slightly different: Michelangelo himself
painted the *Stigmatization*, done "in tempera according to the old manner
[*maniera*] [. . .] nor can one praise it worthily if not by saying that it is by
Michelangelo."[6] Neither author seemed to consider the *Stigmatization* a par-
ticularly noteworthy achievement: it was the least admired of all the works
associated with Michelangelo.

During his first Roman sojourn, Michelangelo had also received the com-
mission for an altarpiece for the funerary chapel of Giovanni Ebu, Bishop
of Crotone, in Sant'Agostino. Michelangelo never completed the painting
and eventually returned the advance payment, but the unfinished *Entombment*
(Fig. 72) has been identified as the altarpiece intended for the bishop's chapel.[7]
Another panel painting from the first Roman period, the Manchester *Madonna*,
was also abandoned.[8]

Even taking these unfinished works into account, the fact remains that in
1504 Michelangelo was a successful sculptor but an inexperienced painter. Until
the 1520s he signed his correspondence, including some letters to his father, as
"Michelangelo scultore," and was identified as "Michelangelo the sculptor"
even in documents relating to earlier commissions for paintings.[9] Leonardo,
conversely, was an established painter with considerable and conspicuous
experience in sculpture, as Vasari noted.[10] In 1504, moreover, Leonardo was
still far more famous than Michelangelo. Michelangelo was mentioned for the
first time in print in that same year, as the sculptor of the *David*. Leonardo was
the universally recognized great man who did not have to sign his works in
order that they be recognized as his creations. Michelangelo could be seen and

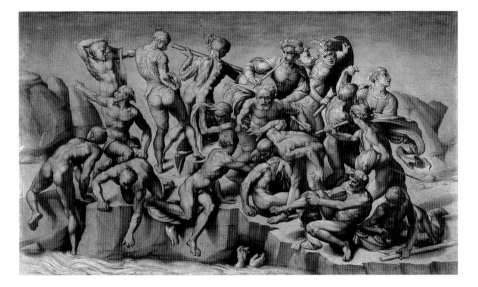

71 Aristotile da Sangallo (attr.). After Michelangelo, *Battle of Cascina*. Grisaille panel.
The Earl of Leicester and the Trustees of the Holkham Estate, Norfolk.

could see himself as the challenger who could neither ignore Leonardo nor deal
with him through intermediaries, as he would do later with other rivals
in Rome. There, Michelangelo responded indirectly to Raphael by enlisting
Sebastiano del Piombo as his agent, thus establishing a life-long pattern of
opportunistic rivalry by proxy. But also beginning with Raphael in Rome,
Michelangelo could see himself as the "defending champion" and other masters
as his challengers. He became the exemplar, the point of reference (as Leonardo
had been for him), and everyone else either acolyte or antagonist. The
apotheosis came half a century later with Varchi's laudatory lectures on
Michelangelo delivered at the Florentine Academy in 1547, and Vasari's exal-
tation of Michelangelo as god of the artistic trinity of painting, sculpture, and
architecture in the first edition of the *Lives* in 1550 – Michelangelo being, as
often noticed, the only living master included in the book – and finally in his
funeral obsequies, ceremonies of unprecedented (and never equaled) grandeur
for an artist, an apotheosis orchestrated by Vasari with an oration by Varchi.[11]
But in Florence in 1504, Michelangelo had still to prove himself, and this neces-
sitated besting, or at least equaling, Leonardo.

 The professional confrontation was exacerbated by their animosity:
Leonardo and Michelangelo were oil and water. Given their different per-
sonalities, it could hardly have been otherwise, as Paolo Giovio, their first
biographer, suggested.[12] Admiring Leonardo and Michelangelo equally as "cel-
ebrated lights of perfect art," Giovio criticized Michelangelo for his character
failings while praising Leonardo for his amenable qualities. Leonardo was an
exemplary person, Giovio opined, "by nature affable, sparkling, generous, with

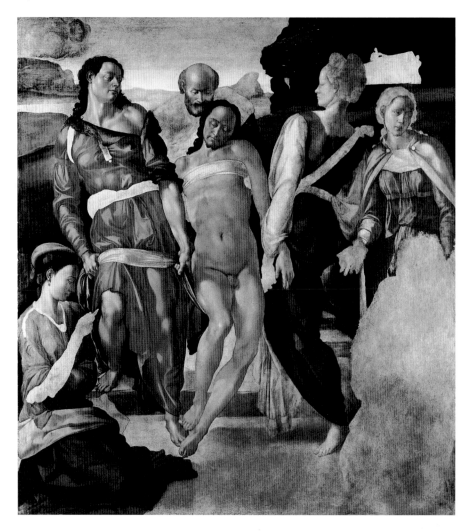

72 Michelangelo. *Entombment*. Panel. London, National Gallery.

an extraordinarily beautiful face."[13] By all accounts, Leonardo was a natural courtier, with a kind of charisma and instinctive grace that look forward to Raphael (Giovio's third biographical subject).[14] Michelangelo, on the contrary, was slovenly where Leonardo was elegant, anti-social where Leonardo was well mannered, notorious for his *terribilità* where Leonardo was famed for his *grazia*. Michelangelo's anti-social disposition may have been related to his competitiveness.[15]

The differences between the artists were not only skin-deep, as Giovio explained in his account of Michelangelo, they had serious consequences for the future of art: "But while a man of so great genius, he was by nature so

coarse and wild as to inform his domestic life with an incredible shabbiness and to deprive successors of disciples who would continue his art. Although implored even by princes, he has never let himself be induced to be the master of anyone or at least to let one into his shop as a spectator and observer."[16] Even Vasari, who loved him, acknowledged Michelangelo's secretiveness: "he never wanted others to see it," Vasari wrote of the *Cascina* cartoon, but describing Michelangelo's behavior in general.[17] There are numerous examples of his professional secretiveness from his biographer, other contemporaries, and from Michelangelo himself. Recounting one of the most pathological instances of this behavior, Vasari rationalized Michelangelo's secrecy as an expression of his genius, related in turn to the problem of his abandoned and unfinished works:

> He had such a perfect power of imagination that things proposed in the idea were such that, unable to express such great and awesome concepts with his hands, he often abandoned his works, indeed, he destroyed many of them, as I know that just before he died, he burned a great number of drawings, sketches, and cartoons made by his hand, so that no one could see the labors protracted by him and the methods of trying his intelligence, so as not to appear anything but perfect.

Vasari owned some of Michelangelo's drawings, he added, which reveal "the greatness of that intelligence" and "that when he wished to carve out Minerva from the head of Jove, he needed the hammer of Vulcan."[18]

Secretiveness about work may have been related to Michelangelo's reputation for venality, though Vasari defended him against this charge by listing gifts of art and money that he had bestowed on strangers, friends, and family:

> Let us come to the monies earned with his sweat, not with revenues, not with financial trading but with his study and effort [. . . one cannot] call avaricious a man who remembered many of the poor, as he did, and who secretly dowered a good number of girls, and who enriched those who helped him in his works and who served him, such as Urbano. [. . .] Once he gave him 2000 scudi in one lump sum, the kind of thing that is usually done by Caesars and great popes.[19]

Similarly, Michelangelo's reputation for social isolation is countered by the explanation that "he did not enjoy solitude [. . . but] it is necessary that one who wishes to attend to studies of that [art] flee company." This justification is followed by a list of Michelangelo's friends, including Jacopo Sansovino, Rosso Fiorentino, Jacopo Pontormo, Daniele da Volterra, and of course Vasari himself.[20]

Such interest in an artist's private life and personal characteristics is anticipated by descriptions of Giotto, the first artist to have been famous during his lifetime and ever since. Admiring his great genius – "he brought this art of painting back to the light" – his contemporaries, including Dante, Petrarch, and Boccaccio, and authors of the next generation, among them Benvenuto da Imola and Francesco Sacchetti, also noted Giotto's good nature, his sense of

humor, his "marvelous" mind, and even his remarkable ugliness.[21] But Giovio's accounts of Michelangelo and Leonardo are both more intimate and more precise delineations of character than the fourteenth-century anecdotes, and more honest than Vasari's and Condivi's. Giovio's biographical sketches of the artists are related in kind to his own *Elogia*, published in Venice in late 1546 and describing men of letters.[22] He had written the original "epitaphs" on pieces of parchment displayed beneath portraits of the represented individuals. Just as the subject's visage was meant to be portrayed accurately, his nutshell biography was to recount both the good and the bad in his character. Giovio could find classical precedents for his *Elogia* in Suetonius and Quintillian and a more immediate prototype in Bartolomeo Facio's *De viris illustribus* (which included lives of artists as well as men of letters). Whereas Facio celebrated his subjects, however, Giovio offered "warts and all" portraits.

In any such cycle there is inevitably an element of juxtaposition, and in Giovio's portrait collection with its parchment *elogia*, the reader/beholder was invited to contrast the characters and accomplishments of the biographical subjects as well as their appearance. The confrontation is as strong or stronger in Giovio's physical and psychological portraits of Leonardo and Michelangelo: their professional competition is imbricated with personal agon. The aversion between Leonardo and Michelangelo, implicit in Giovio's accounts, becomes explicit in Vasari's *Lives*: "There was the greatest disdain" between them.[23] The Anonimo Magliabechiano, writing around 1544, provides a vivid example:

> And [. . .] Leonardo [. . .] was walking by the benches at Palazzo Spini, where there was a gathering of gentlemen [*huomini da bene*] [. . .] debating a passage of Dante. They hailed said Leonardo, saying to him that he should discourse to them on this passage. And by chance at this point Michelangelo passed by and was called over by one of them, and Leonardo said: "Michelangelo will explain it to you." It seemed to Michelangelo that Leonardo had said this to mock him, and he replied with anger: "You [*tu*] explain it yourself, you who have made the design [*disegno*] of a horse to be cast in bronze but who was unable to cast it and abandoned it in shame [*vergogna*]." And having said this, he turned his back on them and left. Leonardo remained there, made red in the face by his words.[24]

The kind of professional selfishness that Giovio imputed to Michelangelo – no pupils, no shop, no studio visitors – was admitted, privately, by Michelangelo himself in a letter to his nephew Lionardo. Indeed, Michelangelo vaunted the fact, bound to his pride in his family's status:

> Tell the priest not to write to me anymore as "Michelangelo the sculptor," because I am known here only as Michelangelo Buonarroti, and if a Florentine citizen wants to have an altarpiece painted, it's necessary that he find a painter: because I was never a painter or a sculptor like those who have a shop. I have always kept myself from doing that for the sake of the honor of my father and my brothers, even if I have had to serve three popes, which was forced labor.[25]

So much for the private admission. But in public, Michelangelo's professional isolationism was denied by Condivi, though the denial in itself is an indirect confirmation of the accusation. "He was never envious of the efforts of others," Condivi asserted; "Neither is it true, despite what many claim, that he has not wished to teach; on the contrary he has done so willingly, and I have known this myself, to whom he has willingly revealed his every secret pertaining to that art."[26] Of course Michelangelo had acolytes, including Condivi, but none of them became an independent artist of any distinction. Their names are known today primarily because of their relationship with Michelangelo.[27] Michelangelo was certainly capable of great professional generosity, providing drawings and advice to Sebastiano and Pontormo, for example. But these acts of generosity were prompted by particular circumstances concerning Michelangelo as much or even more than they did his beneficiaries. Similarly, as the Wittkowers noted, Michelangelo's letters and poetry "are concerned with *his* state of mind, *his* emotions, *his* thoughts [. . .] Leonardo's writings reveal him as the very antithesis of Michelangelo."[28] And Leonardo's writings also reveal his contempt for sculptors in a passage comparing them, quite unfavorably, with painters.

The context of Leonardo's derisive description of the sculptor's squalor is the *paragone* of painting and sculpture. But the ridicule seems directed at Michelangelo in particular, chronically unwashed, unkempt, and covered with marble dust – so notoriously slovenly, indeed, that even his father had chastised him about his living conditions in Rome. Ludovico's letter of advice is dated 19 December 1500, after Michelangelo's brother Buonarroto had returned to Florence from a visit to Rome:

> Buonarroto tells me how you live thus with great economy, or rather misery: economy is good, but misery is bad because it is a vice that displeases God and the people of the world, and besides it will do ill to your soul and your body. [. . .] Live moderately [. . .]; and above all take care of your head, keep it moderately warm, and never wash yourself: scrape yourself off, but do not wash yourself.[29]

Contemporary portraits show Michelangelo with his head covered, keeping it warm as his father advised; descriptions, including Giovio's, indicate that he also heeded his father's counsel never to wash. "As he got older," according to Vasari, Michelangelo "constantly wore dog skin leggings on his bare flesh for whole months at a time, which, when he wanted to remove them, often pulled away his own skin."[30] The only time Michelangelo is known to have been well dressed was when he was buried: the body wore "a black damask gown, boots with spurs and a silken hat with a smooth black velvet hanging."[31]

Michelangelo probably never saw Leonardo's text about dusty sculptors (it was not published in their lifetimes), but Leonardo's scornful opinion of him was no secret. Once personality becomes an issue, agon is given a societal and psychological imprimatur. Exploiting the antipathy between the two masters, their compatriots provided a venue for their rivalry in the Sala del Gran

Consiglio, so that their competition might lead each to outdo himself in hopes of surpassing the other.

A century earlier, the purpose of the contest for the Baptistery doors had been to find the best master among the entrants. The competition panels made by Ghiberti, Brunelleschi, and other masters in 1400–1401 were intended to be seen together only during the course of the decision-making process. Certainly the preservation of the two competition panels was not foreseen when they were made; in the normal course of events, competing designs would be discarded. In 1503–04, the traditional situation was reversed: the purpose was not to decide who should be awarded the contract by comparing various possibilities but rather to memorialize the confrontation itself – limited now, not coincidentally, to Florentine contenders. The paintings by Leonardo and Michelangelo were intended to be seen together, and judged together, not during a transient selection process but for all time.

Leonardo's mural was planned for the wall to one side of the *gonfaloniere's* tribune, where he and the eight men of the Signoria were seated, recalling the placement of the ducal throne in the Venetian Sala del Maggior Consiglio.[32] The arrangement means that a second painting was always planned as its pendant on the other side of the tribune: it would have been unthinkable for sixteenth-century Florentines not to balance the decoration in this symmetrical way, as suggested by the committee deliberations regarding placement of the *David* and the Signoria's plans for his eventual pendant. Even so, the Signoria began the project for the hall with a single commission to Leonardo, waiting almost a year before entrusting Michelangelo with his assignment.

There were two conspicuous public precedents for this kind of inherently agonistic juxtaposition of works by different masters made to be seen together: the statues of guild patron saints at Orsanmichele in Florence itself; and, in Rome, the murals of the Sistine Chapel, where perforce the painters had worked side by side, as Leonardo and Michelangelo would have been compelled to do in the Sala del Gran Consiglio, had they completed their commissions. Lorenzo il Magnifico had provided a third, private precedent in the decoration of his villa at Spedaletto. Whereas the painters in the Sistine Chapel (and presumably in the villa as well) had to accommodate their colleagues by adhering to certain compositional principles, the sculptors at Orsanmichele were confronted with a more overtly competitive situation, obliged by their patrons to use different media representing different saints, varying poses and even dimensions. Civic pride required public monuments to memorialize the ideals and accomplishments of the state, but in the palace, their rivalrous confrontation was almost as much a *raison d'être* for the two murals as the commemoration of Florentine victories. Painting their battles, Leonardo and Michelangelo would battle each other.

Leonardo had been at work on the *Battle of Anghiari* since late fall 1503, so Michelangelo knew exactly what he was up against when he received his commission a year later. He knew the subject, of course; but directly or indirectly, he also seems to have known something about Leonardo's plans. Their

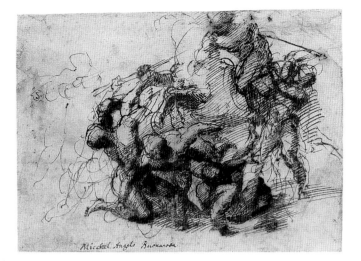

73 Michelangelo. *Battling Horsemen and Soldiers*. Pen and ink.
Oxford, Ashmolean Museum.

patrons most likely expected Michelangelo's composition to accommodate
Leonardo's in fundamental respects: scale, obviously, but also the general
character of the narrative. Each master made a cartoon, known from copies,
representing only part of what they eventually intended – and were expected –
to represent: Leonardo's "Fight for the Standard" was planned as the central
scene of *Anghiari*, Michelangelo's "Bathers" as an episode in his narrative of
Cascina.[33] Like Leonardo, Michelangelo too would have included warring
horsemen. Vasari's description of Michelangelo's cartoon confirms this, refer-
ring to the "large number of soldiers on horseback beginning to fight,"
and several sheets with studies of horses and riders have been associated with
the lost composition.[34] Datable c. 1504–05, these studies suggest that Michelan-
gelo was looking at Leonardo's *Anghiari* as he thought about his own *Battle
of Cascina*. Leonardo, characteristically, seems to have allowed visitors to his
studio in the Sala del Papa and was showing them his drawings for
the cartoon. Presumably the Signoria expected or required that he show them
to Michelangelo as well. It is unclear whether Michelangelo's studies of horses
and cavalry represent copies of Leonardo's work or his own (inevitably
similar?) ideas about the same themes.[35] Leonardo's influence on Michelangelo's
conception, however, is indisputable. In addition to the drawing by
Michelangelo that seems to be an adaptation of Leonardo's *Anghiari*, other
studies attributed to Michelangelo representing battling horsemen may also be
related to the *Cascina* commission (Fig. 73). So each master would eventually
have had to represent both foot soldiers and cavalry, as required by the events
they were commemorating. Each began, however, by following his own
inclinations.

Leonardo started with the episode that would have formed the central part of his composition, the "Fight for the Standard." Everyone, every man and horse, is in motion and interrelated to the other in this swirling activity. Whatever prototypes he may have had in mind for his battle – a Phaeton sarcophagus, for example, or the bronze battle relief by Bertoldo that Michelangelo had consulted for his *Centaurs and Lapiths* – Leonardo interpreted the theme in a completely characteristic way, imposing unity and order on a scene of mayhem.[36] The *Battle of Anghiari* is a bellicose version of the contemporary cartoon for the *Madonna and Child and Saint Anne* – or the cartoon a pacific version of the *Battle* (Fig. 74). Although the figures are intertwined, each reveals individuality in facial expression. Ornamental details of the armor and weapons as well as anecdotal details of combat embellish the narrative. Completed, Leonardo's *Battle* would have been a far more decorative work than Michelangelo's, and far more painterly.

Michelangelo's *Cascina* is instead a composition of individual bodies, most of them nude, and most of them struggling not with each other but with themselves – climbing out of the river, for example, or hastening to dress. Denying Leonardo's "organic unity," Michelangelo created a sculpture garden.[37] Almost all the actors turn their backs on us, and the expressions of the faces that are visible are much less differentiated than their counterparts in Leonardo's *Battle*, who seem in comparison caricatures of violent emotion. These differences are explained only in part by the different narratives.

Leonardo's "Fight" represents the capture of the Milanese flag, the immediate psychological and strategic prelude to the Florentine victory at Anghiari.[38] Michelangelo's "Bathers" records an event that occurred the day before the battle itself, a kind of dress rehearsal staged by Manno Donati. Seeing the Florentines bathing in the Arno, Donati feared that they would be vulnerable to ambush by the Pisans. His cries of alarm jolted the soldiers into action. They learned their lesson well from this surprise drill and the next day won their battle.[39] The armed combatants to the rear and to the right of the composition seem to belong to that fateful day, when the Florentines actually engaged the Pisan forces. In other words, the composition combines sequential events in the same picture space, as many early narratives had done, including Masaccio's *Tribute Money* in the Brancacci Chapel, a work Michelangelo had studied closely. Unlike Masaccio, however, Michelangelo offers little if any narrative clarity to enable the beholder to distinguish episodes and no compositional punctuation comparable with the earlier master's exploitation of setting.

Representing the preliminary episode of the startled bathers, Michelangelo could tackle *his* preferred subject, the male nude in action, privileging each figure's heroic individuality as imaged in his body. Leonardo, in contrast, subjugated the individual body to a pulsating maelstrom, expressing individuality in facial expression. Beginning with this peripheral and preliminary episode, Michelangelo could defer the final confrontation with Leonardo, that is, postpone the day (which never came) when he would be constrained to represent Leonardo's theme, a struggling mass of horses and riders.

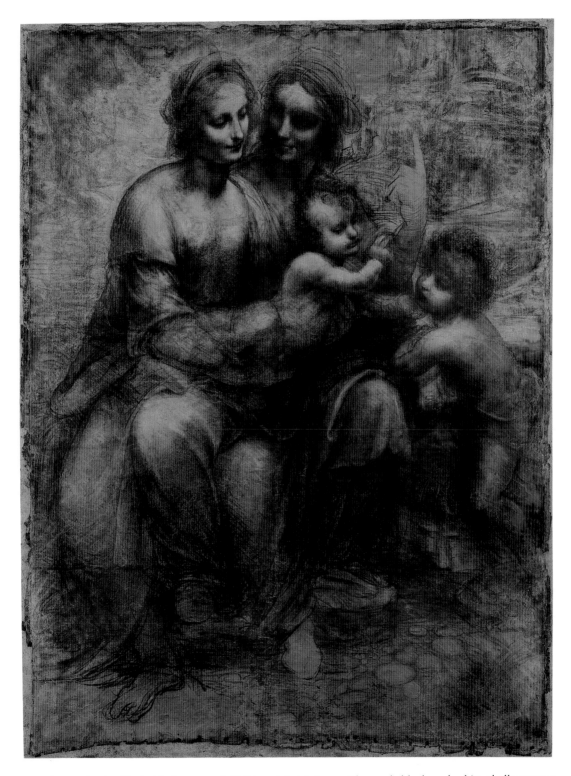

74 Leonardo da Vinci. *Madonna and Child and Saint Anne*. Charcoal, black and white chalk cartoon. London, National Gallery.

Michelangelo set to work with enormous energy. Leonardo was already ensconced at Santa Maria Novella; Michelangelo was given a workroom as far away as possible, across the Arno at Sant'Onofrio in the quarter of Santo Spirito.[40] The Sala Grande of the hospital at Sant'Onofrio was conceded to the Signoria for Michelangelo's use on 22 September 1504, the concession was ratified on 29 October, and payment was made for paper for the cartoon two days later, 31 October. By 31 December, another payment was recorded for assembling the pieces of the cartoon "that Michelangelo is making."[41] Despite this industrious beginning, however, Michelangelo probably never completed the cartoon, referring to it years later as "my cartoon which I had begun."[42] Although representing only part of the intended composition, the cartoon became, as Vasari described it, "a school for craftsmen," when it was exhibited in the Sala del Papa – where Leonardo's cartoon had been prepared.[43] Condivi referred to "that most artful cartoon that enlightened all those who thereafter took brush in hand."[44] Cellini echoed the encomium, dividing Michelangelo's honors with Leonardo: their cartoons were no less than "the school of the world," *la scuola del mondo*.[45] Unhappily, the school was eventually destroyed by its pupils, who cut away pieces of Michelangelo's cartoon much as worshipers might help themselves to pieces of a saintly relic (Condivi said it was treated "as a sacred thing").[46] However it happened, the cartoon was lost and is known only through such copies as that attributed to Aristotile da Sangallo, c. 1542, and engravings of individual figures by Marcantonio Raimondi made as early as c. 1508 (Fig. 75).[47]

Like the *Battle of the Centaurs*, the *Battle of Cascina* represented a group of male nudes in violent action: the figures themselves were more important to Michelangelo than the narrative they were meant to enact. He was obliged to give the "Bathers" more of an environment than he had provided the *Centaurs and Lapiths* – the subject required that he represent the Arno – but as in the relief, here too the setting is minimal. The rocky banks of the river recall the rocks that support the *Pietà* and the *David* (and ultimately derive from Schongauer's rock formations in the *Saint Anthony*); and the outcroppings in the background anticipate the distant mountains of the Doni Tondo (Fig. 83). In the *Cascina*, as always with Michelangelo, it is the figures who matter; he was little concerned with providing sufficient space for them or with defining their world. Leonardo might seem similarly uninterested in landscape in his *Battle of Anghiari*, but the absence of environment is explained by the simple fact that only his studies for the figures have survived, and his copyists recorded only these figures. Had he completed his *Battle*, surely Leonardo would have provided his horsemen with the kind of closely observed natural setting he represented in all his finished works. But Leonardo abandoned the project after an abortive attempt to begin painting on the wall itself. He described the calamitous results in his notebooks:

> On Friday, 6 June 1505, at the stroke of one in the morning, I began to paint in the palace. At the moment of picking up the brush, the weather turned bad and the bell began to toll to summon men to their duty, and the cartoon

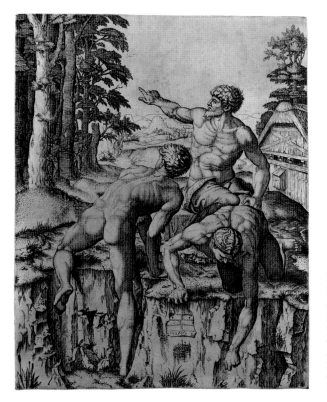

75 Marcantonio
Raimondi. *Climbers.*
After Michelangelo,
Battle of Cascina.
Engraving. New York,
The Metropolitan
Museum of Art, Joseph
Pulitzer Bequest, 1917.
(17.50.56).

came loose, the water ran, and the jug that held the water broke. And
suddenly the weather deteriorated and it poured rain until evening, and it
was dark as night.[48]

Shortly thereafter, when Leonardo left for Milan, his Florentine patrons rightly
assumed that he had abandoned his work in the hall. They much resented this
desertion, not to mention the considerable monies invested in Leonardo's
unsuccessful scheme for a canal connecting the Arno with the sea. Soderini
expressed the Signoria's dismay in a letter to Jafredo Carolo, Bishop of Paris:
"Leonardo da Vinci [. . .] has not comported himself with this Republic as one
should, because he has taken a good sum of money and given small beginning
to a large work that he was to execute," that is, the *Battle of Anghiari.*[49] In
addition to this private expression of his disappointment with Leonardo,
Soderini avenged the Republic with a public announcement of aesthetic judg-
ment: *Michelangelo* was the greatest artist in Italy, indeed, perhaps in all the
world.[50]

No doubt Michelangelo was pleased to hear it, though his sense of compe-
tition with Leonardo was in no way diminished. While confronting Leonardo
directly in the public arena of the Sala del Gran Consiglio, Michelangelo also
engaged him indirectly and privately, in four compositions of the Virgin and

Child.[51] Two of these were commissioned works: the Bruges *Madonna*, begun
in 1503 and shipped in late summer or early fall 1506 for installation in the
funerary chapel of the Mouscroun brothers in the church of Notre Dame in
Bruges; and the tondo for Agnolo Doni, presumably commissioned on the occa-
sion of his marriage to Maddalena Strozzi on 31 January 1504 (Figs. 59, 83).
The other two are unfinished tondi reliefs formerly in the possession of Taddeo
Taddei and Bartolommeo Pitti (Figs. 76, 77). Whether these men commissioned
the reliefs or purchased them at some later date is unknown and their precise
chronology uncertain. At one point, however, Michelangelo must have been
working simultaneously on some if not all four of these works. Whereas the
Bruges *Madonna* was a major commission for a church, netting Michelangelo
100 ducats, the other three works – all tondi – were more modest images for
private devotion.[52] Moreover, Michelangelo undertook these devotional images
at a time when he was also occupied with his two statues of *David*, marble and
bronze; beginning his *Apostle Matthew*; and planning his *Battle of Cascina*,
conceived by maker and patrons in competition with Leonardo's *Anghiari*. The
doubled agon with Leonardo, internal and external, may also help explain
Michelangelo's undertaking the comparatively unimportant commissions of the
tondi when he was otherwise so conspicuously, and more profitably, engaged.
Leonardo himself had invited such rivalry when he displayed his *Madonna
and Child and Saint Anne* cartoon in Florence in 1501 to great acclaim.[53]
Michelangelo's tondi are his response to that challenge, involving not only the
choice of subject but, more importantly, his interpretation of the Virgin and
Child. With the exception of his late presentation drawings for Vittoria
Colonna, the three tondi were to be Michelangelo's last finished (or nearly
finished) devotional images.[54] This fact was determined to a large degree by
the demands of his patrons. Yet it does not seem coincidental that his brief
period of concentration on Marian images – a subject for which Leonardo
was acclaimed – should coincide with the time of their competition in the Sala
del Gran Consiglio.

The Taddei Tondo seems to be the earliest of Michelangelo's three
Madonnas, begun c. 1503. Straddling his mother's leg with his own, Christ
leans sharply to his left while turning to look over his right shoulder toward
the Infant Baptist and the bird that he holds, presumably a goldfinch, a common
symbol of the Passion (Fig. 76).[55] The extraordinary complexity of the pose
suggests two antithetical narrative situations: either Christ is frightened by
the bird and seeks to flee his fate; or he had been sleeping and has now been
suddenly awakened by the Baptist's offering. In either case, Christ awakes to
his future death.[56] The apple he holds in his left hand reminds one of the neces-
sity of that death, his redemption of the Sin of the First Adam. As in the
Madonna of the Stairs, Mary is in profile. In the earlier work, she turns toward
the Innocents; now, she looks at Saint John's ominous bird. Johannes Wilde
described the Taddei Tondo as "the most Leonardesque of all Michelangelo's
works," noting in particular the way in which Virgin and Child are "observed
with acuteness and love in simple everyday situations, the mother a young girl,

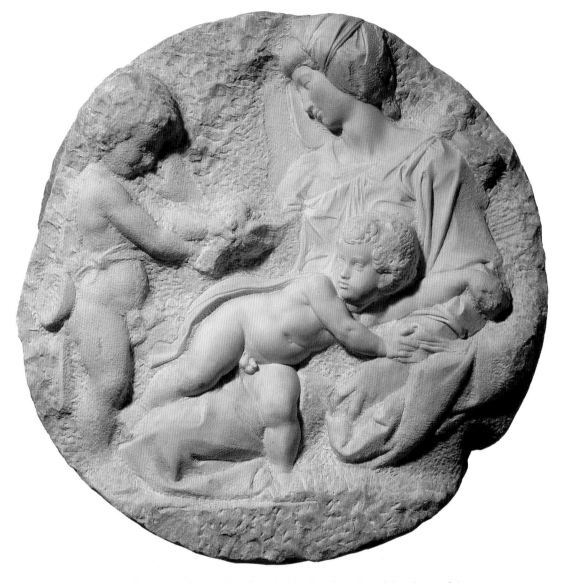

76 Michelangelo. Taddei Tondo. Marble. London, Royal Academy of Arts.

the baby comparatively big." These elements are found already in Leonardo's early works, and Wilde noted a Madonna drawing that seems close to Michelangelo's composition.[57] More precisely, Wilde considered as Leonardesque elements in Michelangelo's tondo "the lyrical mood [. . .] the low seat of the Virgin; the oblique position of her left forearm and left leg; the beautifully carved large folds of her mantle; and above all the tenderness of the gesture of the right arm." These similarities are perhaps over-emphasized,

however, and the profound difference ignored: whereas Leonardo bound his figures in a pyramid, Michelangelo pulled them apart to privilege, or evoke, the block. Christ's body is interlocked with Mary's, but this is achieved by means characteristic of Michelangelo: the fold of her garment that encases the Child and the way in which he straddles her leg with his, a prelude to the artist's later use of the slung-leg motif. Although the relief is a tondo, Michelangelo provided a horizontal ground line for the scene – making this a Madonna of Humility – and he positioned the Baptist to one side, where he defines the left edge of an essentially square composition. It is as though even in a round format Michelangelo was compelled to honor the block. This becomes explicit in the Pitti Tondo, datable to c. 1504 (Fig. 77). Seated on the rectangular block, Mary recalls her predecessor in the *Madonna of the Stairs*: this is the Stone of Unction.[58]

The Madonna in the Pitti Tondo is the first of Michelangelo's overtly masculinized women. Her face so closely resembles that of the *David* that one may posit Michelangelo's having used the same model. Mary's brow is smooth where David's is knotted, but her mouth and nose seem identical with his.[59] In her masculinization, she is unlike her immediate predecessors in Michelangelo's oeuvre, the *Madonna of the Stairs* and the Madonna of the Vatican *Pietà*. But she resembles them in mood. Even while embracing the Child with her left hand, she turns away from him, perhaps distracted by the Baptist's presence behind her, though this seems too mechanical an explanation for her introspective gaze (the effect is no less powerful for the absence of pupils). The winged putto of her headdress, a motif symbolizing prescience, indicates that Mary is contemplating her Son's future.

The Bruges *Madonna* is Michelangelo's most traditional interpretation of the Mother and Child, presumably in keeping with the Belgian patrons' wishes (Fig. 58). Whereas in the Pitti *Madonna* and other depictions of women, he made little or no effort to disguise the use of male models, in this case, the nude man in the drawing for the Bruges *Madonna* is transformed into the heavily draped female figure in the sculpture (Fig. 78).[60] Recalling the Byzantine *Platytera* who signifies the Incarnation, the Child stands between his Mother's legs and grabs her leg with his left arm. Perhaps he is about to take his first step?[61] The physicality of his action is underscored by the Child's proportions. This Infant is preternaturally large, much larger indeed than the child or doll that Michelangelo represented in the preparatory drawing, much larger than the Christ of Donatello's bronze *Madonna and Child* for the high altar of Sant'Antonio in Padua, completed c. 1450, one of Michelangelo's precedents (Fig. 79). In his size and also in his pensive mood, the Infant resembles the Christ Child in Leonardo's Madonna paintings, though with the thicker head of hair that Michelangelo favored, starting with *Bacchus* and his satyr. As in the *Pietà*, here again the handling of drapery recalls Leonardo. The Bruges *Madonna* seems to be Michelangelo's most solicitous Virgin Mother, and in this quality too she is reminiscent of Leonardo's Mary. But her maternity is counterbalanced by the comparative maturity of her Son. It is as though the

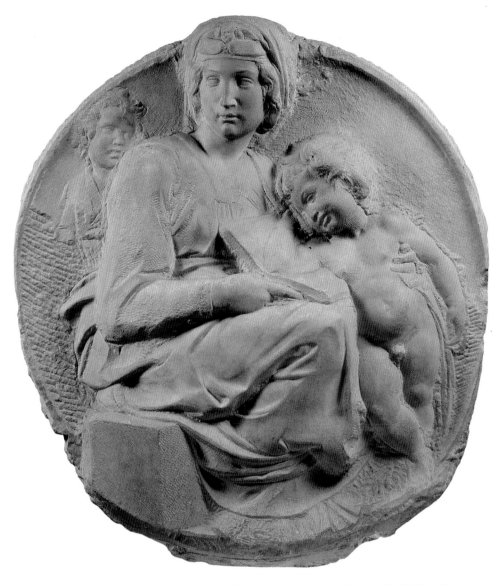

77 Michelangelo. Pitti Tondo. Marble. Florence, Museo Nazionale del Bargello.

less he needs her, the older and more independent he becomes, the more she is willing to express her love for him.

In his first Marian images, then, Michelangelo offered two conceptions of the Virgin, which may be crudely distinguished as feminine and masculine. In the *Pietà*, and to a lesser degree in the Bruges *Madonna* – both for foreign clients – she resembles her feminine self in other Italian Renaissance works, including Madonnas by Bellini, and also those of such contemporary

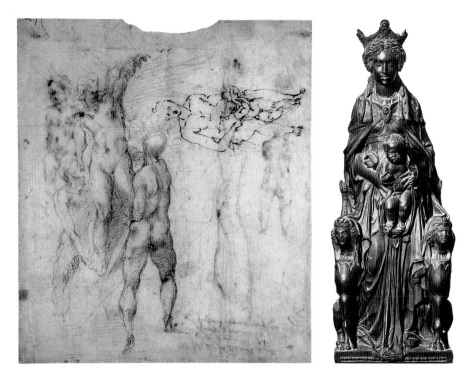

78 (*above left*) Michelangelo. Studies for the *Battle of Cascina* and the Bruges *Madonna*. Black chalk, brown ink over leadpoint. London, British Museum 1859-6-25-564.

79 (*above right*) Donatello. *Madonna and Child*. Bronze. Padua, Basilica del Santo (Sant'Antonio), high altar.

80 (*facing page*) Sandro Botticelli. *Madonna of the Pomegranate*. Panel. Florence, Galleria degli Uffizi.

Florentine masters as Sandro Botticelli. The face of the *Pietà* Madonna may be compared with Botticelli's *Madonna of the Pomegranate*, for example, a work of the later 1480s evidently displayed in the Sala dell'Udienza dei Magistrati di Camera in the Palazzo Vecchio (Fig. 80). Like these women, Michelangelo's Mary has a long oval face with a pointed chin, bowed lips, a straight nose, almond-shaped eyes, smooth eyelids, and thin, curved brows. Her loveliness is already modified, however, in the Bruges *Madonna*, with her surprisingly bushy (masculine?) eyebrows, fleshier eyelids, more deeply set eyes, wider mouth, and fuller face. (Perhaps the boy who posed for the Bruges *Madonna* had such eyebrows.) These modifications individualize but do not compromise the femininity of the Bruges *Madonna*, or at least do not do so in any insistent way. Already in the *Madonna of the Stairs*, however, Michelangelo had conceived a different vision of Mary's beauty, more handsome than lovely. The ancestry of these Madonnas is found in the work of such masters as Giotto and Arnolfo di Cambio in the fourteenth century, and a century later, in the art of

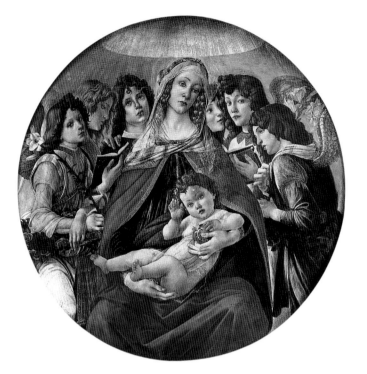

Masaccio. In Michelangelo's masculinized Madonnas, the Virgin is purpose-
fully unlike Leonardo's very feminine vision of her – both the girlish Mary of
Leonardo's early paintings and the more mature, elegant Mother of the
Madonna and Child and Saint Anne. Michelangelo's Madonna is the antithe-
sis of Leonardo's, in physique, physiognomy, and psychology. These differences
are most evident in Michelangelo's only completed panel, the Doni Tondo
(Fig. 83).

The tondo is "the most finished and the most beautiful" of Michelangelo's
few panel paintings, Vasari wrote, but even so, when it was finished, Agnolo
Doni balked at the requested payment of 70 ducats,

> though he well knew that it was worth more, and he said to the delivery man
> that forty was enough, and gave them to him; so then Michelangelo returned
> them to him, sending to tell Doni that he should remit one hundred ducats
> or return the picture. For which reason Agnolo, who liked the work, said:
> "I shall give him these seventy"; but he was not content. On the contrary,
> for Agnolo's little faith, he wanted double of what he had asked the first time:
> so if Agnolo wanted the picture, he was forced to send him a hundred and
> forty.[62]

Doni's initial failure to appreciate Michelangelo's achievement cost him dear:
at least that is what Vasari told his readers. Illustrating the value of art, and

81 Michelangelo. *Madonna and Child and Saint Anne*. Pen and brown ink. Oxford, Ashmolean Museum 291r.

82 Michelangelo. *Male Nude, Head of the Madonna, and Other Heads* (detail). Ink. Oxford, Ashmolean Museum 291v.

warning patrons against penny-pinching, the anecdote also asserts (retroactively) the status that Michelangelo had attained by the first years of the new century. Not coincidentally, the account of his greatest commission for a private painting immediately precedes Vasari's discussion of Michelangelo's commission for the *Battle of Cascina* and his direct confrontation with Leonardo. The tondo represents their indirect confrontation.

The tondo's original carved, gilded, and polychrome frame is decorated with the crescent moons of the Strozzi coat of arms, honoring the family of Doni's wife, Maddalena. The subject, the *Holy Family*, alludes to the couple's establishing a new family of their own, a connection implicit in Varchi's description of the tondo: "the Virgin Mary [. . .] gladly offers Jesus Christ, her Son and our Redeemer, to Joseph, who receives him with love and infinite joy."[63] In these regards, the work is traditional, and traditional too in its tondo format, frequently used for domestic commissions in Renaissance Florence. In nearly every other respect, however, Michelangelo's painting seems to flout tradition – and Leonardo's vision.

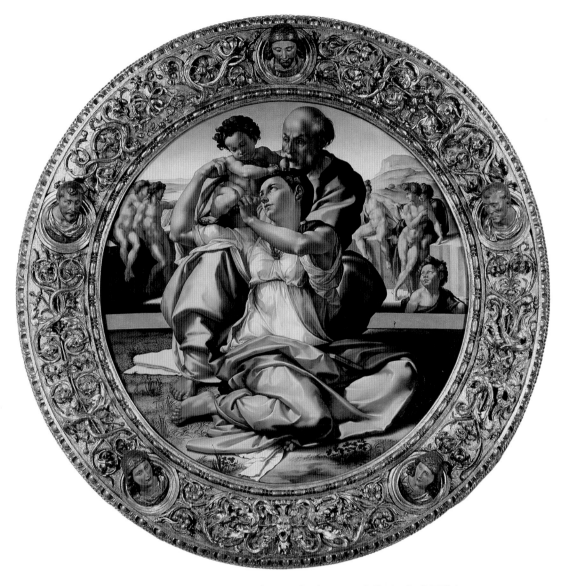

83 Michelangelo. Doni Tondo. Panel. Florence, Galleria degli Uffizi.

The tondo shows Michelangelo's response to Leonardo's newest ideas, not only for the *Battle of Anghiari* but also for the *Madonna and Child and Saint Anne*. Although the *Saint Anne* cartoon (Fig. 74) is apparently not the version that Fra Pietro described to Isabella, it may serve to represent what he and others – including Michelangelo – saw in Florence in 1501. And that Michelangelo saw at least one of Leonardo's cartoons is documented by a sheet with his drawings of Leonardo's composition on the recto and on the verso,

the head of the Madonna (Figs. 81, 82).[64] The page comes from a sketchbook that Michelangelo used during the first two years after returning to Florence from Rome and therefore datable between 1501 and 1503. Representing his observations on Leonardo's composition, Michelangelo employed a technique likewise derived from Leonardo, as Wilde observed: "those short, firm, parallel strokes partly following the curve of the form do not occur in earlier drawings by Michelangelo and are characteristic of all Leonardo's pen and ink studies of this period."[65]

Leonardo's subject, the *Anna Metterza*, presents obvious difficulties for any artist interested in verisimilitude. Francesco Traini in the fourteenth century, and Masaccio and Masolino in the fifteenth, had dealt with the problem by making Saint Anne larger than her daughter, turning her into a kind of human throne for the Virgin and Child.[66] Leonardo's women are the same size, with Mary partly on her mother's lap and partly to her side, and their heads level. Mary holds the Child so that his body crosses Anne's to reach toward the Infant Baptist, to caress his chin and bless him. The figures are bound not only by their interlocking limbs but also by their gazes: Anne looks at her daughter, Mary looks at Christ, and Christ and the Baptist exchange a glance. In Leonardo's fifteenth-century works, Mary was his emendation of Madonnas by Verrocchio and Desiderio, who seem immature and even frivolous in comparison with the adult woman of the *Madonna and Child and Saint Anne*. As a concomitant of her new maturity, Mary now seems a more fully conceived, intelligent individual. Leonardo also abandoned the essentially Quattrocentesque decorative embellishment of drapery which he exploited in his previous works in favor of garments that are now always responsive to the body. He gave the Christ Child and especially the Baptist much fuller heads of hair than his children had had in earlier works. And he arranged his figures in a composition that resembles the rectangular block more than the pyramid, the preferred form to which he returned for the painted version. Was Leonardo looking at Michelangelo?

Michelangelo was certainly looking at Leonardo. But his drawings of the *Anna Metterza* in the Ashmolean and the slightly later sheet in the Louvre, c. 1503–05, record his attempts to break away from Leonardo's solution even while representing Leonardo's theme.[67] These sheets are in effect studies for the *Doni Tondo*, despite the difference in subject matter. As the *Cascina* presents his antithesis to Leonardo's thesis of narrative, here Michelangelo presented his antithesis to Leonardo's thesis of the devotional image. Each composition includes the infant John the Baptist, each is set in a landscape – each is thus a kind of Madonna of Humility – and each involves the placement of one adult in or on the lap of another. Both the tondo and the cartoon represent family groups, with Joseph replacing Anne. Not only in this but in every other regard, the two images are completely dissimilar, visually and psychologically, the visual elements being concomitant with the psychological. Leonardo's exquisite personages convey the tenderness of their love for each other. Michelangelo's heroic beings express instead their awe and veneration for Christ, whose own

serious visage expresses an intellectual and emotional awareness beyond his age.

Had it been painted, Leonardo's cartoon would have seemed even more unlike Michelangelo's tondo. While Leonardo was increasingly suppressing local color in favor of a uniform scheme of black and white modeling – *chiaroscuro* – combined with a smoky blurring of contours – *sfumatura* – Michelangelo continued to employ the kind of color change modeling favored by earlier masters – *cangianti* – and the sharp, even brittle, contours that belie the softening effects of atmosphere, especially in the foreground figures. Perhaps Michelangelo would have been more amenable to a softer palette, more gently modulated modeling, and even the painterly exploitation of the oil medium, had these not been adopted, or coopted, by Leonardo. But Michelangelo's intention, as Timothy Verdon has noted, was precisely to invent a language diametrically opposed to Leonardo's *sfumato*, "muscular and clear like a silogistic demonstration."[68]

Although both Leonardo and Michelangelo unite their figures by entwining them, neither the cartoon nor the tondo represents the graceful pyramidal composition that both artists had used in earlier works.[69] Evidently this fact displeased Leonardo, and when he came to paint the *Madonna and Child and Saint Anne* (Fig. 84), he replaced the Baptist with a lamb, which enabled him to unify the figures more compactly into the pyramid that he had favored ever since the *Adoration of the Magi*. As for Michelangelo, having adopted the pyramid for the *Pietà*, and having adapted it for the Pitti Tondo, now he purposefully abandoned it in favor of a more rectangular, block-like formation. Although painted, the Holy Family evokes Michelangelo's sculpted figures, released by his chisel from their block of stone. The tondo is often compared to a polychrome relief. In fact, what it most resembles is a polychrome sculpture, "a free-standing sculptural group, a group at least as deep as it is wide."[70] The sharp contours heighten this impression, and the wall and background rocks, whatever else they might signify, also call to mind quarries and the quarrying of stone. In the tondo, Michelangelo invested the art of painting with the virtues of sculpture, its rival art, and doing so, abnegates all the virtues of Leonardo's newest thinking about painterly painting.

Michelangelo's image of the Virgin is also entirely different from Leonardo's. In the Doni Tondo, Mary's masculinity becomes explicit, and the beholder can no longer ignore this fact.[71] Michelangelo's study for the Madonna's face, a red chalk drawing in the Casa Buonarroti, records her masculine genesis.[72] It is not Mary's face, however, or even her serpentine contortions that make her masculinity unmistakable. It is rather her bared and very muscular arms, especially the left arm, which flaunt Michelangelo's bi-gendering of the Madonna. Baring Mary's muscular arms and, perhaps even more shockingly, her left underarm, Michelangelo flouted tradition, making her masculinization self-evident in the process.

Seated on the ground, Mary is by definition a Madonna of Humility; she is also a remarkably vigorous *figura serpentinata*, twisting to her right, the

morally superior side, to embrace her Child, with her right arm supported by Joseph's right leg. The conspicuous artificiality of this grouping recalls fourteenth- and fifteenth-century depictions of the Madonna and Child and Saint Anne rather than other representations of the Holy Family – and rather than Leonardo's fluid emendation of the *Anna Metterza* theme.[73] Rejecting or modifying Leonardo's compositional ideas, Michelangelo also replaced Leonardo's graceful figures with his own more forceful, energetic, and athletic beings, that is, in sixteenth-century terms, he replaced *leggiadrìa* or elegance with *gagliardìa* or vigor. Renaissance authors defined these qualities in relation to gender: *gagliardìa* was considered a quality appropriate to men, and *leggiadrìa* to women.[74] In *The Book of the Courtier*, for example, Castiglione cautioned ladies when they dance to avoid "movements that are too *gagliardi* and forced."[75] In the Doni Tondo, the Madonna ignores his advice. The *gagliardìa* of her pose masculinizes her just as certainly as her musculature and the display of her bare arms. She is Michelangelo's most conspicuously and unambiguously virile Virgin Mary.[76] Her *gagliardìa* does not signify that she is engaged in a masculine masquerade, however.[77] Masquerade may imply disparity between mask and face, between appearance and reality. Mary's masculinity, on the contrary, is inherent in her character as interpreted by Michelangelo. His *masculine* Madonna is the *true* Madonna, a woman of virile virtue.[78]

By making Mary's body too powerful for a normal sixteenth-century woman, Michelangelo meant to spiritualize her, masculinizing her face and physique in order to image her *spiritual* virility, that is, her *virtù*.[79] Believing (with most of his contemporaries) that the male was superior to the female, Michelangelo intended to honor Mary by making her male, just as, some thirty years later, he would praise Vittoria Colonna as "a man within a woman."[80] Similarly, when philosophers and theologians praised women, they often did so by ascribing so-called male characteristics of mind to her. Admittedly, the idea of the masculinized Mary was far more familiar to contemporaries than its representation.[81] In images, the Renaissance norm remained the feminine ideal embodied by such Madonnas as Leonardo's. But Michelangelo abandoned this tradition, masculinizing Mary in part to exempt her from his own society's oppression of women and to shield her from dangerous and inappropriate female sexuality.[82]

Generally masculine instead of feminine, athletic instead of gentle in her movements, Michelangelo's Mary is also less maternal than Leonardo's Madonnas. In the Pitti Tondo, she seems remote, even disengaged from her Child, though he presses against her. In the Doni Tondo, she is more worshipful than motherly. Mary's motherhood is secondary to her role as the priest who offers the Eucharistic Christ, her humanity is subsumed in her symbolic identity as the altar and tomb from which he emerges, her maternal affection is subjugated to her veneration of the Child.

The Doni Madonna's worshipful demeanor and her virilization are the means whereby Michelangelo sought to resolve the dilemma faced by Leonardo and

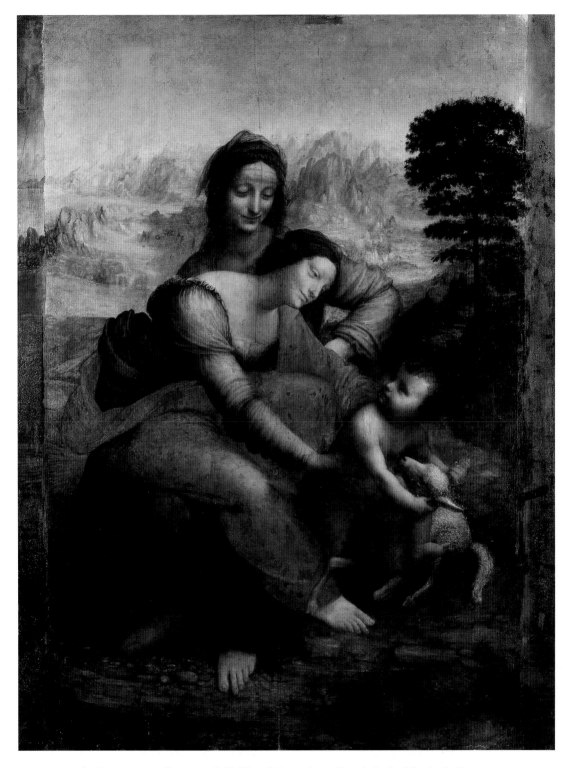

84 Leonardo da Vinci. *Madonna and Child and Saint Anne*. Panel. Paris, Musée du Louvre.

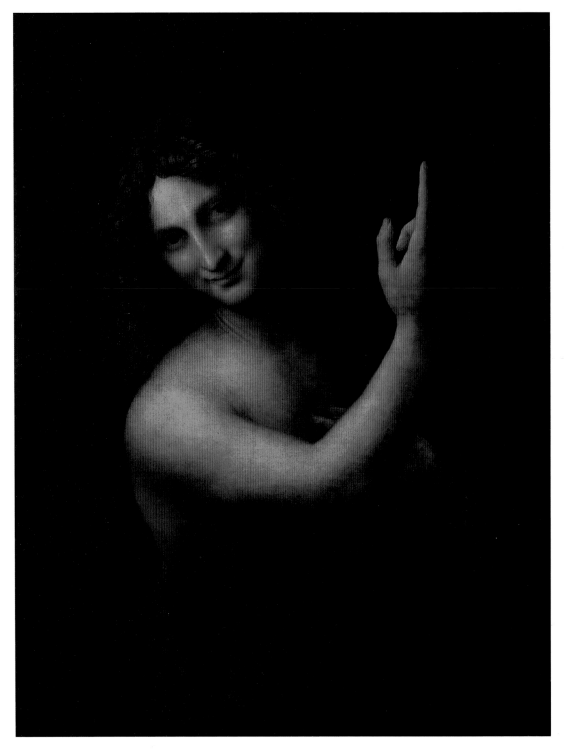

85 Leonardo da Vinci. *Saint John the Baptist*. Panel. Paris, Musée du Louvre.

other masters who, honoring the traditional depiction of Mary as a beautiful woman and loving mother, were challenged to maintain that delicate balance between her loveliness and her purity, or rather, the beholder's recognition of her purity. This balance represents the paradox inherent in the conception of courtly love, which Michelangelo purposefully rejected, at once shielding both Mary and her beholder from an inappropriate (sexualized) response to her image.

Leonardo too was keenly aware of an image's power to "inflame man to love," which he discussed in a passage of the Codex Urbinas, written c. 1500–05, that is during the same years of his direct confrontation with Michelangelo's alternative vision. Unlike Michelangelo, who seemed to be troubled by the spiritual dangers inherent in such power, Leonardo was proud of it. His account of an image's ability to influence the beholder is uninterested in the spritual implications of the problem, and in this sense, amoral: "the painter forces the spirit of men to fall in love with and to love a painting that does not represent a living woman. It has happened that I have painted a picture with a religious theme, bought by a lover who wanted to remove the attributes of divinity from it so that he could kiss it without guilt; but in the end, respect overcame his sighing and desire, and he had to remove the picture from his house."[83] Whereas Leonardo's anonymous client was troubled by his erotic response to a sacred image, Leonardo himself was unconcerned with spiritual endangerment of the viewer-worshiper or with possible impropriety in the conception of the image. It is precisely the power of the image to affect the beholder that matters to him. And this is so even if the account itself is fiction, Leonardo's appropriation to himself of Pliny's anecdotes about the aroused worshiper who stained the Venus of Knidos with his semen.[84]

Two of Leonardo's late works show that he remained undeterred by his unhappy patron's need to divest himself of a too-beautiful sacred image: Saint John the Baptist, c. 1507–09, and his last painting, the Bacchus, conceived as a depiction of the Baptist but given the attributes of the pagan god in the late seventeenth century (Figs. 85, 86).[85] Traditionally, Saint John was represented either as an infant or small child, or as an adult, ascetic and sometimes wild in appearance. Unlike his predecessors, Leonardo's Baptist is an adolescent or young adult, characterized by his liminal sexuality. That the painting depicts the Christian saint is confirmed by his attributes, "but in substance and in more essential meaning it is a recreation of a beauty like that of pagan antiquity."[86] The beholder knows that John is male despite his feminization, just as one perceives Michelangelo's Doni Madonna as female despite her masculinization; but Mary's masculinity protects her, whereas John's femininity eroticizes him (recalling Michelangelo's epicene Bacchus), a quality heightened – or exacerbated – by his seductive expression.[87]

Leonardo knew his rival's Doni Tondo in Florence and the Bacchus in Rome: sojourns in 1504 and again in 1516 are documented, and earlier trips are possible. Whether Leonardo's Saint John was conceived in part as a response to Michelangelo's Bacchus and as a reversal of the Madonna cannot be proved.

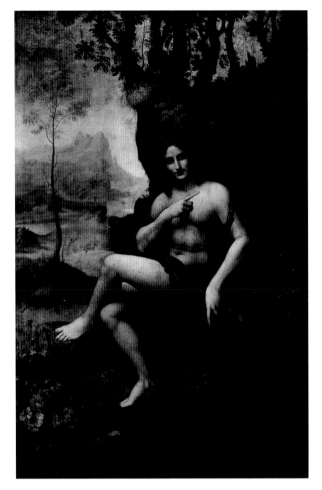

86 Leonardo da Vinci.
Bacchus (Baptist). Panel
transferred to canvas.
Paris, Musée du Louvre.

Leonardo's last painting, however, the *Baptist/Bacchus*, refers unmistakably to
the Sistine *Ignudi*, combining Michelangelesque elements with the poses of
two ancient prototypes (known also to Michelangelo), the *Spinario* and the
Diomedes.[88] Certainly Leonardo was looking at the Sistine frescoes as he pro-
ceeded with his own project, a work in progress during his residence in Rome
in 1516. It is as though he felt compelled to respond both to his great clas-
sical predecessors and to the contemporary rival who had overtaken him. He
soon abandoned the field, however, turning his attention increasingly toward
other, non-artistic interests, and left Italy for France.

6

Raphael

Raphael of Urbino, for all that he wanted to compete with
Michelangelo, many times had to say that he thanked God to have
been born in his time, having taken from him another style than that
which he had learned from his father, who was a painter, and from his
master, Perugino.

<div align="right">Ascanio Condivi[1]</div>

All the discord that was born between Pope Julius and me was
from the envy of Bramante and of Raphael of Urbino; and this was
the reason for the pope's not continuing his tomb during his lifetime,
in order to ruin me. And Raphael had good reason for this, because
everything he had in art, he had from me.

<div align="right">Michelangelo[2]</div>

Carry out your vendettas and mine in one fell swoop.

<div align="right">Sebastiano del Piombo[3]</div>

LEONARDO'S DEVELOPMENT IS FORESHADOWED IN HIS *Adoration* under-painting. Similarly, many of Michelangelo's ideas are prefigured in his two first sculptures, the *Madonna of the Stairs* and the *Battle of Centaurs and Lapiths*. But Raphael's earliest paintings allow no intuition of his future. Nothing in his first undisputed work, the altarpiece of San Nicolò Tolentino commissioned for the church of Sant'Agostino in Città di Castello in 1500 (when "magister" Raphael was seventeen), anticipates his future achievements (Fig. 87).[4] Almost nothing in his Florentine paintings foretells his Stanza della Segnatura in the Vatican, and little in those frescoes prefigures the work in the Stanza d'Eliodoro, and so on. Raphael is art's greatest paradox, at once eclectic and original. Vasari described the extraordinary itinerary of his professional development, "having in his boyhood imitated the style of his master Pietro Perugino," and surpassed him, he turned "all amazed and marveling to Leonardo [. . .] and sought [. . .] to imitate the style of said Leonardo," whom, however, he never surpassed in certain regards. "But Raphael did come closer to him rather more successfully than any other painter, and above all in the grace of colors." And then, finally, Raphael saw Michelangelo's *Cascina*

87 Raphael. *Angel*
(from the San Nicolò
Tolentino altarpiece).
Panel. Brescia,
Pinacoteca Tosio
Martinengo.

cartoon, "and where another would have lost heart, [. . .] Raphael, [. . .] in
order to acquire Michelangelo's style, [. . .] having been a master became again
almost a disciple."⁵ Competing with graceful admiration for his rivals, Raphael
embodies *imitatio* seemingly without animosity – despite Michelangelo's
accusations – and without the concomitant anxiety of influence. His parents
must have done something right.

Certainly Vasari thought so. Unlike Michelangelo, famously sent to a wet-
nurse, Raphael was nursed by his own mother; and unlike Michelangelo, who
was beaten by his father instead of being encouraged to pursue his art, Raphael
was lovingly instructed in painting by his parent.⁶ Giovanni Santi was an indif-
ferent painter – Vasari described him as "pittore non molto eccellente" – and
he has been discounted in consideration of his son's remarkable development,
especially because he died in 1494, when Raphael was only eleven. But Santi
was certainly his son's first teacher: even were Raphael not precocious, he must
have begun his training by that age. And Santi had intellectual ambitions: he
was the first painter-poet of the Renaissance.⁷ Finally, Santi authored the
Disputa de la pictura. The text can be imagined as Raphael's primer. Reading
in his father's *Disputation* about the divine genius of Leonardo and Pietro
Perugino, the boy Raphael dreams of them, aspires to equal them, perhaps even
to surpass them – but in the nicest possible way, being endowed, as Vasari put
it, with "graced affability." The psychological portrait of Raphael is contrasted
with that of Michelangelo:

Nature endowed him [Raphael] with all that modesty and goodness that one sees only sometimes in those who, more than others, have a certain humanity of gentle nature combined with a most beautiful ornament of a graced affability that always shows itself sweet and pleasing with every kind of person. [. . .] Nature made a gift of him to the world when, vanquished by art by the hand of Michelangelo Buonarroti, [Nature] wished in Raphael to be conquered by art and comportment together. [. . .] in Raphael were made clearly resplendent all the rarest virtues of the spirit, accompanied by such grace, study, beauty, modesty, and optimum comportment that would have been sufficient to cover every vice, however ugly, and every stain, however great. Thus one can surely say that those who are in possession of such rare gifts as were seen in Raphael of Urbino are not merely men, but, if it is permitted to say so, mortal gods.[8]

No wonder Michelangelo resented him. Raphael (like Leonardo) had all the social graces and also considerable beauty that Michelangelo, with his broken nose, lacked. His antipathy for Raphael seems to have been inevitable, and rivalry unavoidable once they were both in papal service. The disparity between them was perhaps even greater than that between Michelangelo and Leonardo; indeed, Vasari began his Life of Raphael by contrasting his personality and upbringing with Michelangelo's. In Rome, where Michelangelo lived in squalor that appalled even his father, Raphael "did not live as a painter but as a prince."[9] Whereas terribilità is alienating, "Grazia is an attribute, or rather a gift, that presupposes two parties," the giver and the recipient, in "a specifically vertical relationship [. . .] that moves exclusively in an up and down direction, from the prince to his courtier."[10] Raphael instinctively knew how to take either role. The grazia that characterized Raphael's life and his art – "even the animals honored him"[11] – is the antithesis of Michelangelo's terribilità, similarly a defining characteristic of both the man and his work. As was the case with Leonardo and Michelangelo, the imbrecation of style and personality gave a particular edge to their competition in Rome.

Raphael's various papal commissions were the climax of a career that began with Perugino. Details of their association remain uncertain, that is, whether Raphael was formally associated with Perugino's shop and in what capacity. But Raphael's work from his first period reflects his reliance on the older master, as commentators from Giovio and Vasari to the present day have always recognized. Precisely by imitating Perugino so closely, Raphael had precluded or at least tempered competition with him.[12] In his altarpiece of the Sposalizio or Betrothal of the Virgin, however, Raphael redefined the relationship, declaring his rivalry with Perugino – and asserting victory over him (Fig. 88).[13]

Painted for the chapel of Saint Joseph in the church of San Francesco in Città di Castello, the Sposalizio clearly depends on Perugino's altarpiece representing the same subject for the Chapel of the Holy Ring, dedicated to Saint Joseph in Perugia cathedral, commissioned in 1499 and completed in late December 1503 (Fig. 89).[14] Perugia was honoring its acquisition (or theft) of the ring itself, installed in the cathedral in 1484. Perugino's Sposalizio recalls in turn his own

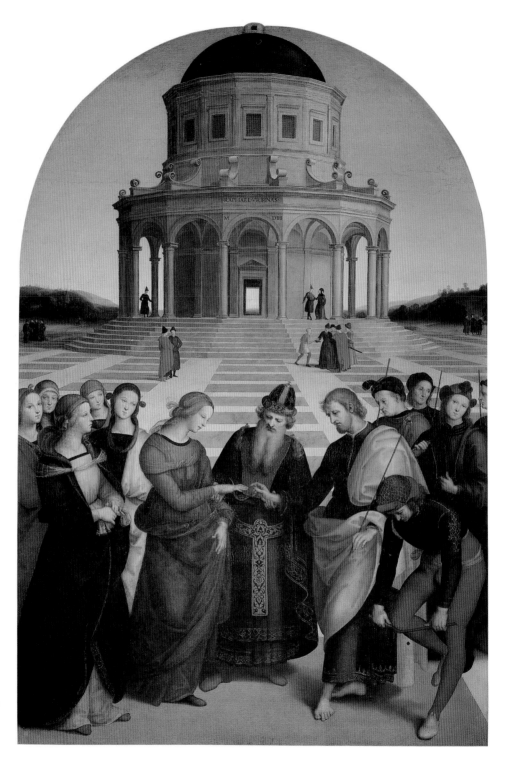

88 Raphael. *Sposalizio (Betrothal of the Virgin)*. Panel. Milan, Pinacoteca di Brera.

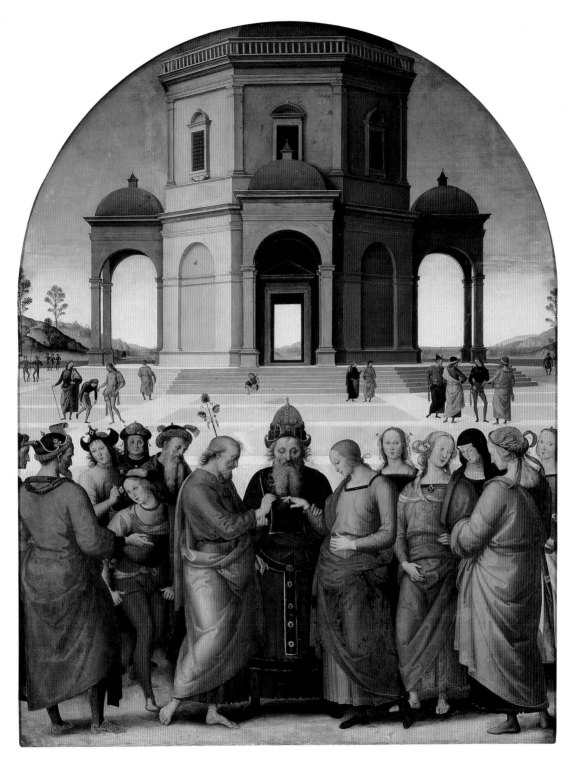

89 Perugino. *Sposalizio* (*Betrothal of the Virgin*). Panel. Caen, Musée des Beaux-Arts.

Sistine Chapel fresco of *Christ Giving the Keys to Saint Peter*, which he had completed in 1481 (Fig. 10). Although this is an extreme instance of such self-referencing for Perugino, it was not uncharacteristic, as contemporaries were quick to note – and to disapprove. Giovio remarked on Perugino's great success until "those stars of a perfect art who are called Vinci, Michelangelo and Raphael [. . .] submerged both his fame and his name with their marvelous works, Perugino in vain emulating and imitating the best things, forced himself to maintain the status he had achieved, because the withering of his imagination constrained him to return always to the mincing faces on which he had been fixated since his youth."[15] Vasari shared Giovio's view that all Perugino's faces had the same expression, *un'aria medesima*. Adding insult to injury, Vasari quoted Michelangelo's devastating opinion: "in public, Michelangelo told him that he was a clod in art."[16]

Vasari went on to expand on the theme, repeating the criticism of all the Young Turks of painting when they first saw Perugino's polyptych for the Santissima Annunziata unveiled in 1507. "They say that when said work was unveiled it was rather censured by all the new craftsmen," Vasari reported, "and particularly because Perugino had made use of those figures that he was accustomed to put in his work at other times." Their criticism did not abate despite Perugino's attempts to defend himself. Subjected to bitter "sonnets and public insult" – critics expressed their views in verse in those days – he fled to his native Perugia.[17] But in 1504, Perugino was still Raphael's exemplar and his point of reference.

Both Raphael and Perugino completed their *Sposalizio* altarpieces in that year. The repetition of subject was of course determined not by the artists but by their patrons. Even so, the repetition naturally underscores the relation between the compositions and encouraged Raphael's allusions to his former master. Indeed, the close similarity suggests that Raphael was instructed by his patrons to make his altarpiece conform to Perugino's and presumably to outdo it.[18] Such "better than" clauses were common in contracts, including Raphael's for the *Coronation of the Virgin*, commissioned for the Poor Clares of Monteluce in Perugia, dated 12 December 1505. In that case, Raphael's painting was to resemble the altarpiece by Domenico Ghirlandaio in San Girolamo in Narni, and if possible to surpass it, *et de migliore perfectione si e possibile*. If not, the Clares warned, they might reduce his fee.[19]

Raphael did not need to be told to outdo his rivals. His signature on the *Sposalizio*, his earliest surviving work to be both signed and dated, documents this agon: .RAPHAEL.VRBINAS./M/DIIII. Raphael's signatures are rare: including the *Crucifixion*, he signed eighteen paintings (and dated but did not sign another, the Ansidei *Madonna*).[20] Signatures with dates are even rarer: only eight works are both signed and dated, beginning with the *Sposalizio* in 1504. None of these inscriptions is so conspicuous as that first dated signature, however. Engraved in the cornice of the Temple, at the very heart of the composition, the *Sposalizio* signature and date are incorporated not only within the image but *within the narrative* and within its symbolic meaning.[21] The two

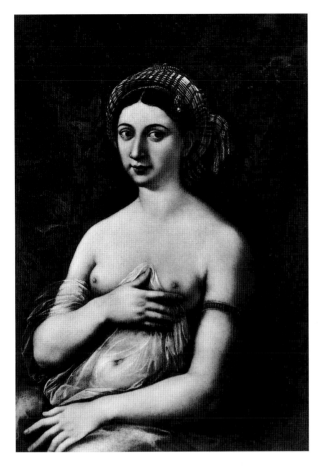

90a and b Raphael. *La Fornarina*
(and detail of signature). Panel. Rome,
Galleria Nazionale.

words of the signature are incised on either side of the painting's central axis,
directly above the vanishing point. Unlike his other signatures, with one notable
exception, that of the *Sposalizio* cannot be overlooked: it is to be seen at first
glance. The signature is not subjugated to the image in any way. On the con-
trary, it dominates the image, labeling it not with the names of the beings rep-
resented or the sacred narrative they enact, as a *titulus* would do, or even with
the name of the donor (as Hadrian's name appears in the cornice of the
Pantheon), but with the name of the maker. Raphael's declaration of authorial
pride recalls Michelangelo's signature on the Virgin's breast in the Vatican *Pietà*
and anticipates his own signature of *La Fornarina* (Fig. 90). In all Raphael's
oeuvre, only this signature is comparably brazen, written, audaciously, on her
arm bracelet, RAPHAEL VRBINAS – with no date, because his possession of her
is eternal. The beautiful woman is the image of beautiful art, and whatever else
she may represent, certainly this anonymous woman, whose pose repeats that
of the Venus Pudica, embodies the beauty of Raphael's art: asserting his pos-
session of her, whose image he has created, he asserts possession of art itself.[22]

The *Sposalizio* signature similarly signifies professional self-awareness and the recognition – shared by contemporaries – that the work signaled a new chapter in his life, a seminal work for Raphael. "In it," Vasari wrote, "one specifically recognizes the growth of Raphael's powers [*virtù*] [. . .] , sharpening and surpassing Pietro's style."[23]

The audacity of Raphael's signature derives not from its wording but from its placement on the Temple façade, and more precisely from the significance of that structure in the composition. The fundamental idea of a domed structure with a central plan derives from Perugino: Raphael's signature on his master's building evokes his source, seems to deny his debt, and vaunts his achievement in surpassing his predecessor. Perugino had first conceived the idea for his *Christ Giving the Keys to Saint Peter* in the Sistine Chapel, as noted. In the fresco, the architectural setting underscores the narrative's sense of dignity and meaning without representing specific buildings or any particular historical site. The flanking triumphal arches could have existed anywhere in the Roman Empire, though they most closely resemble the Arch of Constantine in Rome itself. The event represented took place at Caesarea Philippi (Matt. 16: 13), however, so this is not Rome; and the central, centralized structure cannot be the Temple of Jerusalem, though it may evoke the Temple (or a temple) as an image of the Church built by Christ and announced here in his words to Peter, "On this rock. . . ."

Pleased with his architectural invention for the mural, Perugino revived it in somewhat simplified form for his *Sposalizio*. Given the subject, now it is inevitable that the building be understood as identifying the site: Mary had been living in the Temple of Jerusalem, and there her suitors presented themselves to compete for her hand. In reality, Perugino's domed, centralized building bears no resemblance to the Temple as described in the Bible or as depicted in earlier images.[24] Perugino was referring not to history but to his own visual tradition, and the beholder recognizes his building as the Temple precisely because (only because) of the event that transpires before it. The narrative establishes the site.

Although one may fault Perugino's historicity, his idea was a brilliant one, and Raphael exploited it brilliantly. As in Perugino's works, Raphael's Temple has a centralized plan with a dome. Instead of Perugino's Doric order, however, Raphael used the Ionic, considered feminine according to Vitruvius: the metaphysical relation between the Virgin and the Temple is confirmed.[25] Unlike Perugino's fictive architecture, moreover, Raphael's Temple is conceived as the ideal sacred building as described in Alberti's *On Architecture*, and as visualized by Francesco di Giorgio in his drawings. (Giovanni Santi had read Alberti's works closely; presumably his son did so as well.[26]) As the embodiment of the harmonic order of the cosmos, the Temple reveals the essence of divinity. A bravura display of perspective, Raphael's Temple is also a splendid demonstration of his mastery of the most modern architectural thinking. Like his distant kinsman Donato Bramante, with whose Tempietto the painter's Temple has often been compared, Raphael did not conceive his building in

isolation but as the generating source of a space that echoes its rhythm and structure.[27]

Whereas Raphael's Temple represents the thinking of the most advanced architects and architectural theorists of his day, Perugino's buildings are retardataire. Differently conceived, their buildings are also treated differently. In Perugino's prototypes, the building's dome is cropped by the top of the picture field, only slightly in *Christ Giving the Keys to Saint Peter*, more severely in the *Sposalizio*, where it is cut at the base of the drum. Raphael's dome is complete, including the bottom of the lantern. Each Temple rises on a polygonal base of stairs set in a piazza paved with pink and white stone evoking the Albertian perspectival grid. Perugino's grid includes only two diagonal divisions and broad rectangles of stone which extend uninterrupted by verticals to the edges of the composition at the sides. These two diagonal bands of pavement are not true orthogonals, therefore, and they do not meet at the vanishing point of the composition, which is determined instead by the lines demarcating light and shadow at the corners of the Temple steps. The vanishing point defined by these orthogonals is at the base of the Temple's lower cornice, directly above the high priest's hat and the apex of the entrance pediment. The diagonal bands of pavement lead the eye instead to a lower point or points to the left of the Temple entrance. The result is a rigidly symmetrical composition in which the building appears above the figures rather than behind them, a scene organized in planes parallel with the picture plane. This emphasis on the plane is underscored by the truncation of the Temple at the top and reiterated by the placement of the figures in the immediate foreground, standing in neat rows parallel with the plane and symmetrically placed in relation to the central axis. (The disappointed suitors are rather less orderly than Mary's tranquil companions.)

Raphael took everything and changed everything – starting with the placement of Mary to the priest's right, rather than his left, a choice so obvious that one wonders why Perugino did otherwise (right or dexter being always preferable to the left or sinister). Raphael's vanishing point, more insistently and consistently indicated than Perugino's, is lower, just above the base of the Temple portal. As in the Perugino, here too the door is open to the sky, so that the building is pierced by light at its very center. But now, light and the perspectival space conjoin. Again recalling Perugino, Raphael echoed this motif with the larger openings of the arcade of the Temple porch, which reveal similar luminous vistas. The horizon seen through these various architectural enframements is continuous from left to right, as one would expect, but, perhaps unexpectedly, it is at its lowest point in the center, precisely at the vanishing point. Sloping slightly upward at the sides, the background hills echo the curvilinear forms of the Temple, almost seeming to radiate from the building. Perugino's landscape rises rather more conspicuously, and with more attention to details of the vista, the precise shapes of the hills and their vegetation, details that Raphael suppressed. Raphael's actors stand in an easy semicircle, forming a figural counterpart to the architecture, their grouping neither so

geometrically rigid as Perugino's nor so precisely symmetrical.[28] Avoiding rigid
stasis by enlivening the geometrical scheme of the grouping, the composition
anticipates Raphael's *Disputa*, completed in 1512 in the Stanza della Segnatura.

In the background, where the Temple imposes architectural inflexibility, the
geometry is animated by means of light and shadow, which Raphael observed
with remarkable finesse. Some of the most conspicuous antecedents for such a
luminous interpretation of the setting, incorporating both architecture and
landscape, are found in Venetian painting, primarily in the art of Giovanni
Bellini. Santi had singled out Bellini for praise in his *Disputa*, one of the few
non-Tuscan masters to be mentioned there: "And now, leaving Etruria, [. . .]
Giovanni Bellini whose praises are wide-spread."[29] There is no proof that either
Santi or his son ever visited Venice, though scholars have speculated that
Raphael did so.[30] But even if he never went there, Raphael almost certainly
knew at least one great work by Bellini, the *Coronation of the Virgin* (Fig. 91),
painted c. 1471–74 for the church of San Francesco in Pesaro, close to Urbino,
that is, close to home.[31] Certainly Raphael might have recognized in Bellini a
gentle spirituality like his own, and more precisely, in the way in which the
celestial throne in the Pesaro *Coronation* functions as the architectonic nucleus
of a composition unified by color and light, he might have seen principles of
design that suited his own proclivities.

Like Bellini's heavenly throne, the Temple is the fulcrum of Raphael's com-
position and its generative force, even though it occupies at most a third of the
picture surface. In each case, the disposition of the actors is subordinate to the
architectural forms and curvilinear rhythms. In the *Sposalizio*, these visual ele-
ments are not merely a matter of design. The genius of Raphael's composition
lies precisely in its seemingly effortless amalgamation of design and meaning,
with the Temple as the heart of both elements of the narrative, compositional
and symbolic. Raphael's Temple embodies the law to which Mary and Joseph,
and later the Son, subjugate themselves. Here Mary went to live as a child;
here she is betrothed; here she will be purified after Christ's birth in obedience
to the law, though she has no need of purification; and here she will return to
present her Child to the Temple, that is, to God's service. The twelve-year-
old Christ will debate with the doctors here; and he will return here, as an
adult, to expel the money-changers. Finally, he will be condemned by Caiaphas,
high priest of the Temple, before being committed to his Roman judge and
executioners. The beholder may see in the Temple the encapsulation of the
Marian and Christological cycle precisely because of the refinement of
Raphael's invention, which Vasari admired: "a temple drawn in perspective
with great love."[32]

Earlier masters of perspective, Bellini among them, had exploited spatial illu-
sion to relate the fictive realm to the beholder's world. Raphael did something
rather different. Like all altarpieces, his *Sposalizio* was originally situated above
eye level. Rejecting the illusionistic relation between the viewer's space and the
pictorial, Raphael underscored the Temple's centrality in the composition, and
its dominance. Signing his name on the Temple, Raphael recognized that his

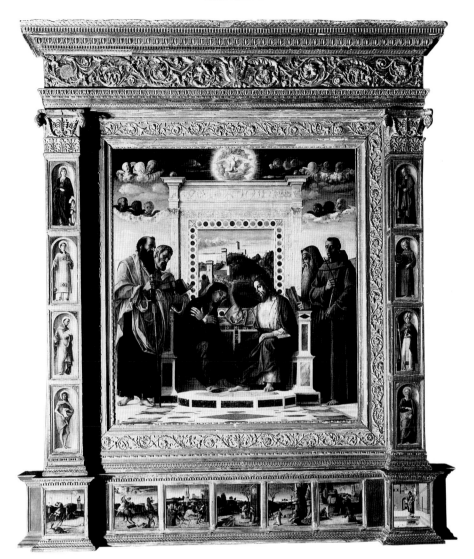

91 Giovanni Bellini. *Coronation of the Virgin* (Pesaro altarpiece). Panel. Pesaro, Museo Civico.

accomplishment, or his originality, was more evident in the setting than in the figures of the *Sposalizio*. The bland sameness of Perugino's faces is modified by Raphael's more precise physiognomies: individualization of characterization replaces Perugino's individualization by elaboration of costume and headgear. But the fact remains that Raphael's people still belong very much to the same clan as Perugino's, and this dependence is most evident in the protagonists: Joseph repeats the movement of the Eritrean Sibyl in the Perugia Cambio fresco of *God the Father with Angels, Prophets, and Sibyls*; and Mary is derived from

Perugino's *Vision of Saint Bernard* (Munich, Alte Pinakothek), only slightly transformed by an accentuated turn of her torso.[33]

Having completed the *Sposalizio*, and with it, a stage in his professional life, Raphael approached Giovanna Feltria della Rovere for her assistance. Feltria was very well placed indeed: daughter of Federico da Montefeltro (of whom Giovanni Santi had written a biography), sister of Guidobaldo (to whom Santi had dedicated this work), she was also Duchess of Sora, Signora of Senigallia, and widow of Giovanni della Rovere – the brother of Julius II, who had been elected to the papacy the previous year, 1503. Whatever else Raphael may have acquired from his father, he seems to have inherited connections at court and to have learned how to use them. On 1 October 1504 Feltria wrote to Soderini in Florence, recommending Raphael, "who, having good ingenuity in his field, has determined to stay for some time in Florence in order to learn."[34] The affectionate tone of the letter indicates that Raphael was well known and well liked at the ducal court of Urbino, presaging his success at the papal court of Rome. And the fact that Raphael considered a Florentine sojourn to be desirable at this stage of his career – he was just twenty-one – is characteristic of his exceptional professional acumen. Florence was indeed, as Vasari later affirmed, the place for an ambitious painter to be at the beginning of the new century.

Raphael was well aware of what was happening in Florence to make it essential for him to be there, even more than in Rome, where he had della Rovere family connections.[35] Indeed, he had most likely already visited Florence before October 1504, given the city's proximity to Siena, where he collaborated for a time with his friend Bernardino Pinturicchio in the fresco decoration of the Piccolomini Library.[36] Raphael himself confirmed his early awareness of contemporary developments in Florence. In the *Sposalizio* and in the *Coronation of the Virgin* for the Oddi Chapel in San Francesco al Prato in Perugia, one already sees clear indications – if not yet a deep understanding – of his knowledge of Leonardesque motifs and drawings.[37]

Again, Vasari was probably correct that Raphael had already heard about Leonardo's *Anghiari* "cartoon [. . .] of a most beautiful group of horses, to execute in the hall of the Palace, and likewise some nudes made in rivalry with Leonardo by Michelangelo Buonarroti, much better" (Vasari had no doubts about the winner of that particular competition).[38] At least two of Raphael's drawings document his study of their cartoons: a silverpoint of battling horsemen (who share the sheet with a Leonardesque profile of an elderly man), c. 1505, and two figures from the *Cascina* in a pen sketch dated c. 1507.[39] His awareness of these works for the Sala del Gran Consiglio – and his hopes for similarly distinguished commissions – stirred in Raphael his "great desire" to settle in Florence, "for the love that he always had for the excellence of art."[40] And so he went there, with a letter that assured his welcome at the highest social and governmental level, starting with Soderini – Michelangelo's most conspicuous patron. Moving in the same circles, Raphael and Michelangelo inevitably came to know each other in Florence, though it is possible that they had met earlier, in Siena. Michelangelo had received the commission to

complete the Piccolomini altar in Siena cathedral in 1501, while from 1503 Raphael was occasionally at work in the adjacent Piccolomini Library, and so the two men might have been in the city at the same time. In Florence, accord-ing to Vasari, both of them participated in the "most beautiful discourses and disputations of importance" on artistic matters held in the shop of Baccio d'Agnolo, Michelangelo joining the group "sometimes, but infrequently, however."[41] Whenever and wherever they first met, there is convincing evidence that the relationship was cordial, at least in the beginning: Raphael evi-dently had knowledge of Michelangelo's drawings. Such knowledge is not to be taken for granted, given Michelangelo's chronic secretiveness. Raphael's awareness of Michelangelo's drawings implies his having shown his work to the younger man.[42] Whatever their personal relationship may have been, and by whatever means he may have come to know Michelangelo's works, Raphael borrowed from him and from Leonardo, reinventing himself in the process.[43]

When Raphael arrived in the city in 1504, despite his social connections and considerable accomplishments, he posed little threat to anyone, and certainly not to Michelangelo, then enjoying his first great public triumph with the *David*. During the next few years in Florence, while Michelangelo and Leonardo gave much of their attention to conspicuous public commissions, the newcomer was occupied with small-scale works for private donors, notably Madonnas and portraits. Whether this was Raphael's choice, or whether his subjects were imposed by his Florentine patrons, is unclear.[44] In any case, though he had undertaken several large-scale projects during the immediately preceding years, Raphael received no such commissions in Florence until the end of his four-year sojourn.[45]

Raphael's Florentine works, though small-scale, were painted for well-placed patrons, including people in Michelangelo's circle, notably Taddeo Taddei and Agnolo Doni. Probably no marriage has ever been more splendidly commem-orated than Doni's to Maddalena Strozzi: while Michelangelo was painting their *Madonna*, Raphael was at work on their portraits (Figs. 83, 92, 93). Whereas Michelangelo's tondo posited an alternative to Leonardo's vision, however, Raphael's portraits celebrated the older man's ideas. The Doni por-traits are variations on the theme of *La Gioconda*, and their first audience was surely as aware of the fact as their makers (Fig. 94). The great difference between the Doni portraits and their prototype is that Raphael eschewed Leonardo's monochromatic *chiaroscuro*. Indeed, Raphael's colorism seems to have been nearly immune to Florentine influence. This is not to say that Raphael's color harmonies remained unchanged during the twenty years of his activity but that for all his conspicuous eclecticism in the conception of figures and composition, his chromaticism remained profoundly self-determined, inde-pendent of Leonardo and also of Michelangelo, whose acid *cangianti* were almost as foreign to Raphael as Leonardo's monochromatics.[46]

The three Doni commissions – two for Raphael, only one for Michelangelo – memorialize the artists' first competition. Perhaps Michelangelo's self-announced contempt for portraiture was prompted or exacerbated by these

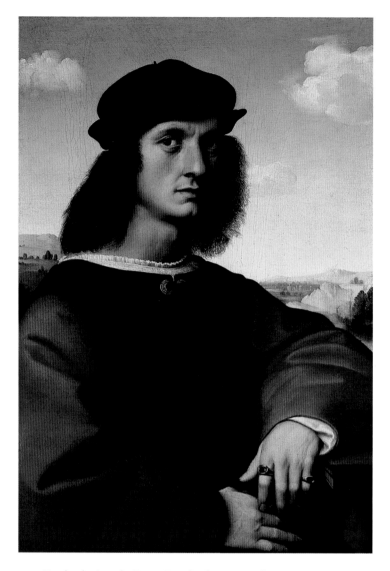

92 Raphael. *Agnolo Doni*. Panel. Florence, Palazzo Pitti.

commissions? (His only portraits *per se* were drawings representing two men
close to him: Tommaso de' Cavalieri and Andrea Quaratesi.[47]) As for Raphael,
he had been drawn to Florence in the first place by Michelangelo's *Battle of
Cascina* and Leonardo's *Battle of Anghiari*, as Vasari reported. Seeing their
works as well as "Masaccio's old things [. . .] made him attend greatly to studies
and in consequence to acquire from them an extraordinary improvement in
art and his style," Vasari explained – rightly, but without mentioning one
of Raphael's most conspicuous instances of "studying" Leonardo, namely

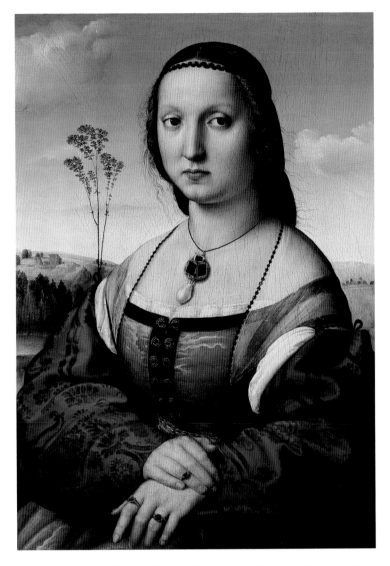

93 Raphael. *Maddalena Strozzi Doni*. Panel. Florence, Palazzo Pitti.

the Doni portraits, in particular *Maddalena Strozzi*, which is in effect a richly colored variant of *La Gioconda*.[48] (*Agnolo Doni* is less dependent on Leonardo's model.) In his Life of Raphael Vasari mentioned the Doni portraits in passing, giving far more attention to the patron than to the pictures. In Michelangelo's Life, conversely, Vasari exploited Michelangelo's profitable dealings with Doni as a demonstration of the value of art in general and, in particular, the great esteem with which Michelangelo was regarded by knowledgeable patrons. Perhaps Vasari was reticent about Raphael's Doni portraits

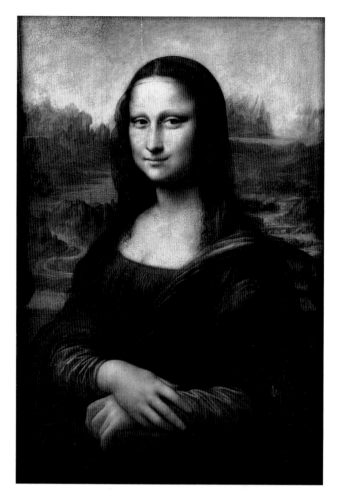

94 Leonardo da
Vinci. *La Gioconda*.
Panel. Paris, Musée du
Louvre.

in deference to Michelangelo? The portraits might have seemed doubly offen-
sive, commissioned by Michelangelo's unappreciative patron and, adding insult
to injury, conspicuously indebted to Leonardo.

Raphael was not the only artist to borrow Leonardo's invention for *La
Gioconda*, but arguably he borrowed it more often than any other master,
playing variations on Leonardo's theme in portraits from the Doni and other
Florentine works to the late *La Velata*, painted in Rome, c. 1515–16 (Fig. 95).
Unlike "the Veiled Woman," however, Gioconda's name is known: she was Lisa
Gherardini, born in Florence in 1479 and married to Francesco del Giocondo
in 1495.[49] According to Vasari, Leonardo began the portrait after his return to
Florence in 1500, worked on it for four years (while also engaged with the
Battle of Anghiari and various engineering projects), and then left it incom-
plete.[50] Although Vasari was essentially correct about the chronology, he erred
about the work's state of completion. Surely *La Gioconda* is a finished work,

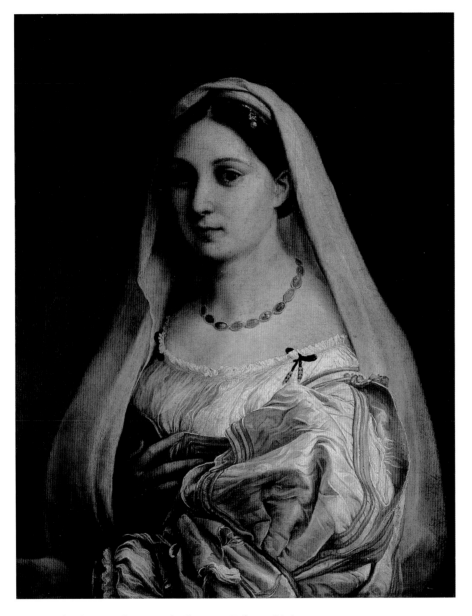

95 Raphael. *La Velata*. Panel. Florence, Palazzo Pitti.

but *when* it was finished is unknowable, and another explanation is wanted to account for Leonardo's failure to consign it to his patron.

Although Lisa's portrait was apparently never displayed in the Giocondo household, Leonardo did make it available to others, including Raphael. A first hint of its influence may be seen in the *Young Man with an Apple*, attributed

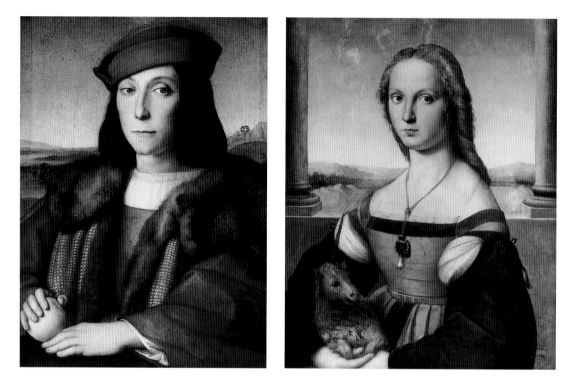

to Raphael c. 1504 (Fig. 96).[51] The sitter has sometimes been identified as
Giovanna Feltria's son, Francesco Maria della Rovere, named heir to the duchy
by his uncle Guidobaldo in 1504 (and portrayed as a ferocious adult some
thirty-four years later by Titian in the Uffizi portrait). Whoever he is, his por-
trait demonstrates Raphael's mechanical understanding of *La Gioconda*: where
she leans on the arm of her chair, the young gentleman leans on a ledge in the
foreground, echoing the angle of her shoulders and its countermovement in the
placement of the head. Like Lisa, the anonymous youth beholds the beholder
with a welcoming smile.

Even closer to Leonardo's composition is the *Lady with a Unicorn*, a por-
trait begun by Raphael c. 1505 (Fig. 97).[52] Like *La Gioconda*, the anonymous
lady is seen before the low wall of a balcony or loggia, enframed by its sup-
porting members. Without her symbolic unicorn to occupy her in Raphael's
preparatory drawing for the portrait, the lady repeats Lisa's gesture almost
exactly and, like her, leans on a parapet, replacing the arm of Lisa's chair as in
the *Young Man with an Apple*.

Two other female portraits, *La Gravida* (Florence, Pitti) and *La Muta* (Fig.
98), reiterate the pose with slight variations, most notably the substitution of
a dark ground for the landscape setting of *La Gioconda*. Both seem to be con-
temporary with the Doni portraits, that is, c. 1507–08; and both exploit the
lower edge of the painting to evoke or replace the parapet of the Louvre

96 (*facing page left*) Raphael. *Young Man with an Apple*. Panel. Florence, Galleria degli Uffizi.

97 (*facing page right*) Raphael. *Lady with a Unicorn*. Panel. Rome, Galleria Borghese.

98 Raphael. *La Muta*. Panel. Urbino, Galleria Nazionale delle Marche.

drawing or the ledge of the *Young Man*.[53] In this way, the psychological and physical qualities expressed by pose and gaze are underscored by the placement of the figure at that point, marked by the frame, where the pictorial space merges with the beholder's world.

Compared with these two anonymous ladies, the Doni are more faithful to Leonardo's model, reiterating the juxtaposition of foreground figure and distant landscape, the motif of the chair arm for her, a variation of the balcony for him. While quoting Leonardo, however, Raphael also revised him, especially in interpreting his male subject, applying compositional variations that are bound to gender distinctions. Closer to the picture plane than Maddalena, and consequently more physically accessible than she, Agnolo is more psychologically available as well, regarding the viewer directly whereas she averts her gaze. His posture is more open than hers and more suggestive of the possibility of movement: Maddalena rests one hand on the other, emulating Lisa, but Agnolo has the fingers of his left hand slightly touching those of the right, held at his waist. Her relaxed stasis becomes his slightly edgy gesture; and her self-enclosure becomes his more expansive pose, the left arm separated from the body.

Whatever the precise chronology of these works, the fact remains that within a short period – and at a moment when *La Gioconda* was likely still a work in progress – Raphael produced as many as six variants of Leonardo's invention, including the Doni portraits. Having discovered his new model, or mentor,

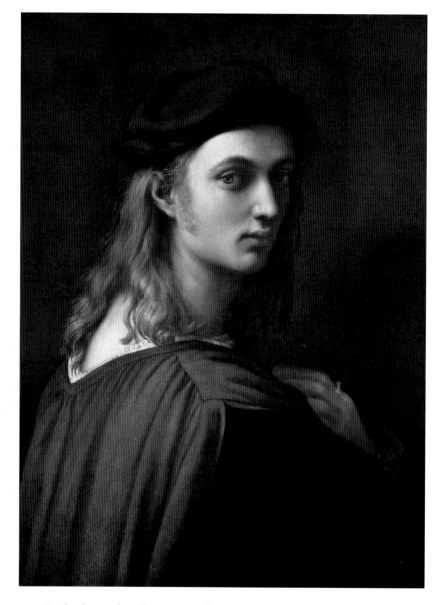

99 Raphael. *Bindo Altoviti*. Panel. Washington, National Gallery of Art, Samuel H. Kress Collection.

Raphael had to absorb him completely in order to continue on his own path. Yet, arguably Raphael never left *La Gioconda*: she remained the point of reference for a number of his later portraits, including *La Velata*, as well as the *Cardinal*, c. 1510 (Madrid, Prado), and *Tommaso Inghirami* (Florence, Pitti) and *Baldassare Castiglione* (Paris, Louvre), both c. 1514–16. Raphael relin-

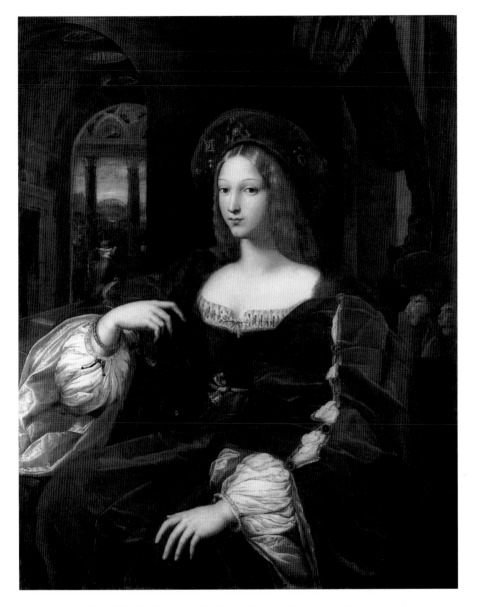

100 Raphael and Giulio Romano. *Isabel of Naples*. Transferred from panel to canvas. Paris, Musée du Louvre.

quished his grasp on Leonardo's model only in his dual portraits – that of *Navagero and Beazzano* (Rome, Galleria Doria Pamphili) and the so-called *Raphael and His Fencing Master* – and in two idiosyncratic portraits of individuals, *Bindo Altoviti* and *Isabel of Naples* (Figs. 99, 100). *Bindo Altoviti* eroticizes its male subject in ways more usually associated with Venetian images

of an anonymous beautiful women: he turns over his shoulder to look side-
ways at the beholder, eyes and half his face concealed in shadow, his long hair
caressing the exposed flesh of the back of his neck. Altoviti presses his hand to
his heart, suggesting perhaps that he is vulnerable there. In stunning con-
tradistinction to the intimacy of Altoviti's portrait, the *Isabel* monumentalizes
the subject. This work, conceived by Raphael and executed by Giulio Romano,
introduced the state portrait to European art.[54] The garment, jewels, and other
trappings of rank are painted with far more attention to detail – literally indi-
vidualized – than the face, so psychologically remote as to seem frozen, so
smoothly painted as to seem porcelain. Isabel was evidently a small woman,
but her figure is monumentalized by her voluminous garments, by her posture
– seated with legs sideways and one arm raised away from the torso – and by
her placement in the composition. Filling the picture space in the foreground,
she is still too large to be contained entirely by the picture space, and larger
still in juxtaposition to the disproportionately small figure and architectural ele-
ments in the background. It is no coincidence that Raphael conceived the type
for a female subject. Represented alone – that is, in an independent portrait
and not part of a diptych or as a pendant of her husband's portrait – a woman
might seem suspect. If she is seen in profile – especially at a time when men
were already being portrayed frontally or in three-quarter view – no one can
accuse her of wantonly exposing herself to his gaze or of looking at him – the
"him" being any man to whom she is unrelated by bonds of kinship. For these
reasons, the profile was used for portraits of women subjects long after it had
been abandoned for men. Isabel faces her beholder, but her trappings, her pose,
her domination of the composition, and above all, her *sang-froid*, protect her
from a beholder's misjudging her status, that is, both her moral and her social
condition.

Just as Raphael had interpreted Bindo Altoviti with the sensuality usually
associated with women, he monumentalized and aggrandized a woman subject
in the *Isabel*, treating her as though she were a man though without compro-
mising her femininity. Raphael's ability to bend or abandon traditional pre-
suppositions about gender and demeanor helps explain one of his most admired
portraits, treating a male subject with the kind of emotionalism and psycho-
logical vulnerability that might have been more expected of a woman. Raphael's
portrait of Pope Julius II has no real precedent in this regard, and indeed very
few successors among portraits of rulers (Fig. 101). (Sebastiano del Piombo
adapted his psychology to portraits of Clement VII de' Medici done after the
Sack of Rome, abandoning the vigorous conception of his first portrait of the
pope begun before 1527.) And of course the *Julius* is a ruler portrait by defi-
nition – but not the image of an energetic man who had once been notorious
for his temper. Instead, Raphael depicted the pontiff as he was nearing the
end of his life and living his last months with the awareness that many of his
political achievements might not long outlive himself.[55] This vulnerability, the
psychological and spiritual conviction of the portrait, no less than its physical
resemblance to Julius, explain the reaction of contemporaries when it was

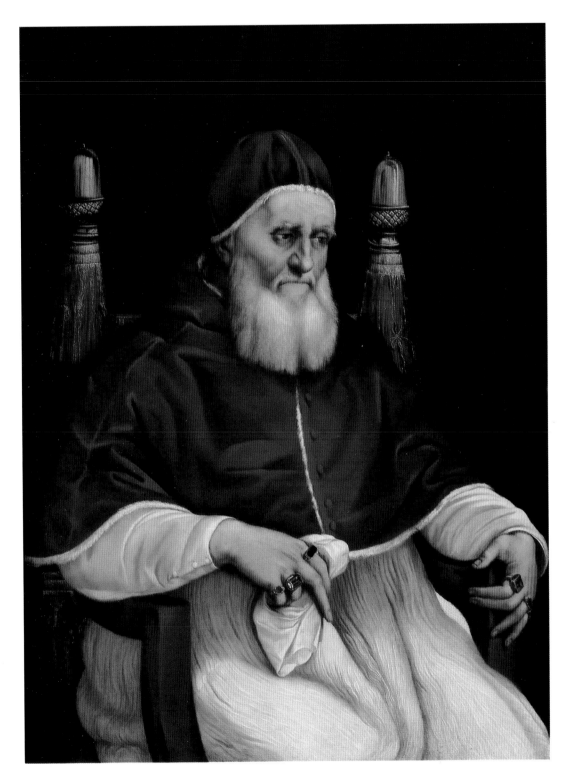

101 Raphael. *Pope Julius II*. Panel. London, National Gallery.

displayed on the altar of Santa Maria del Popolo after his death. In Vasari's words, Raphael's portrait of the pope was "so alive and true that it made one afraid to see it as though it were in fact the living man."[56] Vasari's use of the verb *temere*, "to fear," has been taken to mean that beholders were frightened by – or *of* – Pope Julius. But this is not a frightening portrait: it is a tragic, introspective one. What presumably frightened its first audience was not fear of papal *terribilità* but precisely the sense of the realization of the frailty of life and human enterprise, all the more frightening (in a profound, spiritual sense) when expressed in the visage of a well-known, powerful and self-aware man at the end of his life.

Although nothing in *Isabel of Naples* or *Julius II* seems directly indebted to *La Gioconda*, faint echoes of Leonardo remain. *La Gioconda* prepared the way by introducing the seated *contrapposto* pose that Raphael opened, moving the arms away from the body, and expanded to include more of the figure. And Leonardo's concern with the expression of the mind in the movements of the body led the way for Raphael's compelling psychological likeness of the pope. Indeed, no other portrait could offer Raphael anything so original as *La Gioconda* as an example, though for narrative painting and devotional images, he could consult other masters in addition to Leonardo, most notably Michelangelo. The spiritual grandeur of Raphael's Florentine Madonnas frees them – and freed Raphael from the necessity of providing – mechanistic illustrations of their psychology, in a way that parallels the freeing of the subjects of his portraiture from dependence on traditional symbolic devices to establish personality.

Raphael's Colonna altarpiece illustrates the metamorphosis of his sacred paintings, comparable with the development of his portraiture. Begun for the nuns of Sant'Antonio in Perugia before Raphael moved to Florence, and completed there within the following year, that is, 1505, the altarpiece illustrates a kind of artistic schizophrenia (Fig. 102).[57] The lunette representing *God the Father Blessing with Two Angels* is completely Peruginesque; also indebted to Perugino are the female characters in the main panel representing the *Madonna and Child Enthroned with Saints Peter, Catherine, Paul, (?)Cecilia, and the Infant John the Baptist*. But standing in the foreground, the two male saints belong to another race – a Florentine race – more monumental in every regard. Their draperies respond to the body beneath while suggesting sculptural juxtapositions of volume and void, and they are far weightier beings than any of the others, including God the Father in the lunette, in every way a flimsier character than his male saints. The contrast between God the Father and Saint Peter is particularly telling, involving physical and psychological differences. And though the Mother and Child still resemble their immediate predecessors in Raphael's earliest works, their relationship to Saint John suggests Raphael's first response to the geometry of Leonardo's compositions. Unified by glance and gesture, they are also bound in a pyramid recalling that of Leonardo's *Adoration of the Magi*.

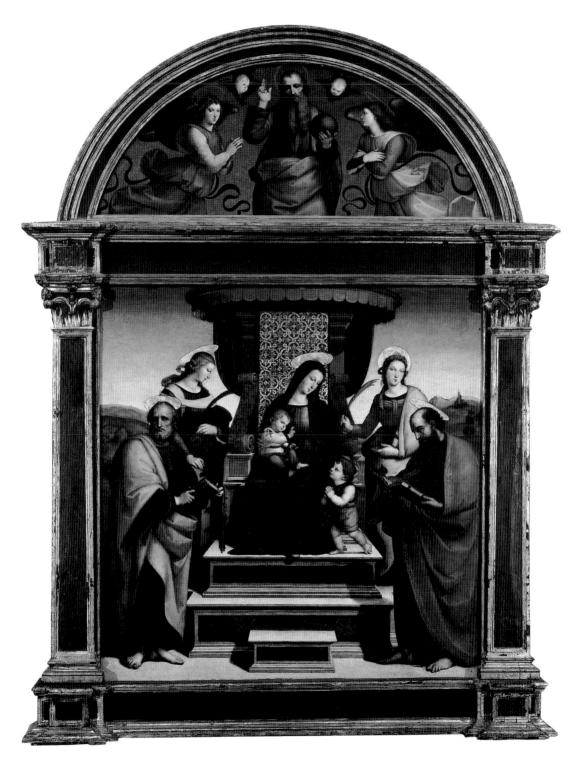

102 Raphael. *Madonna and Child with Saints* (Colonna altarpiece). Panel. New York, The Metropolitan Museum of Art, Gift of J. Pierpont Morgan, 1916. (16.30ab).

Raphael had begun to study Michelangelo as well, though the results are not apparent in his earlier Florentine commissions. Among the first drawings Raphael made in Florence, however, are at least three sketches inspired by the *David* – among the earliest drawings of Michelangelo's statue (Fig. 103).[58] Raphael's drawings of the Taddei Tondo, details of the *Cascina* cartoon, and the unfinished *Saint Matthew* are also among the first copies of those works.[59]

None of the three drawings after *David* reproduces the statue exactly, but rather each presents a variation on Michelangelo's invention. Only one represents the statue itself, without accoutrements and in his original posture: but that one presents him from the back. Of course, *David* was made to be seen from the *front*, and by imposing this rear view on him, Raphael demonstrated that his interest in the statue was not merely to transcribe its appearance the way he recorded various inventions by Leonardo with considerably more fidelity to the original (for example, the contemporary sketch after Leonardo's *Standing Leda*).[60] Showing Michelangelo's figure from the back, Raphael concealed all but the knee of his bent left leg, so that the hero seems to be supported rather awkwardly on his right leg and on the tree stump required by the laws of physics. (The *contrapposto* pose, originally conceived for hollow bronze statuary, necessitates such a prop when the material is solid stone, which is heavier and lacks the tensile strength of metal.) Adding insult to injury, Raphael altered the proportions of Michelangelo's nude, making the hero bulkier and with a larger head in relation to the body, exaggerating the bend at the waist and the tensions of the muscles, and transforming the clear outline of the statue into rippling contours. The stone seems frozen in comparison. Such disruption of his glyphic outlines went very much against the grain for Michelangelo. To preserve their clarity even in painting, Michelangelo treated oil as though it were the more precise medium of tempera. Although the Doni Tondo, like many if not most Italian paintings of its date, was apparently executed in mixed media – "a kind of tempera combined with oils" – Michelangelo's handling remains that of a tempera painter "following a rigorously classical technique."[61] As for Raphael, his sketchy transformation of the *David* suggests that his interest in Michelangelo was anything but slavish admiration. It implies a painter's assertion of control over the work of the sculptor, a visualization of the familiar argument of the *paragone*. Whether Raphael made his drawing from a model of the statue, anticipating Jacopo Tintoretto's similarly free manipulation of such figurines, or whether he turned the *David* in his mind's eye, his drawing is a critique of the original. The drawing hints what soon became apparent: Raphael emulated Leonardo but emended Michelangelo in order to rival him.

Since the sixteenth century viewers have recognized that Raphael's art was shaped and reshaped by what he saw as he moved from Urbino, to Perugia, to Florence, and finally to Rome. Paolo Giovio, for example, explained that Raphael "attained the third place in painting" – after Leonardo and Michelangelo – "by virtue of his marvelous gentleness and alacrity of a talent

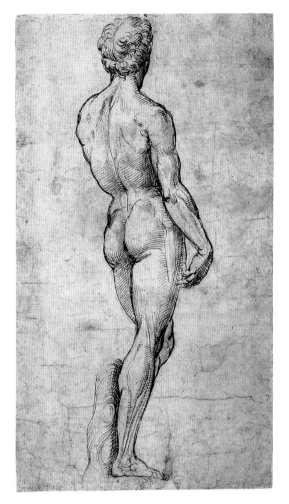

103 Raphael, after
Michelangelo. *David*.
Pen over traces of chalk.
London, British Museum
pp.1–68.

quick to *assimilate*."⁶² The history of Italian Renaissance art would have been
very different had Raphael stayed home. His work represents the most
conspicuous demonstration of the effects of *imitatio* and agon on a genius –
but such forces shaped others as well, including Michelangelo, despite himself
and despite his disavowals of interest in his contemporaries (or denials made
on his behalf by his biographers). In the case of Michelangelo's Taddei Tondo
and Raphael's Terranuova *Madonna*, moreover, the two masters were respond-
ing to the same sources, principally Leonardo's *Madonna and Child and Saint
Anne* (Figs. 74, 76, 104).

Characteristically, Raphael's debt is more straightforward. The treatment of
Mary's foreshortened left hand, the complicated diagonal pose of the Child, the
pyramidal composition, and the mountainous landscape – far grander than any-
thing in his earlier works – reveal Raphael's close observation of Leonardo's

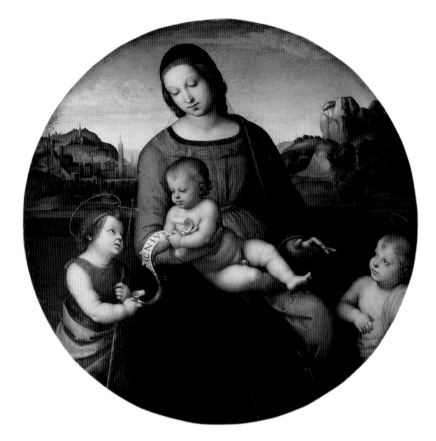

compositions, including the underpainting of the *Adoration of the Magi*, the
cartoon of the *Madonna and Child and Saint Anne*, presumably the version
that Pietro da Novellara mentioned in his letter to Isabella d'Este on 3 April
1501, and the *Madonna of the Yarnwinder* (for Mary's gesture and Christ's
pose), which Novellara described in another letter eleven days later (Fig. 105).[63]
Raphael's composition can be seen almost as a patchwork-quilt of motifs from
these and similar inventions by Leonardo.

In the Terranuova *Madonna*, the Virgin and Child and Infant Baptist are
bound by their glances and also, physically, by the scroll that both children
hold, on which is visible the word AGNIVS. Christ's hand conceals all but the
final letter I from the following word, DEI; the turn of the scroll conceals
the EC of "Ecce" – but the verb itself is redundant, because the Baptist enacts
the meaning: Behold the Lamb of God. To their left, a third child witnesses the
exchange, leaning against Mary and looking reverently toward her. His halo
identifies him as a saint, but which saint? Given the presence of one of Christ's
young cousins, John the Baptist, scholars have suggested that the third child is
another cousin, perhaps Saint James the Less (Saint James Minor), the son of
Mary Cleophas and Alpheus.[64] The idea of a family connection among the

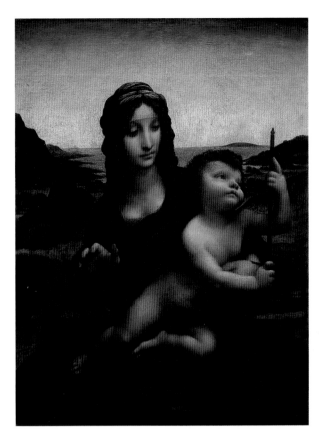

104 (facing page)
Raphael. Terranuova
Madonna. Panel. Berlin,
Gemäldegalerie.

105 Leonardo (attr.).
Madonna of the
Yarnwinder. Panel.
Drumlanrig Castle,
Scotland, Duke of
Buccleuch.

children is an attractive one, but James had two brothers, Simon Zelotes and Thaddeus Jude, equally deserving of a place by Christ's side. Although there is no visual tradition for the depiction of any of these men as boys, there may be reason to identify this child as Thaddeus, as has been suggested.[65] If so, then the tondo was presumably made for Taddeo Taddei, Raphael's great friend in Florence, "who always wanted him in his house and at his table."[66]

The only surviving letter in Raphael's hand, addressed to his beloved uncle Simone di Ciarla in Urbino on 21 April 1508, concerns Taddeo. He will be coming to Urbino – presumably for the funeral of Duke Guidobaldo da Montefeltro, who had died ten days before – and Raphael asks his uncle to receive him with unlimited generosity and for love of Raphael to embrace Taddeo "to whom certainly I am most greatly obliged as to any man alive."[67]

According to Vasari, Raphael painted two works for Taddeo Taddei in gratitude for his friendship and hospitality in Florence. These paintings, Vasari explained, represented a moment of transition in Raphael's development, vascillating between Perugino and Florence: "Raphael, who was kindness itself, so as not to be surpassed in courtesy, made two pictures for Taddeo that adhere to the first style of Perugino and the other style that Raphael, then studying,

learned much better [. . .] which paintings are still in the house of Taddeo's heirs."[68] Vasari did not identify the two works as Madonnas, but that is the implication, because the next painting described is the *Madonna of the Goldfinch* (Florence, Uffizi) that Raphael made for another friend, Lorenzo Nasi.[69] Raphael's two pictures for Taddeo Taddei were mentioned again by Filippo Baldinucci in the late seventeenth century, describing one as a *Madonna and Child with Saint John*.[70] This description could apply equally well to the *Madonna of the Meadow* (Fig. 106), traditionally identified as Taddei's, and the Terranuova *Madonna*: the Baptist is present in both compositions.[71] Admittedly, the evidence identifying the Terranuova *Madonna* with Taddeo Taddei is circumstantial, but no matter who the patron, the tondo can serve as a proxy for one of the works that Raphael did for his friend.

Either this *Madonna* or works like it, that is, paintings done during the first two or three years of Raphael's Florentine sojourn, were made at the same time – the only time – that Michelangelo was also tackling the tondo format, both in sculpture and in painting. Michelangelo's painted tondo for the Doni had already led him to an indirect competition with Raphael, engaged to paint their clients' portraits. If Michelangelo's marble Taddei *Madonna* was in fact commissioned by Taddeo Taddei, and not merely acquired by him, then this tondo and Raphael's Terranuova *Madonna* (arguably for the same patron) memorialize a more direct confrontation: the same subject represented in the same format for the same collection. And even if the answers to all the hypotheses about patronage be negative, the fact remains that these contemporary works illustrate Raphael's response to the Florentines, including Michelangelo, as viewers have recognized since the sixteenth century. At the same time, they also illustrate *Michelangelo*'s response to *his* rivals.

In the Taddei Tondo, the physiognomies, the childrens' full heads of hair (unlike the children in Michelangelo's only earlier Madonna and Child relief, the *Madonna of the Stairs*), and the sweetness of their expressions (also rather different from his other depictions of Mary and Christ) – all are beholden to Leonardo's characterizations. But perhaps most suggestive of Michelangelo's close observation of Leonardo is the psychology of the interrelationships among Mary, Christ, and the Infant Baptist. Again, unlike Raphael, Michelangelo does not quote Leonardo directly but adapts the older master's lessons. The Mother's solicitude in the Taddei Tondo, her embrace in the Pitti Tondo, and the way she holds the Infant's hand in the Bruges *Madonna* are all comparable with the emotion of Leonardo's maternal images. Although it may seem that tenderness between mother and child is natural and does not require an artistic example, it was in fact not natural for Michelangelo, as his earlier and later works demonstrate. He gave expression to such feelings only in these works, done in Florence during the years when Leonardo was also living in the city. And perhaps the example of Raphael, so gracefully reiterating Leonardo's ideas, further motivated Michelangelo's exploration of gentle emotions.

Certainly Raphael was looking at Michelangelo, and in particular at the Taddei Tondo. Raphael sketched the relief twice, in drawings datable c. 1505.

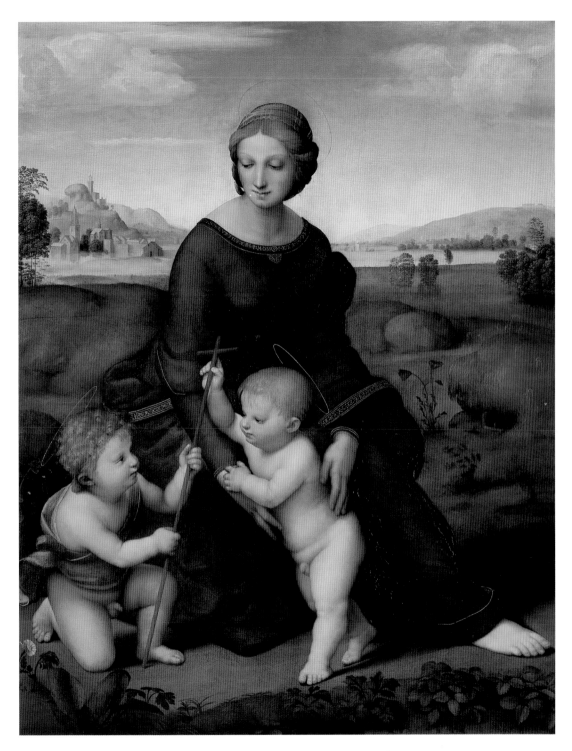

106 Raphael. *Madonna of the Meadow*. Panel. Vienna, Kunsthistorisches Museum.

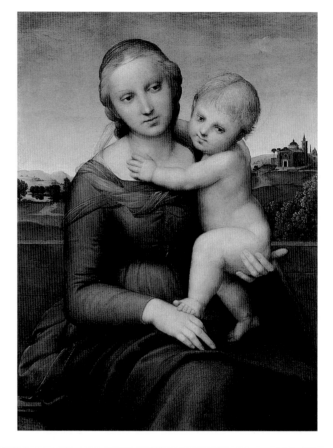

107 Raphael. *Small Cowper Madonna*. Panel. Washington, National Gallery of Art, Widener Collection.

108 (*below*) Raphael, after Michelangelo. Taddei Tondo. Pen over stylus. Paris, Musée du Louvre 3856.

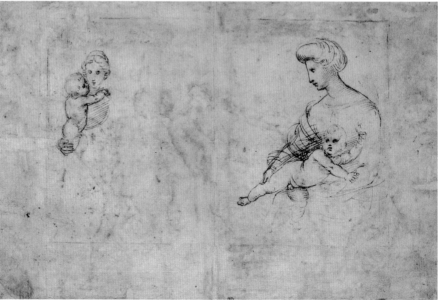

In one drawing, his sketch after the tondo shares the sheet with a small study for a Virgin and Child that resembles the *Small Cowper Madonna* (Figs. 107, 108).[72] Raphael's other sketch of the tondo appears on the verso of compositional studies for the *Madonna of the Meadow*, long identified as one of his paintings for Taddei. The *Madonna* is dated MDVI on the neckline of Mary's gown, and the drawings, clearly preliminary in character, may be reasonably placed slightly earlier, perhaps as early as 1505.[73]

What Raphael depicted in his drawings of Michelangelo's tondo is explained only in part by the relief's incomplete state. Omitting the Infant Baptist in each case, he focused on the Virgin and Child. But in copying these two figures, Raphael eliminated much of Mary's veil so as to isolate her lovely profile. She is one of Michelangelo's more feminine Virgins, and Raphael feminized and classicized her further. Especially in the second drawing, he removed much of her drapery and indeed much of her body (except for the neck, shoulders, and a hint of her left arm) in order to concentrate on the Child. He did not replicate the Infant's posture but altered it to make his fearfulness more explicit. In Raphael's drawings, Christ attempts to escape from something not shown, leaving to the beholder's imagination the sight that alarms him. The movement of the legs is more suggestive of running than in Michelangelo's relief; the torso and head slightly more upright; and, most telling, the relaxed bent left wrist in the tondo is now a hand raised in supplication, or in fear. (These elements are clearer in the second sheet.) Confirming Michelangelo's psychological scenario, Raphael also explicated his meaning.[74]

Characteristically, Raphael made Michelangelo's situation unambiguous, both physically and psychologically, whereas Michelangelo was purposefully inexplicit. Raphael's drawings tell us what to think and feel; Michelangelo's tondo requires that we penetrate the scene both emotionally and intellectually – both to understand the sacred beings and to invest them with our own feelings. But the drawings represent only Raphael's first examination of Michelangelo's ideas. In his final emendation of Michelangelo's invention, the Bridgewater *Madonna*, Raphael achieved a comparable psychological subtlety though – again, characteristically – his depiction of the relationship between Mother and Child is more intimate (Fig. 109). Bound by their gazes, they suggest a dialogue: Christ questions his Mother and she answers with affirmation of his destiny.

Raphael's drawings and paintings indicate that he was responsive to Michelangelo's Taddei Tondo despite its unfinish. Unlike the sculpted tondo, however, the Doni *Madonna* is a completed work, as highly "polished" as Michelangelo's *Pietà*, *David*, and the Bruges *Madonna*. Perhaps Michelangelo was spurred to complete his commission for Agnolo Doni precisely because the patron had also engaged Raphael for the family portraits. Certainly their Doni commissions encouraged each master to consider the other. Raphael's Florentine Madonnas gracefully exploit Leonardo's ideas and make them his own, just as the *Maddalena Strozzi* and other portraits adapt the older man's ideas about portraiture. One wonders whether Michelangelo perceived Raphael

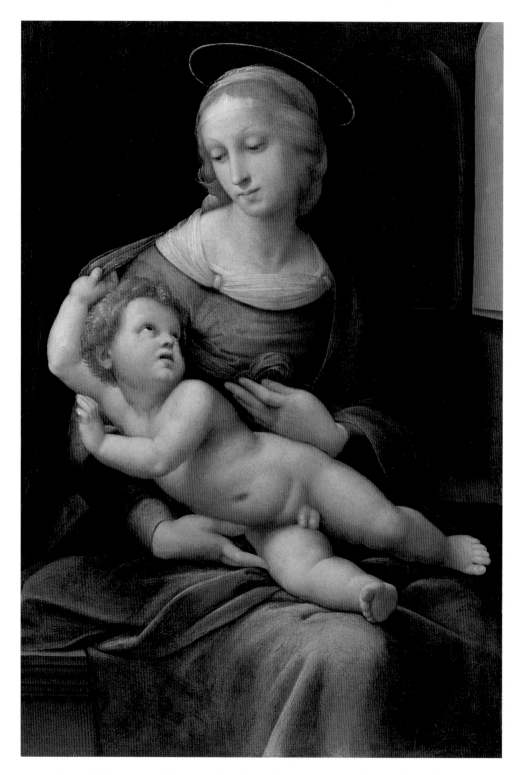

109 Raphael. Bridgewater *Madonna*. Panel transferred to canvas. Duke of Sutherland, on loan
to Edinburgh, National Gallery of Scotland.

only as Leonardo's proxy in Florence, or already as a rival in his own right. In either case, Michelangelo's response to both of them involved his rejection of their thinking about composition, modeling, color, and psychology. Refuting or at least modulating these ideas, Michelangelo reiterated his fealty to Quattrocento and even Trecento predecessors. (Perhaps his anxiety of influence was mitigated by the considerable generation gap between himself and Masaccio, Donatello, or Giotto.) Admiring the "old masters," with his Doni Tondo and other Florentine works, Michelangelo gave his imprimatur to stylistic elements that were soon adopted by his younger Mannerist contemporaries: crystalline modeling, *cangianti* and sharp color harmonies verging on disharmony, the suppression or abnegation of eloquent physiognomies in favor of emotionally expressive postures and gestures, and compositions that integrate individuals into their groups without compromising their individuality. When the group is a horde, as in Bronzino's hell or Vasari's battle scenes, the paradigm shifts to that of ancient battle sarcophagi: the beholder sees a violent throng, and the individual's struggle is subsumed in the heaving mass. The result is inherently and intentionally different from Leonardo's ordered pyramid of cavalry at Anghiari, but also different from Michelangelo's individualized bathers at Cascina. Leonardo's horsemen at Anghiari are inseparably intertwined: the viewer may focus now on this grimace, now on that decorated helmet, but the dominant impression remains of men and beasts bound in a pyramidal mass. Michelangelo's bathers, though interrelated by narrative and by a geometrical scheme (more complicated than Leonardo's pyramid), remain primarily individuals. Their physical isolation, despite the group, expresses also their psychological isolation.

Raphael had been studying Michelangelo by 1505, as the drawings of the *David* and the Taddei Tondo demonstrate, but at that comparatively early date, he found Michelangelo's example less congenial than Leonardo's. Judging from surviving works, Raphael did not make another drawing after Michelangelo until his sketch of the unfinished *Saint Matthew* (Figs. 110, 111). To have seen this unfinished work almost certainly required Michelangelo's assent.[75] The apostle is drawn, not coincidentally, on the verso of a compositional study for the Borghese *Entombment*, dated 1507 (Fig. 112). With its evocations of the *Cascina* and its quotations of the *Matthew*, the Doni Tondo, and the *Pietà*, Raphael's *Entombment* is the "manifesto of his Michelangelism," representing a critical moment in his development, as he moved from Leonardo to Michelangelo.[76]

When Raphael took from Leonardo, he took wholesale, adopting Leonardo's compositional formulas and his conception of the Mother and Child. Raphael so thoroughly integrated Leonardo's aesthetics that imitation became absorption. When Raphael appropriated ideas from Michelangelo, however, his borrowings became more selective: it was not the whole but particular parts that Raphael incorporated into his compositions. From Leonardo, he had taken whole texts; from Michelangelo, he took phrases. The *Entombment* marks Raphael's transition from Leonardo to Michelangelo, from Florence to Rome.

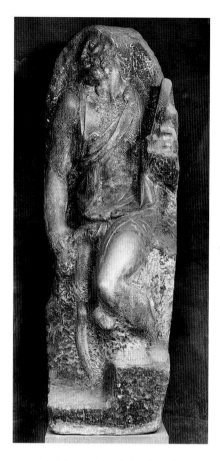

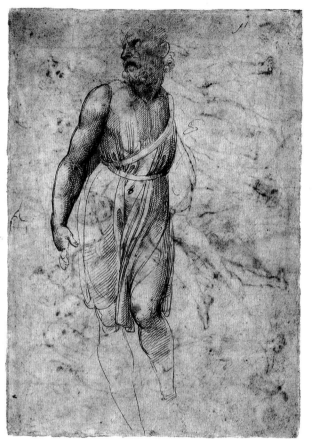

110 Michelangelo. *Saint Matthew.*
Marble. Florence, Galleria
dell'Accademia.

111 Raphael, after Michelangelo. *Saint Matthew.* Pen
over black chalk. London, British Museum 1855-2-14-1v.

Now armed with Leonardo's weapons as well as his own talent, Raphael
challenged Michelangelo.

The *Entombment* was Raphael's first major commission since his move to
Florence, that is, his first altarpiece as opposed to portraits or private devo-
tional images. The patron was not a Florentine, however, but Perugian:
Atalanta Baglioni, who commissioned the painting as the altarpiece of her
son's funerary chapel in San Francesco al Prato in her native city.[77] As many as
twenty-one drawings for the Baglioni altarpiece survive – and there may have
been more – tracing the evolution of Raphael's composition.[78] What began as
a comparatively static scene of the Lamentation, with Christ's body on the
ground, became a narrative of the Entombment, with Christ's body carried
toward his sepulcher. Illustrating this progression, the drawings also reveal
the sequence of Raphael's borrowings, moving rapidly from Perugino to

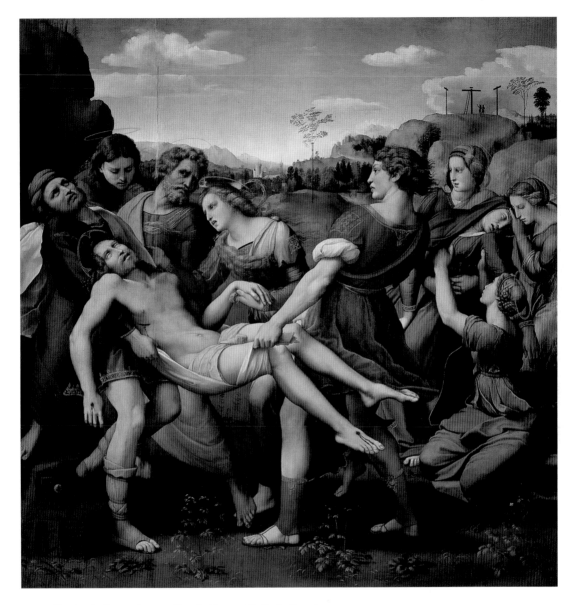

112 Raphael. *Entombment*. Panel. Rome, Galleria Borghese.

Michelangelo, as though in this one painting he were recapitulating the expe-
rience of his Florentine education.

Raphael began with Perugino's Pitti *Lamentation* in mind, then displayed in
the church of Santa Chiara in Florence: the body of Christ in Raphael's first
figure studies for the Baglioni altarpiece is almost a direct quotation of
Perugino's Savior (Figs. 113, 114).[79] The apparent return to his former master

113 Raphael. *Body of Christ*. Pen over stylus. Oxford, Ashmolean Museum 530v.

may seem surprising in relation to his conspicuous abandonment of Perugino's style during his Florentine sojourn. But the Baglioni *Entombment* was Raphael's first altarpiece commission since his move to Florence, his first altarpiece since the Ansidei *Madonna*, dated 1505. During the intervening years, he had had many occasions to perfect his Florentine Madonnas and portraits but no opportunity, until the Baglioni commission, to employ his new style in a large-scale work. His return to Perugino was brief, however. Raphael's first compositional study for his altarpiece (Paris, Louvre 3865) suggests that he was already thinking of Michelangelo's *Cascina* – not quoting it in any specific way, but rather, having learned from it how to compose and energize an active group of interrelated figures, transforming Perugino's stasis into a vibrant narrative.

Similarly, almost from the beginning and even while still thinking of a Peruginesque *Lamentation*, Raphael seems also to have consulted Michelangelo's unfinished *Entombment* and the Doni Tondo (Figs. 72, 83). From the *Entombment*, which he may have seen in Rome in 1503, he adapted the bearer seen from the back at Christ's left; from the tondo, he borrowed Mary – or most of her – for the holy woman seated at the right in three of the earlier sketches (Fig. 115).[80] But perhaps in this instance the derivation is not so straightforward. The seated woman's pose also recalls variants of the ancient *Crouching Venus*, represented in numerous examples and certainly known both to Michelangelo and to Raphael – and indeed to Leonardo, who had transformed the goddess into his *Kneeling Leda* (Figs. 116, 164).[81] In Michelangelo's version, crouching becomes sitting, with both of Mary's legs folded beneath

114 Pietro Perugino.
Lamentation. Panel.
Florence, Palazzo Pitti.

115 Raphael.
Lamentation. Pen over
stylus and black chalk.
Paris, Musée du Louvre
3865.

116 Anonymous Roman. *Crouching Venus* (Doidalsas type). Marble. London, British Museum, on loan from the Royal Collection.

her. The woman in the left foreground of his unfinished *Entombment* is also seated with her legs bent under her, though this figure lacks the torsion of the Doni *Madonna* and Raphael's adaptation of the pose in the Baglioni *Entombment*. Whether the two masters consulted the same ancient prototype for their spiraling seated figures is less important than the fact that Michelangelo had used the pose first, adjusting the placement of the legs. If Raphael's *Entombment* were a scholarly publication rather than a painting, he would have been honor-bound to footnote his source, "Ancient Kneeling Venus, as translated by Michelangelo in the Doni *Madonna* and the unfinished *Entombment*." The point is not merely academic but has to do with Raphael's response to his rival and his manner of artistic invention: before the move to Rome in 1508, Michelangelo was the lens through which Raphael saw antiquity. Michelangelo's Doni *Madonna* guided Raphael to his classical epiphany.

One might expect Raphael to move farther from his Michelangelesque source as he completed his composition, as indeed his borrowings from the Taddei Tondo and his sketches of the *David* suggest was (or had been) his practice. In the *Entombment*, however, he moved *closer* to Michelangelo, and eventually took from the Doni Tondo all of Mary's posture, including her arms, now raised to support the swooning Madonna in his own composition. The torsion of the woman's torso is more exaggerated than Mary's in the tondo, with her left arm made parallel with the picture plane and her face more in profile – a far more flattering view than Michelangelo had allowed his Madonna. The adaptation is typical of Raphael: not merely a quotation but a self-conscious translation, adapting the pose and action of the Mother who supports her Child in Michelangelo's tondo to a holy woman who helps support the Madonna in the *Entombment* – and does so with more grace than her prototype.

So Michelangelo's Madonna was in Raphael's mind almost from the start of his conception of his altarpiece. Then, as his theme changed from Lamentation to Entombment, Raphael turned to the sculptor's unfinished *Saint Matthew* and the Vatican *Pietà*. A sheet in the Ashmolean Museum records the change in subject but not yet the final pose of Christ's body.[82] Having redefined his subject,

Raphael found his example in Michelangelo's *Pietà*, a work he likely already knew firsthand. Three drawings document Raphael's knowledge and his debt, which became increasingly explicit as he moved toward completion of the *Entombment*.[83] At some point between making one sketch and another, Michelangelo's Christ became Raphael's. And at the same time, as the verso of the second sheet attests, Michelangelo's *Saint Matthew*, multiplied, became Raphael's bearers. Freeing Michelangelo's apostle from the stone – something the sculptor himself was unable to do – Raphael used the position of Matthew's legs for the first bearer, supporting Christ's torso at the left. Turning Matthew's bearded face toward the beholder, Raphael transformed it into the tragic visage of Saint Joseph of Arimathaea. Finally, adjusting the apostle's stepping motion to a wide stance, extending his powerful muscular arm from his body, and turning his back to the viewer, Raphael converted him into the heroic youthful bearer.

Raphael's metamorphosis of the Christ is more profound. One of Raphael's drawings is a copy of an ancient relief of the *Death of Meleager* similar to that now in the Museo Archeologico in Perugia.[84] But the relation of Christ's pose to ancient Meleager sarchophagi was secondary for Raphael: Michelangelo's *Pietà* was his primary reference. Awareness of an ancient pedigree presumably made the figure more attractive, but Michelangelo translated the idea for Raphael, making it viable for his composition. The line of the back now curves; the head that falls over the pronated right shoulder now turns more toward the beholder, who may feel deprived of the sight of Christ's visage in the *Pietà*. (In the statue, as in the *Madonna of the Stairs*, the Savior's face is turned from the viewer.) The right hand that seems supported by Mary's drapery here hangs in mid-air; the arms pulled farther from the torso by the action of one of the bearers; the left hand that lies on Christ's thigh is now held, pathetically, by Mary Magdalene. And the knees that bend almost in a sitting position around the Virgin's lap in the statue now are extended in a more horizontal position, appropriate to the action of the narrative. Even elements of Christ's physiognomy, his hair and his athletic body recall Michelangelo's sculpture. But the most remarkable of Raphael's borrowings is seen in a detail: the rippling contours of Christ's right arm are quoted almost exactly. Perhaps Raphael recalled Pliny's anecdote about the line drawn by Apelles? Apelles had traveled to Rhodes to meet Protogenes and study his works. "He went at once to his studio. The artist was not there but there was a panel [. . .] prepared for painting." The old woman in attendance asked Apelles who she should tell Protogenes had come to see him. " 'Say it was this person,' said Apelles, and taking up a brush he painted in colour across the panel an extremely fine line." Returning to his studio, Protogenes immediately recognized Apelles from this line; "and he himself, using another colour, drew a still finer line exactly on top of the first one." When Apelles called again and saw his rival's stroke, "ashamed to be beaten," he added a third line in another color, "leaving no room for any further display. [. . .] Hereupon Protogenes admitted he was defeated."[85]

An allusion to the anecdote is not so far-fetched as it might seem: Raphael's father had cited Pliny in his *Chronicle* and so presumably his son was aware of him; Michelangelo had learned of Pliny while living in the Medici household. Whether recollection of Pliny was purposeful or merely a coincidence, however, it explains what Raphael intended in his *Entombment*. The glyphic outline in the *Pietà*, very much Michelangelo's signature, is here made to sign Raphael's work. And Raphael signed it too with his name and the date, RAPHAEL URBINAS MDVII, on the stone step leading to the tomb (once again to be identified with the Stone of Unction). His name and date are thus displayed under the feet of one of Christ's older bearers, most likely representing Nicodemus, because he is without a halo, unlike the older Joseph of Arimathaea and the younger John the Evangelist behind him. In this way, the artist is identified with one of Christ's mourners who served the Savior by burying him. Is this a foreshadowing of Michelangelo's identification of himself with Nicodemus in the *Pietà* later made for his own tomb?

Raphael's name is also beneath Christ's dead hand, which in effect points to the signature, that is, the inscription of the maker's identity (a motif perhaps derived from Bellini). But the Christ is Michelangelo's invention, and so the relation between maker and image is more complicated, and indeed more secular, than a forthright expression of devotion. The hand carved by the sculptor now indicates the name of the painter.

An artist's signature generally appears in the lower right of a composition, or perhaps in the center. The placement of Raphael's name in the lower left is unexpected but bound to the meaning of the image, instructing the beholder to stop here, at the mouth of Christ's sepulcher. The right-to-left movement of Raphael's *Entombment*, punctuated by his signature, is counter-intuitive for Western narrative: the viewer, like the reader, expects movement from left to right. Raphael counterbalances the narrative progression toward the tomb with the group of the fainting Madonna and her companions. The figures suggest a zigzag or v-movement in space, with the figures in the center closest to the viewer and the flanking groups slightly farther back. This "v" in space is echoed by the "v" on the surface, defined by the torsos of Mary Magdalene, who yearns toward her Lord, and the youthful bearer, who bends away from him with the exertion of carrying his dead weight. The composition evokes Michelangelo's *Cascina*, not in its details, but in the underlying conception of heroic individuals bound by their extreme physical and psychological distress.

Raphael's predella for the *Entombment* underscores his allusions to Michelangelo while recalling his debts to Leonardo (Fig. 117). Representing the Theological Virtues as fictive statues set in niches and roundels, the predella evokes the *paragone* of painting and sculpture. The central Virtue, Charity, is turbaned like the Madonna in Michelangelo's *Taddei Tondo*; and one of the infants she nurtures repeats the motif of the Child's legs from that work, here tranquilized into an expression of infantile contentment. She also recalls the Pitti *Madonna*, but the composition itself is a monumental variant of

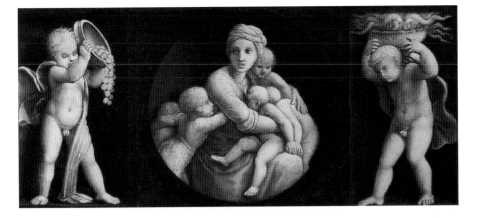

117 Raphael. *Charity*. Predella panel. Vatican City, Pinacoteca Vaticana.

Leonardo's pyramid, and the drapery patterns likewise seem beholden to Leonardo: thus Raphael leavened his allusions to Michelangelo.

Elements of Raphael's palette confirm his close observation of the Doni Tondo. He rejected Michelangelo's sharp tonalities just as he renounced the extremes of Leonardo's *chiaroscuro*, but for the holy woman and for Christ himself – that is, those figures in the altarpiece who are most indebted to Michelangelo – Raphael evoked Michelangelo's sharp white highlighting (in the loincloth) and *cangianti* (in the woman's garments). For the most part, however, in the *Entombment* as in other works, Raphael did not sacrifice his own luminous colorism or his painterly handling to Michelangelo's heightened palette and crystalline contours. Raphael also preserved his interest in landscape, always a significant element for the composition and the psychology of his works, but always minimalistic in Michelangelo.

The *Entombment* is indelibly marked (or perhaps determined) by Raphael's ambitions regarding his competition with Michelangelo, as the *Sposalizio* – dated, remarkably, only three years earlier – had declared Raphael's debt to Perugino and his transcendence of his first great rival. From Michelangelo's point of view, it may have seemed that as his own first rival, Leonardo, was withdrawing from the field, he was replaced by this younger, equally ambitious competitor. Their Florentine past became their Roman prologue.

Although the *Entombment* marked the beginning of Raphael's overt challenge to Michelangelo, it was not his first engagement with the sculptor. The paintings for Agnolo Doni, and perhaps the Madonnas for Taddeo Taddei, had already brought Michelangelo and Raphael together, or rather brought them to their first rivalrous confrontations. There is no evidence of what Doni might have intended by employing Michelangelo and Raphael – whether he engaged both masters for purely practical reasons or whether he perceived nascent

rivalry between them and hoped to benefit from this with simultaneous commissions. (Evidence regarding Taddei's intentions is even less certain.) In any case, the result was the same: a *de facto* competition between the two artists, the prelude to the more explicit rivalry in the more public, and much grander, commissions in Julius II's Rome. And unquestionably, the pope meant to profit from their agon when he set them to work within a few feet of each other in the Vatican Palace.

Giuliano della Rovere had been elevated to the papacy on 30 October 1503. Brother-in-law of Raphael's benefactor, Giovanna Feltria, he may well have heard of Raphael through her. Then too, Raphael had his own connection at the papal court: Bramante, like him, a citizen of Urbino.[86]

Bramante had already established himself in Rome, and demonstrated his genius, during the regime of Julius's despised predecessor, the Spanish pope Alexander VI. Associations with the pontiff brought the architect to the attention of representatives of King Ferdinand of Spain and led to the monarch's commission of Bramante's Tempietto at San Pietro in Montorio.[87] The Tempietto was the first round Renaissance building to revive the ancient motif of the colonnade encircling the cella and the first domed Renaissance building to establish an organic relation among all the elements from the ground up, in this regard evoking the Pantheon – and anticipating Raphael's Temple in the *Sposalizio*. Bramante's synthesis of classical and contemporary conceptions in such buildings as the Tempietto is tantamount to the invention of High Renaissance architecture, an achievement unequaled by any of his early sixteenth-century contemporaries.[88] Even Michelangelo, who loathed Bramante (the feeling was mutual), was compelled to admire him, though he waited some thirty-three years after the architect's death to express his appreciation: "One cannot deny that Bramante was as gifted in architecture as everyone else has ever been, from the ancients to now."[89] Similarly, in a *postilla* written next to Condivi's criticism of the architect's work in Rome, charging that he had used inferior materials that necessitated some rebuilding, Michelangelo said "I don't believe this of Bramante, but he had bad craftsmen in those times. And one didn't know then what one knows now in all the arts."[90]

The sophistication of Bramante's revival of classical antiquity had appealed to Pope Julius. His choice of this papal name, while obviously related to his baptismal name, Giuliano, was also intended to evoke the Roman Julius – Julius Caesar – as ruler of a Rome that would be once again, as in Caesar's time, *Caput mundi*. Such contemporaries as Francesco Guicciardini recognized the allusion and the announcement of the new pope's intentions that it signified.[91] So Julius overlooked Bramante's association with Alexander VI, despite his much-advertised hatred for his predecessor. Indeed, he so abhorred Alexander that Julius refused to live in the Borgia apartments – to which loathing we owe the Vatican Stanze, purposefully built above the apartments as Julius's private quarters.[92] And to Julius's familial ambitions (which he found so distasteful in the Borgia) we owe the Sistine ceiling, commissioned as the crowning glory of the chapel built and decorated by his uncle, Pope Sixtus IV della Rovere.

If Michelangelo is to be believed, he did not want any part in the decoration of the Sistine Chapel: he was a sculptor, not a painter, and had been called to Rome to execute the pope's tomb. Early in its planning, Michelangelo had begun to conceive the tomb as a monument to himself, that is, to his art. "[I]f it had been made after the first design," Condivi opined, "there is no doubt that in his art he would have taken pride of place (be it said without envy) over any other esteemed craftsman who ever was, having a wide field in which to show how much he was worth in this," the first, grandiose project for Julius's tomb.[93] The self-referential grandeur of his ambition – nurtured by the recent success of his *David* – is evident also in Michelangelo's dreams of making a new Colossus of Rhodes. Michelangelo's wry expression of regret about his unrealized colossus in Carrara reflects his ambition and his sorrow for other disappointments – commissions lost, like the *Hercules and Cacus*, or left incomplete, or, like Julius's tomb, completed but not to his satisfaction.

Michelangelo's being prevented from bringing the tomb to completion caused him considerable anguish – it was the "tragedy of the tomb," as he later described it to Condivi – as well as protracted legal difficulties with Julius's heirs in negotiations and renegotiations of the contract.[94] His troubles began as early as Easter 1506. On Holy Saturday, as he wrote to Giuliano da Sangallo on 2 May, Michelangelo had overheard the pope tell a jeweler and the master of ceremonies, Paris de Grassis, "that he did not want to spend another penny either on small stones or on large ones." Even so, the pope asked Michelangelo what he needed for his work, and as he was leaving, told him to return on Monday: "and I went back there on Monday and Tuesday and Wednesday and Thursday. [. . .] Finally, on Friday morning I was sent away, that is, chased out; and that so-and-so who threw me out said that he knew who I was but that he had been given this job," that is, to eject Michelangelo. That Saturday, 18 April, the first stone of Bramante's New Saint Peter's was set into place with great ceremony: Michelangelo's enemy was publicly celebrated and he "in great desperation." Were he to have stayed in Rome, Michelangelo added, his own tomb would have been made before the pope's.[95]

Michelangelo's thwarted ambitions for the pope's monument were inevitably bound to the commission for the Sistine ceiling – ultimately a triumph but a bane in 1506 when he probably began work on the design. The commission also caused him another disappointment, as great or greater than the enforced reduction of the Julius tomb, though Michelangelo did not publicize it in the same way. The enormous block of marble, intended for a colossal companion for Michelangelo's *David*, had been quarried in Carrara at some date before March 1507. Leaving Florence for Rome to undertake Julius's tomb necessitated abandoning the project for a second Giant, but Michelangelo had every reason, then, to believe that the block would eventually be his. In any case, postponing that commission to execute the pope's monument must have seemed well worthwhile in the early stages of the planning, when Michelangelo could imagine the tomb as a universe of major statues. The Sistine Chapel cost him dear. And if contemporary sources are to be believed, the commission was the

result of rivalry as Bramante, perhaps abetted by Raphael, sought to under-
mine Michelangelo's position. Condivi's account says as much. First, motivated
by "envy," Bramante conspired to persuade Julius to abandon plans for his
tomb by Michelangelo.[96] Then, "it was put into the pope's head by Bramante
and other imitators [*altri emuli*] of Michelangelo that Julius have him paint
the vault of the Sistine Chapel, [. . .] giving hope that in this he would perform
miracles. And this service they did with malice, to draw the pope away from
works of sculpture." Thus, almost casually, Condivi dismissed Bramante as
merely another imitator of Michelangelo. These *emuli* hoped, according
to Condivi, either that Michelangelo would refuse the commission, thus alien-
ating the pope, "or, accepting it, would succeed rather less than Raphael of
Urbino, to whom, because of odium for Michelangelo, they were lending every
favor, estimating that Michelangelo's principal art was (as in fact it was) stat-
uary. Michelangelo, who had not yet used colors and knew that painting a vault
was a difficult task, tried with every effort to excuse himself, proposing Raphael
and excusing himself because it was not his art." Michelangelo's eventual
triumph, however, is so extraordinary that it "places him above all envy."[97]

Condivi's scenario is probably true at least in part. While details regarding
the tomb were still being decided, and with Michelangelo in Florence, Bramante
profited from his absence, undermining the pope's confidence in the sculptor's
abilities. Writing to Michelangelo on 10 May 1506, the Florentine mason Piero
Rosselli recorded Bramante's machinations in a dinner-time conversation with
the pope the previous evening:

> I showed the pope certain drawings that we have to put to the test, Bramante
> and I. After the pope had dined, I showed them to him; he sent for Bramante
> and told him, "Sangallo is going to Florence tomorrow morning and will
> bring Michelangelo back." Bramante answered the pope and said: "Holy
> Father, he will not do anything, because I have had a lot to do with Michelan-
> gelo, and he has told me time and time again that he does not wish to take
> on the chapel, and that you wanted to give him such a commission, and that
> for a long time you have not wished to pay attention to anything if not to
> the tomb, and not to painting." And he [Bramante] said, "Holy Father, I
> believe that he does not have spirit enough, because he has not painted many
> figures, and mostly the figures [in the ceiling] are set high and in foreshort-
> ening, and that is a different thing from painting on ground level." Then the
> pope answered and said: "If he does not come, he does me wrong; I believe
> he will return therefore in any case." Then I interrupted and said to him
> [Bramante] a very great incivility, [. . .] and I said to him that which I believe
> you would have said for me; and for a while he didn't know how to respond,
> and it seemed to him to have spoken ill. And in addition I said: "Holy Father,
> he [Bramante] has never spoken with Michelangelo, and of that which he
> has now told you, if it's true, I want you to chop off my head: that he has
> never spoken about it to Michelangelo; and I believe that he [Michelangelo]
> will return at any moment, whenever Your Holiness will wish it." And there

the thing ended. I have no more to tell you. God protect you from evil. If there is anything I can do, let me know, I'll willingly do it.[98]

Rosselli had already done enough. In addition to Michelangelo's concern about intrigue at court and his frustration about being forced to abandon the tomb and the new Giant for the ceiling, there was also his anxiety about being compelled to compete with Raphael. Sometimes amusing, sometimes bitter, his complaints about painting the ceiling are motivated by a self-protective instinct, a kind of psychic camouflage to hide his anxiety from himself and from others. Every comment is permeated by his resentment of Raphael and Bramante. Bramante, whispering in the pope's ear, had suggested the ceiling commission in the first place, hoping that Michelangelo would fail and intending in any case to keep him from the tomb, which Bramante feared would be a triumph. That, at least, was Michelangelo's scenario, and he repeated it long after his antagonists had died. Writing to an unidentified monsignor in October 1542 – twenty-two years after Raphael's death – Michelangelo blamed him and Bramante for all the troubles that he had had with Julius. His complaint is an epigraph to this chapter: "All the discord that was born between Pope Julius and me was from the envy of Bramante and of Raphael of Urbino." A letter to a monsignor is only ostensibly a private communication: the writer might well expect his correspondence to be read by others at the papal court.[99]

Michelangelo also publicized his resentment by means of Condivi's biography. Bramante's and Raphael's envy had been exacerbated by the pope's friendliness with Michelangelo. Julius often visited him at home, talking about plans for the "tomb and other things, as he would have done with one of his brothers." Condivi's assertion is confirmed by one of Michelangelo's letters to his younger brother Buonarroto, dated 1 February 1507, reporting that the pope had visited "my house where I work, and showed that the thing pleased him," presumably referring to something for the tomb.[100] At the Vatican, the pope had a bridge constructed between the corridor and Michelangelo's room so that he might visit the artist secretly as he worked. "These many [. . .] favors were the cause, as often happens at courts, of bringing him envy, and after envy, infinite persecutions; so that the architect Bramante, who was loved by the pope, with telling him what hoi polloi usually say, that it was a bad omen to make his tomb in his lifetime, and other stories, [. . .] made him change his plan. Aside from envy, Bramante was stirred by the fear he had of Michelangelo's judgment."[101] Then, when the ceiling was unveiled in 1511 while still only half-complete (Michelangelo opposed the unveiling for this very reason), "Raphael, having seen the new and marvelous style, as one who was remarkable in imitation, sought through Bramante to paint the rest himself," that is, to displace Michelangelo and complete what he had begun.[102] "Michelangelo was much upset by this," Condivi continued, "and appearing before Pope Julius, solemnly lamented the injury that Bramante was doing him, and in his [Bramante's] presence, complained about this with the pope, revealing to him all the persecutions that he had received from the same Bramante."[103]

Vasari's story is similar. The details may be exaggerated or even invented, but Rosselli's letter of May 1506 confirms Bramante's scurrilous estimation of Michelangelo's skills as a painter and his attempt to undermine his rival's position at court. Whatever Bramante's role may have been – persuading the pope to abandon the tomb and to grant the ceiling commission to Michelangelo or attempting to dissuade him from allowing Michelangelo to complete it, so that Raphael might replace him – clearly he hoped the Florentine would fail.

Michelangelo himself feared as much. Writing to his father on 27 January 1509, for example, he complained that the pope had not paid him "un grosso" for a year, but that he did not ask "because my work does not progress in the way that seems to me to deserve it. And this is the difficulty of the work, and moreover it" – painting – "is not my profession. And so I lose my time without fruit. God help me."[104]

Michelangelo reiterated his despair in a witty, rueful sonnet addressed to his humanist friend Giovanni da Pistoia and illustrated in the margin with a sketch of the artist at work (Fig. 118):

> I've already got myself a goiter from this hardship
> Such as the water gives the cats in Lombardy,
> Or maybe it's in some other place;
> My belly is pushed by force underneath my chin.
> My beard toward Heaven, I feel the back of my skull
> Upon my neck, I'm getting a Harpy's breast;
> My brush, always dripping down above my face,
> Makes it a splendid floor.
> My loins have pushed into my tummy,
> And by counterweight, I make of my ass a horse's rump,
> And without eyes, move my steps in vain.
> Before me, my hide is stretching
> and to fold itself behind, ties itself in a knot,
> And I bend like a Syrian bow.
> Therefore deceptive and strange
> Issues the judgment that my mind produces,
> Because one aims badly with a warped pea-shooter.
> My dead picture
> Defend henceforth, Giovanni, and my honor,
> Because I am not in a good place, and I am not a painter.[105]

The marginal sketch represents Michelangelo nude and bent "like a Syrian bow" as he reaches above his head to paint a figure on the ceiling, indicated by a horizontal line at his fingertip. The composition combines two styles of drawing, sophisticated for the portrait of the artist, childish and giddy for his work in progress. Recognizing in this figure an allusion to God the Father in the *Creation of the Sun and Moon*, Irving Lavin has suggested that the sketch expresses Michelangelo's "sense of inadequacy."[106] Michelangelo did not mean to mock God with this purposefully silly drawing but rather himself, thereby

I o gia facto ugozo iquesto stento
chome fa lacqua agacti ilonbardia
over dalvro paese chessi chesisia
chaforza luetre apicha soctolmeto

Labarba alcielo ellamemoria sento
isullo scrignio especto fo darpia
espennel sopraluiso tuctania
melfa gocciando u riccho pavimeto

E lobi entrati miso nella peccia
e fo delcul p chotrapeso groppa
epassi seza gliochi muouo iuano

Di mazi misalluga lachoraccia
ep piegarsi adietro sragroppa
e tedomi comarcho soriano

po fallace estrano
surgie iludicio che lamete porta
ch mal sitra p cerboctana torta

lamia pictura morta

di fedi orma giouanni elmio onore
no sedo iloco bo ne io pictore

118 Michelangelo. Sonnet with drawing of the artist painting the Sistine ceiling. Pen and brown ink. Florence, Biblioteca Laurenziana, Archivio Buonarroti XIII, fol. 111.

elucidating the sardonic self-deprecation of his poem. As for the rendition of the painter, it is a portrait though not a likeness of Michelangelo: beardless, nude, and almost devoid of facial features, it resembles no one, and certainly not the maker, though it *represents* him. The obvious assurance of handling in this figure, amusingly and starkly in contrast with his own creation, representing the Father, belies the self-defamation explicit in the text and implicit in the drawing of his painting. This admixture of contradictory impulses – fear of public disapprobation ("My dead picture/Defend henceforth, Giovanni, and my honor") combined with self-assurance – is typical of Michelangelo, sure of himself, yet always in need of reassurance from others.

It is impossible to know how much of Michelangelo's complaining in the sonnet and in his contemporary letters was paranoia about Urbinate conspiracy theories, how much based on a realistic assessment of the competitive situation at the papal court, and how much self-protective "spinning." Most likely, to paraphrase the old joke, his paranoia was justified, and his complaints voiced at least in part with the intention of defanging critics by anticipating their criticism with a "diminished capacity" defense: I am not a painter. Such disclaimers would make his triumph all the more remarkable.

Willingly or not, Michelangelo presumably started to make preparatory sketches for the ceiling in 1506 (taking Rosselli's letter as an indication of the project's beginning), began preparatory work on 10 May 1508, and was apparently painting by the end of that year.[107] Repeating and perhaps exaggerating the penchant for secrecy that had characterized his practice in Florence, he tried to impose a closed-door policy in the Sistine Chapel. (According to Condivi, he even ground his own colors.[108]) Of course, in Rome as in Florence, the doors sometimes opened, with or without Michelangelo's approval. Julius himself kept close tabs on his progress, visiting often: Michelangelo would give him a helping hand to mount the scaffold.[109] According to Vasari, among the illicit intruders there was Raphael: "Bramante, having the keys to the chapel, let Raphael see it, as a friend, so that he could learn Michelangelo's methods." Raphael profited from this lesson, "immediately" repainting his *Isaiah* in the church of Sant'Agostino, though he had already finished the fresco; "in which work, thanks to the things by Michelangelo that he had seen, he improved and expanded his style and gave it greater majesty; so that later, when Michelangelo saw Raphael's work, he thought that Bramante, as was true, had done him that wrong in order to be useful to Raphael and his name."[110] Likewise, Raphael's *Sibyls* in the Chigi Chapel of Santa Maria della Pace were painted in "the new style, much more magnificent and grand than his first style," because Raphael had been able to see "Michelangelo's chapel before it was unveiled to the public."[111]

Even without Bramante's connivance, Raphael could have seen Michelangelo's ceiling in 1511 when the chapel was opened on 14 and 15 August for celebrations of the vigil and the feast of the Assumption of the Virgin, the Sistine's dedication. Paris de Grassis recorded the event in his diary, noting that the pope was in attendance to venerate the Madonna and to see

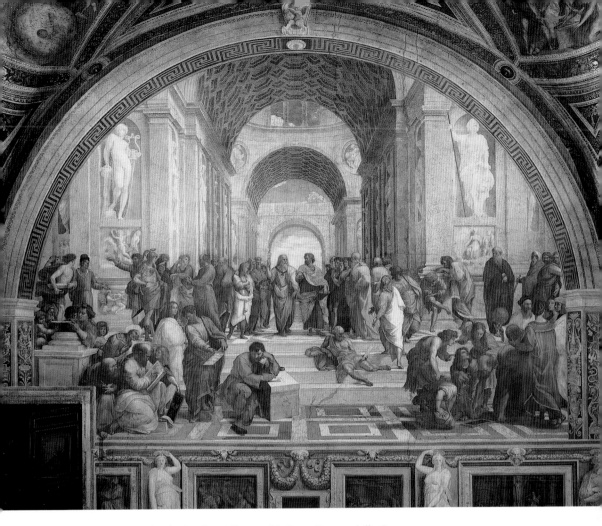

119 Raphael. *School of Athens*. Fresco. Vatican, Stanza della Segnatura.

"the new pictures."[112] The ceiling was not finished until more than a year later, in October 1512: "I have finished the chapel that I have been painting," Michelangelo wrote to his father; "the pope remains rather well satisfied."[113]

Meanwhile, since fall 1508, Raphael had been working next door in the Stanza della Segnatura, beginning where Sodoma had left off, with the painting of the vault. Raphael remembered another papal artist, painting Pinturicchio's portrait next to himself in the *School of Athens* (Figs. 119, 120). Bramante is also honored, represented in the guise of Euclid, and commemorated too in the structure of Raphael's illusionistic basilica. Written in gold on the neck of his garment are the letters RVSM, followed by apparently non-alphabetic markings. If the traditional interpretation of the inscription is correct, it is an abbreviation of the painter's signature, *Raphael Vrbinas Sua Manu* – perhaps the only instance of an artist's signing his name on another artist's portrait.[114] Although unobtrusive and perhaps not immediately

120 Raphael. Detail of Fig. 119. Raphael and
Pinturicchio.

understandable to the uninformed viewer, Raphael's inscription is nonetheless a remarkable acknowledgment of his debt to the older master. It may be seen as the reversal of the extravagant signature of the *Sposalizio*, similarly indebted to another master – Perugino – but which asserts independence to the point of denying the debt.

In addition to Bramante, a number of other contemporaries are also included in the *School*. But the most conspicuous portrait was an afterthought: the so-called Heraclitus seated in the left foreground, a likeness of Michelangelo, represented in Michelangelo's style (Fig. 121). More precisely, Heraclitus evokes the Prophets of the Sistine ceiling, replicating none of them exactly but coming closest in mood to the pensive figure of Jeremiah seated next to the *Separation of Light and Darkness* (Figs. 122, 123). Raphael's drawings for the mural trace the development of his thinking and allow one to pinpoint the moment of his addition of the Heraclitus – or rather, the moment before the addition, because the figure is absent from the otherwise very complete cartoon.[115] Examination of the fresco surface confirms that Raphael added the Heraclitus after he had completed the fresco, painting on a freshly applied section of plaster.[116] Indeed, he took great pains to add this portrait of his rival.

Although art historians have long recognized Michelangelo's style in the Heraclitus, some have been reluctant to recognize Michelangelo himself. In fact, the figure is a far more accurate likeness than Michelangelo's self-portrait that accompanies his sonnet addressed to Giovanni da Pistoia. Bearded, writing, brooding, leaning against a stone block, and somewhat unkempt – he alone wears high leather boots or leggings, more Renaissance than classical in design, which slip down his calves – of course Heraclitus represents Michelangelo, compelled to attend Raphael's school against his will.[117] The real question is whether Michelangelo represents Heraclitus. In any case, his classical identity is coincidental. He is Michelangelo in Michelangelesque guise, represented as a melancholy genius, an apt description of the man employing an imagery

121 Raphael. Detail of Fig. 119. Heraclitus/Michelangelo.

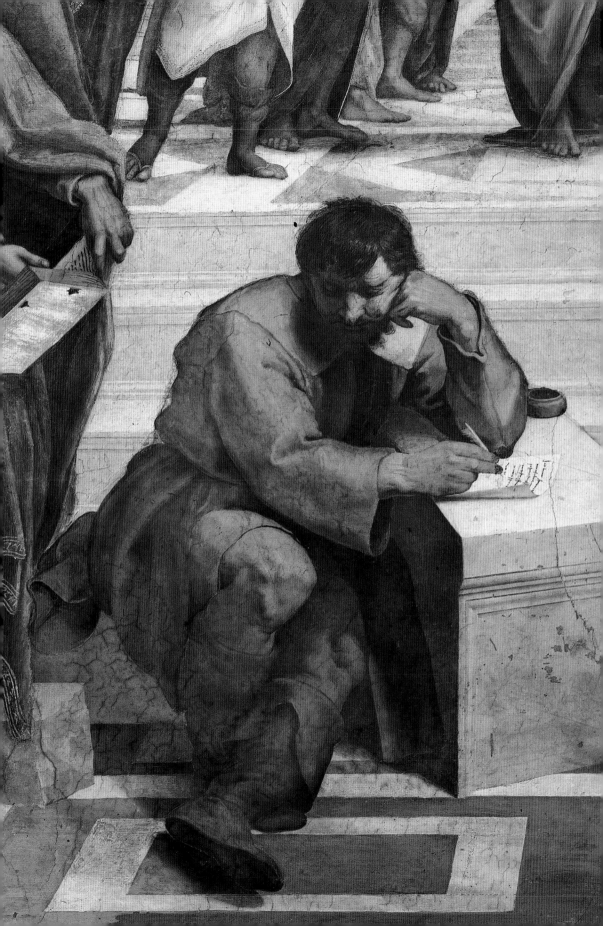

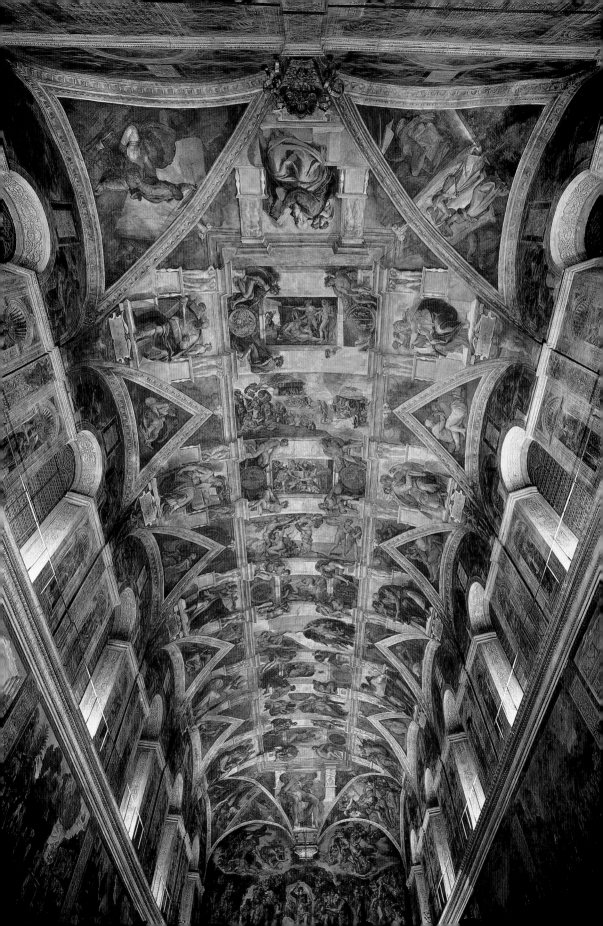

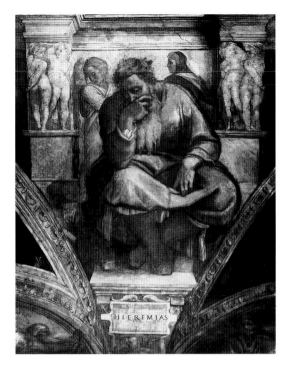

123 Michelangelo. Detail of Fig. 122. Jeremiah. 124 Albrecht Dürer. *Melencolia I*. Engraving. Paris, Musée du Petit Palais.

familiar to contemporaries, intellectually and psychologically isolated though surrounded by a society of great men.

Perhaps the most famous melancholic genius in art, if not in life, and one likely known to Michelangelo and to Raphael, is Dürer's *Melencolia I* (Fig. 124). Indeed, Raphael and Dürer exchanged gifts and admiration: the German sent a portrait head in "tribute" to Raphael, who thought it marvelous and reciprocated with the gift of a number of his own drawings.[118] Paralyzed by too much black gall, the source of both her genius and her paralysis, Melencolia sits, brooding, unable to complete her work. Privately, Michelangelo might admit to "my melancholy [. . .] or rather [. . .] my madness."[119] But public display is another matter. Perhaps recognizing in Raphael's fresco the dual allusions to himself and to the German engraving, Michelangelo later avenged himself by criticizing Dürer's writings to Condivi; his own concepts would have made for a "much more beautiful and useful" treatise.[120]

Raphael's melancholic portrait of Michelangelo might well be seen as self-contradictory and double-edged. A graceful and clever acknowledgment of the Florentine's great achievement in the Sistine Chapel, the portrait is also a reminder of his conspicuous failure to finish the *Battle of Cascina*, the *Saint*

122 Michelangelo. Ceiling fresco. Vatican, Sistine Chapel.

Matthew (not to mention the others of the Twelve Apostles), and the projects that Michelangelo himself may already have feared he would be unable to complete, namely the colossus to accompany his *David* and the tomb for Julius II. As David Rosand has recognized, the portrait is understood also in relation to Raphael's self-portrait: "The *terribilità* of the one needed to be countered by the *grazia* of the other."[121] This is a dark interpretation of the "Heraclitus," and it may not have been Raphael's intention to criticize Michelangelo but only to honor him. Indeed, Michelangelo's champions make Raphael do so explicitly. "To whom does Michelangelo yield?" Condivi asked rhetorically, answering: "By the judgment of men of the art, certainly to no one." Indeed, Condivi continued, Michelangelo's achievements are so remarkable that "this man has overcome envy," and even Raphael, though aspiring to rival him, "often thanked God that he was born in Michelangelo's time."[122]

Benedetto Varchi reiterated Raphael's orison in Michelangelo's funerary oration in 1564: "And Raphael of Urbino, who would have been first in painting (if not for Buonarroti), for all that he had wished to compete with him, nonetheless confessed that he had an immortal obligation to Buonarroti; and he thanked God that he was born and lived in the time of such a great man."[123] Whether Raphael ever voiced such praise or thanked the deity for Michelangelo, the anecdotes reflect his high regard for the Florentine, an esteem Raphael certainly expressed visually in his art if not verbally. Raphael's most overt quotation is his *God the Father Appearing to Moses* (Fig. 125) in the vault of the Stanza d'Eliodoro: Raphael took Michelangelo's God for his own, amalgamating several of the figures from the Sistine Chapel. (Michelangelo was quoting himself: the gesture of God's right hand in the *Creation of Adam* is essentially that of his left hand in the *Creation of the Spheres*.) God's right hand, charging Adam with the spark of life in the *Creation*, is now his left hand, pointing Moses toward Egypt; the arms that are raised to command the

125 Raphael. *God the Father Appearing to Moses*. Fresco. Vatican, Stanza d'Eliodoro, vault.

Separation of Light and Darkness and the *Separation of the Waters*, and the left arm that embraces the yet uncreated Eve in the *Creation of Adam* are compounded to become God's right hand raised to command Moses.[124] The twisting of the torso, the profile head, and the flying beard all derive from the Creator in that scene, but Raphael concealed the lower part of the body in a burst of flames to represent the Burning Bush.[125]

Although contemporaries were silent on the matter, Raphael may also have honored Michelangelo more directly, in a portrait unblemished by the possible equivocations of the Heraclitus. Michelangelo's features have been recognized in the face of the bearded poet at the right of the *Parnassus*.[126] Crowned with laurel and standing beneath a laurel tree, he is one of only two figures to address the beholder directly. The other, at the extreme right, has been identified as the poet Jacopo Sannazaro, whose *Arcadia* was first published in Venice in 1504. According to Vasari, Sannazaro is represented in the *Parnassus*, and this man's resemblance to the poet's portrait medal seems to confirm his identity.[127] Similarly, the bearded poet bears a general resemblance to portraits of Michelangelo. If this is indeed his likeness, he should have had no cause to complain about such an exquisite compliment from Raphael. But Michelangelo did complain, bitterly. And he also took action against his adversary.

Michelangelo's dislike of Bramante, his resentment of Raphael, and his sense that he was outnumbered and sometimes outmaneuvered by them led him to seek, or recognize, an ally in Sebastiano Veneziano (Sebastiano Luciani, later del Piombo), newly arrived in Rome in 1511. Collaboration with the Venetian painter marks the beginning of Michelangelo's use of proxies in his rivalries. Each master could perceive in the other one whose greatest strength was in fact his own greatest weakness: Michelangelo could endow Sebastiano's art with a superior command of Florentine *disegno*, and conversely, Sebastiano could imbue Michelangelo's art with richer *colorito* – expressive color, not coincidentally, being precisely that element that contemporaries considered Raphael's strength and Michelangelo's weakness. Condivi alluded to the problem, without, of course, implying any shortcoming on his protagonist's part – only his inexperience. Vasari was more blunt. Describing the *Last Judgment*, he praised Michelangelo's unsurpassed mastery in depicting "the human body [. . .] and attending only to this end, he has left aside the charms of colors [*le vaghezze de' colori*]."[128] Raphael, conversely, has charming color but cannot compete with Michelangelo's perfection in depicting the male nude.[129] Similarly, Paolo Giovio, while praising Raphael's works for "that particular beauty [*venustas*] that they call grace," added that he was sometimes "excessive" in the way he defined musculature; nor did he observe exactly the rules of perspective. But in his splendid handling of color and light he succeeded precisely with that single quality that was lacking in Michelangelo."[130]

Sebastiano could compensate for this perceived deficiency. From Michelangelo's point of view, moreover, another great advantage of their loose partnership was that with Sebastiano as his *locum tenens*, he could compete indirectly and from afar (from 1516 until 1534, Michelangelo resided mostly

in Florence). This suited Michelangelo's aversion to direct confrontation. Unlike himself, Sebastiano was a natural courtier, better able to ingratiate himself with the Medici popes who succeeded Julius – Leo in 1513, Clement in 1523 – than Michelangelo, despite Michelangelo's long-standing connection with the family. Michelangelo had spent, by his account, the happiest years of his youth in the household of Leo's father, Lorenzo il Magnifico, but never felt certain of Medici goodwill, seeking constant reassurance from friends in Rome. Thus Leonardo Sellaio wrote from Rome on 23 October 1518 to comfort Michelangelo in Florence: Cardinal Giulio de' Medici – Leo's cousin and eventual successor as Clement VII – has most willingly read Michelangelo's letter and has resolved that his plans for San Lorenzo are to be followed, and the pope also has the will to do it. "So do not have any doubts and proceed in good spirit, and do not worry about future annoyances. The cardinal doesn't put faith in anyone or believe anyone who speaks ill of you, even if there are a number of them, and great men, and he makes jokes of them. But it is necessary that you make liars of them. [. . .] And comfort yourself and be cheerful, to complete this work and serve such a man who wishes you well as a brother."[131]

As for Sebastiano, in Vasari's view, he needed the competition with Raphael as a spur. The brutal opening paragraph of his life in the 1550 edition describes Sebastiano as "a most excellent painter who was too well rewarded" – referring to his holding the office of the Papal Seal, the Piombo – so that he became "slothful and most negligent, whereas while the competition (gara) of art between him and Raphael lasted, [. . .] he tired himself continuously, so as not to be held inferior." Without that stimulus, Sebastiano became lazy, "working most unwillingly." There is, in consequence, a great disparity between his earlier and his later works.[132] In the second edition, Vasari excised this paragraph, beginning instead with a reference to Sebastiano's musicality that makes a similar point about his dedication to art, but more gently: "The first profession of Sebastiano, according to what many affirm, was not painting but music."[133] The implication is that the musician should have stuck to his G-string.

Dolce was equally dismissive, having both interlocutors, Pietro Aretino and Fabrini, skewer the painter. Aretino avows that "he does not wish to infer [. . .] that Sebastiano was not a good enough painter," meaning, of course, exactly the opposite. "Everyone knows, moreover, that Michelangelo made drawings for him. [. . .] I remember that when Sebastiano was being pushed by Michelangelo into competition with Raphael, Raphael used to say to me, 'Oh, how delighted I am, Messer Pietro, that Michelangelo helps this new rival, making drawings for him with his own hand; because from the repute that his pictures do not stand up to the *paragone* with mine, Michelangelo will see quite clearly that I do not conquer Sebastiano (because there would be little praise to me to defeat one who does not know how to draw) but Michelangelo himself, who (and rightly) is held to be the Idea of *disegno*." Fabrini replies, "It is true that Sebastiano did not joust as an equal with Raphael even when he had in hand Michelangelo's lance."[134] Living in Rome from c. 1516, the real

Aretino had indeed been friendly with Raphael, but Aretino and Sebastiano were also close, and like both painters, Aretino was employed by Chigi.[135]

Whatever the merits of Dolce's and Vasari's aesthetics and history, Sebastiano undeniably had much more to gain than Michelangelo from their association. In 1511, when Sebastiano arrived in Rome, Michelangelo was already well established there and indeed throughout Italy, already lauded as one of the defining masters of their age. According to Piero Soderini, for example, writing to the cardinal of Volterra in 1506, Michelangelo was uniquely talented – and for this reason, worth the tender care his ego required: "We certify that Your Lordship will find him to be a fine young man [*bravo giovane*], and in his craft alone [*nel mestieri suo l'unico*] in Italy, likewise perhaps in the universe. We cannot recommend him more strongly: he is of the sort who with good words and stroking [*colle buone parole et colla carezza*], if one gives them to him, will do anything; it is necessary to show him love, and do him kindnesses, and he will do things that will amaze whoever sees them. [. . .] he has begun a narrative [*storia*] for the city [*il pubblico*] that will be an admirable thing, and thus the Twelve Apostles, [. . .] which will be an egregious work."[136] The letter was a *laissez-passer*, one of several Michelangelo carried with him as he travelled to meet Julius II in Bologna, "with a leash around my neck to beg his pardon."[137] The gist of Soderini's description is that if not treated kindly, Michelangelo will not perform – a quid pro quo that can be taken for granted today but which in the early sixteenth century required explanation. One might have assumed, in 1506, that a craftsman would fulfill his obligations whether loved by his patron or not, and especially when his patron was the pope.

As for Sebastiano, he had left Venice for Rome in August 1511 in the company of Agostino Chigi, the pope's banker and one of the richest men in Europe.[138] When they arrived, the Sistine Chapel was probably no longer open to the public, after the partial unveiling for the feast of the Assumption on 14 and 15 August, but surely they heard talk of it and perhaps (given Chigi's connections) were permitted to visit it before its completion. Meanwhile, Raphael had almost finished the Stanza della Segnatura, dating it twice with identical inscriptions commemorating the patron, written (appropriately) under *Parnassus* and under the *Virtues*: JULIUS II LIGUR PONT MAX ANN CHRIST MDXI PONTIFICAT SUI VIII.[139] It is impossible to exaggerate the impact of these two great cycles on Sebastiano (among other artists), or on such a perceptive and ambitious patron as Chigi.

Sebastiano apparently set to work as soon as he arrived in Rome, painting eight fresco lunettes in the Sala di Galatea, the garden loggia of Chigi's newly constructed villa (now the Villa Farnesina). The painter had completed most or all of the lunettes before January 1512, when the poet Blosio Palladio took note of them in a laudatory work about Chigi.[140] The poet did not mention the walls where Sebastiano's *Polyphemus* yearns for Raphael's *Galatea* (Figs. 126, 128, 129). The murals were evidently begun after the publication of the poem and completed by 1514. Thereafter, Chigi abandoned plans for further frescoes in the room, and when he returned his attention to the villa's decoration some

four years later, he chose Raphael – not Sebastiano – to paint the entrance loggia with stories of Cupid and Psyche.[141]

Whether the two masters worked side by side on their adjacent frescoes is not documented but would seem to have been unavoidable at least during part of the two-year period when their murals were painted. Raphael and Sebastiano represented two simultaneous episodes of a narrative: as Ovid reported and Poliziano repeated, Polyphemus serenades Galatea as she rides the waves (it is a long song: *Metamorphoses* XIII.789–869).[142] Competing with each other, the frescoes perforce compete also with their literary source(s). Perhaps Chigi intended to set the two painters to work not with but against each other, in the kind of rivalrous situation memorialized in the unrealized plans for the decoration of the Sala del Gran Consiglio in Florence. There is a further similarity between the two projects, revealing though coincidental. As in the Florentine hall, in Chigi's Sala di Galatea the frescoes are related thematically, but neither attempts to accommodate its pendant visually. Galatea's *contrapposto* suggests a statue whose action seems frozen despite the illustration of her means of locomotion, in opposition to Polyphemus's *contrapposto*, which implies imminent action despite his being seated. The confrontation is poignant: Sebastiano's monstrous giant looks with unrequited longing at Raphael's nymph. She is self-contained though accompanied by putti, triton, and nymph; he is responsive though alone.

The stylistic disparity between *Polyphemus* and *Galatea* has often been noted with disapproval, and usually considered a failing on Sebastiano's part. But the disparity may have been intended as a purposeful confrontation of their two styles – or rather, the art of Raphael in confrontation with that of

126 (*facing page*) Rome, Villa Farnesina, Stanza di Galatea, detail of wall with *Polyphemus* and *Galatea*.

127 Sebastiano del Piombo. San Giovanni Crisostomo altarpiece. Panel. Venice, San Giovanni Crisostomo.

Michelangelo as interpreted by Sebastiano, because the *Polyphemus* represents the Venetian's first adaptation of the Florentine's art. Whether Sebastiano and Michelangelo had already met by the time Sebastiano was working on his Cyclops, he had begun to learn from Michelangelo's example, combining Venetian elements – colorism and the observation of luminous atmospheric effects in a landscape setting – with Michelangelo's Florentine grandeur and virtuostic treatment of a heroic nude. The *Ignudi* were Sebastiano's specific point of reference. As Raphael combined several images of Michelangelo's God the Father for his own Father in the Stanza d'Eliodoro ceiling, Sebastiano combined several *Ignudi*, evoking all of them though not replicating any one of them exactly for the *Polyphemus*.[143]

The Cyclops' physique and his complex pose, implying forceful movement in the seated figure, are Michelangelesque; but his psychology is Venetian. His lips are parted as his singing changes to a cry, and his face is shadowed to suggest the depth of his emotion. Back in Venice, the elderly Bellini and Sebastiano's young friends and former colleagues, Giorgione and Titian, were exploiting similar motifs in both sacred and secular works to convey powerful feelings without defining them precisely. These paintings leave emotional specificity to the beholder, whose feelings are engaged by means of sight, as the viewer tries to penetrate the shadow, to complete the image in such figures as

128 Sebastiano del Piombo. *Polyphemus*. Fresco. Rome, Villa Farnesina, Stanza di Galatea.

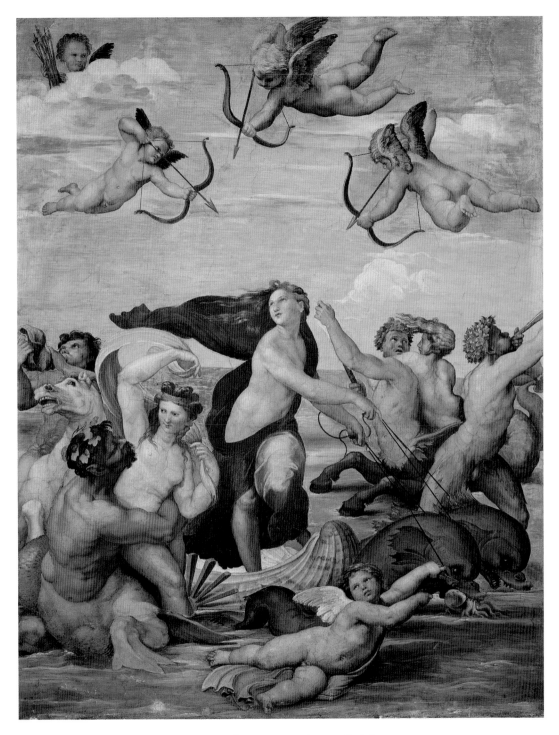

129 Raphael. *Galatea*. Fresco. Rome, Villa Farnesina, Stanza di Galatea.

the Saint Peter in Bellini's San Zaccaria altarpiece of 1505, the Mark of Titian's *Saint Mark* altarpiece of c. 1510, or the musician of Giorgione's *Boy with a Flute*, also c. 1510. Indeed, the titular saint of the San Giovanni Crisostomo altarpiece by Sebastiano himself, completed just before his departure for Rome, prefigures the shadowed profile of the Cyclops, though not his mood: the saint is calm, Polyphemus agitated, as every straining muscle confirms (Fig. 127). But his shadowed face dignifies him, blurring the brutality of his features and making him ominous. It invites the beholder to sympathize with his plight and to anticipate his dreadful retribution. The beholder sees Galatea's frolicking avoidance of her monstrous suitor, sees his distress that his piping and his courtship have been rejected, sees him lower his pipes having completed his serenade – and knows that the story does not end there. Having read Ovid or Poliziano, the beholder knows what the nymphs and tritons do not suspect, and what Polyphemus himself has just begun to realize: Galatea's "triumph" is ephemeral, and the Cyclops will avenge himself, crushing his rival, Galatea's beloved Acis. The shadow foreshadows this tragedy.

Vasari interpreted the Chigi commissions as a three-way rivalry: "Sebastiano [. . .] sought to advance himself as much as he could, spurred by the competition [*concorrenza*] with Baldassare Peruzzi" – architect of the villa who had also painted the vault – "and then with Raphael."[144] Sebastiano and Peruzzi were friends, however. It was surely Raphael whom Sebastiano recognized as his principal if not sole rival in the Chigi villa, and Michelangelo whom he already perceived as his ally, as the *Polyphemus* reveals.

Raphael was hardly oblivious to the competition but expressed his rivalry indirectly and with considerable grace by means of a letter addressed in 1514 to his friend Castiglione – though it may be more correct to say that Castiglione alluded to this artistic agon on Raphael's behalf by ghosting this letter. Raphael was (ostensibly) replying to Castiglione's praise of *Galatea*: "I tell you that to paint one beauty, it is necessary for me to see several beauties, with this condition, that Your Lordship be with me to make the selection of the best. But there being a dearth of good judges and of beautiful women, I make use of a certain Idea that comes to my mind. Whether this has any excellence in it, I do not know; though I push myself to get it."[145] This letter has often and rightly been read in relation to Pliny's anecdote (*Natural History* XXXV.64) about Zeuxis and his multiple models: many beauties posed that the artist might paint one beauty.[146] As Clark Hulse has recognized, however, the passage is "too vague and too conventional to bear any weight as a serious statement about Raphael's compositional habits or the nature of his artistic representation." Rather, "It is a skillful mystification of the creative process by which Raphael comes up with, originates, and thereby owns the beautiful images he produces."[147] To this perceptive analysis, one may add that Castiglione had Raphael cite the *Galatea* as a case in point for a particular reason: in 1514, she best embodied the painter's agon with Sebastiano and Michelangelo, and indeed continued to do so until Raphael painted his last work, the *Transfiguration*, in rivalry with Sebastiano's (and Michelangelo's) *Raising of Lazarus*.

However indebted to Michelangelo and whatever the nature of Michelangelo's assistance (direct or indirect, by means of Sebastiano's observation of the Sistine Chapel), the *Polyphemus* was Sebastiano's commission. There is no evidence that Chigi, hiring Sebastiano, anticipated a Michelangelesque result, or that he had solicited Michelangelo's involvement, as later patrons were to do. For them, the expectation of Michelangelo's involvement in the design became critical to Sebastiano's receiving a commission, in particular for sacred subjects. Not for portraits, however: portraiture was a Venetian specialty and one of Sebastiano's particular strengths.[148] Sebastiano painted his portraits without any contribution from Michelangelo; but after the Venetian's move to Rome, nearly every sacred work was based on Michelangelo's designs. Rivalry determined Sebastiano's career as a religious painter – and the rival was Raphael.

The Viterbo *Pietà* marks the "official" beginning of Michelangelo's collaboration with Sebastiano and their competition with Raphael: the Florentine supplied the preparatory drawings, the Venetian executed the painting itself, providing the heroic figures with a nocturnal landscape illuminated by white moonlight (Fig. 130).[149] Combining the Florentine's *disegno*, his heroic nude, and the massive, masculinized figure of the Madonna with the Venetian's *colorito*, the *Pietà* is Michelangelo's and Sebastiano's answer to Raphael, in particular, the challenge of Raphael's own moonlit nocturne, the *Liberation of Saint Peter*, completed in 1514 in the Stanza d'Eliodoro (Fig. 131). (The fresco is dated 1514, the second year of Leo x's papacy, as the inscriptions explain; but it had been commissioned by his predecessor, Julius ii.) In effect, their partnership replicated Michelangelo's *de facto* but unwilling relationship to (not with) Raphael, who took Michelangelo's figures for his paintings without his blessing. Despite such provocation from his rival, Condivi asserted that Michelangelo "was never envious of the efforts of others, even in his art, more because of goodness of nature than because of the opinion that he had of himself. Indeed, he has always universally praised everyone, even Raphael of Urbino, between whom and himself there was already some competition (*contesta*) in painting, as I have written. Only I have heard him say that Raphael did not have this art from nature but from long study."[150] And what Raphael principally studied, one is repeatedly reminded, was the work of Michelangelo. Indeed, according to Sebastiano, even Cardinal Giulio de' Medici and Pope Leo shared Michelangelo's view of Raphael's debt.[151]

No doubt the cardinal and the pope admired Michelangelo, but during Raphael's lifetime, Giulio's and especially Leo's actions spoke louder than their words. Although (because?) Leo and Michelangelo had known each other since 1492, when the artist was living in the Medici household, the pope consistently and conspicuously favored Raphael during his lifetime and his *garzoni* after his death. In August 1514 Raphael inherited Bramante's position as architect of Saint Peter's. (Raphael was assisted by Fra Giocondo from September 1514 until the cleric's death the following year.) On 27 August 1515 Raphael became the pope's Commissary of Antiquities. And earlier in that same year Leo

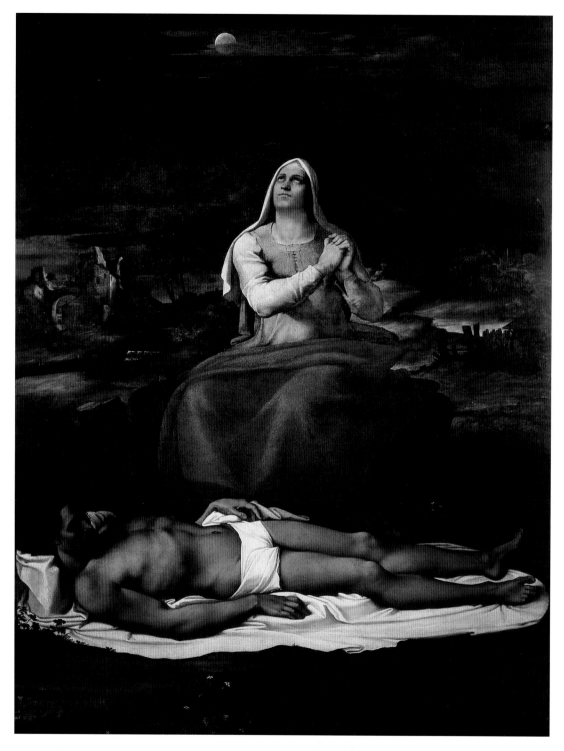

130 Sebastiaǹo del Piombo. *Pietà*. Panel. Viterbo, Museo Civico.

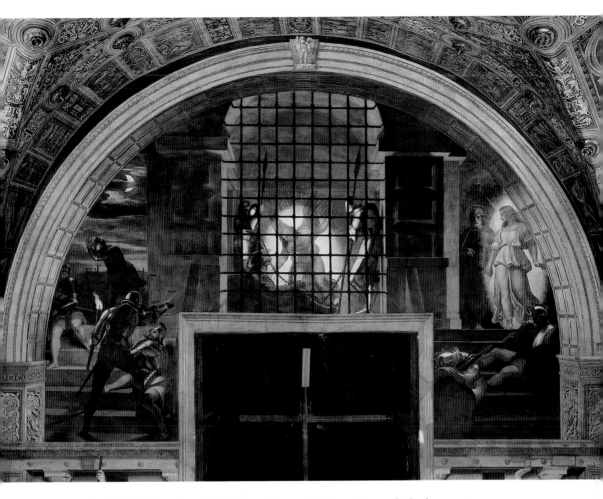

131 Raphael. *Liberation of Saint Peter*. Fresco. Vatican, Stanza d'Eliodoro.

commissioned Raphael to make a set of tapestries for the Sistine Chapel, representing the lives of Saints Peter and Paul (Fig. 132). Raphael received an initial payment on 15 June 1515, and the tapestries were displayed in the chapel for the first time on 26 December 1519.[152] Installed on the lower register of the chapel walls, Raphael's cycle of Saints Peter and Paul would now compete directly with Michelangelo's ceiling.

Michelangelo, meanwhile, concentrated on Julius II's tomb, completing the *Moses* and two *Slaves*. When Leo made known his interest in commissioning a façade for San Lorenzo, the Medici family church in Florence, Michelangelo found his opportunity to compete with Raphael indirectly while escaping from his shadow in Rome.[153] As Michelangelo conceived it, the project would enable him to demonstrate his mastery not only in sculpture but in architecture. In

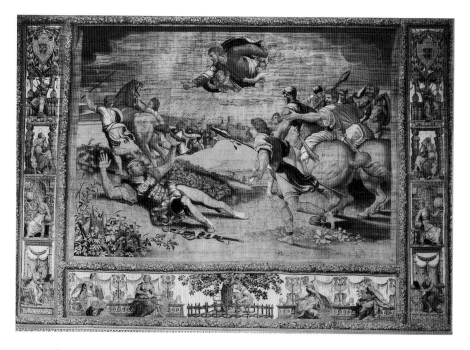

132 After Raphael. *Conversion of Saul (Saint Paul).* Tapestry. Mantua, Palazzo Ducale.

this regard, the San Lorenzo façade would have been the monumental fulfill-ment of his first, ambitious and thwarted plans for Julius's tomb, which like-wise combined those two arts, with architecture providing the enframement for his sculpture (Figs. 133, 134).

The San Lorenzo commission was not Michelangelo's for the asking, however, despite Condivi's bland account: Leo, wanting to furnish the church with a marble façade, thought of Michelangelo, "and sending for him, had him make a design."[154] According to Vasari's more accurate report, Leo staged a competition for the façade, involving Michelangelo's nemesis, "the elegant Raphael"; Bramante's protégé, Jacopo Sansovino; Andrea Sansovino; Michelangelo's friend, Antonio da Sangallo il Vecchio; and his sometime collaborator, Baccio d'Agnolo.[155] (Giuliano da Sangallo also made drawings for the project shortly before his death.[156]) At first, Michelangelo himself was not being considered for the project – though he devoutly wished it, as he made clear to his well-placed supporter (and later, his enemy), Domenico Buoninsegni.[157] Cardinal Giulio's secretary-treasurer, Buoninsegni intervened on behalf of Michelangelo and Baccio d'Agnolo. The façade would be Michelangelo's first major architectural commission; his potential patrons and perhaps he himself may have felt the need for an experienced colleague. Baccio was to design the architecture itself, and Michelangelo would concen-trate on the sculptural decoration.

133 Michelangelo.
Study for the tomb of
Julius II. Pen, brown
wash, over slight traces
of black chalk. New
York, The Metropolitan
Museum of Art, Rogers
Fund, 1962. (62.93.1).

Writing to Baccio d'Agnolo on 7 October 1516, Buoninsegni reported that
he had spoken to Cardinal Giulio about the façade, and that the cardinal in
turn would be speaking with the pope, being content that the commission be
awarded to Baccio and Michelangelo. Now everything depended on them: "But
it would be necessary that you come to find the pope before the court returns
to Rome [. . .] better that the matter be concluded here," at Montefiascone. The
cardinal also considered this to be the best course of action, which suggests
that the conspirators were concerned that once back in Rome, the pope might
be persuaded to award the commission to others. "And if you come, find some
excuse, so that it will not appear that you come for this matter, so that no one
may be able to divine your affairs."[158]
Baccio forwarded Buoninsegni's missive to Michelangelo in Carrara a week
later with a deferential covering letter: you will advise me what you think

134 Michelangelo. Study for the façade of San Lorenzo (first design). Pen, brown ink and wash over black chalk. Florence, Casa Buonarroti 45A.

should be done, and I shall do it.[159] Michelangelo was apparently in conflict about the project, very much wanting the commission though concerned that it would take him from the Julius tomb (at least according to Condivi's account). On 3 November Buoninsegni wrote to Michelangelo, still in Carrara, explaining that Cardinal Giulio had spoken with Leo, and that he himself understood that "for the pope, it will be sufficient that the principal figures be from your hand, and of the others, that you assign them to those whom you consider will be satisfactory; [the pope] intending that you make their models, and thus that you correct [the other sculptors' work] if you see that they make some mistake." Everything will go according to plan, he added, "given that Baccio come here," to Rome, "or truly that Baccio come together with you;" but since Michelangelo seems not to want to come to Rome, Baccio should come "and above all, he should come soon." After discussing money and the quarries at Pietrasanta, Buoninsegni concluded his letter with some (more) urgency: "to me it seems that by no means must you lose this occasion to get this commission," which was bound to be a very lucrative one.[160]

Michelangelo still seemed to be dragging his feet. Three days later, 6 November, Baccio wrote urging him to collaborate: he, Baccio, cannot do anything without him.[161] Notwithstanding all this prodding, work did not proceed apace, and on 21 November 1516 Buoninsegni chastised Michelangelo. After all, he had intervened with the pope and the cardinal on Michelangelo's behalf, but would do nothing more unless Michelangelo himself took action. Furthermore, Michelangelo and Baccio should not complain that non-Florentines were obtaining plum commissions as they themselves were procrastinating about this one.[162] The implication seemed to be that that most conspicuous "non-Florentine," Raphael of Urbino, would win the façade commission if they continued to delay.[163]

Buoninsegni wrote yet again on 19 and 21 November, and finally Michelangelo bestirred himself, arriving in Rome within the week.[164] Their efforts were rewarded by a contract for the façade, the work to be shared by Michelangelo and Baccio. They were to produce two models, one to be sent to the pope. Baccio set to work promptly (by 7 January 1517), and had completed the model on 7 March when Bernardo Niccolini, treasurer to the Archbishop of Florence, wrote to Michelangelo about his seeing it before they sent it on to Pope Leo.[165] Michelangelo did not like what he saw, as he reported to Buoninsegni in a letter from Florence, dated 20 March 1517: it is "a thing for children," *una cosa da fanciulli*. He was returning to Carrara with la Grassa, that is, the stone cutter Francesco di Giovanni, "there to make a model of clay, according to the design." Michelangelo was uncertain, however, whether this new model would be satisfactory, complaining "I believe that it will be necessary in the end that it be made by me. I am saddened by this affair because of my respect for the cardinal and the pope. I cannot do otherwise." In other words, it was too bad for his patrons, but Michelangelo would not proceed on the basis of Baccio's toy.[166] Thus Michelangelo effectively ended his collaboration with Baccio. Although disappointed with the delay, the pope and the cardinal declared that Michelangelo might work with whomever he pleased, but "with all haste, that you make said model" – his own model – "and send it as soon as possible."[167]

Michelangelo's reply was another of his self-justifying letters, at once enigmatic and revealing. Writing to Buoninsegni from Carrara on 2 May 1517, Michelangelo began by saying he had not yet made the model he had promised:

> I have several things to say to you; would you read on patiently for a little, because it is important. That is to say, I feel myself able to execute this project of the façade of San Lorenzo in such a manner that it will be, both architecturally and sculpturally, the mirror of all Italy, but the pope and the cardinal would have to make up their minds quickly as to whether they wish me to do it or not. And if they wish me to do it, they would have to come to some decision. [. . .] I will explain why.

Michelangelo recounted his problems with the quarrying of large blocks of

marble, various mishaps, and his considerable expenditures. Time is short, however, "as I'm an old man" – he was an irascible forty-two – "and because I'm being pressed about my work in Rome [the tomb for Julius II] I must come to terms." Michelangelo asked for a higher price than that initially offered, including another advance payment. He promised to reduce his demands, however, should he discover that he had over-estimated the cost, "such is my loyalty toward the pope and the cardinal."[168]

It was Christmastime when Michelangelo finally dispatched his servant, Pietro Urbano, to Rome with the wooden model, adorned with wax figures.[169] This model became the basis of Michelangelo's contract with the pope, dated 19 January 1518, specifying a marble façade with twelve statues in marble and six in bronze, and seven reliefs, among other embellishments.[170] The principal architectural precedents for such a scheme, transforming the façade into an enframement for monumental statues and figural decoration, are found in the great medieval cathedrals of France and Germany; the principal Italian precedents are not seen in any building but rather in Michelangelo's own Sistine ceiling and in his first designs for the tomb of Pope Julius. The surviving model gives only a faint idea of Michelangelo's extravagant intentions. The ambition of the project is extraordinary, even for Michelangelo. After all, he had had only limited experience in bronze, having executed a version of Donatello's *David* and – with considerable technical difficulty and a number of assistants – the statue of Julius II for Bologna.[171] As for relief sculpture, there too Michelangelo's experience was limited: he had not carved in relief since his boyhood experiments with *schiacciato* (the *Madonna of the Stairs*) and Roman battle scenes (the *Centaurs and Lapiths*), followed by his two Madonna tondi, both of which had been left incomplete some ten or more years earlier.

The façade project seemed doomed almost from the start. Michelangelo had been complaining bitterly about his patrons while maneuvering for total control of the enterprise, and on 30 June 1517 Jacopo Sansovino wrote a coruscating letter of reproach: "I tell you that the pope, the cardinal and [the banker] Jacopo Salviati are men who, when they tell one yes, it is a paper and a contract [. . .] and they are not as you say. But you measure them with your own stick, with which neither a contract nor good faith is valid."[172] The following September the cardinal quizzed Sebastiano about Michelangelo's progress – "whether you have done anything yet; I replied that you have sketched a great number of the figures." Hoping that Michelangelo would forgive him if he spoke out of turn, he added: "the error was the cardinal's and the game the pope's."[173]

It was all over two years later, when Michelangelo's contract was terminated on 10 March 1520: "Now, Pope Leo, perhaps to achieve more quickly the [. . .] façade of S. Lorenzo which he had commissioned me to do [. . .] by agreement liberates me [*d'achordo mi libera*]."[174] In a letter presumably addressed to Buoninsegni around the same date, he was more verbose and more self-pitying. After enumerating his efforts and his expenditures, he concluded: "I do not yet take into account the wooden model of said façade that I sent to

Rome; I do not yet take into account the time of three years that I have lost in this; I do not take into account that I am ruined for the said work of San Lorenzo; I do not take into account the extreme abuse [*vitupero grandissimo*]," and other sacrifices and torments.[175] Aside from these woes, all that Michelangelo and his Medici patrons had to show for their three years' efforts were the models, one of which survives in Casa Buonarroti. As Henry Millon has noted, however, "Even without being constructed, Michelangelo's project for a structurally articulated facade altered contemporary conceptions of architecture."[176]

The story, convoluted and sad, offers further confirmation of Michelangelo's hostility toward Raphael. Michelangelo resented him in part for "nationalistic" reasons: Raphael of Urbino had snared major commissions in Rome from the Florentine Pope Leo; and, had he succeeded in winning the San Lorenzo competition (however informal that competition may have been), he would have had one of the most conspicuous commissions in Florence as well. To forestall that unhappy end, Michelangelo had at first been willing to collaborate with Baccio, a man of considerable experience in architecture, precisely what Michelangelo himself then lacked. If this was a marriage of convenience – and a short-lived one, at that – it was strengthened by their shared hatred for Raphael, documented in a letter from Michelangelo's brother, Buonarroto. Baccio had met with Buonarroto in Florence, and Buonarroto repeated their conversation in a letter to Michelangelo on 25 April 1517 – just over a month after Michelangelo had dismissed Baccio's "childish" model. Although they were no longer to collaborate at San Lorenzo, Baccio had wished to reassure Buonarroto "that he never thought of becoming encumbered [involved] with Raphael of Urbino, and that he was his mortal enemy."[177]

Shared hatred of Raphael was similarly the catalyst for Michelangelo's friendship and support of Sebastiano, as Vasari recognized in describing the relationship among the three masters. The biographer saw Sebastiano as the primary beneficiary of the consortium. While Sebastiano was in Chigi's employ, Vasari wrote, that is, when Raphael was working in the Stanze and Michelangelo in the Sistine Chapel:

Raphael of Urbino had risen to such stature in painting that his friends and supporters were saying that his pictures were, according to the order of painting, more charming [*vaghe*] in *colorito* than those of Michelangelo, beautiful in inventions, and with more charming expressions, and of corresponding *disegno*, and that Buonarroti's paintings did not have any of these, except for *disegno*. And for these reasons these persons judged Raphael to be if not more excellent than he in painting, at least equal; but in *colorito*, they would have it that he surpassed Buonarroti in any case. These humors, disseminated by many craftsmen who adhered more to the grace of Raphael than to the profundity of Michelangelo, had become for various interests more favorable in the judgment of Raphael than of Michelangelo. But Sebastiano was not of their following, because, being of exquisite judgment, he indeed understood the value of each. Therefore, Michelangelo's interest in Sebastiano

135 Raphael. *Sibyls and Angels*. Fresco. Rome, Santa Maria della Pace, Chigi Chapel entrance wall.

> awakened, because his *colorito* and grace much pleased him; he took him
> under his protection, thinking that if he employed the help of *disegno* in
> Sebastiano, he could with this method, without acting himself, beat [*battere*]
> those who held that opinion, and that he (Michelangelo), in the shadow of
> a third person, judge which of them was better.[178]

Vasari continued with an account of Michelangelo's campaign to manipulate
public opinion on Sebastiano's behalf. The Venetian's works are "beautiful
and praiseworthy," but the implication is that Michelangelo's praising them
"greatly, indeed infinitely" influenced their reception. Sebastiano is (unfairly)
presented as Michelangelo's client and his instrument, but one whose art is
lacking in design. This Michelangelo will teach him, or give him, thus "beating"
Raphael and his champions: the use of the verb *battere* suggests more a phys-
ical than an aesthetic trouncing. The beating, moreover, will be inflicted under
cover: exploiting Sebastiano as a cat's paw, Michelangelo would compete with
Raphael without seeming to do so directly. Similarly, Michelangelo planned to
use a third person, ostensibly disinterested, as his cover to judge the results of
the confrontation. The verdict, of course, was predetermined.

 The narrative is unflattering to Michelangelo in ways that Vasari presumably
did not intend, or rather in ways that a sixteenth-century person would not

136 Sebastiano del Piombo. *Two Prophets*. Fresco. Rome, San Pietro in Montorio, Borgherini Chapel entrance wall.

perceive as unflattering. Clearly Vasari did not mean his account of this Tuscan-Venetian alliance to cast his hero in an unfavorable light. He meant the reader to admire Michelangelo's indirection, or misdirection, in his rivalry with Raphael. And when one bears in mind that one's rival is one's *equal*, the implication of Vasari's account becomes clear: the real rivalry, as he saw it, was between the equals, or near equals, Michelangelo and Raphael; Sebastiano was merely an instrument in this contest. But Sebastiano used Michelangelo too, continuing his own rivalry with Raphael, begun in the Sala di Galatea.

According to Vasari, Michelangelo's publicity campaign led directly to Sebastiano's commission for the Viterbo *Pietà*.[179] The *Pietà* became the opening salvo in the tripartite competition, in effect a general response to the criticisms leveled against Michelangelo as a colorist. As the battle continued, the focus became more specific as Michelangelo undertook his next collaboration with Sebastiano, another *de facto* competition with Raphael. Vasari had already described Raphael's coopting Michelangelo's Sistine Sibyls and Prophets for his *Sibyls and Angels* on the entrance wall of the Chigi Chapel in Santa Maria della Pace, c. 1512–14 (Fig. 135). Designing the entrance wall of the Borgherini Chapel in San Pietro in Montorio, Michelangelo and Sebastiano replied to Raphael as if to say "*this* is how it should be done" (Fig. 136). That modern-day viewers have customarily preferred Raphael's version to Sebastiano's

authorized Michelangelism is irrelevant to the intentions of the makers. Their collaboration is documented by Michelangelo's drawings for the chapel and by letters, beginning with one from their mutual friend, Leonardo Sellaio, writing to Michelangelo on 9 August 1516: "You have to send the drawing to Sebastiano."[180]

Michelangelo had gone to Florence the month before (he was not to return to Rome until 1532), but subsequent letters indicate that he was keenly interested in Sebastiano's project. With Sellaio's assistance, he was able to keep close tabs on his friend's progress. On 16 August 1516 Sellaio wrote to report that he had received Michelangelo's letter, and with it, the drawing. He wrote again, 30 August, to inform Michelangelo that "Sebastiano will begin in 15 days." On 11 October Sellaio could write that "Sebastiano has begun the cartoon and has the spirit to do something great, and I believe it. He has made a figurine of clay for the Christ" – employing a practice also employed by Leonardo and other painters – most likely referring to a model for the Christ of the mural altarpiece in the chapel, the *Flagellation* (Fig. 137).[181] A month later, 8 November, Sebastiano had done the Prophets on the entrance wall, "and I think that it will bring us honor."[182] (The invocation of honor, repeated in a letter of 29 November, is bound to the subtext of rivalry: "Sebastiano is working, and I think he will bring you honor."[183]) Sellaio reiterated his enthusiasm for the Prophets on 22 November, while also bringing Michelangelo up to date on Raphael's latest doings: "Sebastiano has done those two Prophets, and up to today, according to those who see the work, there is no one of your manner [*aria*] if not he. And I think well of it. Raphael, as I told you, asked for assistance, and Antonio da Sangallo was given to him. [. . .] He has made a clay model for (the sculptor) Pietro d'Ancona, of a *puttino*, and he has taken it to finish it in marble. And they say that it is rather good. Be advised."[184] Raphael was encroaching on Michelangelo's art, "mia professione."

Perhaps Raphael harbored the same selfish thought about Michelangelo's first foray into architecture. After all, Raphael already had both the title, as *Capomaestro* of Saint Peter's, and the experience, when he lost to Michelangelo the commission for the façade of San Lorenzo. Michelangelo was waging his campaign to win this commission at precisely the time that he was fighting Sebastiano's battle in the Borgherini Chapel. Meanwhile, Raphael and Sebastiano were again confronting each other directly, as they had several years earlier in Chigi's villa.

In early January 1517 or shortly before Cardinal Giulio commissioned two altarpieces for his archepiscopal see, the cathedral of Saint Juste in Narbonne: Raphael was to paint the *Transfiguration*; and Sebastiano, the *Raising of Lazarus* (Figs. 138, 139).[185] The altarpieces were to be of the same dimensions, evidently intended as pendants. They were not to be displayed side-by-side, however: the different directions of lighting suggest that they may have been meant for opposite walls of a chapel or, more likely, opposite sides of the nave (the *Transfiguration* is lit from the left, the *Lazarus* from the right).[186] Whether the cardinal intended to set the masters against each other is not documented,

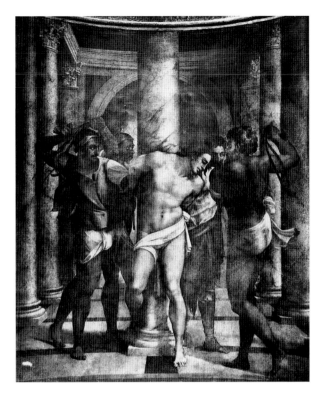

137 Sebastiano del Piombo. *Flagellation of Christ*. Mural altarpiece. Rome, San Pietro in Montorio, Borgherini Chapel.

but he cannot have been unaware of their rivalry or uninterested in exploiting it to his advantage.[187] At the least, the cardinal intended that each painter would seek to do his best in attempting to outdo the other. Giulio might also have expected that Sebastiano would receive Michelangelo's advice, as he had for the Viterbo *Pietà* and the Borgherini *Flagellation*. Indeed, it proved to be so: three drawings survive as proof of Michelangelo's assistance (two in London, British Museum; the third in Bayonne, Musée Bonnat).[188]

Whatever the cardinal's intention, the principals themselves certainly understood that their commissions represented a competition, a *paragone* as Leonardo Sellaio described it in a letter to Michelangelo of 19 January 1517: "three days ago I wrote you how Sebastiano has undertaken to paint that panel: he has been given the money to have the woodwork done. Now it seems to me that Raphael is turning the world upside down to see that he doesn't do it, so as to avoid comparisons [*per non venire a paraghoni*]. Sebastiano remains suspicious of him. And for this reason, I wish that you write to Domenico [Buoninsegni] about this, that they not fail him, because he has the spirit that will do it in a way that he will remain in the field of combat."[189]

Despite Raphael's "world-turning" efforts and Sellaio's concerns, Sebastiano was first to set to work and first to complete his commission, putting other commitments aside in order to do so. "Sebastiano has great spirit, and

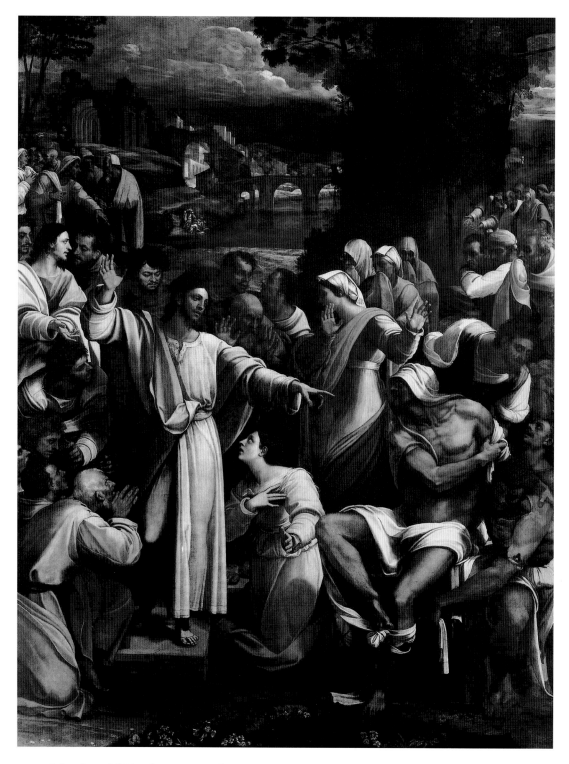

138 Sebastiano del Piombo. *Raising of Lazarus*. Panel transferred to canvas. London, National Gallery.

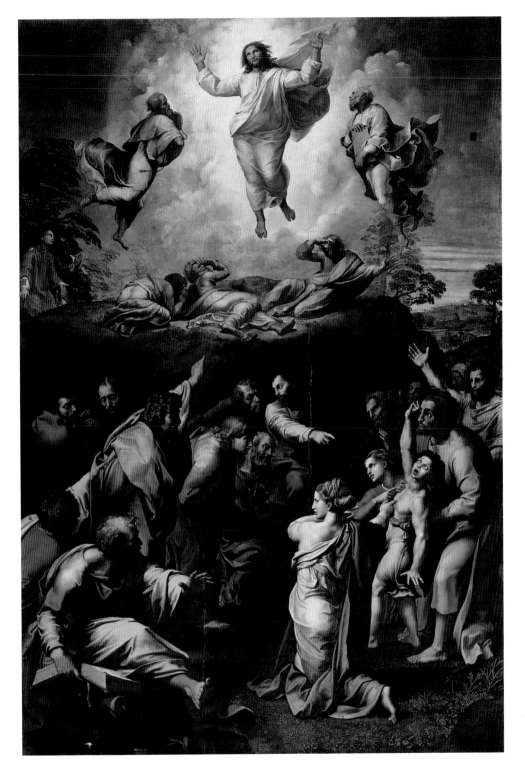

139 Raphael. *Transfiguration*. Panel. Vatican, Pinacoteca Vaticana.

tomorrow he will begin the chapel," Sellaio reported to Michelangelo on 1 March 1517; "God give him victory."[190]

In pursuit of that victory, as Sellaio informed Michelangelo in a letter of 26 September, Sebastiano abandoned his work in the Borgherini Chapel to concentrate on the *Lazarus*. Echoing the rivalrous imagery of the earlier letter ("honor," "paragone," "the field of combat"), Sellaio exulted in Sebastiano's expected triumph: "He has begun the panel and is performing miracles, in such a way that by now one can say he has won."[191]

Michelangelo could see Sebastiano's "miracles" with his own eyes during a visit to Rome in January 1518. And by 2 July that year Sebastiano reported that he had almost completed his work, whereas Raphael had yet to begin. For this very reason, Sebastiano explained to Michelangelo, he had refrained from finishing the *Lazarus*: he did not want Raphael to be able to see it and presumably profit from the knowledge as he executed his own altarpiece. Yet that seems to have been precisely what happened. Cardinal Giulio de' Medici is known to have visited Sebastiano's shop on numerous occasions – as Sebastiano himself informed Michelangelo in this letter of 2 July:

> I believe Leonardo [Sellaio] has told you everything about my affairs, how things are going slowly and about the lateness of my work. [. . .] I have held it back so long because I don't want Raphael to see my work until he has completed his; and this Our Most Reverend Lord [Cardinal Giulio] has promised me, who has been many times to my house. [. . .] And at present I do not attend to anything else but its prompt completion, [. . .] and I believe that I will not shame you. Raphael has not yet begun his painting.
>
> It saddens my spirit that you were not in Rome to see the two paintings by the Prince of the Synagogue [Raphael] which have been sent to France [the *Archangel Michael* and the *Madonna of Francis I*]. I believe you could not imagine anything more contrary than these to your opinion of what you would have seen in similar works. I shall not tell you anything else but that they appear to be figures who have been in smoke, or figures of iron that shine, all light and all black, and drawn in a manner that Leonardo will tell you about. Think how things are going: two fine ornaments received by the French.
>
> [. . .] I pray you to wish to persuade Messer Domenico [Buoninsegni] that he desire to have the panel framed in Rome and that he let it be done by me, because I want [. . .] the cardinal [to understand] that Raphael robs the pope of at least three ducats a day of the day's wages for framing. [. . .] And then my work will have more grace furnished thus than were it naked.[192]

Surely the cardinal was visiting, and talking, with Raphael as well, informing him about Sebastiano's work. Indeed, while Raphael was working on Giulio's *Transfiguration* – or probably *not* working on it – he was painting his portrait in the *Pope Leo X with Cardinal Lorenzo de' Rossi and Cardinal Giulio de' Medici*, which was sent from Rome to Florence in early September 1518.[193] Visiting Raphael's shop, discussing his altarpiece commission, Giulio himself

might have suggested changes in the *Transfiguration*, in order that it better accommodate Sebastiano's composition, which was so much closer to completion.[194] With their patron as intermediary, Sebastiano and Raphael collaborated despite themselves.

Sebastiano continued to worry that his painting would be sent to France for framing, that Raphael was behind this "plot" to defraud him of the money he might make doing it himself, and, more important, of the glory he expected to win when his painting was displayed in Rome. Domenico da Terranuova, a friend of Sebastiano's, wrote to Michelangelo about the problem on 20 July and to alert him to their enemy's machinations: "Raphael shows himself to be himself the boss of this matter, and does as much as he can with our most reverend monsignor [Cardinal Giulio] that such work end up being framed in France, to do disrespect to Sebastiano. Now come Your Lordship to intervene with Messer Domenico Buoninsegni that he act with the most reverend Monsignor de' Medici that the panel be completed in Rome, because the panel will be completed in any case in the middle of August."[195] Whether Michelangelo did intervene, and with what success, is not known.

Meanwhile, concern that Raphael would steal his ideas did not preclude Sebastiano's borrowing from Raphael. Raphael's *Way to Calvary* or *Lo Spasimo di Sicilia* (Fig. 140), completed c. 1515, provided the immediate precedent for Sebastiano's *Lazarus*.[196] It is not the particulars of Raphael's composition but the underlying conception that Sebastiano adopted – including elements borrowed in turn from Michelangelo and ultimately from Leonardo: the grandeur of the figural grouping, their relation to the background setting, the sense of epic drama, heightened by strong lighting and enacted in forceful pantomime.

Sebastiano's delaying tactics (assuming the delays to have been deliberate) were impressive, as Sellaio's letters to Michelangelo attest. The "wondrous thing was almost finished" on 23 October 1518; Sebastiano was "performing wonders" on 31 October; he had "almost completed the panel, which is a wondrous thing" on 13 November; on 28 November he "has in effect produced a wonderful work"; on 1 January 1519, "Sebastiano has nearly finished" – though in fact, the altarpiece was still some months from completion.[197] Even so, Sellaio had seen enough to crow to Michelangelo, the pleasure in Sebastiano's success heightened by Raphael's perceived failure in his latest work for Chigi, the Loggia di Psyche in his villa. "Sebastiano has nearly finished," Sellaio repeated; "and he is succeeding in such a way that there are many experts who put him greatly above Raphael. Agostino Chigi's vault has been unveiled, an offensive thing to a great patron, rather worse than the last stanza of the Vatican Palace; such that Sebastiano has nothing to fear."[198]

On 13 February 1519 Sellaio repeated once again that Sebastiano "is doing wonders, and has brought ruin to everyone." Finally, in spring, the altarpiece really was complete, and on 1 May Sellaio could gloat that "Sebastiano [...] has finished, in such a way that everyone remains dumbstruck. And it will be sent to the chapel within a few days."[199] After this first public display, the

Lazarus was temporarily removed from public view, to be exhibited again by the end of the year, in the Vatican Palace. Sebastiano himself wrote to Michelangelo to inform him of this, and of the baptism of a son, Luciano, to whom he hoped Domenico Buoninsegni would be godfather. "Aside from this," Sebastiano continued, "I have finished the panel and have brought it to the Vatican Palace, and it immediately pleased everyone rather than displeasing, except for the common folk, but they do not know what to say. It is enough for me that the most reverend monsignor [Cardinal Giulio] has told me that I have satisfied him more than he had desired. And I believe that my panel is better designed than the rags of the tapestries that have come from Flanders" – referring to Raphael's tapestries for the Sistine Chapel.[200]

A more impartial viewer, the Venetian nobleman Marcantonio Michiel (known as the chronicler of his compatriots' collections), also made note of the painting's enthusiastic reception: "on the third Sunday of Advent, Messer Sebastiano the painter put a panel that he had made for the cathedral of Narbonne, with the resurrection of Lazarus, on display in the palace, the pope ordering this in the Antechamber, where it was seen with its great praise by all and by the pope."[201]

Meanwhile, Raphael's work was far from completion, though he had wasted no time in doing what he could to interfere with Sebastiano's project. As the correspondence explains, Sebastiano wanted his altarpiece to be framed in Rome, where he could supervise the work. But Raphael attempted to persuade their patron to send the *Lazarus* to France for framing – which would mean, perforce, removing it not only from Sebastiano's supervision but from view by a Roman audience. The implication is that Raphael was not eager to see his *Transfiguration* displayed with Sebastiano's and Michelangelo's *Lazarus*, that is, reluctant to see the paintings compared, at least in Rome. (Did he imagine a French audience would be less discerning – or better disposed toward his art?) Raphael had launched his campaign to send the *Lazarus* to France by 2 July 1518, according to Sebastiano's letter to Michelangelo – that is, when Raphael himself had yet to begin his own altarpiece.[202]

Once Raphael began his *Transfiguration*, he dedicated himself to the enterprise, while delegating the execution of other prestigious commissions – including the Vatican Logge – to assistants. As Sebastiano had feared, Raphael seemed to profit from knowledge of the *Raising of Lazarus*: Raphael's inclusion of the episode of the possessed boy seems to have been an emendation of the initial composition, the intention being to make the *Transfiguration* a more suitable companion piece – and competitor – for the Venetian's altarpiece. Raphael had previously combined two sequential if not simultaneous events in a narrative altarpiece, the Oddi *Coronation of the Virgin*, which includes the apostles at Mary's tomb who witness not her funeral but her reception into heaven. These two scenes, linked theologically and historically, were commonly combined in images, and Raphael's having linked them in this early work does not entirely explain the leap of imagination involved in combining the Transfiguration with the boy's miraculous healing.[203] In the *Transfiguration*, however,

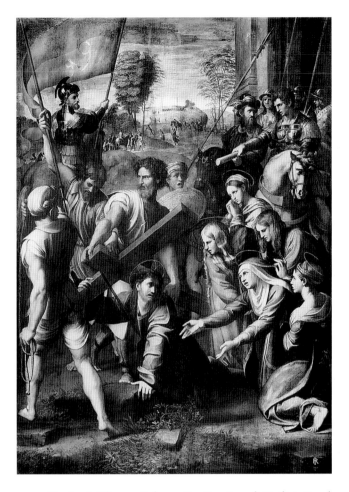

140 Raphael. *Way to Calvary* (*Lo Spasimo di Sicilia*). Panel transferred to canvas. Madrid, Museo del Prado.

as in the Oddi altarpiece, the two episodes are sequential events, described in consecutive Gospel accounts, and theologically related as well.[204]

The *Transfiguration* was essentially complete by Raphael's death on 6 April 1520. "Working continuously" until he could work no more, Raphael had painted it "with his own hand," as Vasari attested.[205] After describing the composition more fully than most works, Vasari concluded that "the shared judgment of the craftsmen is that this work [. . .] is his most celebrated, the most beautiful, and the most divine, so that who wishes to know the depiction in painting of Christ transfigured to divinity, sees him in this work. [. . .] Christ [. . .] dressed in the color of snow [. . .] shows the essence and the godhood of all three Persons [of the Trinity], tightly united in the perfection of the art of Raphael; who it seems so greatly bound himself to his power [*virtù*] in order

to demonstrate the force and the valor of art in the visage of Christ, that finishing it, as the last thing that he had to do, never again touched brushes, death taking him."[206] The act of painting had become an act of prayer.

Technical examinations have confirmed Vasari's assertion that Raphael painted the *Transfiguration* "with his own hand," revealing a few peripheral areas that were left incomplete.[207] The implication is that his assistants chose not to tamper with the work. Giulio Romano and Giovanni Francesco Penni received payments for the *Transfiguration* as Raphael's heirs, but not for having contributed to the altarpiece.

Contemporary response to Raphael's last work was extraordinary: the *Transfiguration* was exhibited at the head of his body as he lay in state in his studio. There is some precedent for the association of a deceased creator with his creation. A humanist scholar might be interred with his books, as Leonardo Bruni was buried with his *History of Florence*; his tomb by Bernardo Rossellino illustrates the fact, recorded also in descriptions of the funeral. But a book is an unobtrusive attribute and might even be mistaken for the Bible, held by pious hands in innumerable monuments. The *Transfiguration*, on the contrary, is both conspicuous and unmistakable for anything but what it is. The display of Raphael's altarpiece memorialized both the painter and his last great work in a kind of artistic transfiguration or apotheosis.[208]

Perhaps not since the ancient Egyptians' deification of Imhotep, architect of the Great Pyramid, had an artist been so highly praised and publicly mourned as Raphael. Giovanni Bellini's death in Venice in 1516 was a private matter, noted only in passing by the diarist Marino Sanudo; Leonardo's death in Cloux in 1519 was also private, mourned primarily by his companions and beneficiaries, Melzi and Salai (only decades later, thanks to Vasari's imagination, did François I come to attend the dying man).[209] But Raphael's funeral was a public affair, involving the display of his last work, the *Transfiguration*, and memorialized in the epigrams of his admirers and in the epitaph by Pietro Bembo, which Vasari included in both editions of the *Lives*.[210] Veneration for the master was bound to veneration for his art, with his final altarpiece as proxy for all of his creations, revered precisely because Raphael had created them.[211]

Commemoration of Raphael did not end with his obsequies. The *Transfiguration* was also displayed in the Vatican, to be seen for the first and only time with its rival, the *Raising of Lazarus*. Death did not diminish Raphael's luster but increased it. His *garzoni*, as Sebastiano dismissively called Raphael's heirs, enjoyed only a brief period of success at court after the master's death – though long enough to deprive him, Sebastiano, of a commission he coveted, decorating the Sala di Costantino. But Raphael's own works remained in Rome and elsewhere as an exemplar and a challenge. Dying, Raphael had become immortal, joining the gods in the Pantheon.

Writing to Michelangelo about Raphael's death six days after the event, Sebastiano wasted no time on false sympathy – the announcement is indeed sarcastic – and went right to business, reporting on this exhibition of their paintings and his hopes to succeed Raphael in the Sala di Costantino:

I think you have heard how that poor Raphael of Urbino has died, which I believe may have rather displeased you; and God forgive him.

Now I shall tell you briefly how one is to paint the Hall of Constantine, about which Raphael's *garzoni* are daring much, and want to paint it in oil. I pray you wish to remember me and recommend me to the most reverend monsignor; and if I am good for such an undertaking, I would like you to set me the task, because I shall not disgrace you, as I believe I have never done up to now. And I advise you how today I took my picture [the *Raising of Lazarus*] once more to the Vatican, with that which Raphael has made [the *Transfiguration*], and I have not been embarrassed. And above all I advise you that one of the *garzoni* of Raphael of Urbino is coming to Florence to get all the work of the palace from the most reverend monsignor.[212]

Shortly thereafter, however, Sebastiano did have great cause for embarrassment. Raphael's *Transfiguration* was installed on the high altar of San Pietro in Montorio, whereas the cardinal dispatched Sebastiano's *Raising of Lazarus* to Narbonne.[213] From Sebastiano's point of view, Cardinal Giulio had added insult to injury. Judging from one of Sellaio's letters to Michelangelo, they and of course Sebastiano himself had dreamed that the *Lazarus* would remain in Rome. On 23 October 1518, before the painting had been completed, Sellaio declared it to be "a miraculous thing, so that I do not believe it will go to France because there has never been anything like it."[214] Vasari's later estimation of contemporary response to the two works confirms Giulio's verdict: both were admired, but Raphael's was considered incomparable.[215]

Two against one: presumably Michelangelo and Sebastiano should have had little difficulty in trouncing their opponent in the altarpiece contest. But precisely the affiliation that was intended to strengthen Sebastiano seemed to weaken him, and his contemporaries generally preferred his portraits and the earlier works done in Venice to those done in collaboration with Michelangelo, with the possible exception of the Viterbo *Pietà*. For what kind of wholeness does such imitation or duplication allow? For Sebastiano and perhaps to a lesser extent for Michelangelo, the answer seems to be a diminished wholeness.[216]

Making matters far worse, Michelangelo's response to Sebastiano's request for help in obtaining the Vatican commission damned him with faint praise. "I beg your most reverend lordship," Michelangelo wrote to Cardinal Bernardo Dovizi da Bibbiena,

> not as a friend or servant, since I do not deserve to be either the one or the other, but as a contemptible man, poor and crazy, that you arrange for Sebastiano Veneziano the painter to have some part of the work in the Vatican Palace, now that Raphael is dead: and if it seems to your reverend lordship that it would be throwing away a favor on me, I think one can yet serve the mad man, that on rare occasions one can find some sweetness in this, as one does with onions to switch foods when he is bored with capons. Of men who matter you make use daily: I pray your lordship please to

try this with me; and the service would be most great; and the aforesaid
Sebastiano is a capable man; and if the favor be wasted on me, it would
not be thus with Sebastiano, because I am certain that he will do honor
to your lordship.[217]

The letter is dated June 1520: Michelangelo had taken his time to reply. And
his sardonic tone ended any hope Sebastiano may have had to succeed Raphael.
Writing to Cardinal Dovizi, moreover, Michelangelo was addressing someone
who had been particularly close to Raphael: the choice of recipient was perni-
cious. The letter made the Venetian a laughing stock at court, when, as he wrote
in an embittered letter to Michelangelo, the cardinal shared it with others –
even the pope had seen it – to the great amusement of all except the victim:

> The cardinal told me that the pope has given the Sala di Costantino to
> Raphael's *garzoni*, and that they have painted on the wall a demonstration
> of a figure in oil which is a beautiful thing, such that no one will ever look
> again at the rooms that Raphael has done; that this room will outdo every-
> thing, and a more beautiful work in painting will never have been done, from
> the ancients until now. Then he asked if I had read your letter. I told him no;
> he laughed a lot, almost as though he were playing a practical joke, and with
> good words, he left me.
> Later I learned from Bacino di Michelangelo [Baccio Bandinelli], who is
> making the *Laocoön*, that the cardinal has shown him your letter and shown
> it to the pope, so that there is almost no other subject being talked about in
> the Vatican Palace if not your letter, and it makes everybody laugh.[218]

Not all the news was bad, however. Sebastiano was able to report that, accord-
ing to Bandinelli (who told him as "a great secret"), the pope did not in fact
like what Raphael's *garzoni* had done, though many were trying to convince
him that he should; "but in truth it doesn't please him. And to tell you the
truth, that room is not a job for young men." Unable to get the commission
for himself, Sebastiano tried to convince Michelangelo to take it:

> this is the finest work and the most beautiful and the most appropriate that
> a man could imagine, and it would win great honor and a great deal of money
> if you wish to take this assignment. I think they want all battle stories, and
> these are no jobs for youths; you well know how much they [battles] entail.
> For my part, hear me, you have no need to have any suspicion in the world,
> you will always have me, boiled or roasted. As for this affair, I shall not
> say anything more to you: you are the boss of everything [*el patron del
> tutto*].[219]

Michelangelo was uninterested in pursuing the commission for himself,
though Sebastiano continued to try to persuade him to do so or at least to
become involved on his, Sebastiano's, behalf. Sebastiano clearly needed
Michelangelo's help. He had been waiting to hear from Michelangelo, he com-
plained in a letter of 6 September 1520,

and much this has amazed me, given that I have written you things of considerable importance, and you should have responded, and I haven't had a single reply. And if you knew, for this [failure to write] how my spirit stands in this thing, perhaps you would be amazed, because already ten days ago, the pope sent me one of his attendants to see whether I had had any response from you. I told him no, and that I was waiting for it from day to day, and on behalf of the pope, he told me: "Then as Michelangelo doesn't answer you, the pope has instructed me that you must be offered the Hall of the Pontiffs downstairs [in the Borgia Apartments]. And I answered that I could not accept anything without your permission, or until I had received your response, and it has yet to arrive. And I told him moreover that [. . .] if the pope wished that Michelangelo do this room, I would not do it, because it seems to me that I am not inferior to the *garzoni* of Raphael of Urbino, especially as I have been offered, from the pope's own mouth, half the room upstairs [the Sala di Costantino], and that it did not seem honest to me that I paint ass-backwards [*codamodo*] the cellars and they the gilded chambers. I told him that they should have it painted by them; and he answered me that the pope was not doing it for another reason if not to fuel competitions [*per fuzir le gare*], and that they have the drawings for that room, and the downstairs hall was as much a hall of the pontiffs as that upstairs. I answered that I did not want to do anything of the sort that people would laugh at my works, and I am in the greatest torment, so that I have become as though rabid. Yet I proposed him this game: "If Michelangelo were to answer me and that he accepts that which I have written him?" He answered me: "Undoubtedly, the pope would be content, and would have them paint elsewhere." So that, my friend, you are the boss of everything, and I cannot believe what you have written me, that I have searched all over Rome for your letters and I have found nothing; or truly some spy [*ioto*] of theirs is standing vigil to have some of our letters, in order to know our affairs. [. . .]

Aside from this, I pray you to write me [. . .] And the reply you have given me, give to the present [letter-]carrier, [. . .] and thus I shall have it. [. . .] write me a letter of fire that I shall show to the pope to animate him [. . .]; because he in truth, by the words he has said to me, holds you in the greatest regard, and he knows you.

Aside from this, I pray you take account of who this is who is dealing with you, that is, the pope, because there is no more honorable commission than this in the world, as I have written you other times. Here you vindicate all the injuries that have been done you, and you silence the cicadas, who won't cry any more, because in this hall are to be represented the most beautiful narratives [*istorie*] that one can paint. [. . .]

The pope told me these stories that are wanted, and that they have the designs from the hand of Raphael. [. . .] To me it seems that, for the choice of narratives, one cannot do better or choose better. Therefore, you do them. [. . .] And I pray you, my friend, for the love between us, deign to answer

me, so that I may know what I am to do, because I am reviled [*vituperato*]
by all of them, above all by the pope, because I do not know what to tell
them, because there goes your honor like mine.[220]

Sebastiano's language reflects his dependence on Michelangelo: he could wrest
the commission from Giulio and Penni only with Michelangelo's cooperation.
Otherwise, the pope would assign him the far less prestigious commission
of completing the Borgia Apartments, identified as "the cellar." Like
other patrons, Leo was most interested in Sebastiano's art when Michelangelo
was his guide. Sebastiano tried to convince him to cooperate with a two-
pronged argument. First, if he returned to Rome to undertake the new project,
Michelangelo could vindicate himself – he had just been deprived of the San
Lorenzo façade, and in any case, his enemies at the papal court were always
conspiring against him (Sellaio's correspondence also reflects Michelangelo's
chronic concern about this). Second, the Sala di Costantino would be the most
important commission to be had, and Sebastiano's summary of the planned
cycle was intended to stir Michelangelo's interest. Unsaid, but presumably
remembered, is the fact that Michelangelo had never completed the *Battle of
Cascina*. The *Battle of Constantine* would be bigger and better.

A letter from Michelangelo arrived the next day, 7 September (it has been
lost), and Sebastiano replied immediately. Reiterating his arguments with the
language of vendetta, Sebastiano attempted to boost Michelangelo's ego and
stir dedication to their joint cause:

> My dearest *compadre*, today, by one of your letters [. . .], which is the answer
> that you make me write to the pope, to me it seems almost to have done you
> sooner an injury than a pleasure, by what you write me. I say thus to you,
> that for the love and goodwill I bear you, I wish to see you emperor of the
> world, because to me it seems that you deserve this; and if it does not seem
> to you that you are that great master which you are, it seems so to me and
> to every person in the world, even to those who do not wish it so. And of
> this there is no better judge than yourself. And when you can not be useful
> or help me in anything, or ever do me a favor, I shall most certainly believe
> that you do this because you are not able [to do so], and not for want of
> faith or of love. And all that which I have said to the pope, and the ends that
> I have used regarding this work, has been for the pure love and reverence I
> bear you, and with your means to carry out your vendettas and mine in one
> fell swoop, and to give those malign people to understand that there are other
> demigods aside from Raphael of Urbino and his *garzoni*.

Sebastiano then expounded on the cycle, explaining that in his previous letter,
he had described the narratives in broad terms (*cossì de grosso*), because that
was how the pope had described them to him. In any case, "these four narra-
tives are those of the Emperor Constantine that Raphael's *garzoni* are to paint;
but it seems to me that the pope has almost changed his opinion, and he has
sent to me many times to learn if I have had your reply, and I have told him

no." There was still no final decision about the Borgia Apartments. Sebastiano concluded his letter with another invocation of Michelangelo's rivalry with Raphael:

> I pray you, for the love you bear me, that you wish to resolve this thing, yes or no, so that I can give the answer to the pope, because he sends to see what you have written to me, and I say that I have not yet had a reply; and if you want me to show him your letter, I shall show it to him. Give me your view about this, because I do not wish to do anything against your will, because this upper room, which is important for love of the Stanze of Raphael of Urbino, one can not have without you, but that downstairs room, I have spirit enough to have it and to execute really big paintings [*depenturazze*] like the others. But what I have been wanting, I was doing in order to work miracles, and give people to understand that even those men who are not demigods still know how to paint.
>
> I shall not tell you anything more. Christ keep you healthy. Forgive me if I am bothersome to you.[221]

The letters were a call to arms, but Michelangelo remained unresponsive. Despite his promise not to say anything more, Sebastiano wrote again the following month, 15 October, still hoping to rouse him by resurrecting Raphael:

> My dearest companion, do not marvel if I have not written to you for many days nor answered your last letter, because I have been for many days at the palace to speak with His Holiness, and never have I been able to have that audience that I was wanting. Most recently I have spoken to him, and His Holiness gave me grateful audience, [. . .] sending away everyone who was in the chamber, and I remained alone with Our Lord and a servant whom I can trust, and the pope listened to me very willingly, because I offered myself to His Holiness, together with you, for every sort of service as appeared to him, and asked him about the narratives [in the Sala di Costantino] and the measurements and everything.[222]

Sebastiano then repeated the pope's criticism of what Raphael's heirs were doing – a surprisingly detailed and even technical list of complaints. Either Leo was remarkably well informed about such matters or Sebastiano was putting words in the pope's mouth (or editing what he said). Sebastiano ends his recitation by quoting the pontiff's remarkable assessment of Raphael's debts to the "terrible" Michelangelo:

> "Sebastiano, [. . .] what they are doing does not please me, nor does it please any one who has seen that work. In some four or five days, I want to see that work, and if they are not doing better than what they have begun to do, I do not want them to do anything more. I will have them do something else, and I will have that which they have done taken down, and I will give this entire room to you, because I want to have something beautiful made, or rather I will have it painted like damask hangings [*a damaschi*]." And

I answered that, with your help, my spirit was sufficient for me to do miracles. And he replied to me: "I do not doubt this, because all of you have learned from Michelangelo." And, for the faith between us, His Holiness told me more: "Look at the works of Raphael, who as he saw the works of Michelangelo, immediately abandoned Perugino's style, and as much as he was able, moved closer to that of Michelangelo. But he is terrible, as you see; one cannot deal with him." And I answered His Holiness that your terribleness [la teribelità vostra] never poisoned anyone and that you seem terrible for the love of the importance of the great works you have. [. . .] I have waited these four days, and I have been to learn if His Holiness has seen [the Sala di Costantino]. I have learned yes, and that [. . .] the more they proceed, the more it displeases him. And more, for the satisfaction of those lads, he wants to wait fifteen or twenty days, until they have finished those figures. And I have not been able to send you the measurements because the pope has not yet deliberated and works continuously with them.[223]

Presumably the pope did say something of the sort about Raphael's debt, though the encomium came after his death and rather than flattering Michelangelo may have irritated him, as his own later complaints about Raphael suggest. But others understood the extraordinary import of these words, which had somehow – perhaps through Michelangelo's own maneuverings? – become sufficiently well known so that Benedetto Varchi could quote Leo's praise in his funeral oration for Michelangelo.[224] A private conversation among the pope, a cardinal, and a painter had become public knowledge and part of Michelangelo's legend.

As for Sebastiano in 1520, he had perhaps been naïve to have expected that Leo would abandon Raphael's garzoni or that he himself might expect Michelangelo's help in this matter. Raphael had been the catalyst for Michelangelo's collaboration with Sebastiano. Now that Raphael had died, Michelangelo's commitment to Sebastiano was bound to be diminished. Both Sebastiano and, implicitly, the pope considered Michelangelo's assistance as the sine qua non for Sebastiano's taking over the Sala di Costantino. But Michelangelo signaled that this assistance would not be forthcoming. His help to Sebastiano had been the greatest in their first endeavor, the Viterbo Pietà, executed when all of them – including Raphael – were living in Rome. Michelangelo's involvement was lessened somewhat in the design of the Flagellation of Christ, the mural altarpiece in the Borgherini Chapel in San Pietro in Montorio, though the patron, Pierfrancesco Borgherini, had awarded the commission to Sebastiano "because Borgherini thought, as was true, that Michelangelo himself would have to execute the disegno for the whole work."[225] Michelangelo's assistance had been further reduced in the planning of the Raising of Lazarus, executed while he was resident in Florence. Absence from Raphael, it seems, made Michelangelo's heart grow if not fonder at least less competitive. Certainly there was, for him, not the same urgency in the rivalry at the papal court as there was for Sebastiano.

Sebastiano continued his attempts to persuade Michelangelo to return to Rome in letters that, though they failed in this objective, are revealing records of both men's characters and of the milieu at court. "His Holiness said that he did not want to disrupt your projects in Florence," Sebastiano wrote on 27 October 1520, referring to work on the tomb of Julius II – "and I said to His Holiness that at present, because Monsignor Aginensis has died, you could take a detour from the work on the tomb." He was referring to one of Julius's executors, Cardinal Leonardo Grosso della Rovere, Bishop of Agen, who had been rightly insisting that Michelangelo fulfill his (revised) contract for the monument. Sebastiano continued:

> And the pope said [. . .] that he did not wish himself to be the source of leading you astray from that work, that one whispers that the cardinal was poisoned, and thus Our Lord will not drive himself crazy over anything of the cardinal's, so as not to give occasion to the brigades of whisperers.
>
> However, my friend, if your thought is to come to Rome [. . .], you have the best occasion in the world to come, that is, now that this cardinal is dead. [. . .] Because, from what one gathers, the cardinal has left no instructions regarding his affairs [. . .]; and it would be very honest that you come to see to your affairs, whether regarding the tomb or every other thing, especially [. . .] a certain castle of Canossa [. . .] which is a fine subject to set your brain on fire. Because, if you were in Rome, you could settle everything and get everything that you would wish – not castles but a city – because I know that in what counts, the pope values you, and when he speaks of you, he seems to discuss one of his brothers, almost with tears in his eyes; because he has told me you were nurtured together, and he shows that he knows you and loves you, but that you frighten everyone, including popes.[226]

Writing some two weeks later, 9 November 1520, Sebastiano reassured Michelangelo, "As for your *terribilità* that you repeat to me, I, for my part, do not consider you terrible; and if I have not written you about this matter, do not wonder, because you do not seem terrible to me except in art, that is, the greatest master who ever was. So it seems to me: if I am in error, mine the injury."[227]

Raphael had triumphed in their last tripartite contest when Cardinal Giulio kept the *Transfiguration* in Rome, sending Sebastiano's – and Michelangelo's – *Raising of Lazarus* to Narbonne. To make matters worse, Sebastiano himself had honored Raphael's *Transfiguration* by imitating it in his fresco in the semidome of the Borgherini Chapel.[228] Did Borgherini require this quotation of Raphael's last work? Or was it impossible for Sebastiano to envision the subject anew, having seen Raphael's altarpiece? Sebastiano's imitation of Raphael is tacit acknowledgment of Raphael's victory, despite the Venetian's assertions to the contrary. Perhaps Michelangelo feared losing to Raphael again, in a posthumous contest between the frescoes Raphael had completed in the Stanze and those that Sebastiano now hoped to execute with his, Michelangelo's, assistance, in the Sala di Costantino.

The commission went, as preordained, to Raphael's heirs. Also preordained was disapproval of their efforts by Michelangelo's friends. Sellaio gave him an early report of the work in progress in a letter of 15 December 1520: "The pope has been away; he returned yesterday. We are waiting for him to go to see the pictures of the Sala di Costantino which are an atrocious thing that my hunchback would do better. If the pope will send for Sebastiano, we shall do it in a way that I know will content him; and not sending for him, Sebastiano will attend to work, because he has taken a panel to Santa Maria della Pace, under Raphael's figures," referring to the *Resurrection* planned as the altarpiece for the Chigi Chapel, already decorated with Raphael's frescoes.[229]

Whatever Michelangelo's motivations for declining to help Sebastiano in the Hall of Constantine, he did make a number of drawings ten years later for the Venetian's altarpiece of the *Resurrection*, commissioned on 1 August 1530 for the Chigi Chapel in Santa Maria della Pace but never executed.[230] In the same contract, Filippo Sergardi (guardian of Chigi's heir) refers to Sebastiano's previous commission four years earlier for the Chigi Chapel in Santa Maria del Popolo. Sebastiano was to have painted the *Assumption* for the Popolo but the subject was now described as the *Nativity of the Virgin*. The Popolo altarpiece was to be painted in oil "in that new manner" that Sebastiano knew about. The oil medium itself, of course, was not new, and Michelangelo himself had used it in the unfinished *Entombment* and in the Doni Tondo (perhaps in combination with tempera). It was not the use of oil *per se*, therefore, but using it "in that new manner," implying a painterly handling, that might have discouraged Michelangelo from assisting his friend with the composition, despite Sebastiano's request for "a little light on the narrative of the Nativity of Our Lady" in a letter of 25 May 1532.[231] The oil medium was morally repugnant to Michelangelo, as he later explained to Vasari, precisely because its malleability, that feature which seemed its greatest advantage to its exponents, seemed feminine weakness to him. Condemning oil, Michelangelo condemned his old friend: "coloring with oil paints is a woman's art and an art of lazy, slothful cat-cats like Sebastiano del Piombo," *persone agiate et infingarde*.[232]

Raphael had been dead for ten years. But the competition among them had not died either for Sebastiano and Michelangelo, or for their patron. Indeed, the *paragone* with Raphael was exactly what their client had in mind for the two Chigi chapels. The contract stipulated that Sebastiano was to "use his every skill and all his knowledge to give it every perfection that will be possible for him to use and that it stand up to comparison with every other panel in Rome, and principally with that of Raphael of Urbino in San Pietro in Montorio," that is, the *Transfiguration* which had remained in Rome to haunt Sebastiano.[233] In Rome, at least, Raphael's *Transfiguration* had become the measure by which altarpieces were to be judged.

Michelangelo provided some fourteen studies for Sebastiano's *Resurrection* altarpiece for the Chigi Chapel in Santa Maria della Pace, first commissioned in 1520, with a second contract in 1530 (Fig. 141). Had Sebastiano completed it, the *Resurrection* would have been seen in confrontation with Raphael's fres-

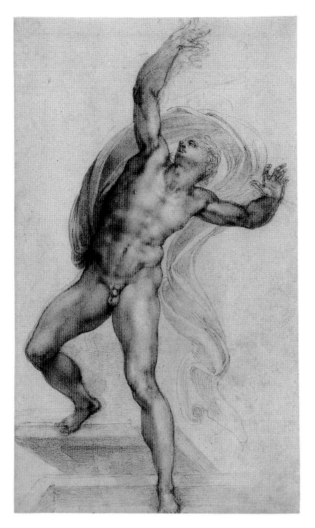

141 Michelangelo.
Resurrected Christ.
Black chalk. Windsor,
Royal Library 12768,
Her Majestry Queen
Elizabeth II.

coes of Sibyls and Prophets – inspired in turn by Michelangelo's in the Sistine
Chapel.[234] Vasari described the inherently competitive situation of the chapel
"where Raphael had done the Sibyls and Prophets, Sebastiano, in order to
surpass Raphael, wanted to paint some works on stone," and the wall surface
was prepared for this purpose.[235] Precisely for this reason – the rivalry with
Raphael – Sebastiano was able to obtain Michelangelo's assistance once again:
a number of drawings of the Resurrection by Michelangelo c. 1532–33 have
been associated with the commission.[236] If the Popolo commission was unin-
teresting or even unattractive to Michelangelo, the Pace altarpiece was another
matter entirely. In Santa Maria della Pace, Sebastiano's *Resurrection* would
be accompanied by Raphael's *Sibyls* in the lunettes – among that master's
most Michelangelesque works. Perhaps for this very reason Michelangelo was

ready to provide drawings for the altarpiece. Sebastiano, in turn, was assisting Michelangelo in his renegotiation of his contract for the Julius tomb and perhaps in mollifying Clement VII about Michelangelo's support of the Republican cause during the siege of Florence in 1527.[237]

Thereafter, Michelangelo continued to help his friend, providing drawings for Sebastiano's *Christ in Limbo* (Madrid, Prado), but either his interest in the project or in helping Sebastiano was clearly waning. While thanking Michelangelo for his assistance in a letter dated 15 July 1532, Sebastiano complained that the master was repeating himself: "I have received [. . .] your letters with the design, for which I thank you as much as one can thank someone, and which much satisfy me. However, the Christ from the arms and the head outward, is almost the same as that in San Pietro in Montorio; but even so I shall make do as well as I shall be able."[238] But Michelangelo had evidently ceased helping Sebastiano even with reiterations of old ideas. When the Venetian asked for "a little light," in regard to his commission for the *Nativity of the Virgin* intended as the altarpiece of the Chigi Chapel in Santa Maria del Popolo, the reply was silence, or darkness.[239]

7

Titian

Titian [. . .] has had some rivals in Venice, but of little worth, so
that he has easily surpassed them with the excellence of his art, and
he knew how to handle himself with, and make himself agreeable to,
gentlemen.

Giorgio Vasari[1]

Only Titian is worthy of the name of Painter.

Lodovico Dolce[2]

T HE VENETIAN PAINTER TITIAN was perhaps Michelangelo's greatest rival,
certainly the longest-lived and the one whose art was most unlike his own.
If Michelangelo became a sculptor by imbibing marble dust with his nurse's
milk, "Titian was a painter even in his mother's womb."[3] Whereas Leonardo
and Raphael aspired essentially to the same goals as Michelangelo, Titian exem-
plified different ideals and did so with unequaled success. Even more than
Michelangelo, Titian was the first great master with an international clientele.
Works by Bellini, Leonardo, Raphael, and Michelangelo himself were sought
by collectors throughout Italy and abroad. But only Titian worked *consistently*
for such great patrons, producing as much or more for European clients as for
Italians, and within Italy, as much for non-Venetians as for Venetians. He did
this, moreover, by transporting his art, and not himself. With the exception of
brief sojourns in other Italian states and cities, a year-long stay in Rome in
1545–46, and two visits to Augsburg at the behest of Emperor Charles v, Titian
lived and worked in Venice. (Born in Cadore in the Alto Adige, however, and
often identified as Cadorino, he was probably resident in Venice before the turn
of the sixteenth century.) He did not become a court artist by living at court,
thus dependent on a particular prince's favor, but by staying home, thus
remaining independent, a courtier-at-large.[4] Practical realities helped him do so.
It was economically viable to paint a Madonna or a mythology, for example,
expecting eventually to find a buyer; but it was prohibitively expensive for a
sculptor without a patron to quarry large quantities of marble for a monument
or a building. Michelangelo's letters are filled with complaints about precisely
this problem – his own expenditures of time and money, the dilatoriness or
failure of patrons in reimbursing his costs, and their demands for satisfaction.

Michelangelo responded to the Venetian's challenge as he had done when answering Raphael with Sebastiano's collaboration: he enlisted a proxy to assist him, namely Jacopo Pontormo. The rivalry between Titian and Michelangelo culminated in the attempts of each master to tackle themes associated with the other. Their agon is bound to war of words among the men of letters who were their champions, Aretino, Dolce, Pino, Varchi, and Vasari. Michelangelo himself enlisted in these literary battles, planning an edition of his poetry, reciting his autobiography to Condivi, and later dictating *postille* to Calcagni for a possible revised edition of the *Life*.

Michelangelo and Titian are known to have met only once, in Rome in 1545–46, an encounter recorded by Vasari, who was also present.[5] But the great likelihood is that they had met before then, during Michelangelo's sojourn in Venice in 1529. Aretino's letter to Michelangelo, dated April 1544, may imply that the two artists knew each other well enough by that time for Titian to hope for a personal favor from Michelangelo.[6] And they must have known *of* each earlier still, through their mutual friend, Sebastiano.

143 Michelangelo. Detail of Fig. 122. Eve.

By whatever means Titian may have known of Michelangelo, the Venetian's art testifies to his early knowledge, long before he can have seen any of Michelangelo's works for himself – and even before Sebastiano can have described them to him. The first witness is the brutalized wife in Titian's fresco of the *Miracle of the Jealous Husband* in the Scuola del Santo in Padua, completed in 1511. The wife reverses the posture of Michelangelo's Eve in the Sistine *Temptation*, reversal being a familiar means of disguising a debt (Figs. 142, 143).[7] It is as though Titian had read Petrarch's advice to use "his mind and style and [. . .] not flee, but conceal the imitation. [. . .] The similarity itself [should] lie hidden, so that it cannot be perceived except by the silent searching of the mind, that it can be understood to be similar rather than said to be so."[8] The pose has ancient prototypes, however, and Titian's "wife" is an amalgam of the two sources, resembling both in almost equal measure. That Titian knew her from an ancient source is shown by the husband: while her pose recalls the victim in certain battle sarcophagi and other Roman reliefs, his

142 Titian. *Miracle of the Jealous Husband*. Fresco. Scuola del Santo, Padua.

recalls that of the assailant.[9] Whereas Titian's recollection of battle sarcophagi is appropriate to his representation of frenzied violence, his reference to Michelangelo's Eve has no narrative relation to his own theme.[10]

The Paduan frescoes are among Titian's earliest documented works, and he was in his twenties when he painted them.[11] His first response to Michelangelo thus came comparatively early in Titian's career. Similarly, Raphael had been twenty-one when he first encountered Michelangelo's art in Florence and twenty-four when he signed and dated his Michelangelesque *Entombment*. Unlike Raphael, however, who adopted many of Michelangelo's ideas openly, vaunting his debt with Heraclitus in the *School of Athens*, Titian disguised his first borrowings to the point of unrecognizability and transformed his later citations to the point of *contradicting* the source.[12] Raphael's Michelangelism was more straightforward, following the pattern of master–pupil relationships involving the pupil's imitation of his master (notwithstanding the fact that there was no such legal relationship between them). Raphael intended to beat Michelangelo at his own game and in the same arena, the court of Julius II. Titian likewise meant to outdo Michelangelo but aimed to do so by playing a different game in a variety of venues, alluding to his rival while following different rules that privilege *colorito* instead of *disegno*.

It was fundamental to Raphael's purpose that references to Michelangelo in such works as the *Entombment*, the *School of Athens*, and the Santa Maria della Pace *Sibyls* be appreciated by knowledgeable viewers. Titian, on the contrary, concealed his first quotation, even though he could assume that his primary audience, members of the Scuola di Sant'Antonio, would be unfamiliar with his source even if the reference were undisguised or unreversed. By the time Titian finished his frescoes, only a privileged few had been able to see the Sistine ceiling, still incomplete at the time of its temporary unveiling on the evening of 14 August 1511. (Drawings that may have circulated would have been known to other artists but not yet to the public at large.) Titian received the final payment for his work in Padua in late November of that year. Between mid-August and late November is a period of some fourteen weeks, a remarkably rapid "response time," more remarkable still given the distance between Padua and Rome. Only Raphael reacted more quickly, adding his Michelangelesque Heraclitus to the *School of Athens*, completed by 25 November – but Raphael was working in the Stanza della Segnatura, next door to the Sistine Chapel.[13]

In the *Miracle of the Jealous Husband*, then, Titian announced his intention to rival Michelangelo, but however precocious or presumptuous, the announcement was addressed to himself and to whatever well-informed *cognoscenti* might happen to visit the Scuola. Titian's audacity for someone at the beginning of his career is remarkable, based more on promise, in 1511, than on achievement. This boldness is reminiscent of Michelangelo's early works. Whereas young Michelangelo had challenged his great predecessors, however, Titian confronted his great contemporary.[14] In 1511 Michelangelo was clearly

144 Titian. *Triumph of Faith* (detail). Woodcut. New York, The Metropolitan Museum of Art, Whittelsey Fund, 1949. [49.95.69(3)].

any ambitious Italian artist's most conspicuous rival, and the Sistine Chapel the most likely point of reference, celebrated even before its partial unveiling.[15]

Titian's next borrowings from Michelangelo were less surprising than the first: implicit and explicit allusions to the *Battle of Cascina*, which had been much copied and much discussed since Michelangelo had abandoned it, unfinished, in 1505. On 31 May 1513 the Doge and Council of Ten heard Titian's petition for a commission in the Sala del Maggior Consiglio, long since a principal arena for rivalry among Venetian painters:

> Most Serene Prince and Most Excellent Lords, since I was a little kid (*puto*), I, Titian of Cadore, have set myself to learn the art of painting, not so much for money-making greed as to acquire some little fame and to be counted among those who in these present times make a profession of that art. [. . .] Therefore desiring [. . .] to leave some memory in this illustrious city, I have determined [. . .] to undertake to come and paint in the Sala del Maggior Consiglio and put all my intelligence and spirit so long as I shall have life, beginning, if it seems suitable to Your Sublimity, with the canvas mural [*teller*] in which there is that battle scene on the side of the room towards the Piazza, which is the most difficult, and no man until this one has wished to undertake such a feat.[16]

Michelangelo's *Cascina* is not mentioned; but any knowledgeable reader of Titian's petition, and any ambitious painter, would think of that great example and also of Leonardo's *Anghiari*. Titian's enormous woodcut, the *Submersion of Pharoah's Army in the Red Sea*, c. 1514–15, reflects both *Cascina* and *Anghiari*, but that Titian was intrigued by Michelangelo in particular is confirmed by the Venetian's woodcut of the *Triumph of Faith* (Fig. 144).[17] The Good Thief Dismas, who carries his cross in front of Christ's chariot, is the soldier who bends to look at the hands of his drowning comrade in *Cascina*.

As Titian had reversed Eve to become the Paduan wife, here the soldier is turned upside down to become the thief. Once again, the pose is divorced from its original significance: the soldier's desperation is transformed into Christian determination in the *Triumph*. In the fresco, the wife is Titian's only quotation, derived from two related sources, Michelangelo and antiquity. In the print, the reference to the *Battle* cartoon is one of many evocations of other works. The *Triumph of Faith* is an anthology. In addition to Michelangelo, there are borrowings from Mantegna, Dürer, Raphael (via Raimondi), from antiquity (*Laocoön* becomes Titian's Abraham), and from a popular literary source, Girolamo Savonarola's *Triumph of the Cross*, published in 1497 in Latin, with an Italian edition the following year. This multiplicity of sources was characteristic of Titian, comparable to his use of multiple literary sources in his *poesie*.[18]

The woodcuts may well have been the first works by Titian known to Michelangelo, certainly the first to have been readily accessible to him before his Venetian sojourn in 1529. If he saw them, surely Michelangelo recognized the references to his *Cascina* cartoon. By 1511 the cartoon had become common property, despite Michelangelo's efforts to control access to it, just as he had attempted to control access to the Sistine Chapel before its completion. There security had been openly breached for observance of the feast of the Assumption (and perhaps breached surreptitiously before then by Bramante and Raphael). After 15 August 1511 the ceiling was again concealed from view by its scaffolding until its completion on 31 October 1512, the feast of All Saints. But the fortunate congregants of mid-August 1511 were not the only viewers permitted to see Michelangelo's ceiling before its final unveiling.

Alfonso d'Este, excommunicated by Julius II for his alliance with Louis XII of France and other political affronts, arrived at the papal court in July 1512 seeking absolution. The duke failed in that mission, and the visit ended abruptly as he fled Rome, fearing arrest. But his sojourn at the court was not entirely unpleasant: Alfonso was granted permission to see the work under way in the Sistine Chapel and the Stanza della Segnatura. What happened next was extraordinary. The Gonzaga agent, Grossino, reported on the duke's visit in a letter to Alfonso's sister Isabella, written shortly after 9 July:

> The Lord Duke arrived at the palace with his gentlemen. [...] His Excellency was very desirous of seeing the vault of the large chapel that Michelangelo is painting, and Signor Federico [Gonzaga] had someone sent to ask the pope's permission, and the Lord Duke went up to the vault [on the scaffolding] with a number of others; together, little by little, everyone came down from the vault, and the Lord Duke remained up there with Michelangelo, and could not satiate himself with looking at those figures, and he paid him many compliments [*assai careze*], and [...] His Excellency desired that Michelangelo make a painting for him, and made him discuss it, and offered him money, and obtained his promise to do it [...] after which, when the Lord Duke had come down [from the scaffolding], they wanted

to send him to see the pope's chamber and those [works] that Raphael is painting, but he did not want to go.[19]

Alfonso's refusal to visit the Stanza della Segnatura after his descent from the Sistine scaffolding should not be interpreted as lack of interest in Raphael's frescoes but rather as evidence of the duke's sense of decorum.[20] Indeed, Alfonso eventually sought works by Raphael as well, possibly during another visit to Rome in spring 1513 after the election of Leo X.[21] Meanwhile, however, the duke cajoled Michelangelo. One wonders whether Alfonso's *careze* included an apology for his role in the destruction of the sculptor's monumental bronze statue of the pope, which had been melted down and recast as the duke's cannon, aptly named "the Julius." The pope's head was saved from the furnace, however, and Alfonso displayed it in his *guardaroba*.[22] None of this can have endeared Alfonso to Michelangelo (or to the pontiff). In any event, he kept the duke waiting for eighteen years before acceding to his request, painting *Leda and the Swan* – and then refusing to consign the picture (Fig. 162).[23] Was this Michelangelo's belated revenge for the duke's destruction of the bronze *Julius*?

There is no certainty that Alfonso and Michelangelo considered any particular subject or venue when they first discussed a commission in Rome in 1512. But in soliciting Michelangelo, it would have been appropriate for Alfonso to describe the great enterprise he had just recently undertaken: the decoration of the room that was to become the Camerino d'Alabastro. Plans for the Camerino were already under way at the time of Alfonso's visit to Rome, and considerable progress had been made by that fall. By then, in relation to his project, the duke had borrowed his sister Isabella's secretary, the humanist Mario Equicola, and evidently also her translation of Philostratus's *Imagines*. Much to Isabella's annoyance, he detained Equicola in Ferrara longer than expected and kept the *Imagines* for several years, as she protested in a letter dated 12 December 1515.[24] Equicola had been delayed in Ferrara, as he wrote to Isabella on 9 October 1511, because he had been working on a program for "the painting of a room in which will go six fables or histories; I have already found them and written them down."[25]

It would have been natural for Alfonso to tell Michelangelo about the Camerino. Perhaps the duke wanted him to do something for that very room?[26] But if Alfonso meant to include "a Michelangelo" in the cycle conceived by Equicola for the Camerino, the subject would not have been Leda and the Swan. The work that Michelangelo eventually painted would have been anomalous as the sole narrative with only four figures (or five, counting the hatchling still in the shell), and only one of them an adult human being. It is an entirely different kind of composition from all the others documented for and in the Camerino.

Whatever Alfonso wanted from Michelangelo in 1512, plans for the duke's Camerino succeeded brilliantly, albeit not according to his original intentions. He was frustrated in his attempts to obtain works by Raphael and by Fra Bartolommeo when these masters died before fulfilling their commissions for

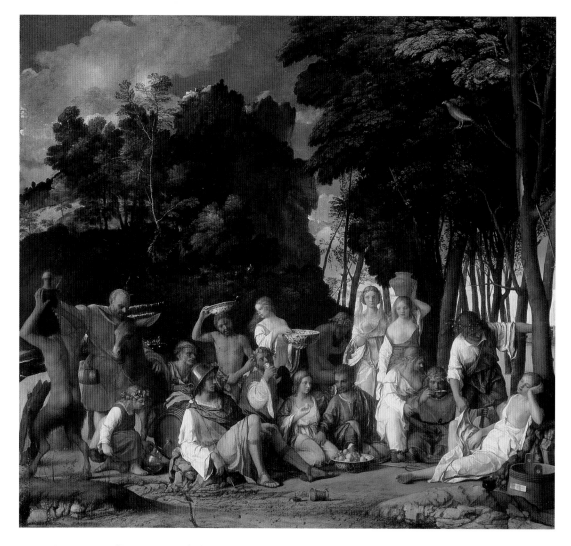

145 Giovanni Bellini. *Feast of the Gods*. Canvas. Washington, National Gallery of Art, Widener Collection.

the room. Nevertheless, Alfonso could console himself with what he did accomplish: a room decorated with Bellini's *Feast of the Gods* (Fig. 145); Dosso's *Bacchanal of Men*; and Titian's three *poesie*, the *Worship of Venus, Bacchus and Ariadne*, and *Bacchanal of the Andrians* (Figs. 146, 148, 149).[27] Isabella's Philostratus was not only the primary source for some of these narratives, but also for the underlying conception of the Camerino as a representation of the patron's discernment.

The patron's connoisseurship and erudition are on view in such cycles, bound with the competition among the artists whose works are displayed. Titian later alluded to this venerable and flattering notion in a letter to the duke dated

146 Titian. *Worship of Venus*. Canvas. Madrid, Museo del Prado.

1 April 1518. He had received canvas, stretcher, and instructions for the *Worship of Venus* intended for the Camerino, Titian wrote, and "The information included seems to me so beautiful and ingenious that I am all the more confirmed in an opinion that the greatness of the art of ancient painters was in great part, indeed, above all aided by those great Princes, who most ingeniously ordered them after which they achieved such fame and praise."[28] Of course, Titian was telling Alfonso what he thought his patron would like to hear. But doing so, he reiterated the interrelated themes of agon and *paragone* that underlie all such cycles and declared his aspiration to win "fame and praise" in fulfilling his own commission. Whether Titian himself wrote the letter or had

a humanist-friend ghost it for him (a service Aretino performed in later years) is irrelevant: by 1518 the artist himself was fully aware of the multifaceted implications of his engagement in the Camerino. Moreover, the competition intrinsic in the cycle was exacerbated for Titian by the way in which his commissions came to him.

Alfonso had begun his contest with a work by Titian's master, Giovanni Bellini. The first painting commissioned for the Camerino and first to be completed was Bellini's *Feast of the Gods*, signed and dated 1514. Although Bellini had had comparatively little experience with such themes, Alfonso may have been particularly keen to have something by him precisely because Isabella had been unable to obtain "a Bellini" for her own study in Mantua. The date of the duke's commission is not known, but the *Feast* was likely begun a year or two before it was finished, thus close to the time in fall 1511 when Equicola was writing his program for the Camerino. According to the duke's account books, Bellini received the final payment for his work on 14 November 1514.[29] Shortly thereafter, in early December, Alfonso made an initial payment of 50 ducats to Raphael for "the work he has to do for me," identified as the *Indian Triumph of Bacchus*.[30] The Camerino, the only setting documented for Bellini's painting in Ferrara, was the intended site for Raphael's painting as well: the cycle, and the competition, were now under way.

Progress was slow. Raphael had perforce to privilege commissions by Leo X and his kinsman Lorenzo de' Medici – a reality that became painfully apparent to Alfonso during a visit to Paris in December 1518. There he could see what Raphael had been doing instead of the *Indian Triumph of Bacchus* – gifts from the Medici to France: the *Saint Michael* for King François himself, signed and dated 1518; *Saint Margaret*, probably for the king's sister, Margaret of Valois; the *Holy Family of François I* for Queen Claudia; a portrait of Lorenzo de' Medici for his bride, Madeleine de la Tour; and the *Isabel of Naples* (Fig. 100), a gift to the king from the pope's newly appointed legate, Cardinal Dovizi (executed by Giulio Romano).[31] Raphael had been busy indeed – but not with his work for Alfonso. The painter's gift of the cartoons for the *Saint Michael*, dispatched on 21 September 1518, was intended in part as expiation for the delay.[32]

Meanwhile, Raphael had at least produced a drawing of the *Indian Triumph of Bacchus*, which had been received in Ferrara by fall 1517. But rather than wait for the master himself to complete the painting, Alfonso gave the drawing to Pellegrino da San Daniele, who was painting a picture based on Raphael's invention. News of this development displeased Raphael, as Alfonso's ambassador to Rome reported in a letter dated 11 September: if Pellegrino is painting the *Indian Triumph*, "Raphael says [. . .] that he will no longer proceed with that subject, as he has been determined to do, but with another. It is therefore necessary that Your Excellency advise if this is indeed the case, and what you want done, because he is ready to begin."[33] Patron and painter came to an accommodation, and by 17 November, Raphael had received another payment of 50 ducats and another subject, the *Hunt of Meleager*.[34]

147 Fra Bartolommeo. *Worship of Venus*. Black chalk. Florence, Galleria degli Uffizi, Gabinetto Disegni e Stampe 1269E.

Like everyone involved in such enterprises, Raphael understood that his work was commissioned precisely – as Raphael himself expressed it – "to go in comparison with many others" in Alfonso's study, beginning with Giovanni Bellini's *Feast of the Gods*.[35] (Bellini had declined Isabella's commission for her study in part to avoid such a confrontation with Mantegna: whether this was in fact his reason, it was one that could be considered credible.) Raphael's wording confirms what Equicola's letter has already told us: other paintings were planned even though Alfonso had not yet commissioned them. The cycle was conceived as an illustration of the agon.

Shortly after soliciting Raphael's *Indian Triumph of Bacchus*, Alfonso had begun negotiations with Fra Bartolommeo. The room would have works by Bellini, a Venetian; Raphael, Umbrian by birth but now Roman by experience; Bartolommeo, a Florentine; and Dosso Dossi, the Ferrarese court painter. Thus the competition was expanded to include a contrast of schools as well as individuals – a confrontation that Alfonso had perhaps intended from the start. But now his Florentine contestant began to cause difficulties. While visiting Ferrara in May 1516, Fra Bartolommeo had agreed to paint the *Worship of Venus* for the Camerino but then apparently had second thoughts about the subject, and in lieu of the mythological picture, offered his excuses, apologies, and two paintings of sacred subjects. "I have not previously been able to satisfy

148 Titian. *Bacchus and Ariadne*. Canvas. London, National Gallery.

Your Lordship," he wrote on 14 June, "because of too many occupations
[. . .] and also because of my usual weak state of health. At present I send your
Lordship, with this [letter], a picture of the Virgin with other figures, masterly
and pleasing in the shared judgment of artists and connoisseurs. [. . .] While
reserving the *storia* to a more quiet and suitable time, I send with this in
addition, to the most illustrious Lady [the duchess, Lucrezia Borgia], a head of
the Savior which was requested of me by her while I was there."[36] Clearly Fra
Bartolommeo was not immune to professional aspirations or indifferent to the
"judgment of connoisseurs" such as the duke. The friar's letter shows that he
was as aware as Bellini and Raphael that the Camerino was a competitive arena

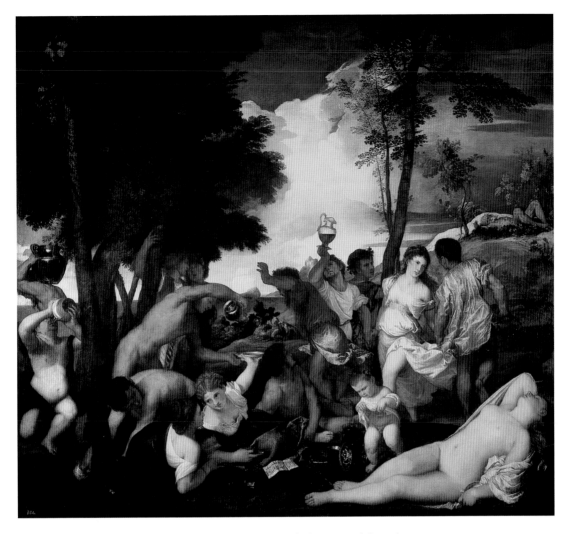

149 Titian. *Bacchanal of the Andrians*. Canvas. Madrid, Museo del Prado.

that reflected the patron's genius no less than the artists' skill in satisfying his requests. Sending the *Madonna* and the *Head of Christ* while excusing himself for not having completed the *Worship of Venus* may suggest that Bartolommeo had pious qualms about the mythological subject matter, as scholars have assumed. But his actions may also reflect his professional sense that his greatest ability lay in the interpretation of sacred themes. In any case, his complaint about his health was justified: the friar died on 31 October 1517, having done no more than sketch the composition of the *Worship of Venus* (Fig. 147).

By spring, Alfonso had decided to proceed with the friar's assigned subject, for which he now turned to Titian. The *Worship of Venus* was not Titian's first

commission for the duke. In February and March 1516 Titian had been the duke's guest at the castle in Ferrara, one purpose of his visit being the delivery of the *Tribute Money*, painted as the door of the cabinet housing Alfonso's coin collection.[37] The *Tribute Money* was Titian's first signed work and his first self-portrait, in the guise of the tax collector: TICIANVS F is written on the taxman's collar, identifying the subject like the inscription beneath the profile portrait on a coin.[38] Clearly Titian intended the painting as a self-advertisement that would remind the duke of its maker. And Alfonso did remember him, dispatching one of Bartolommeo's drawings to Giacomo (or Jacopo) Tebaldi, the duke's agent in Venice, for delivery to Titian. On 23 April Tebaldi wrote to the duke that he had given Titian "the paper where the little figure was sketched, and noted those words for his instruction."[39] Thus Titian inherited from Fra Bartolommeo the commission for the *Worship of Venus* and with it, the friar's drawing.

During his first sojourn in Ferrara in 1516, Titian had been able to see the Camerino and Bellini's *Feast of the Gods*, but there is no evidence that the duke discussed his painting anything for the cycle during that visit.[40] Titian was engaged for the Camerino only as the duke's replacement for Fra Bartolommeo. Dispatching the friar's drawing to Titian together with the commission, Alfonso underscored the fact. Like Pellegrino, to whom the duke had provided Raphael's drawing for the *Indian Triumph of Bacchus*, Titian was presumably intended to make a painting of Fra Bartolommeo's design. The surviving sheet is only a sketch, yet it explains enough of the composition for a painter to complete. Titian indeed used the drawing, though probably not as Alfonso expected. Alluding to Fra Bartolommeo, Titian's sketch at once commemorates and vanquishes his predecessor: it transforms a neatly structured pyramid into an asymmetrical, pulsating throng of revelers; where Bartolommeo's tidy composition imposes self-contradictory order on his scene, Titian's mayhem expresses its meaning perfectly.

Titian completed the *Worship of Venus* in early October 1519. The painter himself delivered the canvas to Ferrara, in order to finish it there and supervise the installation.[41] Meanwhile, Alfonso was still awaiting Raphael's *Hunt of Meleager*. Correspondence about Raphael's painting continued through the first months of 1520 until shortly before the painter's death in April.[42] The *Hunt of Meleager* was far from completion, and Alfonso was uninterested in having Raphael's *garzoni* complete it. A sophisticated collector, Alfonso was surely aware that any master's work involved collaboration; he may even have known that Raphael delegated a great deal to his assistants, especially during the second decade of the century. Raphael himself was of course cognizant of a collector's concern with the artist's hand. When Alfonso requested the cartoon for the portrait of *Isabel of Naples* in compensation for Raphael's dilatoriness in completing the Camerino commission, the painter complied but honorably explained that he himself had not made the cartoon: he had dispatched a student to Naples to do so.[43] Collaboration during the master's lifetime was one thing, however, and quite another his assistants' proceeding after his death

and thus without his guidance. This would subvert Alfonso's purpose, namely to juxtapose works by great masters. The duke did not want a particular *Bacchanal*: he wanted a *Bacchanal by Raphael*. Raphael had died, and so the project was abandoned.[44] For these reasons – that is, for what these events reveal about Alfonso's taste and his conception of the Camerino – it seems unlikely that he would have displayed Pellegrino's *copy* of Raphael's design for the *Indian Triumph of Bacchus* together with original works by Bellini, Dosso, and Titian, as has been suggested.[45] To do so would seem to controvert Alfonso's purpose.

Just as Titian had succeeded Fra Bartolommeo in the Camerino, now he inherited Raphael's unfulfilled commission. Soon after Raphael's death – perhaps within the month – Titian was back in Ferrara, to repair one of the duke's paintings – either the *Feast of the Gods* or one of his own works (the *Worship of Venus* or the *Tribute Money*) – and to undertake this new commission, the *Bacchus and Ariadne*, completed shortly before Christmas 1522.[46] As Titian had alluded to Fra Bartolommeo in his first *poesia* for the Camerino, now he evoked Raphael. The *Bacchus and Ariadne* has been seen as "a tribute to Raphael's style of history-painting," according to John Shearman, "unthinkable without the compositional inventions of the *Cartoons*." Titian would have known at least one of these, the *Conversion of Saul*, which was in Venice in 1520–21: acquired by Cardinal Domenico Grimani (whose family collection of antiquities so enriched his city), the cartoon influenced a number of Venetian masters (Fig. 132).[47] Insofar as Raphael's composition itself reflects lessons learned from the *Battle* cartoon by Leonardo and in this instance to a lesser degree that by Michelangelo, the tapestry design may be considered an additional conduit transmitting their ideas to Titian. He did not quote explicit motifs in the *poesia*, however; the debt is rather a matter of absorption of the Central Italian conception of dramatic narrative. Presumably Titian anticipated, or hoped, that Alfonso and other sophisticated viewers would appreciate his allusions. (Such an audience is to be distinguished from that of the Scuola del Santo in Padua.) And any knowledgeable beholder would have recognized another of Titian's references, his quotation of the *Laocoön*, snakes included. Indeed, one such viewer later identified the *Bacchus and Ariadne* with reference to that work: "a painting by the hand of Titian where the *Laocoön* was painted."[48]

Not all sources are treated equally: the citation of the *Laocoön* is flagrant and contained in one figure, whereas the reference to Raphael is covert and diffused throughout the composition. Titian's citation of *Laocoön* is like a poet's quoting Petrarch: the prestige and rich associations of the original are transmitted to its derivative in a kind of cultural shorthand. But when the borrowing is indirect, as in the case of Titian's reversals of Michelangelo, his revision of Fra Bartolommeo, or here, his transformative adoption of Raphael, the act of imitation becomes an independent act of creation.[49] Titian seems to have illustrated the objective of imitation as defined by Landino in the *Disputationes camaldulenses*, "not to be the same as the ones we imitate, but to be

similar to them in such a way that the similarity is scarcely recognized except by a learned man."[50]

So Titian's references to the *Laocoön* and other ancient statues and reliefs, especially in the group of Bacchus' worshipers, are straightforward, whereas his use of Raphael involves a considerable degree of alteration. Raphael's composition swirls around a central void, defined by the empty foreground and barren mound in the middle of the scene (in this regard, anticipating the *Transfiguration*). Above this, at the center axis, Christ appears in the sky, accusing Saul, blinding him so that he may see. The actors on earth move around the central mound without quite encircling it. At the right, the tangle of horsemen and the foot soldier who runs toward Saul anchor the scene and block spatial recession; at the left, the diagonal established by Saul's body is repeated by the diagonals of his fleeing horse and the attendants who try to restrain it, taking the eye to the agitated group in the distance, behind the mount and under the apparition of Christ. Titian's Naxos, where Bacchus frightened and then seduced Ariadne, is very different from Raphael's road to Damascus: the inhabitants are different of course, but so too the conception of landscape and the figures' relation to their space. Unlike Raphael's centralized setting, Titian's landscape is asymmetrical, closed at left by trees rising to the top of the composition and open to sea and sky at the right, with Ariadne's constellation, Corona, in the uppermost corner. Perhaps Ariadne, fleeing with her back to the beholder, can be compared in a general way with one of the attendants who tries to restrain Saul's horse, though her glance asserts her status as a protagonist whereas the groom naturally remains a supernumerary. But Bacchus, leaping from his chariot, is a far more daring exploration of foreshortening than anything, or anyone, in Raphael's cartoon.[51] Thus Titian exploited the narrative to demonstrate his breathtaking command of anatomy and foreshortening in the depiction of a figure in violent motion – an archetypal Central Italian theme.

Encouraged by circumstances to rival Raphael in *Bacchus and Ariadne*, Titian confronted him even more directly in the altarpiece completed in 1520 for Alvise Gozzi for the church of San Francesco ad Alto in Ancona (Fig. 150).[52] As scholars have long recognized, Titian's source was Raphael's *Madonna of Foligno*, commissioned by Sigismondo Conti for the high altar of Santa Maria in Aracoeli in Rome and painted c. 1511–12 (Fig. 151).[53] However he came to know of it, the *Madonna of Foligno* offered Titian a particularly amenable prototype: it is one of Raphael's most Venetian works, demonstrating his appreciation of Venetian style both in the palette and in the treatment of the landscape. Indeed, Raphael used Venetian *carta azzurra* for the only known study for the altarpiece.[54]

Titian's Ancona altarpiece is both an imitation of Raphael's composition and its inversion. The yellow disk representing Mary's glory in the *Madonna of Foligno* becomes a golden effulgence in Titian's panel (the same kind of transformation from artifice to nature that differentiates Raphael's *Disputa* and Titian's *Assunta*). Three of the monochromatic cherubim who populate

Raphael's blue sky have taken flesh to become Titian's putti and an *angelotto*. They are not casual bystanders but help explicate the meaning of the image. Exchanging a glance with Saint Francis and touching one of the Child's feet, the little angel lifts Mary's mantle to reveal Christ to the saint, who displays his own wounds of Crucifixion. The putti meanwhile divide their attention, one looking and gesturing toward Mary and the other toward Saint Biagio and the donor; they hold two wreaths. (Is one for the donor?) Mother and Child completely transform their prototypes with their more active postures and more volumetric modeling: Raphael's staid classicism is replaced by Titian's vibrance. Raphael's protagonists are tranquil, even coy, whereas Titian's are powerfully vigorous and more responsive, Mary bending toward the donor and Christ striding forward to bless him. A similar transformation occurs with the saints on earth. In Raphael's altarpiece John the Baptist enacts his traditional role, addressing the beholder with his gaze, directing attention to Madonna and Child. Francis kneels next to him, thus counterbalancing the kneeling figure of the donor, presented by his patron saint, Jerome (his lion peeks at us from behind Conti's mantle). Mary and Christ look toward them, but their response is limited to this exchange of gaze. While Francis points toward the beholder to plead for the faithful, Jerome pantomimes his endorsement of Conti. In the center, a putto looks up while showing us a *tavola ansata*, a shaped plaque: nothing is written there, but presumably it was intended to carry a dedicatory inscription, the date or the artist's signature.[55]

The circuit is closed in Titian's variation of Raphael's spiritual and optical scheme, and calm is replaced by energy. No one looks or gestures at the worshiper before the altar: the beholder is now the passive onlooker of a scene representing not only the donor's hope for his reception in heaven but Christ's blessing and Mary's welcome, not only his patron saint's *pro forma* endorsement but his forceful intervention. In Raphael's altarpiece, Saint Jerome puts his hand on the donor's head: a tender gesture that suggests Conti's subservience. In Titian's revision, Saint Aloysius has his hand on Gozzi's back, a less dominating, more *collegial* action. The bishop saint points toward Madonna and Child with such energy that his cope swirls with the effort; bending forward, looking sharply upward, he embodies his role as active intermediary between his client and the divine beings. In the *Assunta*, where Titian had employed a similar juxtaposition of the golden clouds of the celestial realm and the upward gestures of figures on earth, no saint's hand (or putto's foot, for that matter) quite crosses the boundary between heavenly and earthly. Here, however, the bishop's pointing finger does so, thus connecting the two worlds. Raphael's contemplative vision of adoration has been transformed into a scene of action, a dramatization of salvation.

The Ancona altarpiece was the first work that Titian both signed and dated, and the signature itself is one of Titian's earliest, preceded by only six others, if one counts his monogram T.V. inscribed on the parapets of the *Gentleman in Blue* and the *Schiavona*, both around 1510–11.[56] Writing on a *cartellino* in the foreground of the altarpiece, Titian recorded the donor's name and

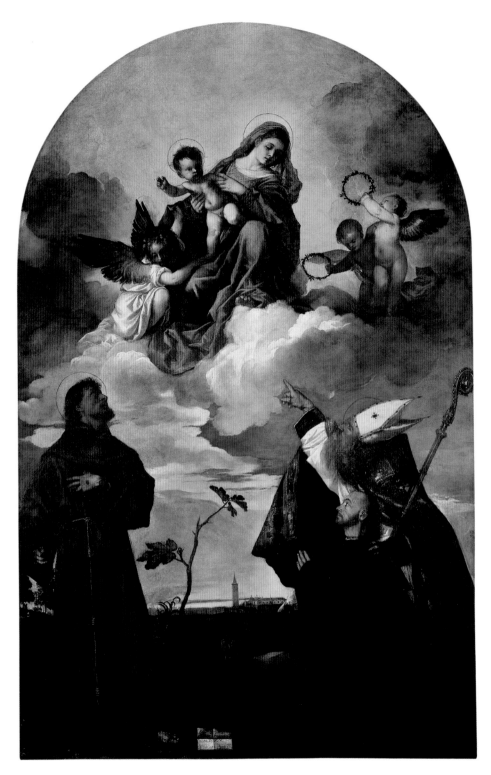

150 Titian. Gozzi altarpiece. Panel. Ancona, Pinacoteca Comunale.

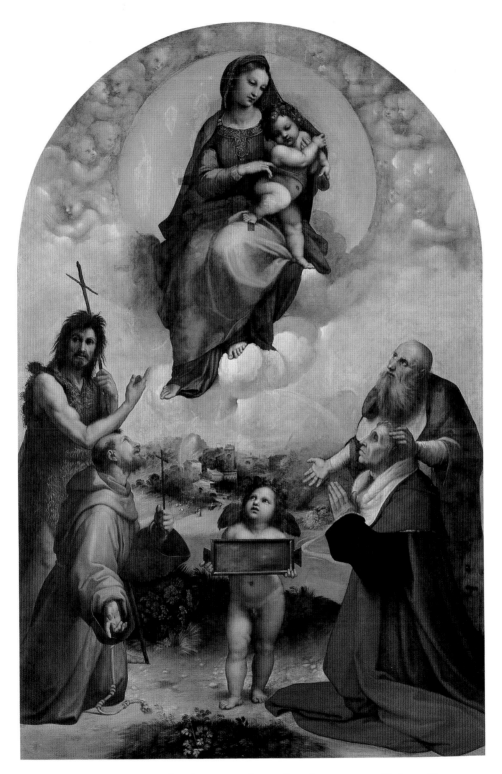

151 Raphael. *Madonna of Foligno*. Panel transferred to canvas. Vatican, Pinacoteca Vaticana.

citizenship as well as his own: "Aloyxius gotus Ragusinus / fecit fieri / MDXX / Titianus Cadorinus pinsit." The signature identifies Titian (still) as a native of Cadore, presumably to parallel mention of Gozzi's Ragusa, whereas the landscape, with its view of the Bacino di San Marco, alludes to Venice, identifying the artist and his creation with his adopted city.[57] The *cartellino* itself may be seen as a homage to Giovanni Bellini, though Titian perforce enlarged the device in order to accommodate the dedicatory inscription. Pride of authorship inherent in the signature's conspicuous foreground placement is mitigated by its proximity to Francis's foot, again recalling Bellini's practice of placing his name beneath the feet or under the hand of a sacred personage (usually Christ himself).

Completing the Gozzi altarpiece, Titian suspended his agon with Raphael and turned his attention to other rivals. Titian's third and last *poesia* for Alfonso, the *Bacchanal of the Andrians*, epitomizes Titian's *paragoni*: with the other arts, with antiquity, and with Renaissance rivals, living and dead.[58] Perhaps inevitably, given the context of the Camerino, Titian challenged his former master and predecessor in the cycle, Giovanni Bellini. Another of Alfonso's commissions illuminates Titian's competitiveness toward Bellini in the years following his death. On 29 May 1520, shortly before Titian's next departure for Ferrara, the duke wrote to Tebaldi with an urgent request: "Arrange to talk immediately to Titian, and tell him on my behalf that [. . .] he paint the portrait from life, and as it is in fact alive, of an animal called 'gazelle' which is in the house of the Magnificent Giovanni Corner [Cornaro], and that he portray it on canvas in its entirety, using good diligence, and then send it immediately, advising us of the cost." Tebaldi replied that he and Titian had gone to Corner's house to see the creature but that it had died. Undeterred, Tebaldi asked to see its hide but was told that the body had been thrown into the Canal. Corner was able to show him and Titian its portrait by Giovanni Bellini, however. On seeing this little picture, Titian offered to redo it for Alfonso, lifesize (bigger is better).[59] As in the Camerino, Titian's rivalry with Bellini was bound to the desire to please their patron. Alfonso was apparently more interested in the animal than in its portrait by Titian, however: there is no evidence that such a lifesize copy of Bellini's work was ever painted. But Titian was still wanted in Ferrara, and his rivalry with his old master still rankled.

At some point, the background of Bellini's *Feast of the Gods* composition had been partly reworked, evidently by Dosso Dossi. Later still, presumably intending to make the older work conform better with his own additions to the cycle, Titian himself repainted the landscape rather more extensively.[60] Continuing his posthumous rivalry with Bellini in the composition of the *Andrians*, Titian enlisted Michelangelo's assistance by coopting the *Battle of Cascina*. Alfonso had acquired a fragment of the cartoon in 1519, which Titian would have been able to see during one of his several sojourns in Ferrara.[61] The allusions are both specific and generic. The celebrant in the foreground, next to the woman who raises her cup to "drink again," is taken directly from

Michelangelo's cartoon, where he reclines in the right corner.[62] In his first borrowings, in the Santo and in his woodcuts, Titian had reversed poses while separating them from their original significance. The reversals had been mechanical: left became right. In the *Bacchanal*, Titian's response to Michelangelo is more sophisticated. Now, though the quoted figure replicates the model in this literal sense, psyche and meaning are more profoundly altered. The rhythms and interlocking poses of Michelangelo's *Battle* pervade Titian's *Bacchanal*, but where there was fear and the threat of violence at Cascina, at Andros, equal energy is expended in the pursuit of sensual gratification. A river where men may drown here becomes wine where they become inebriated – and enamored. Struggle becomes dance; cries of alarm become song; violence becomes sex. And male becomes female: instead of Michelangelo's paean to the striving male nude, Titian represented a sleeping nymph, an icon of unrestrained and satiated female sexuality.

That Alfonso's study should have been the arena for Titian's rivalrous display was to be expected. The venue required such competition. Moreover, Titian must have known the duke's fragment of the *Cascina* cartoon and likely knew of Alfonso's visit with Michelangelo on the scaffolding of the Sistine ceiling. The duke himself may have told Titian of his admiration for Michelangelo and his, Michelangelo's, promised work. Painting the *poesie* and other commissions for Alfonso, Titian could expect that sooner or later his art would be compared with something by Michelangelo: not indirectly, in the knowledgeable mind's eye, but directly, in the same collection – and perhaps in the same room, if Michelangelo's work was meant to be one of the *poesie* for the Camerino.

Titian's close observation of Michelangelo as he completed the *Andrians* and the agonistic purpose of this study are embodied in the *Saint Sebastian* (Fig. 154). Signed and dated 1522, the work was conceived as the right wing of the altarpiece polyptych commissioned by Altobello Averoldi, named Bishop of Brescia in 1512 (Fig. 152).[63] In Rome in the 1490s, Averoldi had been friendly with Cardinal Raffaele Riario, the unwitting purchaser of Michelangelo's "antique" *Cupid* and dissatisfied patron of the *Bacchus*. In 1516 this friendship became a liability, when Riario was imprisoned in Castel Sant'Angelo for complicity in the cardinals' plot against Leo X. At risk for guilt by association, Averoldi paid 6,000 ducats to be named legate to Venice where he resided from 1516 to 1523.[64] There, Averoldi became friendly with Pietro Bembo, one of Bellini's great friends and one of Titian's first noble patrons. Bembo may well have introduced Titian and Averoldi. In any case, in 1519 the legate turned to Titian for the high altarpiece for the church of Santi Nazaro e Celso in Brescia. The polyptych format was presumably stipulated by Averoldi, and so too the depiction of the Archangel Gabriel and Annunciate Virgin in the uppermost panels left and right (many North Italian fifteenth-century altarpieces incorporate the Annunciation in this way). Most scholars denigrate the polyptych format as retardataire for its date, a choice reflecting the presumably provincial taste of the patron. But Averoldi was no rube, and while Titian was painting his polyptych for "provincial" Brescia, Palma il

Vecchio was using the format for his *Saint Barbara with Saints*, still *in situ* in the church of Santa Maria Formosa in cosmopolitan Venice.[65] What may seem outmoded to modern observers was considered viable by these artists and patrons.

However Titian may have proceeded with painting the five panels of the Brescia altarpiece, by late fall 1519 people were talking about his commission. Tebaldi had already heard of it from his friends, "and master Titian has not denied it to me."[66] Titian had also told Tebaldi that he had not been able to do the duke's work (the *Bacchus and Ariadne*) because he had not received the stretcher, canvas, or the measurements that had been promised. Titian swore that he intended to demonstrate what he could do in art but that since none of these necessities had been provided, he had assumed that Alfonso no longer cared about this picture. When the canvas arrived, he would force himself to finish the painting for Ascension Day and hoped it would please the duke.

Still waiting a year later, and with growing impatience, Alfonso wrote to Tebaldi on 17 November 1520, instructing the agent to goad Titian to fulfill his obligations:

> See that you speak with Titian, and tell him in our name that when he left Ferrara he promised us many things, and so far we do not see that he has done anything, and among other things, he promised to make us that canvas which we particularly expect from him. And because it does not seem to us that we deserve that he fail to do what he has promised us, exhort him to do what he has promised us so that we shall not have cause to be vexed with him, and in particular that he see to it that we soon have the said canvas.[67]

Tebaldi replied a week later, 25 November, with more discouraging news for Alfonso: Titian has finished the *Saint Sebastian* for the bishop's altarpiece, and "many people are talking about it [. . .] because it is a most beautiful picture." Tebaldi reported that he had remonstrated with Titian, telling him that his "excuses are no less well colored than your pictures." In reply to Tebaldi's questions, Titian confirmed that he had indeed completed a lifesize figure of the saint, and also a "studio," presumably a study for the altarpiece. The painter then added that the bishop "is giving him 200 ducats for this entire panel" – referring to the altarpiece – "but that this Saint Sebastian is worth all of these 200 ducats." Titian's remark gave Tebaldi an idea: why not serve the duke instead? Titian replied "that neither for priests nor for friars would he ever leave the service of Your Excellency and in order to serve him would remain day and night with the brush in hand."[68]

Tebaldi wrote again on 1 December: "yesterday I went to see the picture of Saint Sebastian that Master Titian has made, and there I found many people from hereabouts who were viewing it with great admiration and praising it, and he said to all of us who were there that it was the best painting that he had ever done. When some of these people had gone, I said to him privately that it was throwing this picture away to give it to a priest, and that he [the priest] would take it to Brescia, a place, etc." – presumably meaning to the dark

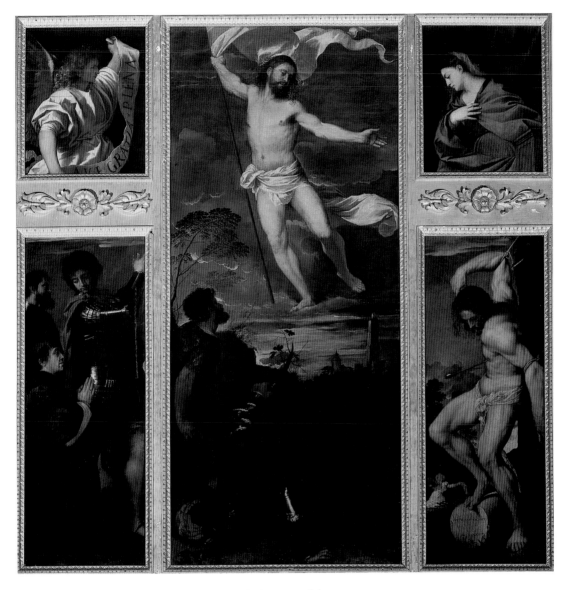

152 Titian. Brescia altarpiece. Brescia, Santi Nazaro e Celso.

side of the moon. Tebaldi encouraged Titian "to give it to Your Excellency"
instead, and

> he answered me that he would not know what part to play in perpetrating
> such a theft, to which I replied that Your Excellency would well show the
> way, and I reminded him that he could immediately begin another like it,
> and then eventually turn the head, a leg, an arm, etc. He answered me that

he was most ready to do everything that he could and knew how to do that would be pleasing to Your Excellency. And with this I left and told him that I wanted to write everything to [Your Excellency]. The said figure is attached to a column with one arm raised and the other lowered, and all turned in such a way that one sees almost the entire back, and in every part of his person he shows himself to have suffering [*passione*] for a single arrow that he has in the center of his body. I do not have an opinion yet, because I do not understand *disegno*, but admiring all the parts and muscles of the figure, to me it seems similar to a body created by nature, and dead.

The figure was essentially complete, though lacking part of a hand and the point of the elbow, having been painted on a narrow panel made to accommodate the dimensions of the polyptych. Titian was willing to attach a strip of wood to complete these missing parts. That is to say, he was willing to sell the *Sebastian* to Alfonso, presumably painting a copy or variant for the altarpiece, as Tebaldi suggested. The duke should tell Tebaldi how to proceed, and "do not talk to anyone about it, who, because of envy or to gratify the Papal Legate," might interfere with their plans and take the panel from Titian before they could get it.[69]

Although Tebaldi mentioned *disegno*, which he professed not to understand, he said nothing about *colorito*: knowingly or not, he seems to have been responding to Titian's references to Michelangelo as the incarnation of *disegno*. In any case, as Tebaldi explained, he was not alone in Titian's shop. There were many other visitors there, all with the same purpose: to view the *Sebastian*. Perhaps like Tebaldi, what they most admired was the conception of the body itself, "all the parts and muscles," its appearance of being a dead body "created by nature." The situation Tebaldi described, suggesting a kind of salon, could not have been more unlike the antisocial isolation of Michelangelo's studio. And among those visitors to Titian's "salon" in 1522 was Paolo Giovio. The humanist physician had accompanied the imperial emissary, Girolamo Adorno, to Venice; and Adorno was sitting for his portrait by Titian. Giovio included the painter in his Life of Raphael, written shortly thereafter, praising "the many virtues of Titian's refined art, which only the knowledgeable and not the uninformed understand."[70]

Giovio and Alfonso were good friends. Perhaps Giovio himself told the duke of his admiration for the artist whose works Alfonso had begun to collect. In any case, reading Tebaldi's account, Alfonso determined to acquire the *Sebastian* for himself. His interest in the panel, like his ambassador's, was an admixture of aesthetics and acquisitiveness. Nothing was said about whatever pious devotion either man may have felt for the saint: the correspondence concerns only a collector's zeal to possess a beautiful work. The only question was: how much would it cost?[71]

Seduced, Titian responded to Tebaldi that no one else in the world could have convinced him to commit this "swindle" (*truffa*) but that he would do it to please the duke – and for a fee of 60 ducats. Repeating what he had earlier

told Tebaldi, he explained that his fee for the entire altarpiece was 200 ducats and that the *Sebastian* alone was worth that amount. If the duke wanted it, Titian would have to paint another *Sebastian* for the legate. In short, after some caviling, Titian's answer was yes. But now Alfonso himself reconsidered the situation, concerned about offending the legate and reawakening the enmity of the papal court in the process. Writing to Tebaldi on 23 December, Alfonso instructed him to tell Titian "that having thought about this matter of the Saint Sebastian we are resolved not to wish to do this injury to the Most Reverend Legate." Titian should concern himself instead with completing his commission for the duke, and for now the duke wanted nothing more from him but this, that is, the *Bacchus and Ariadne*.[72]

Thus the *Saint Sebastian* came to fulfill the purpose for which it had been conceived. Had the panel gone to Ferrara instead of Brescia, Alfonso's and Titian's offense would have been to deprive the bishop of the painting he had commissioned. Alfonso would have been enjoying Titian's work while Averoldi cooled his heels, waiting for the replica. But in addition to this affront, the implication is that the original – the artist's first edition, as it were – is superior to a copy, even if made by the same hand. Alfonso had already demonstrated his sensitivity to such matters by insisting on a work by Raphael himself, even after he had delegated Raphael's drawing of the *Triumph of Bacchus* to Pellegrino: a Pellegrino was not enough, a Raphael was still wanted. Thereafter, the duke declined the offer of Raphael's heirs to complete the master's commission for the Camerino after his death. The *Sebastian* situation was not quite the same, but the same pattern of thinking about works of art as unique creations underlies Alfonso's actions in relation to Titian's saint.

Painting *Saint Sebastian*, Titian mined Michelangelo once again, this time usurping not painting but sculpture. Titian's saint gives flesh and blood and volition to Michelangelo's unfinished *Slaves*, intended for the tomb of Julius II (Figs. 153, 155).[73] The saint's expression, his steady gaze, and the hint of a smile, suggest his willing acceptance of his suffering, a quality that Tebaldi appreciated in describing Sebastian's saintly "passion," his "suffering for a single arrow." No less than Titian's colorism, this psychological conception distinguishes his figure from Michelangelo's prototypes, despite their strong physical resemblance and the similarity of their poses. Sebastian's kinship with the *Slaves* seems direct, not the result of a shared antique source such as the *Dancing Faun*.[74]

How did Titian know of the *Slaves*? Was his patron his source? Averoldi had been at the papal court while Michelangelo was working on these statues for Julius's tomb. Alternatively (or additionally), Sebastiano del Piombo may have been Titian's informant. However Titian knew the *Slaves*, his *Saint Sebastian* testifies to the connection: his figure is an amalgamation of Michelangelo's poses. One detail in particular is significant. Where the *Rebellious Slave* rests his right foot on part of the unfinished block, which would have been carved to represent a rock or a mound of earth, Sebastian rests his on the drum of a column. On the circular face of this finished stone, Titian placed his signature

154 *(facing page left)*
Titian. Detail of Fig.
152. Saint Sebastian.

155 *(facing page right)*
Michelangelo. *Dying
Slave.* Marble. Paris,
Musée du Louvre.

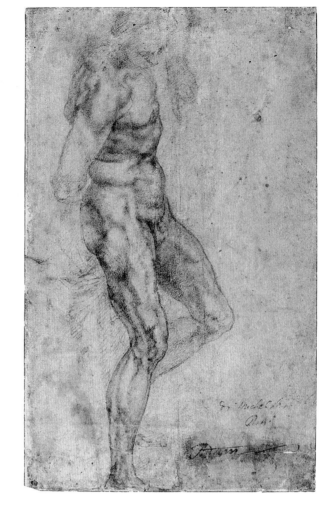

153 Michelangelo.
Slave. Chalk. Paris,
Ecole Nationale
Supérieur des Beaux-
Arts 197r.

and the date: .TITIANVS . FACIEBAT / M. D. XXII (Fig. 154). Just next to this, and
below the saint's right calf, an angel comforts Saint Roch (San Rocco), tending
the wound in his thigh. The tiny scale of these figures suggests their removal
in time and space, but they are related to Sebastian thematically, as images
promising protection from the plague (evoked by Sebastian's arrow wounds
and by an actual plague sore in Roch's thigh). The proximity of Roch and the
angel to Titian's signature makes them an ex-voto, a visual prayer for the artist's
own salvation, anticipating his ex-voto painting-within-the-painting of the
Pietà intended for his own tomb (Figs. 202, 203).

Every detail of Titian's signature is significant. The *Sebastian* is Titian's
second signed and dated work, preceded only by the Gozzi altarpiece in
Ancona. Although two of his six earlier, undated signatures had included the
standard abbreviation "F" for *fecit*, none contained the complete verb. But the

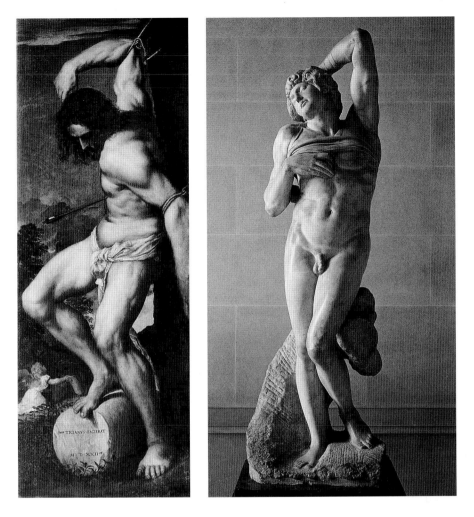

signature of the *Sebastian* spells it out in the imperfect tense. Thereafter, Titian was to use *faciebat* again only three times, albeit without the date, in the San Nicolò ai Frari altarpiece, completed c. 1525, and in two works painted decades later.[75] Alluding to the signatures of the great masters of antiquity, Titian's use of the imperfect tense may also be an allusion to his more recent predecessors, Bellini and Michelangelo. Bellini had signed and dated his *Nude with a Mirror* in this way in 1515, the inclusion of the year explained in relation to his advanced age at the time of his "continuing to paint" the *Nude*. The combination of data and signature makes it more than a general reference to ancient masters: the inscription is an autobiography *in nuce*.[76]

Even before Bellini – and apparently for the first time since antiquity – Michelangelo had used the formulation in signing the Vatican *Pietà*. As described above, Michelangelo's signature blazes across Mary's breast. Titian's

signature in the San Nicolò altarpiece is similarly bold: the words are inscribed
on a *tavola ansata* affixed to the apse of the church where the vault opens
to an apparition of Mary and Christ in the clouds. Its conspicuous placement
recalls Raphael's signature inscribed on the Temple in the *Sposalizio*. But
that inscription is unnoticed by the actors: it is addressed exclusively to the
beholder. In the Venetian altarpiece, as Saints Nicholas, Francis, and Anthony
look up at the celestial vision of the Virgin and Child, and as these beings look
down toward the saints, all seem, coincidentally, as it were, to read Titian's
name. The inherent immodesty of this placement of the signature is counter-
balanced by the humility of the verb: Titian *was doing* this. As in Michelan-
gelo's *Pietà*, the signature is without a date, perhaps because the act of
veneration should be never-ending, just as the act of artistic creation must
remain continuous. Given the original site of the altarpiece in the now destroyed
church of San Nicolò, adjacent to the Frari, the imperfect verb may be read in
a more specifically personal way as well, reminding the beholder of what Titian
had already achieved: the *Assumption of the Virgin*, unveiled in the Frari in
1518.

Titian's signature in the Brescia polyptych is set beneath the feet of Saint
Sebastian, with greater (apparent) modesty than his later signature in the San
Nicolò altarpiece or than Michelangelo's in the *Pietà*. The shadow cast by
Sebastian's foot points to the *faciebat* as though to underscore the sense of tran-
sience: light and shade are inherently ephemeral, so too the artist's achievement.
This time, however, the date *is* included. Recalling Bellini's usage in the *Nude*,
Titian's dated signature is an autobiographical record of his achievements:
this is what Titian was doing in 1522.[77] And what he was doing was quoting
Michelangelo – quoting, furthermore, a self-avowedly *unfinished* work by the
sculptor, a work that Michelangelo himself *faciebat*, "was making."

Titian's signature appears on a finished block of masonry, that is, on stone.
No less than the tense of the verb, this material evokes Michelangelo, espe-
cially in this context, that is, beneath a figure derived from his *Slaves*. Where
Michelangelo always privileged the block, however, Titian preferred a cylinder.
It is as though he wished to insist on his rivalry with every detail of his
invention. (Varying the arrangement of the *Rebellious Slave*, the *Slave* in
Michelangelo's drawing has his left foot raised on what seems to be a carved
block of masonry.) The borrowings, allusions, and reversals are self-evident,
and permeated by the kind of wit that characterizes parodistic imitation. This
is not to say that Titian's imitation of Michelangelo is in any sense comedic;
rather, its parody signals that his creation is not subjugated to his source. Admi-
ration and emulation of Michelangelo are counterbalanced by Titian's painterly
transformation of the sculptor's model. *Sebastian* illustrates Titian's agon with
Michelangelo in the 1520s; the signature is the text of that rivalry.

In the left wing, almost as though to offer an alternative vision to the
Michelangelism of the *Sebastian*, Titian resurrected Giorgione to represent the
soldier saints Nazzarus and Celsus. With their shadowed faces, light-reflecting
armor, and dreamy expressions, these men recall such figures as the Saint

Liberale of Giorgione's Castelfranco altarpiece or Giorgionesque works by Titian himself in his early years (for the luminous armor, his *Saint George*, c. 1511, for example).[78] The retrospective quality of this wing of the Brescia altarpiece signals Titian's concern with a visual autobiography, a stylistic record of his professional itinerary, concomitant with the autobiographical implications of the signature. The altarpiece may be seen as the first chapter of Titian's autobiography, a characteristically self-referential exploitation of style, culminating in such great works of his old age as the *Pietà* and the *Marsyas*.

The main panel of the Brescia altarpiece, representing the *Resurrection of Christ*, alludes to Titian's other great rival in 1520, namely Raphael. Even after his death in April, Raphael remained a lodestar for other painters; if anything, his exemplarity had increased. Whereas Titian's quotations of Michelangelo are specific, however, his references to Raphael are less precise. The dawn sky in the altarpiece, the way in which the soldier falls back as he witnesses the Resurrection, and the silhouette of his companion's profile against the orange light of the sky recall the nocturnal lighting and similar motifs in Raphael's fresco of the *Liberation of Saint Peter* (Fig. 131). Nocturnes and extraordinary lighting were part of Titian's artistic heritage, as Giorgione's *Tempesta* reminds one. So if the *Resurrection*'s similarities to Raphael's *Liberation of Saint Peter* represent Titian's response to Raphael, they also illustrate a coincidence of the two masters' interests and in a sense the Venetian's reasserting his birthright to such luminous effects.

Titian's Resurrected Savior recalls another work by Raphael, the Christ of his *Transfiguration*. Again, the resemblance is a general one, especially in the treatment of the legs standing on "thin air." Titian's allusion to Raphael is like a paraphrase, very different from Sebastiano's more precise citation in his fresco *Transfiguration* in the Roman church of San Pietro in Montorio. Was it Sebastiano's decision to copy the altarpiece that had vanquished his own, or his patrons? Did he see this commission as an opportunity to outdo Raphael by *redoing* him? This is the implication of his letter to Michelangelo of 6 September 1521: Sebastiano had nearly completed the work, and "I am doing it in oil on the wall, which I believe will please you [. . . unlike] the way those [boys] of the [Vatican] Palace are doing it."[79] Although Sebastiano's use of oil was meant in part to surpass and even embarrass Raphael's heirs, his imitation of Raphael himself may be called reproductive or sacramental. Titian's *imitatio*, involving not one but several sources and traditions, might be characterized as "eclectic or heterogeneous," or, as Renaissance rhetoricians termed it, *contaminatio*.[80] All traditions – Giorgione and Venice, Michelangelo and Florence, Raphael and Rome – are treated "as stockpiles to be drawn upon *ostensibly* at random."[81] Indeed, Titian seems to have insisted on the diversity of his sources by exploiting the polyptych format itself. The trouble with polyptychs, from the High Renaissance point of view, was precisely that they consist of discrete elements, forcing separation on painters and viewers who sought unity. Since the fourteenth century spatially adventuresome artists had tackled the problem by suggesting continuity despite the separation imposed by the

frame. All three panels of the Frari triptych, for example, signed and dated by Bellini in 1488, are unified by means of space and light.[82] In the Brescia altarpiece, on the contrary, Titian has insisted on the separateness of his elements. Spatially disparate, the panels are also differently lit, as if to underscore their disparity. The direction of light is the same: throughout the altarpiece the figures are illuminated from the left. But this unity is contravened by the *color* of the light, bound in turn to implications of time. Gabriel and Mary are indoors, set against dark grounds; the saints in both wings are seen in daylight; the Resurrection, appropriately, is at dawn. In other words, the spatial and in some instances psychological separation of the elements is bound to their separation in time, expressed by light. Indeed, Titian intended that the polyptych be understood in this way. The unavoidable anachronism in almost any grouping of Mary, Christ, and saints is here acknowledged rather than ignored, the independence of the panels exploited rather than denied. Admittedly, in the left wing, Saint Celsus (the younger of the two saints) gestures toward the Resurrected Christ in the central panel, and Bishop Averoldi kneels in prayer not only before the soldier saints who accompany him but also before that figure of Christ. In the upper register the Archangel Gabriel who addresses the Annunciate Virgin with his scroll, inscribed AVE GRATIA PLENA, binds left and right by this action and by the direction of his glance, cutting across Christ's space. But focusing inward, Sebastian is oblivious to his Savior's presence, and equally unaware of the angel and Saint Roch at his feet. So the donor and the patron saints of the church are related spiritually to the Resurrected Christ, but Sebastian, Gabriel, and Mary are psychologically separated from him, just as they are separated by differentiated spaces and lighting. Bishop Averoldi and his patrons may respond to the Resurrected Christ because veneration of this event and its promise of redemption for the faithful transcend historical time. But the Annunciation group and Sebastian honor, or obey, history by existing in their separate times and spaces. Using the polyptych format, Titian turned what his immediate predecessors (and present-day art historians) perceived to be its primary limitation into a narrative virtue. Only a master of supreme self-confidence would dare to do so, and to commingle such a variety of sources, without fear of losing his own identity.

One reason for Titian's focus on Central Italian rivals in the 1520s even as he looked back at his own Giorgionesque beginnings was the simple fact that there was no one in Venice to challenge him: Giorgione himself had died in 1510; in 1511 Sebastiano left for Rome; and in 1516, finally (from Titian's point of view), old Bellini succumbed.[83] In Venice, Titian was faced only with such masters as Palma il Vecchio, Andrea Schiavone, Vittore Carpaccio, Alvise Vivarini – great painters but not rivals of the caliber of Michelangelo and Raphael (or Bellini and Giorgione). By the 1520s, moreover, Titian's patronage had moved definitively beyond the Republic's borders, thanks to Alfonso d'Este and other collectors. By then, Titian's chief competitors were non-Venetians; and the primary arenas of his competition likewise foreign, starting in Ferrara but eventually including most of Italy and Western Europe. As the first master

with a consistently international clientele, Titian changed not only the rules of competition but the venue. Leonardo had moved to France at the king's invitation in 1516; but both the artist and his royal host must have understood that Leonardo was approaching the end of his life. Leonardo's principal assignment was to solve certain problems of hydraulics and navigation of the Oise, and François cannot have expected the master to achieve much for him in the arts, except to bring luster to the court. Later Italian émigrés to France, such as Rosso Fiorentino, essentially abandoned their Italian careers as a result of the move; or, conversely, abandoned France in order to resume their activity in Italy, as did Benvenuto Cellini: their careers were international only in this more limited, occasional sense, and they were not regularly engaged by an international clientele. But Titian's list of clients was so extensive that Vasari lost patience with listing them all. "But what loss of time is this? There is hardly a single lord of great name, nor prince, nor great lady, who has not been portrayed by Titian."[84]

Had Raphael lived longer, most likely he too would have been employed by foreign princes, or at least sought by them. The Medici gifts to François would presumably have been followed by French and perhaps other European commissions. As for Michelangelo, he was well aware of the prestige inherent in royal patronage and had briefly considered a move to France in 1529, after the fall of the Florentine Republic. Michelangelo "left Florence," as he explained to his friend Battista della Palla, one of the king's agents in Italy, "meaning to go to France, and once arrived in Venice, I was informed about the route, and [. . .] going from here [Venice], one has to pass through German territory, and that it is dangerous and difficult to go." Would Battista go with him?; "as you know, I wanted to go to France in any case."[85] The artist remained in Italy, but the king acquired his first Michelangelo the following year: the *Hercules*, purchased for the royal collections by Battista.

Condivi's biography does not mention this exchange but does record that François acquired *Leda and the Swan*, eliding the fact that Michelangelo had given the painting to Antonio Mini in 1531 and implying that the monarch's purchase was planned, as it were, rather than opportunistic.[86] François himself wrote to Michelangelo on 8 February 1546. Having "a great desire" to possess some works by Michelangelo, the king has delegated the Abbé of Saint-Martin de Troyes – that is, Francesco Primaticcio – to call upon him with this letter and "praying you, if you have some excellent works already made at his arrival, to give them to him, with his paying you well. [. . .] And moreover, [. . .] that he cast copies of the *Risen Christ* of the Minerva and of the *Pietà*, so that I can decorate one of my chapels with them, as things about which I have been assured are among the most exquisite and excellent of your art."[87]

Michelangelo replied to the king on 26 April: "for a long time, I have desired to serve you." Now busy with work for the pope, however, he could not undertake a new commission. But with the completion of the Pauline Chapel, "if a little life remains to me, I shall try to fulfill my desire [. . .] to execute for Your Majesty a work in marble, [one] in bronze and [one] in painting. But if death

should thwart my desire, I shall not fail to fulfill it in the next life [. . .], if it be possible to carve and paint there."[88] Michelangelo lived for another eighteen years but François died in 1547: death had indeed thwarted the artist's desire, or rather his ambition, because his reference to "a work in marble, in bronze and in painting" suggests that he had something grand in mind to demonstrate the powers of his art, or arts, to the king.

By means of Condivi's biography, Michelangelo could boast about his relationship with François and other exalted patrons, or would-be patrons, including the Ottoman sultans. Bayezid II (1481–1512) had approached him as early as 1504–06 about building a bridge over the Golden Horn from Constantinople to Pera, "and other matters," Condivi reported. And Michelangelo confirmed the fact in a comment to Calcagni: "He told me it was true, and he had already made a model."[89] Later in the biography, Condivi exulted that "the princes of the world" have contested for Michelangelo's works, "from the four pontiffs Julius, Leo, Clement and Paul, to the Great Turk," who ordered letters of credit to cover the master's travel expenses; and "François Valois, king of France, sought him by many means," also making travel funds available. Finally, "from the Signoria of Venice [Antonio] Brucciolo was sent to Rome, to invite him to live in the city whenever he would like to go there, offering the provision of 600 scudi a year, without obligating him to anything, but only that with his person he honor that Republic, with the condition that, were he to make anything in the Republic's service, all would be paid."[90]

Clearly it was important to Michelangelo to vaunt his client list, or its most noble members, noting his service to popes and monarchs. In reality, however, after the Mouscron contract for the Bruges *Madonna* in 1503, Michelangelo was never again directly engaged by a foreign patron. Aside from that *Madonna*, only three of his works left Italy during their maker's lifetime, all of them going to France: the bronze *David*, commissioned by the Republic as a gift for a French diplomat; the *Hercules*, commissioned by Piero de' Medici and sold by the Strozzi; and *Leda and the Swan*, given to Mini, who marketed several copies before selling the original to François in 1532. In 1559, just five years before Michelangelo's death, the Florentine-born queen of France, Catherine de' Medici, failed to convince him to undertake an equestrian monument of her deceased husband, King Henri II. In attempting to cajole Michelangelo, Catherine reminded him of his long association with the Medici: though the monument, had it been made, would have been displayed in France, it was in this sense a Florentine, not to say a Medici commission.[91]

Despite his extraordinary fame, therefore, Michelangelo worked almost exclusively for Italian patrons, and after 1508, almost exclusively for the popes and for the Medici. Titian's list of clients, on the contrary, included as many non-Venetians as Venetians – an expansive pattern of employment that Alfonso d'Este had begun. Meanwhile, after Bellini's death, no one challenged Titian's hegemony in Venice itself, and no major Venetian patron looked beyond the Serenissima for alternatives to her native sons.[92] This situation was encouraged

by the Venetian painters' guild, considered exceptionally xenophobic and effective in discouraging foreign competition. In the 1520s only one master succeeded in breaching these defenses to confront Titian in his city: Giovanni Antonio Sacchis, called Pordenone after his birthplace.[93]

Pordenone, or at least his art, had first come into direct contact with Titian – or *his* art – in the Malchiostro Chapel of the Annunciation in Treviso cathedral.[94] Constructed in 1519, the chapel was completed in January 1523, Pordenone having supplied the fresco decoration and Titian the altarpiece, the *Annunciation*, with the portrait of the patron, Canon Broccardo Malchiostro, in the background.[95] Titian, having bigger fish to fry in Ferrara and elsewhere, seems to have delegated at least the clumsy Gabriel and perhaps also the donor's portrait to an assistant, sometimes identified as Paris Bordone.[96]

Titian's imagery is complemented by Pordenone's frescoes in the cupola, with God the Father, surrounded by wingless putti (or Innocents), commanding the *Annunciation*.[97] The dramatic interrelation of the altarpiece and fresco suggests cooperation between the painters, or at least their having been instructed to exploit such spatial and thematic connections between altar and cupola. In other words, though Malchiostro divided his commissions, he expected his chapel's decoration to be unified both visually and iconographically. Ordering separate but interconnected depictions of God the Father and the Annunciation, perhaps he or his artists had in mind the prestigious example of Giotto's Arena Chapel in nearby Padua. There too, one sees a combination of media: God the Father is represented in a separate image – a panel set into the wall of the triumphal arch – related spatially and iconographically to the frescoes of the Archangel Gabriel and Virgin Annunciate on either side of the arch.

Titian certainly knew Giotto's great Paduan cycle. Before Treviso, furthermore, he had had his own experience with the underlying conception of visual and iconographic unification of disparate elements: his *Assumption* and the triumphal arch of the choir screen in Santa Maria Gloriosa dei Frari. Framing Mary's triumph, the architecture also enframes the altarpiece across the space of the nave.[98] Titian and Pordenone or their patron may also have known of such Roman precedents as Filippino Lippi's Carafa Chapel in Santa Maria sopra Minerva (1488–93), where the altarpiece and surrounding frescoes are similarly related both spatially and iconographically, or Raphael's plans for the Chigi Chapel of Santa Maria del Popolo, where God in the dome is bound to the Virgin in the *Assumption*.[99] That Pordenone at least was looking at Roman art is revealed by his interpretation of God the Father, an amalgamation of Michelangelo's figures of God in the Sistine Chapel.[100]

After their first encounter on the mainland, Pordenone and Titian apparently did not meet again until Pordenone's arrival in Venice in 1528.[101] In Treviso, their competition had been implicit in the juxtaposition of their works. Now the competition became explicit, as Titian, Palma il Vecchio, and perhaps Pordenone vied for the commission of the altarpiece for the chapel of the Scuola di San Pietro Martire in Santi Giovanni e Paolo, the principal Dominican church of Venice.[102] Pordenone's involvement was first mentioned

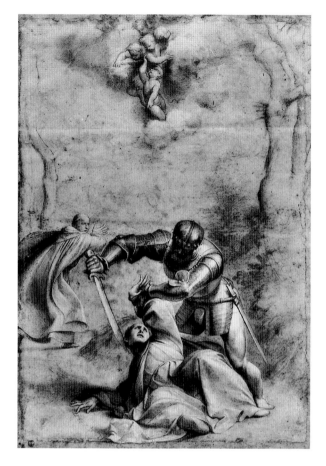

156 Pordenone. *Death of Saint Peter Martyr*. Ink and white chalk. Florence, Galleria degli Uffizi, Gabinetto Disegni e Stampe 725E.

in Carlo Ridolfi's *Maraviglia dell'arte*, published in 1648, but the artist's drawings of the martyrdom confirm his interest if not his engagement in a formal contest (Fig. 156).[103] That is to say, whether Pordenone imposed competition on himself, the drawings illustrate his rivalry with Titian and his intention to prove himself to whoever might see them. But rivaling Titian, Pordenone also imitated him: the central group of the *modello* derives from Titian's *Miracle of the Jealous Husband* (Fig. 142).[104]

That there was some kind of contest, and that it involved at least Titian and Palma il Vecchio if not Pordenone, seems clear. Unlike most of the smaller confraternities (as opposed to the Scuole Grandi), conservative in their taste and modest in their spending, the brothers of San Pietro were notably ambitious. Perhaps they were spurred by rivalry with the Scuola di San Vincenzo e Santa Catterina da Siena? They had shared premises with the Scuola di San Vincenzo since 1493, and by 1531 that confraternity had merged with the Scuola di Santa Catterina.[105] Some thirty-four years later, in 1565, the three confraternities would combine into one, but meanwhile – perhaps while the "Catherines" and

the "Vincents" were negotiating their merger – the confreres of San Pietro Martire had decided to replace their altarpiece by Jacobello del Fiore. There was disagreement, however, about the caliber of the (unnamed) painter whom some of them had in mind. Preferring to commission a work from a master who was "first in that art," some of the brothers offered to pay the greater fees that this would entail. One of these generous members was Jacopo Palma il Vecchio.

Palma il Vecchio would seem to have had the inside track for the job. Moreover, he had already painted an altarpiece of the saint's martyrdom for the church of San Pietro Martire in Alzano Lombardo, completed in the 1520s.[106] From this work and perhaps from drawings he may have provided, his confreres could have had an idea of what he would do for their own altar. His competing for the contract was first noted by Paolo Pino in the *Dialogo di pittura*, published in Venice in 1548 – close enough to the events described to give the account credence.[107] The treatise does not describe a formal contest staged by the confraternity but rather a "duel of competition" (*duello della concorrenzia*) between two competing artists, Palma and Titian, who themselves selected the superior work. Pino's attractive explanation of the San Pietro Martire commission would explain the existence of Pordenone's *modello*, a self-generated submission in a contest effectively organized and adjudicated by the competitors. Pino's omission of Pordenone's name from the narrative has a less attractive but equally likely explanation: Pordenone was a foreigner, after all, and the Venetian author privileged Venetian artists.

The speaker is Fabio, and the context of the story of the altarpiece commission is a social and psychological primer for artists evoking Leonardo's description of the gentlemanly painter's public demeanor and resonating with the kind of more intimate advice offered by Michelangelo to Calcagni:

And above all the painter must abhor all vices, such as avarice [. . .], gambling, gluttony, that debauched mother of ignorance and of sloth, nor should he live to eat, but feed himself soberly for his own sustenance; he should be disgusted by coitus without the bite of reason [. . .] which causes melancholia and which abbreviates life; he should not associate with vile, ignorant or rash persons, but his social intercourse should be with those from whom one can learn and acquire honor and what is useful. I also wish that he keep himself a certain something of reputation, without affectation [. . .] but mixed with affability and courtesy. [. . .] He will not try to whet [a patron's] interest with *disegni* or with an amplitude of formal promises to do a work, because these are the weapons of one who little understands art, but our painter, who will be excellent, will attract everyone to seek him and seek him again for their commissions, except, however, if another of his rivals attempt to overthrow him. In this case, I want him to come to the duel of competition, and each one to execute a work, but with the understanding that the most perfect be acknowledged, as Jacopo Palma has already desired to do with Titian concerning the work of San Pietro Martire here in Venice. And

thus to defend and preserve and increase his honor. Which is legitimate in
heaven and on earth. But God protect him from judges who have blindfolded
eyes or sticky fingers.[108]

Fabio then returns to the theme of the painter's personal hygiene: his hands
should not be paint-spattered, his shirts should be cleaned using aromatic
cleansers, he should dress in those fashions of clothing that have more *disegno*
and a certain something of *gravitas*. Fabio's, or Pino's, point is that appropri-
ate rivalry for a commission is an aspect of the painter's proper comportment,
in public and in private. Significantly, Pino used the word *pittore*, painter,
whereas Vasari always wrote of *artefici*, craftsmen. Citing the San Pietro
Martire commission as his example of professional virtue, Pino envisaged an
entirely salubrious and self-regulating competition in which painters judge
themselves for the good of their art. Indeed, they are better equipped to do so,
he implied, than their patrons. (The story foretells Vasari's fictional accounts
of the disinterested way in which Brunelleschi and Donatello selected the
winning panel in the Florentine Baptistery commission.) An artist faced with a
challenge should of course confront his rival, as opponents in a duel; each
should do his best, with the understanding that the more perfect work will be
acknowledged or recognized by all of them. This is what evidently happened,
or should have happened, at the Scuola di San Pietro Martire.

The subject is murder. Traveling to Milan in 1252, the Dominican inquisitor
Peter of Verona was assassinated by an ax blow to the head and a stab wound
in the chest (saints are traditionally hard to kill). According to legend, there
were two assailants; while one dispatched the saint, the other attacked his com-
panion, Friar Dominic. Although wounded, Dominic was able to flee. Peter of
course died, but before doing so wrote with his own blood the words "Credo
in Deum." Considered the first Dominican martyr, he was canonized the fol-
lowing year.

In one regard at least, the truth of Pino's account is confirmed: the best man,
or best painting, did win. Installed in 1530 for the feast of Peter Martyr, 29
April, and destroyed by fire in 1867, Titian's *Martyrdom of Saint Peter Martyr*
is known from numerous copies, including the painted replica by Carlo Loth
that has replaced it on its altar in the left (south) aisle of the church (Fig. 157).[109]

Titian took liberties with the saint's legend: only one assassin is included –
namely Carino, who later denounced his heresy and became a Dominican lay
brother – and Friar Dominic is shown unwounded as he flees the scene. Peter
is on the ground, pinioned by the murderer's foot on his surplice. Although
clearly distressed, the saint does not seek to defend himself. Rather, he looks
and gestures upward toward two putti who appear with his palm of martyr-
dom, while his right hand is about to write the Credo. The printmaker Martin
Rota understood the significance of the saint's gestures: he reversed his woodcut
so that the right hand in the painting would remain the right hand in the
print.[110]

Contemporaries admired the *Peter Martyr* as Titian's masterpiece, beginning
with the first published reference to the work, a letter by Aretino dated

29 October 1537. Not coincidentally, the letter is addressed to the sculptor Niccolò dei Pericoli, il Tribolo, and quotes his conversation about the altarpiece with another sculptor, Benvenuto Cellini. Thus Sculpture is made to admire Painting in a *paragone* won (of course) by Titian: "you understand all the living terrors of death and all the true sorrows of life."[111]

The violence of Titian's subject may have drawn him to Michelangelo as a source for the "powerful *contrapposto* and vehement movement" of his figures (Carino, for example, seems to derive from the Libyan Sibyl), for their sheer bulk and muscularity, the virtuosic display of complicated, athletic foreshortenings, and the way in which the friar flees the scene, recalling a bather's behavior at the right of the *Battle of Cascina*.[112] But Michelangelo never painted a landscape like this – he was uninterested in landscape – or illuminated his narratives by a combination of differentiated natural and supernatural light such as Titian employed in the altarpiece. The asymmetry of the scene and juxtaposition of closed and open spaces are also typical of Venetian compositions, starting with Jacopo Bellini's drawing books, and Venetian too the way in which the landscape reflects the mood of the actors. These trees are not

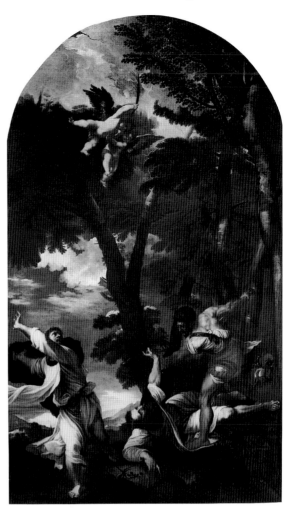

157 Carlo Loth, after Titian. *Death of Saint Peter Martyr*. Venice, Santi Giovanni e Paolo.

sheltering but ominous, and the hacked trunk in the foreground prefigures all too clearly the hacking about to be inflicted on the saint (this detail recalls Giovanni Bellini's interpretation of the martrydom).[113]

While Titian was painting his *Saint Peter Martyr* and other works, his competitor, Pordenone, found employment elsewhere in Venice, with the Scuola Grande di San Rocco. The confraternity was affiliated with Santa Maria Gloriosa dei Frari, where two of Titian's early triumphs were and are *in situ*, the *Assumption* and the Pesaro altarpiece (unveiled in 1526). Nonetheless, the confreres of San Rocco turned to the outsider for their projects, first the doors for an armadio and then frescoes in the choir of their church of San Rocco (next to the scuola building and behind the apse of the Frari). Pordenone had

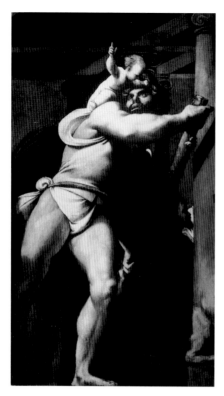

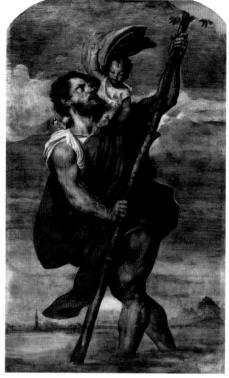

158 Pordenone. *Saint Christopher.*
Detail of panel. Venice, San Rocco.

159 Titian. *Saint Christopher.* Fresco.
Venice, Doge's Palace.

completed his first commission for San Rocco by 1527, the armadio doors with enormous figures of Saints Martin and Christopher (Fig. 158). Pordenone's saints are his response to Titian's works of the earlier 1520s, including the Venetian's fresco *Saint Christopher* in the Doge's Palace (Fig. 159) and his woodcut *Saint Roch.*[114] One aspect of Titian's designs that Pordenone emphasized was their heroic monumentality, the very quality that Michelangelo epitomized. As Titian and Pordenone continued their rivalry, both directly and indirectly, each sought to outdo the other in his Michelangelism. Michelangelo had defined the terms of their battle, though he himself was absent from the field of combat and unconcerned with the outcome.

Pordenone and Titian encountered each other directly for the last time in the church of San Giovanni Elemosinario. As in Treviso, here too Pordenone executed the frescoes of the cupola and Titian the altarpiece, representing the titular saint, *Saint John the Almsgiver* (Figs. 160, 161).[115] Much of Pordenone's fresco was delegated to assistants, even though his patron at San Giovanni was Doge Andrea Gritti.[116] (Presumably these paintings, which seem mediocre to modern eyes, were pleasing to sixteenth-century viewers.) Pordenone left Venice

160 (*above*) Pordenone. Cupola. Fresco. Venice, San Giovanni Elemosinario.

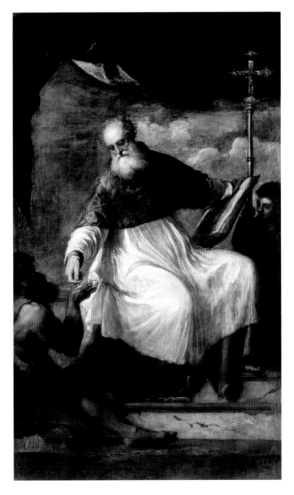

161 Titian. *Saint John the Almsgiver* (*San Giovanni Elemosinario*). Canvas. Venice, Gallerie dell'Accademia.

at the end of the decade, returning in 1532 to work again in San Giovanni Elemosinario, painting an altarpiece for the Corrieri Chapel, and perhaps also a fresco of the saint in the apse of the church, a lost work mentioned in seventeenth-century sources.

During this second Venetian sojourn, Pordenone received two other commissions which, had he completed them, would have placed his work in direct confrontation with Titian's: in 1535 a mural for the Sala del Maggior Consiglio – a most prestigious site where Titian had been notoriously dilatory in regard to his own obligations; and in 1538 a painting for the Albergo of the Scuola Grande della Carità. This too was to have been a mural, adjacent to the wall where Titian's *Presentation of the Virgin* had just been installed. The Carità commission implies that the confreres intended a *paragone* between Pordenone and Titian. There was no competition for the commission, the Scuola having already decided – apparently while Titian was completing his work – to turn to his rival for its pendant, "as it is necessary to have constructed and painted the painting in our Albergo [. . .], a thing truly of the greatest necessity, and very honorable for said Scuola [. . .] said painting [to] be painted by the most ingenious and prudent man, Messer Giovanni Antonio da Pordenone, a man of the greatest ingenuity (*ingegno*) in our times."[117] Pordenone was unable to begin either mural, however, before he was summoned to Ferrara in December 1538, where he died a month later. Had the painter lived longer, his work there would have competed once again with Titian's, in commissions for the same patron, Alfonso d'Este, a catalyst for so many Renaissance rivalries. Meanwhile, the competition between the painters had also engaged men of letters, as Pordenone won the praise of Titian's close friends and champions, Pietro Aretino and Lodovico Dolce.[118] Whereas Raphael's reputation had acquired even greater luster after his death, however, Pordenone's waned, as his erstwhile champions, wishing to hedge their aesthetic bets, now devoted their encomia principally if not exclusively to Titian.

No less than his literary friends, Titian himself was a master of such public relations. One senses his subterranean influence, for example, in Vasari's account of Pordenone's Venetian commissions. For this information as for everything concerning Venice, Titian was one of the biographer's primary informants during Vasari's sojourn in the Republic in 1541–42. Although admiring of Pordenone, Vasari did not grant him sole proprietorship of his life: he is compelled to share it with "other painters of Friuli." Moreover, describing Pordenone's Venetian commissions, Vasari credited their success to the painter's rivalry with Titian. After recounting Pordenone's achievements elsewhere, Vasari described how he went to Venice, completing a number of ingenious works, including a dramatically foreshortened *Curtius on Horseback*:

> That particular work greatly pleased the whole city of Venice, and Pordenone was more praised for it than any other man who had ever worked in that city until then.
>
> But among other things that made him invest incredible study in all his works was the competition [*concorrenza*] of the most excellent Titian;

because, placing himself in rivalry [*a garreggiare*] with Titian, he promised himself through continuous study and a bold method of working quickly in fresco to take from Titian's hand that greatness which he had acquired with many beautiful works. [. . .] And in truth this rivalry [*concorrenza*] was of benefit to him, because it made him invest in all his works the greatest study and diligence that he could.[119]

Vasari then described Pordenone's commissions for San Rocco, including the armadio, a work that so impressed Jacopo Soranzo, a procurator of San Marco who had become his friend, that "he caused him to be placed in rivalry [*concorrenza*] with Titian," working in the Ducal Palace. "And because rivaling [*gareggiando*], he always sought to do works in places where Titian had worked," Pordenone also executed paintings for San Giovanni Elemosinario, one of which "was a beautiful thing, but not however equal to the work of Titian," even though many praised it nonetheless, motivated more by malignity rather than devotion to the truth. The story ends with Pordenone's move to Ferrara and his sudden demise there, perhaps, as many suspected, because he had been poisoned.[120]

Rivalry is the Leitmotif of Vasari's Life of Pordenone. Crediting Pordenone's Doge's Palace commission to Soranzo's good graces, Vasari seemed to suggest that the painter received his contract only because of the procurator's favoritism. But Vasari's preference for Titian is increasingly clear in Titian's biography, which includes a recapitulation of the rivalry with Pordenone in San Giovanni Elemosinario. When Titian returned to Venice from Bologna, where he had painted his portrait of Emperor Charles in armor, he found that many noblemen were now favoring Pordenone, and that they had placed one of his works in the church of San Giovanni, again precisely so that his painting could compete with Titian's. But, Vasari concluded, Pordenone, despite all his efforts, "could not be compared with [*paragonare*] nor even approach Titian's work by a good distance."[121]

Titian's effectiveness in promoting his own legend is best illustrated by Vasari's account of the two altarpieces of the *Annunciation* for the high altar of Santa Maria degli Angeli in Murano, one by himself and the other by his rival. The narrative follows immediately the description of their paintings in San Giovanni Elemosinario. Pordenone's *Annunciation*, completed c. 1537–38, was commissioned when the nuns of Santa Maria rejected Titian's version because his price tag of 500 scudi was too high.[122] Acting on the advice of Aretino, the expert *par excellence* in Renaissance gift-giving and -receiving (or -extorting), Titian sent the *Annunciation* to Empress Isabella, consort of his most august patron, Charles v. The emperor rewarded him for his gift with the extravagant sum of 2,000 scudi.

Aretino gloated about Titian's triumph of marketing in a published letter dated 9 November 1537, addressed to the painter: "Your shrewdness has been wise, my friend, having yet arranged to send the image of the Queen of Heaven to the Empress of the earth."[123] Vasari repeated the anecdote in his Life of

Titian, concluding that Pordenone's version was put on the altar in substitution, *faut de mieux*, as it were.[124]

Pordenone was able to provide an altarpiece for Santa Maria for a more reasonable fee than Titian's, but this success in Murano was overshadowed by failure in the larger arenas of the Holy Roman Empire and the world of letters. Nor do the poor nuns come off very well: pinching their 500 scudi, they have lost the chance to have an altarpiece that was worth four times that sum to the Holy Roman Emperor. Thus Aretino and Vasari and Titian himself warned potential patrons about the high cost of trying to economize on great art (Michelangelo's similar lesson to Agnolo Doni had cost a mere 70 ducats more than the asking price). Moreover, the viewer recognizes what neither Charles nor most readers of Aretino and Vasari would have known: Pordenone borrowed elements of Titian's composition for the *Annunciation*.[125] The Venetian might well congratulate himself for his aesthetic influence as well as his financial and social success.

Pordenone died in Ferrara in January 1539 before he could show what he might have done to rival Titian there. Meanwhile, Michelangelo had begun to respond to Titian's challenge, led to do so by extraordinary circumstances likewise involving Ferrara and Alfonso d'Este. The duke had extracted a promise from Michelangelo when they met on the Sistine scaffolding in 1512, but the artist had been ignoring this debt of honor for years. On 15 May 1527, only nine days after the Sack of Rome (6 May), the Medici had been expelled once again from Florence and once again, a Republic proclaimed. Michelangelo had been resident in the city during these momentous events, occupied with the architecture and sculptural decoration of the New Sacristy or Medici Chapel of San Lorenzo. (The chapel can be seen as the development of ideas first conceived for Julius's tomb, thwarted by Medici rivalry with the della Rovere for Michelangelo's services: Condivi noted the "contention" of Michelangelo's princely patrons.[126]) With the Medici out of power, naturally all work on Medici commissions ceased. Now Michelangelo was in a position to give practical expression to his political convictions. On 29 November he was appointed the Republic's superintendent of the Bologna fortifications. Although no action was taken regarding this brief, Michelangelo continued to be involved in government affairs. In October the following year (1528) he was at work on defensive measures in case of siege; on 10 January 1529 he was elected a member of the Nove della Milizia; on 29 April he was appointed *governatore generale* of Tuscan fortifications. During that month, and in May and June, he inspected fortifications at Pisa and Livorno. His new responsibilities also took Michelangelo to Alfonso's duchy to study Ferrarese defenses. Departing Florence for Ferrara on 28 July, Michelangelo remained there until 9 September.

While Alfonso's guest, Michelangelo was compelled to remember his promise of seventeen years earlier. Indeed, when he wanted to leave, the duke threatened to hold him captive unless he agreed to do so. Condivi's account naturally omits any reference to the artist's procrastination while underscoring the

complete creative freedom that Michelangelo's noble patron granted him: "Michelangelo, you are my prisoner. If you wish me to set you free, I want you to promise to make me something by your hand, [. . .] whatever you like, sculpture or painting."[127]

In Ferrara, Michelangelo saw what other masters, Titian and Raphael among them, had done for Alfonso. Condivi's report of Michelangelo's sojourn includes the artist's warm recollections of that visit and his characteristically qualified estimation of the works he had seen. Proud of his collections, and very happy to receive Michelangelo, the duke "opened all his storerooms for him, showing him everything with his own hand, especially some works of painting and portraits of his elders, by the hand of masters, excellent, given the context of that age in which they were made."[128] The disclaimer – the paintings are excellent in relation to their time – is intriguing, especially as it refers to works that the duke particularly prized, because he himself showed them to Michelangelo. Titian's last work for the Camerino had been completed only a few years before Michelangelo's visit. Whatever Michelangelo might have thought of this and other works in the duke's collection, surely he cannot have considered the *poesie* "old-fashioned" even when he described his sojourn to Condivi some twenty or more years later. The qualified praise is apparently meant as a blanket condemnation of everything in the duke's possession, perforce including works by Titian, famously represented in Ferrara and pointedly unmentioned by Michelangelo in Condivi's text.

Whether Michelangelo intended to fulfill his old and now renewed Ferrarese commission, he was compelled to further delay. Florence was under siege, and shortly after returning to the city, he was in flight, departing for Venice on 21 September, ostensibly *en route* to France. His instincts (or his cowardice) had served him well: nine days later, 30 September, Michelangelo was declared a rebel by the Balìa. Michelangelo remained in Venice about six weeks, leaving for Ferrara on 9 November, where he stayed for a few days, returning to Florence on 20 November. He had been pardoned by the Republic – but not by the Medici.

When Florence surrendered to the papacy on 12 August 1530, Michelangelo went into hiding. In such circumstances, he was in no position to satisfy his promise to Duke Alfonso. And yet, very shortly after his pardon, Michelangelo completed the *Leda and the Swan* for Ferrara (October) and two years thereafter the closely related *Night* for the Medici Chapel. Their chronology proves that these works must have been in progress, at least germinating in Michelangelo's imagination, during this dangerous period. The mythological subject of the painting, and perhaps also the focus on the female nude in both works, suggest that Michelangelo might have been thinking too about what he had seen in Alfonso's collections and in Venice. Whereas the *Night* is necessarily sculpture, part of a tomb that had already been begun, the *Leda* was a painting: a surprising and uncharacteristic choice of medium, especially if the choice was Michelangelo's, as he later indicated to Condivi. A letter dated 22 October 1530, from Alfonso in Venice to Michelangelo in Florence,

possibly confirms this claim. The duke has received "with great pleasure" his Florentine ambassador's report "regarding the picture that you have made for me. And because it has already been a long time that I have desired to have in my house some one of your works, as I told you face to face [*a bocca*], every hour seems to me a year waiting to see this work." Alfonso is dispatching his agent to collect the work and to pay Michelangelo:

> And do not be scandalized if for now I do not send any payment, because I have neither learned from you what you wish nor do I know how to judge the matter, not having seen it [the picture] as yet. But I can well promise you that you have not lost that effort that you have endured for my affection, and you will do me the greatest pleasure if you write me how much it would please you that I send you, because I shall be much more certain of your judgment than of my own in evaluating it. And beyond the prize for your effort, I promise you that I shall always be desirous of pleasing you and being of help to you, as I consider your great valor and rare powers [*virtù*] merit, and I shall always offer you with good heart everything that I can do that would be welcome to you.[129]

Alfonso's letter reflects his great admiration for Michelangelo and his exquisite *savoir-faire* in dealing with the master: the duke acknowledges that only Michelangelo can set a price for his work. While eagerly waiting to see the painting, Alfonso apparently knew little about it, except that it was "made for me": negative evidence but nonetheless substantiating Condivi's assertion that Michelangelo determined everything about the work, including its medium and its subject. Like many if not most sixteenth-century *cognoscenti* thinking of paintings of mythological nudes, as Michelangelo tackled his own *poesia*, he may have been thinking of Titian.[130]

Inconveniently, none of Michelangelo's surviving correspondence refers to what he saw and whom he met during his time in Venice, but an encounter with Titian is more likely than not. If nothing else, the two men shared a good friend in Sebastiano, and, in Alfonso, a devoted patron. In Venice in 1529 Michelangelo almost certainly must have seen Titian's *Assumption* and the Pesaro *Madonna* in the Frari, and possibly his *Saint Peter Martyr*, then a work in progress. Perhaps Michelangelo's presence in the city – or even in Titian's shop – encouraged the heightened Michelangelism of the Venetian's new altarpiece? In Ferrara, before and after that Venetian visit, Michelangelo certainly saw Titian's *poesie*, though when he later described what he had seen there he mentioned only the portrait of *Alfonso d'Este*, presumably meaning to compliment the duke while damning the artist with faint praise, given his, Michelangelo's, advertised disdain for portraiture. In any case, Michelangelo's biographers said nothing about what he thought of the *poesie*. Whatever works he might have seen by Titian, and whatever his opinion of them, when Michelangelo was finally able to attend to his Ferrarese commission, he chose the kind of subject in which Titian had so brilliantly excelled, and moreover chose to produce a *painting* – Titian's art – rather than a sculpture, the medium

with which he had so insistently and persistently identified himself. "I am a sculptor, not a painter," he repeatedly declared, especially when trying to avoid commissions for paintings, signing his letters until 1526 as "Michelangelo sculptor."[131] Yet now, for Alfonso and of his own volition, Michelangelo produced a painting of a female nude as erotic (though differently so) as anything ever painted by Titian. The *Leda* was to be the only classicizing painting that Michelangelo himself brought to completion.

Michelangelo knew that his work for Alfonso would be compared, in one way or another, with Titian's paintings in the duke's collection. If Michelangelo had never before shown himself to be particularly interested in the Venetian's art, now events compelled him to take notice. The duke himself had shown Michelangelo "everything," as he later recalled to Condivi. Did the duke also suggest a confrontation with Titian? In any case, representing the kind of subject for which the Venetian had become renowned, Michelangelo's *Leda and the Swan* is in effect a rebuttal or reversal of Titian's art. Privileging masculine *disegno* over feminine *colorito*, regendering Leda herself from female to male, Michelangelo's *Leda* challenges Titian on every front. Although the Florentine had accepted the Venetian's battlefield, he chose his own weapons.

When he pardoned Michelangelo in winter 1530, Pope Clement had ordered him to resume work on the Medici Chapel.[132] But Michelangelo privileged his commitment to Alfonso, finishing *Leda and the Swan* by October 1530. Michelangelo's *Leda* is the rehearsal for his *Night* for the tomb of Giuliano de' Medici, completed in 1532. The sculpture may serve as proxy for the lost painting, representing the figure of Leda herself (if not the painting's composition) as well or better than copies in various media, including the "reversed" engraving by Cornelis Bos (Figs. 162, 163).[133] Having mated with Jupiter in the guise of a swan, Leda has given birth to the Dioscuri, Castor and Pollux. The twin boys have hatched; one of their sisters, Helen or Clytemnestra, is still in the egg, visible through the translucent shell.[134]

The meaning of Michelangelo's mythology is bound to his interpretation of *Night*. These nearly identical figures derive from the same classical prototype, depictions of Leda and the Swan on Roman sarcophagi, a repetition of form relevant to meaning. That is, Michelangelo's *Leda* and *Night* are made to look alike precisely because they represent closely related themes. Indeed, according to the etymology of the heroine's name, "Leda" was interpreted as the Night.[135] If Michelangelo questioned why the ancients depicted Jupiter's love for Leda on funerary monuments, he could find the answer in familiar Neoplatonic and Christian texts. According to these traditions, one may join with divinity only by being freed from the body, in Michelangelo's (banal) words, "the earthly veil."[136] To die, then, is to be loved by the god, and this death is bound to the tradition of the "death of the kiss" (*morte di bacio*), as Pico della Mirandola had explained:[137]

Through the first death, which is only a detachment of the soul from the body, [. . .] the lover may see the beloved celestial Venus [. . .]; but if he would

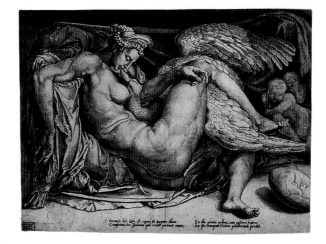

162 Cornelis Bos.
After Michelangelo,
Leda and the Swan.
Engraving. Amsterdam,
Rijksmuseum-Stichtung.

possess her more closely [. . .] he must die the second death by which he is completely severed from the body [. . .]. And observe that the most perfect and intimate union with the lover can have with the celestial beloved is called the union of the kiss [. . .] many of the ancient fathers died in such a spiritual rapture, [. . .] they died the death of the kiss.[138]

Pico's text may explain Michelangelo's *Leda*, dying her own metaphoric *morte di bacio.*

Similar ideas were reiterated by Lorenzo il Magnifico in his commentary on his sonnets. He began the sequence, Lorenzo explained, with a poem on death "because whoever lives for love, first dies to everything else."[139] Michelangelo never forgot his love for Lorenzo; as he worked on the tombs of Lorenzo's kinsmen, recollection of il Magnifico's poetry would have seemed most appropriate to the artist. In both the *Leda* and the *Night*, Michelangelo gave form to the idea voiced by Lorenzo and other humanists that death and love are one, or in Marsilio Ficino's words, that "death is inseparable from love."[140] For these authors, ancient and Renaissance, the *Liebestod* is inherently lyrical; for Michelangelo, the idyll becomes "euphoric stupor," as Edgar Wind recognized, describing *Leda* as "a ruthless picture."[141] Whereas *Leda* signifies death as god's embrace, *Night*, with her owl, mask, and poppies (familiar symbols of Death and Sleep), laments Time's destructive force, of which she herself is part.

Michelangelo himself explained his Medici Chapel program in this way, in a text written on a study for the tombs: "Day and Night speak and say: 'We, in our swift course, have led Duke Giuliano to his death; it is only fair that he should take revenge on us as he does. And his revenge is this: Having been killed by us, he, being dead, has deprived us of light, and by closing his eyes has shut ours, which no longer shine upon the earth. What might he have done with us, then, if he had lived?'"[142] The reader understands that Giuliano has slain those who slew him, namely Time and Death: their eyes too are now shut. Elsewhere, in one of his sonnets, Michelangelo thanks Night, addressing her directly:

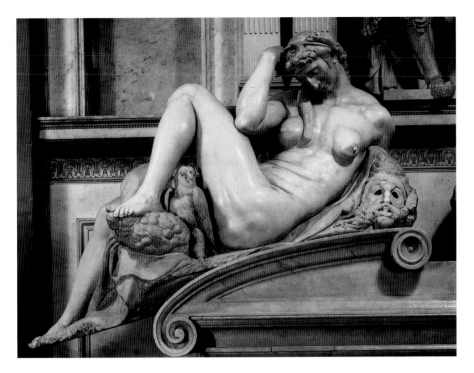

163 Michelangelo. *Night*. Marble. Tomb of Giuliano de' Medici. Florence, San Lorenzo, Medici Chapel.

> O night, O time so sweet, even though black [. . .]
> [. . .] often in my dreams you bear my soul from the lowest
> to the highest sphere, to which I hope to journey.
> O shadow of death, by whom is stilled
> every misery hostile to the heart and soul,
> last and effective remedy for the afflicted.[143]

Some if not all of Michelangelo's ideas about *Night* illuminate *Leda*: they are related not only visually and thematically but pyschologically.[144] And surely Michelangelo intended that these interrelations be appreciated, because he must have realized that any viewer, seeing either the originals or the numerous copies that both works engendered, would inevitably recognize their similarity. The two women represent one theme, "a theory of death in which sorrow and joy coincide."[145] Night's metaphorical death is represented precisely by her sleep, the brother of Death, and Leda's suggested by the limpness of her left arm and hand, the pronation of the shoulder a distant recollection of the Christ of the Vatican *Pietà*.

As is often the case with explicitly sexual imagery that transcends or aspires to transcend its sensuality, however – Titian's Magdalenes offer another example – Michelangelo's *Leda and the Swan* is also obviously and inevitably

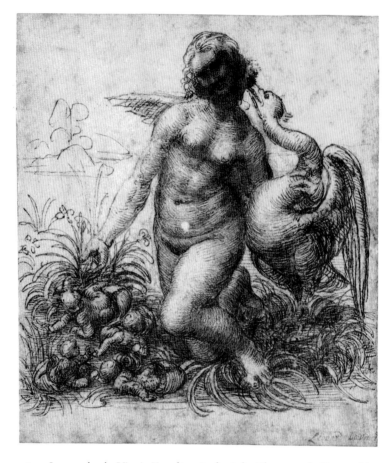

164 Leonardo da Vinci. *Kneeling Leda*. Ink. Chatsworth, Devonshire
Collection, Chatsworth Settlement Trustees.

erotic. The beholder who seeks its ulterior morality must transcend this eroti-
cism in order to do so (one questions whether such an exercise would have had
much appeal for Alfonso d'Este). The very kiss, the *morte di bacio*, that signals
the myth's Neoplatonic meaning coincides, perforce, with its explicit volup-
tuousness, and this coincidence too may have seemed to Michelangelo's
admirers another aspect of his imaginative *tour de force*.

 Like all of Jupiter's affairs, the story of Leda and the Swan "is a rape
and, at the same time, a contact with divinity."[146] In most versions of their
encounter, the birth of their offspring marks the end of their relationship. In
Michelangelo's emendation of the story, the lovers continue their embrace
though this result has been achieved. Leda's contact with divinity endures: their
intercourse is no longer bound to the production of children but has become a
continuing love-dream, emotionally and anatomically explicit. One may argue
that the composition is not to be interpreted in so strict a chronological manner,

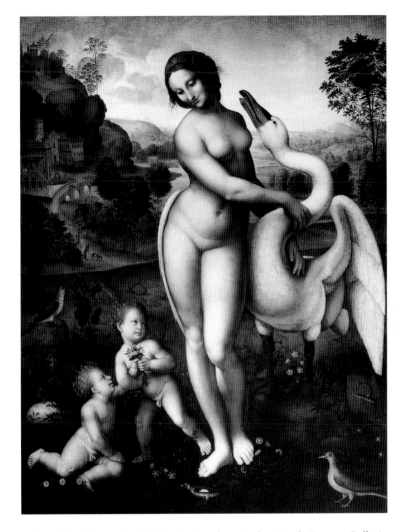

165 After Leonardo da Vinci. *Standing Leda*. Panel. Rome, Galleria
Borghese.

that sequential moments – love-making, child-birth – may be represented
in a unified space, as indeed are various episodes in numerous medieval and
Renaissance narratives. Michelangelo conflated these moments, however,
privileging psychological unity over temporal distinctions.[147]

Michelangelo's seamless interpenetration of past, present, and continuing
future is understood in relation to another famous Leda, or Ledas: Leonardo's
Kneeling Leda, known from his drawings, and the *Standing Leda*, known from
drawings and copies of his lost painting (Figs. 164, 165).[148] Leonardo's Ledas
date from his second Florentine period – that is, precisely when he and
Michelangelo were neck and neck in their race. Michelangelo's choice of Leda's

story for Alfonso's painting signals his recollection of his rival and his intention to engage Leonardo yet again, *post mortem*, as it were.

Before Michelangelo, Leonardo's Ledas had been the single inescapable point of reference for any Italian master representing that myth, including Correggio and Baccio Bandinelli (both men were always responsive to Leonardo's ideas). Indeed, before Leonardo, the subject had been represented only once in Italian art: by Filarete on the bronze doors of Saint Peter's.[149] Anticipating and perhaps influencing Michelangelo, Filarete depicted the lovers' embrace. But Leonardo and his Ledas were Michelangelo's principal points of reference.

Leonardo seems to have chosen the subject himself and painted it for himself: there is no record of a patron for either version of his Leda. Leonardo's earliest thoughts about the subject are found on a sheet with a sketch for an Anghiari horse, indicating a date c. 1504: three sketches of a kneeling woman who soon became identifiable as Leda.[150] Leonardo made at least three known variants of this figure, deriving her pose from the ancient kneeling Venus. Perhaps Leda kneels because she has just now completed her parturition?[151] In fact, Leonardo was the first master to include Leda's children, a remarkable narrative innovation that Michelangelo adopted.[152] The earliest sketches include the children but not their absentee father, the Swan. In one of Leonardo's variants, the Chatsworth sheet, Leda and the Swan embrace side by side, her arm around his neck, his wing around her back (Fig. 164). The Swan aims a kiss at Leda's cheek (her hair seems to block the beak). Despite Leda's nudity, her relationship with her lover is sweet, almost chaste. Meanwhile, she gestures with her right hand toward their four children, just now squirming out of their shells with remarkable energy. If such a scene can be described as verisimilar, Leonardo has made it so: if infants were hatched from eggs, surely this is the way they would emerge.

Leonardo eventually abandoned this composition, after perhaps producing a cartoon or highly finished drawing.[153] The lost painting of the *Leda and the Swan* or *Standing Leda*, variously dated c. 1504–08 or as late as 1516, was first mentioned by the Anonimo Gaddiano, writing c. 1540.[154] Leda stands, embracing and embraced by her Swan: she puts her arms around his long neck, and the beast wraps one wing around her hip and thigh, extending the other in heraldic exuberance. Her spiraling posture suggests vacillation between two kinds of love, eros and maternal affection, that is, between the Swan and the newborn children.[155] She looks down at her two hatched eggs and the two sets of offspring, and they seem to return her gaze. Thus in both versions, Leonardo's interpretation of Leda's story represented the affectionate end of the affair and its consequences, though in the painting the children are seen at a slightly later moment of their hatching process than they were in the *Kneeling Leda*. Perhaps Leda and the Swan will mate again, but this is left to the beholder's imagination and the protagonists' desire. Despite Leda's nudity, despite the muscular energy of the Swan's phallic neck (recalling Gallerani's ermine), the composition suggests a kind of propriety in their embrace, a sexual *inexplicitness*. Indeed, both his Ledas, standing and kneeling, are less about sex

than about fecundity and procreation. Leonardo's primal heroine is "not merely one of Jupiter's conquests, but the origin of life itself."[156]

Leonardo's composition of the *Leda and the Swan* and his drawings for it were copied many times. Both Raphael and Peruzzi, for example, copied the cartoon, and Cesare da Sesto, among others, copied the painting.[157] Numerous drawings related to the Ledas are known by Leonardo himself.[158] There is uncertainty regarding their precise chronology and relation to the painting of the *Standing Leda*, but that problem is not relevant here. What matters, in relation to Michelangelo's interpretation of the theme, is that he took Leonardo's characters and adopted his unprecedented inclusion of the children but rejected everything else, including Leonardo's style. In Leonardo's Ledas, as Johannes Wilde explained, "one feels [. . .] the softness of the flesh. [. . .] In Michelangelo's study the figure has been frozen into a sculpture." The proportions also differ greatly: Leonardo derives his "norms [. . .] directly from nature. Michelangelo believed in ideals, in nature made *divina, onesta e bella* in the immortal soul. The words are his, written on a sheet that contained two studies for his painting of *Leda*."[159] Even in depicting the eggs and hatchlings, Michelangelo took care not to repeat his predecessor exactly. According to Bos's engraving, Michelangelo showed the Dioscuri already hatched and resting after the struggle of their birth, the process that had so intrigued Leonardo; and Michelangelo depicted the other egg still intact. Through its translucent shell is revealed the form of one unborn sister, identified as Helen: whatever significance the choice of moment or his exclusion of Clytemnestra may have in Michelangelo's interpretation of the story, he chose to exploit this motif to represent his mimetic skills as a painter, while distinguishing his conception of dramatic narrative from Leonardo's.

As noted, Michelangelo derived his composition from ancient representations of Leda and the Swan, presumably known to him from cameos or reliefs, including sarcophagi. Leonardo, conversely, had borrowed Venus for his *Kneeling Leda*, and adapted a more generic type of classical figure in *contrapposto* for his *Standing Leda*. Leonardo's theme of nature bursting with energetic life is suppressed if not abandoned altogether in Michelangelo's telling of the story. Copies of Michelangelo's composition show a drapery behind Leda, though one of the paintings (sometimes attributed to Rosso) also includes a few scrappy plants in the foreground. But the greatest thematic difference between the Ledas by Michelangelo and by Leonardo is Michelangelo's depiction of the lovers' union. The result was a painting at once more "archaeologically correct" and far more sexually explicit than what his predecessor had done.

One way in which Michelangelo had distinguished his Virgin Mary from Leonardo's (or from Raphael's) was by masculinizing her, hence neutralizing her sexuality. Now he used the same means to differentiate his Leda from Leonardo's – and, not coincidentally, from Titian's mythological heroines as well. Michelangelo's masculinized Leda is unlike herself in any other depiction of her story, whether classical or Renaissance, and her masculinity is bound to the Neoplatonic significance of her image. Like Michelangelo's Doni *Madonna*,

like his Sistine Sibyls (especially the older Sibyls), his *Leda* is ennobled by her masculinization, redeemed from her gender. Recognizing Leda's maleness, the beholder is to understand that her embrace with the Swan transcends copulation, that the joining of their bodies signifies their spiritual unity. Leda's maleness is represented not only in her powerful musculature: it is equally explicit in the glyphic precision of her contours, her *disegno*. In this too, Michelangelo distinguished himself from Leonardo and from Titian.

Drawing, as everyone agreed, was the foundation of all the arts (everyone, that is, except the Venetians, but even in Venice lip service was paid to its primacy). Michelangelo himself is supposed to have said as much, explaining to Francisco de Hollanda that "design [. . .] or drawing, constitutes the fountain-head and substance of painting and sculpture and architecture and every other kind of painting and is the root of all sciences." *Disegno* is indeed "a great treasure," Michelangelo continued; and "a good painter, making a beginning with a simple outline, will at once be recognized as an Apelles, if he is one. [. . .] There is no need of more."[160]

What Michelangelo did not explain to Hollanda, but as both of them well knew, is that *disegno* is associated with form precisely because *disegno*, in the sense of "drawing," is equated with line. Form may be defined by *disegno*, therefore, and *disegno* defined as form. Equally important, both form and *disegno* – the fundamental essence and defining element of all things – are *masculine*. Thus an anonymous critic writing c. 1496 appreciated the *aria virile*, the manly air, of Botticelli's works, referring to his exquisite use of line or contour, their "optimum reason and complete sense of proportion."[161] Like his old friend Botticelli before him, Michelangelo privileged *disegno* to endow his figures, whether male or female, with the *aria virile* of masculine form. Color, on the contrary, is matter, subsidiary to form – and feminine.[162] Central Italian authors, including Leonardo, advised painters first to draw their outlines, then to add color for embellishment.[163] But Venetian writers, as one would expect, gave color an equal or greater role. "The art of painting [. . .] I shall divide into three parts," Pino explained; "the first part will be *disegno*, the second *invenzione*, the third and ultimate *colorire*."[164]

The perception of *disegno* and *colore* as separate and separable elements provides the theoretical justification for Michelangelo's delegating his drawings to others to complete with their color. In some instances he clearly preferred such divisions of labor, that is, when he could find collaborators able to provide what he himself lacked (or disdained?). In Rome, Sebastiano had served this purpose – and been well served – in the first two decades of the century; now in Florence, Pontormo undertook a similar role.

In April 1531 or shortly before, Michelangelo agreed to a commission from Alfonso d'Avalos, Marchese del Vasto and di Pescara, a general of Charles v, and kinsman, by marriage, of Vittoria Colonna. The commission may have been intended as a gift for Colonna, whom Michelangelo had not yet met but whose name he knew.[165] Avalos himself was not in Florence; acting on his behalf in negotiations with Michelangelo was Nicholas Schomberg, Archbishop of

Capua and interim governor in Florence after the fall of the Republic. Their terms were extraordinary, offering Michelangelo complete freedom to do what he chose, as Giovan Battista Figiovanni, Canon of San Lorenzo, explained in writing to the master in April 1531: "at your convenience [. . .] on canvas or on panel, in your way, and with the choice of subject at your discretion, that everything satisfy you, [. . .] of large or small figures. [. . .] Everything is to be up to you [*Tutto sia in voi*]."[166] Or rather, like Alfonso d'Este, they wanted a painting, and everything *else* was up to Michelangelo.

Michelangelo set to work immediately. By the time Figiovanni wrote again to him, on or around 18 May, he had completed the cartoon of the *Noli me tangere*. The marchese was arriving in Florence that evening or the following morning, Figiovanni reported, and wanted to see Michelangelo's sculptures in the Medici Chapel as well as the work he had commissioned, "la pittura Magdalena." The canon appreciated the rapidity with which Michelangelo had worked and the beauty of the results: "it is finished in the cartoon, in which Michelangelo has worked a miracle in doing it so quickly, and much more, so well that it seems to be a divine thing."[167]

Michelangelo's choice of subject may offer indirect confirmation that Colonna was the intended recipient: her devotion to Mary Magdalene was well known, and more than one of the marchesa's admirers presented her with images of the saint. Michelangelo may well have been aware of one of these gifts, commissioned from Titian by Duke Federigo Gonzaga, dispatched to Mantua in April 1531, and received by Colonna before 25 May – that is, around a week after Michelangelo had completed his cartoon.[168] Colonna's *Saint Mary Magdalene* by Titian may have been the version now in the Galleria Pitti, or at least is likely to have resembled that work, painted c. 1530–31 (Fig. 166). Although Titian's and Michelangelo's compositions could not be more unlike, the coincidence of chronology suggests an agonistic connection between them, both images likely intended for the same recipient, and both depicting the Magdalene.[169] If the two paintings are connected in this way, their chronology means that Michelangelo was reacting to Titian, albeit indirectly (indirection being the Florentine's preferred mode of confrontation), "correcting" not only the Venetian's style but his religiosity, so insistently reversing him that negation becomes acknowledgment.

Having completed his cartoon, however, Michelangelo did not wish to paint it himself, preferring that this work be done by Pontormo: "no one can serve him better than he" (Fig. 167).[170] The marchese agreed to this plan, Vasari wrote, and the work was completed in late 1531 or early 1532. Again according to Vasari, the *Noli me tangere* "was esteemed a rare picture for the grandeur of Michelangelo's *disegno* and for Jacopo's *colorito*."[171] This division of labor suited Michelangelo perfectly. As Vasari himself acknowledged of his hero, Michelangelo was principally interested in "the human figure, and attending to this single end, has left aside the charms of colors" and other "delicacies" of painting.[172] In this case, interest in the human figure meant a juxtaposition of closed and open poses, expressive of their emotional states: Michelangelo's

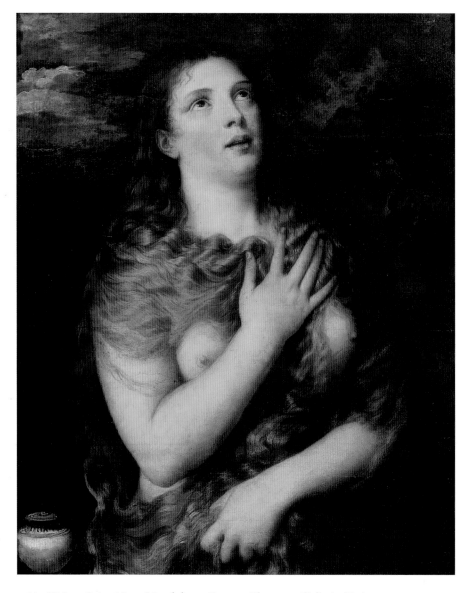

166 Titian. *Saint Mary Magdalene*. Canvas. Florence, Galleria Pitti.

Christ repels the Magdalene decisively, his cool restraint contrasted with her
desperation.

Michelangelo had not necessarily conceived the *Noli me tangere* to be painted
by Pontormo. Their collaboration was the fortuitous result of the patron's
wishing to have a painting by Michelangelo, his willingness to let the artist
write his own ticket, and Michelangelo's apparent uninterest in coloring. But

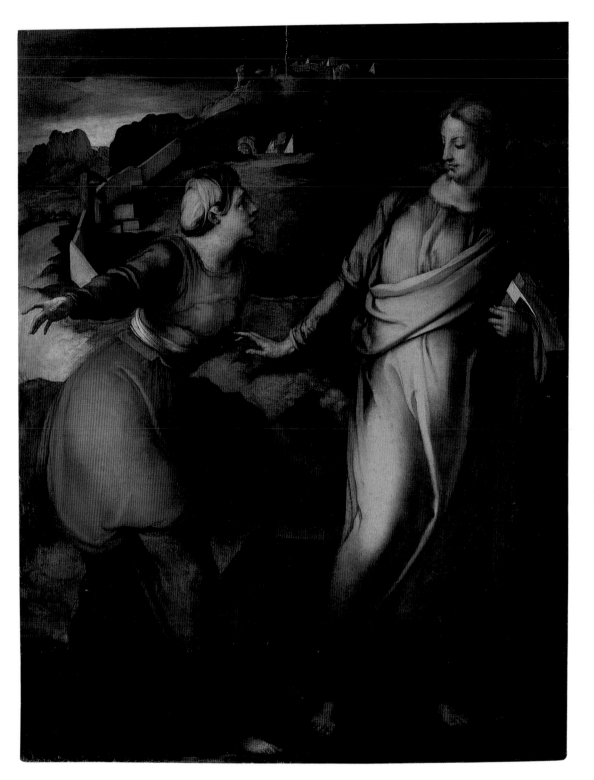

167 Pontormo and Michelangelo. *Noli me tangere*. Panel. Milan, private collection.

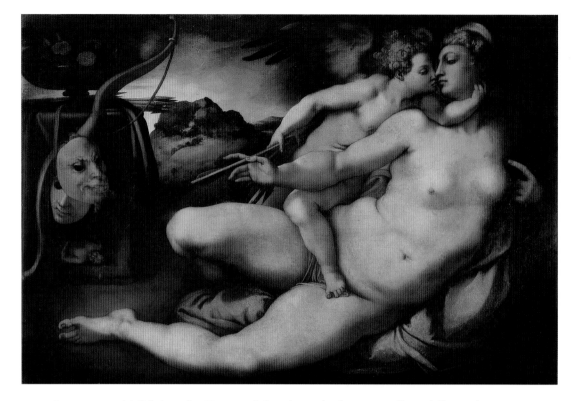

168 Pontormo and Michelangelo. *Venus and Cupid*. Panel. Florence, Galleria dell'Accademia.

now Michelangelo and Pontormo undertook a joint commission, planned from
the start as a cooperative venture: *Venus and Cupid* (Fig. 168). Like *Leda and
the Swan* for Alfonso and the marchese's *Noli me tangere*, *Venus and Cupid*
was created to please a patron whom Michelangelo could not or would not
refuse, his good friend Bartolomeo Bettini.

Following the example of some of Sebastiano's Roman clients, Bettini had
perceived that the best way to obtain "a Michelangelo" was to take advantage
of Michelangelo's friendship for himself and for another artist, in this case
Pontormo. As for the timing of Bettini's request – 1531 or 1532 – presumably
he knew that Michelangelo had recently completed a similar subject for Alfonso
d'Este and so might be disposed to accede to his request. Vasari told the story
in his Life of Pontormo:

> Bettini insisted so much that Michelangelo, his great friend, made him a
> cartoon of a nude Venus with a Cupid who kisses her, to have it made into
> a painting by Pontormo and installed in the center of one of his rooms, in
> the lunettes of which he had begun to have painted by Bronzino [portraits

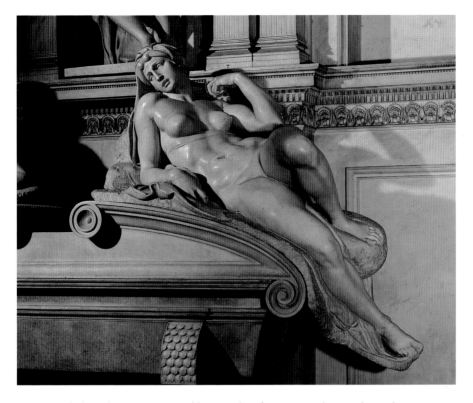

169 Michelangelo. *Dawn*. Marble. Tomb of Lorenzo de' Medici. Florence, San Lorenzo, Medici Chapel.

of] Dante, Petrarch and Boccaccio, with the intention to have represented also the other poets who had with verses and Tuscan prose sung of Love.[173]

Michelangelo's *Venus* would have completed the program, embodying love as the subject of the poets' silent discourse – and thereby illustrating the *paragone* of painting and poetry.[174] But Bettini never got his *Venus*, as Vasari explained:

Jacopo [Pontormo] having [. . .] completed painting the Venus from Bettini's cartoon, which painting was a miraculous thing, it was not given to said Bettini for that price that Jacopo had promised him, but it was taken from Jacopo's hand almost by force by certain sharpies who wanted to do ill to Bettini and given to Duke Alessandro, returning the cartoon to Bettini. When Michelangelo learned of this, he felt great displeasure for love of the friend for whom he had made the cartoon, and he wished Jacopo ill.[175]

Condivi's silence about the *Venus* may confirm Michelangelo's anger with Pontormo. Thus ended any chance of future collaboration.[176]

Michelangelo's cartoon of *Venus and Cupid* has been lost, but a drawing attributed to Bronzino in the Capodimonte of Naples may be a copy of the

composition. One of Michelangelo's own drawings for the cartoon also sur-
vives, representing the two figures.[177] The painting itself has been identified with
a panel in the Galleria dell'Accademia of Florence; if not by Pontormo, at least
it represents the composition that he and Michelangelo produced for Bettini,
c. 1532–34 (Fig. 168). In addition to providing color for Michelangelo's *Venus
and Cupid*, Pontormo seems also to have conceived the landscape setting with
distant mountains and the accretion of attributes in the left foreground.[178] With
her right hand on one of Cupid's arrows, Venus directs attention to these
objects, arranged on an ancient altar apparently in reference to sensual love
and its fatal consequences: bow and arrows, roses, the mask of a smooth-faced
youth, and another of a satyr.[179] On the same altar, a figure lies on his back,
destroyed, presumably, by having submitted his reason to his appetites, recall-
ing the language of one of Michelangelo's poems: "Voglia sfrenata è il senso,
e non Amore; / Che l'alma uccide" ("Unbridled desire is merely the senses, not
love, and slays the soul").[180] Perhaps he is Adonis, whom Venus came to love
when wounded by her son's arrow?[181] According to a contemporary sonnet, the
beholder is meant to remember Venus' wound and her suffering.[182] This inter-
pretation is in keeping with Bettini's intention to surround the *Venus and Cupid*
with depictions of Dante, Petrarch, and Boccaccio, and "other poets who had
[. . .] sung of Love."

Michelangelo's visual love poem translates the pagan personification of Love
into a chaste goddess who transcends the temptations of unbridled desire. A
rather tidy triangle of drapery covers Venus' pudenda, held in place by Cupid's
foot as he straddles her.[183] (Is this for her protection, or the viewer's?) Both of
them have their right hands on the same arrow; it is uncertain whether their
actions are cooperative or contradictory, however. Perhaps Cupid is taking the
weapon from its quiver while Venus attempts to restrain him, that is, to prevent
the arrow's use – an attempt, one knows, that will fail. Cupid's left arm holds
his mother's neck, turning her face toward his own to kiss her lips. In most
sixteenth-century images, as in classical antiquity, Cupid is generally depicted
as a putto. But here, his size and development – both physical and emotional
– make Cupid seem more a small adult than a child. Giulio Romano had pro-
vided a precedent in Mantua, "ageing" Cupid to make him a more appro-
priate lover for Psyche. In Michelangelo's and Pontormo's portrayal, however,
Cupid's maturity enables him to woo not his bride but his mother. (This dis-
turbingly mature Cupid may have spawned the even more adult and more las-
civious versions of himself in works by Pontormo and Bronzino.) Although
Venus does not withdraw from Cupid's incestuous embrace, neither does she
cooperate with his seduction. Her veiled expression, like the veiling of her sex,
shields her; her gesture toward the altar, doubled by her gesture toward herself,
explicates her meaning. In contradistinction to Cupid's vigorous efforts to
satisfy the senses, Michelangelo's goddess counsels spiritual love, not physical
gratification.

Venus achieves her moralizing transcendence of flesh by virtue of her mas-
culinization. Here as elsewhere, Michelangelo made little effort to conceal his

use of a male model; if anything, he seems to have vaunted the fact. In this regard, Venus resembles his other female nudes of the same period, namely the Medici Chapel allegories and the *Leda*. More precisely, the *Venus* recalls *Dawn* on Lorenzo de' Medici's tomb (Fig. 169), much as the *Leda* resembles the *Night*. None of this self-evident masculinization or moralization precluded contemporaries from praising the *Venus* for its eroticism, however. Indeed, in Varchi's eyes, Michelangelo's *Venus* was both powerful *and* erotic. Writing in the *Due lezzioni*, dedicated to Bettini, Varchi extolled her power by comparing Michelangelo's *painting* to ancient *sculptures* of various beings by Agrippa and Callistratus. And Varchi made his point about her eroticism with a loaded reference to yet another ancient statue, the *Venus* of Praxiteles. It was she, as Pliny recorded, who so aroused one of her worshipers that he ejaculated on her image, staining the stone (*Natural History* XXXVI.21). Nowadays, Varchi wrote, men fall in love with Michelangelo's *Venus* as once they did with Praxiteles' goddess.[184] These various classical works were of course known to Varchi and his readers only through copies and such literary sources as Pliny. Thus Varchi's *paragone* is multivalent: antiquity juxtaposed with the present, a painting compared with sculpture, and images with their descriptions.

Varchi's *Lezzioni* were read to the Florentine Academy in 1547 and published in 1549 (modern 1550). In 1554 Dolce turned the tables on Varchi and Michelangelo by evoking the same legend of Praxiteles's *Venus*, yet more explicitly (and arguably with greater reason), to praise Titian's *Venus and Adonis*. While the Florentine *Venus* represents the prelude to her falling in love with Adonis, the Venetian represents the fatal denouement of their affair, as Venus tries to restrain him from the hunt she fears will kill him. Writing to Alessandro Contarini, Dolce described the visceral effects of the ancient Venus on its enamored beholder, without, however, naming the sculptor Praxiteles. He could assume that his readers would understand the reference, but his silence seems purposeful. Whereas the name of the sculptor is omitted, earlier in the letter Dolce compared Titian's *Venus* with depictions of the goddess by Apelles. One painter is praised by reference to another, and in this sense painting itself is privileged, a reversal of Varchi's allusions to sculpture in his encomium to Michelangelo's painting. Perhaps Dolce's letter, though written to Contarini, is addressed to Varchi and other champions of Michelangelo, in the same sense that Titian's painting is addressed to his Florentine rival?[185]

The *Venus* was to be Michelangelo's last female nude and one of his last classicizing subjects. The theme was exceptional for him. Michelangelo had ignored classical subjects for the previous thirty years, since the youthful *Faun*, the *Battle of the Centaurs* relief, *Hercules*, the two statues of *Cupid*, several unnamed forgeries *all'antica*, and the *Bacchus*; and he rarely returned to them again, with the notable exceptions of several drawings, including presentation drawings for Tommaso Cavalieri, and the unfinished *Brutus*. Moreover, after the *Leda* and the *Venus*, Michelangelo effectively abandoned the female nude (the only exceptions appear in the *Last Judgment*). When he dealt again with classical themes, notably in such presentation drawings as *Ganymede*, *Tityus*,

the *Fall of Phaeton*, and *Archers Shooting at a Herm* – featuring male, not female, nudes – both the choice of subject and Michelangelo's interpretations seem intensely personal, bound to his strong feelings for the recipients (in several of these instances, Cavalieri), even if a present-day beholder may not be able to specify those emotions.

Michelangelo's mythological heroines represent themes for which Titian was already renowned throughout Italy and abroad. Michelangelo had been famous far longer than Titian, but now the younger man was enjoying such unprecedented success that the sculptor was compelled to take notice. Circumstances exacerbated their rivalry. Although resident in Florence in these years until the final move to Rome in 1534, Michelangelo was effectively enchained by the papal court, laboring almost exclusively for Clement VII with the exception of a very few private commissions, including the collaborations with Pontormo. Meanwhile, Titian, acting as a free agent, received an entirely different, entirely welcome kind of chain: the golden necklace presented by Emperor Charles V in 1533 as the insignia of the painter's knighthood.[186] Their cordial relationship was vaunted also in Dolce's *Aretino*, describing how the monarch, "imitating Alexander," treated Titian as the equal of anyone at court, and "conceded to him the greatest privileges, provisions, and rewards."[187]

Michelangelo had seen examples of Titian's *poesie* in Ferrara and in Venice. Whatever else Michelangelo may have hoped to achieve in his *Leda*, it was intended as an alternative vision of the female nude and a challenge to his rival. The subject was anomalous for Michelangelo, and through Condivi's biography, he specifically claimed the idea as his own: a classical nude for Ferrara, site of some of Titian's most ravishing female nudes. Their patron Alfonso and other informed viewers would have seen *Leda* in relation to Titian's women.

Having chosen to enter this rivalrous arena, however, Michelangelo then withdrew from the contest. The anecdote regarding his refusal to consign the *Leda* to Alfonso's unappreciative agent is true – the painting never went to Ferrara – but it is also an *apologia* for Michelangelo's exiling the painting to France, conveniently providing the artist and his biographers an opportunity to assert the pricelessness of great art. Titian made similar though not identical arrangements: he gave *poesie* to Philip, requesting payment later; and he sold the *Annunciation* to Charles, for example, finding a royal home and generous fees abroad when his efforts did not satisfy Italian clients. *That*, the painter seems to say, will show them; and Aretino, Condivi, and Vasari underscore the point in their various accounts of such transactions. Whereas Titian's dealings with Charles were fall-back positions, as it were – profitable solutions to the problem of a patron's rejection – Michelangelo's action seems a pre-emptive strike. Perhaps like Alberti, he remembered that the legendary painter "Zeuxis began to give his works away, because, as he said, they could not be bought for money. He did not believe any price could be found to recompense the man who, in modelling or painting living things, behaved like a god among mortals."[188] At the same time, perhaps displeased with the *Leda*, Michelangelo

was willing to allow (or unable to prevent) copies but unwilling that his original be displayed in Ferrara.

Michelangelo's female nudes visualize his rivalry with Titian. In the *Aretino* in 1557 Lodovico Dolce acknowledged Titian's competitive interest in Michelangelo, using the word *giostrare*, "to joust," to describe the Venetian's competition with the Florentine.[189] This joust had been in progress for decades, as discussed. Was Michelangelo aware that Titian had been borrowing from him since 1510? If Michelangelo visited the Scuola del Santo in Padua during his second sojourn in Venice, the answer is yes. Although there is no documentation of such a side trip, it is more likely than not: surely Michelangelo would have wanted to see, if not Titian's early frescoes, then at least the great Paduan works by his Florentine predecessors: Giotto's Scrovegni Chapel and Donatello's Santo altar. In any case, visiting Ferrara later in 1539, he would have recognized Titian's quotation from the *Battle* cartoon in the *Bacchanal of the Andrians*. Perhaps seeing that citation as a gauntlet thrown, and with Titian's nudes now imprinted in his mind's eye, Michelangelo answered the challenge with the *Leda* and the *Venus*. In other words, having seen what his greatest living rival had been doing, Michelangelo determined to try his hand at the same kinds of subject. Titian had been borrowing from Michelangelo for over two decades, and now Michelangelo responded – not with borrowing but with rivalry *tout court*. That is to say, as though to change the rules of discourse, Michelangelo had chosen to depict Titian's subject, the erotic female nude, but not Titian's language. The debate would be fought in Tuscan, not Venetian. At the same time, Michelangelo could hope to demonstrate his inventiveness, answering his critics' complaint of his repetitiveness in representing the male nude.

Titian's response was to appropriate both Michelangelo's subject *and* his style in representations of heroic male nudes whose means of expression are physical, not psychological; muscular, not physiognomic. (Titian's Venetian training had prepared him for this kind of stylistic flexibility, recalling Bellini's multivalence yet unlike Raphael's mutability, which involved the substitution of one mode for another rather than their simultaneous exploitation.) Some of Titian's works of the 1530s and 1540s seem to betray his Venetian predilections, and for this they have been found wanting by many modern historians. By the end of the 1540s, however, Titian integrated his Michelangelism with his own stylistic preferences, and the results include some of the greatest achievements of his maturity from the *Martyrdom of Saint Lawrence* (Venice, Chiesa dei Gesuiti, 1548–59) to the *Pietà* intended for his own tomb and left incomplete at his death in 1576.

Saint John the Baptist, c. 1530–33, may be taken as an opening foray in Titian's campaign (Fig. 170).[190] The painting is almost a demonstration piece, illustrating Titian's newly monumental interpretation of the partly nude male figure but set in an atmospheric landscape in keeping with Venetian tradition and the painter's proclivities. His definition of the saint's rippling muscles may suggest specific knowledge of Michelangelo's athletic ideals, such as the effigy

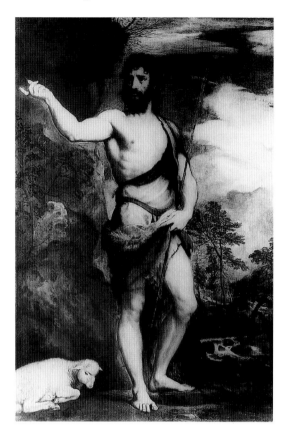

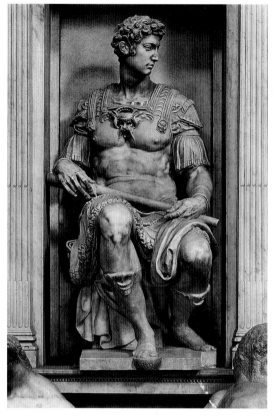

170 Titian. *Saint John the Baptist*. Canvas.
Venice, Gallerie dell'Accademia.

171 Michelangelo. *Duke Giuliano de' Medici*.
Marble. Tomb of Giuliano de' Medici. Florence, San
Lorenzo, Medici Chapel.

of Duke Giuliano de' Medici (Fig. 171).[191] The exaggerated musculature of
Giuliano's cuirass might have provided Titian with a template for his *Baptist*.
Similarly, he might have studied the male allegories of *Day* and *Dusk*,
surely known in Venice though not necessarily in copies provided by Vasari
(Tintoretto's oeuvre testifies to the fact).[192]

Signed TICIANVS on the rock under the Baptist's left foot, an act of submis-
sion to the saint, the painting was made for the church of Santa Maria
Maggiore, according to Dolce who was first to publish the work. Dolce's
description is revealing: "a little panel [*tavoletta*] of a St. John in the desert of
which one believes indeed that there has never been seen anything more beau-
tiful nor superior either in *disegno* or in *colorito*."[193] At 2.10 meters in height,
the *Baptist* can hardly be described as "little"; and it is painted on canvas, not
panel. But Dolce's appreciation of Titian's *disegno* and *colorito* is an accurate
account of the artist's intentions and his achievement, namely to combine

Tuscan design and Venetian colorism. Vasari also described the painting with some inaccuracy, including an angel who isn't there. Like Dolce, he recognized the particularly Venetian characteristics of the work: "a Saint John the Baptist in the wilderness among certain stones, [. . .] and a small section of distant landscape, with some trees above the bank of a river, [which are] very graceful."[194] Thus Vasari applauded the Venetian and ignored the Michelangelesque qualities of the *Baptist*, whereas Dolce explicitly acknowledged both, signaled by the words *disegno* and *colorito*.

Titian's Michelangelism culminates in three cycles: the ceiling of the Sala dell'Albergo in the Scuola Grande di San Giovanni Evangelista, including the *Vision of Saint John the Evangelist*, c. 1544–47; the ceiling paintings for the Augustinian church of Santo Spirito in Isola, apparently under way in 1542–44 though possibly not completed until 1552; and the *Damned*, commissioned by Queen Mary of Hungary in 1548 for her palace at Binche.[195] Despite their different pagan and sacred themes, these works are alike in presenting massive male bodies in positions of "daring foreshortening and contrapposti," characterized by "passionate power of movement" and by the suppression or concealment of facial expression, despite the characters' dramatic situations.[196] This restriction of psychological expression to the body – unusual for Titian – is as much an evocation of Michelangelo as the gigantic forms and vigorous postures: Titian's renditions of Michelangelo's archetypal subject expressed in Michelangelesque language.

The Santo Spirito in Isola cycle may be Titian's most heuristic imitations of his rival, visualizing its own "etiological derivation," in Thomas Greene's words, made possible "only through a double process of discovery" of the other – in this case, Michelangelo – and of oneself, more precisely, Titian's "own appropriate voice and idiom" (Figs. 172, 173, 174).[197] This heuristic quality is due in part to the genesis of the commission, awarded initially to Vasari and transferred to Titian only when the visitor left Venice. Vasari may well have left behind his designs for the project for Titian's use: praising the ceiling in his biography of Titian, Vasari might have been commemorating his own inventions.[198] Whether Titian borrowed Vasari's compositional ideas for the ceiling, he clearly adopted elements of Tuscan style. The presence in Venice of another Tuscan visitor (and rival) provided a further stimulus for Titian to do so: Vasari's old friend, the "glorious youth" Francesco Salviati, resident in the city from summer 1539 until fall 1540.[199] The Santo Spirito cycle included eight roundels with the Doctors of the Church and the Evangelists surrounding three narratives: *Cain and Abel*, the *Sacrifice of Isaac*, and *David and Goliath*. Old Testament themes were new to Titian, and this might have made Vasari's designs particularly welcome. In any case, the compositional scheme that Titian (and Vasari?) introduced to Venetian ceiling painting at Santo Spirito was adapted for later ceiling cycles by Tintoretto, Veronese, and others. In *Cain Killing Abel* and *David and Goliath*, evidently installed on either side of *Abraham and Isaac*, the antagonists are grouped to divide the picture space diagonally, and each is lighted from the right (a burst of celestial light provides

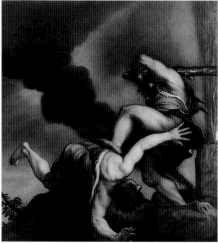

172 Titian. *Cain and Abel*
(Santo Spirito ceiling). Canvas.
Venice, Santa Maria della
Salute, Sacristy.

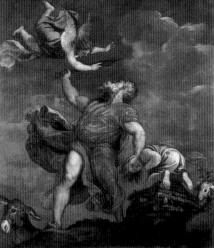

173 Titian. *Sacrifice of Isaac*
(Santo Spirito ceiling). Canvas.
Venice, Santa Maria della
Salute, Sacristy.

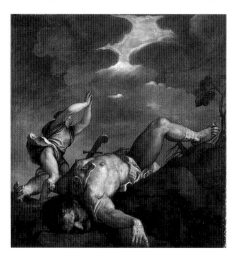

174 Titian. *David and
Goliath* (Santo Spirito ceiling).
Canvas. Venice, Santa Maria
della Salute, Sacristy.

the pictorial source of illumination in *David and Goliath*).[200] *Abraham and Isaac*, presumably the central scene, is appropriately a more centralized composition, with Abraham standing so as to bisect the picture space. In each case, the figures anchor the composition at the bottom of the picture space; the upper part of the space is open to cloudy sky.

Like Venetian mural paintings, then, these ceiling compositions are insistently asymmetrical, juxtaposing closed and open spaces. Whereas the parallel strata and frieze compositions of murals reiterate the plane of the wall, however, the ceiling paintings are aggressively *di sotto in sù*, precisely to insist on their placement above the beholder's head. This radical foreshortening of the figures suggests in turn that, in opening to the sky, each scene opens the ceiling itself. Because of the exaggerated foreshortening, the viewer in effect looks *through* the ceiling to the narratives, their atmospheric settings contrasted with the solid reality of the carved and gilded enframement. Or to put the matter conversely, the solidly three-dimensional ceiling is punctured by the illusion of the paintings. The narratives are bound to the viewer's world not only by these various compositional and perspectival means but also by virtue of a single glance: the glance of Isaac as his father forces his head downward for the fatal blow. Isaac is the only figure who looks directly at the beholder, binding one with his steady gaze.

Elsewhere in the cycle, as indeed in Michelangelo's art, the viewer is ignored, and the actors' emotion is conveyed by pose and gesture, not by facial expression. The angel has stopped Abraham's sword; the beholder knows that Isaac is saved even before he himself can have realized the fact. In this narrative, then, the relationship between viewer and image is psychological and reciprocal. In the two flanking episodes, the relationship is purely physical, as it were: the dead body and severed head of Goliath threaten to slide out of the picture; and similarly, as Cain strikes him, Abel seems to tumble out of the picture space. Mantegna had introduced these kinds of illusionism to ceiling painting, binding image and beholder by glance and by action. The ceiling of his Camera Picta in the Ducal Palace of Mantua, completed in 1474, is as sophisticated as Titian's for Santo Spirito though different in purpose and effect: Mantegna teases the beholder with a urinating putto and a precarious flower pot (Fig. 175). Similarly, Giulio Romano's ceiling and indeed the walls of his Sala dei Giganti in Palazzo Te, also in Mantua, seem to collapse in piles of masonry and tumbling giants – but again, the intent is comedic though tumultuous and slightly sadistic (Fig. 176).[201] Titian terrorizes the beholder, however, not only with the sheer physical weight of the massive bodies that fall on our heads but with the violent causative act. The blow that strikes Abel seems also to strike at us; the head and pointing hand of Goliath seem to implicate us in his fate. Even Abraham's sword, were it not for the angel's restraining the blow, would seem to fall on us while striking Isaac's neck. Whatever ideas Vasari's preparatory drawings might have given Titian, this aggressive illusionism seems to be his own conception, a purposefully disturbing amalgamation of Mantuan and Tuscan traditions.

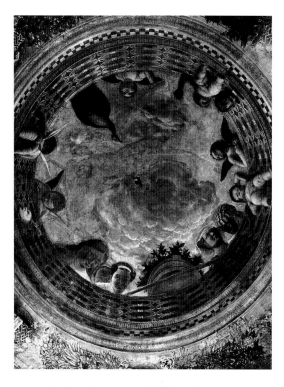

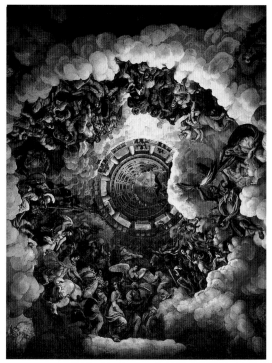

175 Andrea Mantegna. Ceiling fresco. Mantua, Ducal Palace, Camera Picta.

176 Giulio Romano. Ceiling fresco. Mantua, Palazzo Te, Sala dei Giganti.

The *Damned* also menace the beholder.[202] Once again, the contorted postures and muscular torsion of the victims convey their terrible plight, and not their faces, concealed in shadow. Their powerful bodies make us feel the overwhelming strain of the stone on Sisyphus's back and the agony of Tityus as the eagle devours his liver. According to the *Odyssey* XI, 779–94, and other classical texts, the bird that fed on Tityus's liver was a vulture, but Titian was quoting a different source. Michelangelo had replaced the vulture with Jupiter's eagle in his presentation drawing of the *Punishment of Tityus* (Fig. 178), apparently made as a pendant of the *Rape of Ganymede*, in which the eagle is of course canonical. The drawings are identified as Michelangelo's gift to Cavalieri in late 1532.[203] To represent his own Tityus (Fig. 179), Titian combined Michelangelo's two figures, adapting Ganymede's pronated left arm to the Florentine *Tityus*, now turned almost upside down. Michelangelo's Tityus, lying horizontally on his bed of rocks, seems to welcome the eagle, and the way the bird spreads its wings over him seems almost a protective embrace. Titian replaced horizontals with diagonals, making Tityus struggle against his chains (replacing Michelangelo's cloth bindings), bending his head toward his own torso as the eagle tears his liver from his side. The effect is brutal and unnerv-

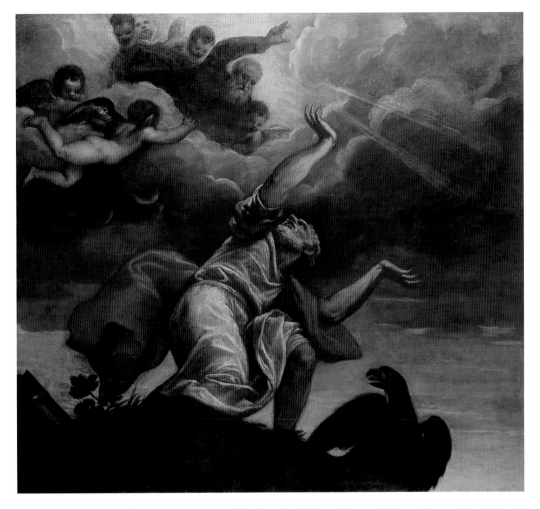

177 Titian. *Saint John on Patmos* (Scuola Grande di San Giovanni Evangelista ceiling). Panel. Washington, National Gallery of Art, Kress Collection.

ing. Titian's ceiling painting for the Scuola Grande di San Giovanni Evangelista, representing *Saint John on Patmos*, is equally turbulent (Fig. 177). The agitation is spiritual, however, without the element of physical danger that threatens protagonist and beholder in the other works.

Whereas Titian's *Baptist*, *Saint John*, the Santo Spirito ceiling and the *Damned* can be seen as his essays in Michelangelesque masculinity, his next *poesia* answered Michelangelo's rivalrous invasion of his own territory: the eroticized female nude. Here too Vasari was the proximate cause of Titian's response. In 1540–41, just before his arrival in Venice, Vasari had produced the first of his two or three copies of Michelangelo's *Venus and Cupid* and *Leda* for Ottaviano de' Medici, ostensibly made with the master's cartoons.[204]

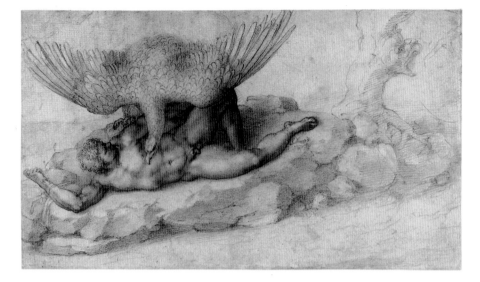

178 Michelangelo. *Tityus*. Black chalk. Windsor, Royal Library 12771r, Her Majesty Queen Elizabeth II.

Although the compositions had not been conceived as pendants, Vasari and his patron apparently treated the works as such, naturally enough, given their subject matter and similar horizontal schema. Either Ottaviano's paintings or duplicates were then sent to Francesco Leoni in Venice.[205] When Vasari himself arrived in 1541, he had with him yet another set of copies of Michelangelo's *Venus and Cupid* and *Leda and the Swan*, which he hawked to Duke Guidobaldo della Rovere of Urbino – one of Titian's great patrons.[206] Vasari's efforts were endorsed by his colleague, client, and compatriot, Aretino. Writing in spring 1542, Aretino advised the duke to acquire the paintings, extolled as brilliant inventions by Michelangelo by the hand of an unnamed but talented youth (perhaps Vasari himself):

> Certainly your ambassador was stunned when he saw them [. . .] aside from the competence of the youth who has painted them, the cartoons of these figures are by the hand of the great, the admirable, and the singular Michelangelo. One of the two images is Leda, but in a soft manner of flesh, grace of members, and slender of person, and so sweet, soft, and graceful in her attitude, and with such unadorned grace of all her parts, that one cannot admire the nude without envying the swan, who enjoys her with an expression very similar to reality, who appears, while extending his neck to kiss her, to want to exhale into her mouth the spirit of his divinity. The other image is Venus, drawn with marvelous roundness of line. And because that goddess defines her properties in the desire of the two sexes, the prudent artist has made in the body of the female the muscles of the man, so that she is moved by virile and feminine feelings with elegant vivacity of artfulness.[207]

179 Titian. *Tityus*. Canvas. Madrid, Museo del Prado.

According to Aretino, Venus is masculinized to show that love rules both men and women, and Leda is so beautiful that the beholder envies the swan. Guidobaldo was unconvinced, however. Vasari finally found a buyer in Don Diego Hurtado de Mendoza, imperial ambassador to Venice – and another of

Titian's powerful friends and patrons. Mendoza paid a hefty 200 *scudi d'oro* for the two works.

If these encroachments on his artistic territory concerned Titian, he none-theless maintained a posture of friendly, even subservient, respect toward Michelangelo, in part because he hoped that Michelangelo would intervene at the papal court on behalf of his cleric son, Pomponio. Titian's admiration and his request were conveyed in Aretino's letter to Michelangelo, dated April 1544 and published in 1546. But before conveying Titian's wishes, Aretino expressed his own, namely, his hope for the gift of a drawing by Michelangelo. After all, who can appreciate Michelangelo's art better than himself? Were Charles V not so glorious, Aretino writes, learning that Michelangelo had accepted his greet-ings would make him even happier than

> the stupendous honors done me by His Majesty. But if Your Lordship is revered thanks to public acclaim, including those who are ignorant of the miracles of his [your] divine intellect, why not believe that I revere you, who am almost capable of the excellence of your fatal genius? And being made thus, in seeing your terrible [*tremendo*] and venerable and terrible [*tremendo*] day of Judgment, my eyes were bathed with the waters of emotion. Now think of what sort of tears I would cry in seeing the work coming from your sacrosanct hand [the drawing he hoped to receive]. That if it were thus, [. . .] I would render thanks to God who has given me the gift of being born in your time. I boast likewise to my having been [alive] in the days of Emperor Charles. But why, O Lord, do you not reward my constant devotion, who reveres your celestial qualities, with a relic of those papers that are less dear to you? Certain that I would appreciate two marks of carbon on a sheet more than however many cups and chains that ever this prince and that presented to me. But, when well my unworthiness would ever be cause that I do not enjoy such a votive, to me the promise that gives me hope is sufficient. I enjoy it while I hope, and hoping for it, contemplating it: and contemplating it, congratulate myself with the fortune that I have in contenting myself with the wished-for thing, which cannot be but a dream not converted into vision. And likewise confirms for himself friend Titian, a man of optimum example, of grave and modest life: he, ardent preacher of your superhuman style, has borne witness his writing to you with the reverence due all the faith of extracting or portraying [*ritrarre*] bread, that for his son [Pomponio] the pope concede [a benefice], in the favor that he awaits from the sincere good-ness of you, who are his idol and mine.[208]

That Titian should ask such a favor suggests that he and Michelangelo had already met (presumably in Venice in 1529) before their only documented encounter in Rome in 1545–46. Aretino's description of Titian as "ardent preacher" of Michelangelo's style, though exaggerated – like everything else in this hyperbolic, sardonic letter – reflects the writer's perception of the Venetian's more recent works, among his most Michelangelesque. Because Titian's veneration is couched in relation to his hope for a favor, his avowed

devotion to Michelangelo's "superhuman style" might seem to modern readers to be tarnished by sycophantic insincerity. But this admixture of lavish praise and servile entreaty was very much a sixteenth-century way of doing things, and Titian's own works affirm his appreciation of Michelangelo's style. At the same time, Aretino's wily wit (who can appreciate a gift from you better than I, who am almost your equal?) leaves the beneficiary of his praise in doubt as to its motive – and its endurance, if the favor is not granted. The relationship between them had long been equivocal. Writing to Aretino on 20 November 1537, when the *Last Judgment* was still four years from completion, Michelangelo regretfully rejected Aretino's suggestions for the composition, explaining that "having completed the narrative in large part, I can not make use of your imagination, which is such that if the day of Judgment had already been, and you had seen it in person, your words could not figure it any better."[209]

For a variety of reasons, knowable (Michelangelo never gave Aretino a drawing, never intervened for Titian's son) and unknowable, by the mid-1540s their admiration for Michelangelo had waned. Aretino, at least, said so in no uncertain terms. His veneration was replaced by excoriating criticism directed in particular at the *Last Judgment*, which had made Aretino cry in 1544 (or so he said) but which now he condemned as lascivious and indecent for its display of nudity.[210] For Titian's part, admiring imitation turned to reversal in response to Michelangelo's mythological forays (how was anyone to know that the *Venus* and *Leda* would be the Florentine's only erotic paintings?) and the threat to his, Titian's, "monopoly" with certain patrons (how was anyone to know that Charles and others would admire Michelangelo but not solicit him, or that Michelangelo would be unable to complete commissions outside papal Rome?).

Titian's *Danae and the Shower of Gold* is his declaration of art war with Michelangelo (Fig. 180).[211] The painting's derivation from Michelangelo's works is blatant: the beholder must recognize the quotation in order to "appreciate the victory."[212] As Dolce reported in his *Aretino* – the first published mention of the painting – Titian was in Rome in 1545 as the guest of Pope Paul III Farnese, at that time Michelangelo's greatest patron. While Titian was at work on his portrait of *Paul III and His Grandsons* (often wrongly identified as his nephews), Cardinal Alessandro and Ottaviano Farnese, he was also completing the *Danae*, commissioned by the cardinal (Fig. 181).[213] These two commissions reflect Titian's predilection for nudes and portraiture, subjects that Michelangelo had abandoned or foresworn. Given his lack of interest in these genres, Michelangelo might have ignored Titian's Roman invasion. But he could not ignore the fact that the *Danae* blatantly borrows from his *Leda* and her marble sister, *Night*, reversing his conception in the process. Titian's *Danae* is an attack on Michelangelo's art – not his preferred subject matter but, more fundamentally, his *style*.

According to Dolce, Michelangelo visited Titian's studio in the Belvedere in Rome and saw the *Danae*, "that most beautiful female nude for the Cardinal [Alessandro] Farnese, which Michelangelo viewed with wonder more than

180 Titian. *Danae and the Shower of Gold*. Canvas. Naples, Gallerie Nazionali di Capodimonte.

once."[214] Dolce is probably correct that Michelangelo visited Titian more than once; and probably correct too in reporting Michelangelo's admiration as it was expressed, politely, to Titian. Behind Titian's back, however, Michelangelo voiced a rather different opinion, and Vasari recorded his withering criticism:

> Going one day to see Titian at the Belvedere, Michelangelo and Vasari saw a painting [. . .] of a female nude, depicted as a Danae, who had in her lap Jove transformed into a shower of gold, and they much praised it, as one does in company. After they had left him, Buonarroti much commended him, saying that his *colorito* and his style [*maniera*] much pleased him but that it was a shame that in Venice one did not learn from the start to draw well and that those [Venetian] painters did not have a better method of study: "With such it would be" – he said – "that, if this man were in fact helped by art and by *disegno*, as by Nature, and above all in counterfeiting the living, one could not do more or better, as he has a most beautiful spirit and a very charming and lively style [*maniera*]." And in fact this is true, because who has not drawn [*disegnato*] enough and studied selected things, ancient or modern, cannot do well in practice, nor to help things that one portrays from

181 Titian. *Paul III and his Grandsons Alessandro and Ottavio Farnese*. Canvas.
Naples, Gallerie Nazionali di Capodimonte.

life, giving them that grace and perfection that art gives beyond the order of
Nature, which normally produces some parts that are not beautiful.[215]

Michelangelo and Vasari thus condemn Titian and indeed all Venetians for
neglecting *disegno*. Vasari has Michelangelo enunciate the archetypal criticism
of Venetian art in relation to Titian not only because Titian epitomizes
Venetian art but because he is Michelangelo's great rival. Venetian *colorito*
is charming, the Tuscans acknowledge, but neither this nor truth to Nature is

sufficient to make beautiful art. In addition to observing Nature, one must study art itself, "ancient or modern." The Tuscan reprimands are at once sincere and disingenuous. Titian's obvious study of Michelangelo is ignored because his consultation entailed not adulatory emulation but critical revision. Surely Michelangelo and Vasari recognized Titian's quotations of Michelangelo's inventions and the gender reversal of his style and chose to ignore the fact, or rather to respond with a counter-attack – even drafting Sebastiano del Piombo to join the battle. Anticipating Michelangelo's criticism, Sebastiano is made to say to Vasari "that if Titian had been in Rome at that time" – that is, already in 1508, early in his career – "and had seen the works of Michelangelo, those of Raphael and the ancient statues, and had studied *disegno*, he would have done the most stupendous things, seeing the beautiful practice he had of coloring."[216] Thus Vasari made Sebastiano criticize Titian, a friend and fellow Venetian (and praise Raphael, a bitter rival), in order to give greater credence to the Tuscan point of view.

Michelangelo's *Leda*, *Night*, and indeed the *Venus* are masculinized as much by their sculptural *disegno* as by their athletic musculature. These are the means whereby his heroines are empowered not only physically but morally. In Titian's subversive rebuttal of Michelangelo, the Florentine's figuration of masculine *disegno* becomes the Venetian's exaltation of female sensuality by means of feminine *colorito*. Adding insult to injury, in the *Danae*, Titian represents Jupiter not embodied as coins but disembodied as color and light in the tactile bursts of yellow pigment with which he suggests the shower of gold. Never had a substance so hard as gold or a form so precise as a circle been so *undermined* as here, by Titian's colorism; never had a being so completely masculine as Jupiter been so completely regendered as in the *Danae*, where the life-creating form of the father is disembodied and dissolved into feminine matter. Having completed the *Danae* and returned to Venice, Titian seemed to have exorcised Michelangelo, or very nearly so.

IV
Coda

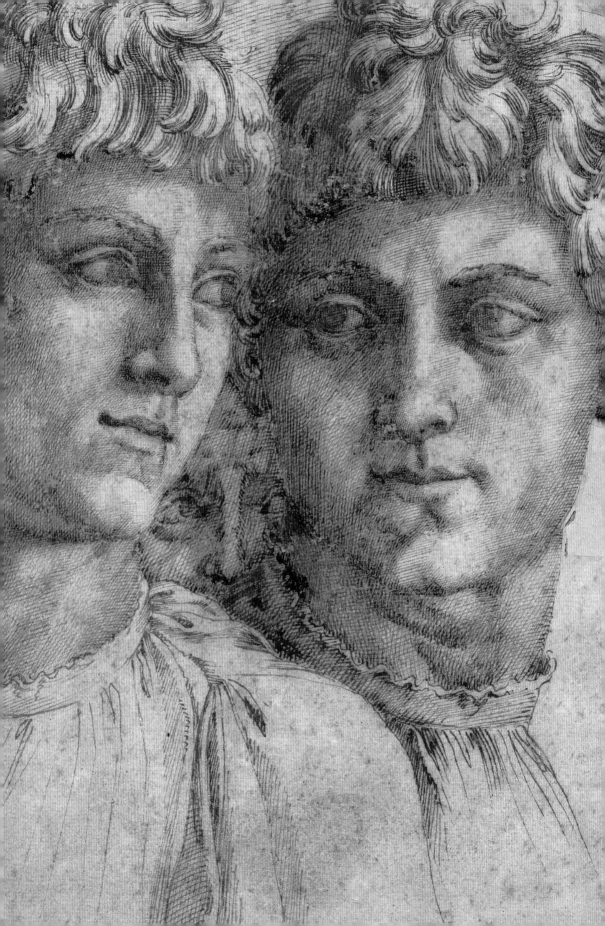

8

Bandinelli and Cellini

A priest friend of his said: "It's a shame that you haven't taken a wife, because you would have had many children [. . .]"; Michelangelo answered: "I have too much of a wife, which is this art that has always given me tribulation, and my children will be the works that I shall leave."

Giorgio Vasari[1]

In painting, in sculpture, and in architecture, Michelangelo is beyond every risk and danger, having conquered envy.

Benedetto Varchi[2]

R ENAISSANCE RIVALRIES REACH THEIR ACME with two Florentines, Baccio Bandinelli and Benvenuto Cellini. Rivaling each other, Bandinelli and Cellini enlist Michelangelo in the fray, each claiming for himself the master's imprimatur. Cellini's *Autobiography* documents his abhorrence of his rival. He warns their mutual patron, Duke Cosimo I de' Medici, "take good care not to let Bandinello go [. . .] because if he goes elsewhere [. . .] he's likely to bring the noble school of Florence into disrepute." On another occasion, he explains to the duke that aesthetic judgment reflects the character of the judge: "understand that Baccio Bandinello is thoroughly evil. [. . .] So no matter what he looks at, [. . .] it is at once turned to absolute evil. But for myself, being only drawn to what is good, I see things in a more wholesome way." Cellini confesses to the reader that he had wanted to kill Baccio but restrained himself when they met because his enemy was accompanied by a child; he satisfied himself instead with posting an anti-Bandinelli poem where people "piss . . . or shit," thus fouling his name.[3] As for Baccio, he did everything he could to hinder Cellini by complaining to Duke Cosimo and other members of the court.[4]

The rivals' principal arena was the Piazza della Signoria, a fact that seemed preordained by Leonardo's involvement with Michelangelo's *David*, first by participating in deliberations regarding its placement, then by sketching designs for its pendant. Although Leonardo's *Hercules* never developed beyond these drawings, his ideas so inform Baccio's *Hercules and Cacus* that the older master might almost be considered to have guided the younger in creating *David*'s companion.

Baccio received this commission largely for political reasons: his father, the goldsmith Michelangelo di Viviano de' Bandini (1459–1528), had been employed by the Medici, like his father before him, and Baccio profited from this ancient family connection.[5] But Baccio also paid a considerable price for this relationship: the deep-seated hatred that many Florentines nurtured for the Medici was readily transferred to the sculptor, rightly perceived as their propagandist. Although Baccio greatly admired Michelangelo, Michelangelo thought ill of him even before the younger sculptor deprived him of the commission for *David*'s pendant; Vasari libeled Baccio with the charge of having destroyed Michelangelo's *Cascina* cartoon because of jealousy; Cellini excoriated Baccio in poems and in the *Autobiography*, gleefully reporting every public and private humiliation that his rival had suffered. Baccio's reputation has never recovered from their attacks.[6] Vasari might have felt some compunction to acknowledge Baccio's considerable talents so as not to offend their patron, Duke Cosimo, and in any case he sometimes admired the sculptor's art despite distaste for the man. Personal dislike was imbricated with rivalry. When Vasari entered the duke's service in 1553, he found Baccio already established at court, his position uncontested. And when Cellini returned to Florence in 1545, he also found Baccio to be his chief competitor. In addition to confronting Baccio directly, both Cellini and Vasari criticized him for having the temerity to challenge not themselves but their idol, Michelangelo. That Cellini himself aspired to rival Michelangelo gives an edge to his resentment of Baccio: rivaling Michelangelo is *his*, Cellini's, prerogative: "I have surpassed many and arrived at the level of the one who was my better."[7] Characterizing Baccio as "that beast of a blockhead," Cellini reminds Duke Cosimo "that marble from which Bandinello made his Hercules and Cacus was quarried for the marvellous Michelangelo Buonarroti, who had made for it a model of a Samson, four figures in all [. . .]: and your Bandinello got only two figures out of it."[8] Baccio was self-deluded, Vasari wrote, "having the firm opinion not only to rival (*di paragonare*) Buonarroti but to surpass him greatly in both professions" of draftsmanship and painting.[9] Aretino similarly chastened Baccio for his overweening ambition (and more): Aretino had hoped to receive four or five drawings as a gift but such is Baccio's natural ingratitude "that to hope for such a little thing is even stupider than your presumption so that you risk with foolhardy daydreams to wish to surpass Michelangelo. And I kiss your hand."[10] Such accusations regarding Baccio's ambition were correct, but none of his critics acknowledged his high regard for Michelangelo, expressed repeatedly in the *Memoriale* and visualized in works that emulate the older man's, "whose judgment I esteemed above all others."[11]

Ignoring Baccio's veneration for his protagonist, Vasari could condemn him more completely. It is as if Baccio were an unconverted pagan, one who failed to see the light and was therefore damned. According to Vasari's theology, Baccio is the anti-Michelangelo who attacks the works of the Divine Michelangelo. With this in mind, he wrote Baccio's and Michelangelo's biographies as parallel lives.

"While still a boy," Baccio made a giant snowman of a reclining Marforio, 8 *braccia* long, according to Vasari. The colossal scale of the snowman looks forward to Baccio's colossi for the Medici, culminating with his *Hercules and Cacus*; but it also looks back to the snowman that the boy Michelangelo had made for the previous generation of Medici.[12] Again, like Michelangelo, the young Baccio also made numerous drawings of great works by earlier masters, copying all of Filippo Lippi's fresco cycle in the chapel of the Pieve, for example.[13]

After first training with his goldsmith-father and then with the painter Girolamo del Buda, Baccio apprenticed with Giovanni Francesco Rustici, another Medici client, and Leonardo's one-time companion in Verrocchio's shop. When Leonardo was in Florence during the first half of 1508, he assisted his old friend with the three-figure bronze group of *Saint John the Baptist Preaching to a Levite and a Pharisee* for the Baptistery (1507–11).[14] Vasari described the collaboration: "While he was carrying out the clay [models] of this work, Rustici did not wish anyone around him but Leonardo da Vinci, who [. . .] never abandoned him until the statues were cast."[15] Vasari's estimation of Leonardo's close involvement with the group has been confirmed by modern observers. "None of the three figures could be explained without reference to the other two," John Pope-Hennessy writes of the dramatic and psychological unity of the group; "There is no precedent in sculpture for a composition of this kind, but it had a parallel in painting, in the fresco of the Last Supper."[16]

Again according to Vasari, during Baccio's apprenticeship with Rustici, the pupil was encouraged in his studies by Leonardo himself: "Seeing Baccio's drawings and pleased by them, he encouraged him to pursue and to undertake working in relief; and he praised greatly the works of Donatello to him, telling him that he should do something in marble, such as heads or low relief. Heartened by Leonardo's encouragements, Baccio set himself to copy in marble an "antique head of a woman" based on one in the Medici collection – much as Michelangelo had made as one of his first works in marble a copy of Lorenzo's ancient *Head of a Faun*.[17] What if anything Leonardo might have said to Baccio, they surely knew each other: born in 1493, Baccio was about fifteen and still in Rustici's shop while Leonardo was assisting with the *Baptist* group. And whether Leonardo noticed and advised young Baccio, the sculptor venerated him and sought to emulate him throughout his career, both in theory and in practice.

At this point, Baccio was encouraged by his father (quite unlike Michelangelo's parent), who gave him some blocks of Carrara marble and built a workshop for him. From one of the blocks, measuring 2.5 *braccia* (approximately 1.45 meters), Baccio carved a group of *Hercules and Cacus*, with the dead cattle thief between the hero's legs, a first version of the Piazza della Signoria colossus. Was Baccio already dreaming of that great commission? The block for *David*'s pendant had been quarried in 1506, and Hercules had likely been selected as the subject.[18] Leonardo's drawings hint as much. Indeed, the

pairing of Hercules and David seems to have been intended already in the fifteenth century, when the Operai commissioned Agostino di Duccio to produce an unnamed giant to accompany the cathedral *Hercules*.[19] The *Hercules* remained *in situ* on a cathedral buttress while that nameless block became Michelangelo's *David*, awaiting his companion in the piazza. Whether Baccio was already fantasizing about the piazza commission as he made his own *Hercules and Cacus*, surely he remembered other Florentine depictions of Hercules, anticipated and actualized, including Michelangelo's early representation of the hero. Likewise in marble and nearly twice the size of his own, if Condivi's measurements are correct, Michelangelo's *Hercules* was then still in Florence. The double coincidence seems too good to be true – the rivalry with Michelangelo, the anticipation of Baccio's own later colossus – but this early *Hercules and Cacus* existed and was apparently known to Vasari, who reported that the marble "sketches" (*bozze*) of these and other early efforts were kept in Baccio's first workshop "in his memory."[20]

The subtext of rivalry with Michelangelo now becomes explicit. Immediately after describing this prophetic *Hercules and Cacus*, Vasari recounted the libelous story of Baccio's destruction of Michelangelo's *Cascina* cartoon. Baccio did it, "some said, for affection of Leonardo da Vinci, from whom Buonarroti's cartoon had taken much repute; others, perhaps interpreting better, gave as the cause the odium that he felt for Michelangelo, as he thereafter made apparent in his entire life."[21] For Vasari, as for Cellini and others, Baccio's "affection of Leonardo" is bound to "odium [. . .] for Michelangelo," and these interlaced emotions are related in turn to their agon, reified in the commissions for the piazza colossi.

Lest the reader miss the point, Vasari followed his report of Baccio's putative destruction of Michelangelo's cartoon with an account of the younger master's misguided attempts to outdo the older in draftsmanship and in painting. In order to do so, Baccio made a cartoon of Leda and the Swan with her hatchlings, which he wished to paint as a demonstration piece.[22] Vasari described the *Leda* immediately after the exposition of Baccio's intention "not only to compete with Buonarroti but to surpass him." Vasari did not say, perhaps assuming that his readers would know, that this was a subject that Leonardo had represented in two versions, both surely known to Baccio. Nor did Vasari say that this was a subject that Michelangelo himself later painted. Painting his own *Leda* in the second decade of the sixteenth century, Baccio cannot have anticipated that lost work; but Vasari did of course know of it and could expect that it was known to his audience, intended to remember it as they read about Baccio's first overt challenge to Michelangelo.

This one-sided, lop-sided competition becomes the Leitmotif of Baccio's life. Having praised his energy and dedication, Vasari proceeded to damn him: whereas he was endowed since childhood with "a most ardent will" and "was never found idle," he lacked "aptitude and skill in art." He was tireless but for the wrong reason, "thinking with continuous working to surpass everybody else."[23] This was hubris, and Baccio would fail, as Vasari implied by going on

to describe how the sculptor's career was advanced not only by his talent but equally or more by his political connections. Baccio made a wax figure of a wizened *Saint Jerome in Penitence*, admired by all the craftsmen and "particularly by Leonardo," and this he presented to Cardinal Giovanni de' Medici and to his brother Giuliano, Duke of Nemours, "and by means of [this figure] he made himself known to them as the son of the goldsmith Michelangelo" – known, that is, as the son of a loyal Medicean – "and they, in addition to praising the work, did him many other favors; and this was in the year 1512, when they [the Medici] had returned to their house and to the state."[24] Precise chronology is rare in the *Lives*. By placing the story of Baccio's destroying the *Cascina* cartoon in 1512, at the same time as his wooing the Medici immediately after their return to power, Vasari connected the two events, linking Baccio's destructive competitiveness regarding Michelangelo with a bent for political machinations and expediency.

182 Baccio Bandinelli. *Saint Peter*. Marble. Florence, cathedral.

Now Baccio, at twenty-one or twenty-two, received his contract for the cathedral *Saint Peter*, thanks to Duke Giuliano (Fig. 182). The duke is mentioned in the deliberation of 25 January 1515, recording the commission, as though the Operai wished to explain how they came to select Baccio, comparatively unknown and inexperienced, for this important public commission.[25] He was not unknown to the Medici, however, and from this point on, they became his loyal patrons. At the same time, the nature of this first great commission set an agonistic course for Baccio's career. By 1515, when he began the *Saint Peter*, the Operai also had Jacopo Sansovino, Benedetto da Rovezzano, and Andrea Ferrucci at work or supposedly at work on the Apostles series. The cycle, originally commissioned to one master – Michelangelo – had become multiplex, an inherently competitive juxtaposition of hands.[26] Vasari put the matter succinctly: "the Apostles [. . .] were made in competition."[27]

Early and continuing Medici patronage is another parallel in the lives of Baccio and Michelangelo, as Vasari wrote them, and so too the sculptors'

youthful successes and their precocious fascination with the colossus. At seventeen Michelangelo had executed his own *Hercules*, his first large-scale marble, measuring approximately 2.33 meters – large, to be sure, but a *private* commission, indeed, made for himself, if one is to believe what he told Condivi (though in reality it was made for Piero de' Medici). At nineteen and twenty Michelangelo was employed in Bologna, completing the tomb of San Dominic with smaller-scale works intended to mimic the styles of the sculptures they were made to accompany. At twenty-one or twenty-two – Baccio's age when he executed the *Saint Peter* – Michelangelo completed his lifesize *Bacchus* (1.84 meters) for Cardinal Riario, only to have the work rejected. Michelangelo's first *successful* monumental sculpture, his first major public commission, was the *Pietà*, unveiled when he was twenty-five.[28] The *Pietà* was a spectacular "debut"; but the fact that Michelangelo had to wait until his mid-twenties for this public triumph provides a frame of reference for Baccio's extraordinary good fortune in Florence only a few years later – and a few years younger.

Baccio's *Saint Peter*, a paraphrase of Donatello's *Saint Mark*, must have pleased his Medici supporters even as a work in progress. When Giovanni, now Leo X, made his triumphal *Entrata* into Florence in 1515 – while Baccio's Apostle was still incomplete – the sculptor was rewarded with several major commissions for the celebratory decoration of the city, transformed into another Rome for the occasion. (A decade before, Soderini had accused the Medici of having lost their "Florentineness"; the Roman decorations for the *Entrata* seemed to confirm Soderini's indictment.[29]) In addition to much of the decoration of the Sala del Papa in Santa Maria Novella, Baccio had sole responsibility for four other works: a triumphal arch at Via Tornabuoni and Via Panzani; the decorations in Via della Scala; a giant column at the future site of the Mercato Nuovo; and a colossal *Hercules* executed in stucco and painted to simulate bronze. This was Baccio's second large-scale depiction of the hero, following the group of *Hercules and Cacus* from a block his father had given him. According to a terse notation by Luca Landucci, *Hercules* "was not much appreciated."[30] According to Vasari, the stucco was Baccio's first failed attempt to rival Michelangelo's Giant: "The colossus was a Hercules, which, according to Baccio's advance publicity [*parole anticipate*], one expected would surpass Michelangelo's *David* nearby; but the saying did not correspond to the making nor the work to the boast, rather diminishing Baccio in the opinion of the craftsmen and of the whole city."[31]

Displayed in the Loggia dei Lanzi, the Medicean *Hercules* challenged Republican *David* at the entrance to the Palazzo Vecchio: the confrontation was no less political than aesthetic.[32] If Vasari's measurements are correct, the *Hercules* was over a meter taller than the *David*; and his record of its size is credible because he was familiar with the lost work.[33] What is known of the appearance of *Hercules* is due largely to Vasari's depiction of it in his *Entrata of Leo X*, an episode in his fresco cycle of the pope's life in the Quartiere degli Elementi in Palazzo Vecchio, painted in 1561 (Fig. 183).[34] As Vasari represented the statue, it resembled Baccio's stucco *Colossi* in the garden of Villa Madama

183 Giorgio Vaṣari. *Entry of Leo X* (detail). Fresco. Florence, Palazzo Vecchio, Quartiere degli Elementi.

outside Rome, executed for Cardinal Giulio in 1519–20 (Figs. 184, 185). All three giants feature "massive thighs and swelling calves," stocky torsos, "bull necks," small heads with small eyes and features crowded below a prominent brow (*Saint Peter* has a similar physiognomy).[35] Although Baccio consulted antique sources for these faces and bodies, notably depictions of gladiators and of Hercules himself, his style is anti-classical.[36]

Made to flank the Villa Madama garden gate, the *Colossi* might have been expected to have been identical, or nearly so. Instead, they are purposefully differentiated, and their juxtaposition to either side of a portal prophesies the relation of *Hercules and Cacus* and Michelangelo's *David* at the entrance of the Palazzo Vecchio. Baccio himself seems to have intended to exploit the Villa Madama commission as a demonstration of what he hoped to do in Florence. The *Colossus* on the left reiterates *David*'s pose, while the one on the right recalls the *contrapposto* of the stucco *Hercules* and predicts that of the marble *Hercules and Cacus*.[37] The arms of this *Colossus* have been damaged, but a drawing by Maarten van Heemskerck shows an extension of the right arm like that of Michelangelo's *Risen Christ*.[38] Thus Baccio confronted his rival in part by turning Michelangelo's invention against its maker.

For Baccio, as Vasari recognized, such imitation was undertaken precisely with the aim of surpassing the model. Baccio's predilection for imitation was encouraged by the example of Raphael and is comparable with Titian's search for alternatives – albeit with very different results. Describing Raphael's

184 Baccio Bandinelli. *Colossus*. Stucco. Rome, Villa Madama.

dilemma in challenging Michelangelo, as he saw it, Vasari might have been explaining Baccio and Titian as well. No one could surpass Michelangelo in representing the male nude, Vasari declared, though admitting that there is more to art than the male body. In any case, recognizing the impossibility of surpassing Michelangelo in this, Raphael (and Baccio and Titian) excelled in other subjects while creating an alternative style by imitating the best charac-teristics of many masters.[39] Like them, one might recall the example of Zeuxis, who made one beauty out of many – an exemplary accomplishment recorded by Pliny and cited by Raphael in his (ghosted) letter to Castiglione.

185 Baccio Bandinelli. *Colossus*. Stucco. Rome, Villa Madama.

Whoever selected Hercules as the theme of Baccio's stucco, the placement of the statue encouraged him to dream of obtaining the commission for *David*'s permanent companion, and the subject itself provided the occasion to confront Michelangelo's own *Hercules*, then still in Florence. The stucco *Hercules* was Baccio's gauntlet. Immune to contemporary criticism of his effort, his Medici patrons rewarded him with further employment in Florence, in Loreto, and at the papal court. For his part, Baccio now turned his attention to David, presenting Pope Leo with the model of the nude hero severing the head of Goliath. According to Vasari, Baccio proposed to execute the work in bronze or in

186 Baccio Bandinelli. *Orpheus and Cerberus.*
Marble. Florence, Medici Riccardi Palace.

marble as a replacement for Donatello's bronze *David* which had been removed from Palazzo Medici in 1494 and installed at the Palazzo della Signoria – where it had been supplanted by Michelangelo's *David* in 1504. Baccio's proposal suggests a doubled agon, with Donatello and with Michelangelo.[40] Admittedly, Vasari did not mention Michelangelo's *David* here, having just recounted Baccio's failure to surpass that work with the stucco *Hercules.* Yet Michelangelo's statue inevitably comes to mind: since the time of its unveiling, it had become difficult if not impossible to think of the Old Testament hero (in sculpture, at least) without thinking of the *David.*

Perhaps in part for this reason, Leo rejected Baccio's offer to create a new *David* for the Medici Palace. Instead, the pope's cousin, Cardinal Giulio (later Clement VII), awarded Baccio a different commission for the palace, representing *Orpheus and Cerberus* (Fig. 186), signed BACCHIVS BANDINELLVS FACIEB. (Was Baccio's abbreviation of the verb intended to invoke Michelangelo's truncated *facieba* on the Vatican *Pietà*?) The Medici viewed *Orpheus* as David's pagan counterpart: both are musicians and poets, both are heroes who establish peace by conquering monsters. Lest recalcitrant Florentines miss the point, the Medici made their message even more explicit by staging a comedy by Jacopo Nardi, *I due felici rivali*, at the conclusion of Carnival in February 1513 – the first Carnival after the restoration of Medici power. Performed in Palazzo Medici, the play ended with an appearance by Orpheus himself. Speaking on behalf of all the poets of the Elysian fields, Orpheus announces the renewal of the world and

urges Apollo's followers to glorify the descendants of the laurel – that is, the Medici.[41] (Some thirty years later, Cosimo de' Medici adopted Orphic imagery for himself, in Bronzino's portrait of *Cosimo I as Orpheus*.[42])

By winter 1520, having finished the *Orpheus*, Baccio was at work in the Cortile del Belvedere on a copy of another great classical monument, indeed, the most conspicuous antiquity from the sixteenth-century point of view because of its recent, dramatic recovery: *Laocoön* (Fig. 187). Michelangelo had been in Rome in 1506, when the great marble group was discovered on the Esquiline on 14 January, and had gone to see the statue even before it was completely excavated. Like other knowledgeable viewers, Michelangelo recognized the *Laocoön* from Pliny's description (*Natural History* XXXVI.iv.37) and endorsed the author's great esteem for the work – but not the claim that it was

187 Baccio Bandinelli. *Laocoön*. Marble. Florence, Galleria degli Uffizi.

carved *ex uno lapide*. In point of fact, *Laocoön* is made of five blocks, and Michelangelo was able to identify the four joints.[43] This was no mere technicality: to carve a large and complex work *ex uno lapide* was considered the greatest demonstration of a sculptor's skill, and Michelangelo himself had already displayed his own genius in precisely this way, first with the *Pietà* and then with the *David*. Although *Laocoön* could no longer be revered as a classical example of the "single stone" virtue, it was nonetheless venerated as "most excellent and deserving of every praise," in the words of Cesare Trivulzio, recording the opinion of the "first artists" of his day, citing Michelangelo among others; "Wrought by skill divine / (Even learned ancients saw no nobler work)," according to the poet Jacopo Sadoleto.[44]

Baccio's undertaking to produce a large-scale version of the *Laocoön* was newsworthy not only because of the extraordinary prestige of the original but because the copy was intended for François I. Michelangelo, in Florence, was promptly informed of the commission by his friend Leonardo Sellaio, writing on 29 January 1520: "You have got to know that they say the king of France wants a Laocoön in bronze; one does not know whether [...] Baccio di Michelangelo [Bandinelli] will make it. I shall inform you about what happens."[45] Meanwhile, the right arm of Laocoön himself was missing from the ancient group; at Giulio's behest, Baccio produced a wax replacement.[46]

Baccio's *Laocoön*, though the most conspicuous copy of that ancient monument, was not the first. At Bramante's request, Jacopo Sansovino had already produced a large wax model of the statue, meant to be used in making a bronze cast. Recounting the commission of the model, Vasari added that Bramante also solicited copies of the *Laocoön* from Domenico Aimo il Varignana, Zaccharia Zacchi, and Alfonso Berruguete. These multiple commissions can be dated between late 1507 and early 1508, the only time when all of the masters are known to have been in Rome. When their models were completed, Bramante asked Raphael to judge which of the copies was best. Sansovino won the competition – which seems to have been engineered by Bramante to advance that sculptor's career – and his wax figure was then cast in bronze for Cardinal Domenico Grimani.[47] Both the wax model and the bronze have been lost, but the Grimani inventory suggests that the bronze measured about 29 cm. high, the same size as a third *Laocoön* by Sansovino, listed in the 1553 inventory of the collection of Cosimo 1 and most likely to be identified with a figurine in the Bargello.[48] Indeed, Sansovino seems to have made a specialty of *Laocoön* copies: in 1525 Aretino requested a version in stucco, intended as a gift for Federico Gonzaga, Marchese of Mantua; and Vasari recorded yet another stucco in the collection of Jacopo's son, Francesco.[49]

Sansovino's bronzes and stuccoes were all small-scale works. Baccio's *Laocoön* is a lifesize marble (rather than bronze as first intended, according to Sellaio's letter). Baccio's sculpture represents a more direct agon with the ancient work precisely because the medium is the same and the measurements comparable. Today, copies of works, no matter how distinguished the original, are usually deprecated; often, the more highly regarded the original, the more despised the copy. Sixteenth-century viewers, contrariwise, could esteem a copy as much or more as its source precisely because they were accustomed to the concept of *imitatio* as a worthy creative endeavor. Imitating a great work, a master rivals it with the hope of equaling or excelling the model. Imitating on a monumental scale one of the greatest ancient works then known, and probably the most famous, Baccio was engaged in no mean mechanical task but a commission that would profoundly influence his standing with contemporaries. Vasari's account of the undertaking explicates its agonistic significance. When the French ambassadors praised the *Laocoön* as a work their monarch would be pleased to possess, Cardinal Giulio promised "either this one or one so like it that there shall be no difference." Sending for Baccio, Giulio asked "whether he had the spirit to make a Laocoön equal to the first. Baccio answered that not only would he make an equal but he had enough spirit to surpass the original in perfection."[50] Having made a wax model, Baccio began to carve the marble itself, setting to work in the courtyard of the Belvedere, where the original *Laocoön* was and is displayed. Writing to Michelangelo on 3 July 1520 about happenings at the papal court, Sebastiano included an update on Baccio's progress. This letter begins with the news that Raphael's *garzoni* have received the commission for the Sala di Costantino, that they had experimented with the use of oil on the wall, and that everyone was laughing about

Michelangelo's letter ostensibly endorsing Sebastiano's hope for that same com-
mission. Then he added, "I have learned from Bacino di Michelangelo that he
is making the *Laocoön*, that the cardinal has shown him your letter and has
shown it to the pope."[51] The diminutive, "Bacino," is sarcastic, not affec-
tionate: Sebastiano is calling the sculptor "Michelangelo's Little Smooch,"
referring to Baccio's father with a locution that invites confusion. In the context
of Sebastiano's lament about the humiliation Michelangelo's letter was causing
him, the reference to the *Laocoön* seems to be a dig at both sculptors: at Baccio,
for his hubris in attempting to remake the ancient group, and at Michelangelo,
who resented the younger sculptor's cordial relationship with their Medici
patrons. Baccio had left Rome for Florence after Leo's death in 1522 but
returned to the city after the year-long papacy of Hadrian VI. Just as he had
been a conspicuous contributor to the decorations for Leo's Florentine *Entrata*
in 1515, now Baccio played a major role in decorating Rome for Giulio's coro-
nation as Clement VII on 19 November 1523.

Baccio had abandoned his *Laocoön* during Hadrian's papacy (the Dutchman
was uninterested, if not hostile, toward the arts), but now returned to work,
completing the statue in 1525, signing it after 1530 with his name and newly
acquired imperial title, SANTI IACOBI EQVES, Knight of Saint James. Baccio's
Laocoön was never sent to François I as originally intended, however: admir-
ing the work, Pope Clement "changed his idea and resolved to send other
ancient statues to the king, and this one to Florence," installing it in the Medici
Palace.[52]

While still at work on the *Laocoön*, Baccio had undertaken another great
project, a funerary monument for Henry VIII of England, as Sellaio reported
to Michelangelo, writing from Rome on 14 December 1521: "Giovanni
Cavalcanti has had Baccio di Michelangelo make a model [*modello*], a large
thing, in the manner of the arch that is at the base of the Campidoglio, with
an enclosure [*recinto*] of stairs, and above in the manner of a funeral canopy.
Where there are to go [. . .] 142 lifesize figures in bronze, and above the king
on horseback, and panels in bas-relief, likewise of bronze. [. . .] They'll never
do it."[53] Sellaio's prediction proved correct, but meanwhile the commission
itself was enviable (it would have surpassed by far even Michelangelo's most
ambitious plans for Julius II's monument). At the same time, Baccio received
another papal commission that put him directly in Michelangelo's path: the
fresco decoration of the choir of San Lorenzo, the Medici family church in
Florence, where Baccio was to represent the martyrdom of Saints Cosmas and
Damian on one wall, the martyrdom of Saint Lawrence on the other. Like the
project for Cavalcanti, this too was eventually abandoned, though not before
Baccio had produced a preparatory design for the *Saint Lawrence*, a composi-
tion much indebted both to Michelangelo's *Cascina* and to Raphael's Stanze.
Engraved by Marcantonio Raimondi at Clement's behest, Baccio's *Martyrdom
of Saint Lawrence* became one of his most renowned works – despite the mis-
spelling of the artist's name in the first printing. The pope rewarded Baccio for
his invention with the knighthood of Saint Peter.[54]

Clement himself owned another painting by Baccio, now lost, *Saint John the Baptist in the Wilderness*, a gift from the artist. If Baccio's primary ambition, and perhaps the pope's ambition for him, was to confront Michelangelo in both painting and sculpture, the *Saint John* also entailed Baccio's rivalry with his former master, Rustici. Returning to Florence and finding Rustici at work on a painting of the *Conversion of Saint Paul*, as Vasari explained, Baccio "decided to make in rivalry [*concorrenza*] with his master in a cartoon a nude figure of the young St. John in the Wilderness, holding a lamb in his left arm and the right raised to heaven."[55] Baccio produced a panel painting of his cartoon, which he displayed in his father's shop and then presented to Clement. His fellow artists praised Baccio's *disegno*, Vasari reported, but not his *colorito*, considered "raw" (*crudo*), and not painted with *bella maniera*. The pope was evidently pleased with this work, displaying it in his *guardaroba*.[56]

Meanwhile, Michelangelo was also employed at San Lorenzo. The coveted commission for the church façade had been taken from him in March 1520, and he was to concentrate instead on plans for the New Sacristy of San Lorenzo, intended to function as the Medici family funerary chapel. Michelangelo was at work on designs for the chapel in November 1520 and at work on the chapel itself by 1522. The tombs of Giuliano and Lorenzo are the culmination of his earlier projects for Julius and for the church façade, albeit in reduced scale.

Baccio returned to Rome in 1523 to contribute to the ceremonial decoration of the city for Giulio's coronation. Less eager, Michelangelo did not arrive to pay his respects to the pontiff until a month later, in December, and his attentions were rewarded in January, when Clement granted him a monthly stipend of 50 ducats. Now, in addition to the Medici Chapel, Michelangelo was also to design the Laurentian Library at San Lorenzo. As a result, Michelangelo was "otherwise engaged" at the Medici family church when the great block of marble intended to become *David*'s pendant finally arrived in Florence from Carrara on 20 July 1525 – though he still very much wanted to do the new Giant.[57] Baccio Bandinelli, likewise keenly interested, had just completed his *Laocoön* which had so pleased Clement. From the patron's point of view, Baccio offered certain practical and psychological advantages over Michelangelo. More deferential to his clients than Michelangelo, Baccio was also more adept at delegating responsibility to a cadre of studio assistants. Whereas Michelangelo boasted of never having run a shop, Baccio prided himself on being the master of a large studio, vaunting his pedagogy (and his social status) in a widely circulated engraving by Enea Vico, the *Academy of Baccio Bandinelli* (Fig. 188). As Baccio explained in his *Memoriale*, this was "a print designed by me and caused to be printed in Rome with the words: 'Academia Bacci ex Senariis comitibus Bandinellis.'"[58] His pupils draw not from life but from death and from art, that is, from skeletons, from casts of antiquities, and from works by the master himself. The shop is made to resemble a university lecture hall, with Baccio seated like a professor delivering a lecture to his class. Unlike garden-variety academics, however, he announces his nobility by the display of the Bandinelli arms over the fireplace and in the inscription adver-

188 Enea Vico. *Academy of Baccio Bandinelli*. Engraving. New York, The Metro-
politan Museum of Art, Purchase, Joseph Pulitzer Bequest, 1917. [17.50.16(135)].

tising his knightly rank. In reality, Baccio's studio might not have been at all
like this neatly ordered chamber; but whatever the engraving's accuracy, it pub-
lishes the view of his shop and of his role that he wished to commemorate.

Raphael, and before him, Leonardo, seem to have been the *exempla virtutis*
for Baccio's large studio and his gentlemanly disengagement from the dust and
sweat of execution – in stark contrast with Michelangelo's professional isola-
tionism and notorious hygiene, a concomitant of his dedication to the actual
process of sculpting. Again, unlike Michelangelo, Raphael prefigured Baccio's
pattern of dealing with growing commitments by increasingly delegating proj-
ects to assistants. Such delegation is predicated on the cooperation or at least
tacit approval of the patron, and both Raphael and Baccio found such agree-
able patronage in the two Medici popes. As Leo x had accepted Raphael's del-
egation of much of the Stanza dell'Incendio to his *garzoni*, Clement vii accepted
works designed by Baccio but executed by assistants.[59]

Emulation of Raphael did not preclude Baccio's imitation of Michelangelo –
not Michelangelo's unsavory personal habits, but his art.[60] Baccio's ready
combination of elements taken from Raphael, Michelangelo, and other
sixteenth-century masters was a procedure typical of Renaissance eclecticism.
But atypically and contrariwise, when he quoted from the ancients, he imitated
"individual works [. . .] rather than combining various antique sources into a

new image,"[61] an approach that may parallel contemporary arguments about antique imitation in language.

Unlike Raphael and Baccio – and indeed, unlike Bellini, Leonardo, and Titian – Michelangelo refused to take on pupils and had indeed been chastened for this dereliction of professional duty. To make matters worse, Michelangelo exaggerated his professional solitude by his insistence on working in secrecy and (falsely) advertising through Condivi's biography that he worked alone. In reality, he had a number of associates at San Lorenzo, as the detective work of William E. Wallace has shown, and delegated parts of the Julius tomb and Medici Chapel and Library to others.[62] (With such projects it could not have been otherwise, and indeed he made no attempt to conceal the fact in these cases.) But from the beginning of his career, Michelangelo's repeatedly stated preference had been for isolation and independence: "it is necessary that who wishes to attend to studies of art flee company."[63] So in fall 1525, when the pendant for *David* was finally to be carved, Clement was effectively able to hoist Michelangelo on his own petard: he could not do, or have, it all. Such was the pope's ostensible reasoning when he insisted that Michelangelo concentrate his attentions on papal commissions.

At one point – presumably earlier in that year, when he still hoped that the pope would award him the commission and while Baccio was making models of *Hercules and Cacus* – Michelangelo tackled *Hercules and Antaeus*, the subject of several drawings and a wax model that he later gave to his friend Leone Leoni.[64] Preferring Antaeus to Cacus, Michelangelo revealed his competitive intentions: Cacus is beaten to the ground, but Antaeus must be lifted up from his mother Earth, source of his strength, if Hercules is to vanquish him – and if Michelangelo is to vanquish his rival.

Clement was unpersuaded. In the 1550 biography of Michelangelo and again in 1568, Vasari wrote that the pope was led to give the commission to Baccio because of the "competition and rivalry" between him and Michelangelo.[65] In his Life of Baccio (1568), Vasari explained Clement's decision. The pope was acting on the nefarious advice of Domenico Buoninsegni, "saying that His Holiness, by means of this competition [*concorrenza*] of two such great men, would be served better and with more diligence and promptness, stimulating emulation of the one and the other to his work."[66] So the block and the commission were given to Baccio precisely in order to exacerbate the rivalry between him and Michelangelo, for the benefit of their holy patron. As for the marble, according to a Florentine wag quoted by Vasari, "because it was deprived of the *virtù* of Michelangelo, knowing it was to be mangled by the hands of Baccio, desperate over such an evil fate, it threw itself into the river," that is, it tried to drown itself.[67] The block had indeed fallen into the Arno *en route* to Florence but never actually explained its reasons. According to Vasari, this report of the block's attempted suicide was only one of many Tuscan and Latin verses skewering Baccio for this commission.

Clement was indifferent to these criticisms. Moreover, whatever Buoninsegni might have said, he needed little if any encouragement to set Baccio and

Michelangelo against each other. As a cardinal in 1518, he had staged the even more direct confrontation between Raphael's *Transfiguration* and Sebastiano's *Resurrection of Lazarus* – designed, as the patron well knew, with Michelangelo's assistance. Now, as pope in 1525, Clement exploited the "rivalry and competition between" Michelangelo and Baccio; and Baccio, at least, rose to the bait, "boasting that he would surpass Michelangelo's *David*."[68] For his part, Michelangelo was anguished by the loss of the commission that he had, rightly, considered his own since the block had first been quarried. Michelangelo "felt the greatest displeasure" and argued that the block be given (back) to him, Vasari reported.[69] He was unable to change Clement's mind, however. Michelangelo's correspondence documents his unsuccessful efforts. Writing to his friend Giovan Francesco Fattucci in Rome in October 1525, he explained how several citizens had broached the subject of his doing the new Giant, and declared that he would be willing to do so even "as a gift, if the Pope were agreeable [. . .] since, being committed to him, I could not work on anything else without his permission."[70]

Clement rejected this offer, as Fattucci informed Michelangelo in a letter from Rome dated 14 October 1525. He had spoken with the pope, who read Michelangelo's letter and saw his *fantasia*, that is, his project for the new Giant, and announced that he had written to the cardinal that he have Baccio make models and then choose among those.[71] Then, Fattucci continued, the pope explained what he really had in mind for Michelangelo, perhaps hoping to distract him with other commissions, which would be explicitly Medicean and with no risk of reawakening Republican sentiments inherent in the *David* and therefore capable of tainting its pendant. "I would like him," Clement said of Michelangelo, "to think about my things, because I would like to make a tomb for Leo and one for myself, and erect a ciborium over the altar of San Lorenzo on four columns. And I want to put in [the ciborium] all our vases which belonged to the Magnificent Lorenzo the Elder, and I want to put many beautiful reliquaries in it."[72] Finally, the pope tempted Michelangelo with the possibility of a commission even larger than the new Giant: "he wants to have made a colossus as high as the blackbirds at his house [Palazzo Medici], that is, to put it on the corner facing Messer Luigi della Stufa and toward the barbershop; and in order that it be so large, he wants it to be made in pieces." Fattucci returned to the subject at the end of the letter, mentioning the proposed Medici giant in relation to the Giant commission that Michelangelo really wanted: "As for Baccio, for now he will do nothing but make models. [. . .] And you think of this [Medici] colossus, which according to the pope will be at least twenty-five *braccia*; however, he wants to make it in pieces" – not *ex uno lapide*. "And do not tell anyone."[73]

Michelangelo said nothing about these various possibilities in writing to Fattucci ten days later, 24 October, but seemed to refer obliquely to the pope's decision regarding the Giant. After reporting on delays in the Medici Chapel (the marbles had not been delivered to the site) and on his plans for completing the Julius tomb, Michelangelo reiterated his dedication to the pontiff: "I

shall never cease to work for Pope Clement with those powers that I have, which are few because I am old." He added, however, that he had been treated with some disrespect, and "they have not allowed me to do the thing that I wished for many months already: [. . .] one cannot work on one thing with the hands and another with the brain, and especially [not so] in marble. Here they say that these things are done to spur me on, and I tell you that they are evil spurs, those that make one turn backward."[74]

Michelangelo also complained about the Giant and about Baccio to his friend Jacopo Salviati in Rome, and his laments were answered by a reassuring letter dated 30 October 1525:

> It grieves me most greatly to have learned the fantasies that have been put into your head, and all the greater the displeasure as I know that they prevent you from working, which is nothing other than to make content those who wish you ill, to confirm what they have always preached against you and to go against the will of Our Lord, the pope. [. . .] all those things that they do are done to goad you [. . .] they are all whims and inventions found by those who wish you little good [. . . being] jealous of your glory, [. . . but] on no account can Baccio be put on the same level as you, or make the least *paragone* with your works, and I rather marvel that you wish to give this credit. [. . .] However, let them say what they want and attend to work, and relieve your mind of these vain fantasies.[75]

Such fantasies would be inappropriate for himself and for the pope, Michelangelo's loyal supporter who would never fail him.

The Giant was a lost cause for Michelangelo, however, and writing to him on the same day, 30 October, Fattucci tried again to distract him with the grandiose projects that Clement had in mind for San Lorenzo, proposals detailed in his letter of 14 October. Now Fattucci chastened Michelangelo for being unresponsive: "Know that Our Lord is amazed that you have not given any answer at all to the colossus or about the tombs or about the ciborium above the altar of San Lorenzo." The colossus, as Fattucci had explained in the earlier letter, was to be "made in pieces." To Michelangelo, this technical instruction added insult to injury, and he rejected the proposition as a ludicrous fantasy. Finally replying to Fattucci (and to Clement) on 1 December 1525, he said that he had been thinking about the proposed colossus, sarcastically inflating the height that the pope had mentioned:

> As to the colossus of forty *braccia*, which you inform me is to go, or rather to be put at the corner of the loggia of the Medici garden, [. . .] I've considered it not a little in that position, as you instructed me. It seems to me that at the said corner it would not be well placed, because it would take up too much of the roadway; but at the other corner where the barbershop is, it would in my opinion look much better, because it has the piazza in front and would not be such a nuisance to the street. And since there might be some objections to doing away with the said shop, because of the income it pro-

vides, I thought that the said figure might be made to sit down and the said work to be hollow beneath [. . .] its seat could come at such a height that the barbershop could go underneath, and the rent would not be lost. And as at present the said shop has an outlet for the smoke, I thought of putting a cornucopia, which would be hollow inside, into the hand of the said statue to serve as a chimney. Then, as I would have the head of such a figure hollow like the other members, I believe it too could be put to some use, for there is a huckster here in the piazza, a great friend of mine, who suggested to me in confidence that a handsome dovecote could be made inside. Another idea also occurred to me [. . .] the figure would have to be considerably larger – which it could be, since a tower is made up of blocks – and that is that the head might serve as a much-needed campanile for San Lorenzo. And with the bells clanging inside and the sound issuing from the mouth, the said colossus would seem to be crying aloud for mercy, especially on feast days when there is more ringing and with larger bells.[76]

Whether Clement was serious about the colossus for San Lorenzo, he certainly admired the art of both Michelangelo and Baccio but in part for political reasons preferred Baccio for the new public monument and Michelangelo for the private commission of the Medici funerary chapel in the New Sacristy. Although Soderini had already referred to a Hercules as the subject for the second giant, Vasari attributed to Michelangelo the choice of *Hercules and Cacus*: "In this marble Michelangelo Buonarroti had had the idea to make a giant in the person of Hercules who kills Cacus to place in the piazza next to the *David* giant, already previously made by himself, to be, the one and the other, the insignia [*insegna*] of the palace; and he made several drawings and various models [*disegni e variati modelli*], seeking the favor of Pope Leo and of Cardinal Giulio de' Medici."[77] Whether any of these drawings and models survives is uncertain, and uncertain too whether *Hercules and Cacus* was ever Michelangelo's subject. Whatever subject he had in mind, the second Giant was a commission that Michelangelo no doubt pursued with Leo, as he is known to have done later when Cardinal Giulio became Pope Clement. Vasari's account appears in the Life of Bandinelli, not in Michelangelo's biography, and credits Michelangelo for determining the subject eventually executed by Baccio. Whoever chose the theme, and whenever it was chosen, it was certainly amenable to Baccio.[78] Hercules' defeat of the cattle thief was also a characteristically Florentine choice of subject, involving struggling male nudes. One recalls Pollaiuolo's *Battle of Ten Nude Men*, conceived not so much (or at all) as a narrative but as demonstration piece. Leonardo's *Battle of Anghiari* and Michelangelo's *Battle of Cascina* evoke the same tradition, and so too do other works by Baccio himself, including his model for *David and Goliath*, c. 1515, and his widely admired design for the *Massacre of the Innocents*, engraved in 1525 by Marco Dente and Agostino Veneziano.[79]

Baccio had already begun to prepare several models of *Hercules and Cacus* by fall 1525, as Fattucci had written to Michelangelo in the letter of 14 October

quoted above; one of these models has been convincingly identified with the
wax *Hercules and Cacus* (Berlin, Staatliche Museen).[80] The pope himself even-
tually selected which of them should be executed – a choice that Vasari depre-
cated. (One of the sculptor's models was displayed in Cosimo's Guardaroba in
1568.[81]) The agon with Michelangelo, already visualized in Baccio's early
Saint Peter, the stucco *Hercules*, and the *Colossi*, became recklessness in the
Hercules and Cacus, made to challenge *David* directly. In the opinion of its
first audience, Baccio's *Hercules* lost the contest resoundingly.

Hercules and Cacus were infrequently depicted in sculpture, though Baccio
had already represented them in an over-lifesize statue done at the beginning
of his career. Suiting his own proclivities and the Florentine taste for scenes of
combat, the Cacus story offered Baccio another advantage. Michelangelo had
carved a single figure; now Baccio would carve *two*, thereby demonstrating his
greater dramatic, compositional, and technical skill.[82] (Michelangelo also con-
templated a two-figure group.) But Michelangelo's *David* was *ex uno lapide*,
like the greatest works of the ancients, according to Pliny. Michelangelo thus
rivaled the literary tradition of antiquity, the *ideal* of the colossus carved from
a single block as described in the *Natural History*. Baccio, on the contrary,
achieved only the semblance of a monolith, combining twenty pieces of marble
to compensate for the physical limitations of the block.[83] Vasari pointedly crit-
icized Baccio for this practice of combining "small and large pieces of marble,"
though the author under-estimated the number of pieces in the *Hercules and
Cacus*. Baccio's "additive" process is opposed to Michelangelo's preference for
the single block, from which the figure is liberated by removal or subtraction
of the excess stone.[84] Baccio's practice freed him from the limitations of the
block but denied him the prestige traditionally associated with the statue carved
ex uno lapide.

In 1525, when Clement assigned the "Hercules" block to Baccio, the pope
had formed an alliance with François I, to be consecrated with bonds of mat-
rimony between the Medici and the French royal family. The horrible, unfore-
seen consequence of their treaty was the Sack of Rome by imperial forces on
6 May 1527. At first imprisoned in Castel Sant'Angelo, the pope managed to
escape to Orvieto on 9 December, where he lived in hiding from Charles v's
soldiers.[85] Meanwhile, the Medici had been expelled from Florence and a new
Republic proclaimed. Indelibly stained by his Medici associations and in fear
of his life, Baccio fled to Lucca. Michelangelo, contrariwise, took an active role
in the new regime, though he did not entirely abandon art for armaments.

The commission that most drew Michelangelo's attention was of course the
second colossus for the Piazza della Signoria. Baccio's preliminary cutting of
the stone may have constrained Michelangelo to abandon his earlier idea of
depicting Hercules and Antaeus. In any case, presumably because Baccio had
begun work on a Hercules for the Medici, Michelangelo and his Republican
patrons now apparently rejected that hero as the subject. The document of 22
August 1528, assigning the block and the commission to Michelangelo, speci-
fies that he "must carve and make within [it] one figure together or joined

with another, however it appears to and may please the said Michelangelo."[86] In other words, while everyone agreed that the new colossus would be a two-figure group, the identity of the actors was now to be determined by Michelangelo. According to Vasari, however, the subject was *Samson and Two Philistines* – that is, *three* figures, as if Michelangelo were rising to Baccio's bait. The agonistic intentions are clear: Michelangelo planned to outdo his rival by outnumbering him. Vasari reported that Michelangelo produced a model considered "marvelous and a most charming thing [*vaga*]", which seems an inappropriate phrase describing combatants.[87] In any case, Samson has already dispatched one Philistine, dead at his feet, while he grapples with the other. Some of Michelangelo's surviving sketches and a terracotta model show only two opponents, but whether they are Samson and a Philistine or Hercules and Cacus – and whether they were meant to fight in the piazza – remains uncertain (Fig. 189).[88] Nevertheless, the model surely reflects what Michelangelo would have done there, given the opportunity. The two combatants are interlocked in a spiral or *figura serpentinata* as the victor raises his right arm to strike the fatal blow. Whereas David anticipates

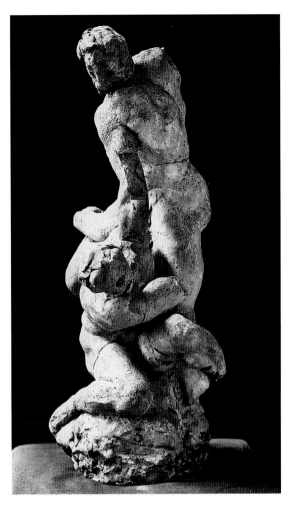

189 Michelangelo. *Two Combattants* (*Samson and a Philistine* or *Hercules and Cacus*?). Terracotta. Florence, Casa Buonarroti.

his battle and the death of his adversary, Samson (or Hercules) enacts the deadly culmination.

Little over a year after the block had been assigned to Michelangelo, the Republic was under siege. He fled to Venice on 21 September 1529 and was declared a rebel nine days later. Despite the obvious danger – he could have been put to death – Michelangelo returned to the city on 20 November and went into hiding. The city capitulated on 12 August 1530, and the Medici returned to power, with the pope's (?) illegitimate son Alessandro named ruler by imperial decree in October (he became duke by papal decree in May 1532).[89]

Baccio meanwhile had managed to ingratiate himself with Charles V, presenting him with several gifts: in 1527 a bronze relief of the *Crucifixion*; two

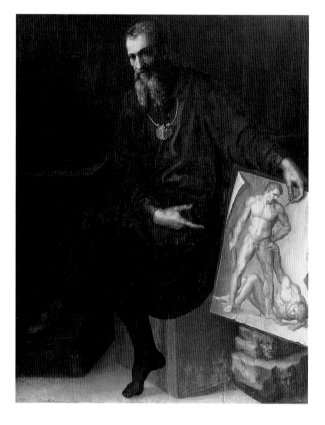

190 Baccio Bandinelli.
Self-Portrait. Canvas.
Boston, Isabella Stewart
Gardner Museum.

years later another relief representing the *Deposition*, a gift rewarded with the
knighthood of the Order of Saint James in October 1529; and finally, in Rome
in 1536, "a most beautiful *Venus* admired as the equal of that of Phidias," as
Baccio himself described it.[90] To be eligible for the knighthood, Baccio had
claimed descent from the noble Bandinelli family of Siena – a genealogy only
slightly more fanciful than Michelangelo's assertion of kinship with the counts
of Canossa but not tolerated by contemporaries scornful of Baccio's preten-
sions.[91] According to Cellini, for example, "His family was very undistinguished
and he was the son of a charcoal-burner. There is no blame attached to
Bandinello because of this, and after all he founded the fortunes of his family.
But it is a pity he did it so dishonourably."[92]

 Baccio's *Self-Portrait* in Boston (Fig. 190) – one of many, in various media –
shows him wearing the gold chain with the shell badge of Santiago and point-
ing to a sanguine drawing of *Hercules and Cacus* represented at a preliminary
stage of its conception, perhaps c. 1530: past honors and future glory are thus
commemorated.[93] It is significant, moreover, that Baccio presents a *drawing*.
The depiction of fictive drawings in painting was comparatively rare in the six-
teenth century, whereas the imitation of sculpture had long been common-
place.[94] In the case of Baccio's *Self-Portrait*, a model of his sculpture would

191 Baccio Bandinelli. *Hercules and Cacus*. Marble. Florence, Piazza della Signoria.

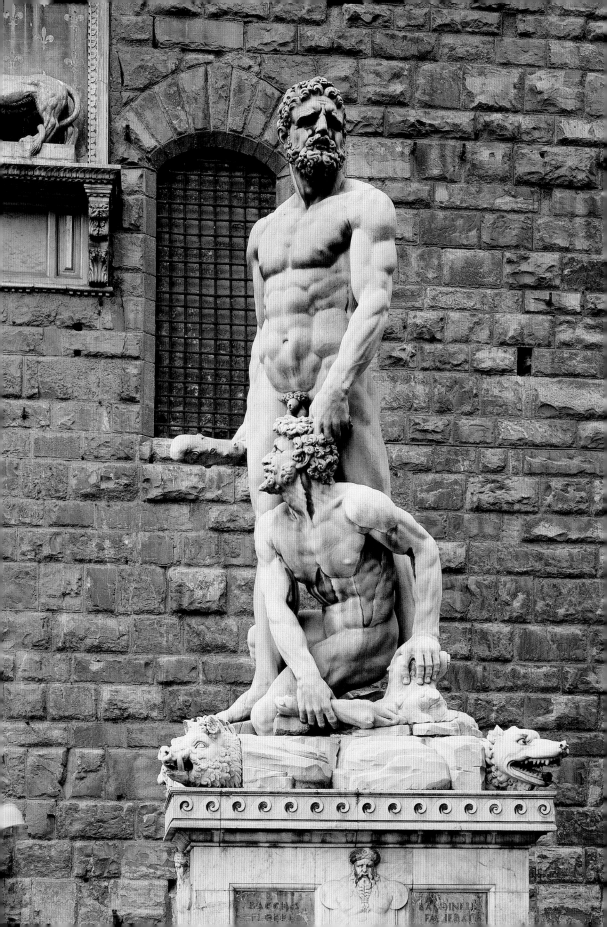

have been the more obvious attribute as well as the more familiar, but by representing a drawing the artist was vaunting his skill as a draftsman and his command of *disegno*, the fundamental principle of all the arts.[95]

While Baccio went to Bologna for Clement's coronation of Charles as Holy Roman Emperor in 1530, Michelangelo remained in hiding in Florence until pardoned by the pope.[96] Of course, there was no question of Michelangelo's continuing work on the second Giant (or Giants), and the pope awarded or rewarded to Baccio the commission that Michelangelo had expected and desired for a quarter of a century.

Many great works of art are difficult to see anew precisely because their success has predetermined one's vision, conditioned by their fame and by the lauds of generations of admirers. Completed in 1534, Baccio's *Hercules and Cacus* is difficult to see anew for the opposite reason, because it has always been excoriated (Fig. 191). From the moment of its unveiling – indeed, even before its completion – the statue aroused animosity from friends of Michelangelo and enemies of Baccio and of the Medici. A poem by Antonfrancesco Grazzini, il Lasca, "Against Baccio Bandinelli the Sculptor, for his statues made in the Choir of the cathedral of Florence" inspired, as it were, by another of Baccio's works reflects contemporary views of *Hercules* and its maker: "O ladro micidiale,/ch'ammazzi i marmi, e rubi altrui l'honore" (O homicidal thief,/who murders marbles and robs others of honor).[97]

Was aesthetic judgment colored by politics? Certainly Baccio's Medici patrons intended a political opposition, which may have engendered a stylistic one. Hercules' association with Florence was even more venerable than David's, but confronting the Old Testament warrior-king and defender of the Republic in the piazza, the pagan hero is (re)conceived as a Medici icon.

Duke Alessandro was not oblivious to popular resentment and delayed installation of Baccio's colossus, hoping for a more propitious moment, which never came: there could be no "good time" for this work, given the political situation. In the end, Clement himself intervened to see the project to completion, thereby revealing himself as the true patron of the *Hercules* and rewarding the sculptor with properties confiscated from a political enemy, a gift that exacerbated public disapproval of Baccio and his statue.[98] Thus Clement avenged Michelangelo's betrayal, though Michelangelo himself evidently blamed – or found it more politically expedient to blame – Alessandro for the loss of the commission. Carried to the piazza, the *Hercules* was stoned en route by anti-Medici protesters, recalling or reversing the pro-Medici stoning of the *David* thirty years earlier. After the *Hercules* had been installed on 1 May 1534 (by Baccio d'Agnolo and Antonio da Sangallo il Vecchio), and Baccio was able to see his monument *in situ*, he found that the muscles seemed "too soft" (*troppo dolci*). Working behind screens (like Michelangelo?), he carved the musculature more deeply to accommodate effects of ambient lighting. Bandinelli put the finishing touches on his colossus – and in September Michelangelo left Florence for ever.

Intimately related by site, scale, and iconography, *David* and *Hercules* are antitheses. Baccio's colossus reiterates the implicit criticism of Michelangelo's

Giant as visualized in Leonardo's drawings: *David* is too slender, too static, and functions only from the frontal view. Perhaps Baccio knew these or similar studies by Leonardo; certainly he shared fundamental principles of Leonardo's vision for the second colossus.[99] Baccio's evocations of the older master are a declaration of professional fealty; having apprenticed with Leonardo's friend and colleague, Rustici, he could see himself as Leonardo's heir and now the vindicator of his vision.

David stands in classical *contrapposto*; *Hercules* repeats the pose of Donatello's *Saint George*, legs apart and weight evenly distributed. Like all of Michelangelo's figures, *David* honors the block from which he was released, recalling the rectangle. The *Hercules* spirals, his turning motion reiterated by Cacus crouching between his legs, and punctuated by the grotesque animal heads emerging from the corners of the base, carved, like *David*'s, to imitate rough-hewn rock. Both victors turn their heads, staring so intensely that their brows are deeply furrowed, especially those of Hercules, distorted in keeping with physiognomic theories of the leonine features considered appropriate for the heroic man of arms.[100] Whereas David seems to focus on his future battle, however, Hercules is apparently unseeing. His forceful gaze does not refer to what Hercules sees or does not see but rather visualizes his contemplation and even distress regarding the terrible denouement of his defeat of Cacus. Both heroes will certainly kill their vanquished foes. David's slaying of Goliath is in the future, however, while Hercules' slaying of Cacus is *imminent*. Holding the thief by the hair with his left hand, he has his club in the right, ready to strike the fatal blow; and with a horrified, all-too-focused gaze, Cacus sees that weapon, indeed, almost sees it strike his own head. The expressions of their mouths are also differentiated: each man has parted lips, those of Hercules to suggest distress, those of Cacus, his fear. (The juxtaposition of Cacus' face and Hercules' genitals was possibly intended to increase the thief's degradation.) Whereas Michelangelo's *David* is supremely self-confident, then, Baccio's *Hercules* is tormented by doubt, reluctant to kill even though, according to the story, his victim deserves to die.

Of course, *David* and *Hercules* were not alone in the piazza; Donatello's *Judith* was and is also there. Each statue represents a different narrative moment in the story of a victory: David foresees his battle; Judith has already struck her fatal blow though Holofernes' head is not yet severed from his body; and Hercules, his battle concluded, anticipates the death of Cacus. Thus Baccio chose a liminal moment, unlike the other two tyrannicides, and also in effect the transitional moment between them. In Baccio's interpretation of the myth, the hero traditionally associated with Florence figures Clement's reluctance to exact vengeance on his vanquished Republican foes – and the certainty that, however unwillingly, he will do so as surely as Hercules slew Cacus.[101]

The confrontation between *David* and *Hercules* comprehends also their bases and pedestals. *David* stands on a base carved to simulate rocky ground, and this rests in turn on the pedestal designed by Antonio da Sangallo and Cronaca, a simple block or socle with a cornice and moldings.[102] *Hercules and Cacus*

stands on a base also simulating the ground but now embellished at the four corners with the projecting heads of animals. Baccio himself conceived the pedestal for his group, far more elaborate than *David*'s and decorated on its four faces with reliefs of Atlantes.[103] Moreover, unlike Michelangelo's *Giant*, Baccio's colossus is signed:

> BACCIVS BANDINELL.
> FLOR. FACIEBAT.
> MD XXXIIII.

The imperfect tense of the verb alludes of course to Pliny's anecdote about the signatures of great masters of antiquity – but in this context inevitably alludes also to Michelangelo's only signature. By 1534 the use of *faciebat* was no longer unusual – Baccio himself used it elsewhere, including the *Laocoön* signature – but the juxtaposition of his *Hercules* with Michelangelo's *David* suggests that the reference to his rival was intended. (One of Baccio's versifying critics mocked the signature's pretensions in a poem beginning "O Baccius faciebat Bandinello."[104]) The conspicuous placement of Baccio's signature is also reminiscent of Michelangelo's inscription – though conspicuous in a different way. Michelangelo signed the *Pietà* on a band across Mary's breast. Hercules, nude, provides no comparable convenient surface. Instead of signing the figure, Baccio signed the red slate inserts of the front of the pedestal, inserts that he himself designed. Renaissance inscriptions were customarily written in the "material of the statue itself," as Kathleen Weil-Garris Brandt has explained. Baccio's using the red stone for this purpose is in itself remarkable, but more remarkable still, from a sixteenth-century point of view, is the fact that inscriptions on pedestals were traditionally devoted to the donor or the dedication of the monument. Signing in this way and in this place, Baccio purposefully identified himself both with Hercules, the subject of his colossus, and with its Medici patrons – thus obliterating any distinction between maker and subject, the monument and the politics of its sponsors.[105]

The firestorm of criticism that greeted the *Hercules and Cacus* and Baccio himself was naturally exacerbated by Republican sentiment and, bound with this, the resentment of Michelangelo's supporters that he had been deprived of the commission. Disapproval of the new colossus was vociferous and nearly universal. The Medici themselves, however, were pleased. Duke Alessandro "was compelled" to imprison some of the more vocal critics, motivated less by their perceived aesthetic misjudgment than by the suspicion of anti-Medici sentiment.[106] And the duke rewarded Baccio with the commissions for funerary monuments for the Medici popes Leo and Clement in Santa Maria sopra Minerva in Rome – where Michelangelo's *Risen Christ* had been installed in 1521.[107] Baccio left completion of the tombs to his assistants, returning to Florence in 1541 to enter Duke Cosimo I's service (Cosimo having succeeded Alessandro in 1537).

Cosimo's first Florentine commission to Baccio was for the tomb of the duke's father, Giovanni delle Bande Nere, intended for a side chapel in San Lorenzo.[108]

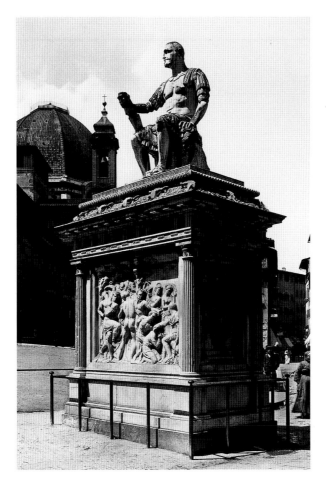

192 Baccio Bandinelli. *Giovanni delle Bande Nere Seated*. Marble. Florence, Piazza di San Lorenzo.

The monument was never completed, however, and eventually the statue of *Giovanni delle Bande Nere Seated* was installed in Piazza di San Lorenzo, set on a pedestal with Baccio's relief of *Giovanni delle Bande Nere Receiving Tribute* (Fig. 192). Whereas *Hercules and Cacus* represented an alternative to Michelangelo's art, the statue of *Giovanni delle Bande Nere* is clearly derived from Michelangelo's Medici Chapel effigies (Fig. 171). Rivalry with Michelangelo continued to the end of Baccio's life, but meanwhile he was compelled to confront another competitor.

Although Benvenuto Cellini was apprenticed to Baccio's father after Baccio himself had left the shop, the fact that both of them had trained with Michelangelo di Viviano set the stage for their later rivalry, in Vasari's words, their "competition or rather enmity."[109] Their patron Cosimo exploited this agon, deflecting their hostility into constructive action. According to Vasari, the duke had been amused by their mutual dislike until, in his presence, Cellini threatened Bandinelli's life. Cosimo silenced them, fearing that things would

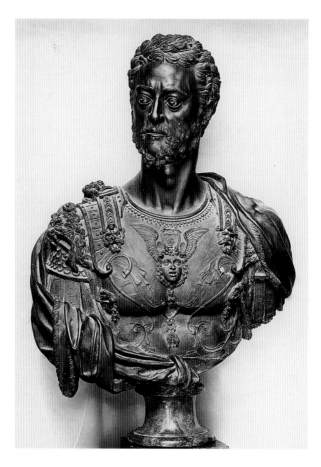

193 Benvenuto
Cellini. *Cosimo de'
Medici*. Bronze.
Florence, Museo
Nazionale del Bargello.

end badly, "and he had each of them make a large bust portrait of himself from
his head to the waist, which each of them was to cast in bronze, so that whoever
did it better would have the honor," that is, would win the contest (Figs. 193,
194).[110] Vasari's account is confirmed by the existence of the portraits by the
two enemies, but they themselves wrote nothing about the contest. Cellini
recorded only the existence of *his* bronze bust, reminding Cosimo of its quality:
"that fine bronze bust I made of you [. . .] that has been sent to Elba."[111] The
duke kept Baccio's bust while exiling Cellini's.

 The duke's choice of medium may suggest that he meant to give Cellini a
challenger's advantage – Cellini was far more experienced in bronze than
Baccio, whose predilection was marble carving. But the sculptors followed their
bronzes with nearly identical portrait busts in marble.[112] The implication of
these quasi-replicas is that Cosimo or the artists themselves wished to expand
the arena of their competition to include both media. Cellini finished gilding
his bronze in February 1548 and began the marble version shortly thereafter,
completing it by 1554. The two are nearly identical.[113] Like Cellini's contem-

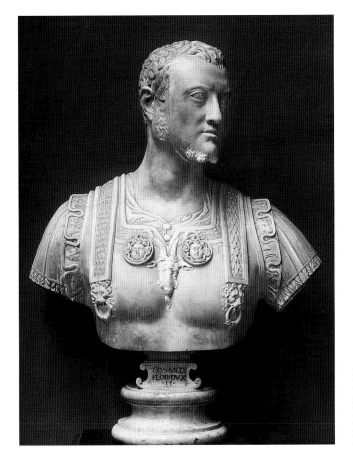

194 Baccio Bandinelli. *Cosimo de' Medici*. Marble. Florence, Museo Nazionale del Bargello.

poraneous bronze bust of *Bindo Altoviti* (who had been portrayed in his youth by Raphael), the portraits of Cosimo capture a transient moment and mood, expressed both in the face and the posture of the body.[114] It was precisely this expressiveness that did *not* appeal to Cosimo, who preferred the physical and emotional stasis of state portraiture. Although the duke dispatched Cellini's bronze bust to Elba – the marble was still in the artist's studio at his death – Cosimo kept Bandinelli's bronze, listed in the "camera di Penelope" in the Medici inventory of 1553.[115]

The duke's portrait busts are contemporary with another commission from Cosimo, Cellini's masterpiece, the *Perseus*. Contracted in August 1545, cast in June 1548 (*Medusa*) and December 1549 (*Perseus*), transported to the Loggia dei Lanzi in summer 1553, completed *in situ*, the *Perseus and Medusa* was finally unveiled to great acclaim in April 1554 (Fig. 195).[116] Presenting his petrifying attribute to the beholder, Perseus displays it also to *David* and *Hercules*: it is as if these two marble giants have been turned to "stone without blood" by the power of Cellini's bronze hero. Jonathan Cole explains: "Cellini's group

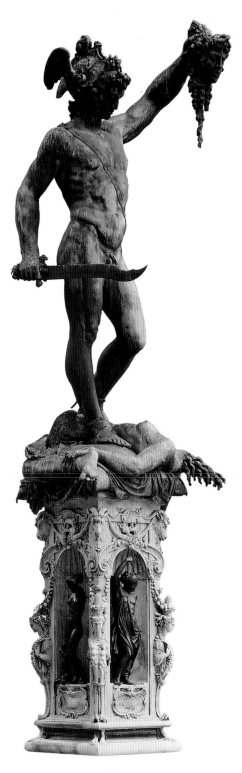

195 Benvenuto Cellini. *Perseus and Med-usa*. Bronze. Florence, Loggia dei Lanzi.

realized a subject that thematized the petrifaction of the beholder in a material that was perspicuously *not* stone, and it occupied an architectural plot on which two gigantic marble works seemed to gaze. [. . .] Perseus could seem to transform his two stone predecessors into the first and lasting evidence of his own petrifying weapon."[117]

If Cellini meant to rival his hero Michelangelo (while trouncing his enemy, Bandinelli), he also meant to honor him. Recalling the placement and wording of Michelangelo's signature on the Vatican *Pietà*, Cellini signed his *Perseus* on the band across the hero's chest: *benvenvtvs cellinvs civis fiorent. faciebat mdliii.* Thus Cellini reminds us that not all Renaissance rivalries entail hostility. On the contrary, one's greatest rival may be one's god, as Cellini himself explained to Eleonora of Toledo. He is supremely confident of his studies for the Neptune fountain competition: "I rely on winning the contest, even were it against that great Michelangelo Buonarroti, from whom alone and from no one else I have learnt all I know. And I'd be far more pleased if he who knows so much should make a model [for the competition], rather than those who know so little. For by competing with this great master of mine I'd gain a great deal of honour, where as with these others I cannot gain a thing."[118]

Michelangelo did not submit a model for the fountain competition, though the commission was eventually awarded to his protégé, Bartolomeo Ammannati. In addition to Ammannati, who arrived in Florence in 1555, Cellini was also compelled to deal with other new rivals, notably "little Giorgio Vasari" in 1553, followed by Giambologna in 1556 and

Vincenzo Danti in 1557.[119] But the rivalry with Bandinelli remained Cellini's principal concern, judging from the *Autobiography*, and it culminated in the works that each master intended for his own tomb.

The competition between Benvenuto and Baccio was thus both public and private. In the private sphere, they competed in portraying their patron, Duke Cosimo, in both bronze and marble. Their principal public arena was of course the Piazza della Signoria, the first site of Baccio's rivalry with Michelangelo, beginning with the stucco *Hercules* for Leo's *Entrata* and culminating with the marble *Hercules and Cacus*. Cellini's *Perseus* joined the *David* and *Hercules and Cacus* there in 1554, thus making the dissonant duet a trio. Cellini and Bandinelli extended their agon to their graves, each planning to decorate his tomb with a monument of his own making. Doing so, they were emulating – and hence, once again, competing with – Michelangelo, who had begun the Florence *Pietà* for his funerary chapel (Fig. 196). Michelangelo himself was revisiting, and emending, the subject of his first public success in Rome, the Vatican *Pietà*, the earliest monumental interpretation of that theme in Italian sculpture, and made for a funerary chapel (Fig. 55). The first *Pietà* is signed; the second, inevitably recalling the subject of the first, does not declare Michelangelo's authorship with an inscription but with his self-portrait (Fig. 197). Such a work is inevitably autobiographical and inevitably suggests the dedication of the maker's life and work to *his* Maker.

Michelangelo abandoned his sculpture after having assaulted it with a hammer in a fit of rage. Before his assistant Antonio was able to stop him, Michelangelo had damaged Christ's arms, left hand and chest, Mary's fingers, and the Magdalene's right arm.[120] But the work had already been damaged, apparently because of flaws in the block; part of Mary's arm and Christ's left leg had been broken. That is to say, the most conspicuous damage to the statue seems to have been accidental and related to some defect in the stone – in itself, quite enough to enrage Michelangelo. (Years earlier, he had abandoned a first version of the *Risen Christ* for Santa Maria sopra Minerva when a disfiguring vein of black marble was discovered in the face.[121]) Whatever the cause of the first damage to the *Pietà*, the remedy would have required piecing: it would obviously be impossible to complete the statue *ex uno lapide*. That being the case, of course Michelangelo wanted to destroy his work. From the very beginning of his career, Michelangelo had insisted on achieving this ancient and Renaissance desideratum of sculpture. His devotion to the ideal was undiminished (or perhaps strengthened?) by the realization that *Laocoön* was *not* in fact "of one stone." But in 1546, forty years after the discovery of the *Laocoön*, another (so-called) monolithic group known from Pliny was unearthed at the Baths of Antoninus in Rome: the monument now known as the *Toro Farnese* (*Farnese Bull*), representing the punishment of Dirce. Vasari mistook the subject, but what mattered to him more than the identities of the actors was "to see such perfect figures in one solid block and without pieces." (He was mistaken in this too, but it is the thought that counts.) Michelangelo recommended that the group be used as a fountain, which was in fact its ancient

function, and thus restored it was installed in one of the Farnese palaces under his supervision.[122]

It was precisely the technical difficulty of carving in one block either a single colossal figure, such as *David*, or a group, such as the Vatican *Pietà*, that made the accomplishment sublime. When Vasari first saw the Florence *Pietà* as an unfinished work, he praised it for this reason in the 1550 edition of the *Lives*: "There is roughed out [*bozzato*] still in his house a group of four figures in one stone [*in un marmo*]. [. . .] if he gives it finished to the world, his every other work will be surpassed by this one for the difficulty of carving so many perfect things from that stone." Similarly, Condivi described the "group of four figures, over-lifesize. [. . .] it is a rare thing and one of the most difficult that he has made so far, especially because one sees all the figures separately, and the draperies of one do not become confused with the draperies of the others." And Vasari, in 1568, gave the *Pietà* the ultimate encomium, even while compelled to acknowledge that Michelangelo's triumph had been irrevocably negated by his own destructive act: "he put himself to work on a piece of marble to carve four figures in it, in the round and larger than lifesize. [. . .] A demanding work, rare in one stone and truly divine; and this [. . .] remained unfinished and suffered many disgraces."[123] The shattered *Pietà* was acquired by Francesco Bandini in 1561, three years before Michelangelo's death, and then restored at Bandini's behest by Tiberio Calcagni, who was responsible for the "finished" Magdalene.[124] Calcagni himself died in 1565, before he could perpetrate further restoration.

Michelangelo made the *Pietà* for himself, as both Condivi and Vasari reported, intending it for his tomb in the church of Santa Maria Maggiore in Rome. The depiction of a donor in his funerary monument was an old idea, of course; but when the donor is also the maker, his effigy becomes a self-portrait, a comparatively new idea when Michelangelo introduced it on a monumental scale in the *Pietà*. Earlier artists' tombs had typically included self-portraits in the form of bust-length reliefs, not as a full-length figure.[125] Unlike other donor portraits in funerary monuments, moreover, which represent their subjects as themselves, Michelangelo's self-portrait assumes the guise of Nicodemus, as Condivi explained. This "ruler of the Jews [who] came to see Jesus by night" (John 3:1–2) is mentioned only three times in the Bible, in three chapters of John, but the passages are of profound significance for a Christian contemplating his death. Spiritual rebirth is the subject of John 3: "How can a man be born when he is old?," Nicodemus asks; and Christ answers, "I say to you, unless one is born of water and the Spirit, he cannot enter the kingdom of God. [. . .] For God so loved the world that he gave his only Son, that whoever believes in him should not perish but have eternal life" (John 3:4–6, 16). Later, when the Pharisees complain that Christ has not been arrested after preaching in the Temple, Nicodemus defends him, saying "Does our law judge a man without first giving him a hearing and learning what he does?" (John 7:51). Finally, returning after the Crucifixion, Nicodemus helps Joseph of Arimathaea prepare Christ's body for entombment: "Nicodemus also, who had at first come

196 Michelangelo. *Pietà*. Marble. Florence, Museo dell'Opera del Duomo.

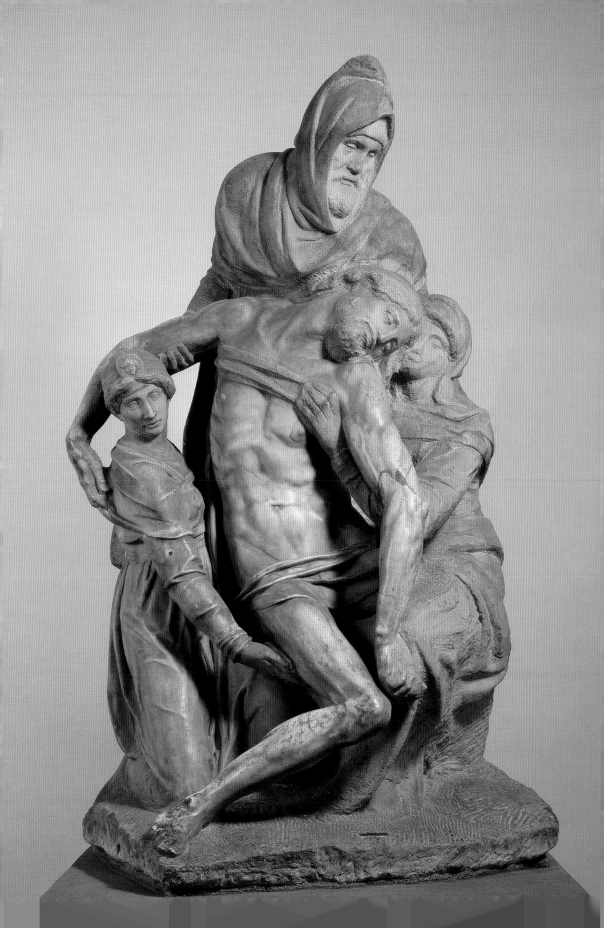

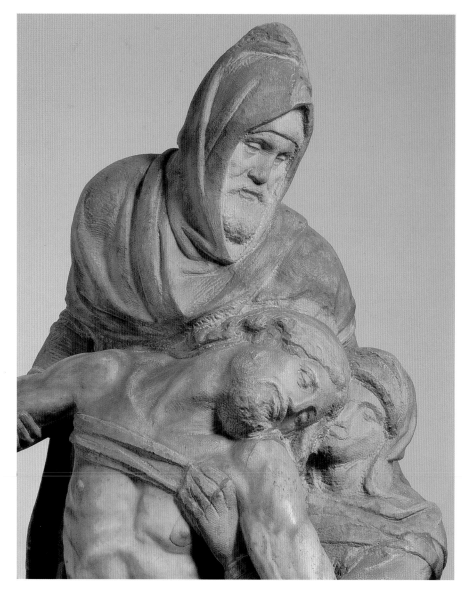

197 Michelangelo. Detail of Fig. 196. Self-Portrait.

to him by night, came bringing a mixture of myrrh and aloes. [. . .] They took
the body of Jesus and bound it in linen cloths with the spices" (John 19:39–40).
The appropriateness of Michelangelo's choice of Nicodemus's identity is
obvious: he evokes Christ's explanation and his promise of rebirth and eternal
life; he defended Christ against his accusers; and he was one of Christ's
mourners who helped prepare his body for burial.[126] Michelangelo's *Pietà* is

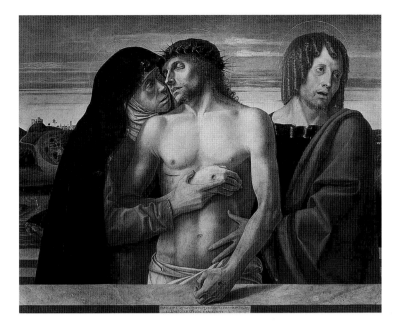

198 Giovanni Bellini. *Pietà*. Panel. Milan, Pinacoteca di Brera.

true to the spirit though not the letter of these texts, recalling but not representing precisely the actions described by John. But Nicodemus was appropriate for another reason as well: according to legend, he was a sculptor who portrayed Christ. In Michelangelo's *Pietà*, the maker contemplates his creation as Nicodemus contemplates his Savior.

In order to accommodate Nicodemus, that is, himself, Michelangelo invented a new theme, or rather a variation on the old theme of the Pietà as it had been known before his own transformative monument in Rome some fifty years earlier. The real points of reference for the iconography of this late, mangled work are not his own early masterpiece but Pietàs by Giovanni Bellini and other fifteenth-century masters, representing the Crucified Christ between mourners. In such compositions as Bellini's Brera *Pietà*, for example, one sees a similar relationship between Mary and her Son, their union expressed by the intimacy of their embrace with their heads pressed together (Fig. 198). A second mourner – John in the painting, the Magdalene in the sculpture – is seen to the other side but slightly separated from Christ thus to privilege Mary's greater grief and the greater intimacy of their bond. Apart from the obvious differences of medium and scale, half-length as opposed to full-length figures, the great difference between these images results from the inclusion of Nicodemus–Michelangelo. Nicodemus had appeared before in narratives of the Entombment, usually and appropriately paired with Joseph of Arimathaea, but never previously so privileged as here, where he is one of only three mourners. Looming over Christ and his Mother, Nicodemus seems almost a

pater familias, in this regard recalling Joseph in the Doni Tondo. Although Nicodemus holds Christ's right arm with his right hand, he does not support Christ's body: perhaps Michelangelo considered it presumptuous that he do so. That weight is born by the Magdalene and by the Virgin Mary. Nicodemus's support is not physical, then, but psychological, expressed by his shadowed gaze, the comforting gesture of his left hand on Mary's back, and his protective posture as he bends over Mother and Son as though to shelter them. In every detail of his person, Nicodemus expresses compassion and consolation. But the eloquence of the work is not limited only to posture and visage: it exists also and perhaps primarily in Michelangelo's late style of carving, in this regard comparable with the equally personal, inimitably expressive brushwork of Titian's late style.[127]

Nicodemus prepared Christ's body for burial, but Michelangelo represented an earlier moment after the Deposition, when Mary embraces her Son for the last time. She is seated on a block, Michelangelo's icon, here as in earlier works evoking the Stone of Unction. But Christ's remarkably complex pose obscures or confuses the narrative sequence. His zigzagging limbs recall depictions of the Deposition, and the bands of fabric around his chest and groin are the devices by which the corpse was taken from the Cross (they are seen, too, in the *Entombment*, Fig. 72). But his right foot is on the ground, the Magdalene seems to place that leg on Mary's lap, and the left leg, had it not been removed, would straddle the Virgin's lap.[128] Whether his body is being placed on her lap or is being removed to be placed in the tomb – that is, Michelangelo's own tomb, presumably in the pavement before the *Pietà* – remains purposefully unclear. And the uncertainty derives from the body of Christ himself.

Displaying an image of the dead Christ with mourners in a funerary context goes back to Bellini's day at least; his Rimini *Pietà*, for example, was used in this way, as were innumerable Northern European images. But Michelangelo's Vatican *Pietà* was the first Italian monumental sculpture to have been conceived as part of a funerary chapel, and his late *Pietà* recalls the early one in this regard. In every other respect, however, in iconography, emotion, and composition, the Florence *Pietà* is unlike its predecessor. And in all of these respects, Nicodemus' presence is critical, identifying the scene as one of mourning but also of promise, establishing the mood of sorrowful reverence, and transforming a block-like composition into an attenuated pyramid of interlocking figures. In this arrangement, Michelangelo did not evoke his own early triumph but rather two compositions by Leonardo, his first great rival: the *Madonna and Child and Saint Anne* and the *Leda*. Although less lyrical than Leonardo's compositions, Michelangelo's balletic scheme is clearly quoted from his works. In his funerary *Pietà*, Michelangelo meant to put his demons to rest, at last. Flaws in the stone, and perhaps other considerations, frustrated his efforts. But abandoning that *Pietà*, Michelangelo did not abandon the theme. Although partly disabled by an apparent stroke, he was at work within the last weeks of his life on the Rondanini *Pietà* (Fig. 199).[129] It is a prayer in stone that transcends agon.

Well aware of Michelangelo's Florence *Pietà* and its intended purpose, both Bandinelli and Cellini planned similar autobiographical memorializations for themselves: Bandinelli a *Pietà*, though differently conceived; and Cellini a Crucifix, thus representing an earlier moment of the Passion (Figs. 200, 201). It is not so much the subject matter that relates these works, however, but their self-commemorative function – and rivalry. Cognizant of this shared purpose, Vasari could recognize Bandinelli's rivalrous imitation of Michelangelo, whereas Cellini could claim that Bandinelli was in fact imitating *him*: "Bandinelli had heard about my making the Crucifix [. . .] , and he straight away set to work on a piece of marble and made the Pietà that can be seen in the church of the Annunziata," behind the altar in the first chapel right of the apse. Cellini had been negotiating with the Dominicans of Santa Maria Novella regarding the construction of his tomb at the foot of his Crucifix, with a tondo memorializing a vision he had had in prison, and, below this, his sarcophagus. The sarcophagus was particularly important to Cellini's plans precisely because, exceptionally for an artist's tomb and unlike those of Bandinelli and Michelangelo, his monument included no self-portrait.[130] The tomb site itself was of the greatest significance: Cellini's Crucifix would be installed on a pier in the transept, its position corresponding to that of Brunelleschi's wooden Crucifix in the opposite transept (Fig. 42). Lest anyone miss the rivalrous point, Cellini's Crucifix was to be the same size as Brunelleschi's.[131] The choice of subject, its site, dimensions, and medium – marble instead of wood – seem even

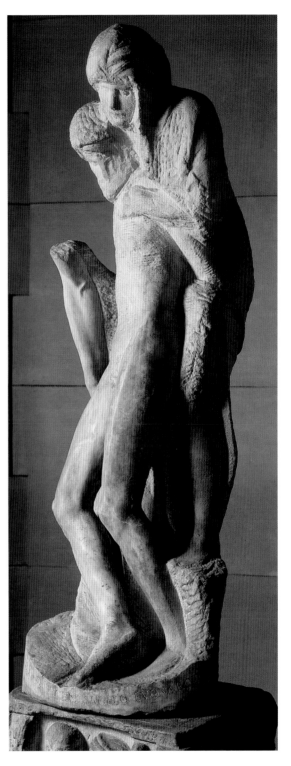

199 Michelangelo. Rondanini *Pietà*. Marble. Milan, Castello Sforzesco.

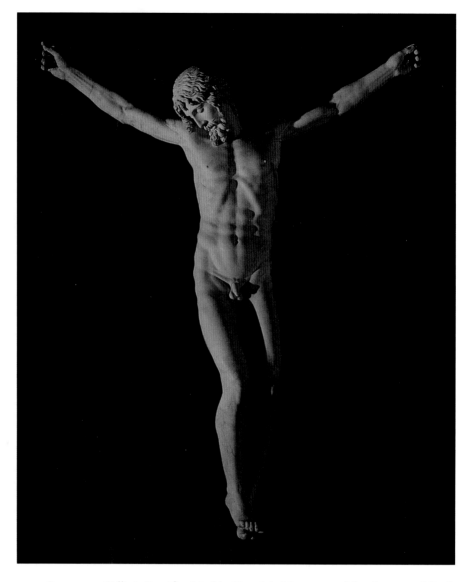

200 Benvenuto Cellini. Crucifix. Marble. Escorial, Monastery of San Lorenzo el Real.

more agonistic when one remembers, as Cellini surely did, Vasari's anecdote about the genesis of Brunelleschi's Crucifix: its having been made in rivalry with Donatello's in Santa Croce, and Donatello's acknowledgment of its superiority. Cellini meant to historicize his achievement, to contextualize his Crucifix in relation to those of his great fifteenth-century predecessors. At the same time, representing Christ naked on the Cross, he could evoke the naked Savior of Michelangelo's Santo Spirito Crucifix (Fig. 40). Michelangelo's Christ,

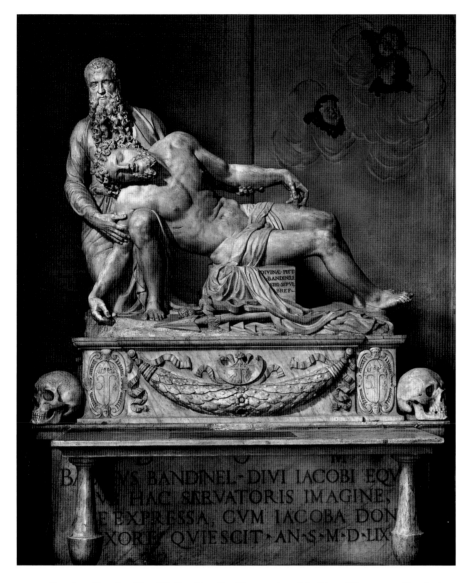

201 Baccio Bandinelli. *Pietà*. Bandinelli tomb. Marble. Florence, Santissima Annunziata.

like Brunelleschi's and Donatello's and indeed like that of most Crucifixes, was made of wood, so Cellini's marble entailed a *paragone* of medium, a self-imposed competition all the more audacious for the fact that bronze was more familiar to him, as marble was the favored medium of his predecessors.[132]

According to Cellini's *Autobiography*, when the Dominicans rejected his plan, he came to an agreement with the church of Santissima Annunziata.[133] But Cellini's narration tells only part of the story. By summer 1556, a year after

first mentioning plans for the Crucifix in his testament, the sculptor had promised it to Cosimo. Imprisoned for assault, Cellini petitioned for release so that
he might continue work on the Crucifix. The marble has already been "roughed
out," he explained, and had he not lost the previous seventy-six days in jail,
by now the Crucifix "would be at such a point of completion that Your Most
Illustrious Excellency would derive no small pleasure from it, *it being yours.*"
Jailed again in early March 1557, Cellini submitted another petition: if he were
granted house arrest, "I could finish the marble Christ, which is nearly done,
and which will be *your own glory.*"[134] Completing the Crucifix for the duke's
glory did not preclude its honoring its sculptor as well, however. That at least
was Cellini's hope when he addressed a letter to Cosimo on 26 December 1557
requesting that the Crucifix be installed in Florence: "should you desire to
locate this work of mine in a place in your city that seems fitting to you, then
I [. . .] will do whatever you order of me. But if, alternatively, you are content
that I place it in a church in your most glorious city, the price of my labour
[. . .] will be my satisfaction. [. . .] Otherwise, our agreements require that I
should be paid."[135] Clearly, for Cellini, whose *campanilismo* and pride in
Florentine art are reiterated throughout his *Autobiography*, what mattered
most was that his monument be seen in Florence and not exiled, as was his
bust of Cosimo, sent to Elba earlier in 1557. The duke replied that Cellini might
put the Crucifix where he liked. But Cellini's wish that it be displayed in
Florence was never fulfilled. Signed and dated in 1562, the Crucifix was in his
shop when, in 1565, Cellini abandoned negotiations with Ognissanti, with
whom he had been in discussion during a break in his dealings with Santissima
Annunziata. Now it was to be installed in the duke's private chapel in Palazzo
Pitti, but the work was still unpacked at the time of Cosimo's death in 1574.[136]
Two years later his successor, Grand Duke Francesco I, presented it to Philip
II of Spain. Cellini's Crucifix had been seen in Florence only while in the possession of its maker.

 More often than not, when an artist signed a work intended for display in
his native city, he would omit mention of his nationality. One's citizenship is
taken for granted except in those works made for foreign patrons, including
Michelangelo's *Pietà* for the French cardinal or Titian's *poesie* for the Duke of
Ferrara. But Ghiberti and Donatello, among others, had signed many if not all
of their public works in Florence as Florentines. Thus Cellini, whose desire that
he be remembered in his native Florence with a *marble* sculpture *ex uno lapide*,
combined piety and professional pride and spelled out his national identity in
signing the black marble Cross of his Crucifix:

<div align="center">

BENVEN

VTVS CEL. NT. FACIEB

LINVS. CIV AT. MDLXII

IS. FLORE

</div>

Whereas the wording and tense of Cellini's inscription allude to Michelangelo's
first *Pietà*, the self-commemorative function of the Crucifix recalls the later

Pietà that Michelangelo intended for his own monument. Baccio Bandinelli also remembered Michelangelo's example, though Cellini thought otherwise. Describing his Crucifix, Cellini accused Bandinelli of coopting *his* conceit while ignoring his own and Bandinelli's debt to Michelangelo. When Bandinelli learned of his plans for a monument in Santissima Annunziata, Cellini recounted, "he set to work very diligently in the attempt to finish his Pietà, and he asked the Duchess to obtain for him the Pazzi chapel" of Saint James in that same church.[137] More fortunate than Cellini, Bandinelli got his funerary chapel, now rededicated to the Pietà, with his own *Pietà* or *Dead Christ Supported by Nicodemus* installed "above the altar" (Fig. 201).[138]

Cellini's assertion of his influence on Bandinelli is wishful thinking or an attempt to rewrite history. In point of fact, Bandinelli had made his own testamentary provisions for his monument in the Annunziata some three months before him.[139] Even after Bandinelli's death and interment there in 1560, Cellini continued to negotiate with the church. Cellini's burial in the Annunziata is mentioned in his wills of 23 April 1567, 28 March 1569, and 18 December 1570 – that is, after he had delivered the Crucifix to Duke Cosimo (the sculptor considered making another one for his monument).[140] So Cellini was willing, not to say eager, to be buried in the same church as Bandinelli, thus to continue their rivalry even after death. Yet he unfairly accused Bandinelli of taking *his* idea for a monument and *his* choice of the Annunziata as a burial site, and further reproached him for having dared to ape Michelangelo in making a self-commemorative *Pietà* – while omitting mention of Michelangelo's determinative influence for his own sepulcher. Of course, Michelangelo's example was decisive for both Cellini and Bandinelli. Michelangelo was their critical point of reference, triangulating their rivalry even while remaining aloof from it. Cellini's account of his tomb project and Bandinelli's *Pietà* omits reference to Michelangelo as though unwilling to confront or emulate his hero directly. Indeed, Cellini's plans for his funerary monument were completely unlike Michelangelo's in appearance, though identical in the self-commemorative function.

Following Michelangelo's Florentine example more literally, Bandinelli represented a moment after the Crucifixion and included his self-portrait, representing himself in the guise of Nicodemus or Joseph of Arimathaea. The compositions are entirely different, however. Instead of Michelangelo's steep pyramid of mourners surrounding the dead Christ, in Bandinelli's monument the Crucified is mourned by an imperturbable Nicodemus, his upright torso a vertical counterpoint to the horizontal of Christ's body.[141] Although the composition is unlike Michelangelo's, Bandinelli sought to evoke him in another way, no less important for being difficult to discern: his *Pietà* is apparently carved *ex uno lapide*. The paradigm extolled as the exemplary achievement for any ancient or Renaissance sculptor was perhaps especially meaningful for Bandinelli because he had never before accomplished it. If Bandinelli's *Pietà* is in fact carved *ex uno lapide*, as seems to be the case, the achievement would be doubly resonant, evoking both Michelangelo's *Pietàs* and the examples

extolled by Pliny, the *Laocoön* most notable among them. Precisely because the *Laocoön* had been discovered to be *not* of a single stone and had been copied by Bandinelli himself – likewise in several pieces – its example was in his mind. Indeed, in his *Memoriale* he cited his *Laocoön* and the *Hercules* among primary examples of his work.[142] With his *Pietà*, Bandinelli could expiate his professional sins and redeem himself and his art.

Bandinelli had intended to accompany his two-figure *Pietà* with a free-standing statue of John the Baptist, which has been lost.[143] Not coincidentally, the Baptist is the patron saint of Florence: Bandinelli's conflation of personal and political piety in his funerary monument declares his fealty and reifies his identification with the state he served. In this regard, Bandinelli recalls Cellini's desire that his Crucifix be displayed in his native city so that his art might be remembered there. But unlike Cellini, Bandinelli included his self-portrait so that the maker himself would be remembered together with – and by means of – his creation. Doing so, Bandinelli had Michelangelo's example in mind, though their conceptions of their self-portraits (and of themselves) are profoundly different. By excluding the Virgin Mary and the Magdalene, whom Michelangelo had included in his "single stone," Bandinelli's *Pietà* exalts the artist as the sole mourner of the Crucified.[144] (Bandinelli's *Saint John* was conceived and carved separately, as a flanking figure, rather than being incorporated with the central two-figure group of Christ and his mourner.)

Bandinelli also reversed Michelangelo's conception of the self-portrait. Whereas Michelangelo represented himself completely absorbed in the Christ and oblivious to the beholder, Bandinelli addresses the worshiper directly as he displays the Crucified. Michelangelo had subsumed his identity (and idealized his physiognomy) in his act of devotion; Bandinelli subjugates the expression of personal mourning to a declaration of professional self-awareness. Supporting the body of Christ that he himself made, Bandinelli asserts his direct relationship with the Crucified and his role in mediating between worshiper and the object of devotion.[145] And yet his visual declaration of authorship is not entirely accurate. As Bandinelli himself described it, it was a collaborative work: "the *Pietà* for my sepulcher [was] made in great part with the help of Clemente, my son, the which Clemente, had he lived, I have no doubt would have achieved in sculpture the fame of the most famous Greeks, and the great [Michelangelo] Buonarroti, admiring him, said as much to me."[146] Recording Michelangelo's admiration for Clement in the context of acknowledging Clement's role in the *Pietà*, Bandinelli implied that Vasari's intuition (or accusation) was correct: Bandinelli's monument was made in imitation of Michelangelo's.

Unlike Michelangelo but like Cellini, Bandinelli signed his works. Expecting that he would die before signing his *Pietà*, he instructed his sons to sign it on his behalf, "with my arms and with that inscription that most pleases" them.[147] They saw fit to include not only his signature but several inscriptions. The dedication of the altar and Bandinelli's name as both donor and maker are inscribed on the block supporting the body of Christ: DIVINIAE PIET[ATI] B. BANDINELLI

H[OC] SIBI SEPUL[CHRUM] FABREF[ACIEBAT] (In dedication to the Pietà and in hope of divine mercy the donor wrought his tomb with skillful art)."[148] Another inscription is written on the plinth:

> D.O.M
> BACCIVS BANDINEL. DIVI IACOBI EQVES
> SVB HAC SAL[ER]VATORIS IMAGINE,
> A SE EXPRESSA, CVM IACOBA DONIA
> VXORE QVIESCIT. AN.S.M.D.LIX.

(Baccio Bandinelli, Knight of the Order of Saint James, rests with his wife Jacoba Doni beneath this image of the Saviour, which he made himself. 1559.)[149]

Bandinelli himself is represented again in a relief on the back of the monument, together with the portrait of his wife.

The form of the signature is noteworthy: elsewhere, Bandinelli had always used *faciebat*. The verb *fabrefaciebat* or *fabrefecit* may be intended to emphasize the maker's skill, whereas the assertion that he made the *Pietà* "himself" belies the fact that it had been begun by his natural son, Clement, legitimized in 1552.[150] But the *Pietà* was signed by Bandinelli's sons on his behalf after his death, a posthumous signature, and one conceived to ignore their bastard brother's participation while commemorating their father's achievement. If they wrote the text, however, the placement of the signature was probably determined by Baccio: inscribed on the block, Michelangelo's icon, and before him, Donatello's, it binds him both to his great predecessor and to his great contemporary.

The rivalrous Florentine sculptors Bandinelli and Cellini were not the only masters to imitate Michelangelo's *Pietà*: Titian did so as well. Indeed, the Venetian painter's *Pietà* more closely approximates the ideals and spirituality of Michelangelo's monument than do the marbles by Cellini and Bandinelli (Fig. 202). Evoking Michelangelo, Titian's *Pietà* is also a profoundly retrospective work, much more explicitly autobiographical than the sculpted monuments by Cellini, Bandinelli, or Michelangelo himself.[151] Remembering his artistic origins, Titian inevitably recalled his nearly life-long engagement with Michelangelo: the two allusions are woven together in the tapestry of his art. If only from Vasari and Condivi, though perhaps also from copies, Titian knew about Michelangelo's *Pietà* when he painted his own variation of the theme, likewise intended for his funerary monument, planned for the Venetian church of Santa Maria Gloriosa dei Frari, and also including his self-portrait as one of Christ's mourners. And from his sojourn in Rome in 1545–46, Titian knew Michelangelo's first *Pietà*, a work he now called to mind.

Titian's painting was already a work in progress when one of Philip II's agents described it in a letter dated 27 April 1575, and very nearly complete when the master died on 27 August the following year.[152] Although Titian was indeed buried in the Frari, the altarpiece was never permanently installed at his tomb site but came into the possession of Palma il Giovane. Putting a few finishing

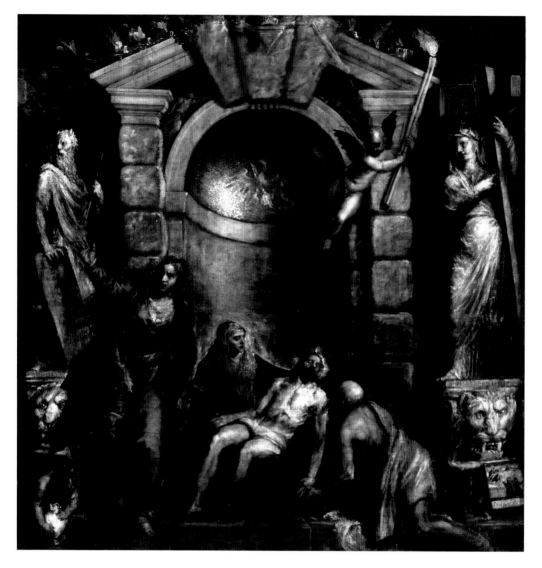

202 Titian. *Pietà*. Canvas. Venice, Gallerie dell'Accademia.

touches on the canvas, he then signed it with both their names in the inscrip-
tion on the stone platform where Mary sits with her dead Son:

> QVOD TITIANVS INCHOATVM RELIQVIT
> PALMA REVERENTER ABSOLVIT
> DEOQ. DICAVIT OPVS.

As Michelangelo's iconography and composition recall aspects of earlier art,
and in particular works by his first rival, Leonardo, Titian too was retro-

spective in his treatment of the theme, recalling his master and first great rival, Giovanni Bellini – and likewise his last great rival, Michelangelo himself. Bellini's frequent motif of the gold-ground mosaic is revived here, for example, a device seen in his Frari triptych of 1488, among other works, but never before used by Titian. Similarly, the emotionally restrained portrayal of Mary recalls Bellini's psychology, and also, not coincidentally, Michelangelo's (Bellini and Michelangelo shared this kind of subdued emotionalism). In Titian's *Pietà*, however, Mary's restraint is contrasted with the Magdalene's explosion. The Magdalene is an emended quotation of the hysterical Venus seen in Adonis sarcophagi, here encapsulating Titian's agon with antiquity.[153] Running from the sight of the Crucified, the saint nearly ruptures the balance of the composition: she both completes the figural group and disrupts it. Counterbalancing her frantically running figure is the kneeling figure of Titian himself, in the guise of Saint Jerome.[154] Whereas Michelangelo/Nicodemus crowns his *Pietà* and allows us to behold him directly, as he beholds the Mother and Christ, Titian/Jerome turns away, revealing only a profile and that partly concealed in shadow. While the fictive sculptures of Moses and the Hellespontine Sibyl and the massive architecture of the painting recall the *paragone* in general and competition with Michelangelo in particular, the self-portrait seems almost to correct him or reinterpret the conception of his effigy. But the greatest correction is expressed by the way in which Titian signed his work. The signature *per se*, the written declaration of dual authorship, was added posthumously by Palma il Giovane. Titian himself wrote several inscriptions on the painting: the names of Moses and the Hellespontica in Latin on the socles of their statues; an indecipherable Greek text above each one; and on the fictive panel painting, a phrase in dialect that has resisted translation.[155]

Whether Titian intended to sign his name on the stone that carries Palma's inscription is unknown. But in another sense, Titian had already included his signature: he signed his *Pietà* with a *picture* (Fig. 203). Resting against the base of the Sibyl's statue, thus partly concealing the artist's coat of arms, a fictive votive picture represents Titian and his surviving son, Orazio, in prayer before a heavenly image of the Pietà. The last word in Titian's agon is a painting.

203 Titian. Detail of Fig. 202. Votive picture.

Notes

Abbreviations

ASE Modena, Archivio di Stato, Archivio Segreto
 Estense
ASF Florence, Archivio di Stato
ASM Mantua, Archivio di Stato
ASV Venice, Archivio di Stato
Condivi Ascanio Condivi, *Vita di Michelagnolo
 Buonarroti* (Tabulae Artium 2), ed. Giovanni
 Nencioni (Florence, 1998).
Barocchi and Ristori, *Carteggio* Paola Barocchi
 and Renzo Ristori, eds., *Il carteggio di Michelan-
 gelo*, 5 vols. (Florence, 1965–83).
Vasari-Barocchi Giorgio Vasari, *Le vite de' più
 eccellenti pittori, scultori e architettori nelle
 redazioni del 1550 e 1568*, ed. Rosanna Bettarini
 and Paola Barocchi, 6 vols. (Florence, 1966–87).
Vasari-Milanesi Giorgio Vasari, *Le opere di
 Giorgio Vasari*, ed. Gaetano Milanesi, 9 vols.
 (Florence, 1906; rpt. 1973).

Author's Note

The Florentine measurement of the *braccio* is cal-
culated at approximately 58.36 cm. (22⅞ in.). The
Florentine calendar (*more fiorentino*), like the
Venetian (*more veneto*), began the new year on
25 March, the feast of the *Annunciation*. Thus 14
February 1502 *m.f.* or *m.v.*, for example, would be
1503 according to the modern calendar, introduced
by Pope Gregory XIII in 1582, beginning the year
on 1 January, the feast of the Circumcision.

Preface

1 Marsilio Ficino, letter to Giacomo Bracci-
 olini (*Marsilii Ficini Opera omnia*, Leiden,
 1676, vol. 1, p. 658), quoted and translated
 in Erwin Panofsky, "The History of Art
 as a Humanistic Discipline" [1940], in
 *Meaning in the Visual Arts: Papers in and
 on Art History* (Garden City, NY, 1955),
 p. 25.

1 Imitatio *and* Renovatio

1 Jean Paul Richter, *The Notebooks of
 Leonardo da Vinci*, 2 vols. [1883], (rpt.
 New York, 1970), vol. 1, p. 250, no. 498. As
 the words of the Gospel indicate, and as
 Fred Licht reminded me, competition is un-
 Christian. For this dispute in Luke, see Neal
 W. Gilbert, "Comment," *Journal of the
 History of Ideas* 48 (1987): 47, and p. 49
 regarding "the moral shortcoming of arro-
 gance" in relation to the *paragone* debate.
2 Thomas M. Greene, *The Light in Troy: Imi-
 tation and Discovery in Renaissance Poetry*
 (New Haven and London, 1982). In addition
 to sources cited below, see also Hermann
 Gmelin, "Das Prinzip der Imitatio in den
 romanischen Literaturen der Renaissance,"
 Römische Forschungen 46 (1932): 83–360,
 esp. pp. 98–228 on Petrarch and Bembo;
 and Rensselaer W. Lee, *Ut pictura poesis:
 The Humanistic Theory of Painting* (New
 York, 1967), first published in *Art Bulletin* in
 1940.
3 Vasari-Barocchi 6: 49. Vasari's injunction
 comes at the end of his description of the
 Sistine ceiling in both editions of the *Lives*,
 1550 and 1568.
4 Mark W. Roskill, *Dolce's "Aretino" and
 Venetian Art Theory of the Cinquecento*
 (New York, 1968). I have followed Dolce in
 taking the same masters as my Renaissance
 Rivals, though was reminded of my debt
 only when the book was nearly finished by
 a passing comment in Claire J. Farago,
 *Leonardo da Vinci's "Paragone": A Critical
 Interpretation with a New Edition of the
 Text in the Codex Urbinas* (Leiden, 1992),
 p. 21.
5 Erwin Panofsky, *Renaissance and
 Renascences in Western Art* (Stockholm,
 1960).
6 Wayne A. Rebhorn, "The Crisis of the
 Aristocracy in *Julius Caesar*," *Renaissance
 Quarterly* 43 (1990): 77. See also G.W.

Pigman, III, "Versions of Imitation in the Renaissance," *Renaissance Quarterly* 33 (1980): 1–32, esp. p. 4 for eristic imitation, pp. 16–22 on "good" and "bad" *eris*, and pp. 22–32 on distinctions between emulation and imitation (first differentiated by Erasmus). Titian's imitation of Michelangelo (and of antiquity) may be described as eristic.

7 The pulpit was completed in 1302. For a transcription and translations (which I have combined and slightly modified), see Michael Ayrton, *Giovanni Pisano Sculptor* (New York, 1969), p. 123, and John Pope-Hennessy, *Italian Gothic Sculpture*, Part 1 of An Introduction to Italian Sculpture (London and New York, 2nd ed. 1972), p. 177. Vasari quoted this part of the signature in his Life of Nicolà and Giovanni Pisano; Vasari-Barocchi 2: 68. The Pistoia inscription may be the earliest written assertion of the conception of artistic talent as God-given; see Antje Middeldorf Kosegarten, "The Origins of Artistic Competitions in Italy (Forms of Competition between Artists before the Contest for the Florentine Baptistry Doors Won by Ghiberti in 1401)," in *Lorenzo Ghiberti nel suo tempo: Atti del convegno internazionale di studi*, 2 vols. (Florence, 1980), vol. 1, pp. 173, 175. I am quoting here from Rona Goffen, "Signatures: Inscribing Identity in Italian Renaissance Art," *Viator* 32 (2001): 306–07.

8 For his assorted acts of murder and manslaughter, see Benvenuto Cellini, *The Autobiography of Benvenuto Cellini*, trans. George Bull (London, rev. ed. 1998), pp. 91, 128. Cellini apparently did not commit all the crimes enumerated in his *Autobiography*, however, while he kept silent about those documented in contemporary records; see Paolo L. Rossi, "The Writer and the Man: Real Crimes and Mitigating Circumstances: *Il caso Cellini*," in *Crime, Society and the Law in Renaissance Italy*, ed. Trevor Dean and K.J.P. Lowe (Cambridge and New York, 1994), pp. 157–83.

9 The Florentines had averted civil war in the 1390s and were able to exploit the continuing threat from Milan as "to arouse patriotic sentiment." See Gene Brucker, "Domestic Politics, 1382–1400," *The Civic World of Early Renaissance Florence* (Princeton, 1977), pp. 60–101, p. 101 for this quotation. For the Baptistery's prestige and the sequence of events leading to the contest, see Richard Krautheimer and Trude Krautheimer-Hess, *Lorenzo Ghiberti*, 2 vols. (Princeton, 1970), vol. 1, pp. 31–34. As they explain, p. 32, work on major public buildings in Florence was traditionally supervised by the seven Greater Guilds. Of these, the Calimala was the logical choice to administer decoration of the Baptistery, dedicated (like all baptisteries) to Saint John the Baptist, patron saint of the Merchants. For the contest, see the excellent essay by Kosegarten, "Origins of Artistic Competitions."

10 For the doors, see Anita Fiderer Moskowitz, *The Sculpture of Andrea and Nino Pisano* (Cambridge, 1986), pp. 7–30, 177–85. Installed facing the cathedral, Pisano's doors were removed in 1452, transferred to the south portal to be replaced by Ghiberti's Gates of Paradise.

11 Ibid., pp. 7–8, 182, 199 (doc. 13).

12 Ibid., p. 198 (doc. 2), 6 November 1329; my translation.

13 See Richard A. Goldthwaite, *The Building of Renaissance Florence: An Economic and Social History* (Baltimore and London, 1980), pp. 4–5.

14 Krautheimer and Krautheimer-Hess, *Ghiberti*, 1: 40. The Sienese contestants were Jacopo della Quercia and Francesco da Valdambrino. Sienese masters had been awarded important public commissions in the past, including Tino da Camaino, who had been engaged in decorating the Baptistery doors in 1322; Moskowitz, *Andrea and Nino Pisano*, p. 198 doc. 1. The cathedral Operai were similarly broad-minded in 1418, announcing an open competition for the cathedral cupola; see D.S. Chambers, *Patrons and Artists in the Italian Renaissance* (Columbia, SC, 1971), pp. 390–400, no. 20.

15 Lorenzo Ghiberti, *Lorenzo Ghibertis Denkwürdigkeiten (I Commentarii)*, ed. Julius von Schlosser, 2 vols. (Berlin, 1912), p. 46.

16 For the *Vita di Brunelleschi*, traditionally attributed to Antonio Manetti and written after 1471, see Krautheimer and Krautheimer-Hess, *Ghiberti*, 1: 35. Apart from a difference in tone – Ghiberti is a villain in the *Vita di Brunelleschi* – there is only one important disagreement concerning a matter of fact: according to the biography, the contest was a tie between Brunelleschi and Ghiberti. Ghiberti sought to deny this in the *Commentarii* (ed. Schlosser 1: 46), but the Krautheimers (1: 42–43) argue that it was likely the case. A tie would explain the preservation of the competition panels by Brunelleschi and Ghiberti, whereas the others were evidently melted down to recover the bronze. The competition for the dome of Florence cathedral, announced 19–20 August 1418, resulted in a quasi-tie: the

contract was awarded jointly to Brunelleschi and Ghiberti on 28 January 1426, but Brunelleschi was to receive a much higher stipend, 100 gold florins as opposed to 36 for Ghiberti. See Chambers, *Patrons and Artists*, pp. 39–41.

17 The other competitors were the two Sienese masters mentioned in n. 14 above, Quercia and Valdambrino; two Aretines, Niccolò Spinelli and Niccolò Lamberti – though Lamberti had moved from Arezzo to Florence; and Simone da Colle from the Florentine territory of Val d'Elsa; but not Donatello, as later asserted by Vasari in his Lives of Ghiberti and Brunelleschi (see Vasari-Milanesi 2: 223–27, 334–36; and Krautheimer and Krautheimer-Hess, *Ghiberti*, 1: 36). For Ghiberti's account, see Krautheimer and Krautheimer-Hess (1: 12–13) and Ghiberti, *Commentarii* (1: 45–46; the contest is a *combattimento* and the contestants *combattitori*, p. 46).

18 Ghiberti's competition panel, cast in one piece, weighs 18.5 kilos, as opposed to Brunelleschi's, weighing 25.5 kilos. See Giorgio Bonsanti, "Aperto per restauri," *Giornale dell'arte* 180 (September 1999): 73.

19 Krautheimer and Krautheimer-Hess, *Ghiberti*, 1: 36–37.

20 Vasari-Barocchi 3: 146–47 (Life of Brunelleschi). In *Het Schilder-boeck* (1604), Karel van Mander evoked Envy's "black wings" in describing rivalry among artists; see Beverly Louise Brown, "The Black Wings of Envy: Competition, Rivalry and Paragone," in *The Genius of Rome, 1592–1623*, exh. cat., London, Royal Academy of Arts (London, 2001), p. 250.

21 For the church and its guild statues, see Diane Finiello Zervas, *The Parte Guelfa, Brunelleschi and Donatello* (Locust Valley, 1987); and Diane Finiello Zervas, *Orsanmichele: Documents 1336–1452/Documenti 1336–1452* (Modena, 1996), pp. 19–20 (the document recording the commune's ordering construction of Orsanmichele, 25 September 1336), and *passim*. On the church, see also Patricia Lee Rubin, "Patrons and Projects," in Patricia Lee Rubin, Alison Wright, and Nicholas Penny, *Renaissance Florence: The Arts of the 1470s*, exh. cat., London, National Gallery (London, 1999), pp. 50–52, and pp. 53–55 on guild commissions for the cathedral and Baptistery.

22 For the document, see Zervas, *Parte Guelfa*, pp. 120–21. A few guilds had already fulfilled their obligations; see Krautheimer and Krautheimer-Hess, *Ghiberti*, 1: 71. As work progressed at Orsanmichele, the Arte della Lana came to feel that the niches of the Calimala and Cambio greatly exceeded their own, necessitating the construction of a new tabernacle and statue of Saint Stephen. For the resolution of 11 April 1427, see Krautheimer and Krautheimer-Hess, *Ghiberti*, 2: 385–86 (doc. 107). The result was Ghiberti's *Saint Stephen*; ibid., 1: 93–95: thus the Lana tried to outdo their rivals by hiring the same master to outdo himself.

23 For this joint attribution, see John Pope-Hennessy, *Donatello* (New York, 1993), pp. 30, 34, 322n3, and pp. 29–55 for a summary of the commissions. For Ghiberti's statues, Krautheimer and Krautheimer-Hess, *Ghiberti*, 1: 71–100; and for these and the others, also Joachim Poeschke, *Donatello and his World: Sculpture of the Italian Renaissance*, trans. Russell Stockman (New York, 1993), pp. 357–58, 360, 372–74, 377–81, 384–85. With the exception of Donatello's *Saint Louis*, now in the Santa Croce Museum, most of the original sculptures have been transferred to the Museo Nazionale del Bargello in Florence.

24 Chambers, *Patrons and Artists*, p. 43, no. 22; and Hannelore Glasser, *Artists' Contracts of the Early Renaissance* (New York and London, 1965), pp. 71–72; my translation departs slightly from theirs. The patrons' deference to the maker's judgment is another sign of the changing status of artists.

25 Michelangelo is quoted in the Life of Ghiberti; Vasari-Barocchi 3: 100; and in Benedetto Varchi, *Orazione funerale di M. Benedetto Varchi fatta, e recitata da lui pubblicamente nell'essequie di Michelagnolo Buonarroti in Firenze, nella chiesa di San Lorenzo* (Florence, 1564), p. 38.

26 My free translation. For the duke's letter dated 23 August 1476, see Glasser, *Artists' Contracts*, p. 78; and for his patronage and concerns about "too many hands," see Evelyn S. Welch, *Art and Authority in Renaissance Milan* (New Haven and London, 1995), p. 253 and *passim*.

27 See Gaetano Milanesi, ed., *Le lettere di Michelangelo Buonarroti pubblicate coi ricordi ed i contratti artistici* (Osnabrück, 1875; rpt. 1976), p. 615, for Michelangelo's declaration dated Florence, 22 May 1501, regarding his negotiations with Cardinal Francesco Piccolomini (later Pope Pius III). For the first contract, written 5 June 1501, signed 25 June (Florence, Archivio Buonarroti, Codice 2–3, no. 2), see Michael Hirst, "Michelangelo in Florence: 'David' in 1503 and 'Hercules' in 1506," *Burlington Magazine* 142 (2000): n. 2. Hirst attributes

the lowest orders of the altar tabernacle to Michelangelo. A year after Pope Pius's death, on 15 September 1504, his heirs renewed the contract with Michelangelo; Milanesi, ed., *Lettere*, pp. 616–19, 617–18 for the passages quoted above, reiterating a requirement of the first contract. Both contracts stipulated that Michelangelo undertake no other commissions until he had completed the altar, but he violated this clause in signing his contracts for *David* and later the *Apostles*, as explained by Hirst, p. 487. See also Creighton E. Gilbert, "What Did the Renaissance Patron Buy?," *Renaissance Quarterly* 51 (1998): 410; and Joachim Poeschke, *Michelangelo and his World: Sculpture of the Italian Renaissance*, trans. Russell Stockman (New York, 1996), pp. 77–79. For Michelangelo's enmity with Torrigiani, see pp. 71, 74.

28 For fifteenth-century examples of the *sua mano* stipulation, see Glasser, *Artists' Contracts*, p. 73. Pintoricchio's contract with Cardinal Francesco Todeschini-Piccolomini for the Piccolomini Library, Siena cathedral, 29 June 1502, has a similar clause; see Chambers, *Patrons and Artists*, pp. 25–27, no. 15; and n. 27 above for his contract with Michelangelo for the Piccolomini altar. Andrea Sansovino's contract with the Florentine council, 10 June 1502, stipulated that his *Christ* for the Sala del Gran Consiglio be "by his own hand and by no one else"; Chambers, pp. 85–87, p. 86 no. 44, for this quotation.

29 Ottavio Morisani, "Art Historians and Art Critics – III: Cristoforo Landino," *Burlington Magazine* 95 (1953): 270n6, with the text of Landino's passage on artists from the *Apologia di Dante* which opens his commentary, 1481, on the *Divine Comedy*; my free translation.

30 The letter from Alberto da Bologna in Venice to Isabella in Mantua, dated 26 November 1496, refers to Bellini's having agreed "yesterday evening" to provide a painting for the Studiolo. See Rona Goffen, *Giovanni Bellini* (New Haven and London, 1989), pp. 264–65, no. 23. For the marchesa and Bellini, I have borrowed from Goffen, "Giovanni Bellini: Il Rinascimento visto da Rialto," in *Il colore ritrovato: Bellini a Venezia*, ed. Goffen and Giovanna Nepi Scirè, exh. cat., Venice, Gallerie dell'Accademia (Milan, 2000), pp. 10–16. For Isabella's collections, see Sylvia Ferino Pagden et al., *"La prima donna del mondo": Isabella d'Este, Fürsten und Mäzenatin der Renaissance*, exh. cat., Vienna, Kunsthistorisches Museum (Vienna, 1994), pp. 145–288 and *passim*; and Leandro Ventura et al., *Isabella d'Este: I luoghi del collezionismo: Mantova-Palazzo Ducale Appartamenti isabelliani*, exh. cat., Mantua, Palazzo Ducale, *Civiltà Mantovana*, 3rd ser., anno xxx, Quaderno nos. 14–15 (1995). However other artists may have behaved or mis-behaved with their patrons, the relationship between Isabella and Bellini is the first documented case of such "artistic temperament" in action.

31 *Fantasia* (fantasy, imagination) is the word used by Bellini and Isabella in reference to such subjects which the next generation described as *poesie* or *favole*, words that underscore the relation between painting and poetry. For the word *poesia*, see Jaynie Anderson, *Giorgione: The Painter of "Poetic Brevity"* (Paris and New York, 1997), pp. 45, 48–49; and Rona Goffen, *Titian's Women* (New Haven and London, 1997), pp. 9, 107. For Mantegna's works for Isabella, see Claudia Cieri Via, "Lo studiolo di Isabella d'Este a Mantova," in Cieri Via with Daniela Pagliai, *L'antico fra mito e allegoria: Il tema dell'amore nella cultura di immagini fra '400 e '500*, Corso di Iconografia e Iconologia Anno Accademico 1985–86, Università degli Studi di Roma "La Sapienza" (Rome, 1986), pp. 188–98; and Ronald Lightbown, *Mantegna: With a Complete Catalogue of the Paintings, Drawings and Prints* (Berkeley and Los Angeles, 1986), pp. 186–209.

32 Lightbown, *Mantegna*, p. 189.

33 See Goffen, "Bellini," p. 11.

34 Luca's was probably commissioned by the cathedral Operai in 1431; the first mention of Donatello's commission in 1433 alludes to it. Donatello's "pulpit" (*cantoria* is a modern term) is to be installed opposite Luca's. Donatello's contract stipulates that his pulpit be at least as good as his predecessor's. Donatello is to be paid at the same rate as Luca, 40 florins a panel; but if his work surpasses Luca's, Donatello will receive 50 florins for each panel. See H.W. Janson, *The Sculpture of Donatello* (Princeton, 1963), pp. 119–29; and Pope-Hennessy, *Donatello*, p. 104.

35 For Vianello's letter (ASM, Busta 1439, c. 317), see Clifford M. Brown and Anna Maria Lorenzoni, *Isabella d'Este and Lorenzo da Pavia: Documents for the History of Art and Culture in Renaissance Mantua* (Geneva, 1982), p. 157, no. ii; and Goffen, *Bellini*, pp. 265–66, no. 30. My translation here and in following quotations from this correspondence.

36 An altarpiece by Bellini in 1497 could cost 300 ducats; Goffen, *Bellini*, p. 265, no. 24.

37 ASM, Busta 1439, c. 318; see Brown and Lorenzoni, *Isabella and Lorenzo*, p. 158, no. v; and Goffen, *Bellini*, p. 266, no. 31.

38 Isabella to Vianello, 23 June 1501 (ASM, Busta 2993, Libro 12, c. 58); Vianello to Isabella, 25 June 1501 (Busta 1439, c. 319); see Brown and Lorenzoni, *Isabella and Lorenzo*, p. 159, nos. VII–VIII.

39 In chronological order: Mantegna, the *Triumph of Minerva*, completed in summer 1502, and two grisailles; Perugino, the *Combat between Love and Chastity*, 1503–05; Lorenzo Costa, the *Coronation of a Lady*, 1505, and *Reign of Comos*, 1510–11; Correggio, the *Allegory of Vice* and *Allegory of Virtue*, c. 1530–31. See Marilyn Bradshaw, "Pietro Perugino: An Annotated Chronicle," in Joseph Antenucci Becherer, et al., *Pietro Perugino: Master of the Italian Renaissance*, exh. cat., Grand Rapids Art Museum (New York and Grand Rapids, 1997), pp. 277, 283, 286, 290; Keith Christiansen, "The Studiolo of Isabella d'Este and Late Themes," pp. 418–26, and "Andrea Mantegna, *Pallas Expelling the Vices from the Garden of Virtue*," pp. 427–30, no. 136, in Suzanne Boorsch, Keith Christiansen, David Ekserdjian, Charles Hope, David Landau, et al., *Andrea Mantegna*, ed. Jane Martineau, exh. cat., Royal Academy of Arts and Metropolitan Museum of Art (London and New York, 1992); David Ekserdjian, *Correggio* (New Haven and London, 1997), pp. 274–75, 278–79; Ferino Pagden, "*Prima donna*," pp. 199–205, 210–16, 229–339, 221–27. The paintings are nos. 201–08 in the inventory of Isabella's collection prepared by Odoardo Stivini in 1542 (ASM, Busta 400); see Daniela Ferrari in Ferino-Pagden, pp. 282–88; and Ferrari, "L'Inventario delle gioie'" and "Trascrizione del codice," in *Isabella d'Este: I luoghi del collezionismo*, pp. 11–33. Although Isabella must have provided detailed instructions for all of these *istorie*, only the text given to Perugino survives, having been copied in his contract; see Fiorenzo Canuti, *Il Perugino*, 2 vols. (Siena, 1931), vol. 2, pp. 212–13, doc. 316. Isabella first approached Perugino in 1497, shortly after having offered Bellini a contract for a *fantasia* for the Studiolo; Brown and Lorenzoni, *Isabella and Lorenzo*, p. 149. For her dealings with these two painters, see also Martin Kemp, "From 'Mimesis' to 'Fantasia': The Quattrocento Vocabulary of

Creation, Inspiration and Genius in the Visual Arts," *Viator* 8 (1977): 358–59.

40 My italics here and in following translations from the correspondence. ASM, Busta 1439, c. 319; see Brown and Lorenzoni, *Isabella and Lorenzo*, p. 159, no. VIII; Goffen, *Bellini*, p. 266, no. 32.

41 See Lightbown, *Mantegna*, pp. 188–90.

42 For Isabella's letter of 28 June 1501, ASM, Busta 2993, Libro 12, c. 62v, see Brown and Lorenzoni, *Isabella and Lorenzo*, p. 160, no. IX; and Goffen, *Bellini*, p. 266, no. 33.

43 Gonzaga to Bellini, 4 October 1497, Creighton E. Gilbert, *L'arte del Quattrocento nelle testimonianze coeve* (Florence and Vienna, 1988), pp. 163–64.

44 Bellini to Gonzaga, 12 October 1497; Goffen, *Bellini*, p. 265, no. 26.

45 For Lorenzo's letter of 3 August 1501 (ASM, Busta 1439, cc. 310–11), see Brown and Lorenzoni, *Isabella and Lorenzo*, p. 58, no. 43; and for the painting, Goffen, *Bellini*, pp. 217, 266, no. 34, p. 321n61.

46 According to the letter from Lorenzo to Isabella, 10 September 1502 (ASM, Busta 2993, c. 32), in Goffen, *Bellini*, p. 266, no. 36.

47 Isabella to Vianello, 15 September 1502 (ASM, Busta 2993, Libro cc. 16r–v); see Brown and Lorenzoni, *Isabella and Lorenzo*, p. 162, no. XXII; and Goffen, *Bellini*, p. 266, no. 37.

48 Isabella to Vianello, 20 October 1502; Goffen, *Bellini*, pp. 266–67, no. 39.

49 Isabella to Vianello, 20 October 1502 (ASM, Busta 2993, Libro 14, cc. 25v–26r); see Brown and Lorenzoni, *Isabella and Lorenzo*, p. 163, no. XXV; and Goffen, *Bellini*, pp. 266–67, no. 39.

50 According to the letter from Michele Vianello to Isabella, 3 November 1502 (ASM, Busta 1440, c. 125); see Brown and Lorenzoni, *Isabella and Lorenzo*, p. 164, no. XXVI; and Goffen, *Bellini*, p. 267, no. 40.

51 Isabella to Vianello, 12 November 1502, ASM, Busta 1993, Libro 14, c. 37v; see Brown and Lorenzoni, *Isabella and Lorenzo*, p. 164; and Goffen, *Bellini*, p. 267, no. 41.

52 ASM, Busta 2993, Libro 14, c. 51; see Brown and Lorenzoni, *Isabella and Lorenzo*, pp. 164–65, no. XXVIII; and Goffen, *Bellini*, p. 267, no. 42.

53 Francesco Malatesta to Isabella, 8 October 1503, ASM, Busta 1440, c. 299; Brown and Lorenzoni, *Isabella and Lorenzo*, p. 165; and Goffen, *Bellini*, p. 267, no. 43. Malatesta added that the painting "will be completed this month."

54 Isabella to Alvise Marcello, 10 April 1504, ASM, Busta 2994, Libro 17, cc. 14v–15; see Brown and Lorenzoni, *Isabella and Lorenzo*, pp. 165–66, no. XXXVII; and Goffen, *Bellini*, p. 267, no. 45.

55 Bellini to Isabella, 2 July 1504, ASM, Raccolta d'Autografi, Cassetta 7, c. 686; see Brown and Lorenzoni, *Isabella and Lorenzo*, pp. 166–67, no. XL; and Goffen, *Bellini*, pp. 267–68, no. 46.

56 ASM, Busta 2994, Libro 17, c. 29v; see Brown and Lorenzoni, *Isabella and Lorenzo*, p. 167, no. XLIII.

57 ASM, Busta 1890, c. 336; see Brown and Lorenzoni, *Isabella and Lorenzo*, pp. 82–83, no. 90; Goffen, *Bellini*, p. 268, no. 47.

58 For the letter, see the previous note. "Invention" here seems to refer to the kind of mythological *fantasia* that Mantegna had painted for the Studiolo, and which Bellini had refused to produce.

59 ASM, Busta 1890, c. 337; see Brown and Lorenzoni, *Isabella and Lorenzo*, p. 84, no. 92; and Goffen, *Bellini*, p. 268, no. 47.

60 Lorenzo to Isabella, 31 August 1504, ASM, Busta 1890, c. 341; Brown and Lorenzoni, *Isabella and Lorenzo*, p. 85, no. 93. In the same letter, Lorenzo lamented the quality of the wood employed by Bellini: "the panel is very sad." The painter's using an inferior panel confirms one's impression that he was not much concerned with pleasing Isabella.

61 Letter of 6 July 1504, cited in n. 57 above.

62 For Bembo's letter of 1 January 1505 (*more veneto*, modern 1506), see Giovanni Gaye, *Carteggio inedito d'artisti dei secoli XIV.XV.XVI*, 3 vols. (Florence, 1840; rpt. Turin, 1968), vol. 2, pp. 71–73; and Goffen, *Bellini*, p. 268, no. 49.

63 Isabella's interest in having a work by Perugino for her Studiolo is first documented in her correspondence with Lorenzo da Pavia in 1497; see Brown and Lorenzoni, *Isabella and Lorenzo*, p. 149, and docs. 8–9. The marchesa's contract with Perugino, dated 19 January 1503, includes detailed instructions for the "battle of Chastity against Lasciviousness, that is, Pallas and Diana fighting in a virile way (*virilmente*) against Venus and Love" (my translation). For the contract, see Gaye, *Carteggio inedito*, vol. 2, p. 68; and Canuti, *Il Perugino*, vol. 2, pp. 212–13, doc. 316. Isabella also provided "a small drawing. [. . .] But if you think that perhaps there are too many figures in this for one picture, it is left to you to reduce them as you please, provided that you do not remove [. . .] the four figures of Pallas, Diana, Venus and Cupid"; Chambers, p. 137. Similarly, in 1495

Isabella's contract with Perugino for an altarpiece for Perugia specifies which saints are to be depicted, and suggests that the lunette depict a *Pietà* or another figure, at the painter's discretion, "ad electionem Magistri Petri." See Gilbert, "Renaissance Patron," p. 418.

64 I have slightly modified the translation in Creighton E. Gilbert, *Italian Art 1400–1500: Sources and Documents* (Englewood Cliffs, 1980), p. 132. For the Italian texts, see Gilbert, *L'arte del Quattrocento*, pp. 153–54. The marchese went on to explain that Mantegna would prefer to paint a *Madonna* or another subject on a larger scale. Was the painter's suggestion motivated in part by the higher fee that a larger painting would bring? At the end of his life Mantegna was recalcitrant about satisfying another non-Mantuan commission, in this case from the Venetian Corner family – and his reluctance was related at least in part to the fee (see p. 18 above). Bona of Savoy was the consort of Galeazzo Maria Sforza.

65 Goffen, *Bellini*, p. 268, no. 50. The wording "avemo dato tanta battaglia" (we have waged such a battle) implies that Bembo was assisted in his siege of Bellini. See n. 72 below.

66 For the letter of 19 October 1505, ASM, Busta 2294, c. 130, see Goffen, *Bellini*, p. 268, no. 51. A subsequent letter from the marchesa to the painter, dated 6 November 1505, implies that they had come to an agreement about a painting or paintings for the Studiolo; she was waiting for the arrival of their mutual friend Bembo, "who having seen the other inventions that are in our Studiolo, could find the invention of those (*quelle*) that you are to do"; Carlo D'Arco, *Delle arti e degli artifici di Mantova: Notizie raccolte ed illustrate con disegni e con documenti*, 2 vols. (Mantua, 1857–59), vol. 2, p. 61, no. 74. But Isabella never received her *fantasia* (or *fantasie*?) by Bellini.

67 Of course any painter can paint any subject "on speculation," that is, without a commission. The only two patrons who apparently commissioned works by Michelangelo without specifying the subject were Alfonso d'Este and Alfonso d'Avalos; see pp. 307–08, 317.

68 A possible exception is Lodovico Gonzaga's explanation of Mantegna's rejecting the commission for a small-scale work; see pp. 16–17 above.

69 The letter is cited in n. 62 above.

70 For her letter of 31 January 1506 (modern style), see Paul Kristeller, *Andrea Mantegna*

(London, New York, and Bombay, 1901), p. 579, doc. 176.

71 George Knox, "The Camerino of Francesco Corner," *Arte veneta* 32 (1978): 79–84; and Lightbown, *Mantegna*, pp. 214–18, 451–52.

72 Bembo's letter to Isabella of 1 January 1506 (modern style) indicates that Corner knew Bellini. Perhaps he accompanied Bembo in the siege of the Bellini "fortress"? For Corner and Bellini, see Lightbown, *Mantegna*, p. 214; and for Bellini's *Scipio*, Goffen, *Bellini*, pp. 238–42.

73 Philostratus the Elder and Philostratus the Younger, *Imagines*, trans. Arthur Fairbanks (Cambridge, MA, and London, 1979), p. 7 (bk. 1. 1). See also Beverly Louise Brown, "On the Camerino," in *Bacchanals by Titian and Rubens*, ed. Görel Cavalli-Björkman (Stockholm, 1987), 50 and *passim*; Goffen, *Titian's Women*, pp. 107–26, on the "Poesie for Alfonso d'Este"; and "Antagonists: Titian," pp. 272–74, 278–80, 284–85.

74 Such collections had a dual purpose, combining "private self-cultivation" and the display of the "cultivated self" of the collector whose judgment is reflected in his possessions. See Stephen J. Campbell, "Mantegna's *Parnassus*: Reading, Collecting and the *Studiolo*," in *Revaluing Renaissance Art*, ed. Gabriele Neher and Rupert Shepherd (Aldershot, 2000), p. 71; also Dora Thornton, *The Scholar in his Study: Ownership and Experience in Renaissance Italy* (New Haven and London, 1997), pp. 106–26 and *passim*.

75 See L.D. Ettlinger, *The Sistine Chapel before Michelangelo: Religious Imagery and Papal Primacy* (Oxford, 1965), pp. 17–22; p. 28 for the chronology; pp. 30–31 for Perugino's being in charge; pp. 33, 41, for the cycle's unifying elements; and pp. 120–21, Appendix A, for the contract. For the iconography of the Sistine murals, see Rona Goffen, "Friar Sixtus IV and the Sistine Chapel," *Renaissance Quarterly* 39 (1986): 218–62; and Carol F. Lewine, *The Sistine Chapel Walls and the Roman Liturgy* (University Park, PA, 1993).

76 For Botticelli, Ghirlandaio, and Perugino as assistants in Verrocchio's shop, see David Alan Brown, *Leonardo da Vinci: Origins of a Genius* (New Haven and London, 1998), p. 40. Leonardo seems to have entered the shop in 1489 and remained with Verrocchio even after he had achieved independent status as a master.

77 Vasari-Barocchi 3: 432.

78 For these lost frescoes, see Jean K. Cadogan, *Domenico Ghirlandaio: Artist and Artisan*

(New Haven and London, 2000), pp. 287–88, cat. 69. The della Rovere pope had been complicit in plots against the Medici, and relations between Sixtus and Lorenzo were strained.

79 Sooner rather than later was a real concern for Renaissance patrons. The disparity between contractual obligations (completion within a year, for example) and reality (delivery ten years later) was chronic. A brief table of relevant data is published by Glasser, *Artists' Contracts*, pp. 80–81.

2 Agon

1 This paragraph is adapted from Goffen, "Bellini," p. 3. For Vasari's innovative use of the word *rinascita* to describe this secular rebirth, see M.L. McLaughlin, "Humanist Concepts of Renaissance and Middle Ages in the Tre- and Quattrocento," *Renaissance Studies* 2 (1988): 131.

2 Petrarch's letter to the Dominican Giovanni Colonna, written before 1356; *Epistolae familiares* VI, 2, in Francesco Petrarca, *Rerum familiarium libri I–VIII*, trans. Aldo S. Bernardo (Albany, NY, 1975), p. 293. For Petrarch's conception (or invention) of a dark age between antiquity and his own time, see Theodor E. Mommsen, "Petrarch's Conception of the 'Dark Ages'," *Speculum* 17 (1942): 226–42; and McLaughlin, "Humanist Concepts of Renaissance," pp. 132–33 and *passim* for the later development of such periodization.

3 Dolce's Aretino describes a similar, albeit abbreviated, biological progression in Venetian art from Bellini to Giorgione to Titian; see Mark W. Roskill, *Dolce's "Aretino" and Venetian Art Theory of the Cinquecento* (New York, 1968), pp. 85–86. Petrarch divides history into old and new in the letter to Colonna cited in the previous note; Petrarca, *Rerum familiarium*, 294. The word he used for the Christian era is *nova* ("in novis"), as noted by Neal W. Gilbert, "Comment," *Journal of the History of Ideas* 48 (1987): 42n3.

4 Flavio Biondo, *Italia illustrata*, written in 1453, cited by Roberto Weiss, *The Dawn of Humanism in Italy: An Inaugural Lecture* (New York, 1947; rpt. 1970), p. 3.

5 For the *renovatio litterarum* before Petrarch, see Weiss, *Dawn of Humanism*, pp. 3–10; and now Ronald G. Witt, *"In the Footsteps of the Ancients": The Origins of Humanism from Lovato to Bruni* (Leiden, 2000).

6 Weiss, *Dawn of Humanism*, p. 10.

7 Believing that the attempt to surpass one's rivals spurs artistic progress, Vasari also recognized the inherent danger of destructive envy; see Vasari-Barocchi 3: 146–47 (Life of Brunelleschi). For the Renaissance idea that competition is necessary for creativity, see also G.W. Pigman, III, "Versions of Imitation in the Renaissance," *Renaissance Quarterly* 33 (1980): 18.

8 Prints themselves might be used for competitive self-promotion – Baccio Bandinelli exploited them in this way – or in specific instances of rivalry; see "Coda," pp. 353, 359. For a singularly rivalrous engraving, see Iris Cheney, "The Print as a Tool of Artistic Competition: Salviati and Michelangelo," in *Renaissance Papers 1985*, ed. Dale B.J. Randall and Joseph A. Porter (Durham, NC, 1985), pp. 87–95.

9 Roskill, *Dolce's "Aretino,"* pp. 96–97: the speaker is Aretino, reiterating the familiar idea that painting is the imitation of nature; Fabrini adds that "the painter is a mute poet, the poet a painter who speaks" (my translation). For painting and poetry, see also Roskill, pp. 100–101. According to the ancients, an *ekphrasis* might be any description of anything visual, not only a work of art; see Ruth Webb, "*Ekphrasis* Ancient and Modern: The Invention of a Genre," *Word and Image* 15 (1999): 7–18. This issue of *Word and Image*, ed. Mario Klarer, is dedicated to *Ekphrasis*, and also includes Klarer's "Introduction," pp. 1–4 (with extensive bibliography); James A.W. Heffernan, "Speaking for Pictures: The Rhetoric of Art Criticism," pp. 209–17; and John Hollander, "The Poetics of *Ekphrasis*," pp. 211–12, on Aretino's ekphrastic sonnet on Titian's portrait of *Francesco Maria della Rovere*.

10 Roskill, *Dolce's "Aretino,"* pp. 92–93, with slight changes in the translation.

11 Ibid., p. 120; my translation.

12 Pico in Giorgio Santangelo, ed., *Le epistole "De imitatione" di Giovanfrancesco Pico della Mirandola e di Pietro Bembo* (Florence, 1954), p. 24 (my translation). The text is quoted and discussed in Eugenio Battisti, "Il concetto d'imitazione nel Cinquecento da Raffaello a Michelangelo," *Commentari* 7 (1956): 88. Raphael seems to incarnate Pico's point of view. For the "debate whether or not Cicero should be the only model for Latin prose," see the essential essay by Pigman, "Versions of Imitation," p. 2 for this quotation, pp. 6–7 for Poliziano's apian metaphor of imitation. As Pigman explains, p. 3, "the two *major* categories of [Renaissance] imitation are imitation (*imitatio*) and emulation

(*aemulatio*)." See also ch. 7 in Ingrid D. Rowland, *The Culture of the High Renaissance: Ancients and Moderns in Sixteenth-Century Rome* (Cambridge and New York, 1998), pp. 193–244, esp. pp. 195–98, 207–11, on Pico and Bembo, who knew each other at the papal court in 1512.

13 Santangelo, *Epistole*, p. 31 (my translation). See also Battisti, "Il concetto d'imitazione," p. 89; and esp. Pigman, "Versions of Imitation," p. 20.

14 Santangelo, *Epistole*, p. 45; and Battisti, "Il concetto d'imitazione," pp. 94, 95.

15 Quoted in Pigman, "Versions of Imitation," p. 20; and Santangelo, *Epistole*, p. 46.

16 Or was considered to have been by his later fourteenth- and fifteenth-century compatriots. Echoing Petrarch's and Pier Paolo Vergerio's ideas about the imitation of models and anticipating Bembo, Cennino Cennini cast Giotto as his "Cicero." See Andrea Bolland, "Art and Humanism in Early Renaissance Padua: Cennini, Vergerio and Petrarch on Imitation," *Renaissance Quarterly* 49 (1996): 469–87, esp. pp. 470–73 on Cennini and Vergerio, pp. 479–82 for the relation to Petrarch.

17 See William E. Wallace, *Michelangelo at San Lorenzo: The Genius as Entrepreneur* (Cambridge and New York, 1994), p. 467 and *passim*; and Wallace, "Michelangelo's Assistants in the Sistine Chapel," *Gazette des Beaux-Arts* 110 (1987): 203–16.

18 Angelico died in 1455. The reference to the artist's giving his income to Christ pertains to his having been a Dominican friar, hence sworn to poverty. For the epitaph, variously attributed to Lorenzo Valla and to Pope Nicholas V (one of the painter's patrons), see Elsa Morante and Umberto Baldini, *L'opera completa dell'Angelico* (Milan, 1970), p. 11.

19 Nicolò Liburnio, *Opere gentile ed amorose* (Venice, 1502), Sonnet 30, fol. 8r: "O quanto a te Natura e ciel arride/Ioanni mio."

20 Benvenuto Cellini, *La vita*, ed. Carlo Cordié (Milan and Naples, 1960; rpt. 1996), p. 414, which is Libro II, lxxix. Cellini followed this anecdote with the text of a laudatory letter he said Michelangelo wrote to him c. 1552, reiterating his appreciation of the Altoviti bust (now Boston, Isabella Stewart Gardner Museum). For the letter, see also Barocchi and Ristori, *Carteggio* 4: 387, MCLXXXI.

21 See Mary Pardo, "Paolo Pino's 'Dialogo di pittura': A Translation with Commentary," Ph.D. dissertation (University of Pittsburgh, 1984), pp. 29–33, for the jousting among authors and publishers. Note also the first publication of Francesco Sansovino, *Venetia*

città nobilissima et singolare (Venice, 1556), which vaunts the city's major monuments and works of art.

22 Vasari gave a wonderfully lurid account of the putative murder in his double biography of Castagno and Domenico; Vasari-Barocchi 3: 361.

23 See Susan Delaney, "*L'Olive* and the Poetics of Rivalry," *Classical and Modern Literature* 14 (1993–94): 183. See also p. 193: "And yet a rival is often also a model. Plato again provides an apposite example."

24 Aretino died on 20 October 1556, while the *Dialogue* was still in progress. The other interlocutor, Giovan Francesco Fabrini (1516–80), was still very much alive: unlike Castiglione in the *Book of the Courtier*, Dolce clearly did not intend to record (or recreate) posthumous conversations. The dedicatory letter of Dolce's *Dialogue* is dated 12 August 1557. See Roskill, *Dolce's "Aretino,"* pp. 196–99, and p. 219, for Aretino's and Fabrini's dates.

25 Vasari-Barocchi 6: 160.

26 Nine of the ten known letters survive; the first, informing the Gonzaga of the availability of the vases, has been lost. For the correspondence, 20 April to 13 June 1502, see Clifford M. Brown, "Little Known and Unpublished Documents concerning Andrea Mantegna, Bernardino Parentino, Pietro Lombardo, Leonardo da Vinci and Filippo Benintendi (Part Two)," *L'arte* 7–8 (1959): 194–206. As Brown explains, Francesco left most of the negotiating to Isabella.

27 "Michael, more than mortal, angel divine": Ariosto, *Orlando furioso*, trans. A. H. Bilbert (New York, 1954), 33.1–2. Michelangelo is also "Divine" in Aretino's letter to him, April 1545; Pietro Aretino, *Lettere sull'arte di Pietro Aretino*, ed. Fidenzio Pertile and Ettore Camesasca, 3 vols. (Milan, 1957–60), vol. 2, pp. 62–63, CCXXI. For Leonardo's divinity, see above, p. 46 and n. 34.

3 Paragoni

1 The speaker is Aretino, referring in particular to the *paragone* of Michelangelo and Titian, in Roskill, *Dolce's "Aretino,"* p. 88; my translation.

2 From the draft of Leonardo's letter to Lodovico il Moro in Jean Paul Richter, ed., *The Notebooks of Leonardo da Vinci*, 2 vols. (1883, rpt. New York, 1970), vol. 2, p. 398. The text is discussed above, pp. 40–42.

3 Vasari-Barocchi 4: 299 (Life of Lorenzo di Credi).

4 Three weeks earlier, the commission had been awarded to Piero del Pollaiuolo (the Pollaiuolo brothers were Verrocchio's chief competitors in the Florentine art market). See David Alan Brown, *Leonardo da Vinci: Origins of a Genius* (New Haven and London, 1998), p. 150, for this first recorded commission, 10 January 1478 (modern style). Leonardo's commission later passed to Ghirlandaio and finally to Filippino Lippi, whose completed painting is dated 1485 (Florence, Galleria degli Uffizi).

5 Vasari-Milanesi 4: 27.

6 For these portraits, see Brown, *Leonardo*, pp. 105–06, 109–10, 114, 116–17, 119; Brown, *Virtue and Beauty: Leonardo's Ginevra de' Benci and Renaissance Portraits of Women*, exh. cat., Washington, National Gallery of Art (Princeton, 2001); Daniel Arasse, *Leonardo da Vinci: The Rhythm of the World*, trans. Rosetta Translations (New York, 1998), pp. 386–412, pp. 397–400 on the *Gallerani*; David Bull, "Two Portraits by Leonardo: *Ginevra de' Benci* and the *Lady with an Ermine*," *Artibus et Historiae* 13 (1992): 67–83; Mary D. Garrard, "Leonardo da Vinci: Female Portraits, Female Nature," in *The Expanding Discourse: Feminism and Art History*, ed. Norma Broude and Mary D. Garrard (New York, 1992), pp. 59–86; Martin Kemp, *Leonardo da Vinci: The Marvellous Works of Nature and Man* (London, 1981; rpt. 1989), pp. 49–53, 200, 203; and Barbara Fabjan, Pietro C. Marani, et al., *Leonardo: La dama con l'ermellino*, exh. cat., Kraków, Muzeum Narodowe w Krakowie (Milan, 1998). For the artist's use of cartoons in these two works and the *spolvero* transfer process (frequently used for portraits), see Carmen C. Bambach, *Drawing and Painting in the Italian Renaissance Workshop: Theory and Practice, 1300–1600* (Cambridge and New York, 1999), p. 23.

7 See Bambach, *Drawing and Painting*, for the *pentimenti* in the *Adoration* and in two versions of the *Madonna of the Yarnwinder*. She considers Leonardo's "finished" cartoon for the *Battle of Anghiari* to be the exception in Leonardo's practice rather than the rule, perhaps produced at the insistence of his patrons; ibid., pp. 24, 247–48.

8 Paris, Institut de France, BN 2038 (Ashburnam II), 29v, quoted in Kemp, *Leonardo*, p. 190.

9 "Look," that is, with hindsight. The presumption is that such physiognomical and pyschological variety was a desideratum; but this was not necessarily the case. At other times and according to other mentalities,

such variety might be intentionally suppressed in favor of types. Some of the following discussion is taken from Rona Goffen, "Mary's Motherhood according to Leonardo and Michelangelo," *Artibus et historiae* 20 (1999): 35–69.

10 For Vasari's appreciation of *allegrezza* and *letizia* in Leonardo's cartoon of the *Madonna and Child and Saint Anne*, see John Onians, "On How to Listen to High Renaissance Art," *Art History* 7 (1984): 425 (with reference to *La Gioconda* but relevant here as well). For the relation of Leonardo's Benois *Madonna* to its sculptured models, see Goffen, "Mary's Motherhood," p. 41 (with bibliography).

11 For uses of the term, see Claire J. Farago, *Leonardo da Vinci's "Paragone": A Critical Interpretation with a New Edition of the Text in the Codex Urbinas* (Leiden, 1992), pp. 8–14. The rivalry concerned music as well as poetry. In addition to Leonardo – the only artist to have written so much about the subject – the *paragone* was discussed by Francesco Colonna in *Hypnerotomachia Poliphili* (Venice, 1499); Pomponius Gauricus, *De sculptura* (Florence, 1504); Luca Pacioli, *Divina proportione* (completed in Milan before 1499 and published in Venice, 1509); and Francesco Lancilotti, *Tractato di pictura* (Rome, 1509). See Onians, "How to Listen," p. 412 and *passim*. According to Onians, p. 415, these authors were the first to develop the *paragone* as a "broad theme," though the subject had been treated earlier by Cennino Cennini and Bartholomeo Fazio, among others. See also Gilbert, "Comment," p. 42 for the medieval *Querelle* among "ancients and moderns," pagans and Christians, *antiqui* and *moderni*: "The format in which their merits or demerits were compared was called variously *synkrisis*, *comparatio*, or *paragone*."

12 Paris, Institut de France, BN 2038 (MS Ashburnam II), 1r and 22, quoted in Kemp, *Leonardo*, p. 97. As Kemp explains, Leonardo had formulated the basic concepts of tonal painting by 1483–86. Eventually, shadow will absorb color: "Different colours with a common shadow appear to be transformed into the colour of that shadow" (Vatican, Codex Urbinas Latinus 1270, 66r, c. 1508).

13 Meyer Schapiro, "Freud and Leonardo: An Art Historical Study" (1968), rpt. in his *Theory and Philosophy of Art: Style, Artist, and Society* (New York, 1994), pp. 180–81.

14 I am paraphrasing and applying to Leonardo the claims made for Michelangelo by Leo

Steinberg, "Michelangelo's Medici Madonna and Related Works," *Burlington Magazine* 113 (1971): 146, 149.

15 Whatever motivated Leonardo's exclusion from the pope's roster, the timing of the departure for Milan does not seem fortuitous. He was to remain there for seventeen years, until late 1499, supported in part by a stipend from Lodovico Sforza. This arrangement is documented, ironically, by Lodovico's non-payment of Leonardo's salary for two years toward the end of his Milanese sojourn, compelling the artist to petition for back pay. See Kemp, *Leonardo*, p. 92.

16 I use Leonardo's spelling of "Lodovico" rather than "Ludovico," favored by some modern authors, including Kemp. Although already ruling in Milan in the name of his nephew, Duke Gian Galeazzo Maria, Lodovico did not assume the title of duke until September 1494. Leonardo's traveling companion and fellow envoy was the lutenist Atalante Migliorotti. Leonardo's musical mission is described by his first biographer, the Anonimo Gaddiano (the Anonimo Magliabechiano), *Il Codice Magliabechiano* (c. 1540), ed. Carl Frey (Berlin, 1892), p. 110. See also Arasse, *Leonardo*, 220, 241 (identifying the instrument as a silver lyre), and Farago, *Leonardo da Vinci's "Paragone"*, pp. 42–43. For Leonardo's portrait of a musician sometimes identified as Migliorotti, see above, p. 48.

17 For Leonardo as Lorenzo's protégé, see Carlo Pedretti, *Leonardo: A Study in Chronology and Style* (Berkeley and Los Angeles, 1973), pp. 54, 55; and Patricia Lee Rubin and Alison Wright, "Artists and Workshops," in Rubin, Wright, and Nicholas Penny, *Renaissance Florence: The Arts of the 1470s*, exh. cat., London, National Gallery (London, 1999), p. 103 and n. 59. For Leonardo and the Medici garden, see Caroline Elam, "Lorenzo de' Medici's Sculpture Garden," *Mitteilungen des Kunsthistorischen Institutes in Florenz* 36, Heft 1–2 (1992): 41–83, esp. p. 58.

18 Leonardo's letter to Lodovico Sforza is Codex Atlanticus 391ra; see Richter, ed., *Notebooks*, vol. 2, pp. 395–98, no. 1340; and Martin Kemp, ed., *Leonardo on Painting*, trans. Kemp and Margaret Walker (New Haven and London, 1989), pp. 251–53. Regarding the source's anomalies, see Richter's note for doc. 1340, pp. 395–97. The Italian passages quoted above are from Richter; the English paraphrases and translations are my modifications of his translations.

19 For Domenico's letter dated Perugia, 1 April 1438 (ASF, Mediceo avanti il principato, VII, fol. 290), see Helmut Wohl, *The Paintings of Domenico Veneziano: A Study in Florentine Art of the Early Renaissance* (New York and London, 1980), pp. 6, 14–15, 339–40 (a transcription of the letter). The letter is also discussed in Rudolf Wittkower and Margot Wittkower, *Born under Saturn: The Character and Conduct of Artists. A Documented History from Antiquity to the French Revolution* (London, 1963; rpt. New York, 1969), p. 34.

20 My translation and italics. For the Italian text, see Richter, ed., *Notebooks*, vol. 2, p. 398.

21 As suggested by Brown, *Leonardo*, pp. 56, 67, 190nn39–40, citing evidence for Leonardo as a sculptor.

22 Richter, ed., *Notebooks*, vol. 1, p. 356, no. 680; my translation. See also Brown, *Leonardo*, p. 190n39.

23 Pollaiuolo's drawing for the Sforza monument, 28.8 × 25.4 cm., is pricked for transfer; see Andrew Butterfield, *The Sculptures of Andrea del Verrocchio* (New Haven and London, 1997), p. 167. For the Pollaiuolo shop, see Patricia Lee Rubin, "Artists and Workshops," in Rubin, Wright, and Penny, *Renaissance Florence*, pp. 87–93. Although he failed to win the Sforza commission, Pollaiuolo remained interested in the possibility of executing an equestrian monument, as documented by his letter of 13 July 1494 to Virginio Orsini, offering to "do the whole of you seated on a large horse, which would be to your eternal fame." See Chambers, *Patrons and Artists*, pp. 175–77, no. 108.

24 Kemp, *Leonardo*, p. 203; and above, p. 45.

25 See Butterfield, *Verrocchio*, p. 166.

26 Ibid., pp. 166, 167.

27 Ibid., p. 166, citing the diary entry of a German Dominican, Felix Fabri, dated 3 May 1483.

28 For the difference in their characters, see Wittkower and Wittkower, *Born under Saturn*, pp. 71–77; and above, pp. 145–47.

29 For the "tragedy of the tomb," see Condivi, p. 36, and below, n. 94, for chapter 6.

30 See *inter alia* Martin Kemp, "Leonardo's Drawings for 'Il Cavallo del Duca Francesco di Bronzo': The Program of Research," in Diane Cole Ahl, ed., *Leonardo da Vinci's Sforza Monument Horse: The Art and the Engineering* (Bethlehem, PA, and London, 1995), pp. 64–78.

31 Quoted in Kemp, *Leonardo*, p. 203.

32 For example, the fresco equestrian monuments in Florence cathedral: Paolo Uccello, *Sir John Hawkwood*, 1436, and Andrea del Castagno, *Niccolò da Tolentino*, 1456; and the anonymous wooden monument of Jacopo Savelli (d. 1405), Venice, Santa Maria Gloriosa dei Frari.

33 The model had been destroyed by 1501. For the vandalism, see Carlo Pedretti, "The Sforza Horse in Context," in Cole Ahl, ed., *Sforza Monument*, p. 27. For the model's "immense fame," including the Latin epigrams it inspired, and its display in the cathedral during the marriage ceremonies in summer 1493, see Kemp, *Leonardo*, p. 207. As Kemp notes, the clay model had a rider.

34 For Santi or Sanzio, see *Giovanni Santi: Atti* (Milan, 1999); and Renée Dubos, *Giovanni Santi: Peintre et chroniqueur à Urbin, au XVe siècle* (Bordeaux, 1971), *passim* and pp. 161–63 for Santi's dedicatory letter to Federigo's son and successor, Duke Guidobaldo. Santi's *Disputa de la pictura* (MS Cod. Vat. ottob. lat. 1305, fol. 311r–314r) is incorporated in his life of Federigo da Montefeltro, Duke of Urbino, the *Cronaca rimata* written in *terza rima* and unfinished at the time of Santi's death. See Lise Bek, "Giovanni Santi's 'Disputa de la pictura': A Polemical Treatise," *Analecta Romana Instituti Danici* 5 (1969): 76–102, including the entire text of the *Disputa*, also available in Creighton E. Gilbert, *L'arte del Quattrocento nelle testimonianze coeve* (Florence and Vienna, 1988), pp. 119–24; Gilbert's translation is in his *Italian Art 1400–1500: Sources and Documents* (Englewood Cliffs, 1980), pp. 95–100. Santi's verses are the first survey of artists to privilege living masters, as noted by Gilbert. For Santi's description of Leonardo as the equal of Perugino, see Arasse, *Leonardo*, p. 9, and pp. 12–14 on Leonardo's *fortuna critica*. By the 1490s Leonardo was already the beneficiary of "a fame based more on what was said about him than on what was seen or known of his work" (Arasse, p. 12). Regarding the painter's divinity: Leonardo himself later characterized the artist as "*signore e dio* of all the things he wishes to generate," whereas Alberti had claimed divine status only for the painting, not the painter; see Kemp, "From 'Mimesis' to 'Fantasia': The Quattrocento Vocabulary of Creation, Inspiration and Genius in the Visual Arts," *Viator* 8 (1977): 383, 393, and 397 for the infrequent use of the word *divino* to describe art and artists (Brunelleschi among them).

35 This was the wedding of Isabella of Aragon and Gian Galeazzo Maria Sforza, who suc-

ceeded his father Galeazzo Maria and preceded his uncle Lodovico as Duke of Milan. Other extravaganzas created by Leonardo in 1492 may have come too late for Santi to have known of them before completion of the *Chronicle*: the jousts for the wedding of il Moro and Beatrice d'Este and the costumes for Baldassare Taccone's *Danae*, performed in honor of Anna Sforza and Alfonso d'Este (Beatrice's and Isabella's brother).

36 Leonardo's "treatises" were inaccessible during his lifetime, as noted by A. Richard Turner, *Inventing Leonardo* (Berkeley and Los Angeles, 1992), p. 74, *inter alia*. A treatise on painting attributed to Leonardo was published in Italian in 1651.

37 ASM, Archivio Gonzaga, serie FII9, Busta 2993, c. 12, n. 80, fol. 28, 28 March 1501, to Lorenzo da Pavia in Venice; Marani and Villata, "Documentary Appendix," in Pietro C. Marani, *Leonardo da Vinci: The Complete Paintings*, trans. A. Lawrence Jenkins (New York, 2000), p. 349, no. 35; my translation and Isabella's run-on sentence.

38 Ibid., no. 36, for Novellara's letter (ASM, Archivio Gonzaga, serie E, XXVIII, 3, Busta 1103). The patron may have been François I, according to an undated letter from Padre Resta to Giampietro Bellori (d. 1696). Novellara's description does not match either the cartoon in London (Fig. 74) or the painting in the Louvre (Fig. 84) and is usually interpreted as a reference to an earlier version, now lost but apparently reflected in a painting by Brescianino, formerly in Berlin, Kaiser-Friedrich-Museum. The *Saint Anne* was an unfinished sketch, *schizo* [*sic*], when Novellara described it, however, and the composition may well have changed as Leonardo continued to work on it, perhaps transforming it into a composition more like that described by Vasari. For the various versions, see Arasse, *Leonardo*, pp. 445–61; Bambach, *Drawing and Painting*, p. 460, n. 2; Martin Clayton, "The Madonna and Child with St. Anne," in *Leonardo and Venice*, ed. Giovanna Nepi Scirè, Pietro C. Marani, et al., exh. cat., Venice, Palazzo Grassi (Milan, 1992), pp. 242–43; and Kemp, *Leonardo*, pp. 220–26. For sketches related to the cartoon, see A.E. Popham, *The Drawings of Leonardo da Vinci*, rev. ed. Martin Kemp (London, 1994), pp. 49–51.

39 Vasari-Barocchi 4: 29. As explained by Bambach, *Drawing and Painting*, p. 257, the public display of such cartoons as Leonardo's *Saint Anne* and later his *Anghiari* and Michelangelo's *Cascina* "helped establish [. . .] a new ideal, that of the '*ben finito cartone*'. [. . .] Cartoons had ceased to be regarded as mere working drawings."

40 Paris, Institut de France, BN MS A, fol. 106r, quoted by Bambach, *Drawing and Painting*, p. 257.

41 Lorenzo was also a maker of musical instruments. For his correspondence with the marchesa regarding Bellini's work, see above, pp. 13, 14–16.

42 For the visit to Milan and for Cecilia's letter of thanks after Isabella had returned the portrait, see Brown, "Little Known and Unpublished Documents concerning Andrea Mantegna, Bernardino Parentino, Pietro Lombardo, Leonardo da Vinci and Filippo Benintendi (Part Two)," *L'arte* 7–8 (1959): 189–90.

43 Colin Eisler, *The Genius of Jacopo Bellini* (New York, 1989), pp. 38, 43, 531, App. E, doc. 1441 (XI).

44 See chapter 2, n. 19 above.

45 Goffen, *Bellini*, p. 293n4 (*Selvetta 6*).

46 Baccio Ziliotto, *Raffaele Zovenzoni: La vita, i carmi* (Trieste, 1950), p. 78, *carme* 28.

47 He has been identified as Atalante Migliorotti, the musician who had accompanied Leonardo to Milan in 1481; see Marani, *Leonardo*, pp. 164–65; Farago, *Leonardo da Vinci's "Paragone"*, pp. 42–43, and n. 41.

48 See Arasse, *Leonardo*, pp. 394–96; Kemp, *Leonardo*, p. 199; and Marani, *Leonardo*, pp. 177–82, summarizing the debate regarding attribution and arguments in favor of her identification as Lucrezia Crivelli and publishing translations of Latin epigrams in praise of her portrait by Leonardo. Cf. Janet Cox-Rearick, *The Collection of Francis I: Royal Treasures* (New York, 1996), pp. 145–46, IV-2, attributing the portrait to Leonardo or his workshop, with a query; and endorsing Sylvie Béguin's suggestion that the subject is Beatrice d'Este. Lucrezia was recognized as one of Lodovico's official mistresses in 1496. In 1497 she gave birth to his son, and in that same year, his duchess, Beatrice d'Este, died in childbirth.

49 Janice Shell, "Cecilia Gallerani: una biografia," in Fabjan, Marani, et al., *Leonardo*, pp. 50–65.

50 ASM, Archivio Gonzaga, II, Busta 2992, c. 9, n. 169, fol. 54, in Marani and Villata, "Documentary Appendix," in Marani, *Leonardo*, p. 348, no. 30.

51 I am paraphrasing Kemp, "Leonardo verso 1500," in Nepi Scirè, Marani, et al., *Leonardo and Venice*, p. 48.

52 Kemp, ibid., p. 47. Calepino also cites Foppa, included perhaps out of loyalty for a fellow son of Bergamo.

53 See Brown, "Little Known and Unpublished Documents," pp. 188–91.

54 Written by Leonardo on a drawing of an ermine willingly captured by a hunter; Cambridge, Fitzwilliam Museum (formerly Clarke Collection); Popham, *Drawings of Leonardo*, pp. 122–23, no. 109A, c. 1494, kindly brought to my attention by Paul Joannides. A similar idea is expressed in Leonardo's Manuscript H, 48v (Paris, Institut de France), cited *inter alia* in Marani, *Leonardo*, p. 169. Weasels, including the ermine, may be associated with pregnancy and childbirth; if that is the case in the portrait, it may have been painted when Cecilia was pregnant or at the time of her son's birth in May 1491; see Jacqueline Marie Musacchio, "Weasels and Pregnancy in Renaissance Italy," *Renaissance Studies* 15 (2001): 176 and *passim*. Lorenzo Costa copied the composition, replacing the ermine with a dog, in a portrait of an unknown lady sometimes wrongly identified as Isabella d'Este; for Costa's *Portrait of a Lady with a Lap-dog* (Royal Collection, Hampton Court), see John Shearman, *The Early Italian Pictures in the Collection of Her Majesty the Queen* (Cambridge, London, and New York, 1983), pp. 82–84.

55 For the cartoon in the Louvre, see Françoise Viatte, *Léonard da Vinci: Isabelle d'Este* (Paris, 1999).

56 The motto's author was the Venetian nobleman Bernardo Bembo, Ginevra's admirer. The back of the portrait is painted to simulate porphyry, which "must have stressed the nobility and durability of Bernardo's love, and to allude to the antique culture through which he expressed it," as explained by Suzanne B. Butters, *The Triumph of Vulcan: Sculptors' Tools, Porphyry, and the Prince in Ducal Florence*, 2 vols. (Florence, 1996), vol. 1, p. 109. She adds that "It is possible that Leonardo also thought of his Ginevra invention as an allusion to the superiority of painting over sculpture and poetry." For the portrait, see also the references in n. 6.

57 See Goffen, *Bellini*, pp. 191–221, on the portraits, p. 161 on the "Bembo," pp. 205, 219 for the patrician ideal of imperturbability. See also Rona Goffen, "Crossing the Alps: Portraiture in Renaissance Venice," in *Renaissance Venice and the North: Cross-currents in the Time of Dürer, Bellini, and Titian*, ed. Bernard Aikema, Beverly Louise Brown, and Giovanna Nepi Scirè, exh. cat., Venice, Palazzo Grassi (Milan, 1999), pp. 114–31; Alison Luchs, *Tullio Lombardo and Ideal Portrait Sculpture in Renaissance Venice, 1490–1530* (Cambridge and New York, 1995), pp. 20–22; and, for social theory and practice, Margaret Leah King, "Caldiera and the Barbaros on Marriage and the Family: Humanist Reflections of Venetian Realities," *Journal of Medieval and Renaissance Studies* 6 (1976): 19–50. For various expressions in Leonardo's other portraits of women – but not Isabella – see Arasse, *Leonardo*, pp. 408–09.

58 For the painting in Venice, Gallerie dell' Accademia, see the conservation report by Gloria Tranquilli, p. 82, and the catalog entry by Goffen, pp. 136–37, in Rona Goffen and Giovanna Nepi Scirè, ed., *Il colore ritrovato: Bellini a Venezia*, exh. cat., Venice, Gallerie dell'Accademia (Milan, 2000).

59 Pietro Bembo, *Prose della volgar lingua: Gli asolani, Rime*, ed. Carlo Dionisotti (Turin, 1966), pp. 521–23; and sonnets 77 and 78 in *Petrarch's Lyric Poems: The Rime sparse and Other Lyrics*, trans. and ed. Robert M. Durling (Cambridge, MA, and London, 1976), pp. 176–79. For Bembo's first sonnet in relation to its Petrarchan model, see also Deborah Parker, *Bronzino: Renaissance Painter as Poet* (Cambridge and New York, 2000), pp. 84–85.

60 For the identity of Bembo's mistress, see Carlo Dionisotti in Bembo, *Prose*, pp. 521–23, note to sonnet XIX. In 1502–03 Bembo was living in Ferrara, where Alfonso d'Este's consort, Lucrezia Borgia, occupied his heart and mind; he and Isabella inevitably knew of each other even before their first documented meeting in Mantua in 1505.

61 Venice, Gallerie dell'Accademia; see the conservation report by Alfeo Michieletto, p. 78, and the catalog entry by Goffen, pp. 136, in Goffen and Nepi Scirè, ed., *Il colore ritrovato*.

62 As I suggested in "Crossing the Alps," pp. 117–18. A hint of what Bellini's female portraits might have looked like is seen in drawings made to illustrate works in the Vendramin collection; see Tancred Borenius, *The Picture Gallery of Andrea Vendramin* (London, 1923).

63 Vienna, Kunsthistorisches Museum; see Rona Goffen, *Titian's Women* (New Haven and London, 1997), pp. 86–98.

64 The cartoon is pricked, and the back of the paper is rubbed with pouncing dust, indicating that it was used for transfer. A rectangular patch of paper was glued to the back

of the cartoon for reinforcement of the lower left corner and on top of other strips of reinforcing paper. The pricking extends to these reinforcements. According to Carmen Bambach, this evidence suggests that the cartoon was prepared for transfer by someone other than Leonardo. She notes that Isabella's letter to Novellara, dated 27 March 1501, requests another copy of Leonardo's portrait drawing; "the Louvre cartoon may have been an attempt at such a reconstruction." This technical evidence, plus the four known copies of the portrait, indicate that Leonardo's invention was much copied. See Bambach, *Drawing and Painting*, p. 112, citing copies in Florence, Uffizi; Munich, Staatliche Graphische Sammlung; and London, British Museum. To these may be added the copy published in Viatte, *Léonard: Isabelle*.

65 Arasse, *Leonardo*, p. 404.

66 Kemp, *Leonardo*, p. 200.

67 ASM, Archivio Gonzaga, serie F II, o, Busta 2994, c. 17, n. 56, fol. 20r; Pietro C. Marani and Edoardo Villata, "Documentary Appendix," in Marani, *Leonardo*, p. 354, no. 51; my translation. On 27 May 1504, Angelo del Tovaglia wrote from Florence to inform the marchesa that Leonardo promised to do the *Young Christ* and that he, Angelo, would continue to solicit the painter to do so, though he was uncertain of success. The letter closes with a pun on the painter's name: "tengho per certo Lionardo habbi a essere vincitore tuttavia dal canto mio." ASM, Archivio Gonzaga, serie E, LXI, I, Busta 1890 (27 May 1501), in Marani and Villata, p. 354, no. 52.

68 Ibid., p. 355, no. 55. No such painting by Leonardo has survived, but many versions of the subject suggest that it or studies for it once existed, among them the *Young Christ as Salvator Mundi* (Nancy, Musée des Beaux-Arts) attributed to his follower Marco d'Oggiono c. 1504 by Cox-Rearick, *Collection of Francis I*, pp. 147–48.

69 For the rejected portrait and Santi's replacement, see Lightbown, *Mantegna*, pp. 188–89, 463.

70 Paris, Institut de France, BN 2038 (Ashburnham II), 26v, in Kemp, *Leonardo on Painting*, p. 205.

71 Popham, *Drawings of Leonardo*, p. 123, no. 109B (Bayonne, Musée Bonnat).

72 Farago, *Leonardo da Vinci's "Paragone"*, p. 40, citing the debate held at Carnival in 1423, celebrating the entry of the Sforza, and Castiglione, *Book of the Courtier*, I: 49–53.

73 Farago, *Leonardo da Vinci's "Paragone"*, p. 41 and n. 36. The only contemporary record of the event is provided by Luca Pacioli, a most reliable source.

74 Simon Hornblower and Antony Spawforth, ed., *The Oxford Classical Dictionary* (Oxford and New York, 3rd ed. 1996), pp. 41–42, *s.v.* agones. The Pythian Games featured three musical contests and a painting competition (Pliny, *Natural History* XXXV.58). For the opposition of Homer and Hesiod, see also Farago, *Leonardo da Vinci's "Paragone"*, pp. 36–37. As she notes, the more immediate model than the Greek *agon* or Latin *certamen* for fifteenth-century debates was provided by medieval poetry contests or debates.

75 Farago, *Leonardo da Vinci's 'Paragone'*, pp. 48–49; and E.H. Gombrich, "The Heritage of Apelles," in *The Heritage of Apelles: Studies in the Art of the Renaissance* (Ithaca, NY, 1976), pp. 14–15.

76 For Cecilia's response to Isabella, ASM, Archivio Gonzaga, serie E, XLIX, 2, Busta 1615, see Marani and Villata, "Documentary Appendix," in Marani, *Leonardo*, p. 348, no. 31. For the relationship between Cecilia and Lodovico and her portrait, see Marani, *Leonardo*, pp. 166–77, p. 169 for a translation of Bernardo Bellincioni's sonnet in praise of the portrait, published in 1493.

77 The event was recorded by Marino Sanuto [Marin Sanudo], *I diarii di Marino Sanuto*, ed. Rinaldo Fulin et al., 58 vols. (Venice, 1879–1902), vol. I, p. 96.

78 Bellini was exceptionally welcoming to Dürer, who praised him in a letter to Willibald Pirckheimer dated 7 February 1506; Goffen, *Bellini*, p. 268, no.52. Solari had earned Bellini's friendship and admiration in Venice in 1494 (when Michelangelo was also in the city), though they apparently had a falling out. Bellini's high regard for Solari's work and his account of their friendship are recorded in a letter from Don Bernardo Gadolo da Pontevico, prior of San Michele in Isola, to Cardinal Francesco Todeschini Piccolomini (the future Pope Pius III). See Vittore Meneghin, "Un grande artista del rinascimento giudicato da alcuni illustri contemporanei," *Ateneo Veneto* N.S. 8 (1970): 255–61; and Anne Markham Schulz, "Cristoforo Solari at Venice: Facts and Suppositions," *Prospettiva (Scritti in ricordo di Giovanni Previtali)* 53–56 (1988–89): 309.

79 For Lorenzo Gusnasco da Pavia's letter to Isabella, 13 March 1500, ASM, Archivio Gonzaga, serie E, XLV, Busta 1439, fol. 55,

see Marani and Villata, "Documentary Appendix," in Marani, *Leonardo*, p. 349, no. 34.

80 The question of Leonardo's influence on Venetian painters, and on Giorgione in particular, have been much studied; see esp. Nepi Scirè, Marani, et al., *Leonardo and Venice*, *passim*.

81 See Gaetano Milanesi in Vasari-Milanesi 4: 98n1; and Anderson, *Giorgione*, p. 66.

82 A suspicion first hinted by the editors of Paolo Pino, *Dialogo di pittura*, ed. Rodolfo Pallucchini and Anna Pallucchini (Venice, 1946), p. 140n2. They relate Giorgione's *paragone* to Savoldo's portrait (Fig. 28). Whether Giorgione's painting existed is questioned by Pardo, "Pino's 'Dialogo'," p. 265; and her "Testi e contesti del 'Dialogo di pittura' di Paolo Pini," in *Paolo Pino teorico d'arte e artista: Il restauro della pala di Scorzè*, ed. Angelo Mazza (Scorzè, 1992), p. 39. Cf. Jaynie Anderson, *Giorgione: The Painter of "Poetic Brevity"* (Paris and New York, 1997), p. 66: the independent accounts in Pino and Vasari "guarantee that both record something authentic." For Vasari's account, see pp. 61–62 above.

83 I have slightly changed the translation in Pardo, "Pino's 'Dialogo'," p. 367, whose discussion of this passage is on pp. 129, 265–69. See also Paul Hecht, "The *Paragone* Debate: Ten Illustrations and a Comment," *Simiolus* 14 (1984): 125–27. For the Italian text, see Pino, *Dialogo*, pp. 139–40; and Paolo Pino, "Dialogo di pittura," in *Trattati d'arte del Cinquecento fra manierismo e controriforma*, ed. Paola Barocchi (Bari, 1960), p. 131.

84 Vasari-Barocchi 1: 23.

85 Vasari-Barocchi 4: 46 (in 1568 only).

86 Maurizio Calvesi suggested the relation of the two works; "Il San Giorgio Cini e Paolo Pino," in *Venezia e l'Europa* (Venice, 1955), pp. 254–57. For the *Saint George* (Venice, Cini Foundation), see Harold E. Wethey, *The Paintings of Titian: Complete Edition* (London, 1969), vol. 1: *The Religious Paintings*, pp. 132–33. The panel is a fragment from a larger work. For a later variant of Giorgione's subject, a painting of a male nude reflected in his cuirass, recorded in the seventeenth century in the collection of Giovanni and Jacopo van Voert of Antwerp, see Carlo Ridolfi, *Le Maraviglie dell'arte ovvero le vite degli illustri pittori veneti e dello stato* [1648], ed. Detlev von Hadeln, 2 vols. (Berlin, 1914), vol. 1, p. 106; noted also in Pino, *Dialogo*, p. 139n2.

87 For the portrait's relation to Giorgione's *paragone*, see Pallucchini and Pallucchini in Pino, *Dialogo*, p. 140n2, followed by Pardo, "Pino's 'Dialogo'," pp. 266–67; and on the portrait itself, Creighton Gilbert, "Newly Discovered Paintings by Savoldo in Relation to their Patronage," *Arte lombarda* 96–97 (1991): 29–46; Cox-Rearick, *Collection of Francis I*, pp. 244–47 (endorsing Gilbert's identification of the work as *Self-Portrait with Mirrors*); Francesco Frangi's catalog entry in Michel Laclotte and Giovanna Nepi Scirè, ed., *Le Siècle de Titien: L'Âge d'or de la peinture à Venise*, exh. cat., Paris, Grand Palais (Paris, 1993), pp. 400–01; Andrew John Martin, *Savoldos sogennantes "Bildnis des Gaston de Foix": Zum Problem des Paragone in der Kunst und Kunsttheorie der italienischen Renaissance* (Sigmaringen, 1995); and Elena Lucchesi Ragni, "*Ritratto di uomo con armatura* (cosiddetto *Gastone de Foix*)," in Bruno Passamani et al., *Giovanni Gerolamo Savoldo tra Foppa, Giorgione e Caravaggio*, exh. cat., Brescia, Monastero di Santa Giulia, and Frankfurt, Schirn Kunsthalle (Milan, 1990), pp. 164–66. Gilbert and others date the painting c. 1528–30, though the armor is datable c. 1515 (perhaps it was a studio prop?). For the armor, see F. Rossi, "Armi e cronologia in Gian Girolamo Savoldo," in Gaetano Panazza, ed., *Giovanni Gerolamo Savoldo, pittore bresciano: Atti del convegno (Brescia 1983)* (Brescia, 1985), pp. 99–108.

88 The inscription is now illegible except for the name, SAVOLDO, or SAVOLDU[s]. The text was transcribed by a later hand in the lower left of the canvas: OPERA DI JOVANI JERONIMO DE BRESSA DI SAVOLDI. See Lucchesi Ragni, in Passamani et al., *Savoldo*, pp. 164, 166. Pino also used the *cartellino*, which he called *la boletta*, though it had become outmoded by 1548; Pardo, "Pino's 'Dialogo'," p. 355.

89 Pino, *Dialogo*, pp. 138–39. The passage is analyzed in Norman E. Land, "*Narcissus pictor*," *Source* 16, 2 (1997): 13, with reference to classical authors, including Ovid, Quintilian, and Philostratus, who possibly suggested the Narcissus imagery to Alberti (and thus to Pino). For Narcissus in Alberti, see Leon Battista Alberti, *On Painting and On Sculpture: The Latin Texts of De pictura and De statua*, ed. Cecil Grayson (London, 1972), bk. 2, para. 26. For the Albertian "revival" in the 1540s and for Alberti's influence on Pino, see Pardo, "Testo e contesti," pp. 35, 40, 43–44. *De pictura* was first published in Basel in 1540, and its first

Italian translation, by Ludovico Domenichi, in Venice in 1547.

90 Pino, *Dialogo*, p. 139; Land, "*Narcissus pictor*," p. 13.

91 BN 2038, 25r, and Codex Urbinas Latinus, 23r, in Kemp, *Leonardo on Painting*, p. 38.

92 The first section of the Codex Vaticanus Urbinas Latinus 1270, consisting of the first twenty-eight folios and labeled the *Parte prima* in the manuscript (also known as MS. A), constitutes the text of Leonardo's *Paragone*, as it was titled by the editor of the first published edition, Guglielmo Manzi, in 1817. The last twenty-four folios of the codex are separately bound as Ashburnham II. See Farago, *Leonardo da Vinci's "Paragone"*, pp. 3, 289. For Leonardo's continued interest in the *paragone* rivalry until "1508 or 1510," see Farago, p. 15, and Carlo Pedretti, *The Literary Works of Leonardo da Vinci, Compiled and Edited from the Original Manuscripts by Jean Paul Richter: Commentary*, 2 vols. (Berkeley and Los Angeles, 1977), vol. 1, pp. 76–86.

93 Codex Urbinas Latinus 1270, 33v, in Kemp, *Leonardo on Painting*, p. 202.

94 For these passages from BN 2038 (Ashburnham II), 24v, and the Codex Urbinas Latinus 132r–v, see Kemp, ibid. In Codex Atlantico, 184b (Milan, Biblioteca Ambrosiana), Leonardo again exhorts the painter to "keep his mind like nature which is like the surface of a mirror, assuming colours as various as those of the different objects." On this text, see Catherine Dunton, "Meaning and Appearance: A Merleau-Pontian Account of Leonardo's Studies from Life," *Art History* 22 (1999): 334. For the painting as mirror, see Land, "*Narcissus pictor*," p. 12.

95 *Parte prima*, ch. 1, modifying the translation in Farago, *Leonardo da Vinci's "Paragone"*, p. 179. "Painting alone remains noble" – unlike "sciences which can be imitated," including letters, which can be copied, and sculpture, which can be cast. Only painting "honors its author and remains precious and unique and never bears children equal to itself" (ch. 8 in ibid., pp. 186–89). On medieval precedents for Leonardo's argument, see Farago, pp. 305–06; and ibid., pp. 315–22, for an analysis of Leonardo's comparisons of painting and poetry, comprising chapters 1–28 of the *Parte prima*.

96 *Parte prima*, ch. 14, modifying the translation in Farago, ibid., pp. 196–99, and pp. 334–35 for her analysis of this text. See also *Parte prima*, ch. 31, pp. 244–45, for the hierarchy of the senses.

97 *Parte prima*, ch. 15, in Farago, ibid., pp. 200–01, 336.

98 *Parte prima*, ch. 19, in Farago, ibid., pp. 208–11, and the discussion on pp. 341–44. See also *Parte prima*, ch. 21, in ibid., pp. 216–17: "Painting is a mute poem and poetry is a blind painting."

99 *Parte prima*, ch. 27, in Farago, ibid., pp. 234–35. King Matthias (d. April 1490) was known for his "humanistic interests." For his relationships with Italian humanists and his ties with the Sforza court (his illegitimate son was engaged to Bianca Maria from 1489 to 1490), see Farago, pp. 356–57: Leonardo's anecdote about the king is likely a "set piece," which invites comparison with the kind of polemics described in book 1 of *The Courtier* (Castiglione was resident at the Sforza court from 1496 to 1499).

100 As noted by Farago, ibid., p. 383. She suggests that "Leonardo's arguments defending painting against sculpture were probably originally intended as elegant sophistry to amuse an educated audience" (p. 384) and that "Some arguments, notably Chapter 37, may parody humanist claims for eloquence as the art of persuasion" (p. 385), and concludes that "The quarrel between painting and sculpture is in large part Leonardo's own creation and that of his sixteenth-century editor" (p. 388). That I do not agree with her here is evident from the present book.

101 *Parte prima*, ch. 35, slightly modifying the translation in Farago, ibid., pp. 256–57. Of the chapters comparing painting and sculpture (chs. 35–45), "Only one passage [. . .], Chapter 38, is extant in Leonardo's original manuscript" (Farago, p. 383). Other material comes from the lost *Libro A*, reconstructed by Carlo Pedretti.

102 *Parte prima*, ch. 36, slightly modifying the translation in Farago, ibid., pp. 256–57. Leonardo's descriptions evoke actual practice but also recall the Lucian's "Dream" allegory (Farago, pp. 392–93). When Dante described God as a sculptor, however, he imagined the Creator as (obviously) exempt from such sweat and dust; his sculpted reliefs surpass both Polyclitus and nature and render speech visible (*Purgatory* x, 32–33, 94–96); see Barbara J. Watts, "Artistic Competition, Hubris, and Humility: Sandro Botticelli's Response to *Visibile parlare*," *Dante Studies* 114 (1996): 41–78.

103 For this relief in Oxford, Ashmolean Museum, see Marion Boudon, "Le relief d'*Ugolin* de Pierino da Vinci: Une réponse sculptée au problème du *paragone*," *Gazette des Beaux-Arts* 132 (1998): 1–18. As

Boudon explains, Pierino's subject is derived from Dante's *Inferno*, Canto XXXIII, and the work was made at the suggestion of Luca Martini, a man of letters and close associate of Cosimo I. Martini assisted in the preparation of Varchi's *Lezzioni* in 1547 (Boudon, p. 5), and the relief, completed in 1548, is Martini's and Pierino's reply to the author's *paragone* question (p. 6 and *passim*).

104 For the letter, see Parker, *Bronzino*, pp. 113–14; and Leatrice Mendelsohn, *Paragoni: Benedetto Varchi's Due lezzioni and Cinquecento Art Theory* (Ann Arbor, 1982), pp. 150–52. The letter is undated but was presumably written in 1546 or 1547.

105 *Parte prima*, ch. 36, slightly modifying the translation in Farago, *Leonardo da Vinci's "Paragone"*, pp. 260–61.

106 *Parte prima*, ch. 42, in Farago, ibid., pp. 274–75, and pp. 407–09 for her discussion of this text.

107 *Parte prima*, ch. 37, in Farago, ibid., pp. 262–63. Sebastiano later experimented with painting on slate in order to achieve permanence; see p. 263 above.

4 Michelangelo

1 Condivi, p. 63: "qualche contesa nella pittura."

2 One of Bronzino's poems in praise of Michelangelo, trans. in Deborah Parker, *Bronzino: Renaissance Painter as Poet* (Cambridge and New York, 2000), pp. 91–92. As Parker explains, p. 93, though Bronzino wrote poems in praise of works of art, the only artist to whom he dedicated poems was Michelangelo. In this example as in others, Bronzino puns on the artist's name, evoking Archangel Michael, and elsewhere playing on Buonarroti (*buono*, "good," and so on). For other such puns, see Janet Cox-Rearick, *Bronzino's Chapel of Eleonora in the Palazzo Vecchio* (Berkeley and Los Angeles, 1993), p. 370n2. Angelic word play is also a feature of Benedetto Varchi's *Orazione funerale di M. Benedetto Varchi fatta, e recitata da lui pubblicamente nell'essequie di Michelagnolo Buonarroti in Firenze, nella chiesa di San Lorenzo* (Florence, 1564).

3 I am paraphrasing Vasari's description of Michelangelo's having vanquished not only his predecessors in the Sistine Chapel but also conquering himself, excelling his own ceiling with the *Last Judgment*; Vasari-Barocchi 6: 71. Varchi also paraphrased this encomium in his *Orazione funerale*, p. 21: "as in paint-ing [. . .] the vault Michelangelo had surpassed all the painters, both ancient and modern, thus in painting the *Last Judgment* [. . .], he surpassed himself." On the biographers, see Johannes Wilde, *Michelangelo: Six Lectures* (Oxford, 1978), pp. 1–16; and for an introduction to Michelangelo himself, see William E. Wallace, *Michelangelo: The Complete Sculpture, Painting, Architecture* (Hong Kong, 1998), pp. 13–29.

4 Girolamo Mancini, "Vite d'artisti di Giovanni Battista Gelli," *Archivio storico italiano*, 5th ser., 17 (1896): 41. According to Gelli's dedicatory letter of the *Vite*, p. 36, Michelangelo was unsurpassed in painting, sculpture and architecture, "in which three arts he has surpassed all the moderns and equalled the ancients." In this triple mastery, Michelangelo was preceded only by Giotto and by Orcagna; ibid., p. 42 (Life of Giotto). For his interest in "old" art, see also William E. Wallace, "Friends and Relics at San Silvestro in Capite, Rome," *Sixteenth Century Journal* 30 (1999): 419–39; and for Giotto's frescoes, Rona Goffen, *Spirituality in Conflict: Saint Francis and Giotto's Bardi Chapel* (University Park, PA, and London, 1988), pp. 51–77.

5 For Michelangelo's drawing (Paris, Louvre), datable before 1496, see Michael Hirst, *Michelangelo and his Drawings* (New Haven and London, 1988), pp. 4–5, 59–60; Alexander Nagel, *Michelangelo and the Reform of Art* (Cambridge and New York, 2000), pp. 5–8 (distinguishing his treatment of Giotto and Masaccio); Alexander Perrig, *Michelangelo's Drawings: The Science of Attribution*, trans. Michael Joyce (New Haven and London, 1991), p. 67; and for the early drawings after Giotto and Masaccio, Charles de Tolnay, *Corpus dei disegni di Michelangelo*, 4 vols. (Novara, 1975–80), vol. 1, pp. 23–25.

6 In the 1550 edition: Florence had already proved herself more worthy than any other city to be the home of such a genius, having already spawned Cimabue, Giotto, Donatello, Brunelleschi, and Leonardo. Because of them, God determined that Florence should also be the home of the universal genius, Michelangelo. The revised text in the second edition eliminates mention of all predecessors except Giotto. Vasari-Barocchi 6: 3–4.

7 Ibid., p. 410. And, Vasari continued, Michelangelo's contemporaries could not have accomplished what they had done, had it not been for him.

8 Ibid., p. 12. See the references cited in n. 5 above for Michelangelo's drawing (Munich, Staatliche Graphische Sammlung) after Masaccio's Saint Peter in the fresco of the *Tribute Money* (Florence, Santa Maria del Carmine, Brancacci Chapel) and the sketch in Vienna, Albertina, after a lost work, presumably the *Sagra*. Cf. Perrig, *Michelangelo's Drawings*, p. 67; he does not accept the two drawings after Masaccio as autograph.

9 Vasari-Barocchi 6: 12.

10 Condivi, p. 65: the cartilage was almost detached, and Michelangelo "was carried home like a dead man." Torrigiani or Torrigiano died of starvation in 1528, a prisoner of the Inquisition in Seville. See Hellmut Wohl in Ascanio Condivi, *The Life of Michelangelo*, ed. Hellmut Wohl, trans. Alice Sedgwick Wohl (Baton Rouge, 1976), p. 146n129, noting that Cellini reported Torrigiani's version of the incident: Torrigiani, Michelangelo, and other students used to go to the Brancacci Chapel to make drawings after Masaccio. Michelangelo was in the habit of teasing the others, and one day apparently went too far for Torrigiani, who responded with his fist. See Benvenuto Cellini, *La vita*, ed. Carlo Cordié (Milan and Naples, 1960, rpt. 1996), pp. 25–26. According to Varchi, *Orazione funerale*, p. 33, Michelangelo, himself impervious to envy, inspired envy in Torrigiani, who "crushed and broke his whole nose."

11 Varchi, *Orazione funerale*, p. 13. For Michelangelo's opinion of Donatello, see p. 134 above.

12 Vasari-Barocchi 6: 6–7. Cf. Condivi, p. 10: "he [Ghirlandaio] never gave him any help." The contract published by Vasari was dated 1 April 1488, stipulating a three-year apprenticeship; a record of payments to Michelangelo and his father is appended, dated 16 April. Vasari 6: 441 acknowledged a debt to what Nagel calls Domenico Ghirlandaio's "notes on the history of Florentine art." See Nagel, *Michelangelo*, p. 2, and pp. 1–22 for "Michelangelo's Work as an Art Historian." Michelangelo's association with Ghirlandaio was cited by Varchi, *Orazione funerale*, pp. 12, 13, 33. The author was indirectly related to the Ghirlandaio: his mother's first husband had been Benedetto Ghirlandaio, Domenico's brother, and Benedetto Varchi was named for him (ibid., p. 13).

13 For the record identifying Michelangelo as Ghirlandaio's collection agent, see now J.K. Cadogan, "Michelangelo in the Workshop of Domenico Ghirlandaio," *Burlington Magazine* 135 (1993): 30–31. Cadogan reasons that Michelangelo likely entered the shop in April 1487, around the time of his twelfth birthday, when Ghirlandaio was employed in the Tornabuoni Chapel of Santa Maria Novella. See also Jean K. Cadogan, *Domenico Ghirlandaio: Artist and Artisan* (New Haven and London, 2000), pp. 3, 162.

14 Vasari-Barocchi 6: 7. On Vasari's collection, but minus this lost sheet, see Per Bjurström, *Italian Drawings from the Collection of Giorgio Vasari*, trans. Roger Tanner (Stockholm, 2001). Francesco Granacci (c. 1469–1543) had been a close friend of Michelangelo, and like him, had been apprenticed to Domenico Ghirlandaio and a student in the Medici sculpture garden. The two young artists lived on the same street in the Santa Croce quarter, and Granacci acted as Michelangelo's *capomaestro* and handled his affairs when he fled to Venice in 1529. See William E. Wallace, "Michelangelo's Assistants in the Sistine Chapel," *Gazette des Beaux-Arts* 110 (1987): 205.

15 Vasari-Barocchi 6: 8. For the fresco cycle, representing the life of the Virgin Mary, see J. Cadogan, *Ghirlandaio*, pp. 67–90, 167–68, 236–43. For the drawing, see also Varchi, *Orazione funerale*, p. 13.

16 Vasari-Barocchi 4: 19. For the painting in London, National Gallery, see David Alan Brown, *Leonardo da Vinci: Origins of a Genius* (New Haven and London, 1998), pp. 27, 30–34.

17 Condivi, pp. 9–10; Vasari-Barocchi 6: 8; Varchi, *Orazione funerale*, p. 13. According to Varchi, the *Saint Anthony* stirred envy in other masters, including Ghirlandaio. See also Letizia Treves, "Bottega di Domenico Ghirlandaio, fine secolo xv, *Le tentazioni di sant'Antonio tormentato dai demoni* (da Martin Schongauer)," in Kathleen Weil-Garris Brandt, Cristina Acidini Luchinat, James David Draper, and Nicholas Penny, ed., *Giovinezza di Michelangelo*, exh. cat., Florence, Casa Buonarroti (Florence and Milan, 1999), p. 329. Treves cites another painting after the print, formerly in the Bianconi collection in Bologna. Assuming that the two paintings were copied from Michelangelo's lost panel and not directly from Schongauer's print, their existence confirms the biographers' assertion that Michelangelo's early work was much admired. Treves optimistically attributes to Michelangelo himself the exhibited version (in a private collection). She is incorrect to argue that the combination of oil and tempera, found also in the Doni Tondo and

the *Entombment*, can be taken as confirmation of his authorship: such mixed media were commonplace in fifteenth- and early sixteenth-century Italian painting. Other scholars have also rejected the attribution to Michelangelo; see the incisive study by Karl Möseneder, "Der junge Michelangelo und Schongauer," in *Italienische Frührenaissance und nordeuropäisches Spätmittelalter: Kunst der frühen Neuzeit im europäischen Zusammenhang*, ed. Joachim Poeschke (Munich, 1993), pp. 260–61.

18 For the importance of the lost *Medusa* in the creation of Leonardo's legend, see A. Richard Turner, "Words and Pictures: The Birth and Death of Leonardo's Medusa," *Arte lombarda* 66 (1983): 103–11.

19 Vasari-Barocchi 6: 8 (1550 and 1568).

20 Condivi, p. 9.

21 Vasari-Barocchi 6: 8–9.

22 Condivi, pp. 9, 10. Adding that Ghirlandaio refused to lend Michelangelo a sketchbook because of his envy of the younger artist, among other discourtesies, Condivi explained that he recounted this information because Domenico's son, Ridolfo, was claiming that Michelangelo owed his *divinità* to Domenico as his teacher – a fact that Condivi and Michelangelo sought to deny.

23 Vasari-Barocchi 6: 8–9 (1568 only). Referring to the lost *Cupid*, Edgar Wind also defends Michelangelo's forgeries as "not plain fraud but emulation"; see "Bacchic Mystery by Michelangelo," in his *Pagan Mysteries in the Renaissance* (New Haven and London, 1958), pp. 150–51.

24 Lorenzo inquired of Ghirlandaio about the best young artists in his shop. Ghirlandaio named "among others Michelangelo and Francesco Granacci"; Vasari-Barocchi 6: 9–10. For the garden and artists who studied there, see Caroline Elam, "Lorenzo de' Medici's Sculpture Garden," *Mitteilungen des Kunsthistorischen Institutes in Florenz* 36, Heft 1–2 (1992): 41–83; and Paola Barocchi, ed., *Il giardino di San Marco: Maestri e compagni del giovane Michelangelo*, exh. cat., Florence, Casa Buonarroti (Milan, 1992). For the distant but nonetheless significant bonds of kinship between Michelangelo and the Medici, see William Wallace, "Michael Angelvs Bonarotvs Patritivs Florentinvs," in *Innovation and Tradition: Essays on Renaissance Art and Culture*, ed. Dag T. Andersson and Roy Eriksen (Rome, 2000), pp. 61–62, 69–70n12, 70n14.

25 Condivi, pp. 10–14; Vasari-Barocchi 6: 9–12.

26 Vasari-Barocchi 6: 10. See also James David Draper, "Bertoldo e Michelangelo," in Weil-Garris Brandt et al., ed., *Giovinezza*, pp. 57–63.

27 In 1550 Vasari referred only to "una testa antica," which Condivi identified as the *Head of a Faun*, followed by Vasari in 1568; Vasari-Barocchi 6: 10; Condivi, p. 11. For related works, including drawings by Michelangelo, see the entries in Weil-Garris Brandt et al., ed., *Giovinezza*, pp. 219–28.

28 Condivi, p. 11.

29 Vasari-Barocchi 6: 10. Condivi, p. 11, echoed the description of Lorenzo's amazement.

30 Condivi, ibid.

31 Pliny, *Natural History, Books XXXIII–XXXV*, trans. H. Rackham (Cambridge, MA, and London, rpt. 1995), XXXV.58. Pliny's text is cited in this connection by Kathleen Weil-Garris Brandt, "'The Nurse of Settignano': Michelangelo's Beginnings as a Sculptor," in *The Genius of the Sculptor in Michelangelo's Work*, ed. Pietro C. Marani, exh. cat., Montreal Museum of Fine Arts (Montreal, 1992), p. 26. Mantegna employed the open-mouthed motif to express extreme suffering in his *Pietà* (Copenhagen, Statens Museum for Kunst) and the *Saint Sebastian* (Venice, Ca' d'Oro).

32 Landino's edition was published by Nicholas Jenson in Venice. For Pliny in the Renaissance, see Martin Davies, "Making Sense of Pliny in the Quattrocento," *Renaissance Studies* 9 (1995): 240–57; and Charles G. Nauert, Jr., "Humanists, Scientists, and Pliny: Changing Approaches to a Classical Author," *American Historical Review* 84 (1979): 72–85, p. 75 for Landino.

33 Condivi, pp. 11–12.

34 Ibid., p. 12; Vasari-Barocchi 6: 10–11.

35 Condivi, p. 11.

36 Ibid., p. 13. For Michelangelo's relationship with Poliziano, see David Summers, *Michelangelo and the Language of Art* (Princeton, 1981), pp. 242–49. Poliziano died in Florence on 29 September 1494; see Elam, "Lorenzo de' Medici's Sculpture Garden," pp. 58, 73. For the relief, see Kathleen Weil-Garris Brandt, "Michelangelo Buonarroti, *Battaglia dei centauri*," in Weil-Garris Brandt et al., ed., *Giovinezza*, pp. 188–98; for its conservation, Agnese Parronchi, "Nota sul restauro della *Battaglia dei Centauri*," in Barocchi, ed., *Il giardino di San Marco*, pp. 61–62; and for such works as demonstrations pieces, Claire J. Farago, *Leonardo da Vinci's "Paragone": A Critical Interpretation with a New Edition of the Text in the Codex Urbinas* (Leiden, 1992), pp. 50–51.

37 Vasari-Barocchi 6: 11 (1568 only).

38 For the relief, see Vasari-Milanesi 2: 423; James David Draper, *Bertoldo di Giovanni: Sculptor of the Medici Household. Critical Reappraisal and Catalogue Raisonné* (Columbia and London, 1992), pp. 133–45, p. 144 for the date; and Draper, "Bertoldo di Giovanni, *Scena di battaglia*," in Weil-Garris Brandt et al., ed., *Giovinezza*, p. 208.

39 See E.H. Gombrich, "The Early Medici as Patrons of Art," and "The Style *all'antica*: Imitation and Assimilation," in *Norm and Form: Studies in the Art of the Renaissance* (London, 1966), pp. 56, 123; and Draper, *Bertoldo*, pp. 136–37. The central figure is identified as Hercules by his lion skin; this was first noted by Wilhelm von Bode, followed by Draper, *Bertoldo*, p. 141, among others.

40 As noted by Howard Hibbard, *Michelangelo* (Cambridge and Philadelphia, 2nd ed. 1985), p. 24. For the engraving, see David Landau and Peter Parshall, *The Renaissance Print 1470–1550* (New Haven and London, 1994), pp. 73–70, 101–02.

41 The relief "contained a programme for a whole lifetime"; Wilde, *Michelangelo*, p. 28.

42 Condivi, p. 13.

43 The *postille* are identified both by the letters that Calcagni used (except for the last four, unlabeled) and by the editors' numbers in Condivi; the *postilla* quoted above is 1A. For transcriptions of the *postille* by Caroline Elam and Giovanni Nencioni, see Condivi, pp. XXI–XXII. The *postille* themselves and two of Calcagni's letters are illustrated in ibid., pp. 67–72. On these marginal notes, see Elam, "'Che ultima mano!' Tiberio Calcagni's *Postille* to Condivi's Life of Michelangelo," in ibid., pp. XXV–XLVI, esp. p. XXVII for Calcagni's handwriting, p. XXX for the interrelated concepts of labor lightened by love and *difficoltà* expressed in 1A. As Elam explains, the *postille* were first published by Ugo Procacci, "Postille contemporanee in un esemplare della vita di Michelangelo del Condivi," in *Atti del convegno di studi Michelangioleschi* (Rome, 1966), pp. 279–94, though he did not identify the author. Calcagni (1532–65) is perhaps best known for reworking Michelangelo's Florence *Pietà* and for having completed his *Brutus* (Florence, Bargello). *Postilla* 20 refers to the "*Brutus* that I gave you," that is, Calcagni. For the younger master, see Elam, p. XXVI and nn. 10, 12. Her essay has also been published as "'Che ultima mano!': Tiberio Calcagni's Marginal Annotations to Condivi's *Life of Michelan*-

gelo," *Renaissance Quarterly* 61 (1998): 475–95.

44 Two distinguished scholars have argued that the *Madonna* is not a "slavish" replication of Donatello's technique: Weil-Garris Brandt, "'Nurse of Settignano'," p. 28; and Michael Hirst, "Michelangelo Buonarroti, *Madonna della scala*," in *Il giardino di San Marco*, ed. Barocchi (Milan, 1992), p. 87. Nevertheless, the relief is sufficiently like Donatello in handling and in composition that any knowledgeable viewer (including Vasari) would have recognized it as Donatellesque, then as now.

45 For the *Madonna*, see Luciano Berti, "Due opere prime, un passaggio," pp. 65–68, Kathleen Weil-Garris Brandt, "I primordi di Michelangelo scultore," pp. 69–75, and Eike D. Schmidt, "Michelangelo Buonarroti, *Madonna della Scala*," pp. 170–72, in Weil-Garris Brandt et al., ed., *Giovinezza*; and Joachim Poeschke, *Michelangelo and his World: Sculpture of the Italian Renaissance*, trans. Russell Stockman (New York, 1996), pp. 68–70.

46 The letter is datable between April and June 1547; see Barocchi and Ristori, *Carteggio* 4: 265–66, MLXXXII; and pp. 262–63, MLXXX, for a draft of the opening lines of the letter and, sharing the paper, fragments of one of Michelangelo's sonnets and the complete text of another. As the editors explain, p. 266n1, Michelangelo's closing criticism was apparently directed at Castiglione (though he is not named) because it refers to the discussion of the *paragone* in relation to the depiction of (female) beauty in *The Book of the Courtier*, bk. 1, 49–53. (Leonardo's writings on the *paragone* had not yet been published.)

47 It was returned to Casa Buonarroti in 1616. The *Madonna*'s importance for contemporaries is also reflected in copies and variants by Vincenzo Danti and others, "taken as the relief's certificate of authenticity by emulation," as explained by Colin Eisler, "The Madonna of the Steps: Problems of Date and Style," in *Stil und Überlieferung in der Kunst des Abendlandes*, vol. 2: *Michelangelo* (Berlin, 1967), p. 116.

48 Barocchi and Ristori, *Carteggio* 1: 11–12, VII, dated 31 January 1506 (modern 1507). The editors suggest, p. 364n5, that the "Our Lady" was the Bruges *Madonna*, but that work had already been packed for shipping on 21 August 1505, repacked on 20 April 1506, and again on 18 June 1506. It was finally transported to Bruges in October 1506; see Poeschke, *Michelangelo*, p. 80. Milanesi identified the "Our Lady" with the

Madonna of the Stairs; Gaetano Milanesi, ed., *Le lettere di Michelangelo Buonarroti pubblicate coi ricordi ed i contratti artistici* (Osnabrück, 1875; rpt. 1976), p. 7 and n. 2. In the same letter, Michelangelo asked his father to send him a bundle of drawings that he had prepared; see p. 120.

49 As suggested by Eisler, "Madonna of the Steps," pp. 116–17. Eisler, p. 119, recognizes Donatellesque elements in Ghirlandaio's frescoes in Santa Maria Novella, a work in progress while Michelangelo was associated with the shop.

50 In the following discussion I repeat parts of Rona Goffen, "Mary's Motherhood according to Leonardo and Michelangelo," *Artibus et historiae* 20 (1999): 35–69.

51 For the artist's family tree, real and imaginary, see Karl Frey, *Michelangelo Buonarroti: Sein Leben und seine Werke. Michelangelos Jugendjahre*, 2 vols. (Berlin, 1907), vol. 1, pp. 3–21; William E. Wallace, "How Did Michelangelo Become a Sculptor?," in Marani, ed., *Genius of the Sculptor*, pp. 151–67, esp. pp. 152–53, 156, on family ties; and Wallace, "Michael Angelvs," pp. 60–63, citing Count Alessandro's letter of 1520 to his "Parente honorando" (Barocchi and Ristori, *Carteggio* 2: 245, CDLXXIII). The relationship was also mentioned by Varchi, *Orazione funerale*, p. 11.

52 Vasari-Barocchi 6: 11. Vasari's description may confirm Eisler's suggestion that Michelangelo made the relief as a forgery; see n. 49 above.

53 Wilde, *Michelangelo*, p. 19, thought Michelangelo took the profile from a Greek coin. For the relation of Michelangelo's Madonna to ancient funerary reliefs, see Kathleen Weil-Garris Brandt, "I primordi di Michelangelo scultore," in Weil-Garris Brandt, et al., ed., *Giovinezza*, p. 71. For the wealth of ancient Greek material known to the Italian Renaissance, see Giovanni Pugliese Carratelli, ed., *The Western Greeks*, exh. cat., Venice, Palazzo Grassi (Milan, 1996).

54 The relation of the Dudley *Madonna and Child* to Michelangelo's *Madonna of the Stairs* was first recognized by Wilhelm von Bode in 1887. See John Pope-Hennessy with Ronald Lightbown, *Catalogue of Italian Sculpture in the Victoria and Albert Museum*, 2 vols. (London, 1964), vol. 1, pp. 138–41, no. 114, citing Bode and suggesting a date before 1478. Leonardo consulted the same relief or a variant for his Benois *Madonna*, apparently begun that year and thus providing an *ante quem* for the relief; see p. 33

above. Although the relief's attribution to Desiderio remains uncertain, its authorship is not crucial for the relation with Michelangelo's work (or Leonardo's, for that matter).

55 The *Madonna Litta* may have been begun by Leonardo and completed by Boltraffio or another follower. An autograph drawing by Leonardo (Paris, Louvre, no. 2376), representing the Madonna's head, is clearly related to the painting.

56 The motif had never before occurred in Italian art, according to Charles de Tolnay, *Michelangelo*, 5 vols. (Princeton, 1943–60), vol. 3: *The Medici Chapel*, p. 71, though he notes a similar motif in northern Gothic ivories. Cf. Sheryl E. Reiss, "A Medieval Source for Michelangelo's Medici Madonna," *Zeitschrift für Kunstgeschichte* 50 (1987): 394–400, calling attention to the anonymous fourteenth-century *Madonna di San Zanobi* (Florence, San Lorenzo) as a precedent for Michelangelo. In this painting, the nursing Child is clearly in profile, with his legs and right shoulder perpendicular to the picture plane and his face visible in three-quarter view. The relation to Michelangelo's relief and to his Medici *Madonna* seems distant to me. For this *Madonna*, see Goffen, "Mary's Motherhood," pp. 60, 62. For the *Pietà*, see pp. 371–76 above.

57 For this Passion iconography, see Hibbard, *Michelangelo*, p. 28, though he does not identify the children as Innocents. Elsewhere Michelangelo represented wingless angels, e.g., in the *Last Judgment*. These children may likewise be angels but their identity as Innocents makes iconographic sense.

58 Hibbard, ibid., cites the popular *Libro* [...] *della* [...] *scala del Paradiso*, first published in 1477 and reprinted for the third time in Florence in 1491, and the *Scala della vita spirituale sopra il nome di Maria*, published in 1495. The author of this book was Domenico Benivieni, a friend of Poliziano and therefore someone whom Michelangelo would have known about and possibly met.

59 Wisdom and her cubic throne are juxtaposed with Fortune, seated on an inherently unsteady ball. For the use of the square block by Donatello and his followers as a symbol of "gravity, stability and constancy," see Rudolf Wittkower, "Chance, Time and Virtue" (1937–38), rpt. in his *Allegory and the Migration of Symbols* (London, 1977), p. 104.

60 The Stone of Unction is commonly represented as a rectangular form. See Mary Ann Graeve, "The Stone of Unction in Caravaggio's Painting for the Chiesa Nuova," *Art*

Bulletin 40 (1958): 223–38, esp. pp. 227–29; rpt. in *The Garland Library of the History of Art*, ed. James S. Ackerman, Sumner McKnight Crosby, Horst W. Janson, and Robert Rosenblum, vol. 8, *Seventeenth Century Art in Italy, France, and Spain* (New York and London, 1976): 1–20. See also Rona Goffen, "Giovanni Bellini: Il Rinascimento visto da Rialto," in *Il colore ritrovato: Bellini a Venezia*, ed. Rona Goffen and Giovanna Nepi Scirè, exh. cat., Venice, Gallerie dell'Accademia (Milan, 2000), p. 8.

61 For this tondo, see Jean K. Cadogan, *Ghirlandaio*, pp. 256–57, cat. 32.

62 The *Annunciation* (from Monteoliveto; now Florence, Uffizi) was traditionally attributed to Domenico Ghirlandaio, but Michelangelo would have known better. The *Ginevra* was first mentioned in Antonio Billi, *Il libro di Antonio Billi* (c. 1530), ed. Annamaria Ficarra (Naples, n.d.), p. 67.

63 Not imitation but "conscious criticism and opposition" as suggested by Johannes Wilde, "Michelangelo and Leonardo," *Burlington Magazine* 95 (1953): 65, explaining that Leonardo's influence came later in Michelangelo's career.

64 For a summary and clarification of the confusion, see Janet Cox-Rearick, *The Collection of Francis I: Royal Treasures* (New York, 1996), pp. 302–13. For Michelangelo's response to the statue's departure for France, see Caroline Elam, "Art in the Service of Liberty: Battista della Palla, Art Agent for Francis I," *I Tatti Studies: Essays in the Renaissance* 5 (1993): 33–109, citing in n. 102 an undated letter written before 8 April 1529 by Lorenzo Strozzi to his father Filippo in Lyons: "the giant, or more precisely the *Hercules*, was delivered to Battista della Palla. Many people are displeased that we are parting with it, especially Michelangelo."

65 For its height, see Condivi, p. 14. I wonder whether the biographer's giving the lost statue almost the same height as the Capitoline *Hercules* is confirmation that Michelangelo's statue resembled that work. For the relation of Michelangelo's *Hercules* to that ancient model, see Charles de Tolnay, "L'Hercule de Michel-Ange à Fontainebleau," *Gazette des Beaux-Arts*, 6th ser., 64 (1962): 125–40, followed *inter alia* by Cox-Rearick, *Collection of Francis I*, pp. 305, 306, 310–11, 312. For the putative wax model, see Jeannine A. O'Grody, "*Nudo virile*," in Pina Ragionieri, ed., *I bozzetti michelangioleschi della Casa Buonarroti* (Florence, 2000), pp. 26–30, no. 1: the same

all-purpose model, as she explains, has been related to other works. Paul Joannides has argued that the lost colossus did not resemble the Capitoline *Hercules* but stood with the right leg crossed over the left. See Paul Joannides, "Michelangelo's Lost Hercules," *Burlington Magazine* 119 (1977): 550–54; and his "A Supplement to Michelangelo's Lost Hercules," *Burlington Magazine* 123 (1981): 20–23; *Michelangelo and his Influence: Drawings from Windsor Castle*, exh. cat., Washington, National Gallery of Art, and elsewhere (Cambridge, 1997), pp. 16, 110; and "Michelangelo *bronzista*: Reflections on his Mettle," *Apollo* 145, N.S. 424 (June 1997): 14. But the known examples of this type seem to be reliefs, figurines, or drawings, and the crossed-leg posture seems unsuitable or at least unwieldy for a free-standing colossus such as Michelangelo's lost work.

66 Piero's likely patronage has been suggested *inter alia* by Elam, "Lorenzo de' Medici's Sculpture Garden," p. 60; Michael Hirst, "Michelangelo, Carrara and the Marble for the Cardinal's Pietà," *Burlington Magazine* 127 (1985): 154–59; and his "Appendice 2," in Paola Barocchi, Katherine Loach Bramanti, and Renzo Ristori, ed., *Il carteggio indiretto di Michelangelo*, 2 vols. (Florence, 1988–95), vol. 2, pp. 323–24. As explained in Hirst, "Appendice 2," p. 324n1, the statue was probably given or sold by Piero to his friend Filippo Strozzi the Younger in 1494. Piero's patronage has been confirmed by Francesco Caglioti, *Donatello e i Medici: Storia del David e della Giuditta*, 2 vols. (Florence, 2000), vol. 1, pp. 262–63, kindly brought to my attention by Professor Hirst.

67 As implied by Lorenzo Strozzi's letter from Venice, 20 June 1506, to Michelangelo's brother Buonarroto in Florence (Florence, Archivio Buonarroti xxvi, no. 118), published in Hirst, "Appendice 2," pp. 323–24. Piero and the Strozzi maintained their friendship, and Piero's kinsmen continued their patronage of Michelangelo. In 1508 Piero's daughter Clarice became Filippo's wife. Piero's brother Giovanni became another patron of Michelangelo's as Pope Leo x. Lorenzo's youngest son, Giuliano, future Duke of Nemours (d. 1516), is buried in Michelangelo's Medici Chapel.

68 Condivi, p. 14; Vasari-Barocchi 6: 12 (1568 only).

69 Believed lost, the Crucifix was identified by Margrit Lisner, "Die Kruzifixus Michelangelos im Kloster S. Spirito in Florenz,"

Kunstchronik 16 (1963): 1–2; and now her "Il Crocifisso ligneo di Michelangelo per il vecchio coro della Chiesa di Santo Spirito a Firenze/The Wooden Crucifix of Michelangelo for the Old Choir of the Church of Santo Spirito in Florence," in Laura Lucchesi et al., *Il Crocifisso di Santo Spirito/The Crucifix of Santo Spirito* (Florence, 2000), pp. 31–68. Although the attribution has been accepted by most scholars, it remains controversial, as explained by Lucchesi, "La fortuna critica del Crocifisso di Santo Spirito/Criticism of the Crucifix of Santo Spirito," in ibid., pp. 25–28. The polychromy and inscription panel (but not the cross itself) are original. For this and other technical information, see Barbara Schleicher, "Il restauro/The Restoration," in ibid., pp. 69–97. After its conservation by Schleicher, the Crucifix was returned to Santo Spirito.

70 Vasari-Barocchi 3: 144–45 (Life of Brunelleschi) and pp. 204–06 (Life of Donatello); p. 206 for the quotation. Dolce mentioned the same criticism of Donatello's Christ: "he had put a peasant onto the Cross"; see Mark W. Roskill, *Dolce's "Aretino" and Venetian Art Theory of the Cinquecento* (New York, 1968), pp. 118–19.

71 The first *Risen Christ* was partly executed between 1514 and 1516. When Michelangelo discovered a black vein in the white marble, he abandoned the statue, beginning work on a new block in Florence in 1519. In March 1520 that statue was sent to Rome to be completed there by Pietro Urbano. Urbano mangled the work, as Sebastiano del Piombo wrote to Michelangelo (6 September 1520), suggesting that he be replaced by Federico Frizzi; Barocchi and Ristori, *Carteggio* 2: 313–15, DXXVIII: "Urbano [. . .] has embarrassed you. [. . .] Everything he has worked has distorted everything," from the toes to the beard. Frizzi completed the *Resurrected Christ*, which was installed at the entrance of the chancel of the church on 27 December 1521. Displeased with the results, Michelangelo offered to do yet another version of the statue, but his patron did not agree. Baccio adapted Christ's raised arm in making the replacement for *Laocoön*'s missing arm. For general information, see Poeschke, *Michelangelo*, pp. 99–101. For the statue's reception – enthusiastic in the sixteenth century, cool in modern times – see William E. Wallace, "Michelangelo's Risen Christ," *Sixteenth Century Journal* 28 (1997): 1251–80. A statue has recently been identified as the first, discarded version; see Irene Baldriga, "The First Version of

Michelangelo's Christ for S. Maria sopra Minerva," *Burlington Magazine* 142 (2000): 740–45, and Silvia Danesi Squarzina, "The Bassano 'Christ the Redeemer' in the Giustiniani Collection," *Burlington Magazine* 142 (2000): 746–51. This *Christ* indeed has a black vein on the left side of the face, running from nose to jaw. The statue is nude though exhibited wearing the *perizoma*. These are suggestive coincidences; whether this is the sculpture begun by Michelangelo, it has become the rather mediocre work of the modest carver who finished it.

72 Francesco Albertini, *Memoriale di molte statue et picture sono nella inclyta cipta di Florentia per mano di sculptori et pictori excellenti moderni et antiqui* (Florence, 1510; rpt. Letchworth, 1909), p. 18. In 1550, Vasari said only that Michelangelo's Crucifix over the high altar was made of wood; in 1568, he added the information published by Condivi. See Vasari-Barocchi 6: 13 (both editions) and Condivi, p. 15. The Anonimo Magliabechiano also took note of Michelangelo's interest in dissection, claiming that he went to a tomb "where there were many remains of the dead"; *Il codice Magliabechiano*, ed. Carl Frey (Berlin, 1892), p. 115. For the practice of dissection in fifteenth- and sixteenth-century Italy, see Katharine Park, "Masaccio's Skeleton: Art and Anatomy in Early Renaissance Italy," in Rona Goffen, ed., *Masaccio's "Trinity"* (Cambridge and New York, 1998), pp. 119–40.

73 Condivi, p. xxi, *postilla* 4D.

74 Condivi himself hoped to publish a study in collaboration with a scholar identified as Realdo Colombo; see Michael Hirst, "Introduction," in Condivi, p. ix.

75 The illustrations were first attributed to Titian by Erica Tietze-Conrat, "Neglected Contemporary Sources Related to Michelangelo and Titian," *Art Bulletin* 25 (1943): 156–59. More recently on the illustrations for *De humani corporis fabrica libri septem* (Basel, Johannes Oporinus, 1543), see David Rosand and Michelangelo Muraro, *Titian and the Venetian Woodcut*, exh. cat., Washington, National Gallery of Art; Dallas Museum of Fine Arts; Detroit Institute of Arts (Washington, 1976), pp. 211–15; and Monique Nicole Kornell, "Artists and the Study of Anatomy in Sixteenth-Century Italy," Ph.D. dissertation, 2 vols. (University of London, Warburg Institute, 1992), vol. 1, pp. 72–75. Kornell argues against the attribution to Titian, noting that his name was first mentioned in relation to Vesalius's work in the seventeenth century. Even so, the illus-

trations speak for themselves, declaring a considerable debt to Titian no matter who made the plates. Professor Bette Talvacchia kindly brought Kornell's dissertation to my attention.

76 Poeschke, *Michelangelo*, p. 71.

77 Vasari-Barocchi 6: 12: "bellissima."

78 Only the *Angel* and the *Petronius* are mentioned in Condivi, p. 17; followed by Vasari-Barocchi 6: 13 (in 1568; but Vasari said nothing about these Bolognese commissions in 1550). See also Giorgio Bonsanti, "Michelangelo Buonarroti, *Statue dell'Arca di San Domenico*," in Weil-Garris Brandt et al., ed., *Giovinezza*, pp. 292–96.

79 For Aldovrandi's conversation with Michelangelo, see Condivi, p. 17.

80 For Michelangelo's re-creation of thirteenth-century facial types, see Alison Luchs, "Michelangelo's Bologna Angel: 'Counterfeiting' the Tuscan Duecento?," *Burlington Magazine* 120 (1978): 222–25. For differences between his handling and that of his predecessors, see Michael Hirst in Hirst and Jill Dunkerton, *Making and Meaning: The Young Michelangelo* (London, 1994), p. 19.

81 Pliny, *Natural History*, trans. D.E. Eichholz (Cambridge, MA, and London, rpt. 1989), XXXVI: 22–23. Dolce repeated the anecdote of the *Venus* stained by an ejaculating worshiper in his *ekphrasis* of Titian's *Venus and Adonis*; see "The Letter of Dolce to Alessandro Contarini," in Roskill, *Dolce's "Aretino*," p. 217; and Rona Goffen, *Titian's Women* (New Haven and London, 1997), p. 246.

82 See Paul F. Norton, "The Lost *Sleeping Cupid* of Michelangelo," *Art Bulletin* 39 (1957): 251.

83 Michelangelo offered to buy the *Cupid* back from Baldassarre, who refused, saying he would sooner smash the "bambino" into "a hundred pieces"; this according to Michelangelo in Rome, writing to Lorenzo di Pierfrancesco (known as il Popolano) in Florence, 2 July 1496; Barocchi and Ristori, *Carteggio* 1: 1–2, 1. The letter was addressed to Sandro Botticelli, presumably because Michelangelo did not want his correspondence with a disgraced Medici to be known (Lorenzo di Pierfrancesco had been expelled two years earlier). Baldassarre displayed the *Cupid* to potential buyers in the house of Cardinal Ascanio Maria Sforza; Norton, ibid., p. 251. In 1485 Riario (1460–1521), nephew of Sixtus IV and cousin of Giuliano della Rovere (the future Julius II), had bought

property in Campo de' Fiori for the construction of a new palace, which became the Cancelleria (Papal Chancellery) after his forced retirement in 1517. On Riario, see Ingrid D. Rowland, *The Culture of the High Renaissance: Ancients and Moderns in Sixteenth-Century Rome* (Cambridge and New York, 1998), pp. 33–41. Given the date of Michelangelo's letter, Riario must have returned the *Cupid* and Baldassarre had already found another client by late June. The episode was recorded by Paolo Giovio in his unpublished Life of Michelangelo, written between 1525 and 1532; see T.C. Price Zimmerman, "Paolo Giovio and the Evolution of Renaissance Art Criticism," in *Cultural Aspects of the Italian Renaissance: Essays in Honour of Paul Oskar Kristeller*, ed. Cecil H. Clough (Manchester, 1976), pp. 408–10. Giovanni Battista Gelli also knew of it; Gelli, "Vite d'artisti," ed. Girolamo Mancini, *Archivio storico italiano*, 5th ser., 17 (1896): 32–62, esp. 36. See also Condivi, pp. 17–18; Vasari-Barocchi 6: 14; and Varchi, *Orazione funerale*, p. 24. For the *Cupid*'s fate and records of its appearance, see Kathleen Weil-Garris Brandt, "Sogni di un *Cupido dormiente* smarrito," in Weil-Garris Brandt et al., ed., *Giovinezza*, pp. 315–17, and the entries on pp. 318–22. In the same volume, see also Christoph Luitpold Frommel, "Raffaele Riario, la Cancelleria, il teatro, e il *Bacco* di Michelangelo," pp. 143–48; Nicoletta Baldini, Donatella Lodico, and Anna Maria Piras, "Michelangelo a Roma: I rapporti con la famiglia Galli e con Baldassarre del Milanese," pp. 149–62; and for the statue itself, Eike D. Schmidt, "Michelangelo Buonarroti, *Bacco*," pp. 362–64.

84 A partner in the bank of the Florentines Giovanni and Baldassare Balducci in Rome, Galli became Michelangelo's banker as well as his host during his first year in Rome. See Christoph Luitpold Frommel, "Jacopo Gallo als Förderer der Künste: Das Grabmal seines Vaters in S. Lorenzo in Damaso und Michelangelos erste römische Jahre," in *Kostinos: Festschrift für Erika Simon* (Mainz, 1992), pp. 450–60, esp. 451–58; and Hirst in Hirst and Dunkerton, *Making and Meaning*, p. 74n15.

85 Barocchi and Ristori, *Carteggio* 1: 1, 1. Payments to Michelangelo, from 18 July 1496 until 3 July 1497, confirm that the work he and the cardinal discussed was the *Bacchus*; and the payments were disbursed by the Balducci bank. Michael Hirst, "Michelangelo in Rome: An Altarpiece and

the 'Bacchus'," *Burlington Magazine* 123 (1981): 581n8, 592–93, Appendix C; and in Hirst and Dunkerton, *Making and Meaning*, p. 31.

86 In 1496 Isabella herself had been uninterested when told about the "perfect" work that seemed to be antique, according to her correspondent, who did not, however, mention the sculptor's name (which in any case would have meant little or nothing to her at that early date). Some time after 1496 Michelangelo's *Cupid* traveled from Rome to Urbino, though the details of its voyage are not known. When Cesare Borgia conquered Urbino in 1502, he took possession of the *Cupid* as well, and then presented it to Isabella with an antique Venus. (Did she realize that this was the sculpture she might have purchased six years earlier?) The two works had arrived in Mantua by 21 July that year, and the following day the marchesa wrote to her husband: "the *Cupid*, for all that it is a modern thing, has no equal." Three years later she acquired a *Cupid* ascribed to Praxiteles which she displayed paragonistically with Michelangelo's work. See Frommel, "Gallo als Förderer," pp. 452–53; Hirst in Hirst and Dunkerton, ibid., pp. 24–28, citing the marchesa's letter of 22 July 1502; C. Malcolm Brown, " 'Lo insaciabile desiderio nostro de cose antique': New Documents on Isabella d'Este's Collection of Antiques," in *Cultural Aspects of the Italian Renaissance: Essays in Honour of Paul Oskar Kristeller*, ed. Cecil H. Clough (Manchester and New York, 1976), pp. 324–53; Sylvia Ferino Pagden et al., "*La prima donna del mondo": Isabella d'Este, Fürsten und Mäzenatin der Renaissance*, exh. cat., Vienna, Kunsthistorisches Museum (Vienna, 1994), pp. 310–16. Acquired by King Charles I of England in the early 1630s, the *Cupid* was lost in a fire at Whitehall in 1698. For Cornelius Vermeule's notes on the drawings of the statues in a Royal Collection volume of the Whitehall collection made before the fire, see A.H. Scott-Elliot, "The Statues from Mantua in the Collection of King Charles I," *Burlington Magazine* 101 (1959): 223, no. 29. Michelangelo's *Cupid* may survive in a detail of Jacopo Tintoretto's *Venus and Mars Surprised by Vulcan* (Munich, Alte Pinakothek), as suggested by Tolnay, *Michelangelo*, vol. 1: *The Youth of Michelangelo*, pp. 201–03.

87 This documented instance of Michelangelo's dissembling about patronage is of a pattern with his (or Condivi's) misleading claims about the patronage of the lost *Hercules*. For another rejection of a commissioned work with an even happier, more lucrative, ending, see p. 306 above.

88 Heemskerck's drawing is in Berlin, Kupferstichkabinett. For Galli's collection of ancient sculpture, see Kathleen Weil-Garris Brandt, "Michelangelo a Roma: il giardino dei Galli," in Weil-Garris Brandt et al., ed., *Giovinezza*, p. 350. As she explains, p. 351, the *Bacchus* was acquired by the Medici in 1572 and transported to Florence at that time.

89 Summers, *Michelangelo*, p. 265.

90 Vasari-Barocchi 6: 15.

91 For the letter, written after 16 April 1542, see Pietro Aretino, *Lettere sull'arte di Pietro Aretino*, ed. Fidenzio Pertile and Ettore Camesasca, 3 vols. (Milan, 1957–60), vol. 1, p. 247; and the incisive analysis of the letter in relation to Sperone Speroni's *Dialogue* in Mary Pardo, "Artifice as Seduction in Titian," in *Sexuality and Gender in Early Modern Europe: Institutions, Texts, Images*, ed. James Grantham Turner (Cambridge and New York, 1993), p. 77. See also Rona Goffen, *Titian's Women*, p. 142, and p. 313n79 for Aretino's allusion to Plato's *Symposium*.

92 I have slightly modified the translation in Roskill, *Dolce's "Aretino,"* p. 141.

93 Ibid., p. 143, with some changes in the translation. In Venetian parlance, *gentiluomo* signified a nobleman, so I have translated that word accordingly. For Dolce's distinction between muscular and soft or fleshy nudes, see also Elizabeth Cropper, "The Place of Beauty in the High Renaissance and its Displacement in the History of Art," in *Place and Displacement in the Renaissance*, ed. Alvin Vos (Binghamton, NY, 1995), pp. 185–86.

94 When the hermaphrodite is asleep, as in the type attributed to Polykles of Athens, the beholder is surprised, or intended to be so, at the first sight of the genitals of the sleeping "woman." Other hermaphrodites startle with the sight of an erect penis. For hermaphrodites and their "shock value," see Andrew Stewart, *Art, Desire, and the Body in Ancient Greece* (Cambridge and New York, 1997), p. 228. Stewart cites one hermaphrodite who is endowed with both a penis and a vulva.

95 He may have been influenced by ancient literary descriptions of a feminized Bacchus, e.g., the *Bacchae* of Euripides. For this and for different kinds of effeminacy in depictions of Bacchus, Apollo and Hercules, see Stewart, ibid.

96 For statues of Antinous, see Diana E. E. Kleiner, *Roman Sculpture* (New Haven and London, 1992), pp. 243–44.

97 Tullio Lombardo's statue was made for the tomb of Doge Andrea Vendramin (d. 1478), formerly in the church of Santa Maria dei Servi, Venice (now in Santi Giovanni e Paolo), c. 1489–93, signed on the base: TVLLII. LOMBARDI. O[PVS]. See Alison Luchs, *Tullio Lombardo and Ideal Portrait Sculpture in Renaissance Venice, 1490–1530* (Cambridge and New York, 1995), pp. 44–45. In addition to the *Bacchus*, *Adam* seems to have influenced the feminized "pensive youths" of such works by Giorgione as the *Boy with an Arrow* and the *Shepherd with a Flute* (ibid., p. 73). Discussing the *Bacchus*, Hirst observes that variations in finish and the "widespread use of a drill" are "at odds with much later fifteenth-century Florentine practice"; in Hirst and Dunkerton, *Making and Meaning*, pp. 34–35. I suggest that such works as Tullio's may have influenced Michelangelo's "unFlorentine" handling and technique.

98 Sansovino had just returned to Florence from Rome when he received the first payment for the *Bacchus*, 26 March 1510, commissioned by Giovanni Battista Bartolini for the garden of his new palace in Florence. After Bartolini's death in 1544, c. 1550, his brother presented the statue to Cosimo I. In 1553 the *Bacchus* was installed in a chamber of the ducal apartments in Palazzo Vecchio, displayed with Michelangelo's *Apollo-David* and Bandinelli's *Bacchus*. See Bruce Boucher, *The Sculpture of Jacopo Sansovino*, 2 vols. (New Haven and London, 1991), vol. 1, pp. 3, 14; vol. 2, p. 317, cat. 6. For Sansovino's rivalry with Michelangelo, culminating in the Apostle series for Florence cathedral, see John Pope-Hennessy, *Italian High Renaissance and Baroque Sculpture*, Part 3 of An Introduction to Italian Sculpture, 3 vols. (London, 1963), vol. 1, p. 43.

99 Varchi in Paola Barocchi, ed., *Trattati d'arte del Cinquecento*, 3 vols. (Bari, 1960–62), vol. 1, pp. 48–49.

100 Vasari-Barocchi 6: 181. Sansovino's *Bacchus* is seen as Cellini's "locus classicus of two-figure sculpture"; John Pope-Hennessy, *Cellini* (New York, 1985), p. 229.

101 Vasari-Barocchi 6: 15.

102 For Condivi's emphasis on literary rather than visual sources, see Summers, *Michelangelo*, p. 265.

103 Pliny, *Natural History, Books XXXIII–XXXV*, XXXIV: 69. Although the text is undeniably mangled, its relation to Michelangelo's *Bacchus* is clear; see Summers, *Michelangelo*, pp. 265–68.

104 Summers, ibid., p. 265.

105 Hirst in Hirst and Dunkerton, *Young Michelangelo*, p. 32, adding that the subject was more frequently represented in reliefs than in freestanding figures.

106 Condivi, p. 19. Condivi misidentified the pelt that Bacchus holds as a tiger skin (Bacchus' cat is the panther), explaining that the tiger is a grape-loving animal. He added that Michelangelo represented the skin and not the living beast to show that overindulgence leads to death (the passage quoted above). Condivi also mistook Bacchus' garland of grapes and ivy for grapevines, as noted by Wind, *Pagan Mysteries*, p. 184.

107 See Craig Hugh Smyth, "Venice and the Emergence of the High Renaissance in Florence: Observations and Questions," in *Florence and Venice: Comparisons and Relations*, vol. 1: *Quattrocento* (Florence, 1979), pp. 209–49.

108 See Rona Goffen, "*Allegorie*," in Goffen and Nepi Scirè, ed., *Il colore ritrovato*, pp. 134–35.

109 Galli's statue depicted either Cupid (according to Vasari and Condivi) or Apollo (according to Ulisse Aldovrandi, describing Galli's collection in 1533). A marble statue now in New York, Services Culturelles de l'Ambassade de France, was first identified as Galli's statue by Alessandro Parronchi, *Michelangelo scultore* (Florence, 1969), pp. 17, 34. Recently the case for an attribution to Michelangelo has been argued by Kathleen Weil-Garris in various publications, including "A Marble in Manhattan Attributed to Michelangelo," *Burlington Magazine* 138 (1996): 644–59, and "I primordi di Michelangelo scultore," in Weil-Garris Brandt et al., ed., *Giovinezza*, pp. 84–96. The attribution has been rejected by most other scholars.

110 Abbot of Saint-Denis, French ambassador to the papal court, and, from 1493, cardinal of Santa Sabina, de Bilhères died on 6 August 1499. He had acquired his funerary chapel in Santa Petronilla by 7 April 1498. The contract with Michelangelo is dated 27 August 1498, though by November the previous year the sculptor had already gone to Carrara to select marble for the statue, riding a horse paid for by the cardinal. The *Pietà* had been moved from its original site by 1524, even before the destruction of Santa Petronilla during the construction of New Saint Peter's. The *Pietà* was installed in its present site, the Cappella del Crocefisso, the first chapel

on the right of Saint Peter's, in 1749. See Condivi, pp. 19–20; Vasari-Barocchi 6: 16–18; Kathleen Weil-Garris Brandt, "Michelangelo's *Pietà* for the Cappella del Re di Francia," in *"Il se rendit en Italie": Etudes offertes à André Chastel* (Paris, 1987), pp. 77–108; and William E. Wallace, "Michelangelo's Rome *Pietà*: Altarpiece or Grave Memorial?," in *Verrocchio and Late Quattrocento Italian Sculpture*, ed. Steven Bule, Alan Phipps Darr, and Fiorella Superbi Gioffredi (Florence, 1992), pp. 243–55.

111 Now in the Grotte of Saint Peter's, the cardinal's tomb slab is carved with an effigy of the deceased in his ecclesiastical robes, his head on a pillow and a dedicatory inscription on a plaque at his feet. See Weil-Garris Brandt, ibid., pp. 82, 97n61 (with a transcription of the inscription); and Wallace, ibid., fig. 197. As argued by Wallace, the *Pietà* served as the cardinal's grave memorial; by Weil-Garris Brandt, that it was the chapel altarpiece. In either case, the sculpture is unfinished (or less highly finished) in the back, indicating that it was made to be set against a wall, as noted by Weil-Garris Brandt, p. 84.

112 The text comes from a letter addressed by the cardinal to the Anziani of Lucca, asking those officials to assist in Michelangelo's quarrying and transporting the marbles (the cardinal used the plural, "li marmi") for the statue. The cardinal's language indicates that the commission was already under way: "Newly (*novamente*) we are agreed with master Michelangelo [. . .] that he make a *Pietà*." For a transcription, see Giorgio Chiarini in Paola Barocchi and Giorgio Chiarini, *Michelangelo: Mostra di disegni, manoscritti e documenti* (Florence, 1964), pp. 102–03, CXVIII. (The transcription in Milanesi, *Lettere*, p. 613n1, reads "una pietra di marmo," an error for "pietà.") Michelangelo's trip in fall 1497 is confirmed by two payments to him from the bankers Baldassare and Giovanni Balducci, dated 18 November 1497, one for the purchase of the dapple gray horse used for the trip and the other for travel expenses. The sculptor's presence in Florence on 29 December 1497 is confirmed by another record in the Balducci account books. Perhaps he had already been to the Carrara quarries by that date. He was back in Rome by 10 March 1498, the date of a recorded repayment of 30 ducats to the exiled Piero de' Medici. The marble for the *Pietà* arrived in mid-June 1498, was unloaded on 19 June, and transported to Michelangelo's shop ("fare portare e marmi

a chasa") on 30 August, three days after the signing of the final contract for the statue. For these various historical records, see Hirst, "Michelangelo, Carrara."

113 Milanesi, ibid.

114 For the contract in Florence, Archivio Buonarroti, II, 1, see Milanesi, ibid., pp. 613–14, and Giorgio Chiarini in Barocchi and Chiarini, *Michelangelo*, pp. 102–03. According to both Weil-Garris Brandt and Hirst, "Michelangelo, Carrara," p. 159, the contract suggests a "shift in design" from what was originally described (Weil-Garris Brandt, "Michelangelo's 'Pietà,'" p. 81), but I am not convinced of this.

115 My translation; Brunetto Latini, *Li livres dou tresor*, quoted in James D. Garrison, *Pietas from Vergil to Dryden* (University Park, PA, 1992), pp. 14–15. These authors followed the Aristotelian distinction between *pietà* (which may mean "piety" or "pity") and *misericordia*, "mercy" (Garrison, p. 14). Lorenzo Valla likewise insisted on this distinction (Garrison, p. 40). For biblical precedents for the word "pietà," see Tadeusz Dobrzeniecki, "Medieval Sources of the Pietà," *Bulletin du Musée National de Varsovie* 7 (1967): 5–24.

116 For Alciati's *Emblemata* (1531) illustration of *Pietas*, titled "Pietas filiorum in parentes," and other such depictions, see Garrison, *Pietas*, pp. 49–52.

117 Ibid., p. 53.

118 Ibid., pp. 53, 55.

119 Ibid., pp. 59–60.

120 Condivi, pp. 19–20; my italics. The *Pietà*'s "single piece of marble" is also mentioned by Varchi, *Orazione funerale*, pp. 24–25. For the significance of a sculpture made from a single block, an achievement extolled by classical authors, see Irving Lavin, "The Sculptor's 'Last Will and Testament'," *Allen Memorial Art Museum Bulletin* 35, 1–2 (1977–78): 4–39, and his "*Ex Uno Lapide*: The Renaissance Sculptor's *Tour de Force*," in *Il Cortile delle Statue: Der Statuenhof des Belvedere im Vatikan: Akten des internationalen Kongresses zu Ehren von Richard Krautheimer*, ed. Matthias Winner, Bernard Andreae, and Carlo Pietrangeli (Mainz, 1998), pp. 191–210; see also pp. 119, 120 above. The inscription on Beatrizet's engraving of the *Pietà*, 1547, praises the monument for its being hewn from a single block; see Wallace, "Michelangelo's Rome *Pietà*," p. 254n41. "One piece of stone" was also a desideratum in architecture, in relation to the ideal of the monolithic column; see William E. Wallace, *Michelangelo at San Lorenzo:*

The Genius as Entrepreneur (Cambridge and New York, 1994), pp. 48–51.

121 Most scholars agree that the original setting included a cross behind the *Pietà*, as Condivi's description seems to suggest. The *Pietà* was in fact displayed before a cross in 1575; see Weil-Garris Brandt, "Michelangelo's 'Pietà'," p. 85. Punning on the saint's name (Peter, *petra*, rock), Christ had called him the rock on which he would build his church (Matt. 16: 18). The rock may also refer to Saint Petronilla, Saint Peter's daughter. For these various petrine associations, and *Maria super petram* as an image of Mater-Ecclesia, see also Weil-Garris Brandt, p. 80; and Wallace, "Michelangelo's Rome *Pietà*," pp. 250–51.

122 The open gesture made the hand vulnerable to breakage, and it required repair in 1736 by the sculptor Giuseppe Lironi. These repairs were minor, however; see Irving Lavin, "Michelangelo's Saint Peter's Pietà: The Virgin's Left Hand and Other New Photographs," *Art Bulletin* 48 (1966): 103–04.

123 Rona Goffen, *Giovanni Bellini* (New Haven and London, 1989), pp. 67, 94, 299n48. The painting is signed in Gothic miniscule: "Ioannes bellinus pingebat." Perhaps Bellini meant to evoke Ovid's description of Arachne's weaving in *Metamorphoses* VI, l. 23: "seu pingebat acu." For the significance of the imperfect tense of the verb in signatures, see pp. 114–15, 116, 117, 291, 292 above.

124 Condivi, p. 19; Vasari-Barocchi 6: 16.

125 As noted by Weil-Garris Brandt, "Michelangelo's 'Pietà'," p. 80. For the theme in France, see William H. Forsyth, *The Entombment of Christ: French Sculptures of the Fifteenth and Sixteenth Centuries* (Cambridge, MA, 1970).

126 Such as the *Pietà with Donors* from the chapel of the château de Biron, cited by Wallace, "Michelangelo's Rome *Pietà*," p. 246.

127 From Villeneuve-lès-Avignons, Charterhouse, c. 1470. William H. Forsyth postulated that this compositional type originated with Claus Sluter's lost *Pietà* for Champmol, c. 1390, in which the body of Christ lay across Mary's lap "in an almost unbroken curve"; "Medieval Statues of the Pietà in the Museum," *Metropolitan Museum of Art Bulletin* 11 (1953): 180–81.

128 I should have thought of this myself but it was necessary for Paul Joannides to remind me. See Ronald Lightbown, *Sandro Botticelli*, 2 vols. (Berkeley and Los Angeles, 1978), vol. 2, pp. 74–75, B61. Poliziano had assumed the *priorato* of the church in 1477.

129 The statue is 1.74 meters high, according to Tolnay, *Michelangelo*, vol. 1, p. 45. As noted by Wallace, there were such monumental Italian precedents as Niccolò dell'Arca's *Lamentation* group, which Michelangelo had seen in Santa Maria della Vita in Bologna; Wallace, "Michelangelo's Rome *Pietà*," p. 253.

130 Mary's gesture in the *Pietà*, like Christ's in the *Last Supper*, suggests "the still acceptance of the Divine Will"; Wilde, "Michelangelo and Leonardo," p. 66.

131 Ibid., pp. 65–66. Michelangelo's drawing of the *Madonna and Child and Saint Anne* (Fig. 81), inspired by Leonardo's invention and so datable after its display at the Annunziata in summer 1501; Tolnay, *Corpus*, 1: 35–36, 17r.

132 For Leonardo's emulation of Michelangelo's "formal or sculptural style of drawing" in 1501, see Kenneth Clark with Carlo Pedretti, *The Drawings of Leonardo da Vinci in the Collection of Her Majesty the Queen at Windsor Castle*, 3 vols. (London, 2nd ed. 1968), vol. 1, p. xxvii.

133 Vasari-Barocchi 6: 16.

134 Wilde, "Michelangelo and Leonardo," p. 66.

135 Ibid. These patterns are foreshadowed in an early drawing of a "Mourning Woman" attributed to Michelangelo, formerly in the Castle Howard collection, sold at Sotheby's, London, 11 July 2001.

136 Vasari-Barocchi 4: 17. On his models and early drapery studies, see David Alan Brown, *Leonardo*, pp. 79–82; and Laurie Fusco, "The Use of Sculptural Models by Painters in Fifteenth-Century Italy," *Art Bulletin* 64 (1982): 175–94.

137 Wilde, "Michelangelo and Leonardo," p. 66.

138 See Rona Goffen, "Signatures: Inscribing Identity in Italian Renaissance Art," *Viator* 32 (2001): 320–25, with bibliography; and Aileen June Wang, "Michelangelo's Signature," *Sixteenth Century Journal*, forthcoming.

139 For the Latin text and a translation, see Michael Ayrton, *Giovanni Pisano Sculptor* (New York, 1969), p. 160. Vasari abbreviated the inscriptions in his biography, because they could be "boring to the reader"; Vasari-Barocchi 2: 69. For Giovanni's boastful signature on the Pistoia pulpit, see p. 4 above.

140 Such a signature may be called "*perlocutionary*, one that *causes* the beholder to do something"; Claude Gandelman, "The Semiotics of Signatures in Painting: A Peircian Analysis," *American Journal of Semiotics* 3, 3 (1985): 94.

141 Written on the upper edge of the frame, Andrea's inscription commemorates the date of completion of his wax prototype in spring 1330; the doors themselves were not installed until June 1336. Andrea's choice of the date in his signature thus privileges the conception or idea of the doors over their execution. See Anita Fiderer Moskowitz, *The Sculpture of Andrea and Nino Pisano* (Cambridge, 1986), pp. 1, 8, and p. 201, doc. 32.

142 Installed in 1424; see Richard Krautheimer and Trude Krautheimer-Hess, *Lorenzo Ghiberti*, 2 vols. (Princeton, 1970), vol. 1, pp. 131–32. Until 1442 the sculptor signed his name simply as "Lorenzo" but thereafter began to sign as the son of Cione Ghiberti, identifying himself more fully but perhaps fraudulently; ibid., pp. 3–4.

143 The inscription on the hexagonal base was discovered during the restoration of the statue in 1972; Francesco Valcanover, "Il San Giovanni Battista di Donatello ai Frari," *Quaderni della Soprintendenza ai Beni Artistici e Storici di Venezia* 8 (1979): 23–32. For the sculptor's signatures, see H.W. Janson, *The Sculpture of Donatello* (Princeton, 1963), vol. 1, pp. 33–41, 77, 101–02, 151–61, 198–205, 215 and n. 7. Except for the tomb slab of Giovanni Pecci in Siena cathedral, c. 1426–30 (Janson, pp. 75–77 and fig. 32a), all Donatello's known signatures specify his nationality, including the Erevan *Madonna*, a relief recently attributed to him c. 1425; see Charles Avery, *Donatello: Catalogo completo delle opere*, trans. Tania Gargiulo and Rossella Foggi (Florence, 1991), p. 36.

144 For Michelangelo's signature as the first Renaissance *faciebat*, ten years after Poliziano's commentary in *Miscellanea*, see Vladimir Juřen, "Fecit faciebat," *Revue de l'art* 26 (1974): 29, and *passim* for the formula in Renaissance signatures.

145 Pliny, *Natural History, Preface and Books 1–2*, trans. H. Rackham (Cambridge, MA, and London, rpt. 1997), pp. 16–19 (Preface, 26). Pliny included this passage in his Preface as his own "disclaimer of completeness"; see Michael Baxandall, *Giotto and the Orators: Humanist Observers of Painting in Italy and the Discovery of Pictorial Composition 1350–1450* (Oxford, 1971), p. 64, for this and for Petrarch's suggestive misinterpretation of the text.

146 Much of this discussion is taken from Rona Goffen, "Signatures." Annotating his copy of Pliny's *Natural History*, Petrarch drew a pointing hand (*manicula*) in the margin next to this passage (xxiv.65) and the injunction,

"Watch out for this, Francesco, when you are writing"; see Baxandall, *Giotto and the Orators*, p. 63.

147 For this passage in the *Liber miscellaneorum* (Basel, 1553), 264, see Juřen, "Fecit faciebat," p. 28, and n. 8 for the Latin text. Poliziano was visiting Rome with Piero de' Medici.

148 For the signature, see Janson, *Donatello*, p. 77, and John Shearman, *Only Connect . . . : Art and the Spectator in the Italian Renaissance* (Washington and Princeton, 1992), p. 14.

149 The omission of "the final 'T' (though there was room for it)" constitutes "a visual pun"; see Weil-Garris Brandt, "Michelangelo's 'Pietà'," p. 93. For another suggestive truncation of words on a drawing by Michelangelo, see p. 131 above.

150 Armando Petrucci, *Public Lettering: Script, Power, and Culture*, trans. Linda Lappin (Chicago and London, 1993), p. 30. See also p. 29, for Michelangelo's having been taught "the commercial hand, *mercantesca*, which he later abandoned for the chancery italic hand," which he wrote with "great care." Michelangelo also insisted that his nephew Lionardo learn to write "an elegant, legible hand." Michelangelo's writing in letters and poems is thus differentiated from the trilingual inscription of the early wooden Crucifix (Fig. 40) "with elongated forms echoing Romanesque models then common in Tuscany." Regarding Michelangelo's epigraphy, see now Wang, "Michelangelo's Signature."

151 Aileen June Wang generously shared her observations and photographs of the sculpture, clarifying the treatment of the band. The band ends in a kind of tightly compressed tassle at Mary's waist, visible in Poeschke, *Michelangelo*, pl. 19. At Mary's shoulder, the band disappears under her veil but does not reappear in the back. Admittedly, too much should not be made of this fact, given the comparative unfinish of the back, which would not have been visibile when the statue was *in situ*. Cf. *David*, completely finished in the round, including the band of the sling down his back.

152 Pollaiuolo's inscriptions honor his multimedia fame. The tomb of Sixtus IV is inscribed "The work of Antonio Pollaiuolo the Florentine, famous in silver, gold, painting, and bronze," with the date 1493, on the small plaque between the pope's feet. The undated inscription on the tomb of Innocent VIII a few years later enumerates Pollaiuolo's

specialties and cites his own earlier monument for Sixtus: "Antonio Pollaiuolo, famous in gold, silver, bronze and painting, he who finished the sepulcher of Sixtus here by himself brought to an end the work he had begun." For the tombs and their Latin inscriptions, see Philipp Fehl, "Death and the Sculptor's Fame: Artists' Signatures on Renaissance Tombs in Rome," *Biuletyn historii sztuki* 59 (1997): 197–98 (Sixtus) and pp. 199, 202, 203 (Innocent). Innocent's tomb also includes a shorter, inconspicuous signature on a plaque at the pope's right foot: OPVS. ANTONII.DEFLORENTIA.

153 Vasari-Barocchi 6: 17, in the 1550 edition, emended in 1568; see p. 117 above. Benedetto Varchi offered a similar explanation of the signature in *Orazione funerale di Michelangelo Buonarroti* (Florence, 1564), p. 24.

154 Weil-Garris Brandt, "Michelangelo's 'Pietà'," p. 93. Pollaiuolo had preceded him in doing this, as explained above.

155 Ibid., pp. 84–85. Suggesting an installation of the sculpture recessed in the wall behind the altar, Weil-Garris Brandt adduces such comparisons as Andrea Sansovino's *Saint Anne, the Virgin and Child* (1510–12) and Jacopo Sansovino's *Madonna del parto* (commissioned in 1516), both in the church of Sant'Agostino in Rome and both postdating the *Pietà*. An earlier example in a different medium is Masaccio's *Trinity* in Santa Maria Novella in Florence, obviously known to Michelangelo. The fresco served as the altarpiece of a funerary chapel, with the altar set in front of the image. See Goffen, ed., *Masaccio's "Trinity."*

156 Billi, *Libro*, ed. Ficarra, p. 70. Written before Vasari's *Lives* and perhaps also before Gelli's, Billi's *Libro* on Florentine painters, sculptors, and architects starts with Cimabue and culminates in Michelangelo. The phrase "fare stupire tutti gli intelligenti" echoes Petrarch's praise of his *Madonna* by Giotto in the poet's testament and seems to have become a trope in the sixteenth century. For the relevant passage, quoted from the edition of Petrarch's works published in Basel in 1554, see Roberto Salvini, *Giotto bibliografia* (Rome, 1938; rpt. 1970), p. 5, no. 11. On sixteenth-century views of the statue, see Rebekah Smick, "Evoking Michelangelo's Vatican *Pietà*: Transformations in the Topos of Living Stone," in *The Eye of the Poet: Studies in the Reciprocity of the Visual and Literary Arts from the Renaissance to the Present*, ed. Amy Golahny (Lewisburg and London, 1996), pp. 23–52.

157 Vasari-Barocchi 6: 18; Giorgio Vasari, *Le vite de' più eccellenti architetti, pittori, et scultori italiani insino a' tempi nostri nell'edizione per i tipi di Lorenzo Torrentino Firenze 1550*, ed. Luciano Bellosi and Aldo Rossi, introduction by Giovanni Previtali (Turin, 1986), p. 886; and Condivi, pp. 20–21.

158 There are some exceptions: RAPHAELLO URB is written just above Mary's foot in Raphael's *La Belle Jardinière*, and the date M.D.V.III next to her elbow. Name and date are very hard to discern among the gold motifs of the borders. Inscriptions on garments may also be words spoken by the subject, as in Verrocchio's *Christ and Saint Thomas* for Orsanmichele.

159 Giovio, *De viris illustribus*, quoted in Zimmerman, "Giovio and Art Criticism," p. 412, with the Latin text in n. 35.

160 Vasari-Barocchi 6: 411.

161 Vasari-Barocchi 6: 17 (1550), quoted in full above, p. 116.

162 See Karl Frey and H.W. Frey, ed., *Der literarische Nachlass Giorgio Vasaris*, 3 vols. (Munich, 1923–40), vol. 2, pp. 64–66, CDXXXVIII. Frey, p. 64, suggested that the letter was written either 18 or 24–25 March 1564 but put queries after the names of possible authors and even after Vasari's name as recipient, though Vasari obviously read it. This paragraph and the following are taken from Goffen, "Signatures."

163 Vasari-Barocchi 6: 17 (1568).

164 The lion pun does not refer to Leonardo, of course, but to Isaac Newton. With these words, Jean Bernoulli recognized Newton as the author of an anonymous solution to a mechano-geometrical problem; see Joannis Bernoulli, "Lettre a Monsieur Basnage," dated June 1697, in *Opera omnia* (Lausanne and Geneva, 1742), vol. 1, p. 196 (no. 38, "Sur le problème des isoperimetres"). See also Dereck Gjertsen, *The Newton Handbook* (London and New York, 1986), p. 68. I owe these references to the generosity and erudition of Professor Antoni Kosinski of the Department of Mathematics, Rutgers University. Perhaps Leonardo made *not* signing fashionable, because by the time the Venetian painter-theoretician Paolo Pino published his *Dialogo di pittura* in 1548, he felt it necessary to defend the use of signatures. See Paolo Pino, "Dialogo di pittura," in *Trattati d'arte del Cinquecento fra manierismo e controriforma*, ed. Paola Barocchi (Bari, 1960), pp. 124–26; and Mary Pardo, "Paolo Pino's 'Dialogo di pittura': A Translation with Commentary," Ph.D.

dissertation (University of Pittsburgh, 1984), pp. 355–57.

165 Born in Milan, Cristoforo Solari (c. 1468–1524) was employed by Lodovico Sforza during most of the years of Leonardo's association with the court. Like Leonardo, Cristoforo fled Milan after Lodovico's defeat in fall 1499 and later returned to the city where, in 1508, he served on a commission with Leonardo and other masters to advise about construction of the cathedral choir stalls. See Richard Schofield and Janice Shell, in *The Dictionary of Art*, ed. Jane Turner (London and New York, 1996), vol. 29, pp. 23–25, *s.v.* Cristoforo Solari (il Gobbo). For the *Bust of the Redeemer* usually attributed to Solari in Venice, San Pantalon, which derives from Christ in Leonardo's *Last Supper*, see the catalog entry by Maria Teresa Fiorio in Giovanna Nepi Scirè, Pietro C. Marani, et al., *Leonardo and Venice*, exh. cat., Venice, Palazzo Grassi (Milan, 1992), p. 398. The attribution was accepted by John Pope-Hennessy, *Italian Renaissance Sculpture* (London and New York, rev. ed. 1971), pp. 326–27, with further information about the sculptor. Cristoforo's painter-brother, Antonio (c. 1465–before 8 August 1524), was a close follower of Leonardo's. See David Alan Brown, in *Dictionary of Art*, vol. 29, pp. 25–26, *s.v.* Antonio Solari.

166 Solari and Bellini had become friendly during the sculptor's sojourn in Venice; see p. 60 and chapter 3, n. 78 above. The letter describing their friendship was addressed to Cardinal Francesco Todeschini Piccolomini – Michelangelo's patron in Siena cathedral.

167 Vasari-Barocchi 6: 16; also Condivi, p. 20.

168 So described in both editions: Vasari-Barocchi 6: 18–19. Vasari misidentified the perpetrator as Simone da Fiesole, who seems to have existed only in his imagination. The hapless sculptor was Bartolomeo di Pietro, called Bacellino. The Simone myth is debunked in Charles Seymour, Jr., *Michelangelo's David: A Search for Identity* (Pittsburgh, 1967), pp. 23–24. Michelangelo's first contract for the statue, 16 August 1501, described the block as "male abozatum," without laying blame for this "bad blocking out"; Giovanni Poggi, ed., *Il Duomo di Firenze: Documenti sulla decorazione della chiesa e del campanile tratti dall'Archivio dell'Opera* (1909), ed. Margaret Haines, 2 vols. (Florence, rpt. 1988), doc. 449.

169 Poggi, ed., ibid., vol. 1, pp. 80–82, no. 437 (the contract for the first figure, the "ghughante overo Erchole," 16 April 1463)

and no. 441 (the contract for the "gughante . . . profeta," 18 August 1464). The ellipses indicate that the prophet's name has been lost. See also Seymour, *Michelangelo's David*, pp. 23–24, 36–38, arguing that Agostino di Duccio was hired as Donatello's assistant in making the *Giant*. Because Donatello, not Agostino, was to have designed the figure, Agostino's contract was cancelled 30 December 1466, a few days after Donatello's death. Seymour, p. 90n18, cites a report of 1525 identifying Donatello as the master first entrusted with the *David* block and publishes the contract with Agostino di Duccio, pp. 126–31.

170 See Irving Lavin, "Bozzetti and Modelli: Notes on Sculptural Procedure from the Early Renaissance through Bernini," in *Stil und Uberlieferung in der Kunst des Abendlandes: Akten des 21. Internationalen Kongresses für Kunstgeschichte in Bonn 1964*, vol. 3: *Theorien und Probleme* (Berlin, 1967), p. 98; Seymour, *Michelangelo's David*, pp. 130–33; and Poggi, *Duomo di Firenze*, p. 444.

171 Pliny, *Natural History* XXXVI.iv.37; see also pp. 351, 357, 360, 371–72 above.

172 In the normal course of events, the rough spot would have been invisible to anyone but himself; it was discovered only when the statue was cleaned in the eighteenth century. See Seymour, *Michelangelo's David*, p. 24.

173 *Deliberazioni degli Operai dal 1406 al 1507*, carta 186, first published by Giovanni Gaye, *Carteggio inedito d'artisti dei secoli XIV.XV.XVI*, 3 vols. (Florence, 1840; rpt. Turin, 1968), vol. 2, p. 454; rpt. with slight emendations by Poggi, *Duomo di Firenze*, p. 448; and Seymour, *Michelangelo's David*, 134–37, doc. 36. The Operai assigned the block to Antonio Rossellino in 1476, but he was able to do little or nothing with it by the time of his death the following year; Seymour, pp. 134–35, doc. 34. Seymour, p. 38, notes that the descriptions of the block in 1501 indicate that it had legs on which it could stand and a breast on which there was a "node" that Michelangelo removed on 9 September (see p. 122 above). The record of the inspection on 2 July 1501 provides the first mention of the "spoiled block," as explained by Saul Levine, "The Location of Michelangelo's *David*: The Meeting of January 25, 1504," *Art Bulletin* 65 (1974): 45–46. The complication of the spoiled block is mentioned again in the contract of 16 August with Michelangelo. By the time Condivi and Vasari described the making of

the *David*, the problem of the block had become part of its legend.

174 The name was lost from the record of 18 August 1464 (see n. 169 above). The passage regarding the Operai's intentions for the statue's use is analysed in N. Randolph Parks, "The Placement of Michelangelo's *David*: A Review of the Documents," *Art Bulletin* 57 (1975): 561. He argues, p. 562, that in July 1501 the Operai still intended to install it on a buttress because no other site is mentioned in the documents; but documents do not record everything. Michelangelo's fee in his first contract (16 August 1501) was 144 florins, increased to 400 florins in a revised agreement noted on 25 and 28 February 1502, which also extended his stipulated date of completion by six months to 25 February 1504. See the unnumbered note in Milanesi, *Lettere*, p. 622.

175 For the possibility of Leonardo's receiving the *David* commission, see Vasari-Barocchi 6: 18. In 1568 but not in 1550, Vasari also mentioned discussion that the block be given to the sculptor Andrea Contucci, that is, Andrea Sansovino, who apparently actively sought the commission. For his competition with Michelangelo, see p. 238 above.

176 Ariosto, *Orlando furioso*, XXXIII, ii. See Clark Hulse, *The Rule of Art: Literature and Painting in the Renaissance* (Chicago and London, 1990), pp. 2, 4, 6, 181n4. The 1532 edition was the last published during Ariosto's lifetime; he died in 1533. Aretino emended Ariosto's encomium: "More than Angel, Divine." Ariosto's reference to Titian in the same canto associates him with Raphael and Sebastiano: "Sebastiano, Raphael and Titian, who brings honor to Cadore no less than the other two to Venice and Urbino."

177 Vasari-Barocchi 6: 19. For the payment documents of 14 October 1501 (the walls) and 20 December 1501 (the roof), see Karl Frey, "Studien zu Michelagniolo Buonarroti und zur Kunst seiner Zeit, III," *Jahrbuch der königlich preuszischen Kunstsammlungen*, Beiheft 13 (1909): 107, nos. 12, 13.

178 "I pray you that you get all those drawings, that is, all those papers that I put in that sack that I told you about, and that you make a bundle and send it to me by wagon. But see that you wrap it well for love of the water [i.e., to avoid water damage], and take care, when you wrap it, that the least paper not be damaged"; Barocchi and Ristori, *Carteggio* 1: 12, VII (for the editors' suggestion that the drawings might have been related to plans for Julius's tomb, see p. 363n3). Michelan-

gelo was particularly concerned about the danger of water damage because a shipment of marble for the tomb had just been involved in a storm at sea. See also Milanesi, *Lettere*, p. 7, n. 2.

179 His father hasn't answered, Michelangelo accuses, "because you don't read my letters"; Barocchi and Ristori, *Carteggio* 1: 121, LXXXIX, 4 October 1511.

180 Although many of Leonardo's compositions and individual motifs were widely copied, few if any reproductive prints were made of his completed works, aside from a "few undistinguished prints after *The Last Supper*"; see A. Richard Turner, *Inventing Leonardo* (Berkeley and Los Angeles, 1992), p. 59. An adaptation of the *Last Supper* appeared in Venice very shortly after it was unveiled, and figural motifs from it appeared in Venetian painting after Leonardo's visit to the city in 1500; see David Alan Brown, "The Cenacolo in Venice," "Leonardo, *Study for the Apostle Peter*," and "Giorgione, *Three Ages of Man*," in Giovanna Nepi Scirè, Pietro C. Marani, et al., ed., *Leonardo and Venice*, exh. cat., Venice, Palazzo Grassi (Milan, 1992), pp. 335–38. For the marble relief after the *Last Supper*, attributed to the circle of Tullio Lombardo in Venice, Ca' d'Oro, see the catalog entry by Maria Teresa Fiorio in ibid., p. 390. For plaster and wax models of Michelangelo's sculptures and graphic copies of the Sistine frescoes, widely available by mid-century, see Turner, pp. 24–25, 27–29. For knowledge of Michelangelo's drawings and models possibly as early as the first decade of the century, see Dominique Cordellier, "Fragments de jeunesse: Deux feuilles inédites de Michel-Ange au Louvre," *Revue du Louvre* 41, 2 (1991): 43–55. For Raimondi's partial copies of Michelangelo's cartoon and his engravings of details of the Sistine Ceiling, c. 1512–13, see Joannides, *Michelangelo and his Influence*, p. 20.

181 Vasari-Barocchi 6: 18–19. Vasari's account has frequently been debunked but deserves credence for various reasons, as explained by Carmen C. Bambach, "A Leonardo Drawing for the Metropolitan Museum of Art: Studies for a Statue of *Hercules*," *Apollo* 153 (2001): 21.

182 For Michelangelo's contract, see Milanesi, *Lettere*, pp. 620–23; and Seymour, *Michelangelo's David*, pp. 136–37. The contract stipulated that he complete the statue within two years of September 1501. The "node" may have been a malformation or a pointing-reference made by Agostino, as suggested by

Lavin, "Bozzetti and Modelli," pp. 98–99: Michelangelo "removed the *nodus before* the wall was built" (p. 99), i.e. the wall that he had built around the block so that he could work unobserved; but he evidently wanted everyone to know about his removal of the node.

183 *Delizie degli eruditi toscani* 21 (1785), p. 203, cited in Wilde, "Michelangelo and Leonardo," p. 70, n. 6.

184 Pomponio Gaurico, *De sculptura*, ed. and trans. Paolo Cutolo (Naples, 1999), pp. 250–51. Michelangelo's name comes near the end of the list, preceded by Benedetto da Maiano and followed by Andrea Sansovino and Francesco Rustici. The contemporary singled out for particular praise is Tullio Lombardo. The significance of the treatise's date of publication in relation to the completion of the *David* was recognized by Charles de Tolnay, cited by Eugenio Battisti, "La critica a Michelangelo primo del Vasari," *Rinascimento* 5 (1954): 118, also noting Gauricus's friendship with the Doni, Michelangelo's private patrons in Florence.

185 Condivi, p. 21; Vasari-Barocchi 6: 18, 19.

186 For references to David as the "Giant" in fifteenth-century sources, see p. 119 above; for such references in the sixteenth-century sources, see Battisti, "Critica a Michelangelo," p. 118. *David*'s stance recalls Nicola Pisano's *Fortitude* on the pulpit of Pisa Baptistery, as noted *inter alia* by Hibbard, *Michelangelo*, p. 57. Regarding *David*'s large hands, see Shearman, *Only Connect . . .* , pp. 23n19, 215: the name "David" means "fortis manu, sive desiderabilis" (strong hand, lovable), according to Saint Jerome, *Liber de nominibus hebraicis* in *Patrologia latina* xxiii, cols. 813, 839. Whereas Donatello emphasized "lovable," Michelangelo chose the "semantic alternative."

187 Vasari-Barocchi 6: 20.

188 Ibid., p. 21: the *Marforio*, the *Tiber*, the *Nile*, and *Giants* of Monte Cavallo (referring to the Capitoline *Dioscuri*).

189 As suggested by Seymour, *Michelangelo's David*, pp. 27–28 (Milan cathedral), p. 56 (the Baptistery competition).

190 For the meeting of 2 July, see n. 173 above; for the contract, see Poggi, *Duomo di Firenze*, ed. Haines, vol. 1, p. 449; and Seymour, *Michelangelo's David*, pp. 136–37. In awarding the contract, the Operai were joined by the Consuls of the Arte della Lana, who traditionally provided funding for cathedral projects.

191 Note also Donatello's giant terracotta *Joshua*, commissioned in 1410 to replace the lifesize marble *David* of 1408–09: the lighter weight of the material allowed for buttress figures on a giant scale. For various techniques used to give the terracotta figures the appearance of white marble and experiments with different media for colossi, see Seymour, *Michelangelo's David*, pp. 29–32: some finish was necessary also to protect the friable clay from exposure to the elements (p. 29). Although he notes the "engineering problem" of installing a marble figure of *David*'s size on a buttress, neither Seymour nor any other scholar seems to have related these practical problems to Michelangelo's thinking about the eventual placement of his statue. Professor Yogesh Jaluria of the Department of Mechanical and Aerospace Engineering at Rutgers University tells me that a viable installation on a buttress of a marble statue of *David*'s dimensions would have required either considerable buttressing of the figure itself and/or a plinth approximately one third its height, embedded into the fabric of the cathedral. Even then, the neck or limbs would have been in danger of breaking without struts or some kind of buttressing.

192 Parks, "Placement of Michelangelo's *David*." Another explanation: perhaps the necessity to abandon the original idea of placing the figure on a buttress had become clear by early 1504, either for visual or engineering reasons, but no decision had been reached before the January meeting; Seymour, *Michelangelo's David*, p. 57.

193 Some scholars have asserted that the back was completed *after* the decision to place the sculpture had been made. I do not agree with this sequence of events. The sling can hardly have been an afterthought, nor the placement of the raised arm to hold it. The statue's planar frontality (unlike *Bacchus*' spiral) also suggests that Michelangelo conceived it to be seen against a wall and not equally visible from several or all points of view on a buttress. Baccio Bandinelli criticized the *David* for succeeding only from the frontal view, according to Benvenuto Cellini, who repeated the charge with the intention of discrediting the critic; "but in fact it is true," as Virginia Bush has noted. See Virginia L. Bush, "Bandinelli's *Hercules and Cacus* and Florentine Traditions," in *Studies in Italian Art and Architecture 15th through 18th Centuries*, ed. Henry A. Millon (Cambridge and Rome, 1980), p. 183.

194 For the *deliberazione* (Florence, Archivio dell'Opera del Duomo, Seconda Seria II, 9, Deliberazione 1496–1507, fol. 59v), see

Michael Hirst, "Michelangelo in Florence: 'David' in 1503 and 'Hercules' in 1506," *Burlington Magazine* 142 (2000): 487. He considers that the *David* was "probably complete" by June 1503, yet the *practica* of January 1504 (cited in n. 3) describes the statue as "quasi finita." If *David* were in fact complete in June 1503, why did the Florentines wait nearly a year to install it?

195 The Signoria intervened after 25 and 28 February 1502, the dates of Michelangelo's revised agreement for the statue, involving only the Operai and Arte della Lana. For this transaction, see p. 120 above; and Milanesi's note in Vasari-Milanesi 7: 622. For the record of the meeting (Archivio dell'Opera del Duomo, Deliberazioni 1496–1507), see Seymour, *Michelangelo's David*, Appendix II, pp. 140–55.

196 My italics and translation, here and in following quotations from the document, slightly altering the translation in Seymour, ibid., pp. 140–55 (with the Latin text), pp. 140–41 for this passage.

197 Michelangelo himself seems to have raised the practical questions about installation, according to the introductory paragraph of the deliberations: "the installation must be solid and structurally trustworthy according to the instructions of Michelangelo, master of the said Giant." For a complete list of the committee, see Seymour, ibid., pp. 140–43. In addition to those mentioned above, better-known participants included Piero di Cosimo, Lorenzo di Credi, Piero Perugino, il Riccio, Andrea della Robbia, and Andrea Sansovino. The minutes also record the comments of two other men not listed among the discussants: Francesco Monciatto (wood-carver) and Angelo di Lorenzo Manfidi da Poppi (Second Herald, Francesco Filarete's nephew).

198 For Parenti's evidence, see Irving Lavin, "David's Sling and Michelangelo's Bow: A Sign of Freedom," in *Past-Present: Essays on Historicism in Art from Donatello to Picasso* (Berkeley, Los Angeles, and Oxford, 1993), p. 274n64. For Vasari's evidence, see p. 130 above. That the Palazzo della Signoria was Michelangelo's choice for the site was suggested by Carl Neumann, "Die Wahl des Platzes für Michelangelos David in Florenz im Jahr 1504," *Repertorium für Kunstwissenschaft* 38 (1916): 1–27; followed by Tolnay, *Michelangelo*, vol. 1, p. 97; and Levine, "Location of Michelangelo's *David*," pp. 43, 47. For an opposing view (and for corrections of Levine's translations), see Parks, "Placement of Michelangelo's *David*."

199 For Botticelli's diptych of the *Return of Judith to Bethulia* and the *Discovery of the Dead Holofernes*, c. 1469–70 (Florence, Uffizi), the damaged *Return of Judith* of about the same date (Cleveland, Art Museum), and *Judith Leaving the Tent of Holofernes* (Amsterdam, Rijksmuseum), datable 1497–1500, see Lightbown, *Botticelli*, vol. 2, pp. 21–22, 97–98.

200 As argued by Levine, "Location of Michelangelo's *David*," pp. 35–36.

201 See Seymour, *Michelangelo's David*, pp. 59–64 and fig. 27 (a photomontage showing *David* installed in the Loggia), followed by Parks, "Placement of Michelangelo's *David*."

202 Wendy Stedman Sheard, "Sanudo's List of Notable Things in Venetian Churches," *Yale Italian Studies* 1 (1977): 243n5. The *Warrior* now occupies the niche in the tomb of Doge Andrea Vendramin originally intended for the *Adam* (New York, Metropolitan Museum of Art). Installed in the Venetian church of Santa Maria dei Servi by early 1494, the tomb was subsequently moved to its present site in Santi Giovanni e Paolo. As Sheard observes, p. 222, the "tomb was probably the only architecture-sculpture ensemble by a contemporary to achieve anything approaching" what Michelangelo later hoped to accomplish in the Julius tomb.

203 As noted by David Summers, "David's Scowl," in *Collaboration in Italian Renaissance Art*, ed. Wendy Stedman Sheard and John T. Paoletti (New Haven, 1978), pp. 113–24, pp. 113–14 for the publication of Gauricus and his ancient sources. For a modern edition of the treatise, see Pomponius Gauricus, *De sculptura* (Florence, 1504), ed. André Chastel and Robert Klein (Geneva, 1969). Summers explains that *David*, the "lion of Judah," is depicted as the leonine type considered to exemplify manly courage; his leonine identity is reified in his scowl. Less convincingly, the hero's hair is compared with the lion's mane (p. 115); but *David*'s hair is typical of all of Michelangelo's figures at this date, leonine or not. Michelangelo might have known one exemplary leonine visage, the *Colleoni*, as a work in progress when he was in Venice in October 1494: Verrocchio had completed the final model before his death in 1488. (It was cast in 1496 by Alessandro Leopardi.) For *Colleoni*'s leonine expression as the visualization of his appropriately bellicose personality, see Peter Meller, "Physiognomical Theory in Renaissance Heroic Portraits," in *Studies in Western Art: Acts of the Twentieth International Congress of the History of Art,*

vol. 2: *The Renaissance and Mannerism*, ed. Ida E. Rubin (Princeton, 1963), pp. 53–69.

204 Seymour, *Michelangelo's David*, pp. 148–49; and Levine, "Location of Michelangelo's *David*," pp. 34, 42 (for il Riccio's opinions). Levine notes that hostility toward the statue was frequently aimed at the head.

205 For Bronzino's sonnet on Cellini's *Perseus*, 1553, and his use of this Petrarchan motif, see Parker, *Bronzino*, pp. 88–91, esp. p. 91 for the transfixing glance.

206 See Hirst, "Michelangelo in Florence," p. 490, citing documents published by Frey: a *Deliberazione* dated 30 April 1504 indicates that the *Operai* were planning to install *David* in the Loggia (Archivio dell'Opera, Deliberazioni 1496–1507, fol. 78v, and ASF, Deliberazioni dei Signori e Collegi 168, fol. 38v). The first document to make reference to an installation "before the door of the Palace" is a *Deliberazione* from the end of May 1504 (ASF, Deliberazioni dei Signori e Collegi 168, fol. 49v).

207 Royal Library, Windsor, no. 12591r, which converts David into Neptune with seahorses around his feet; see Joannides, *Michelangelo and his Influence*, p. 20; and Bambach, "Leonardo Drawing," pp. 19, 21.

208 Luca Landucci, *A Florentine Diary from 1450 to 1516 by Luca Landucci Continued by an Anonymous Writer till 1542 with Notes by Iodoco del Badia*, trans. Alice de Rosen Jervis (London and New York, 1927), pp. 213–14 (14 May 1504). See also Karl Frey, *Sammlung ausgewählter Briefe an Michelagniolo Buonarroti* (Berlin, 1899), doc. 22. Four days and specially constructed machinery were necessary to move the *David*. Vasari credited Giuliano and Antonio da Sangallo with making the device; Vasari-Barocchi 6: 20. The Otto di Guardia later arrested four vandals for the stoning, all members of pro-Medici families; see Hirst, "Michelangelo in Florence," p. 490. Their political affiliation implies that the *David* was perceived as anti-Medici from the start – naturally enough, given its Republican patronage – as previously suggested by Levine, "Location of Michelangelo's *David*," pp. 39–40, 45. Perhaps, then, the structure behind which Michelangelo worked had a protective function as well as suiting his taste for secrecy. Whether the vandals were also offended by the statue's nudity is unknown, but its nudity was considered problematic. The problem was solved by gilt grape leaves before 1545 and perhaps as early as 1504; see Poeschke, *Michelangelo*, p. 85; and Carl A. Isermeyer, "Das Michelangelo-Jahr 1964

und die Forschungen zu Michelangelo als Maler und Bildhauer von 1959–65," *Zeitschrift für Kunstgeschichte* 28 (1965): 307–52.

209 Karl Frey, "Studien zu Michelagniolo," p. 132, nos. 189, 190, 192, the Opera payment records dated 30 June 1504 for gilding the *Giant*'s wreath or garland, sling, and tree stump. During rioting on 26 April 1527 (as the Medici were being banished), the statue's left arm was broken into three pieces, repaired in 1543. See Vasari-Barocchi 5: 512–13 (Life of Francesco Salviati).

210 Vasari-Barocchi 6: 19. In Venetian texts, "palazzo" with no other specification similarly refers to the Palazzo Ducale. Vasari said that Michelangelo began the project by making a wax model of the *David* "per la insegna del Palazzo." In order to serve as *insegna*, the statue would have to be displayed at the palace entrance. Vasari implied that Michelangelo planned the statue for that site. For Vasari's apparently unprecedented "use of a term like *insegna* [. . .] to describe a work of art as a *genius loci*," see Lavin, "David's Sling," p. 29; see also p. 123 above. After 1550 Cosimo moved to Palazzo Pitti.

211 Vasari-Barocchi 6: 19.

212 For his term of office in March and April 1501, to which Vasari alluded, see Sergio Bertelli, "Pier Soderini 'Vexillifer Perpetuus Reipublicae Florentinae' 1502–1512," in *Renaissance Studies in Honor of Hans Baron*, ed. Anthony Molho and John A. Tedeschi (Florence, 1971), p. 344. Until Soderini's election as *gonfaloniere a vita*, the term of office was two months. He was deposed on 1 September 1512. See Nicolai Rubinstein, *The Palazzo Vecchio 1298–1532: Government, Architecture, and Imagery in the Civic Palace of the Florentine Republic* (Oxford, 1995), pp. 43–46. The first known reference to Rohan's wish for a bronze *David* is a letter of the Florentine ambassadors dated 22 June 1501; see Hirst, "Michelangelo in Florence," p. 490. Soderini was not in office at that time but even so a public man whose commission had official implications.

213 For the contract, see Milanesi, *Lettere*, p. 624, v. See O'Grody, "*Nudo virile*," in Ragionieri, ed., *Bozzetti michelangioleschi*, p. 28, cat. 1, for the wax model also sometimes related to the lost *Hercules* (see p. 88 and n. 65 above). Sent to France in 1502 and displayed in the castle of Bury, the bronze *David* has been lost but is known from an anonymous drawing (Paris, Louvre, 714); see Bellosi and Rossi in Vasari, *Vite 1550*,

p. 888n32. The lost *David* may also be represented in paintings by Francesco Granacci and Rosso Fiorentino, cited by Perrig, *Michelangelo's Drawings*, p. 122n10. Michelangelo's *Julius II* for the façade of San Petronio in Bologna was also executed in bronze, but not, of course, the Bruges *Madonna*, incorrectly described as such by Condivi, p. 22. For the importance of bronze in the master's early career, see Joannides, "Michelangelo *bronzista*," pp. 11–20.

214 Condivi, p. 22. Presumably he emphasized the point about the medium at Michelangelo's behest (bronze reliefs planned for the Julius tomb are mentioned on p. 25). Michelangelo's expertise in various media was underscored also by Varchi, *Orazione funerale*, pp. 8, 29. Vasari mentioned the *bellissimo* bronze *David* without noting the significance of its medium; Vasari-Barocchi 6: 21.

215 Varchi, *Orazione funerale*, p. 29.

216 Francesco Petrarch, *Petrarch's Lyric Poems: The Rime sparse and Other Lyrics*, trans. and ed. Robert M. Durling (Cambridge, MA, and London, 1976), pp. 443–44. For the drawing in Paris, Louvre, 714r–v, see Tolnay, *Corpus*, vol. 1, pp. 37–38, 19r. In the verso, he recognized references to Quercia's Adam in the Genesis cycle at San Petronio, Bologna, where Michelangelo lived and worked in 1495–96. The verso also contains the fragment of a poem in Petrarchan style and various figural sketches. For the text on the verso, see Carl Frey, *Die Dichtungen des Michelagniolo Buonarroti* (Berlin, 1897), pp. 255–59, 301–03, no. CLXVI. The evocation of Petrarch in the text on the recto has long been recognized by scholars. Both of Michelangelo's inscriptions are assumed "to have been written at the same time," datable before the completion of the marble *Giant* in 1504 but after the commission of the bronze *David* in August 1502; see Seymour, *Michelangelo's David*, p. 5. On the style and technique of this sheet, see also Perrig, *Michelangelo's Drawings*, pp. 22–27, 29, 38; for his comment on the signature on the recto as exceptional, p. 38.

217 The reference to the *trapano* was suggested by Marcel Brion, *Michelangelo* (New York, 1940), p. 102; followed by Seymour, *Michelangelo's David*, pp. 7–8, 84–85. The allusion to the *seste ad arco* was recognized by Lavin, "David's Sling," p. 33. Presumably Michelangelo used this device in relation to the wax model of the *David* mentioned by Vasari-Barocchi 6: 19. Lavin's analysis of other instances of bow and arc metaphors,

both visual and literary (pp. 34–38), includes Michelangelo's sonnet comparing himself to "a Syrian bow," bending to paint the Sistine ceiling; the poem is discussed on p. 218 above.

218 As suggested by Lavin, ibid., p. 51.

219 Petrarch, *Lyric Poems*, p. 442.

220 Seymour, *Michelangelo's David*, pp. 5–6, followed by Lavin, "David's Sling," pp. 51–52.

221 Petrarch, *Lyric Poems*, p. 442.

222 Condivi, p. 22.

223 Ibid., XXI, 91.

224 Vasari-Barocchi 6: 116.

225 Ibid. 6: 21–22 (1568 only).

226 For the anecdote about Apelles and the critical cobbler who should "stick to his last," see Pliny, *Natural History, Books XXXIII–XXXV*, xxxv.85. The anecdote is analyzed in Martin Kemp, *Behind the Picture: Art and Evidence in the Italian Renaissance* (New Haven and London, 1997), pp. 1–2.

227 Vasari-Barocchi 6: 21.

228 Michelangelo completed none of these works; of the Twelve Apostles, he began only the *Saint Matthew*. The contract for the Apostles was signed on 24 April 1503; Milanesi, ed., *Lettere*, pp. 625–26, VI. The block for the *Saint Matthew* was delivered from Carrara in December 1504; Michelangelo left for Rome in March 1505; the contract for the Apostle series was annulled on 18 December 1505. For this annulment, see Poggi, *Duomo di Firenze*, ed. Haines, vol. 2, parti X–XVIII, pp. 146–47, no. 2158. Michelangelo was also sluggish about completing the bronze *David*, which was ultimately cast in his absence. See the letter from the herald Tommaso di Balduccio in Florence to Michelangelo in Rome, 2 September 1508, exhorting the sculptor in the name of Soderini: "it is necessary to finish, and soon, your David of bronze" (Barocchi and Ristori, *Carteggio* 1: 83, LIX).

229 As noted by Bush, "Bandinelli's *Hercules*," p. 167.

230 Ibid., pp. 167–70.

231 Ibid., p. 174.

232 Ibid., p. 168, and L.D. Ettlinger, "Hercules Florentinus," *Mitteilungen des Kunsthistorischen Institutes in Florenz* 16 (1972): 120–21. The hero had also been represented in the Palazzo della Signoria; see Maria Monica Donato, "Hercules and David in the Early Decoration of the Palazzo Vecchio: Manuscript Evidence," *Journal of the Warburg and Courtauld Institutes* 54 (1991): 83–95.

233 The new giant's name is missing from the *Opera*'s contract with Agostino di Duccio;

see Carlo Pedretti, "L'Ercole di Leonardo," *L'arte* 57 (1958): 166–67. Dante compares David's victory over Goliath with that of Hercules over Antaeus in *De monarchia* 2.9. 11, and *Convivio* 3.3.7–8, cited in Jean Pépin, "Christian Judgments on the Analogies between Christianity and Pagan Mythology" (1981), in Yves Bonnefoy, ed., *Roman and European Mythologies*, trans. Wendy Doniger et al. (Chicago and London, 1991), p. 166.

234 Donato, "Hercules and David," p. 90. This *Hercules* was most likely a painting, accompanied by an inscription datable between 1385 and 1414; see Donato, pp. 86, 89, and 97–98 for the political message represented by the two heroes and for Soderini's plans for a *Hercules* to accompany Michelangelo's *David*.

235 As noted by Bush, "Bandinelli's *Hercules*," p. 169, and Pedretti, "L'Ercole di Leonardo." Regarding the purpose of Leonardo's drawing, see Clark with Pedretti, *Drawings of Leonardo*, vol. 1, pp. 117–18, no. 12591r. Clark argued convincingly that Leonardo "drew the pose as a David, and converted it into a Neptune as an afterthought" by the addition of the horses. He suggested that the sheet is related to Leonardo's lost *Neptune* for Antonio Segni, which may have been the first "Renaissance presentation drawing" with a classical subject, and as such, inspiration for Michelangelo's presentation drawings; Clark with Pedretti, vol. 1, pp. 109–10, no. 12570, a preparatory drawing for Segni's *Neptune*.

236 For the drawing in Turin, Biblioteca Reale, no. 15630, and other drawings of the hero by Leonardo, see Bambach, "Leonardo Drawing," p. 16 and *passim*. Bambach notes that a second drawing in Turin, no. 15577, may also represent Hercules (her fig. 5).

237 As Bambach explains, ibid., n. 7, Leonardo made a number of other double-sided drawings. The figure on the verso corresponds perfectly with that on the recto; the head on the recto reveals experiments with at least three different positions. The figure resembles that of the black chalk *Hercules with the Nemean Lion* (Turin, Biblioteca Reale, Inv. 15630), dated c. 1505 by Carlo Pedretti, *Disegni di Leonardo da Vinci e della sua scuola alla Biblioteca Reale di Torino* (Florence, 1975), pp. 21–23 and illustration, p. 18.

238 For Daniele's lost sculpture which became his double-sided painting in the Château de Fontainebleau, see Vasari-Barocchi 5: 545, and Lavin, "David's Sling," pp. 48–50.

Derived from Michelangelo's Sistine ceiling fresco of *David Slaying Goliath*, the painting represents a terracotta model that Daniele made, presumably using Michelangelo's drawings (i.e., his sketches of the subject in New York, Pierpont Morgan Library). The model and painting were commissioned by Giovanni della Casa, who was planning a treatise on the *paragone*.

239 He was alluding to the dwarf's sexual prowess or proclivities. Nude except for vine leaves across his groin, Morgante holds a small bird while an owl perches on his shoulder. These feathered friends represent penises and, in the case of the owl, may further signify that the dwarf is a sodomite. For the portrait (Florence, Uffizi), see Parker, *Bronzino*, pp. 157–58. Morgante was the dwarf servant of Duchess Eleonora, and the painting is listed in the 1553 Medici inventory. The dwarf was also depicted in a similar pose in a bronze statue by Valerio Cioli (Florence, Boboli Gardens). See James Holderbaum, "A Bronze by Giovanni Bologna and a Painting by Bronzino," *Burlington Magazine* 98 (1956): 439–45; and Leatrice Mendelsohn, *Paragoni: Benedetto Varchi's Due lezzioni and Cinquecento Art Theory* (Ann Arbor, 1982), p. 151.

240 Leonardo's memorandum on a sheet of geometrical studies, c. 1508, mentions "The Labors of Hercules for Pier Francesco Ginori. The Medici garden" (Codex Atlanticus, fol. 288v-b). Bambach, "Leonardo Drawing," p. 17, relates this notation to the double-sided Metropolitan drawing. She explains technical evidence showing that "the artist traced the figure through from one side of the sheet to the other." She dates the sheet c. 1508 (pp. 16, 17, 20) in part in relation to Leonardo's note in the Codex, datable to that year. For the artist's interest in Hercules, see Carlo Pedretti, *Leonardo: A Study in Chronology and Style* (Berkeley and Los Angeles, 1973), pp. 78–96, and p. 76 for the memorandum regarding the Labors.

241 Bambach, ibid., p. 17, and pp. 17–18 for ancient depictions of the hero known to the Renaissance – including Michelangelo's lost *Hercules*, c. 1493–94 (p. 88 above).

242 The possibility is "worth pondering"; ibid., p. 21.

243 For the letter, see Christiane Klapisch-Zuber, *Carrara e i maestri del marmo (1300–1600)*, trans. Bruno Cherubini (Massa, 1973), p. 161n26. For its relevance to the second giant, see Jeannine Alexandra O'Grody, "'*Un semplice modello*': Michelangelo and his Three-Dimensional Preparatory Works," Ph.D.

dissertation (Case Western Reserve University, 1999), p. 252, following an unpublished note by Giovanni Poggi, cited in her n. 2. O'Grody explains that the Marchese of Massa was well known for the quality of his marble; Michelangelo's *Pietà* had been carved from one of his blocks.

244 During the sixteenth century only three blocks of such enormous dimensions were quarried. All three were used for the Piazza della Signoria: Michelangelo's *David* (9 *braccia*); Baccio's *Hercules and Cacus* (8.5 *braccia*); and Ammannati's *Neptune* (10.5 *braccia*). Fifty years separate the quarrying of the blocks used for *Hercules* and for *Neptune*, quarried c. 1558. See Bush, "Bandinelli's *Hercules*," p. 170; Gaye, *Carteggio inedito*, vol. 3, p. 464; Kathleen Weil-Garris Brandt, "On Pedestals: Michelangelo's *David*, Bandinelli's *Hercules and Cacus* and the Sculpture of the Piazza della Signoria," *Römisches Jahrbuch für Kunstgeschichte* 20 (1983): 393–95. Soderini wrote at least five letters to the marchese concerning the block, beginning with the letter of 7 August 1506 (see n. 243 above), followed by those of 21 August 1507, 10 May 1508, 4 September 1508, and 16 December 1508. See also Hirst, "Michelangelo in Florence," p. 491.

245 Or, Condivi added, p. 23, if the purpose for which Michelangelo had come to Carrara allowed, that purpose being quarrying marbles for Pope Julius II's tomb. For *postilla* L, see Caroline Elam, " 'Che ultima mano!': Tiberio Calcagni's *Postille* to Condivi's Life of Michelangelo," in Condivi, p. xlii. Michelangelo's presence in Carrara is documented on 14 November 1505, when he contracted with boatmen to transport those blocks that had already been excavated. He was back in Florence by mid-December 1505 but returned to Rome either late December or early January 1506 – in time to see *Laocoön* when it was unearthed on 14 January. See Barocchi and Ristori, *Carteggio* I: 360–61.

246 For Calcagni's *postilla* L, see Condivi, p. XXI.

247 For Soderini's letters of 1508, see Gaye, *Carteggio inedito*, vol. 2, pp. 97, 107; and Bush, "Bandinelli's *Hercules*," p. 170.

248 Gaye, *Carteggio inedito*, vol. 2, pp. 97, 107.

249 Or Cacus? Perhaps Michelangelo was toying with *both* ideas? For the pen sketch c. 1508 apparently representing *Hercules and Cacus*, see Bush, "Bandinelli's *Hercules*," p. 170; Frederick Hartt, *The Drawings of Michelangelo* (London, 1971), no. 61; and Hirst, "Michelangelo in Florence," p. 492. For

evidence that the intended subject for the new colossus was more likely Hercules and Antaeus, see p. 356 and chapter 8, n. 64 below.

250 He was still in Florence on 28 February 1505, when he received a payment for the *Cascina* cartoon (Fig. 71); see p. 143 above. In Rome in March and April, Michelangelo prepared drawings of the tomb according to his first agreement with the pope, now lost. Michelangelo spent some months in Carrara in 1505 quarrying marble for the monument. His contract with boatmen who were to bring the marble to Rome, dated 14 November 1505, was witnessed by Baccio di Giovanni (who later briefly collaborated with him on the San Lorenzo façade) and a stone cutter. See Barocchi and Ristori, *Carteggio* I: 360, with further references. For Michelangelo's various plans for the tomb in Rome, San Pietro in Vincoli, and statues related to it including the *Moses*, see Poeschke, *Michelangelo*, pp. 89–99, 103–04, 119.

5 *Leonardo*

1 Benvenuto Cellini, *The Autobiography of Benvenuto Cellini*, trans. George Bull (London, rev. ed. 1998), p. 18. The comment is in the context of Torrigiani's seeing one of Cellini's drawings after Michelangelo's *Battle of Cascina*.

2 On 24 October 1503 the Sala del Papa in Santa Maria Novella was being prepared for Leonardo's use as a studio for work on the cartoon. The revised contract between Leonardo and the palace *Opera* is dated 4 May 1504. These and other documents published in Luca Beltrami, *Documenti e memorie riguardanti la vita e le opere di Leonardo da Vinci* (Milan, 1919) appear in Pietro C. Marani and Edoardo Villata, "Documentary Appendix," in Pietro C. Marani, *Leonardo da Vinci: The Complete Paintings*, trans. A. Lawrence Jenkins (New York, 2000), p. 352, no. 44, and pp. 353–54, no. 49. Work on the cartoon was under way, and Leonardo had already received a payment of 25 florins. In the same deliberation, the Signoria voted Leonardo a monthly stipend with the obligation of completing the cartoon within a year, and with the authority to begin painting directly on the wall in the Sala del Gran Consiglio, even before he had completed the cartoon, should he think this necessary. If, however, Leonardo should be able to complete the cartoon but not the mural within the stipulated time, the council

agreed not to commission another artist to complete the work without Leonardo's consent. For other documents relating to the commission in 1504 (8 January, 28 February, 30 June, 30 August, 31 October, 31 December) and in 1505 (14 March, 30 April, 31 August, 31 October, 30 May, and 18 August), see Marani and Villata, pp. 353–56, nos. 46, 48, 49, 53, 54, 56, 57, 60, 61, 62, 63.

3 Benedetto Varchi, *Orazione funerale di M. Benedetto Varchi fatta, e recitata da lui pubblicamente nell'essequie di Michelagnolo Buonarroti in Firenze, nella chiesa di San Lorenzo* (Florence, 1564), p. 17. Varchi's reference to "that other wall" (*quell'altra facciata*) may be understood to describe surfaces facing each other as *recto* and *verso* in a book. According to Wilde's reconstruction, the murals would have been located on the east wall to either side of the Signoria's seat. See Johannes Wilde, "The Hall of the Great Council of Florence," *Journal of the Warburg and Courtauld Institutes* 7 (1944): 65–81, and his "Michelangelo and Leonardo," *Burlington Magazine* 95 (1953): 73. Wilde interpreted Vasari's evidence to refer to the east wall but west seems more likely; see H. Travers Newton and John R. Spencer, "On the Location of Leonardo's *Battle of Anghiari*," *Art Bulletin* 64 (1982): 45–52; and Nicolai Rubinstein, *The Palazzo Vecchio 1298–1532: Government, Architecture, and Imagery in the Civic Palace of the Florentine Republic* (Oxford, 1995), Appendix VIII, pp. 114–15. For the chronology of the work by the two artists, see Carmen C. Bambach, "The Purchases of Cartoon Paper for Leonardo's *Battle of Anghiari* and Michelangelo's *Battle of Cascina*," *Villa I Tatti Studies* 8 (1999–2000): 105–33. For Sangallo's copy of Michelangelo's work (Fig. 71), see Alessandro Cecchi's entry in Antonio Natali et al., *L'officina della maniera: Varietà e fierezza nell'arte fiorentina del Cinquecento fra le due repubbliche 1494–1530*, exh. cat., Florence, Uffizi (Venice, 1996), p. 112, no. 20; and Martin Kemp's entry in Jay A. Levenson, *Circa 1492: Art in the Age of Exploration*, exh. cat., Washington, National Gallery of Art (Washington, New Haven, and London, 1991), pp. 266–68, no. 167. For the rivalry between Leonardo and Michelangelo, see also Jürg Meyer zur Capellen, *Raphael in Florence*, trans. Stefan B. Polter (London, 1996), pp. 86–97.

4 The hall was transformed into the present Sala dei Cinquecento by Vasari at the behest of Cosimo de' Medici, continuing a program of renovation and transformation that had been begun in the 1540s. See Leon Satkowski, *Giorgio Vasari: Architect and Courtier* (Princeton, 1993), pp. 45–59, 53–55 on the Salone.

5 Sansovino is so described in his contract, 10 June 1502; see D. S. Chambers, *Patrons and Artists in the Italian Renaissance* (Columbia, SC, 1971), pp. 85–87, no. 44. Savonarola had declared Christ the King of Florence after the expulsion of the Medici on 9 November 1494, and the Savior became head of state again during the short-lived Republic of 1527. Sansovino's statue was to be installed above the *gonfaloniere*'s seat. For the altar of the wall opposite the planned murals by Leonardo and Michelangelo, the Signoria planned an altarpiece of the *Madonna and Child and Saint Anne*, in commemoration of the expulsion of the Duke of Athens on that saint's feastday. The altarpiece was first assigned to Filippino Lippi (d. 1504) and then, in 1510, to Fra Bartolommeo. He abandoned the project in 1512, when the Medici returned to power.

6 Vasari-Barocchi 6: 15; and Varchi, *Orazione funerale*, p. 16. For this lost work, see Giovanni Agosti and Michael Hirst, "Michelangelo, Piero d'Argenta and the 'Stigmatisation of St. Francis'," *Burlington Magazine* 138 (1996): 683–84. They tentatively identify the painter of the *Stigmatization* as Piero d'Argenta and note that the painting was first mentioned in the Codice Magliabechiano in a passage apparently written before fall 1544 and ascribing the design but not the execution to Michelangelo. Finally, they recognize a drawing of the lost work in MS Lansdowne 802, Libro I, fol. 214 (London, British Library). Their reference to Varchi is misleading, however: they conclude from his description that he saw the composition as derivative. But Varchi's reference to "la maniera antica" refers specifically to its being painted in tempera: the comment has to do with technique, not with style.

7 Ebu's commission is identified with Michelangelo's unfinished *Entombment* (Fig. 72); see Michael Hirst, "Michelangelo in Rome: An Altarpiece and the 'Bacchus'," *Burlington Magazine* 123 (1981): 587–90. The painting was apparently Michelangelo's next Roman commission after the completion of the *Pietà*. His being paid in advance and in full for this altarpiece in November 1500 might confirm the biographers' claims regarding his success, as suggested by Hirst,

p. 584. Abandoning the altarpiece when he returned to Florence in late spring 1501, Michelangelo eventually reimbursed the Augustinians. For the various payments and for Michelangelo's repayment, recorded in the Balducci ledgers in Florence and in Rome, see Hirst, pp. 589–90, Appendices A and B. Ebu's testament documents Michelangelo's patronage network: Galli was to arrange for the chapel's decoration, and the executors included Cardinals Riario and Francesco Todeschini-Piccolomini, who was likewise an executor of Cardinal de Bilhères's will and who in May 1501 commissioned Michelangelo to complete the Piccolomini altar in Siena cathedral. For more on the *Entombment*, see Michael Hirst and Jill Dunkerton, *Making and Meaning: The Young Michelangelo* (London, 1994); Alexander Nagel, "Michelangelo's London 'Entombment' and the Church of S. Agostino in Rome," *Burlington Magazine* 136 (1994): 164–67; and Nagel, *Michelangelo and the Reform of Art* (Cambridge and New York, 2000), pp. 25–48, 83–112.

8 For the Manchester *Madonna* or *Madonna and Child with Saint John and Angels* (London, National Gallery), see Hirst and Dunkerton, *Making and Meaning*, pp. 37–46, 83–105.

9 For example, the letter from "Vostro Michelagniolo scultore in Roma" to his father in Florence, 4 October 1511, in Barocchi and Ristori, *Carteggio* 1: 121, LXXXIX, and the payment record of 60 ducats, 30 July 1500, for work on Bishop Ebu's painting by "Michelagnolo Schultore," in Harold R. Mancusi-Ungaro, Jr., *Michelangelo: The Bruges Madonna and the Piccolomini Altar* (New Haven and London, 1971), pp. 152–53. Later, however, Michelangelo protested that letters should *not* be addressed to him as "sculptor": his social status was such that this required no such designation (see p. 148 above).

10 Vasari-Barocchi 4: 17. On Leonardo as sculptor, see pp. 41–42, 45–46 above.

11 Vasari described the proceedings, publishing some of the relevant correspondence and epitaphs, at the end of his Life of Michelangelo; Vasari-Barocchi 6: 122–41. See also Rudolf Wittkower and Margot Wittkower, *The Divine Michelangelo: The Florentine Academy's Homage on his Death in 1564: A Facsimile Edition of "Esequie del Divino Michelagnolo Buonarroti" Florence 1564* (Greenwich, CT, 1964).

12 Giovio as quoted in T.C. Price Zimmermann, "Paolo Giovio and the Evolution of Renais-

sance Art Criticism," in *Cultural Aspects of the Italian Renaissance: Essays in Honour of Paul Oskar Kristeller*, ed. Cecil H. Clough (Manchester, 1976), p. 415. The lives of Leonardo, Michelangelo, and Raphael were written around the same time as Giovio's *De viris illustribus*, that is, after the Sack of Rome in 1527. For the Latin texts of the artists' lives and Italian translations, see Paola Barocchi, ed., *Scritti d'arte del Cinquecento*, 3 vols. (Milan and Naples, 1971–77), vol. 1, pp. 7–18.

13 Paolo Giovio, "Leonardi Vincii Vita," in Barocchi, ibid., p. 9. Giovio was probably Vasari's principal source for his own biography of Leonardo: the project of writing the *Lives* had been Giovio's suggestion, as Vasari recorded in his autobiography, Vasari-Barocchi 6: 389–90. See also T.C. Price Zimmermann, *Paolo Giovio: The Historian and the Crisis of Sixteenth-Century Italy* (Princeton, 1995), pp. 214–15.

14 Paolo Giovio, "Raphaelis Urbinatis Vita," in Barocchi, *Scritti d'arte*, vol. 1, pp. 13–16 (followed by briefer accounts of Sebastiano, Titian, Costa, Sodoma, and the Dossi, pp. 16–18). For Giovio's criticisms of Raphael, see Zimmermann, "Giovio and Art Criticism," pp. 416, 417. The Anonimo Magliabechiano also noted Leonardo's elegance: "He was of beautiful appearance, proportioned, graceful and with a beautiful aspect" and fashionably dressed; see Carl Frey, ed., *Il codice Magliabechiano* (Berlin, 1892), p. 115.

15 This is the case among modern academics, according to Mark N. Bing, "Hypercompetitiveness in Academia: Achieving Criterion-Related Validity from Item Context Specificity," *Journal of Personality Assessment* 73 (1999): 80–99. The idea of *terribilità* derives from *deinotes*, mentioned by Quintilian (6.2.24); see Brian Vickers, *In Defence of Rhetoric* (Oxford, 1988), pp. 78, 358.

16 For the Latin text, see Barocchi, *Scritti d'arte*, p. 12. Cf. the translation in Zimmerman, "Giovio and Art Criticism," p. 416. Michelangelo's claim "never to have run a workshop [. . .] is true," as confirmed by W[illiam] E. Wallace, "Instruction and Originality in Michelangelo's Drawings," in *The Craft of Art: Originality and Industry in the Italian Renaissance and Baroque Workshop*, ed. Andrew Ladis and Carolyn Wood (Athens, GA, and London, 1995), p. 114. But some of Michelangelo's drawings were used in "an informal sort of pedagogy" (Wallace, pp. 114, 118–19).

17 Vasari-Barocchi 6: 23.

18 Ibid., pp. 108–09. The unfinished works are more esteemed than "perfectly finished" works by other masters, according to Varchi, *Orazione funerale*, p. 28.

19 Vasari-Barocchi, 6: 114, ending the list with the large estate that Michelangelo bequeathed to his nephew. Condivi, p. 63, also attested to his generosity. In general, the question of an artist's avarice is related to his charging appropriate (high) fees for his art, but in Michelangelo's case, the issue was complicated by questions raised in relation to his failure to complete the Julius tomb in accordance with his various contracts.

20 Vasari-Barocchi 6: 109–11, 109 for the quotation and p. 110 for the list of names of "his craftsmen [whom] he loved [and] with whom he worked." But Michelangelo was to break with Pontormo. Sebastiano del Piombo, whom Vasari disliked, is conspicuously absent from the list. For Daniele, see Letizia Treves, "Daniele da Volterra and Michelangelo: A Collaborative Relationship," *Apollo* 154, n.s. no. 474 (August 2001): 36–45; and Ben Thomas, " 'The Lantern of Painting': Michelangelo, Daniele da Volterra and the *Paragone*," in ibid., pp. 46–53.

21 The quotations are from Giovanni Boccaccio, *Decameron*, Sixth Day, Fifth Tale. Similarly, Cennino Cennini, *Il libro dell'arte*, ed. Francesco Brunello (Vicenza, 1982), p. 3: he "translated the art of painting from Greek into Latin." Giotto's ugliness and good-natured wit are appreciated by various authors, including Francesco Sacchetti in two *Novelle* (c. 1388), nos. 63 and 75; Giotto's fame and unsurpassed talent are noted in *Novelle* 63 and 136. Filippo Villani praised Giotto's personality, his fame, equal to that of the ancients, and his *ingenio*, superior to theirs. See Roberto Salvini, *Giotto bibliografia* (Rome, 1938; rpt. 1970), pp. 3–8, for these and other fourteenth-century sources, pp. 11–15 for the fifteenth century.

22 This discussion is indebted to Zimmermann, *Giovio*, pp. 206–07. See also Linda S. Klinger, "The Portrait Collection of Paolo Giovio," Ph.D. dissertation (Princeton University, 1991).

23 Vasari-Barocchi 4: 35 (Life of Leonardo).

24 Frey, ed., *Codice Magliabechiano*, p. 115. The Anonimo, ibid., continues with another anecdote showing once again how Michelangelo wished "to bite" Leonardo. For the antipathy between Leonardo and Michelangelo, see also Meyer zur Capellen, *Raphael in Florence*, pp. 84–97, citing the Anonimo Magliabechiano on pp. 84–85.

25 Barocchi and Ristori, *Carteggio* 4: 299, MCIX. This quirky letter begins with the happy news that Michelangelo has received the eighty-six splendid pears, thirty of which are to be sent to the pope; and the sad news that his gallstones have been preventing him from urinating, though "I am better now." For Michelangelo's sensitivity "about being considered an artisan," see William E. Wallace, *Michelangelo at San Lorenzo: The Genius as Entrepreneur* (Cambridge and New York, 1994), pp. 1–4; and his "Michael Angelvs Bonarotvs Patritivs Florentinvs," in *Innovation and Tradition: Essays on Renaissance Art and Culture*, ed. Dag T. Andersson and Roy Eriksen (Rome, 2000), p. 67.

26 Condivi, p. 63. This passage also includes Condivi's report of Michelangelo's opinion of Raphael, quoted on p. 69 above. One of the unnamed "many who claim" that Michelangelo did not teach was presumably Baccio Bandinelli, whose letters to Cosimo chastened Michelangelo and other masters for not teaching. Baccio specifically accused Michelangelo of shirking assistants precisely to avoid having to train them, lest they become rival artists employed by the Medici. See Louis Alexander Waldman, "Bandinelli and the Opera di Santa Maria del Fiore: Patronage, Privilege, and Pedagogy," in *Santa Maria del Fiore: The cathedral and its Sculpture: Acts of the International Symposium for the VII Centenary of the cathedral of Florence*, ed. Margaret Haines (Fiesole, 2001), pp. 232–33.

27 Aside from Sebastiano and Pontormo, collaborating in specific situations, the most successful painters and sculptors associated with Michelangelo were Tiberio Calcagni, Antonio Mini, and Marcello Venusti. Calcagni completed Michelangelo's *Brutus* and the Magdalene of the Florence *Pietà*. For his role as *postillatore* of Condivi's *Vita*, see p. 79 above. Mini made a profitable career in France, copying the master's *Leda*, which Michelangelo had given him, eventually selling the original to the king; see p. 296 above. Venusti is remembered for his portrait of the master and for his copy of the *Last Judgment*. Condivi is known primarily as Michelangelo's biographer and achieved little as an artist, despite the master's having "revealed his secrets" and having provided him with a cartoon for a painting of the *Epiphany* (the panel is in Florence, Casa Buonarroti); see chapter 7, n. 176 above. The master's record is much better in relation to architecture: "Michelangelo educated a whole generation," as noted by

Wallace, *Michelangelo at San Lorenzo*, p. 187. But this education was assured by the collaborative nature of architecture more than any pedagogical instinct on the master's part.

28 Rudolf Wittkower and Margot Wittkower, *Born under Saturn: The Character and Conduct of Artists. A Documented History from Antiquity to the French Revolution* (London, 1963; rpt. New York, 1969), p. 75.

29 Barocchi and Ristori, *Carteggio* 1: 9–10, VI. Concerned about a swelling in his son's abdomen, Ludovico also recommended a wholesome diet: "eat boiled bread or chicken or egg and take a little *chassia*," a herbal supplement. He ended the letter with the injunction to "come back as soon as you can." Whatever the value of his advice, the letter gives a far more sympathetic picture of Michelangelo's father than most sources.

30 Vasari-Barocchi 6: 122.

31 Wittkower and Wittkower, *Divine Michelangelo*, p. 77n46, citing Giovanni Gaye, *Carteggio inedito d'artisti dei secoli XIV.XV.XVI*, 3 vols. (Florence, 1840; rpt. Turin, 1968), vol. 3, p. 133. But see now Wallace, "Michael Angelvs," pp. 65–66, which includes evidence for Michelangelo's interest in dressing well and notes his penchant for fashionable black. The spurs with which Michelangelo was buried remind us that he knew how to ride a horse, another marker of social status (Wallace, p. 65).

32 Like the Sala del Maggior Consiglio, the Florentine hall also seated the head of state with his councillors in front of one of the narrow walls of the rectangular room, facing their colleagues. In Venice, the doge was enthroned before a mural of the *Paradiso* depicting the Coronation of the Virgin (the fresco by Guariento was replaced in 1592 by Tintoretto's canvas). In Florence, however, the gonfaloniere's tribune was opposite the altar, situated on the other narrow wall, and meant to be flanked by the two murals representing Florentine military triumphs.

33 For Leonardo's mural and the evidence of sixteenth-century copies, see Paul Joannides, "Leonardo da Vinci, Peter-Paul Rubens, Pierre-Nolasque Bergeret and the 'Fight for the Standard'," *Achademia Leonardi Vinci* 1 (1988): 76–86. Joannides argues convincingly that a drawing sold at Christie's in 1974 and now in a private collection is an authentic record of more of Leonardo's composition, including additional figures to either side who are not represented in other copies of the cartoon. For a panel after the lost work, painted before 1563

(Florence, Palazzo Vecchio, on loan from the Gallerie Fiorentine), see Alessandro Cecchi, "Anonimo del XVI secolo da Leonardo da Vinci, *Copia dalla Battaglia di Anghiari*," in Natali et al., *L'officina della maniera*, p. 104, no. 16.

34 Vasari-Barocchi 6: 23, and Wilde, "Michelangelo and Leonardo," p. 74.

35 Clark thought that a drawing by Michelangelo in the British Museum (1895-9-15-496) was likely a copy after Leonardo, perhaps representing the group of horsemen planned for the left section of the *Battle of Anghiari*, that is, left of the "Battle of the Standard"; Kenneth Clark with Carlo Pedretti, *The Drawings of Leonardo da Vinci in the Collection of Her Majesty the Queen at Windsor Castle*, 3 vols. (London, 2nd ed. 1968), vol. 1, pp. 34–35, nos. 12339, 12340, reiterating arguments from the first edition of his catalog (1935). Wilde, "Michelangelo and Leonardo," p. 74, disagreed: "There is no evidence to show that Michelangelo, except when quite a boy, ever copied a contemporary work." He found a common source for their equestrian motives in a *cassone* panel of the *Battle of Anghiari* (London, J.A. Bryce Collection). But Michelangelo's battling horsemen look markedly Leonardesque, and surely he had to take his rival's composition into account in planning his own mural.

36 The importance of Bertoldo's relief for Leonardo's conception of his *Battle* has long been recognized; see now James David Draper, *Bertoldo di Giovanni, Sculptor of the Medici Household: Critical Reappraisal and Catalogue Raisonné* (Columbia and London, 1992), p. 145, noting also Kenneth Clark's recognition of the "generative influence" of a Phaeton sarcophagus. For Leonardo's conversion of "chaos into [. . .] order," see A. Richard Turner, *Inventing Leonardo* (Berkeley and Los Angeles, 1992), p. 233.

37 Wilde, "Michelangelo and Leonardo," p. 77.

38 To assist him in recording the event as an eyewitness might remember it, Leonardo was evidently given a description of the battle written by a secretary of Niccolò Machiavelli (Machiavelli was one of the two Signoria officials who signed the artist's revised contract of 4 May 1503). For Leonardo's possible use of the secretary's *pro memoria*, see Carlo Pedretti, *Leonardo: A Study in Chronology and Style* (Berkeley and Los Angeles, 1973), p. 87; and Peter Meller, "La Battaglia d'Anghiari," in *Leonardo: La pittura* (Florence, 1985), pp. 131–32.

Leonardo might also have consulted the description in Neri di Gino Capponi's *Commentaries*, as suggested by Martin Kemp, *Leonardo da Vinci: The Marvellous Works of Nature and Man* (London, 1981; rpt. 1989), p. 243.

39 The story was recorded by Filippo Villani in his *Chronicle* and repeated by Machiavelli in the *Florentine Histories*. The man at right of center is the "charging figure of the bearded Manno Donati, alarming his bathers," according to Howard Hibbard, *Michelangelo* (Cambridge and Philadelphia, 2nd ed. 1985), p. 80. The man in the center, who unwinds a cloth from his head, is identified as the Florentine commander, Galeotto Malatesta. *Malatesta* suggests "headache" (*mal di testa*); presumably Michelangelo meant to pun on the leader's name.

40 Via Sant'Onofrio was located between Lungarno Soderini and Borgo San Frediano. For the concession of the Sala Grande at Sant'Onofrio, see Luisa Morozzi, "La 'Battaglia di Cascina' di Michelangelo: Nuova ipotesi sulla data di commissione," *Prospettiva* 53–56 (1988–89): 320. As she notes, given this chronology, Michelangelo's lost contract for the mural must have been written before 22 September 1504. Leonardo had left the city a month earlier (22 August) to work on his project for the deviation of the Arno; the Signoria perhaps turned to Michelangelo at this moment.

41 See Hibbard, *Michelangelo*, p. 77.

42 As noted by Wilde, "Michelangelo and Leonardo," p. 73. But he must have finished at least a major section of it; see Vasari-Barocchi 6: 30. Discussing the artist's flight from Rome back to Florence after Pope Julius had refused to see him, Vasari says that Michelangelo spent three months working on the cartoon which Soderini wanted him to execute.

43 First displayed in the Sala del Papa, Michelangelo's cartoon was then taken to the "great upper hall" of Palazzo Medici, where it was eventually torn "into many pieces"; Vasari-Barocchi 6: 24, 25. See also Varchi, *Orazione funerale*, pp. 17, 19.

44 Condivi, p. 28. The two cartoons did not become a "school" until the second decade of the century, according to Anna Forlani Tempesti, *Raffaello e Michelangelo*, exh. cat., Florence, Casa Buonarroti (Florence, 1984), p. 14, noting that Raphael was the first to understand the formal structures and orchestration of interrelated figures in a large format. On the cartoon's influence, see

also Wilde, "Michelangelo and Leonardo," p. 77.

45 Benvenuto Cellini, *La vita di Benvenuto Cellini scritta da lui medesimo*, ed. B. Bianchi (Florence, 1903), p. 23.

46 Condivi, p. 28. Varchi repeated the idea in *Orazione funerale*: fragments are treated "as holy things." Similarly, Vasari wrote that fragments "are held in great reverence," and that he treated as a relic one of Michelangelo's drawings in his collection; Vasari-Barocchi 6: 25 and 6: 7 (see also p. 71 above). Hibbard, *Michelangelo*, p. 162, suggested that the cartoon may have been cut up and distributed to artists in December 1515, to be used in making decorations for Leo X's triumphant entry into Florence. Vasari told another story, equally horrific but almost certainly untrue, claiming that it was destroyed by a jealous Baccio Bandinelli; Vasari-Barocchi 5: 241 (Life of Bandinelli).

47 The painting is usually identified as the copy that Sangallo made for Vasari in the 1540s. Whoever painted it, the panel records only part of the composition – figures respond to others who are unseen; cropped hands in the center have no body. Raimondi's engravings based on the cartoon are *The Climber*, c. 1508, and *The Climbers*, dated 1510, for which see Innis H. Shoemaker and Elizabeth Broun, *The Engravings of Marcantonio Raimondi*, exh. cat., Lawrence, Spencer Museum of Art, and Chapel Hill, Ackland Art Museum (Lawrence, 1981), pp. 76, 90–92, cat. 19.

48 Madrid, Biblioteca Nacional, MS 8937 (Madrid Codex I), 1r; the translation is my mélange of Martin Kemp, ed., *Leonardo on Painting*, trans. Martin Kemp and Margaret Walker (New Haven and London, 1989), p. 264; and Turner, *Inventing Leonardo*, p. 233.

49 For the letter dated 9 October 1506, ASF, Signori, Missive Minutari, filza 19, fol. 12v, see Marani and Villata, "Documentary Appendix," in Marani, *Leonardo*, p. 359, no. 73.

50 Karl Frey, "Studien zu Michelagniolo Buonarroti und zur Kunst seiner Zeit, III," *Jahrbuch der königlich preuszischen Kunstsammlungen*, Beiheft 13 (1909): 113, no. 54; and Wilde, "Michelangelo and Leonardo," p. 70.

51 Michelangelo experimented with Leonardesque compositions of the Virgin and Child in drawings made and kept for himself. For Leonardo's influence on Michelangelo's drawing style and technique in this period,

see Wilde, ibid., pp. 66, 69, 74; but he also noted differences, p. 77.

52 For a summary of documentation and previous bibliography, see Joachim Poeschke, *Michelangelo and his World: Sculpture of the Italian Renaissance*, trans. Russell Stockman (New York, 1996), pp. 79–81. For the 100 ducats, paid in two equal installments on 14 December 1503 and 9 or 10 October 1504, see Mancusi-Ungaro, *Bruges Madonna*, pp. 36–37, 161, 169 (nos. 4, 9). As Mancusi-Ungaro notes, both Condivi and Vasari mention the 100 ducat fee – a fact that Michelangelo presumably reported to them – though both authors wrongly described the marble Bruges *Madonna* as bronze. Did Michelangelo mislead them? Regarding the commission, see the letter from the banker Giovanni Balducci in Rome to Michelangelo in Florence, 14 August 1506; Barocchi and Ristori, *Carteggio* 1: 366–67, XI; and chapter 4, n. 48 above.

53 As suggested by Poeschke, *Michelangelo*, p. 81. On the cartoon, see Eric Harding, Allan Braham, Martin Wyld, and Aviva Burnstock, "The Restoration of the Leonardo Cartoon," *National Gallery Technical Bulletin* 13 (1989): 5–27.

54 Michelangelo's biographers mentioned three drawings presented by him to Colonna, *Christ on the Cross* and a *Pietà* (cited by Condivi, pp. 51, 61) and *Christ and the Woman of Samaria at the Well* (noted by Vasari; Vasari-Barocchi 6: 112). He also gave presentation drawings with classical themes to Tommaso de' Cavalieri; Vasari-Barocchi 6: 109–10 lists the *Ganymede*, *Tityus*, *Phaeton*, and a *Bacchanal of Putti* – not mentioned by Condivi. Michelangelo's mythological presentation drawings were anticipated by Leonardo; see chapter 4, n. 235 above.

55 Or a dove? Christ's posture anticipates the "slung leg" motif of later works; see Leo Steinberg, "The Metaphors of Love and Birth in Michelangelo's *Pietàs*," in *Studies in Erotic Art*, ed. Theodore Bowie and Cornelia V. Christenson (New York and London, 1970), pp. 231–85. For the recent conservation and observations on technique, see John Larson, "The Cleaning of Michelangelo's Taddei Tondo," *Burlington Magazine* 133 (1991): 844–46; and R.W. Lightbown, "Michelangelo's Great Tondo: Its Origins and Setting," *Apollo*, N.S. 89 (January 1969): 22–31. Some of the following discussion is adapted from Rona Goffen, "Mary's Motherhood according to Leonardo and

Michelangelo," *Artibus et historiae* 20 (1999): 35–69.

56 Larson, "Taddei Tondo," p. 845, suggests that Michelangelo intended to carve a crown of thorns in the roughly cut piece of marble between the Baptist's hands. Cf. Malcolm Easton's innocent interpretation of the Child's actions, answering "no" to the rhetorical question of his title; Malcolm Easton, "The Taddei Tondo: A Frightened Jesus?," *Journal of the Warburg and Courtauld Institutes* 32 (1969): 391–93.

57 For the drawing in Oxford, Ashmolean Museum, c. 1480, see Wilde, "Michelangelo and Leonardo," p. 69. Wilde suggested that both Michelangelo and Raphael knew the drawing or another version of Leonardo's composition, which he identified as the common source for the Doni Tondo and for Raphael's Alba *Madonna*. For Raphael's debt to Leonardo in relation to this *Madonna*, see also Paul Joannides, *The Drawings of Raphael with a Complete Catalogue* (Berkeley and Los Angeles, 1983), p. 183, pen and ink studies of the Virgin and Child in Florence, Uffizi, 496E, 202v.

58 For the Stone of Unction, see chapter 4, above. The pose of the Christ Child is derived from a putto on the Phaedra sarcophagus in the Pisa Camposanto; Johannes Wilde, "Eine Studie Michelangelos nach der Antike," *Mitteilungen des Kunsthistorischen Institutes in Florenz* 4 (1932–34): 58.

59 Whichever was begun first, the two tondi are close in date; see Poeschke, *Michelangelo*, pp. 81–84, dating the Taddei Tondo c. 1503, followed by the Pitti, c. 1504–05. Michelangelo apparently used another model on at least two occasions, for the *Pietà* and the Santo Spirito Crucifix; see p. 112 above. His use of male models for female subjects was not unique: many contemporaries did likewise, including Raphael, Sarto, and Tintoretto. Other masters concealed the fact, however, whereas Michelangelo made comparatively little effort to do so here and indeed announced it in slightly later works, including the Doni *Madonna* and the Sistine Sibyls. For this announcement of "male qualities," see Creighton Gilbert, "The Proportion of Women," in his *Michelangelo On and Off the Sistine Ceiling: Selected Essays* (New York, 1994), p. 100.

60 Johannes Wilde, *Michelangelo: Six Lectures* (Oxford, 1978), p. 38, notes that drawings for the *Madonna* appear on the same sheets as the artist's first studies for the *Battle of Cascina*, which proves that he was working

on the statue in Florence, before his departure for Rome in spring 1505. For the drawing (British Museum 1859-6-25-564r), see also Charles de Tolnay, *Corpus dei disegni di Michelangelo*, 4 vols. (Novara, 1975–80), vol. 1, pp. 56–57.

61 Paul Joannides suggested this attractive explanation for the Child's posture to me. Whatever the Child's action, however, his placement between Mary's legs evokes the *Platytera*.

62 Vasari-Barocchi 6: 22–23. According to Condivi, p. 22, Agnolo Doni paid the stipulated 70 ducats for his tondo. If Vasari concocted the story, which seems to be the case, the point was to admonish patrons to be generous, or at least not to break contractual agreements.

63 Varchi, *Orazione funerale*, p. 16. Among numerous publications on Michelangelo's tondo, see Luciano Berti et al., *Il Tondo Doni di Michelangelo e il suo restauro*, Gli Uffizi, Studi e Ricerche 2 (Florence, 1984); and the splendid analysis by Timothy Verdon, "'Amor ab Abspectu': Maria nel tondo Doni e l'Umanesimo cristiano," in *Teologia a Firenze nell'età di Giovanni Pico della Mirandola = Vivens homo: Rivista teologica fiorentina* 5, 2 (1994): 531–52. The tondo has sometimes been dated in relation to the birth of the patron's first child, Maria, on 8 September 1507; see Andrée Hayum, "Michelangelo's *Doni Tondo*: Holy Family and Family Myth," *Studies in Iconology* 7–8 (1981–82): 231–32; and Antonio Natali, "Dating the Doni Tondo through Antique Sculpture and Sacred Texts," in Pietro C. Marani, ed., *The Genius of the Sculptor in Michelangelo's Work*, exh. cat., Montreal Museum of Fine Arts (Montreal, 1992), pp. 320, 321. Apart from the fact that the birth of a girl was unlikely to generate such a conspicuous commemoration, this late date for the *beginning* of work means that Michelangelo would have been painting the tondo while working on the Sistine ceiling. I think he must have had the panel near completion by the time of Maria's birth.

64 See Wilde, "Michelangelo and Leonardo," p. 66. For Fra Pietro's description, see p. 47 above.

65 Wilde, ibid.

66 Traini's panel is in Princeton, Art Museum; that by Masaccio and Masolino in London, National Gallery. For Anne as a remarkably "fashionable" saint in the late fifteenth and early sixteenth century and for a concomitant interest in the Holy Family, see Meyer Schapiro, "Freud and Leonardo: An Art Historical Study" (1956), in his *Theory and Philosophy of Art: Style, Artist, and Society* (New York, 1994), pp. 167–73.

67 See Wilde, "Michelangelo and Leonardo," fig. 6. Wilde suggests that the sheet in the Ashmolean (his fig. 5) may have been intended for a statuary group, though there is no record of Michelangelo's having been engaged in such a project. The sheet in the Louvre, according to Wilde, is even more clearly sculptural in conception.

68 Verdon, "'Amor ab Abspectu'," p. 545. On Leonardo's handling, see also E.H. Gombrich, "Blurred Images and Unvarnished Truth," *British Journal of Aesthetics* 2 (1962): 170–79; and John Shearman, "Leonardo's Color and Chiaroscuro," *Zeitschrift für Kunstgeschichte* 25 (1962): 13–47.

69 Verdon, "'Amor ab Abspectu'," p. 544.

70 Wilde, *Michelangelo*, p. 45.

71 Ibid. For her androgyny and for much of the following discussion, see Goffen, "Mary's Motherhood." The couple's "wedding portraits" by Raphael (Florence, Uffizi) might date as early as 1505, though many scholars date both works a little later, c. 1507–08; see Roger Jones and Nicholas Penny, *Raphael* (New Haven and London, 1983), pp. 29–30.

72 The drawing is usually called a life study, but Antonio Natali argues convincingly that it is based on such Hellenistic heads of Alexander (or Helios) as the so-called *Dying Alexander* in the Uffizi; "L'antico, le Scritture e l'occasione: Ipotesi sul Tondo Doni," Berti, *Tondo Doni*, pp. 26–27; and Berti, "Dating the Doni Tondo," in Pietro C. Marani, *Genius of the Sculptor*, pp. 314–15.

73 Wilde, *Michelangelo*, p. 45, mentions an iconographic relation to images of the Madonna and Child and Saint Anne but seems to mean a compositional likeness.

74 As explained in a seminal study, Sharon Fermor, "Movement and Gender in Sixteenth-Century Italian Painting," in *The Body Imaged: The Human Form and Visual Culture since the Renaissance*, ed. Kathleen Adler and Marcia Pointon (Cambridge, 1993), pp. 129–45, p. 130 for the distinction of *gagliardìa* and *leggiadrìa*; pp. 131, 132, 137 for citations of Castiglione and Firenzuola, among others.

75 Baldassar Castiglione, *Il libro del cortegiano*, ed. Giulio Carnazzi, with introduction by Salvatore Battaglia (Milan, 1987), p. 212 (bk. III, ch. viii).

76 Conversely, there is only one markedly feminized male in his oeuvre, the *Bacchus*, praised by Vasari for its union of male and

female qualities; see Vasari-Barocchi 6: 15, and pp. 97–98 above. In this case, the sexual admixture is meant to suggest uncertain morality – whereas a masculinized woman is a morally good thing, a feminized man is bad.

77 The following sentences on masquerade are from Rona Goffen, "Lotto's *Lucretia*," *Renaissance Quarterly* 52 (1999): 776.

78 The fundamental study on the female masquerade is the essay by Joan Riviere, "Womanliness as Masquerade" (1929), in *Formations of Fantasy*, ed. Victor Burgin, James Donald, and Cora Kaplan (London and New York, 1986), pp. 35–44. On the distinction between the masquerade and the role, see Harry Brod, "Masculinity as Masquerade," in *The Masculine Masquerade: Masculinity and Representation*, ed. Andrew Perchuk and Helaine Posner (Cambridge, MA, and London, 1995), pp. 13–19.

79 See Yael Even, "The Heroine as Hero in Michelangelo's Art," *Women's Art Journal* 11 (1990): 29–33.

80 "A man within a woman, or rather a god, speaks through her mouth"; in James M. Saslow, *The Poetry of Michelangelo: An Annotated Translation* (New Haven and London, 1991), p. 398. As Saslow and others have noted, Michelangelo refered to Colonna as his "lord" (*signore*) and as *amico*, in the masculine.

81 Such ideas were commonplace; see the postscript in Mirella Levi d'Ancona, "The *Doni Madonna* by Michelangelo: An Iconographic Study," *Art Bulletin* 50 (1968): 43–50.

82 See Francette Pacteau, "The Impossible Referent: Representations of the Androgyne," in *Formations of Fantasy*, ed. Burgin, Donald, and Kaplan, p. 70.

83 Codex Urbinas, fol. 13v, quoted in Daniel Arasse, *Leonardo da Vinci: The Rhythm of the World*, trans. Rosetta Translations (New York, 1998), p. 465.

84 A possibility suggested by Arasse, ibid., who adds that the passage "illustrates Leonardo's painterly ambition, to paint pictures with the power of making men and women who look at them fall in love with them." See also Arasse, pp. 475–87, on "Leonardo as a Person."

85 A preparatory red chalk drawing for the latter work, showing the saint nude, was formerly in Varese (present whereabouts unknown). The *Baptist/Bacchus* was still unfinished when Leonardo took it with him to France. It was one of the paintings that he showed Cardinal Luigi d'Aragona and his secretary Antonio de Beatis when they visited Leonardo's studio there on 10 October 1517, together with a portrait of "a Florentine woman [...] made for [...] Giuliano de' Medici" (presumably not *La Gioconda*, therefore, though they may have been mistaken about its patronage) and the *Madonna and Child and Saint Anne* (now Paris, Louvre). See Edoardo Villata, "Il *San Giovani Battista* di Leonardo: Un'ipotesi per la cronologia e la committenza," *Raccolta vinciana* 27 (1997): 187–236, esp. pp. 187, 189. Writing c. 1625, Cassiano del Pozzo described it as a "St. John in the desert," but at some date between 1683 and 1695, the saint was transformed into Bacchus. See Arasse, *Leonardo*, pp. 470, 471, 473; and Marani, *Leonardo*, pp. 46, 278, 308. Both compositions are related in turn to a drawing of the *Angel of the Annunciation*, c. 1513–14 (Germany, private collection), which features both a bare female breast and an exposed, erect phallus, which Arasse, p. 468, aptly describes as "blasphemous" (the sheet is his fig. 319). Arasse accepts an attribution of the drawing to Leonardo himself but it may be a copy by a student after a lost original, according to Marani, p. 309. For the drawing, see also Carlo Pedretti, "The 'Angel in the Flesh'," *Achademia Leonardi Vinci* 4 (1991): 34–51; and for the *Baptist*'s relation to folio 489 (ex-179ra) of the Atlantic Codex, Kemp, *Leonardo*, p. 320.

86 S.J. Freedberg, "A Recovered Work of Andrea del Sarto with Some Notes on a Leonardesque Connection," *Burlington Magazine* 124 (1982): 285.

87 The saint is "almost perversely sensuous [...] with erotic, possibly homosexual implications," according to Marani, *Leonardo*, p. 308. For Leonardo's departure from hagiographic tradition in this work, see also Arasse, *Leonardo*, p. 462.

88 The *Spinario* was one of the most-quoted ancient figures, appearing in the competition panels by Ghiberti and Brunelleschi, *inter alia*. An example of the *Diomedes* formerly in the collection of Lorenzo il Magnifico was drawn by Leonardo c. 1503. For Leonardo's allusions to these monuments and for his response to Michelangelo, see Arasse, ibid., p. 471.

6 Raphael

1 Condivi, p. 54.

2 For the letter addressed to an unknown cardinal and datable before 24 October 1542,

see Barocchi and Ristori, *Carteggio* 4: 155, MI. Twenty-two years after Raphael's death in 1520, Michelangelo was still envious of his success: like many complaints, Michelangelo's lament is more revealing about himself than about his rival.

3 Sebastiano to Michelangelo, 7 September 1520, in Barocchi and Ristori, *Carteggio* 2: 242, CDLXXI; see also p. 258 above.

4 The contract for the altarpiece, 10 December 1500, names Raphael and Meleto, who had been an associate of Raphael's father since 1483; but the younger man is named first and described as *Magister*, "master." See Vincenzo Golzio, *Raffaello nei documenti, nelle testimonianze dei contemporanei e nella letteratura del suo secolo* (Vatican City, 1936; rev. ed. Farnborough, 1971), pp. 7–8. For the four surviving fragments of the altarpiece, see Jürg Meyer zur Capellen, *Raphael: A Critical Catalogue of his Paintings*, vol. 1: *The Beginnings in Umbria and Florence ca. 1500–1508*, ed. and trans. Stefan P. Polter (Münster, 2001), pp. 98–105, cat. 1.

5 Vasari-Barocchi 4: 204, 205. See also André Chastel, "Raffaello e Leonardo," in Micaela Sambucco Hamoud and Maria Letizia Strocchi, ed., *Studi su Raffaello: Atti del Congresso internazionale di studi (Urbino–Firenze 1984)*, 2 vols. (Urbino, 1987), vol. 1, pp. 335–43.

6 For the biographer's partly imaginary description of Raphael's happy home life, in sharp contradistinction to his largely accurate account of Michelangelo's childhood, see Vasari-Barocchi 4: 154–57, 6: 5. Raphael's mother, Magia di Battista Ciarla, died on 7 October 1491; Santi remarried in 1492 and died two years later (1 August 1494). Raphael was his father's only surviving child. For the Santi family and Raphael's professional beginnings, see Meyer zur Capellen, *Raphael: Critical Catalogue*, pp. 16–17; and Paul Joannides, "Raphael and Giovanni Santi," in *Studi su Raffaello*, ed. Sambucco Hamoud and Strocchi, vol. 1, pp. 55–61. For a psychoanalytic interpretation of Raphael's relationship with his parents and stepmother, see Laurie Schneider, "Raphael's Personality," *Source* 3, 2 (Winter 1984): 9–22.

7 As noted by John Onians, "On How to Listen to High Renaissance Art," *Art History* 7 (1984): 428. Raphael also tried his hand at sonneteering but failed in the attempt. Almost all of his poetry is written on drawings for the *Disputà*, therefore datable c. 1509–10. See Golzio, *Raffaello nei documenti*, pp. 181–88.

8 Vasari-Barocchi 4: 155–56.

9 Ibid., p. 212. For Michelangelo's wretched living conditions, see p. 149 above.

10 Eduardo Saccone, "*Grazia, Sprezzatura*, and *Affettazione* in Castiglione's *Book of the Courtier*," *Glyph: Johns Hopkins Textual Studies* 5 (1979): 36, 37. Saccone considers the Christian usage of the word and the interdependence of *grazia* with *sprezzatura*, the paradoxical conception of "art without art," seen as an "enormous extension of *grazia*" and as dissimulation (pp. 44, 43, 46), and its negation, *affetazione* (pp. 41, 43). See also Daniel Arasse, "Raffaello senza venustà e l'eredità della grazia," in *Studi su Raffaello*, ed. Sambucco Hamoud and Strocchi, vol. 1, pp. 703–14, esp. p. 706.

11 Vasari-Barocchi 4: 212, adding "to say nothing of men." Vasari related Raphael's graciousness to his liberality.

12 Raphael's training with Perugino is asserted by Vasari in biographies of both painters; ibid. 3: 611–12 (Perugino), 4:157–58 (Raphael). For rivalry tempered by imitation, see Valeria Finucci, "In the Name of the Brother: Male Rivalry and Social Order in Baldassare Castiglione's *Il libro del cortegiano*," *Exemplaria* 9 (1997): 101.

13 See Meyer zur Capellen, *Raphael: Critical Catalogue*, pp. 25, 140–41. For the preparative drawings, see Paul Joannides, *The Drawings of Raphael with a Complete Catalogue* (Berkeley and Los Angeles, 1983), p. 148, nos. 63r–v, 64; note also Joannides, p. 147, no. 59, a pen drawing of the meeting of Frederick II and Eleanor of Portugal in a composition anticipating the *Sposalizio*.

14 The Holy Ring – the ring believed to have been presented by Joseph to Mary at their betrothal – had been stolen from Chiusi in 1478. Veneration of the ring may be related to contemporary efforts by the Church to regulate marriage (before Trent, a private matter between two families) and to the growing cult of Saint Joseph – despite the fact that rings were not used in marriage ceremonies in Joseph's time. The ring was installed in the chapel of the Confraternita or Compagnia di San Giuseppe in Perugia cathedral, which commissioned an altarpiece from Pinturicchio in 1489. Ten years later, with nothing to show for their efforts, the priors of the confraternity turned to their native son for the altarpiece. Perugino began work in November 1500, but the altarpiece was still unfinished at the end of December 1503, when Paride di Baldassare Petrini made his testamentary bequest to the Compagnia di San Giuseppe of 5 fiorini to be paid

only when Perugino's painting was completed, "and not before"; see Fiorenzo Canuti, *Il Perugino*, 2 vols. (Siena, 1931), vol. 2, pp. 258–59. Its prestigious site endowed Perugino's altarpiece with "authority," as noted by Sergio Bertelli, "Caen and Brera: From Marriage to Divorce," in *Raphael before Rome*, ed. James Beck (Washington, DC, 1986), p. 31. See also Jörg Traeger, *Renaissance und Religion: Die Kunst des Glaubens im Zeitalter Raphaels* (Munich, 1997), pp. 61–76, 105–08, 118–22 (on the iconography of the betrothal and the cults of Joseph and the ring); pp. 266, 268, 420–21 (on Raphael's patron in Città di Castello, Filippo di Ludovico Albizzini); and ch. 4 (the chapel in Perugia cathedral).

15 Giovio, *Fragmentum trium dialogorum*, in Paola Barocchi, ed., *Scritti d'arte del Cinquecento*, 3 vols. (Milan and Naples, 1971–77), vol. 1, pp. 19–20.

16 Vasari-Barocchi 3: 608.

17 Ibid., pp. 608, 609–10. The Servites of Santissima Annunziata had previously approached Leonardo, according to Vasari, and then (15 September 1503) turned to Filippino Lippi, who died on 15 April 1504 before completing the commission. Perugino's agreement is dated 5 August 1505, with the last payments recorded in October 1507. The main panels represent the *Deposition from the Cross* (Florence, Accademia) and the *Assumption of the Virgin* (Santissima Annunziata); the flanking panels with saints are dispersed among collections in Altenburg, New York, and formerly in Paris.

18 By 1512 the tables were turned: Perugino's commission in 1512 for the *Assumption* altarpiece for Santa Maria in Corciano requires that it resemble and surpass Raphael's Oddi altarpiece. See Patricia Rubin, "Il contributo di Raffaello allo sviluppo della pala d'altare rinascimentale," *Arte cristiana* 78 (1990): 173, 174, 182n39; and Canuti, *Perugino*, 2: 458, no. 430: "et melioribus."

19 Golzio, *Raffaello nei documenti*, pp. 11–13. The assumption that Raphael would know Ghirlandaio's painting in Narni, midway between Perugia and Rome, is germane to arguments of his having been to Rome before his first documented trip there in 1508; see John Shearman, "Raphael, Rome and the Codex Escurialensis," *Master Drawings* 15 (1977): 131. The *Coronation* (Pinacoteca Vaticana) was to be delivered by 1 January 1508, but nothing had been done by 21 June 1516, when the contract was renegotiated. The Claires finally got their altarpiece only

after Raphael's death, when Giulio Romano and Giovan Francesco Penni completed the work on 21 June 1525.

20 For the Ansidei *Madonna* or *Madonna and Child Enthroned with Saints John the Baptist and Nicholas of Bari* (London, National Gallery), see Meyer zur Capellen, *Raphael: Critical Catalogue*, pp. 163–70. The date, on the edge of Mary's mantle near her left hand, can be read as MDV, MDVI, or MDVII. See Cecil Gould, *The Sixteenth-Century Italian Schools*, National Gallery Catalogues (London, 1975; rpt. 1987), p. 216. The inscription with the fragmentary date 1505 beneath Raphael's fresco of the *Trinity* (Perugia, San Severo) has been restored but is accepted as authentic: RAPHAEL DE URBINO.DOMINO.OCTAVI/ANO.STEPHANI. VOLATE [. . .] ANO.PRIO/RE. SANCTAM TRINITATEM.ANGE/LOS.ASTANTES/SANTOSQ [. . .]/PINXIT/A.D.[. . .]D.V. See Jürg Meyer zur Capellen, *Raphael in Florence*, trans. Stefan B. Polter (London, 1996), p. 34 and fig. 15.

21 The same might be said of the *Entombment* signature, but in that later work, it is marginalized in the lower left corner, a traditional and far less conspicuous placement than in the *Sposalizio*. For the *Entombment* (Fig. 112), see above, pp. 205–08, 210–13.

22 On this theme, see Elizabeth Cropper, "On Beautiful Women, Parmigianino, Petrarchismo, and the Vernacular Style," *Art Bulletin* 58 (1976): 374–94; and Rona Goffen, *Titian's Women* (New Haven and London, 1997).

23 Vasari-Barocchi 4: 159. For Raphael's awareness of the importance of his achievement, indicated by the signature, see also Pierluigi De Vecchi, *Raffaello: La mimesis, l'armonia e l'invenzione* (Florence, 1995), pp. 27, 29.

24 As noted by Pierluigi De Vecchi, *Lo Sposalizio della Vergine di Raffaello* (Florence, 1973), n. 9, with reference to an iconographic tradition starting in the eleventh century identifying the so-called Mosque of Omar or Dome of the Rock with the Temple of Solomon. See also Carol Herselle Krinsky, "Representations of the Temple of Jerusalem before 1500," *Journal of the Warburg and Courtauld Institutes* 33 (1970): 1–19; and Cristina Acidini Luchinat, "L'idea' del Tempio nello 'Sposalizio della Vergine,'" in Sambucco Hamoud and Strocchi, ed., *Studi su Raffaello*, vol. 1, pp. 229–38.

25 I am paraphrasing Bertelli, "Caen and Brera," p. 31.

26 For the painter-poet, see Ranieri Varese, *Giovanni Santi* (Fiesole, 1994). On Alberti's importance for Santi, see Lise Bek,

"Giovanni Santi's 'Disputa de la pictura': A Polemical Treatise," *Analecta Romana Instituti Danici* 5 (1969): 89, 91, 98, 99. For Alberti's "Ideal Church" and the symbolism of round buildings, see Rudolf Wittkower, *Architectural Principles in the Age of Humanism* (New York, 1949; rpt. 1965), pp. 3–13, 27–30; and for his influence on Raphael's architecture, see Pierluigi De Vecchi, *Lo Sposalizio della Vergine di Raffaello Sanzio* (Milan, 1996), p. 43.

27 See De Vecchi, ibid., pp. 46–48, with an explanation of Raphael's precise calculation of measurements. Raphael's altarpiece differs from Perugino's also because of their different sites: Perugino's was displayed with the ring itself, whereas Raphael was compelled to evoke that relic with reiterations of its circular form. See Traeger, *Renaissance und Religion*, pp. 277–80, 287–92, 327–28. Raphael's kinship to Bramante has been questioned by Charles Robertson, "Bramante, Michelangelo and the Sistine Ceiling," *Journal of the Warburg and Courtauld Institutes* 49 (1986): 96.

28 My discussion is much indebted to De Vecchi, *Sposalizio della Vergine di Raffaello* (1996).

29 Bek, "Santi's 'Disputa'," p. 84, verse 127.

30 Whether he had been to Venice, Santi knew Madonnas by Bellini, as Paul Joannides reminds me. Santi's *Madonna and Sleeping Child* (London, National Gallery), c. 1488, recalls Bellini's panel in Boston, Isabella Stewart Gardner Museum. For Santi's debt, see Oskar Fischel, "A Motive of Bellinesque Derivation in Raphael," *Old Master Drawings* 13 (1939): 50–51; and Renée Dubos, *Giovanni Santi: Peintre et chroniqueur à Urbin, au XVe siècle* (Bordeaux, 1971), p. 118.

31 For convincing arguments that Raphael knew the Pesaro altarpiece and works by Bellini in Venice, see Germano Mulazzani, "Raphael and Venice: Giovanni Bellini, Dürer, and Bosch," in *Raphael before Rome*, ed. James Beck (Washington, DC, 1986), pp. 149–53; and the following essays in Sambucco Hamoud and Strocchi, *Studi su Raffaello*, vol. 1: Cecil Gould, "Raffaello a Venezia," pp. 111–15; Konrad Oberhuber, "Raphael and Giorgione," pp. 117–24; and Lionello Puppi, "Raffaello a Venezia," pp. 563–79. Several of Raphael's Madonnas evoke Bellini's in composition and mood, e.g., the *Madonna and Child with a Book* or *Madonna at Nones* (Pasadena, Norton Simon Museum), c. 1502–03, which adapts Christ's pose from Bellini's Frizzoni *Madonna* (Venice, Civico Museo Correr), a work of the early 1470s. For Raphael's studies for the Norton Simon *Madonna*, see Joannides, *Drawings of Raphael*, p. 414, cat. 32r-v (Oxford, Ashmolean, 508a). Another drawing by Raphael shows a profile portrait of a man wearing the ducal cap (*camauro*) and corno. Only the doge wore such headgear, but the man portrayed by Raphael is clearly not Leonardo Loredan, doge from 1501 to 1521. For the drawing in Lille, Musée des Beaux-Arts, no. 468, c. 1504–05, see Joannides, p. 151, cat. 76. Konrad Oberhuber, *Raphael: The Paintings* (Munich, London, and New York, 1999), p. 130, notes Raphael's use of Venetian *carta azzurra* for another sheet (London, British Museum, 1900-8-24-107), for which see also Joannides, p. 203, cat. 281, and p. 280 above. Raphael of course knew works by Venetian artists active in Rome, namely Sebastiano del Piombo and Lorenzo Lotto, who received two payments for work in a room in the Vatican, probably a chamber adjoining the Stanza della Segnatura, in March and September 1509. See Peter Humfrey, *Lorenzo Lotto* (New Haven and London, 1997), pp. 32, 169n15; and Arnold Nesselrath, "Lorenzo Lotto in the Stanza della Segnatura," *Burlington Magazine* 142 (2000): 3–12.

32 Vasari-Barocchi 4: 159.

33 Following Venturi, De Vecchi, *Sposalizio della Vergine di Raffaello* (1996), pp. 53–54, notes Raphael's reliance on Perugino for these figures and Raphael's role in painting the Cambio frescoes. My description owes much to De Vecchi's analysis.

34 Golzio, *Raffaello nei documenti*, pp. 9–10.

35 Raphael was almost certainly in Rome in October 1503, on the occasion of the election of Feltria's brother-in-law Giuliano as Pope Julius II. See Shearman, "Raphael, Rome."

36 Vasari suggested such a visit in the Life of Raphael and ascribed the "sketches and cartoons" for the frescoes to him in the Life of Pinturicchio; see Vasari-Barocchi 4: 159 (Raphael) and 3: 571–72 (Pinturicchio). For drawings by Raphael representing episodes of the life of Aeneas Silvius Piccolomini (Pius II), related to Pinturicchio's fresco cycle in the Piccolomini Library, see Carmen C. Bambach, *Drawing and Painting in the Italian Renaissance Workshop: Theory and Practice, 1300–1600* (Cambridge and New York, 1999), p. 346; and Joannides, *Drawings of Raphael*, pp. 48–51, 146–47, nos. 56, 57r-v, 58r-v.

37 As noted by De Vecchi, *Sposalizio della Vergine di Raffaello* (1996), p. 24. On the *Coronation*, see also Sylvia Ferino Pagden, "Iconographic Demands and Artistic Achievements: The Genesis of Three Works by Raphael," in *Raffaello a Roma: Il convegno del 1983*, ed. Christoph Luitpold Frommel and Matthias Winner (Rome, 1986), pp. 14–18.

38 Vasari-Barocchi 4: 159.

39 The silverpoint (Oxford, Ashmolean 535) is related to the *Trinity* in San Severo, Perugia. The pen sketch with a partial copy of the *Cascina* cartoon is Vatican, Lat. 13391. Raphael returned to the *Battle of Anghiari* later in his career, sketching one of Leonardo's screaming warriors on a sheet with a study of two men for the *School of Athens*, c. 1509–10 (Oxford, Ashmolean 550) and the head of a "Leonine" horse in a drawing c. 1511–12 (Ashmolean 556). Eventually, his heirs adapted Leonardo's ideas for the battles in the Sala di Costantino, c. 1519–20. See Joannides, *Drawings of Raphael*, p. 26.

40 Vasari-Barocchi 4: 159. Once he was in the city, Vasari added, pp. 159–60, Florence itself pleased Raphael no less than her art, and he became friendly with the artists Ridolfo Ghirlandaio and Aristotile da Sangallo and the collector Taddeo Taddei, for whom he made two paintings which Vasari knew in the collection of Taddei's heirs. See pp. 199–200 above.

41 Ibid., p. 610 (Life of Baccio d'Agnolo). Among the participants were Andrea Sansovino, Filippino Lippi, Benedetto da Maiano, Cronaca, Antonio and Giuliano da Sangallo, and Granacci. Vasari explained, p. 611, that Baccio (1462–1543) was the architect of Taddeo Taddei's house. Baccio was also *capomaestro* of Florence cathedral and Michelangelo's erstwhile collaborator at San Lorenzo. See pp. 238–41 above.

42 For Raphael's access to Michelangelo's works while they were still in the shop, see Anna Forlani Tempesti, *Raffaello e Michelangelo*, exh. cat., Florence, Casa Buonarroti (Florence, 1984), p. 14.

43 See *inter alia* Joannides, *Drawings of Raphael*, p. 17. Joannides notes that initially Raphael was more responsive to those works by Michelangelo that were themselves influenced by Leonardo, notably the Taddei Tondo. During this Florentine period, Raphael painted a copy of Leonardo's *Benois Madonna* (Fig. 13); for the *Madonna with a Carnation* (Alnwick Castle, Duke of Northumberland), c. 1506, see Meyer zur

Capellen, *Raphael: Critical Catalogue*, pp. 210–12.

44 I suspect that Raphael would have happily accepted a large-scale commission were it offered him, but cf. Joannides, ibid., p. 16, who suggests that the painter's concentration on small-scale works "is an indication that he had no immediate intention of establishing himself in a workshop organization for large-scale projects."

45 Namely the *Madonna del Baldacchino* for the Dei chapel in Santo Spirito; Meyer zur Capellen, *Raphael: Critical Catalogue*, pp. 276–81, no. 40. These were nomadic years for Raphael but that did not preclude his undertaking two major commissions in Perugia: the *Entombment* and the *Trinity*, a fresco in the church of San Severo. Both the Dei altarpiece and the Perugia fresco were left incomplete when Raphael moved to Rome in 1508.

46 See Marcia B. Hall, *Color and Meaning: Practice and Theory in Renaissance Painting* (Cambridge and New York, 1992), pp. 116–36 for "the modes of coloring" used by Leonardo, Raphael, and Michelangelo; John Shearman, "Leonardo's Color and Chiaroscuro," *Zeitschrift für Kunstgeschichte* 25 (1962): 13–47; and Shearman, "Isochromatic Color Compositions in the Italian Renaissance," in Marcia B. Hall, ed., *Color and Technique in Renaissance Painting* (Locust Valley, 1987), pp. 151–60.

47 The likeness of Cavalieri, drawn in the 1530s, has been lost but is known to have shown him holding a medal, like Sandro Botticelli's *Young Man* (Florence, Uffizi); see Giovanni Agosti and Michael Hirst, "Michelangelo, Piero d'Argenta and the 'Stigmatisation of St. Francis'," *Burlington Magazine* 138 (1996): 684. The drawing of Quaratesi (London, British Museum), a work of the 1520s, shows Michelangelo to have been a brilliant portraitist despite his stated uninterest in the genre. See Michael Hirst, *Michelangelo and his Drawings* (New Haven and London, 1988), p. 11 and pl. 25, for this and for a drawing of a child (Haarlem, Teylers Museum); although categorized as a portrait by Hirst, I think it is more accurately described as a likeness rather than a portrait in the sense of a commemoration of that individual.

48 Vasari-Barocchi 4: 163. Vasari also omitted mention of Raphael's Florentine Madonnas, the other conspicuous instance of his "studying" Leonardo.

49 For the woman and her portrait, see Frank Zöllner, *Leonardo da Vinci Mona Lisa: Das*

Porträt der Lisa del Giocondo, Legende und Geschichte (Frankfurt, 1994), and Janice Shell and Grazioso Sironi, "Salaì and Leonardo's Legacy," *Burlington Magazine* 133 (1991): 100.

50 Vasari-Barocchi 4: 30–31.

51 See Meyer zur Capellen, *Raphael: Critical Catalogue*, pp. 284–86, no. 42. For Raphael's response to Leonardo's portrait, see also Luba Freedman, "Raphael's Perception of the Mona Lisa," *Gazette des Beaux-Arts* 114 (1989): 169–82.

52 Joannides, *Drawings of Raphael*, pp. 62–63, no. 15 and cat. 175, suggests that Ridolfo Ghirlandaio might have completed the portrait and dates the related drawing by Raphael (Paris, Louvre, inv. 3882) c. 1507. Cf. Meyer zur Capellen, *Raphael: Critical Catalogue*, pp. 290–93, no. 44, who accepts the attribution to Raphael himself, with a slightly earlier dating, c. 1505–06.

53 For these portraits, see Meyer zur Capellen, ibid., pp. 298–302.

54 On the portrait, formerly believed to represent Joanna of Aragon, see Michael P. Fritz, *Giulio Romano et Raphaël: La vice-reine de Naples, ou la renaissance d'une beauté mythique*, trans. Claire Nydegger (Paris, 1997), identifying the subject as Doña Isabel de Requesens i Enríquez de Cardona-Anglesola, consort of the viceroy of Naples. A letter from Beltrando Costabili, Alfonso d'Este's envoy to the papal court, 2 March 1519, refers to "the portrait that his [Raphael's] *garzone* has made." The unnamed assistant is surely Giulio. For this letter and the correspondence about Alfonso's acquisition of the cartoon, 29 December 1518 to 2 March 1519, see Golzio, *Raffaello nei documenti*, pp. 75–77; and p. 278 above. It is difficult to assess Raphael's contributions to the *Isabel* if he did neither the cartoon nor the painting itself. I believe that the conception of the portrait (including the composition) can be credited to the master – which in fact proved its most influential element.

55 On this portrait and the tradition of papal portraiture, see Loren Partridge and Randolph Starn, *A Renaissance Likeness: Art and Culture in Raphael's Julius II* (Berkeley, Los Angeles, and London, 1980). The portrait was first displayed on the altar of Santa Maria del Popolo in early September 1513, some eight months after the pope's death (2 February); ibid., pp. 75–103. Unlike Partridge and Starn, pp. 5, 116, and *passim*, I do not see in this portrait traces of the pope's

terribilità but recognize the "broken old man" they describe on p. 4.

56 Vasari-Barocchi 4: 174. The first account of the painting, by Vetor Lippomano writing in early September 1513, also takes note of its lifelikeness: the portrait is "very similar to nature" and "all Rome" came to see "him" at Santa Maria del Popolo (quoted in Partridge and Starn, *Renaissance Likeness*, p. 1).

57 The painting takes its name from the Colonna family who owned it in the seventeenth century. The lunette and main panel are in New York, Metropolitan Museum of Art; the three predella panels are divided among three museums: *Agony in the Garden*, also in the Metropolitan Museum; the central panel, the *Way to Calvary*, in London, National Gallery; and the *Pietà* in Boston, Isabella Stewart Gardner Museum. Standing figures of saints identified as from the bases of the lateral pillars of the altar frame are in London, Dulwich Picture Gallery; New York, Christie's (May 2000); and Urbino, Palazzo Ducale. For these various panels and their reconstruction, see Meyer zur Capellen, *Raphael: Critical Catalogue*, pp. 172–87, no. 17. The cartoon for the *Agony in the Garden* is in New York, Pierpont Morgan Library I, 15; see Joannides, *Drawings of Raphael*, p. 152, no. 83, and p. 153, nos. 84r–v, 85r, 86, for figure studies related to the altarpiece.

58 For the drawings in Oxford, Ashmolean Museum, P II 522, and in London, British Museum, Pp. 1–65 and Pp. 1–68, see Joannides, ibid., p. 153, nos. 85v, 87v, and p. 156, no. 97 (Fig. 103 above); and J. A. Gere and Nicholas Turner, *Drawings by Raphael from the Royal Library, the Ashmolean, the British Museum, Chatsworth and Other English Collections* (London, 1983), pp. 59–61, nos. 37–39. These authors agree in interpreting Pp. 1–65 as a life study of a model posed to recall the *David*. A sheet in New York, Metropolitan Museum 87.12.69, has been identified as an old copy after another drawing by Raphael after the *David*; Jacob Bean, *15th and 16th Century Italian Drawings in the Metropolitan Museum of Art* (New York, 1982), p. 211. Note also the drawing of male nudes based on the *David* attributed to Raphael by Konrad Oberhuber, *Raphael in der Albertina* (Vienna, 1983), pp. 47–48.

59 See Forlani Tempesti, *Raffaello e Michelangelo*, p. 14; and Joannides, ibid., p. 202, for the drawing in Lille, 278r, with a Child derived from the Taddei Tondo.

60 For the drawing of *Leda*, Windsor 125759, see Gere and Turner, *Drawings by Raphael*, pp. 61–62, no. 40, and Joannides, ibid., p. 156, no. 98. Joannides notes that Raphael's "contour hatching shows a knowledge of Leonardo's graphic technique." Whether Raphael made other, more faithful drawings after the *David* which have been lost is unknowable, but the three that survive take liberties with the model, unlike the drawing after Leonardo.

61 See Ezio Buzzegoli, Luca Giorgio, Duilio Bertani, Maurizio Cetica, and Pasquale Poggi, "Alcune indagini sulla tecnica pittorica," in Luciano Berti et al., *Il Tondo Doni di Michelangelo e il suo restauro*, Gli Uffizi, Studi e Ricerche 2 (Florence, 1984), p. 77. The authors explain the difficulty of certainly establishing the tondo's technique because of the problem of collecting pigment samples: the painting is in an excellent state of conservation with no losses or flaking of color that could be used for this purpose. Even if the tentative conclusions should prove wrong, the tondo *looks* like a tempera painting. The unfinished *Entombment* is an oil painting; Jill Dunkerton, "The Painting Technique of the *Entombment*," in Michael Hirst and Jill Dunkerton, *Making and Meaning: The Young Michelangelo* (London, 1994), p. 111. But here too the medium is handled with the precision of tempera. For Michelangelo's extreme disapprobation of oil and the sacrifice of *disegno* that it seemed to encourage, see pp. 228, 262 above.

62 Paolo Giovio, "Raphaelis Urbinatis Vita," in Barocchi, *Scritti d'arte*, vol. 1, pp. 13–14; my italics.

63 According to Novellara's letter of 14 April 1501, the *Madonna* was intended for Florimond Robertet, then Secretary to King Louis XII of France – and the eventual owner of Michelangelo's bronze *David*. See A. Thereza Crowe, "Florimond Robertet – International Politics and Patronage of the Arts," in *Leonardo da Vinci: The Mystery of the "Madonna of the Yarnwinder"*, ed. Martin Kemp, exh. cat., Edinburgh, National Gallery of Scotland (Edinburgh, 1992), pp. 25–33. Known from Novellara's description and from various copies and variants, Leonardo's *Madonna* is best represented by the version in the collection of the Duke of Buccleuch, which recent criticism has accepted as autograph in part. See Kemp, "Leonardo's *Madonna of the Yarnwinder* – The Making of a Devotional Image," in ibid., pp. 13–14, 16–23, further arguing that

another version in a New York collection may also be partly autograph. See also the catalog entries in ibid., pp. 40–41, and Meyer zur Capellen, *Raphael in Florence*, pp. 62–64.

64 Henning Bock et al., *The Complete Catalogue of the Gemäldegalerie, Berlin* (New York, 1986), p. 63.

65 Sylvia Ferino Pagden and Maria Antonietta Zancan, *Raffaello: Catalogo completo dei dipinti*, ed. Pietro C. Marani (Florence, 1989), p. 41.

66 Vasari-Barocchi 4: 160.

67 For the letter (Biblioteca Vaticana, Borg. lat. 800), see Ettore Camesasca, ed., with Giovanni M. Piazza, *Raffaello: Gli scritti. Lettere, firme, sonetti, saggi tecnici e teorici* (Milan, 1994), pp. 100–06, no. 26, p. 104 for this quotation. Raphael may have been introduced to Taddei by Pietro Bembo; see Roger Jones and Nicholas Penny, *Raphael* (New Haven and London, 1983), p. 33.

68 Vasari-Barocchi 4: 160.

69 The *Madonna of the Goldfinch* reveals the use of *spolvero* underdrawing. For Raphael's use of pricked cartoons and *spolvero* here and in other Madonnas, including the *Madonna of the Meadow*, see Bambach, *Drawing and Painting*, pp. 102–05.

70 Filippo Baldinucci, *Notizie de' professori del disegno* (c. 1681), in *Opere* (Milan, 1811), vol. 6, p. 230. The paintings were still in the Taddei collection.

71 Taddei's paintings were identified as the *Madonna of the Meadow* and the *Madonna of the Palm* tondo (Edinburgh, National Gallery of Scotland) by Johann David Passavant, *Rafael von Urbino und sein Vater Giovanni Santi*, vol. 1 (Leipzig, 1839), followed among others by Camesasca and Piazza, ed., *Raffaello: Gli scritti*, p. 105, n. 12. But there is no particular reason to associate the Edinburgh tondo with Taddei.

72 Joannides relates this part of the sketch to the *Small Cowper Madonna* (Fig. 107) and dates both drawing and painting c. 1505. For the two drawings (Paris, Louvre, 3856; Chatsworth, 783), see Joannides, *Drawings of Raphael*, p. 155, no. 93v, and p. 159, no. 111r–v. For the *Small Cowper Madonna*, see Meyer zur Capellen, *Raphael: Critical Catalogue*, pp. 203–06, also suggesting a date c. 1505.

73 Raphael may have seen the tondo while it was still in Michelangelo's shop; see pp. 183, 196, and n. 41 above and n. 75 below. Alternatively, Paul Joannides has argued that Raphael is more likely to have seen the

tondo in his friend Taddeo's collection than in the artist's studio. If this is correct, the second sheet would confirm Taddeo's possession of Michelangelo's tondo by that date. See Joannides, ibid., p. 159, no. 111v. Barring the discovery of new evidence, it seems impossible to know which scenario is correct.

74 Ferino Pagden and Zancan, *Raffaello*, p. 60. The practice of making a number of studies for a composition was a comparatively recent development in Italian art, introduced by Leonardo who used "drawing as an instrument of creative exploration," followed by Raphael; Onians, "How to Listen," pp. 424, 428.

75 For this likelihood, see Forlani Tempesti, *Raffaello e Michelangelo*, p. 14. For the drawing in London, British Museum 1855-2-14-1, see Joannides, *Drawings of Raphael*, p. 165, no. 133r-v.

76 Forlani Tempesti, ibid. For Raphael's debts to Michelangelo's *Saint Matthew* in the altarpiece and in the *Saint Catherine* (London, National Gallery, c. 1507–08), see also Anna Forlani Tempesti, "Raffaello e il Tondo Doni," *Studi in onore di Luigi Grassi: Prospettiva* 33–36 (1983–84): 145.

77 Atalanta's son, Grifone, had been murdered by kinsmen in 1500, during one of the family's bloodier conflicts. Patronage of Raphael may have run in the family: Atalanta's sister-in-law, Leandra degli Oddi, was possibly the patron of Raphael's *Coronation of the Virgin* (Vatican, Pinacoteca), painted for the Oddi Chapel in San Francesco al Prato, c. 1503. For the family connections, see Alison Luchs, "A Note on Raphael's Perugian Patrons," *Burlington Magazine* 125 (1983): 25–29. On the *Entombment*, see Meyer zur Capellen, *Raphael: Critical Catalogue*, 233–46, no. 31, and Ferino Pagden, "Iconographic Demands," pp. 19–23.

78 Joannides, *Drawings of Raphael*, pp. 18–19, 58 no. 13, pp. 163–68 nos. 124–42, p. 169 no. 148v, p. 171 no. 158v. For the sheets in the Ashmolean and British Museums, see also Gere and Turner, *Drawings by Raphael*, pp. 93–105, nos. 72–80; and for the pricked patterns in the Ashmolean and Oxford sheets, Bambach, *Drawing and Painting*, pp. 88, 405n51. The crude and partial pricking of the *modello* for the *Entombment* in the Uffizi (inv. 538 E) seems to have been done by a "scavenger" seeking to copy Raphael's composition; Bambach, pp. 122, 417n228.

79 The first studies are Ashmolean 530 and Louvre 3865; Joannides, ibid., p. 163, nos. 124v, 125. Perugino's *Lamentation* is signed and dated 1495. Raphael might also have consulted Perugino's *Pietà* (Florence, Uffizi), painted c. 1494–95 for the Florentine church of San Giusto. According to Jones and Penny, *Raphael*, p. 44, another possible source was Mantegna's engraving of the *Entombment*, c. 1488–89.

80 Drawings that show Raphael's debt to the tondo are: Paris, Louvre 3865; Oxford, Ashmolean 529; London, British Museum 1895-9-5-636. For the relation to Michelangelo's *Entombment* as seen in Raphael's drawing in the British Museum, see John Shearman, *Only Connect . . . : Art and the Spectator in the Italian Renaissance* (Washington and Princeton, 1992), p. 86; and his "Rome, Raphael," arguing convincingly for the artist's early undocumented trip to Rome. Raphael could have seen the tondo once it was installed in the Doni household if not earlier, that is, in Michelangelo's studio.

81 The two related classical prototypes show Venus crouching on the ground with one leg folded beneath her and the other with raised knee. They differ in the posture of the upper body: in the *Venus and a Tortoise*, her torso twists at an angle to her hips and her right arm is raised; in the *Crouching Venus*, she bends forward with shoulders and hips aligned and turns her head over her shoulder. For the ancient statues and Leonardo's drawings of *Leda and the Swan* (Chatsworth collection and Rotterdam, Museum Boymans-van Beuningen), see Francis Ames-Lewis and Joanne Wright, *Drawing in the Italian Renaissance Workshop*, exh. cat., London, Victoria and Albert Museum (London, 1983), pp. 214–16, no. 45. Leonardo later abandoned the seated pose for the *Standing Leda*, which was copied by Raphael (Windsor, Royal Collection 125759); see Martin Clayton, *Raphael and his Circle: Drawings from Windsor Castle*, exh. cat., London, Queen's Gallery (London, 1999), pp. 57–59, no. 12, dated c. 1507; Gere and Turner, *Drawings by Raphael*, pp. 61–62, no. 40; and Joannides, *Drawings of Raphael*, p. 156, no. 98, dated c. 1505. For Leonardo's lost Ledas, see pp. 313–15 above.

82 Ashmolean 530 shows the nude body of Christ on the ground and is considered "presumably preparatory" to Louvre 3865, a compositional study of the Lamentation; see Joannides, ibid., p. 163, nos. 124v, 125.

83 British Museum 1963-12-16-1 and 1855-2-14-1r-v. For Raphael's use of the *Saint Matthew*, see also Alexander Nagel, *Michelangelo and the Reform of Art* (Cambridge and New York, 2000), p. 134.

84 See Gere and Turner, *Drawings by Raphael*, pp. 96–98, no. 75; and Joannides, *Drawings of Raphael*, p. 165, no. 132r (Oxford, Ashmolean 539).

85 Pliny concludes that Apelles never let a day pass without "drawing a line." Pliny, *Natural History, Books XXXIII–XXXV*, trans. H. Rackham (Cambridge and London, rpt. 1995), pp. 320–22, xxxv.xxxvi.81–84. On this anecdote, see H. van de Waal, "The Linea summae tenuitatis of Apelles: Pliny's Phrase and its Interpretations," *Zeitschrift für Asthetik und allgemeine Kunstwissenschaft* 12 (1967): 5–32; and Antje Middeldorf Kosegarten, "The Origins of Artistic Competitions in Italy (Forms of Competition between Artists before the Contest for the Florentine Baptistry Doors Won by Ghiberti in 1401)," in *Lorenzo Ghiberti nel suo tempo: Atti del convegno internazionale di studi*, 2 vols. (Florence, 1980), vol. 1, pp. 184–85.

86 In his biographies of Bramante, Raphael, Giuliano and Antonio da Sangallo, and of Sodoma, Vasari reiterated that Bramante brought Raphael to Rome; Vasari-Barocchi 4: 84, 165, 146, and 5: 384.

87 On the Tempietto, see Wolfgang Lotz, *Architecture in Italy 1500–1600* (London, 1974; rpt. New Haven and London, 1995), p. 11. As Deborah Howard explains in her "Introduction" to the 1995 edition (p. 1), "the inscription dated 1502 in the crypt" cannot be assumed to refer to construction of the Tempietto, as Lotz believed. In agreement with Arnaldo Bruschi (1969), she argues for a later date; Deborah Howard, "Bramante's Tempietto: Spanish Royal Patronage in Rome," *Apollo* 136 (October 1992): 211–12.

88 Lotz, *Architecture in Italy*, p. 13.

89 From Michelangelo's letter to Bartolomeo Ferratini, Rome, datable to the last days of 1546 or the first of 1547; Barocchi and Ristori, *Carteggio* 4: 251–52, MLXXI. The context is an attack on Sangallo's plans to alter plans for Saint Peter's, changes that would have entailed "tearing down to the ground the Chapel of Paul, the rooms of the Piombo [used for papal seals], the Sacra Ruota and many others; nor would the chapel of Sixtus, I believe, escape intact." Such destruction, Michelangelo added in a postscript, "would be a most grave injury."

90 Condivi, pp. XXI and 24 (*postilla* 11M). The comment resonates with the same confidence in progress that characterizes Vasari's *Lives*.

91 Lotz, *Architecture in Italy*, p. 13.

92 For this and Julius's other measures to expunge "cursed memory" of the Borgia, see Felix Gilbert, *The Pope, His Banker, and Venice* (Cambridge, MA, and London, 1980), p. 75.

93 Condivi, p. 24. Bramante is blamed for having convinced Julius to abandon the tomb and to set Michelangelo to work instead on the Sistine ceiling; see also Vasari-Barocchi 6: 31. Immediately preceding this account in Condivi is his criticism of Bramante, which inspired Michelangelo's *postilla*, quoted on p. 214 above. Michelangelo prepared the first designs for the tomb in March and April 1506, according to the stipulations of the first agreement, now lost.

94 Condivi, pp. 36, 47. Julius had made testamentary provisions for the completion of his tomb. His executors, Cardinal Aginensis (Leonardo Grosso della Rovere) and Cardinal Santi Quattro the Elder (Lorenzo Pucci), considering the first design too grand, had Michelangelo prepare a new one, and "Thus Michelangelo entered again into the tragedy of the tomb" (Condivi, p. 36). The story ended some years and several contracts later: "and the tragedy of the tomb and the tomb had an end" (ibid., p. 47). According to Michael Hirst, "Introduction," in ibid., p. x, the *Vita* has "its very particular agenda: to exonerate Michelangelo over his delays in working on the tomb of Julius II and his failure to complete the monument in an adequate fashion."

95 Barocchi and Ristori, *Carteggio* 1: 13, VII. Michelangelo had another reason for his departure but did not wish to write it (*non voglio scrivere*). Nonetheless, he reiterated his desire to do the tomb, ibid., pp. 14, 364–66, VIII.

96 Condivi, p. 23; and such envy led to "infinite persecutions" at the papal court. Whether Bramante actually plotted against him, clearly Michelangelo and his champions believed this to have been the case. See also Benedetto Varchi, *Orazione funerale di M. Benedetto Varchi fatta, e recitata da lui pubblicamente nell'essequie di Michelagnolo Buonarroti in Firenze, nella chiesa di San Lorenzo* (Florence, 1564), p. 20: "after many excuses for his [Michelangelo's] insufficiency, as he was modest and knew very well that the commission was being procured for him more from envy and because they thought he could not succeed or stand up to Raphael of Urbino (*stare à petto di Raffaello*), he accepted the battle (*partito*)." The architect is defended against such charges by Robertson, "Bramante, Michelangelo."

97 Condivi, pp. 29–30.

98 Barocchi and Ristori, *Carteggio* 1: 16, x. Bramante's criticism suggests that he knew something of Michelangelo's previous experience as Ghirlandaio's assistant. As Robertson notes, "Bramante, Michelangelo," pp. 98–99, Bramante's points about Michelangelo are well taken. But the fact remains that these criticisms voiced to the pope were surely meant to undermine Michelangelo's standing at court. Robertson also considers Rosselli's possible motivations in writing to Michelangelo. Rosselli (or Roselli) later assisted Michelangelo in the Sistine Chapel, completing the scaffolding and preparing the vault for painting; see William E. Wallace, "Michelangelo's Assistants in the Sistine Chapel," *Gazette des beaux-arts* 110 (1987): 205.

99 As was Michelangelo's letter "recommending" Sebastiano to succeed Raphael in the Stanze; see pp. 255–56 above.

100 Condivi, p. 23; and Barocchi and Ristori, *Carteggio* 1: 24, xv.

101 Condivi, pp. 23–24. Julius was also frequently visiting Raphael at work, as Jörg Traegger observed in a colloquium at the Institute for Advanced Study in 2000: the pope's bedchamber, the *camera segreta*, was adjacent to the Stanze, and he had to pass through those rooms to leave his own.

102 Condivi, p. 34. In *postilla* 14Q (p. XXII), Michelangelo corrected Condivi's claim that the work lacked the "last touch" (*l'ultima mano*): "What last touch? It was done as now, but I didn't want to make it known piecemeal" (literally, "in pieces").

103 Condivi, ibid.

104 Barocchi and Ristori, *Carteggio* 1: 88, LXII. There is no evidence that Michelangelo had denied painting as his profession in relation to earlier commissions in Rome or in Florence (the Doni Tondo). His claim *not* to be a painter was provoked by his work in the chapel and presumably related to his inexperience with fresco as opposed to panel painting, and to painting anything on such a grand scale.

105 My combination of translations in Creighton Gilbert, *Complete Poems and Selected Letters of Michelangelo*, ed. Robert N. Linscott (Princeton, 1963; rpt. 1980), pp. 5–6, and James M. Saslow, *The Poetry of Michelangelo: An Annotated Translation* (New Haven and London, 1991), pp. 70–72. The poem is a *sonetto caudato* or tailed sonnet, in this case with a doubled tail of six lines rather than the customary three (Saslow, p. 72). The form was used again by Michelangelo in sonnets 25 and 71 in Saslow's edition. Michelangelo voiced similar complaints in Barocchi and Ristori, *Carteggio* 1: 88–89, LXII (see above); pp. 101–02, LXX; p. 133, C; p. 136, CIII; and pp. 140–41, CVII. For the sheet itself (Florence, Casa Buonarroti), see Michael Hirst, *Michelangelo Draftsman*, exh. cat., Washington, National Gallery of Art (Milan, 1988), pp. 50–51, no. 19; and Charles de Tolnay, *Corpus dei disegni di Michelangelo*, 4 vols. (Novara, 1975–80), vol. 1, p. 126.

106 Irving Lavin, "Bernini and the Art of Social Satire," in Lavin et al., *Drawings by Gianlorenzo Bernini from the Museum der Bildenden Künste Leipzig, German Democratic Republic*, exh. cat., Princeton Art Museum (Princeton, 1981), p. 34.

107 For drawings related to the ceiling, see Hirst, *Michelangelo Draftsman*, pp. 32–49, nos. 11–18; Hirst, *Michelangelo and his Drawings*, pp. 25, 67–68; Hirst, "Observations on Drawings for the Sistine Chapel," in Carlo Pietrangeli, Michael Hirst, et al., *The Sistine Chapel: A Glorious Restoration* (New York, 1994), pp. 8–25; and Alexander Perrig, *Michelangelo's Drawings: The Science of Attribution*, trans. Michael Joyce (New Haven and London, 1991), pp. 50–52.

108 Condivi, pp. 34–35. For a more accurate account of the artist's procedures, see Wallace, "Michelangelo's Assistants." Wallace documents the contributions of thirteen assistants in the chapel, including Michelangelo's boyhood friend Francesco Granacci, Pietro Urbano, Aristotile and Giuliano da Sangallo, and Piero Rosselli, for whom see p. 216 above. As Wallace explains, p. 211n4, the myth of Michelangelo's working without assistants started with Condivi and was repeated by Vasari in 1568 (Vasari-Barocchi 1: 38) and by Varchi in the *Orazione funerale*, p. 20 ("alone, without help of any kind").

109 Condivi, p. 34.

110 Vasari-Barocchi 4: 175–76. According to Vasari, this happened when Michelangelo fled to Florence after his contretemps with the pope, but the chronology is wrong: that flight occurred in spring 1506, before he had begun painting the ceiling.

111 Ibid., p. 176.

112 For the Latin text, see Charles de Tolnay, in *Michelangelo*, 5 vols. (Princeton, 1943–60), vol. 2: *The Sistine Chapel*, p. 235, no. 52.

113 The letter is dated "primi di ottobre 1512"; see Barocchi and Ristori, *Carteggio* 1: 137, CIV. Michelangelo goes on to complain that "the other things are not turning out for me

as I was hoping," referring to the pope's tomb or perhaps to other commissions.

114 Pinturicchio was identified by Paul Watson, as cited in Joanna Woods Marsden, *Renaissance Self-Portraiture: The Visual Construction of Identity and the Social Status of the Artist* (New Haven and London, 1998), p. 122.

Raphael's signature was first identified by Deoclecio Redig de Campos, "Il pensieroso della Segnatura," *Michelangelo Buonarroti nel IV centenario del "Giudizio universale" (1541–1941)* (Florence, 1942), pp. 205–19; see now David Rosand, "Raphael's *School of Athens* and the Artist of the Modern Manner," in *The World of Savonarola: Italian Élites and Perceptions of Crisis*, ed. Stella Fletcher and Christine Shaw (Aldershot, 2000), p. 218. The inscription is clearly illustrated in Arnold Nesselrath, *Raphael's School of Athens*, Recent Restorations of the Vatican Museums 1 (Vatican City, 1996), p. 53, figs. 17, 18.

115 See Joannides, *Drawings of Raphael*, p. 82 no. 25, pp. 189–91 nos. 227–34, for related drawings and the cartoon (Milan, Ambrosiana).

116 See Redig de Campos, "Il Pensieroso della Segnatura"; and Nesselrath, *Raphael's School of Athens*, p. 20. As Nesselrath explains, traces of red chalk in the *giornate* around this figure, applied before its insertion, show that Raphael drew it on the *intonaco*, that is, on the surface of the "finished" fresco. He probably then traced the red chalk drawing onto the wall and then made a cartoon from this tracing. Traces of *spolvero* on the knee prove that a cartoon was used. Finally, to insert the figure, Raphael had to cut out the old plaster surface to prepare a new surface with fresh plaster.

117 For the leggings, see also Rosand, "Raphael's *School of Athens*," p. 223; and p. 149 above.

118 Vasari-Barocchi 4: 189–90. Vasari added that Raphael was inspired by Dürer's engravings to collaborate with Marc'Antonio Raimondi, and that Giulio Romano inherited Raphael's portrait by Dürer. Lodovico Dolce reported that Raphael displayed drawings by the German master in his studio; Mark W. Roskill, *Dolce's "Aretino" and Venetian Art Theory of the Cinquecento* (New York, 1968), pp. 120–21. See also Arnold Nesselrath, "Raphael's Gift to Dürer," in *Essays in Memory of Jacob Bean (1923–1992)*, ed. Linda Wolk-Simon and William M. Griswold with Elizabeth K. Allen, *Master Drawings* 31 (1995): 376–89; and Roberto Salvini,

"Raffaello e Dürer," in Hamoud and Strocchi, *Studi su Raffaello*, vol. 1, pp. 145–50. For *Melencolia I*, see Erwin Panofsky, *The Life and Art of Albrecht Dürer* (Princeton, 1955), pp. 156–71; and cf. Joseph Leo Koerner, *The Moment of Self-Portraiture in German Renaissance Art* (Chicago and London, 1993), pp. 23–27. For Melencolia's relation to Heraclitus, see Rosand, "Raphael's *School of Athens*," p. 228; and for Raphael's depiction of Michelangelo as a melancholy "rustic," see also Charles Seymour, Jr., *Michelangelo's David: A Search for Identity* (Pittsburgh, 1967), p. 70; and David Summers, *Michelangelo and the Language of Art* (Princeton, 1981), p. 117 ("Saturnine melancholic").

119 Barocchi and Ristori, *Carteggio* 3: 156, DCCIV. Dated May 1525, this affectionate letter to Sebastiano in Rome explains that Michelangelo emerged from his "malinchonicho" during a pleasant dinner conversation the night before, which he particularly enjoyed when Sebastiano was praised by their mutual friend, Capitano Chuio: "you are unique in the world, and so considered to be in Rome. [. . .] So don't deny to me that you are unique when I write to you, because I have too many witnesses to it; and there is a painting here, by God's grace, that proves my faith to whoever sees light." This presumably refers to one of Sebastiano's portraits of Clement VII.

120 Condivi, p. 57.

121 Rosand, "Raphael's *School of Athens*," p. 224.

122 Condivi, p. 54. Raphael's expression of gratitude is quoted as an epigraph to this chapter. He was made to thank God yet again in Varchi, *Orazione funerale*, p. 40.

123 Quoted in Forlani Tempesti, *Raffaello e Michelangelo*, p. 15.

124 Leo Steinberg identified the figure under God's arm as Eve, who turns toward Adam, and the boy on whose shoulder God's left hand rests as Christ, the Second Adam. See Leo Steinberg, "Who's Who in Michelangelo's *Creation of Adam*: A Chronology of the Picture's Reluctant Self-Revelation," *Art Bulletin* 74 (1992): 552–66.

125 For the preparatory sketch in Oxford, Ashmolean 462, and arguments in favor of its attribution to Raphael, see Gere and Turner, *Drawings by Raphael*, pp. 178–79, no. 145; and Joannides, *Drawings of Raphael*, p. 100, no. 34, relating the figure to God the Father in the *Creation of Adam*. (I see a relation to several of Michelangelo's depictions of the

Father.) Joannides also notes Raphael's quotation from Dürer for the rendition of the conflagration. The vault of the Stanza d'Eliodoro may have been repainted c. 1513–14; see Konrad Oberhuber, "Die Fresken der Stanza dell'Incendio im Werk Raffaels," *Jarhbuch der Kunsthistorischen Sammlungen in Wien*, N.S. 22 (1962): 35; and John Shearman, "Raphael's Unexecuted Projects for the Stanze," in *Walter Friedländer zum 90. Geburtstag* (Berlin, 1965), p. 174.

126 Forlani Tempesti, *Raffaello e Michelangelo*, p. 15. For the identities of other characters, see Deoclecio Redig de Campos, "Dei ritratti di Antonio Tebaldeo e di altri nel 'Parnaso' di Raffaello," *Archivio della Società romana di storia patria* 75 (1952): 51–58.

127 Redig de Campos, ibid., pp. 51–52.

128 Vasari-Barocchi 6: 69. "Aretino" also praised Michelangelo's *disegno* and his treatment of the nude "to perfection" in Roskill, *Dolce's "Aretino*," pp. 86–87. For Dolce and his "Aretino," Michelangelo is surpassed in color and in all other aesthetic virtues by Titian (of course); see also ibid., pp. 90–93, for the comparative merits of Michelangelo and Raphael; pp. 170–77, for their nudes (Raphael's are to be preferred); pp. 177–79, for their color ("everyone knows that he [Michelangelo] has given little attention to this").

129 Vasari-Barocchi 4: 206.

130 Paolo Giovio, "Raphaelis Urbinatis Vita," in Barocchi, *Scritti d'arte*, 1: 15.

131 Barocchi and Ristori, *Carteggio* 2: 100, CCCLVIII.

132 Vasari-Barocchi 5: 85 (1550). The motif of Sebastiano's presumed laziness comes up again in Vasari's account of his suggesting that Michelangelo paint the *Last Judgment* in oils, a medium Michelangelo disparages as one appropriate only for the indolent; see p. 262 and n. 232 below.

133 Vasari-Barocchi 5: 85 (1568).

134 Roskill, *Dolce's "Aretino*," pp. 94–95; my translation. In real life, they were good friends: Sebastiano was godfather to one of Aretino's daughters. In *Talanta*, Aretino boasts of Raphael's having sought his advice. See Christopher Cairns, *Pietro Aretino and the Republic of Venice: Researches on Aretino and his Circle in Venice 1527–1556* (Florence, 1985), p. 238.

135 As a bank clerk! See Gilbert, *Pope, Banker, and Venice*, p. 98.

136 Giovanni Gaye, *Carteggio inedito d'artisti dei secoli XIV.XV.XVI*, 3 vols. (Florence, 1840; rpt. Turin, 1968), vol. 2, pp. 91–92,

XXXVII. Ibid., pp. 83–85, 93, for other correspondence relating to Michelangelo's going to Bologna. The "storia" to which Soderini referred is the *Battle of Cascina*; as discussed in chapter 4, Michelangelo is known to have begun only one of the Apostles, the *Saint Matthew* (Figs. 78 and 110 above).

137 Michelangelo's description of himself in a letter to Giovan Francesco Fattucci, late December 1523, Barocchi and Ristori, *Carteggio* 3: 8, DXCIV. But cf. Julius's brief to the Signoria, 8 July 1506, in which he wrote reassuringly of Michelangelo's not having to be "afraid of returning" because "we [. . .] are not angry with him, knowing the humours of such men of genius." John Addington Symonds, "Michelangelo," in *The Life of Michelangelo Buonarroti*, 2 vols. (London, 1893), vol. 1, p. 180.

138 For Sebastiano's arrival in Rome and the "artistic transformation of the city," see Michael Hirst, *Sebastiano del Piombo* (Oxford, 1981), p. 32. On Chigi, see Gilbert, *Pope, Banker, and Venice*; and Ingrid Rowland, "Render unto Caesar the things which are Caesar's: Humanism and the Arts in the Patronage of Agostino Chigi," *Renaissance Quarterly* 39 (1986): 673–730.

139 The eighth year of Julius's pontificate was calculated from the date of his coronation on 26 November, as explained by Creighton E. Gilbert, "Some Findings on Early Works of Titian," *Art Bulletin* 62 (1980): n. 30. The *Virtues* reveal Raphael's further assimilation of Michelangelo's style in the Sistine Chapel. After the recent conservation of the frescoes, the mural to the left of this one (*Tribonian Presenting the Pandects to the Emperor Justinian*) was attributed to the Venetian Lotto, active in Rome between 1509 and 1511 and documented as working in the Vatican; see Nesselrath, "Lotto in the Segnatura."

140 January 1512 is the publication date of Palladio's poem, *Suburbanum Agostini Chisii*; the relevant passage is quoted in Almamaria Mignosi Tantillo, "Restauri alla Farnesina," *Bollettino d'arte*, 5th ser. 57 (1972): 42n17. Sebastiano's lunettes are considered "something of an embarrassment for the painter's admirers," according to Hirst, *Sebastiano*, pp. 34–35.

141 No one knows why Chigi ceased work in the Sala di Galatea, as noted by Mignosi Tantillo, "Restauri alla Farnesina," p. 42. For the condition and conservation of the frescoes, see ibid., pp. 33–35 and *passim*, p. 41 for Chigi's continuing employment of Raphael. Raphael delegated execution of the

second loggia, including the *Banquet of the Gods* in the vault, to Giulio Romano and other assistants. After Raphael's death in 1520, Sebastiano "inherited" commissions for the Chigi chapels in the Roman churches of Santa Maria del Popolo and Santa Maria della Pace. Chigi himself may have been the patron of Sebastiano's *Death of Adonis* (Florence, Uffizi); see Hirst, *Sebastiano*, p. 33.

142 Both Raphael and Sebastiano consulted Poliziano's *Stanze* (*Stanze di Messer Angelo Politiano cominciate per la Giostra del Magnifico Giuliano di Piero de Medici*, 1475); and Poliziano himself drew on Ovid and Philostratus (*Imagines* II, 18). For Ovid's interpretation of the story, see Alan H. F. Griffin, "Unrequited Love: Polyphemus and Galatea in Ovid's *Metamorphoses*," *Greece and Rome* 30 (1983): 190–97. On Raphael's fresco and his sources, see *inter alia*, Christof Thoenes, "Galatea: Tentativi di avvicinamento," in *Raffaello a Roma: Il convegno del 1983*, ed. Christoph Luitpold Frommel and Matthias Winner (Rome, 1986), pp. 59–72. According to Vasari-Barocchi 5: 87, Raphael had completed his *Galatea* before Sebastiano began his *Polyphemus*. For the reverse chronology, i.e., that Sebastiano's fresco was first, see Mignosi Tantillo, "Restauri alla Farnesina," pp. 33, 39–40. Whereas *Polyphemus* accords with the lunettes as part of a homogeneous decorative program, *Galatea* obeys her own rules. Mignosi Tantillo concludes, p. 40, that Raphael's fresco was painted 1513–14. Whatever the precise chronology, *Polyphemus* was always intended to pine for *Galatea*.

143 Hirst, *Sebastiano*, p. 36, sees the *Polyphemus* as "a tribute to the *ignudo* above and to the right of Joel." This is true for the legs, but Cyclops' torso is essentially frontal, not profile, and much closer to the pose of the *Ignudo* above the Erithrean Sibyl. My point is that Sebastiano's figure is a paraphrase, not a "one-on-one" quotation.

144 Vasari-Barocchi 5: 87. Chigi had previously employed Raphael in November 1510 as a designer of two bronze tondi silverware (evidently for salvers); see Jones and Penny, *Raphael*, p. 92. The *Galatea* was his first painting for Chigi.

145 Golzio, *Raffaello nei documenti*, p. 31. Raphael and Castiglione would have met in Urbino between 1506 and 1507. See Vittorio Cian, *Un illustre nunzio pontifico del Rinascimento: Baldassar Castiglione* (Vatican City, 1951), p. 81. Cian, p. 83, dates the "Idea" letter 1514, explaining that it was first published by Lodovico Dolce in 1559. The letter pretends to reply to a letter from Castiglione; but Castiglione's letter to Raphael is lost (assuming that it ever existed). Uncertain about the authorship of the "Idea" letter, Cian notes that Castiglione ghosted Raphael's letter or report dated 1519 regarding the ancient monuments of Rome, as proved by the first drafts in the Castiglione family archives in Mantua. For this letter, see Francesco P. Di Teodoro, *Raffaello, Baldassar Castiglione e la lettera a Leone X* (Bologna, 1994); and for confirmation of Castiglione's authorship of the "Idea" letter, John Shearman, "Castiglione's Portrait of Raphael," *Mitteilungen des Kunsthistorischen Institutes in Florenz* 38 (1994): 69–97.

146 See Erwin Panofsky, *Idea: A Concept in Art Theory* (1924), trans. Joseph J. S. Peake (New York, 1968), pp. 59–60; and Clark Hulse, *The Rule of Art: Literature and Painting in the Renaissance* (Chicago and London, 1990), pp. 86–87. As Hulse explains, the text signifies that "The authority of the artist [. . .] was manifested above all through his power of invention." For Vasari and the Plinian anecdote, see Goffen, *Titian's Women*, pp. 240–41. The story of Zeuxis' multiple models was recounted also by Cicero, *De Invent.*, II, 1, 1. Alberti seems to have been the first Italian author to cite the anecdote, in relation to his recommendation that the artist use many models (thus anticipating the exchange between Pico and Bembo); see Eugenio Battisti, "Il concetto d'imitazione nel Cinquecento da Raffaello a Michelangelo," *Commentari* 7 (1956): 90 and n. 22, and p. 348 above. According to his biographers, Michelangelo emulated Zeuxis in the use of multiple models; see Robert J. Clements, "Michelangelo and the Doctrine of Imitation," *Italica* 23 (1946): 95, though Michelangelo himself apparently contradicted this view by extolling the imitation of God's ideal rather than nature as such (Clements, pp. 92, 93, quoting Hollanda and Michelangelo).

147 Hulse, *Rule of Art*, p. 87.

148 In Rome, Sebastiano abandoned his other Venetian specialty, mythological subjects: after *Polyphemus*, he was to paint only one more mythology, the *Death of Adonis* (Florence, Uffizi).

149 See Costanza Barbieri, "Sebastiano del Piombo and Michelangelo in Rome: Problems of Style and Meaning in the Viterbo *Pietà*," Ph.D. dissertation (Rutgers University, New Brunswick, 1999).

150 Condivi, p. 63.

151 Sebastiano repeated their words in a letter to Michelangelo in Florence, dated 15 October 1520; Barocchi and Ristori, *Carteggio* 2: 246–47, CDLXXIV, and p. 260 above.

152 Vasari-Barocchi 4: 202. For the tapestry cycle and surviving cartoons, see John Shearman, *Raphael's Cartoons in the Collection of Her Majesty the Queen and the Tapestries for the Sistine Chapel* (London, 1972); and Sharon Fermor, *The Raphael Tapestry Cartoons: Narrative, Decoration, Design* (London, 1996).

153 See William E. Wallace, *Michelangelo at San Lorenzo: The Genius as Entrepreneur* (Cambridge and New York, 1994), pp. 9–74, for the façade project, with references in n. 6.

154 Condivi, p. 36: Michelangelo had to be persuaded to undertake the commission because it meant abandoning work on Julius's tomb.

155 The biographies of Jacopo Sansovino and Baccio Bandinelli in 1568 and of Michelangelo in both editions: Vasari-Barocchi 5: 248 (Bandinelli); 6: 50–53 (Michelangelo); and 6: 182–83 (Sansovino). For the extensive correspondence dealing with the project, 1517 to 1520 (by which time Michelangelo had been dismissed), see Barocchi and Ristori, *Carteggio* 1: 266, CXI; 1: 277, CCXXI; 1: 295, CCXXXV; 2: 109, CCCLXVI; 2: 134, CCCLXXXVI; and 2: 218–21, CDLVIII. For the project designs, including the wooden model, see Henry A. Millon, "Michelangelo and the Facade of S. Lorenzo in Florence," and catalog entries in Millon and Vittorio Magnago Lampugnani, ed., *The Renaissance from Brunelleschi to Michelangelo: The Representation of Architecture*, exh. cat., Venice, Palazzo Grassi, and Washington, National Gallery of Art (Milan, 1994), pp. 565–72; Millon, "The Facade of San Lorenzo," in Henry A. Millon and Craig Hugh Smyth, *Michelangelo Architect: The Facade of San Lorenzo and the Drum and Dome of St. Peter's*, exh. cat., Washington, National Gallery of Art (Milan, 1988), pp. 3–89; Manfredo Tafuri, "Raffaello, Jacopo Sansovino e la facciata di San Lorenzo a Firenze," *Annali di architettura* 2 (1990): 24–44; and Wallace, *Michelangelo at San Lorenzo*, pp. 9–74.

156 Wallace, ibid., p. 9.

157 For Buoninsegni's perfidy, see Vasari-Barocchi 5: 248 (Life of Bandinelli). Vasari claimed that Buoninsegni, angered by Michelangelo's refusal to connive, was instrumental in the cancellation of the façade project. See also Barocchi and Ristori,

Carteggio 1: 163, CXXV; 1: 168, CXXX; and 2: 366–67, DLXXI.

158 Barocchi and Ristori, *Carteggio* 1: 204–05, CLXII.

159 Ibid. Baccio's letter is dated 13 October 1516, Florence.

160 Ibid., pp. 207–08, CLIV: Buoninsegni in Rome, 3 November 1516, to Michelangelo in Carrara.

161 Ibid., p. 211, CLXVII.

162 Ibid., p. 218, CLXXII.

163 As suggested by Bruno Contardi in Giulio Carlo Argan and Bruno Contardi, *Michelangelo architetto* (Milan, 1990), p. 163.

164 Barocchi and Ristori, *Carteggio* 1: 218–21, CLXXII–CLXXIII. Michelangelo went to the city shortly after 15 December, returning to Florence by 22 December, when Buoninsegni wrote yet another letter. For this and for the contract, see Millon, in *Brunelleschi to Michelangelo*, p. 565. Millon's cat. no. 236, p. 572, is Michelangelo's receipt for payment for marble for the façade. But in his letter datable between the end of February and 10 March 1520 Michelangelo said that he left Carrara for Rome on 5 December 1516 and returned to Carrara on the last day of the month; Barocchi and Ristori, *Carteggio* 2: 218–21, CDLVIII, and p. 242 above.

165 Baccio was already at work on a model by 7 January 1517 and was waiting to hear from Michelangelo about foundations; Barocchi and Ristori, *Carteggio* 1: 239, CLXXXIX. The model was to follow the design agreed upon in Rome and would have ten statues of saints; Buoninsegni in Rome to Michelangelo in Carrara, 2 February 1517, ibid., pp. 245–47, CXCV. The model had been nearing completion by mid-February and was finished on 7 March; ibid., p. 256, CII, and p. 260, CCVI.

166 Ibid., p. 267, CCXII. Michelangelo wrote to Buoninsegni in April 1517 to assure him that he had had a *modelletto* made to send to him. This he failed to do, however, as he explained in a subsequent letter, 2 May 1517, ibid., pp. 277–79, CCXXI, discussed above.

167 Ibid., p. 268, CCXIII, Buoninsegni to Michelangelo, 27 March 1517.

168 Ibid., pp. 277–79, CCXXI. I have slightly altered the translation in E.H. Ramsden, ed., *The Letters of Michelangelo*, 2 vols. (Stanford, 1963), vol. 1. pp. 106–07. Cf. Raphael, who set his own (high) prices, "I am paid for that [which] I do however much seems [appropriate] to me"; see his letter to his uncle Simone di Battista Ciarla, 1 July

1514, in Camesasca with Piazza, ed., *Raffaello: Gli scritti*, p. 175.

169 Millon, in *Brunelleschi to Michelangelo*, p. 565, and Millon's catalog entry for the wooden model in Casa Buonarroti, in ibid., p. 572, no. 235. Urbano arrived in Rome in the third week of December 1517.

170 Gaetano Milanesi, ed., *Le lettere di Michelangelo Buonarroti pubblicate coi ricordi ed i contratti artistici* (Osnabrück, 1875; rpt. 1976), pp. 671–72. See also Condivi, p. 25.

171 For the five assistants who helped with *Julius*, see Wallace, *Michelangelo at San Lorenzo*, p. 4. For a more favorable view of his expertise with bronze and his interest in that medium, see Paul Joannides, "Michelangelo *bronzista*: Reflections on his Mettle," *Apollo* 145, N.S. 424 (June 1997): 11–20. I think that Michelangelo's plans to use bronze for elements of the Julius tomb and the façade have more to do with his ambition than with his expertise.

172 Barocchi and Ristori, *Carteggio* 1: 291, CCXXXI, Sansovino in Florence to Michelangelo in Carrara, referring to a venerable principle of contract law: an oral contract is, or should be, binding. Sansovino also resented Michelangelo's having preferred Baccio Bandinelli to himself. But Michelangelo rejected the assistance of all other masters, including Bandinelli; Kathleen Weil-Garris, "Bandinelli and Michelangelo: A Problem of Artistic Identity," in *Art the Ape of Nature: Studies in Honor of H. W. Janson*, ed. Moshe Barasch, Lucy Freeman Sandler, and Patricia Egan (New York and Englewood Cliffs, 1981), p. 230.

173 Barocchi and Ristori, *Carteggio* 2: 86, CCCXLVI, 25 September 1518. Sebastiano's letter goes on to complain about Buoninsegni's "terribilità."

174 Lucilla Bardeschi Ciulich and Paola Barocchi, ed., *I ricordi di Michelangelo* (Florence, 1970), pp. 101–02, XCVIII. He was still complaining about the loss of the commission over twenty years later; see his letter written before 24 October 1542 to an unidentified cardinal, in Barocchi and Ristori, *Carteggio* 4: 152, MI.

175 Barocchi and Ristori, *Carteggio* 2: 220, CDLVIII, datable between the end of February and 10 March 1520 and presumably addressed to Buoninsegni in Rome.

176 Millon, in *Brunelleschi to Michelangelo*, p. 566, and p. 572 for the model.

177 Barocchi and Ristori, *Carteggio* 1: 274–75, CCXIX.

178 Vasari-Barocchi 5: 88 (Life of Sebastiano).

179 Ibid., p. 89.

180 Barocchi and Ristori, *Carteggio* 1: 190, CXLVIII. For the chapel of Pierfrancesco Borgherini, see Hirst, *Sebastiano*, pp. 49–65.

181 Barocchi and Ristori, *Carteggio* 1: 192, 196, CL and CLIV. There is another figure of Christ in the chapel decoration, that of the *Transfiguration* in the semidome; but that image is adapted from Raphael's altarpiece of the same subject, unveiled in 1520. The figurine was therefore almost certainly made for the Christ of the *Flagellation*, which indeed looks more sculptural than the Christ of the *Transfiguration*.

182 Ibid., p. 212, CLXCVIII.

183 Ibid., p. 229, CLXXXI.

184 Ibid., p. 222, CLXXIV. This figurine may be the same Cupid described by Castiglione as "by the hand of Raphael." See Jones and Penny, *Raphael*, p. 111.

185 For the commissions, see Hirst, *Sebastiano*, pp. 66–75, and Jones and Penny, *Raphael*, pp. 237–39. On Raphael's painting, see also Ferino Pagden, "Iconographic Demands," pp. 24–27; and David Alan Brown, "Leonardo and Raphael's Transfiguration," in *Raffaello a Roma: Il convegno del 1983*, ed. Cristoph Luitpold Frommel and Matthias Winner (Rome, 1986), pp. 237–44.

186 The original intended placement for the two paintings is unknown. For the lighting, see also Hirst, *Sebastiano*, p. 67n9. In the cathedral of Narbonne, a surviving fragment of the original frame of Sebastiano's altarpiece reveals that the frame was "architecturally conceived." This suggests in turn that the *Lazarus* was not framed as a *laterale* for display in a chapel with Raphael's *Transfiguration* but independently, as a monumental altarpiece. See Christa Gardner von Teuffel, "Sebastiano del Piombo, Raphael and Narbonne: New Evidence," *Burlington Magazine* 126 (1984): 765.

187 Cf. Hirst, *Sebastiano*, pp. 66–67. Wishing to "acquit the cardinal of the charge of deliberately exacerbating an already keen competitive situation," Hirst suggests that Raphael's commission was awarded first and that Michelangelo may have been involved in obtaining Sebastiano his commission (ibid., p. 67n6). For the implication that Raphael's commission preceded Sebastiano's, see also Cecil Gould, *The Raising of Lazarus by Sebastiano del Piombo* (London, 1967), p. 11. Hirst and Gould based their reasoning on their reading of Leonardo Sellaio's letter to Michelangelo, 19 January 1517, in Barocchi and Ristori, *Carteggio* 1: 243, CXCIII, quoted p. 247 above.

188 For the first two, see Johannes Wilde, *Michelangelo and his Studio: Italian Drawings in the Department of Prints and Drawings in the British Museum* (London, 1953; rpt. 1975), pp. 29–31; for the third, see Jacob Bean, *Bayonne, Musée Bonnat: Les dessins italiens de la Collection Bonnat* (Paris, 1960), no. 65. More recently, see Hirst, *Michelangelo Draftsman*, pp. 55–57, no. 21; and ibid., *Sebastiano*, pp. 66–75. Cf. Perrig, *Michelangelo's Drawings*, pp. 24, 27–28, figs. 46, 47, attributing these sheets to Sebastiano.

189 Barocchi and Ristori, *Carteggio* 1: 243, CXCIII.

190 Ibid., p. 258, CCIV.

191 Ibid., p. 301, CCXL.

192 Ibid., 2: 32–33, CCCIV. It is difficult to understand what Sebastiano could have meant by calling Raphael "Prince of the Synagogue," though the phrase is plainly anti-Semitic. The end of the letter suggests that it refers to Raphael's evidently making more money than he, profiteering by overcharging the pope on framing or gilding. Sebastiano used the word *dorare*, which can mean either "to gild" or "to frame" (Hirst, *Sebastiano*, p. 68n15, argues for the second meaning in this case). The two paintings for France to which Sebastiano was referring were commissioned in 1518 by Lorenzo de' Medici on behalf of his uncle, Pope Leo, intended as gifts for the French monarch (the *Michael*) and his consort, Queen Claudia (the *Holy Family*), both Paris, Louvre. For these and Raphael's other works for France, see p. 274 above.

193 The painting was being prepared for shipment on 1 September 1518. Lorenzo de' Rossi, who became cardinal in 1517, was the son of an illegitimate sister of Lorenzo il Magnifico. Giulio was also illegitimate – the posthumous son of the Giuliano killed in the Pazzi conspiracy of 1478 – but Leo legitimized him by means of invented documentation of his parents' supposed clandestine marriage. See Gould, *Raising of Lazarus*, p. 9.

194 Hirst, *Sebastiano*, p. 68n15.

195 Barocchi and Ristori, *Carteggio* 2: 38, CCCIX.

196 Gould, *Raising of Lazarus*, p. 24, makes the comparison. Agostino Veneziano's engraving of *Lo Spasimo di Sicilia* is dated 1517. *Lo Spasimo* itself may be dated two years earlier in relation to the cartoons, according to Oberhuber, *Raphael*, pp. 214–16.

197 Barocchi and Ristori, *Carteggio* 2: 100, CCCLVIII; 103, CCCLXI; 106, CCCLXIII; 115, CCCLXX; and 138, CCCLXXXIX.

198 Ibid., p. 138, CCCLXXXIX.

199 Ibid.

200 Before receiving his final payment, Sebastiano had been told that his patron wanted Michelangelo's judgment of the work. Meanwhile, he was flat broke: "son al verde" (ibid., pp. 206–07, CDXLVIII). See also his letter to Michelangelo dated 28 January 1520, ibid., p. 212, CDLIII. Prices were related to the number of figures. On the same subject, Sellaio noted that Raphael's *Madonna* for the Bishop of Salerno, which has about five figures, is 200 gold ducats; letter of 29 January 1520, ibid., p. 214, CDLIV. Sebastiano was still waiting for final payment on 3 July 1520, and asked Michelangelo to intervene; ibid., pp. 233–35, CDLXVII: "At least they might tell me why; but to say, 'I don't want to pay you,' seems to me to be assassinated" (p. 235).

201 Hirst, *Sebastiano*, p. 69; my translation.

202 Barocchi and Ristori, *Carteggio* 2: 32–33, CCCIV, and p. 250 above. The outcome of Raphael's efforts to have the painting sent to France for framing is not known; see Hirst, *Sebastiano*, pp. 68–69.

203 For the combination of episodes in these works, see Rubin, "Contributo di Raffaello," pp. 171–73.

204 They are described as sequential events by Matthew and Mark; Luke (9: 37) specifies that the cure occurred on the day after the Transfiguration. For another explanation of Raphael's combination of events as cause and effect, see Gordon Bendersky, "Remarks on Raphael's Transfiguration," *Source* 14, 4 (1995): 18–25.

205 Vasari-Barocchi 4: 202.

206 Ibid., pp. 203, 204.

207 Revisions made during execution confirm Raphael's involvement in all stages of the execution according to Fabrizio Mancinelli, "La Trasfigurazione," in Bruno Santi, *Raffaello* (Florence, 1977), p. 74 and *passim*.

208 See Sylvia Ferino Pagden, "From Cult Images to the Cult of Images: The Case of Raphael's Altarpieces," in *The Altarpiece in the Renaissance*, ed. Peter Humfrey and Martin Kemp (Cambridge and New York, 1990), p. 174, and *passim*. See pp. 174–75 for a letter from Pico della Mirandola to Isabella d'Este in Mantua, describing heavenly signs at Raphael's death like those "which indicated the death of Christ," and Tebaldeo's epigram calling Raphael "the God of Art." For the god's tomb in the Pantheon, temple of the gods, see Tilmann Buddensieg, "Raffaels Grab," in *Munuscula discipulorum: Kunsthistorische Studien Hans Kauffmann zum 70. Geburtstag 1966*, ed. Buddensieg

and Matthias Winner (Berlin, 1968), pp. 45–70. For Bruni's monument in Florence, Santa Croce, see John Pope-Hennessy, *Italian Renaissance Sculpture*, Part 2 of An Introduction to Italian Sculpture (London and New York, rev. ed. 1971), pp. 278–79.

209 For the artist in France, see Janet Cox-Rearick, *The Collection of Francis I: Royal Treasures* (New York, 1996), pp. 133–39, and pp. 135–36 for the deathbed story, first published by Vasari: Vasari-Barocchi 4: 36 (both 1550 and 1568).

210 Vasari-Barocchi 4: 213.

211 For the notion of the artist as godlike creator, in addition to Ferino Pagden, "Cult Images," see David Summers, "Form and Gender," *New Literary History* 24 (1993): 244–71; and Rudolf Wittkower and Margot Wittkower, *Born under Saturn. The Character and Conduct of Artists: A Documented History from Antiquity to the French Revolution* (London, 1963; rpt. New York, 1969).

212 Barocchi and Ristori, *Carteggio* 2: 227, CDLXX. Here and throughout, I have called "la salla de' pontefici" the Sala di Costantino, which is how the room has come to be known.

213 Vasari-Barocchi 4: 210, and Golzio, *Raffaello nei documenti*, pp. 230, 252. Sebastiano's painting was possibly sent to France in 1521; see Hirst, *Sebastiano*, p. 77n9.

214 Barocchi and Ristori, *Carteggio* 2: 100, CCCLVIII, and p. 228 above. This is the letter in which Sellaio assured Michelangelo that the cardinal did not believe what people might have been saying against him.

215 Vasari-Barocchi 5: 90–91, and Golzio, *Raffaello nei documenti*, p. 252.

216 For such "narcissistic identification," see Finucci, "In the Name of the Brother," pp. 100–01.

217 Barocchi and Ristori, *Carteggio* 2: 230, CDLXV. It was Cardinal Dovizi who wanted Raphael to marry his niece, according to the artist's letter to his uncle Simone di Battista Ciarla, 1 July 1514. See Camesasca and Piazza, *Raffaello, Gli scritti*, pp. 170–77, 175–76 for the letter itself.

218 Barocchi and Ristori, *Carteggio* 2: 233, CDLXVII, 3 July 1520. For Bandinelli's Laocoön, see p. 351 above. The "figure in oil" refers to a Caryatid in the corner.

219 Barocchi and Ristori, *Carteggio* 2: 234, CDLXVII. Sebastiano then asked Michelangelo's help in persuading Buoninsegni and his brother-in-law, Benedetto Strozzi, to pay

him. If he wanted the money "to give to some whore," he would have been paid long since; but not to dower his sister.

220 Ibid., pp. 239–41, CDLXX. The Hall of the Pontiffs in the Borgia Apartments had been severely damaged by lightning on 20 June 1500, and Pope Alexander himself nearly killed. Since then, the room had been left in disrepair. Its redecoration was finally completed by Perino del Vaga. See Symonds, *Michelangelo*, vol. 1, p. 355, n. 1; D. S. Chambers, *Patrons and Artists in the Italian Renaissance* (Columbia, SC, 1971), pp. 32–34, no. 18.

221 Barocchi and Ristori, *Carteggio* 2: 242–43, CDLXXI.

222 Ibid., p. 247, CDLXXIV.

223 Ibid., pp. 246–47, CDLXXIV.

224 For Varchi's quotation, see Michael Hirst, "The Chigi Chapel in S. Maria della Pace," *Journal of the Warburg and Courtauld Institutes* 24 (1961): 165n25.

225 Vasari-Barocchi 5: 89. For Michelangelo's role in Sebastiano's commission, see Hirst, ibid., p. 161; and Hirst, *Sebastiano*, p. 69n25, noting a diminution of Michelangelo's involvement with Sebastiano's commissions: with each project, Michelangelo helped less than he had done before, judging from the number of surviving drawings.

226 Barocchi and Ristori, *Carteggio* 2: 252–53, CDLXXVII. The "castle of Canossa" has to do with Michelangelo's belief that the Buonarroti were descended from the counts of Canossa. Allusions to the pope's fraternal feelings for Michelangelo may reflect not only their long acquaintance but the fact that the Buonarroti and Medici were distantly related by marriage – a kinship that would probably be inconsequential today but which mattered for Renaissance people. See William Wallace, "Michael Angelvs Bonarotvs Patritivs Florentinvs," in *Innovation and Tradition: Essays on Renaissance Art and Culture*, ed. Dag T. Andersson and Roy Eriksen (Rome, 2000), p. 60 and *passim*.

227 Barocchi and Ristori, *Carteggio* 2: 256, CDLXXIX.

228 Hirst, *Sebastiano*, pp. 55–58.

229 Barocchi and Ristori, *Carteggio* 2: 266, CDLXXXVII. Sellaio's letter later refers to the "houses of Canossa" which Michelangelo hoped to purchase.

230 Hirst, "Chigi Chapel" and *Sebastiano*, pp. 126–28, 131.

231 Barocchi and Ristori, *Carteggio* 3: 405, DCCCLXIX. For the change of subject from the *Assumption* to the *Nativity of the Virgin*, see Hirst, *Sebastiano*, p. 126.

232 Vasari-Barocchi 5: 101–02 (1568). For Michelangelo's attitude toward oil, see Goffen, *Titian's Women*, pp. 233–34, in relation to the gendered discourse of style and technique; and Nagel, *Michelangelo*, pp. 193–94.

233 See Hirst, "Chigi Chapel," p. 184, for the Italian text of the contract dated 12 March 1526; my translation.

234 For the drawings, see ibid. For the competitive situation of the chapel, see Robert S. Liebert, *Michelangelo: A Psychoanalytic Study of his Life and Images* (New Haven and London, 1983), pp. 66–67.

235 Vasari-Barocchi 5: 93. For painting on stone and related theoretical arguments concerning the *paragone*, see also Suzanne B. Butters, *The Triumph of Vulcan: Sculptors' Tools, Porphyry, and the Prince in Ducal Florence*, 2 vols. (Florence, 1996), vol. 1, p. 110.

236 Hirst, "Chigi Chapel," pp. 179–81, esp. p. 180, argues that Sebastiano would not have made such preparations without some idea of what he intended to paint – though it should be noted that the preparation of the wall is bound to the painting's medium and technique, not to its subject. Hirst further suggests that a number of Michelangelo's drawings of the Resurrection, c. 1532–33, "could well have been done on his friend's behalf." Regarding the date of the drawings, see also Wilde, *Michelangelo and his Studio*, pp. 89–90.

237 As suggested by Hirst, ibid., p. 181.

238 Barocchi and Ristori, *Carteggio* 3: 419, DCCCLXXXI.

239 Ibid., p. 405, DCCCLXIX, dated 25 May 1532.

7 Titian

1 Vasari-Barocchi 6: 169.

2 Mark W. Roskill, *Dolce's "Aretino" and Venetian Art Theory of the Cinquecento* (New York, 1968), p. 236; my translation. The speaker is Aretino, quoting Duke Alfonso d'Este.

3 So "Giorgione used to say," according to Fabrini in ibid., pp. 186–87.

4 Dolce has Aretino brag about Titian's staying in Venice though famous throughout Italy and Europe and despite Pope Leo's attempts to bring him to Rome; ibid., pp. 192–93.

5 Vasari-Barocchi 6: 164 (Life of Titian); and above, p. 308.

6 See above, p. 267 and n. 208. For Aretino's first letter to Michelangelo, 16 September 1537, see Pietro Aretino, *Lettere, Libro secondo*, ed. Francesco Erspamer (Parma, 1998), pp. 400–05: "the world has many kings and only one Michelangelo" (p. 402). According to Erspamer, ibid., p. 402n3, Michelangelo and Aretino did not meet; but they could have met in Venice in 1529. Moreover, though there is no record of a meeting in Rome, it is possible that they met during Michelangelo's visit in December 1523: they had in common at least one good friend, namely Sebastiano. For that painter's friendship with Aretino, see Ettore Camesasca, "Sebastiano del Piombo," in Pietro Aretino, *Lettere sull'arte di Pietro Aretino*, ed. Fidenzio Pertile and Ettore Camesasca, 3 vols. (Milan, 1957–60), pp. 463–64.

7 See Creighton E. Gilbert, "Some Findings on Early Works of Titian," *Art Bulletin* 62 (1980): 36, 38, citing Theodor Hetzer, who first recognized Titian's quotation in "Vecellio," *Allgemeines Lexikon der bildenden Künstler*, ed. Ulrich Thieme and Hans Becker, vol. 34 (Leipzig, 1940), p. 161. Neither Hetzer nor Gilbert considers the ancient source for the pose. For Raphael's use of the type in the Borghese *Entombment*, see p. 208 above.

8 For Petrarch's letter to Boccaccio, *Fam.* 23.19.10, see G.W. Pigman, III, "Versions of Imitation in the Renaissance," *Renaissance Quarterly* 33 (1980): 10–11, explaining that "the possibility of alluding in order to be recognized is left open" (p. 11).

9 I am paraphrasing Rona Goffen, *Titian's Women* (New Haven and London, 1997), p. 19. For the ancient poses, see David A. Levine, "The Roman Limekilns of the Bamboccianti," *Art Bulletin* 70 (1988): 571; and Diana E.E. Kleiner, *Roman Sculpture* (New Haven and London, 1992), pp. 160, 258, 289–90, and fig. 134.

10 As noted by Gilbert, "Some Findings," p. 38. Marcantonio Raimondi might have been Titian's source for Michelangelo's Eve; Paul Joannides, "On Some Borrowings and Non-Borrowings from Central Italian and Antique Art in the Work of Titian c. 1510–c. 1550," *Paragone*, n.s. 23, 487 (1990): 22.

11 Titian's birthdate is known but was almost certainly some time after the year 1476 that he implied in later claims about his advanced age. Were this correct, Titian would have been 100 when he died in 1576. In itself, this strains credulity; but credulity breaks altogether when one considers his early works. No Renaissance painter started his career as late as Titian must have done, had he in fact been born in 1476. A birth date about ten years later makes more sense in relation to his first works, datable c. 1505. On his early

career, see Paul Joannides, *Titian to 1518: The Assumption of Genius* (New Haven and London, 2001), which appeared while the present book was in press.

12 Titian's process recalls dissimulation as "imitative imagery," a transformation that makes the model unrecognizable because it has been thoroughly digested; Pigman, "Versions of Imitation," pp. 9–10.

13 Gilbert, "Some Findings," p. 42. Titian painted the fresco in only five *giornate*; see Francesco Valcanover with Corrado Cagli, *L'opera completa di Tiziano* (Milan, 1969), p. 93.

14 Michelangelo had also translated Schongauer, an older rival from across the Alps – separated by geography if not by time.

15 See Gilbert, "Some Findings," p. 44, for the first published reference to the ceiling: Francesco Albertini, *Opusculum de mirabilis novae urbis Romae*, 1510. A reader's knowledge of what the ceiling looked like did not derive from such texts, however, but from prints and drawings.

16 ASV, Consiglio de' Dieci, Misto, Registro 35, fols. 236v–237r (old fols. 103v–104r); and Giovanni Battista Lorenzi, *Monumenti per servire alla storia del Palazzo Ducale di Venezia* (Venice, 1868), pp. 157–58, no. 337. In return for painting the mural, Titian requested the first *sansaria* or broker's patent in the Fondaco dei Tedeschi that became available, like that held by Giovanni Bellini – tantamount to guaranteed income. Titian finally painted his *Battle* in 1537–38; it was destroyed by fire in 1577. For the lost work, see Harold E. Wethey, *The Paintings of Titian: Complete Edition*, 3 vols. (London, 1969–75), vol 3: *The Mythological and Historical Paintings*, pp. 47–52, 225–29, L–3. For related drawings, see the catalog entries by Richard Harprath, pp. 230–32, and Catherine Whistler, pp. 232–35, in Susanna Biadene with Mary Yakush, ed., *Titian: Prince of Painters*, exh. cat., Venice, Palazzo Ducale, and Washington, National Gallery of Art (Milan, 1990); and by W. Roger Rearick in Michel Laclotte and Giovanna Nepi Scirè, ed., *Le Siècle de Titien: L'Âge d'or de la peinture à Venise*, exh. cat., Paris, Grand Palais (Paris, 1993), pp. 574–76.

17 See David Rosand and Michelangelo Muraro, *Titian and the Venetian Woodcut*, exh. cat., Washington, National Gallery of Art; Dallas Museum of Fine Arts; Detroit Institute of Arts (Washington, 1976), pp. 37–44 for the *Triumph of Faith*, pp. 70–73 for the *Red Sea*. The *Triumph of Faith* is dated 1508 in Vasari-Barocchi 6: 157. Rosand and Muraro, among others, have dated the first version of the woodcut c. 1510–11. For compelling arguments for a later date of 1517, see Michael Bury, "The 'Triumph of Christ' after Titian," *Burlington Magazine* 131 (1989): 188–97, followed by Konrad Oberhuber, "*Le Triomphe de la Foi*," in Laclotte and Nepi Scirè, *Siècle de Titien*, p. 473, cat. 130.

18 For his use of multiple sources, see Erwin Panofsky, *Problems in Titian, Mostly Iconographic* (New York, 1969), p. 59; and Rosand and Muraro, *Titian*, p. 43, noting also a more general debt to the art of Bellini and Giorgione. Titian returned to *Cascina* for his *Bacchanal of the Andrians* (p. 284 above), for *Saint Peter Martyr* (p. 301 above), and for his *Battle* mural in the Maggior Consiglio (p. 269 above).

19 ASM, Archivio Gonzaga, Series E, Busta 860, fol. 369; my translation. For the Italian text, see Charles de Tolnay, *Michelangelo*, 5 vols. (Princeton, 1943–60), vol. 2: *The Sistine Chapel*, p. 243; for the date, see John Shearman, "Alfonso d'Este's Camerino," in "*Il se rendit en Italie*": *Etudes offertes à André Chastel* (Rome and Paris, 1987), p. 222n37. Federico Gonzaga, Isabella's son and Alfonso's nephew, was a hostage at the papal court. Alfonso arrived in Rome on 4 July and fled with the help of the Colonna on 19 July. "Extremely indignant," Julius instituted proceedings against him as a rebellious vassal. See Ludwig Pastor, *The History of the Popes, from the Close of the Middle Ages*, ed. Frederick Ignatius Antrobus (St. Louis, MO, 1912), vol. 6, pp. 419–20, citing Sanudo's *Diaries*.

20 As suggested by Tolnay, *Michelangelo*, vol. 2: *Sistine Chapel*, p. 7. For their meeting in the chapel and years later in Ferrara, see now Charles M. Rosenberg, "Alfonso I d'Este, Michelangelo and the Man Who Bought Pigs," in *Revaluing Renaissance Art*, ed. Gabriele Neher and Rupert Shepherd (Aldershot, 2000), pp. 89–100.

21 Georg Gronau, "Alfonso d'Este und Tizian," *Jahrbuch der kunsthistorischen Sammlungen in Wien*, N.S. 2 (1928): 235, followed by Shearman, "Alfonso d'Este's Camerino," p. 213.

22 Vasari-Barocchi 6: 32–33.

23 Condivi, p. 43, and pp. 324–25 above.

24 Equicola was able to return before Philostratus. See Alessandro Luzio and Rodolfo Renier, "La coltura e le relazioni letterarie di Isabella d'Este Gonzaga," *Giornale storico*

della letteratura italiana 33 (1899): 22; and Gronau, "Alfonso und Tizian," p. 235.

25 For Alfonso's cycle, see Goffen, *Titian's Women*, pp. 107–26.

26 As suggested by Shearman, "Alfonso d'Este's Camerino," p. 219.

27 Referring to the duke's Camerino, Vasari mentioned a "very good *Bacchanal of Men*" by Dosso, the only Ferrarese master included there; see Vasari-Barocchi 5: 417 (Lives of Benvenuto Garofalo and Girolamo da Carpi) and 6: 158 (Life of Titian). Dosso's painting is presumed lost though it has recently been identified as a canvas in New Delhi, the Prince of Wales Museum; see Lorenzo Finocchi Ghersi and Giuseppe Pavanello, "La 'Baccanaria d'uomini' di Dosso Dossi ritrovata in India," *Arte veneta* 54 (1999): 22–31. Having seen the painting, I think its identification as the missing *Bacchanal* optimistic. The composition derives from Titian's *Bacchus and Ariadne* (unless one wants to suggest that Titian's work derives from Dosso's composition) and features an almost equal number of women and men (counting Silenus and a male infant), making the title "Bacchanal of Men" inappropriate. Dosso's *Bacchanal* in London, National Gallery, which has sometimes been identified as the painting for the Camerino, belonged instead to the Gonzaga; see Martin Eidelberg and Eliot W. Rowlands, "The Dispersal of the Last Duke of Mantua's Paintings," *Gazette des Beaux-Arts* 123 (1994): 250–51.

28 My emended translation from Wethey, *Titian*, vol. 3, p. 147, with the Italian text.

29 For the record of Bellini's final payment of 85 gold ducats, see Giuseppe Campori, "Tiziano e gli Estensi," *Nuova antologia di scienze, lettere ed arti*, 1st ser., 27 (1874): 581. This document is now in ASE, Camera Ducale, *Giornale de uscita*, fol. cxl, as noted by Shearman, "Alfonso d'Este's Camerino," n. 33.

30 Shearman, "Alfonso d'Este's Camerino," p. 212, and pp. 213–14, identifying Raphael's *modello* for the *Indian Triumph of Bacchus* as the drawing formerly in the Reynolds collection. See also pp. 214–16 for another possible commission to Raphael in 1514, a portrait of the elephant Hanno (the animal was a gift to the pope from Manuel I, King of Portugal). Independent portraits of exotic animals were considered a worthy subject for a great master; see p. 284 above.

31 All now Paris, Louvre, with the exception of *Lorenzo de' Medici* in New York, Ira Spanierman Collection. For Alfonso's visit to Paris, see Shearman, ibid., p. 210; for

the Medici commissions for France, Sylvie Béguin, "Raphaël (Raffaello Santi)," in André Chastel et al., *Hommage à Raphaël: Raphaël dans les collections françaises*, exh. cat., Paris, Grand Palais (Paris, 1983), pp. 91–101; Konrad Oberhuber, *Raphael: The Paintings* (Munich, London, and New York, 1999), pp. 203–04, 206, 218–60; and for *Isabel of Naples*, chapter 6, n. 54. The signature on the *Saint Michael*, RAPHAEL.VRBINAS.PINGEBAT.M.D.X.VIII, written on the hem of the saint's robe, might have been intended as a dig at the earthly Angel Michael. Although Raphael wrote his name on the costumes of other beings in other works, notably the Virgin Mary, the *Michael* is the only painting of a saint signed in this way. Thus Raphael inscribed his own identity on the great rival's onomastic saint. Using the imperfect verb *pingebat*, he managed to evoke the esteemed masters of antiquity without conjuring Michelangelo's *faciebat*.

32 Vincenzo Golzio, *Raffaello nei documenti, nelle testimonianze dei contemporanei e nella letteratura del suo secolo* (Vatican City, 1936; rev. ed. Farnborough, 1971), pp. 74, 76–77, and pp. 53–54 for Alfonso's copy of the *Saint Michael*. Although Raphael had written to the duke that the *Saint Michael* was *not* to be copied, Alfonso commissioned a copy by an anonymous Lombard (Rome, Galleria Doria-Pamphili). See Shearman, "Alfonso d'Este's Camerino," p. 211.

33 Raphael's informant was one of his *garzoni* who had been in Ferrara. For the translation and the situation, see Shearman, ibid., p. 211; for the Italian text, Golzio, ibid., pp. 53–55.

34 As suggested by Cecil Gould, *Titian: The Studio of Alfonso d'Este and Titian's Bacchus and Ariadne* (London, 1969), followed by Shearman, ibid., pp. 211–13, with additional archival evidence.

35 Quoted in Shearman, ibid., p. 216.

36 The text was difficult to consult until republished, with this translation, by Creighton E. Gilbert, "Some Findings," p. 54, with the Italian in n. 57. My discussion of the relation of Fra Bartolommeo's project to Titian's painting of the *Worship of Venus* is much indebted to Gilbert's essay. Fra Bartolommeo's reference to his sojourn in Ferrara in the letter has been confirmed by a payment record of 23 May 1516 for horses supplied for his first day's travel returning to Florence; see Charles Hope, "The 'Camerini d'Alabastro' of Alfonso d'Este," *Burlington Magazine* 113 (1971): 712n2. Hope, n. 1, suggests that

Bartolommeo may have received the commission around March 1516.

37 See Campori, "Tiziano e gli Estensi," p. 584. The cabinet was not in the Camerino but another room; see Gilbert, "Some Findings," p. 62.

38 Gilbert, ibid., p. 65. This is one of a small number of Renaissance signatures written on a garment, in this sense related to Michelangelo's far more conspicuous signature on the *Pietà*.

39 For Tebaldi's letter, ASE, Cancelleria Ducale, Estero, Ambasciatori, Venezia 14, 77-II-35, see Campori, "Tiziano e gli Estensi," p. 587; and Wethey, *Titian*, vol. 3, p. 147, suggesting that the "words" come from the text of Philostratus represented in the painting. For Titian's use of Fra Bartolommeo's drawing and the *Worship of Venus*, see Goffen, *Titian's Women*, pp. 109, 111, 113–16. The two painters possibly knew each other; and Fra Bartolommeo might have influenced Titian's conception of the *Assumption*, unveiled in 1518; see Gilbert, "Some Findings," pp. 55–62.

40 Tebaldi's letter, cited in the previous note, informs the duke that Titian wished to know where in the Camerino his painting was to be displayed: from his previous visit, the artist remembered having seen three spaces on one wall.

41 See Tebaldi's letter of 10 October, in Adolfo Venturi, *Storia dell'arte italiana*, vol. 9, pt. 3 (Milan, 1928), p. 107.

42 For the correspondence, see Golzio, *Raffaello nei documenti*, pp. 55, 64, 105–06. The painting's subject is not specified so there has been uncertainty whether the letters refer to the *Indian Triumph of Bacchus* or *Hunt of Meleager*, but for convincing arguments that it was the latter, see Shearman, "Alfonso d'Este's Camerino," pp. 211, 218.

43 See chapter 6, p. 192 and n. 54 above. Raphael sent the cartoon to Ferrara in early February 1519, and offered to have it painted. Cf. his injunction that the *Saint Michael* cartoon which he had previously presented to Alfonso was *not* to be painted; n. 32 above.

44 Alfonso not only rejected their offer to complete the painting: he wanted his 50-ducat deposit returned. For the letters of 4 and 14 May 1520 (ASE, Cancelleria Ducale, Estero, Ambasciatori, Roma 26 (170-VII-2) and Archivio per Materie, Pittori, 16/4, see Golzio, *Raffaello nei documenti*, pp. 122–25). As Shearman explains ("Alfonso d'Este's Camerino," p. 212), the 50 ducats had been paid for the *Hunt of Meleager* in 1517. The duke had also provided a canvas for the

painting as he did later for Titian's *Worship of Venus*. Raphael's heirs returned the duke's 50 ducats on 16 January 1521. For the date, see Shearman, n. 221, correcting Golzio's transcription. See also p. 19 above.

45 See Shearman, "Alfonso d'Este's Camerino," pp. 217, 218.

46 Titian received his final payment for the painting on 30 January 1523; see Goffen, *Titian's Women*, p. 117, and pp. 117–21 on the painting.

47 Shearman, "Alfonso d'Este's Camerino," p. 218; and John Shearman, *Raphael's Cartoons in the Collection of Her Majesty the Queen and the Tapestries for the Sistine Chapel* (London, 1972), p. 144, explaining that the tapestry of the *Conversion of Saul* was also in Venice in 1528 but that Titian seems to have studied the cartoon itself. It evidently remained in Venice until c. 1716, when it was sent to Spain. The cartoon has since been lost. Shearman cites other examples of its influence on Venetian painters; *Raphael's Cartoons*, n. 62. For Raphael's influence on Titian, see Joannides, "On Some Borrowings," pp. 29, 31, 34–35; and for the Grimani collection, Marilyn Perry, "Cardinal Domenico Grimani's Legacy of Ancient Art to Venice," *Journal of the Warburg and Courtauld Institutes* 41 (1978): 215–44, and Irene Favaretto and Giovanna Luisa Ravagnan, ed., *Lo statuario pubblico della Serenissima: Due secoli di collezionismo di antichità, 1597–1797* (Cittadella and Padua, 1997).

48 For the letter from Annibale Roncaglia to Cesare d'Este, 1 December 1598, see Hope, "'Camerini d'Alabastro'," p. 641.

49 For "creative imitation" and for humanist distinctions among degrees of imitation – *traslatio, paraphrasis, imitatio* – each freer from the original than the last, see Thomas M. Greene, *The Light in Troy: Imitation and Discovery in Renaissance Poetry* (New Haven and London, 1982), pp. 38–41, 51.

50 Quoted (in another context) and translated in Pigman, "Versions of Imitation," p. 11.

51 Paul Joannides has suggested to me that Bacchus and Ariadne recall the angel in Raphael's *Expulsion of Heliodorus* and the woman who recoils in the foreground of that fresco, completed in 1512 in the Stanza d'Eliodoro. But once again, Titian's figures are more daringly foreshortened than Raphael's.

52 Wethey, *Titian*, vol. 1: *The Religious Paintings*, pp. 109–10; and Michele Polverari, ed., *Tiziano. La pala Gozzi di Ancona. Il restauro e il nuovo allestimento espositivo*, exh. cat.,

Ancona, Pinacoteca Comunale (Bologna, 1988). Gozzi, a Ragusan nobleman, was resident in Ancona. The bishop saint is identified as San Biagio, patron of the Slavic confraternity in that city. Sometimes labeled Sant'Alvise, that is, Saint Louis of Toulouse, the patron's onomastic, the bishop is far too old to be that Franciscan bishop saint, dead at twenty-three.

53 Conti, *camerlengo*, secretary of Julius II, and prefect of the *fabbrica* of Saint Peter's, died 18 February 1512 and was buried in Santa Maria in Aracoeli. Looted by Napoleon's forces, the altarpiece was recovered for Italy by Antonio Canova. See Oberhuber, *Raphael*, pp. 127, 130–32. For the painting's influence on Titian's altarpiece, see Pietro Zampetti, "Tiziano fino al 1520," in Polverari, *Tiziano*, pp. 11–21, esp. pp. 19–20 on the artists' different interpretations.

54 See Oberhuber, Raphael, pp. 127, 130–32, for the "strongly Giorgionesque" landscape, proving "that at this moment paintings from Giorgione's circle were part of Raphael's experience," and for the drawing on Venetian paper in London, British Museum, 1900-8-24-107. Oberhuber adds that Raphael sent a pupil to Venice to purchase pigments. See also Paul Joannides, *The Drawings of Raphael with a Complete Catalogue* (Berkeley and Los Angeles, 1983), p. 203, cat. 281.

55 Titian's San Nicolò altarpiece is signed on a *tavola ansata*; see p. 292 above.

56 Gilbert, "Some Findings," p. 41n19 and Appendix II, an analytic survey of Titian's signatures. On the latter portrait, see Luba Freedman, "'The Schiavona': Titian's Response to the Paragone between Painting and Sculpture," *Arte veneta* 41 (1987): 31–40; and Goffen, *Titian's Women*, pp. 45, 51–52.

57 Sebastiano had done likewise, perhaps with the same intention, in the background of his *Death of Adonis*, painted in Rome c. 1513. Of course, in either case, the patron might have requested the view of Venice: it is impossible to know. For this painting (Florence, Uffizi), see Michael Hirst, *Sebastiano del Piombo* (Oxford, 1981), pp. 33, 37–39.

58 For the *Andrians*, see Goffen, *Titian's Women*, pp. 121–26. Installed in 1525, the painting was probably under way in winter 1522–23, while Titian was completing the *Bacchus and Ariadne*. For this chronology, see Gould, *Titian*, pp. 12–14; followed by Wethey, *Titian, Mythological and Historical Paintings*, pp. 151–52, *inter alia*.

59 For Titian's sojourn in Ferrara in spring 1520, see p. 279 above. For the correspondence, see Giuseppe Campori, "Tiziano e gli Estensi," in *Artisti degli Estensi: I pittori* (Modena, 1875), pp. 589–90; and for the commission, Erica Tietze-Conrat, "Again: Giovanni Bellini and Cornaro's Gazelle," *Gazette des Beaux-Arts*, 6th ser., 29 (1946): 187–90, and 30 (1946): 185. Bellini's painting is lost.

60 See David Bull and Joyce Plesters, *The Feast of the Gods: Conservation, Examination, and Interpretation* (Hanover, NH, 1990).

61 In addition to the visit in spring 1520, Titian was in Ferrara for a month at the end of January 1523 (delivering *Bacchus and Ariadne*), from mid-April to late June 1524, and from early December 1524 to mid-February 1525. See Goffen, *Titian's Women*, p.300nn43–46; and Charles Hope, "The Camerino d'Alabastro: A Reconsideration of the Evidence," in *Bacchanals by Titian and Rubens*, ed. Görel Cavalli-Bjorkman (Stockholm, 1987), pp. 26, 39–40, nn. 11, 13, 14.

62 "Drink again" is part of the lyric of the song for which Titian provides words and music on the scroll in the foreground; Goffen, *Titian's Women*, p. 125. For the quotation from Michelangelo, see Leo Steinberg, "An El Greco 'Entombment' Eyed Awry," *Burlington Magazine* 116 (1974): 477.

63 On the bishop, see Giovanni Agosti, "Sui gusti di Altobello Averoldi," in Elena Lucchesi Ragni and Giovanni Agosti, ed., *Il polittico Averoldi di Tiziano restaurato*, exh. cat., Brescia, Monastero di Santa Giulia (Brescia, 1991), pp. 55–80, pp. 55–56 for the friendship with Riario. Averoldi was also a patron of letters, in 1519 commissioning a translation of Hippocrates by Favio Calvo, Ravennate antiquarian and friend of Raphael; the book was published by Manenti, physician of Francesco Maria della Rovere, Duke of Urbino. Francesco Francia painted a portrait of Alveroldi, c. 1505; see Fern Rusk Shapley, *Catalogue of the Italian Paintings*, National Gallery of Art, 2 vols. (Washington, 1979), vol. 2, pp. 191–92.

64 See Marino Sanuto [Marin Sanudo], *I diarii di Marino Sanuto*, ed. Rinaldo Fulin et al. 58 vols. (Venice, 1879–1902), vol. 33, col. 554.

65 For Titian's altarpiece, see Bruno Passamani, "Tiziano, Averoldi, Brescia: Il polittico di San Nazaro tappa nodale nell'arte di Tiziano e polo catalizzatore per la pittura bresciana del primo Cinquecento," in Lucchesi Ragni and Agosti, ed., *Polittico Averoldi*, pp. 7–32; and

for Palma's, 1523–24, see Philip Rylands, *Palma Vecchio* (Cambridge, 1992), p. 213, no. 70.

66 For ASE, Cancelleria Ducale, Ambasciatori, Venezia, Busta 14, letter dated 10 October 1519, see Elena Lucchesi Ragni, "Le vicende del polittico," in *Polittico Averoldi*, ed. Lucchesi Ragni and Agosti, p. 89. Tebaldi had been instructed by the duke to see the artist because "we think that Titian the painter must for once bring our picture to completion"; 29 September 1519, in Campori, "Tiziano e gli Estensi," p. 588.

67 Campori, ibid., p. 590, rpt. in Roberto Tassi, *Tiziano: Il polittico Averoldi in San Nazaro* (Brescia, 1976), pp. 44–45.

68 ASE, Cancelleria Ducale, Ambasciatori, Venezia, Busta 14, in Lucchesi Ragni, "Le vicende," in Lucchesi Ragni and Agosti, ed., *Polittico Averoldi*, pp. 89–90, and p. 91, fig. 66, for an illustration of the letter. On the preparatory drawings for the *Saint Sebastian* (Berlin, Kupferstichkabinett, and Frankfurt, Städelsches Kunstinstitut), see Vincenzo Pialorsi, "I disegni preparatori, Il medaglione della cornice originale, Le ante," in ibid., pp. 111–12; W. Roger Rearick, "Tiziano Vecellio dit Titien, *Etudes pour un Saint Sébastien et pour une Vierge à l'Enfant*" and "Tiziano Vecellio dit Titien, *Etudes pour un Saint Sébastien*," in Laclotte and Nepi Scirè, ed., *Siècle de Titien*, pp. 559–61; and M. Agnese Chiari Moretto Wiel, "Six Studies for Saint Sebastian and the Madonna and Child," in Biadene with Yakush, ed., *Titian*, pp. 181–82. The *Sebastian* was much copied: see Elena Lucchesi Ragni and Renata Stradiotti, "Copie del San Sebastiano," in Lucchesi Ragni and Agosti, pp. 115–22; David Rosand, "Titian's Saint Sebastians," *Artibus et historiae* 30 (1994): 23–39; and Wethey, *Titian*, vol. 1, pp. 127–28, listing ten known replicas of the *Sebastian* (of which five have been lost).

69 ASE, Cancelleria Ducale, Ambasciatori, Venezia, Busta 14, in Lucchesi Ragni, ibid., p. 90, and p. 91, fig. 67, for an illustration of the letter. As she and others have noted, Tebaldi's description does not quite fit the *Saint Sebastian* in Brescia (he mistook the tree for a column, possibly because of the drum on which the saint rests his foot).

70 See Paolo Giovio, "Raphaelis Urbinatis Vita," in Paola Barocchi, ed., *Scritti d'arte del Cinquecento*, 3 vols. (Milan and Naples, 1971–77), vol. 1, p. 17. The significance of this early public mention of Titian's name was noted by Mina Gregori, "Tiziano e l'Aretino," in *Tiziano e il Manierismo*

europeo, ed. Rodolfo Pallucchini (Florence, 1978), p. 295. Giovio's praise echoes Petrarch's encomium of Giotto in the poet's testament. For Giovio and Adorno in Venice and their contact with Titian, see T.C. Price Zimmermann, *Paolo Giovio: The Historian and the Crisis of Sixteenth-Century Italy* (Princeton, 1995), pp. 50–51. In addition to his portrait, Adorno asked Titian to draw one of Giovio's ideas for an *impresa*; Zimmerman, p. 51. Giovio himself later obtained a copy of Titian's portrait of *Ippolito d'Este*; ibid., p. 127.

71 For the duke's letter, ASE, Cancelleria Ducale, Ambasciatori, Venezia, Busta 26, dated 17 December 1520, see Lucchesi Ragni, in *Polittico Averoldi*, ed. Lucchesi Ragni and Agosti, pp. 90, 92, and fig. 68. Regarding Titian's prices, see Peter Humfrey, "The Venetian Altarpiece of the Early Renaissance in the Light of Contemporary Business Practice," in *Saggi e memorie di storia dell'arte* 15 (1986): 68–69. For patrons' interest in a work's beauty more than or rather than its religiosity in relation to Raphael, see Sylvia Ferino Pagden, "From Cult Images to the Cult of Images: The Case of Raphael's Altarpieces," in *The Altarpiece in the Renaissance*, ed. Peter Humfrey and Martin Kemp (Cambridge and New York, 1990), pp. 165–89.

72 For Alfonso's letter, ASE, Cancelleria Ducale, Ambasciatori, Venezia, Busta 26, see Campori, "Tiziano e gli Estensi," p. 592.

73 Tassi, *Tiziano*, p. 16, notes the resemblance to both the *Rebellious Slave* and *Dying Slave* statues; Michael Hirst, *Michelangelo and his Drawings* (New Haven and London, 1988), p. 18, analyzes the relation of Titian's painting to Michelangelo's study for another Slave. See also Paul Joannides, "Two Bronze Statuettes and their Relation to Michelangelo," *Burlington Magazine* 124 (1982): 3n4; and Joannides, "On Some Borrowings," pp. 31–32. Joannides argues that "Titian knew a drawing or model [. . .] showing an intermediate stage" of Michelangelo's ideas for the Slave in the drawing (p. 32). Titian's first conception of his saint is recorded in a drawing in Berlin, Kupferstichkabinett; Hans Tietze, "An Early Version of Titian's *Danae*: An Analysis of Titian's Replicas," *Arte veneta* 8 (1954): 200. Gilbert, "Some Findings," p. 39, traces the figure's evolution, a process documented by six surviving drawings for the *Sebastian*.

74 The *Dancing Faun* (Florence, Uffizi) might have been part of the Medici collections and therefore known to Michelangelo, as

suggested by G.B. Cavalcaselle and J.A. Crowe, *Tiziano: La sua vita e i suoi tempi*, 2 vols. (Florence, 1877–78; rpt. 1974), vol. 1, p. 219, following Alessandro Sala (1817).

75 For the altarpiece formerly in the church of San Nicolò della Lattuga, Venice, now in the Pinacoteca Vaticana, see William Hood and Charles Hope, "Titian's Vatican Altarpiece and the Pictures Underneath," *Art Bulletin* 59 (1977): 534–52. The Uffizi portrait of Ludovico Beccadelli (Beccadelli was Bishop of Ravello and papal legate to Venice, 1550–54) is signed and dated 1552 on the paper held in his hands; see Wethey, *Titian*, vol. 2: *The Portraits*, p. 81, cat. 13, and Aretino's description of the portrait in a letter and sonnet of October 1552 in Aretino, *Lettere sull'arte*, vol. 2, pp. 411–12. The Escorial *Saint John the Baptist*, c. 1560, is signed TITIANVS FACIEBAT. This signature has been repainted; Wethey, *Titian*, vol. 1, p. 137, no. 110.

76 On the painting and the signature, see Rona Goffen, "Giovanni Bellini's *Nude with Mirror*," *Venezia Cinquecento* 1 (1991): 185–202; and Goffen, "Signatures: Inscribing Identity in Italian Renaissance Art," *Viator* 32 (2001): 320–25.

77 See also Gilbert, "Some Findings," n. 19.

78 For the panel in Venice, Cini Collection, see Wethey, *Titian*, vol. 1, pp. 132–33, no. 102. Wethey's suggested date c. 1516 seems too late to me.

79 Barocchi and Ristori, *Carteggio* 2: 315, DXXVIII. "Sebastiano's *Transfiguration* was his rebuttal to the Raphael, and his critique of it," according to S.J. Freedberg, *Painting of the High Renaissance in Rome and Florence*, 2 vols. (Cambridge, MA, 1961), vol. 1, pp. 391–92, 394.

80 See Greene, *Light in Troy*, p. 38, for these various strategies of imitation.

81 Ibid., p. 39; my italics.

82 See Rona Goffen, *Piety and Patronage in Renaissance Venice: Bellini, Titian, and the Franciscans* (New Haven and London, 1986), pp. 40–61.

83 Bellini had evidently stood in the way of Titian's receiving a *sansaria*, for which see n. 16 above. Vasari took note of Titian's good fortune in relation to local competition in the passage quoted as an epigraph to this chapter.

84 Vasari-Barocchi 6: 165, with a partial list of Titian's subjects.

85 Barocchi and Ristori, *Carteggio* 3: 280, DCCXCVIII, datable late September or early October 1529. Regarding Michelangelo's motivations for leaving Florence at this

time, see E.H. Ramsden, ed., *The Letters of Michelangelo*, 2 vols. (Stanford, 1963), vol. 1, pp. 291–92.

86 Condivi, p. 43. See Barocchi and Ristori, *Carteggio* 3: 377–79, DCCCLII, for Mini's letter to Michelangelo, dated Lyons, 27 February 1532, referring to his needing some help – "Bansta [*sic*] [...] una minima parola" – in getting to see the king to whom he hopes to sell the painting. The king's acquisition of the *Leda* "at a very great price" is recounted in Benedetto Varchi, *Orazione funerale di M. Benedetto Varchi fatta, e recitata da lui pubblicamente nell'essequie di Michelagnolo Buonarroti in Firenze, nella chiesa di San Lorenzo* (Florence, 1564), p. 16. For the lost *Leda*, see pp. 309–15 above.

87 Barocchi and Ristori, *Carteggio* 4: 229, MLIV.

88 Ibid., p. 237, MLXI. The relationship of Michelangelo and the French king is discussed in Janet Cox-Rearick, *The Collection of Francis I: Royal Treasures* (New York, 1996), pp. 283–85, 294–97, pp. 295–97 for this exchange of letters.

89 Condivi, p. 27; see also ibid., p. 54 (the sultan wanted his services), and p. XXII for *postilla* 13. Condivi explained that Franciscan friars acted as the sultan's messengers. See Caroline Elam, "'Che ultima mano!': Tiberio Calcagni's *Postille* to Condivi's Life of Michelangelo," in Condivi, pp. XLII–XLIII, for the date of this project and for a letter to Michelangelo from Tommaso da Tolfo in Adrianopoli, 1 April 1519. The writer recalls conversations in 1504 in the house of Giannozo Salviati, concerning the possibility of Michelangelo's going to Constantinople. Against the idea then, Tommaso now recommends it; the new sultan, Selim II (1512–20), was more interested in the figural arts than his predecessor. For the letter, see Barocchi and Ristori, *Carteggio* 2: 176–77, CDXXIV.

90 Condivi, pp. 54–55. Benedetto Varchi, *Orazione funerale*, pp. 44–45, also remembered Michelangelo's great foreign patrons, notably Charles V, who "wanted a painting or sculpture by him," and Doge Andrea Gritti, who wanted him to move to Venice. It does not seem coincidental that the emperor and doge were two of *Titian*'s greatest patrons.

91 Michelangelo declined because of his age; but he did make drawings for the monument, one of which survives (Amsterdam, Rijksmuseum). He delegated the project to Daniele da Volterra, who succeeded in casting the bronze horse for the monument

the year before his own death in 1566. It was eventually sent to France and used for the monument of Henri IV. For the exchange between Catherine and Michelangelo and for the projected tomb of Henri II, see Cox-Rearick, *Collection of Francis I*, p. 296.

92 The situation had been different in earlier times. In the fourteenth century the Venetians had turned to the Paduan Guariento for the *Coronation of the Virgin* mural of the Maggior Consiglio; and in the first half of the fifteenth, had hired Gentile da Fabriano for the Sala del Maggior Consiglio, Andrea del Castagno for the Cappella dei Maschi in San Marco and for the San Tarasio Chapel at San Zaccaria, and other foreigners (mostly Tuscans) for other prestigious commissions.

93 For Pordenone (c. 1483/84–1539), documented as a master in 1504, see now Charles E. Cohen, *The Art of Giovanni Antonio da Pordenone: Between Dialect and Language*, 2 vols. (Cambridge and New York, 1996). Some of my discussion of the relationship between Pordenone and Titian derives from my review essay in *Art Bulletin* 80 (1998): 180–88.

94 The frescoes were largely destroyed by bombing in the Second World War. See Cohen, *Pordenone*, vol. 1, pp. 141, 163n29, and vol. 2, pp. 572–78, no. 32.

95 Ibid., 1: 144, and Wethey, *Titian*, vol. 1, pp. 69–70, no. 8.

96 These "clumsy" figures "are unthinkable as Titian's own," according to Wethey, ibid., p. 69. The portrait was defaced in 1526, however, and repainted thereafter, so one cannot be certain about Titian's role here. For Bordone's possible role, see Wethey, pp. 69–70.

97 The cupola's Father may be seen "as actively participating in, and iconographically completing, the *Annunciation*" in which he is not represented; Cohen, *Pordenone*, vol. 1, pp. 146, 147, following John Shearman and Juergen Schulz.

98 David Rosand, "Titian in the Frari," *Art Bulletin* 53 (1971): 196–213; Goffen, *Piety and Patronage*, pp. 86, 87, 97, 112, 193n57; and Goffen, *Giovanni Bellini* (New Haven and London, 1989), p. 184. Note also the spatial and thematic relations in the juxtaposition of altarpieces by Bellini (1513) and Tullio Lombardo (c. 1499–1502) in the Venetian church of San Giovanni Crisostomo.

99 See Goffen, *Piety and Patronage*, pp. 98–100, for the Minerva. The Broccardo Chapel's "cross-space references and illusionism" recall Raphael's chapel in Santa

Maria del Popolo; Cohen, *Pordenone*, vol. 1, pp. 147–48.

100 See also Cohen, ibid., p. 149.

101 Ibid., p. 261.

102 Ibid., pp. 260–65, and Patricia Meilman, *Titian and the Altarpiece in Renaissance Venice* (Cambridge and New York, 2000), pp. 82–89.

103 Carlo Ridolfi, *Le Maraviglie dell'arte ovvero le vite degli illustri pittori veneti e dello stato* (1648), ed. Detlev von Hadeln, 2 vols. (Berlin, 1914), vol. 1, p. 167. For the *modello* (Florence, Uffizi) and the study for the figures of the saint and his assassin (Los Angeles, J. Paul Getty Museum), see Cohen, *Pordenone*, vol. 1, pp. 262, 263–64, and pls. 338, 339.

104 As recognized by Hans Tietze, *Tizian Leben und Werk* (Vienna, 1936), pp. 114, 155.

105 I refer to the Scuola building itself, as distinct from their altars in Santi Giovanni e Paolo. As independent institutions, the confraternities of Saint Catherine and Saint Vincent had already endowed their separate altars in the church with altarpieces by Giovanni Bellini. See Rona Goffen, "Giovanni Bellini and the Altarpiece of St. Vincent Ferrer," in *Renaissance Studies in Honor of Craig Hugh Smyth*, ed. Andrew Morrogh, Fiorella Superbi Gioffredi, Piero Morselli, and Eve Borsook, 2 vols. (Florence, 1985), vol. 2, pp. 277–96, p. 279 for the chronology of the mergers; Goffen, *Bellini*, pp. 119–22; and Sandro Sponza, "Il polittico di San Vincenzo Ferrer," in Rona Goffen and Giovanna Nepi Scirè, ed., *Il colore ritrovato: Bellini a Venezia*, exh. cat., Venice, Gallerie dell'Accademia (Milan, 2000), pp. 145–48, no. 27. The polyptych is *in situ*, whereas the *Virgin and Child Enthroned with Saints* for the Scuola di Santa Catterina was destroyed in the same fire as Titian's *Saint Peter Martyr* in 1867. On the patronage of smaller confraternities, see Peter Humfrey, "Competitive Devotions: The Venetian *Scuole piccole* as Donors of Altarpieces in the Years around 1500," *Art Bulletin* 70 (1988): 401–23.

106 For Palma's *Martyrdom of Saint Peter Martyr* (Alzano Lombardo, Museo della Basilica di San Martino Vescovo), see *Restituzioni 2000: Capolavori restaurati* (Vicenza, 2000), pp. 178–85, no. 25, suggesting a date c. 1520. The painting, oil on panel, was restored by Bruno Sesti and Delfina Fagnani. See also Rylands, *Palma Vecchio*, pp. 62–64, 235, no. 92, dating the work c. 1526–28.

107 Paolo Pino, "Dialogo di pittura," in *Trattati d'arte del Cinquecento fra manierismo e controriforma*, 3 vols., ed. Paola Barocchi (Bari, 1960–62), vol. 1, p. 137. Meilman, *Titian*

and the Altarpiece, p. 84, suggests that Pino evokes (though he does not mention) Pliny's description of the way in which "The most celebrated [artists] have also come into competition with each other, although born at different periods, because they had made statues of Amazons; when they were dedicated [. . .] it was agreed that the best one should be selected by the vote of the artists themselves" (*Natural History* XXXIV.xix. 52–54).

108 Pino, "Dialogo," p. 137, with a reference to *le mani pillose*, "hairy hands," which I have translated colloquially as "sticky fingers" – i.e., some judges are corrupt. Pino's sexual advice foreshadows Michelangelo's *Postilla* 23 discountenancing coitus altogether; the injunction is written in the margin of Condivi's reference to his abstinence (Condivi, p. 65). Saint Augustine, followed by Saint Thomas Aquinas, *inter alia*, warned against sex in general and in particular against loving one's wife too much, which is adultery against God. Vasari implied that Raphael died of too much insalubrious loving. For these various sources, see Goffen, *Titian's Women*, pp. 25, 233, with bibliography.

109 Wethey, *Titian*, vol. 1, pp. 154–55, lists two extant replicas and ten "other copies or versions." The painting was completed by 27 April 1530 (the date of the deed for the altar), and Wethey suggests that it would have been unveiled two days later, the feast of Saint Peter Martyr (or perhaps for the vigil, the night before?). See also Meilman, *Titian and the Altarpiece*, pp. 82–83, regarding the commission and the marble frame by Guglielmo Bergamasco.

110 Wethey, *Titian*, vol. 1, fig. 154.

111 Pietro Aretino, *Lettere, Libro primo*, ed. Francesco Erspamer (Parma, 1995), pp. 445–47, no. 214, p. 446 for this passage, p. 447 for the "brush of the divine Titian." The letter begins with the architect Sebastiano Serlio's describing Tribolo's *Pietà* to Aretino. As Ersparmer notes, ibid., p. 446n3, Cellini did not mention this episode in his *Autobiography* and refered to Titian only once. See also the important study by Norman E. Land, "Titian's *Martyrdom of St Peter Martyr* and the 'Limitations' of Ekphrastic Art Criticism," *Art History* 13 (1990): 293–317.

112 Walter Friedlaender, "Titian and Pordenone," *Art Bulletin* 47 (1965): 118–21, describes the painting in this way, suggesting that Pordenone provided the more accessible example of this Michelangelesque "plastic force." For Michelangelo's influence on the altarpiece, see also Joannides, "On Some Borrowings," pp. 32–33; both Sebastiano and Michelangelo sojourned in Venice while Titian was at work on his altarpiece (ibid., p. 33).

113 For Bellini's *Saint Peter Martyr* (London, National Gallery), see Jennifer Fletcher and David Skipsey, "Death in Venice: Giovanni Bellini and the Assassination of St. Peter Martyr," *Apollo*, N.S., 133, 347 (1991): 4–9. The version in London, Courtauld Institute, showing the trees themselves bleeding where they have been cut, has sometimes been attributed to Andrea Previtali after Bellini. See Anchise Tempestini, *Giovanni Bellini*, trans. Alexandra Bonfante-Warren and Jan Hyams (New York, London, and Paris, 1999), p. 176, following Giles Robertson.

114 Cohen, *Pordenone*, vol. 1, p. 269, and vol. 2, pp. 623–27, cat. 51: the *Saints* (oil on panel) were painted as the doors of the silver cupboard or *armadio*, later combined with the detached frescoes of worshipers – an arrangement not foreseen by Pordenone.

115 The canvas was originally arched and presumably given its present rectangular shape to accommodate the new high altar in 1633. *Pentimenti* show that the saint originally wore his bishop's miter. See Giovanna Nepi Scirè, "Recent Conservation of Titian's Paintings in Venice," in *Titian*, ed. Biadene with Yakush, p. 122; and Francesco Valcanover, "Tiziano Vecellio, dit Titien, *Saint Jean l'Aumônier*," in Laclotte and Nepi Scirè, *Siècle de Titien*, pp. 531–32. Titian's painting has often been dated to the mid-1540s, but according to Vasari's Life of Pordenone (1550), Pordenone's Corrieri altarpiece (mentioned above) was done in rivalry with the Venetian work (Vasari-Barocchi 4: 433); in 1568 (ibid.) Titian's subject, *Saint John the Almsgiver*, is attributed to Pordenone. If Vasari was correct in 1550, Titian's altarpiece must predate 1539, the year of Pordenone's death, as argued by Charles Hope, "The Early Biographies of Titian," in *Titian 500*, ed. Joseph Manca, Studies in the History of Art, 45, Center for Advanced Study in the Visual Arts Symposium Papers, 25 (Hanover, NH, and London, 1993), p. 174.

116 For the participation of assistants, see Cohen, *Pordenone*, vol. 1, pp. 274, 318n43, noting Pordenone's increasing use of assistants in the 1530s.

117 For Pordenone's Palazzo Ducale commission, see ibid., pp. 411–13; and for the Albergo della Carità, see David Rosand, *Painting*

in Cinquecento Venice: Titian, Veronese, Tintoretto (Cambridge and New York, rev. ed. 1997), pp. 104 and 173, doc. 19 (the contract of 6 March 1538). As Rosand explains, the confreres and Pordenone differed about what subject he would represent: they wanted an *Assumption*, and he – perhaps wishing to *avoid* evoking one of Titian's most famous works – suggested instead a *Betrothal of the Virgin*. That the confreres intended a *paragone* of the two masters is confirmed by their actions after Pordenone's death, when they held a competition to choose his successor; see Rosand, p. 173, doc. 20.

118 See Cohen, *Pordenone*, vol. 1, pp. 416–17. The artist died on 14 January 1539; "there may have been some effort by Titian partisans after Pordenone's death to minimize his role" (Cohen, p. 391). For Dolce, Pordenone was "an experienced and fluent master" but always inferior to Titian; Roskill, *Dolce's "Aretino,"* p. 236. Who can gainsay him?

119 Vasari-Barocchi 4: 431.

120 Ibid., 432, 433. Pordenone's frescoes in the Doge's Palace are lost but known from copies and drawings.

121 Ibid., 6: 161.

122 See Cohen, *Pordenone*, vol. 1, p. 133; and Rona Goffen, Review Essay: *Jacopo Bassano and his Public: Moralizing Pictures in an Age of Reform, ca. 1535–1600*, by B. Aikema (Princeton, 1996), and *The Art of Giovanni Antonio da Pordenone: Between Dialect and Language*, 2 vols., by C.E. Cohen (Cambridge and New York, 1996), in *Art Bulletin* 80 (1998): 180–88, from which I repeat some of the following account.

123 Aretino, *Lettere, Libro primo*, ed. Erspamer, pp. 466–67, no. 224. The quoted phrase opens the letter, which then goes on to describe the beauties of the *Annunciation*, notably its color and light, Titian's "colorire" (p. 466).

124 Vasari-Barocchi 6: 161–62.

125 For his debts, see Cohen, *Pordenone*, vol. 1, p. 434.

126 The chapel may also be understood as a reduction of Michelangelo's plans for the San Lorenzo façade. See pp. 241–42 above.

127 Condivi, p. 43.

128 Ibid.

129 Barocchi and Ristori, *Carteggio* 3: 290, DCCCIII; and *Trattati d'arte*, vol. 3, pp. 1102–03 for Alfonso's letter, pp. 1101–23 for further information about the *Leda*. The letter is discussed also by Rosenberg, "Alfonso, Michelangelo," pp. 91–92. For a biography of Alfonso's hapless agent, Jacopo

Lachi, il Pisanello, whose failure to appreciate the painting's value deprived his master of the *Leda*, see Rosenberg, pp. 95–96.

130 Michelangelo's Christ in a drawing for the *Resurrection* (Paris, Louvre, 691B) is adapted from the fleeing Dominican in Titian's *Saint Peter Martyr*; see Meilman, *Titian and the Altarpiece*, pp. 87–88. In addition, motifs from two of Alfonso's *poesie* by Titian reappear in two other drawings by Michelangelo. Titian's *Worship of Venus* (Fig. 146) is quoted in Michelangelo's presentation drawing of the *Children's Bacchanal* (Windsor, Royal Collection); see Hirst, *Michelangelo and his Drawings*, p. 116. The Venetian's *Bacchanal of the Andrians* (Fig. 149) influenced the Florentine's sketch of the *Lamentation* (Bayonne, Musée Bonnat); see Alexander Nagel, *Michelangelo and the Reform of Art* (Cambridge and New York, 2000), p. 161. Michelangelo's response to Titian and his relationship with Alfonso are considered also by William E. Wallace, "Michelangelo's *Leda*: The Diplomatic Context," *Renaissance Studies* 15 (2001): 473–99, esp. p. 484.

131 Barocchi and Ristori, *Carteggio* 3: 239–40, identified as the last letter to be signed in this way by William E. Wallace, *Michelangelo at San Lorenzo: The Genius as Entrepreneur* (Cambridge and New York, 1994), p. 1.

132 Giovanni Gaye, *Carteggio inedito d'artisti dei secoli XIV.XV.XVI*, 3 vols. (Florence, 1840, rpt. Turin, 1968), vol. 3, pp. 221–22.

133 Bartolomeo Ammannati made a copy in marble c. 1540 (Florence, Bargello) and other sculptures after the painting are known; Joachim Poeschke, *Michelangelo and his World: Sculpture of the Italian Renaissance*, trans. Russell Stockman (New York, 1996), pp. 196–97. Among paintings after *Leda*, note that by Peter Paul Rubens in Dresden (Gemäldegalerie) and a copy in London (National Gallery), and the related cartoon in the Royal Academy, both sometimes attributed to Rosso Fiorentino. See Cox-Rearick, *Collection of Francis I*, pp. 237–41, VII-4; Cecil Gould, *The Sixteenth-Century Italian Schools*, National Gallery Catalogues (London, 1975; rpt. 1987), pp. 150–51; Robert S. Liebert, *Michelangelo: A Psychoanalytic Study of his Life and Images* (New Haven and London, 1983), pp. 241–61; Tolnay, *Michelangelo*, vol. 3: *The Medici Chapel*, pp. 106–07, 190–93; Vasari-Barocchi 6: 56; and Johannes Wilde, *Michelangelo: Six Lectures* (Oxford, 1978), pp. 270–80. On Michelangelo's drawing for Leda's head (Florence, Casa Buonarroti, 7F),

see Hirst, *Michelangelo and his Drawings*, pp. 73–74 and pl. 8.

134 This discussion is adapted from Goffen, *Titian's Women*, p. 232. *Leda*'s children are mentioned in the first description of the lost painting; see Condivi, p. 43, and Tolnay, *Michelangelo*, vol. 3, p. 191. Leda was wife of King Tyndareus of Sparta. In some versions of the myth, he was father of Castor and Clytemnestra, whereas Pollux (Polydeuces) and Helen were Jupiter's children. According to this genealogy of the Dioscuri, Castor was mortal and Pollux divine; but Pollux shared his divinity with his twin. Michelangelo emends these ancient versions of the myth by showing both the Dioscuri as well as one sister (Helen?) to be children of Jupiter.

135 This interpretation follows Edgar Wind, *Pagan Mysteries in the Renaissance* (New Haven and London, 1958), pp. 129–41, esp. pp. 129–30, citing Plutarch's explanation of the name "Leda."

136 Michelangelo used this phrase, "terrestre velo," in at least two sonnets, nos. 209 and 215 in James M. Saslow, *The Poetry of Michelangelo: An Annotated Translation* (New Haven and London, 1991), pp. 371, 377. The idea is a Neoplatonic commonplace, expressed elsewhere in his poetry and in that of many other authors; for example, "earthly prison" (ibid., p. 238, no. 106). Note Saslow's discussion of "Neoplatonism and the Body," pp. 30–33. In his art Michelangelo privileged the body; in his poetry he professed to despise it, an ironic disjunction, as Saslow notes, p. 32.

137 For Pico's excursus on the *morte di bacio* in the *Commento*, see Wind, *Pagan Mysteries*, p. 131. Pico associated the death of Alcestis, among others, with the Song of Songs (*Commento* III, viii, quoted in English in Wind, p. 131n2).

138 Pico, *Commento* III, viii, quoted in Wind, *Pagan Mysteries*, p. 131n2. Wind, p. 131, calls attention to similar arguments in Leone Ebreo, *Dialoghi d'amore*; Pierio Valeriano, *Hieroglyphica*; and Castiglione, *Cortegiano*, among others.

139 Lorenzo, *Opere*, vol. I, pp. 24–25, quoted in Wind, *Pagan Mysteries*, p. 133.

140 Wind, ibid., p. 133 (Lorenzo) and p. 135 (quoting Ficino, *De amore* II, viii, in *Opere*, p. 1327). According to Ficino, "resident philosopher" in Lorenzo's household, Orpheus had called Love bittersweet, *dulce amarum*.

141 Wind, *Pagan Mysteries*, pp. 137–38, for this and the following information.

142 For the text written on Casa Buonarroti, 10A, recto, see Liebert, *Michelangelo*, p. 241; and Saslow, *Poetry of Michelangelo*, p. 84, no. 14 (I have quoted Saslow's translation).

143 Saslow, ibid., p. 232, no. 102.

144 Liebert, *Michelangelo*, p. 248.

145 Wind, *Pagan Mysteries*, p. 138.

146 Clive Scott, "A Theme and a Form: Leda and the Swan and the Sonnet," *Modern Language Review* 74, 1 (1979): 1. Scott reminds the reader of "The collisions [...] of the short act with the enduring consequences – Helen and the Trojan War" (pp. 1–2).

147 Correggio, conversely, whose *Leda and the Swan* was painted c. 1531–32, while Michelangelo was working on his own picture or immediately thereafter, reverted to the older narrative scheme. In addition to two maids, two putti, and a lyre-playing Cupid, Correggio represented three Ledas and three Swans at three different times, including the Swan's flying departure from the scene. The painting and its pendant, the *Danae*, as well as the vertical pendants, *Jupiter and Io* and the *Rape of Ganymede*, were commissioned by Federico Gonzaga as gifts for Charles V; see David Ekserdjian, *Correggio* (New Haven and London, 1997), pp. 282–91.

148 See now Gigetta Dalli Regoli, Romano Nanni, and Antonio Natali, ed., *Leonardo e il mito di Leda: Modelli, memorie e metamorfosi di un'invenzione*, exh. cat., Vinci, Palazzini Uzielli (Milan, 2001), with bibliography.

149 For Leda's "fleeting presence" in Filarete's doors (1433–45), see *inter alia* Gigetta Dalli Regoli, "Leda e il cigno: un mito per Leonardo," in Dalli Regoli, Nanni, and Natali, *Leonardo e Leda*, pp. 11–12. For Leda in Italian literature, including Boccaccio's *Amorosa visione*, Landino's commentary on Horace, and Sacchetti's *Rime*, see Gigetta Dalli Regoli, *Mito e scienza nella "Leda" di Leonardo* (Vinci, 1991), pp. 8–9.

150 See Martin Kemp, *Leonardo da Vinci: The Marvellous Works of Nature and Man* (London, 1981; rpt. 1989), p. 270. The kneeling pose derives from the ancient *Venus Doidalsas*, and perhaps more precisely from the variant known as the *Venus Kneeling on a Tortoise* as argued by Ann H. Allison, "Antique Sources of Leonardo's *Leda*," *Art Bulletin* 56 (1974): 375–81. The British Museum *Crouching Venus* of the Doidalsas type (on loan from Her Majesty the Queen) was formerly in the collection of Guidobaldo da Montefeltro and then acquired, together with Urbino itself, by Cesare Borgia in 1502

– when Leonardo was in his service; Allison, n. 5.

151 The composition is represented in drawings, one formerly at Chatsworth, Duke of Devonshire; another in Rotterdam, Boymans-van Beuningen; and in a third version, known from a painting by a follower in Munich, Alte Pinakothek. In this painting, the Swan is absent, and Leda holds one of her children.

152 Daniel Arasse, *Leonardo da Vinci: The Rhythm of the World*, trans. Rosetta Translations (New York, 1998), p. 424.

153 As suggested by Kemp, *Leonardo*, p. 273.

154 The Anonimo's notation, "and also a Leda," is crossed out. The painting is also mentioned by Lomazzo in the *Trattato* (1584), in a sonnet in his *Grotteschi* (1587), and in his *Idea del tempio della pittura* (1590). It was seen by Cassiano del Pozzo in Fontainebleau in 1625 (he noted its poor condition), and recorded in the inventories of 1692 and 1694. By 1775 it had vanished, according to Carlo Goldoni. A cartoon was recorded in the Casnedi collection in Milan in 1721; they had acquired it from the Arconati, one-time owners of the *Saint Anne* cartoon now in London. For these sources, see Pietro C. Marani, *Leonardo da Vinci: The Complete Paintings*, trans. A. Lawrence Jenkins (New York, 2000), pp. 264, 278, dating the lost painting c. 1504–08. Cf. Kemp, *Leonardo*, p. 275, who dates Leonardo's first drawings for what became his painting of *Leda and the Swan* c. 1507–08, arguing that the latest make use of antiquities the artist saw in Rome in 1516. Noting the resemblance of Leda's babies to the infants of the *Nile*, unearthed in Rome c. 1512, Kemp concludes that the painting was finished during Leonardo's Roman sojourn. Kemp further suggests that the painting may have been completed after Leonardo's move to France. In any case, the chronological relation between the various "Leda" drawings and lost painting is not tidy, and nothing precludes the possibility that Leonardo continued to make drawings related to the theme even after having begun (and completed?) the painting. See also n. 158 below.

155 For Leda's "moment of uncertainty," and the adaptation of her standing posture from the ancient *Venus of Cyrene*, see Dalli Regoli, *Mito e scienza nella "Leda,"* pp. 7, 12–13.

156 Mary D. Garrard, "Leonardo da Vinci: Female Portraits, Female Nature," in *The Expanding Discourse: Feminism and Art History*, ed. Norma Broude and Mary D. Garrard (New York, 1992), p. 75. For similar interpretations, see Kemp, *Leonardo*, pp. 275, 277, and Dalli Regoli, *Mito e scienza nella "Leda,"* pp. 20–21.

157 For Raphael's copy, Windsor, Royal Collection 12759, c. 1505, see Joannides, *Drawings of Raphael*, p. 156, no. 98. The Spiridon version of Leonardo's *Standing Leda*, now in Florence, Palazzo Vecchio, has been attributed to Ferrando Spagnolo (Fernando Yanez de la Almandina); see Pietro C. Marani's entry in Antonio Natali et al., *L'officina della maniera: Varietà e fierezza nell'arte fiorentina del Cinquecento fra le due repubbliche 1494–1530*, exh. cat., Florence, Uffizi (Venice, 1996), p. 128. The Peruzzi drawing is in Florence, Uffizi, Gabinetto Disegni e Stampe; the painting attributed to Cesare da Sesto in Wilton House, Pembroke collection. There are also anonymous copies of the painting in London, Richeton Col-lection, and Philadelphia Museum of Art, Johnson Collection.

158 Leda's figure in Windsor (12642 v), c. 1507–08, and a series of studies for her head and hair: Windsor nos. 12515, 12516, 12517, 12518; and a sheet in the Codex Atlanticus, fol. 423r, variously dated between c. 1514 and c. 1515–16. A group of twelve studies of plants, also in Windsor, seem related to both compositions. See Kenneth Clark with Carlo Pedretti, *The Drawings of Leonardo da Vinci in the Collection of Her Majesty the Queen at Windsor Castle*, 3 vols. (London, 2nd ed. 1968), vol. 1, pp. 65–66, no. 12419.

159 Johannes Wilde, "Michelangelo and Leonardo," *Burlington Magazine* 95 (1953): 77.

160 He then recalled Pliny's story of distinguishing Apelles' line from that of Protogenes. Michelangelo is quoted in Hollanda's third dialogue: Francisco de Hollanda, *Four Dialogues on Painting*, trans. Aubrey F.G. Bell (Oxford and London, 1928), pp. 68, 71. The book was first published in 1548, completed on Saint Luke's day, 18 October (Hollanda, p. 110). He had been in Italy ten years earlier, in Rome in summer 1538. How accurately he remembered such conversations is moot and in this case, irrelevant: if he was putting words in Michelangelo's mouth, they nonetheless express ideas with which the artist agreed.

161 For the unsigned memorandum from the papers of Lodovico il Moro Sforza in the Archivio di Stato, Milan, see Paul Müller-Walde, "Beiträge zur Kenntnis des Leonardo da Vinci," *Jahrbuch der königlich preussischen Kunstsammlungen* 18 (1897): 165: "le cose sue hano aria virile et sono cum optima

ragione et integra proportione." A slightly misleading translation is given in D. S. Chambers, *Patrons and Artists in the Italian Renaissance* (Columbia, SC, 1971), p. 153, no. 95. Chambers was puzzled by the appropriateness of the description, but whichever reading is correct (I have not been able to consult the original), the meaning is the same. The adjective *virile* is explained in relation to the idea of gendered style. In addition to Botticelli, the memorandum also briefly characterizes Filippino Lippi, Perugino, and Domenico Ghirlandaio, implying a competition among them. All of them have worked in the Sistine Chapel, the author writes, except for Filippino, and all of them at the Ospedaletto of Lorenzo il Magnifico.

162 Some of this discussion is taken from Goffen, *Titian's Women*, pp. 232–33. On this subject, see David Summers, "Form and Gender," *New Literary History* 24 (1993): 244–71; Jaqueline Lichtenstein, *The Eloquence of Color: Rhetoric and Painting in the French Classical Style*, trans. Emily McVarish (Berkeley, 1993), esp. ch. 6; Patricia L. Reilly, "The Taming of the Blue: Writing Out Color in Italian Renaissance Theory," in *Expanding Discourse*, ed. Broude and Garrard, pp. 87–99; and Philip Sohm, "Gendered Style in Italian Art Criticism from Michelangelo to Malvasia," *Renaissance Quarterly* 48 (1995): 759–808.

163 Goffen, *Titian's Women*, p. 232; and Reilly, "Taming of the Blue," p. 89.

164 Pino in Paola Barocchi, ed., *Trattati d'arte del Cinquecento*, 3 vols. (Bari, 1960–62), vol. 1, pp. 113, 116. Pino was the first theorist to apply this triad to the definition of art; see Brian Vickers, *In Defence of Rhetoric* (Oxford, 1988), p. 354, quoting this passage. As he explains, pp. 354–57, Lodovico Dolce also divided painting into three parts – *inventione, disegno, colorito* – but Dolce added that "the painter should have at his command one other element. [. . .] [T]he figures should stir the spectators' souls." In this way, Dolce associated *overe* (as in "move the emotions") with *elocutio*; Vickers, pp. 356–57, quoting the Roskill translation.

165 Colonna and Michelangelo met for the first time four years later. For their friendship and for his poems dedicated to her, see Saslow, *Poetry of Michelangelo*, pp. 18–19, 50–52; and Emidio Campi, *Michelangelo e Vittoria Colonna: Un dialogo artistico-teologico ispirato da Bernardino Ochino, e altri saggi di storia della Riforma* (Turin, 1994). Citing a letter from the Mantuan ambassador dated 9 May 1531, Wilde argued that Marchese del

Vasto's commission of the *Noli me tangere* was intended as a gift for Colonna; Johannes Wilde, *Michelangelo and his Studio: Italian Drawings in the Department of Prints and Drawings in the British Museum* (London, 1953; rpt. 1975), p. 106; followed by William E. Wallace, "Il 'Noli me tangere' di Michelangelo: Tra sacro e profano," *Arte cristiana* 56 (1988): 449, 450n29. Alfonso d'Avalos (1502–1546) was a cousin of Colonna's husband and inherited his title of Marchese of Pescara. Avalos became a patron of Titian's as well, commissioning at least two works: his portrait, *Alfonso d'Avalos with Page*, 1533 (Paris, Marquis de Ganay), and an allegorical painting, *Allocution of Alfonso d'Avalos*, 1539–41 (Madrid, Prado); see Wethey, *Titian*, vol. 2, pp. 78–80.

166 Barocchi and Ristori, *Carteggio* 3: 301, DCCCXII. For the commission and the three known versions of the composition, see Wallace, "'Noli me tangere.'" For Figiovanni, see also Vasari-Barocchi 6: 63. Pope Clement's amnesty for Michelangelo after the fall of the Republic in 1530 had been addressed to Fiogiovanni; Gaye, *Carteggio inedito*, 3: 221.

167 Barocchi and Ristori, *Carteggio* 3: 328, DCCCXXVII. The letter may be dated in relation to the letter from Giovanni Borromeo to Federigo Gonzaga, dated 19 May 1531, cited above; Wallace, "'Noli me tangere,'" pp. 443, 450n6. Figiovanni's second letter, referring to del Vasto's arrival "this evening or tomorrow morning," must therefore date before 18 May, when Michelangelo visited Borromeo.

168 Gonzaga commissioned Titian's *Magdalene* on 5 March 1531. The painter had been working on a painting of the saint, and his dispatching a finished work to Mantua in mid-April means that it was this composition that was presented to Colonna, that is, a work already near completion and not one conceived with the recipient in mind. For the gift, the correspondence among artist, patron, and recipient, and Colonna's poem inspired by the painting, see Goffen, *Titian's Women*, pp. 177–79.

169 Their interpretations of the same theme are also very different: Titian's *Noli me tangere* (London, National Gallery), painted c. 1510–11, shows an ardent Magdalene at Christ's feet, and a Savior who bends toward her even as he pulls his drapery away: a tender, solicitous rejection; ibid., p. 170.

170 Vasari-Barocchi 5: 326 (Life of Pontormo). Vasari's version of the history of the *Noli me tangere* is contradicted by the correspon-

dence quoted here. According to Vasari – purportedly repeating what Michelangelo had told him – Michelangelo had completed a cartoon representing the *Noli me tangere* which then came into the possession of Avalos. The marchese wished to have the cartoon completed as a painting. Not wanting to paint the work himself, Michelangelo recommended Pontormo. Vasari mentioned Pontormo's painting the *Noli me tangere* cartoon again in the Life of Michelangelo; Vasari-Barocchi 6: 741. Michelangelo's cartoon has been lost.

171 Ibid. 5: 326 (Life of Pontormo). Vasari added that having seen it, Alessandro Vitelli, captain of the guard in Florence, requested Pontormo to make another painting based on the cartoon. Pontormo's second version, for Vitelli, is identified with a painting in a private collection in Milan (Fig. 167). See Wallace, "'Noli me tangere'," p. 446, citing Timothy Verdon's observation that the landscape background of the Milan version may refer to Città di Castello, Vitelli's native city. Michelangelo's cartoon was used a third time, by Battista Franco (Florence, Casa Buonarroti). A replica of the lost work, also in Casa Buonarroti, is attributed to Bronzino.

172 Vasari-Barocchi 6: 69 (Life of Michelangelo).

173 Ibid. 5: 326–27. On Bettini himself and his plans for his bedroom decoration, see Jonathan Nelson, "Dante Portraits in Sixteenth Century Florence," *Gazette des Beaux-Arts* 120 (1992): 69–71. The *Venus and Cupid* was first mentioned by the Anonimo Gaddiano (*Anonimo Magliabechiano*), 1537–42; see Leatrice Mendelsohn, *Paragoni: Benedetto Varchi's Due lezzioni and Cinquecento Art Theory* (Ann Arbor, 1982), p. 269n73.

174 See Mendelsohn, ibid., pp. 120–21.

175 Vasari-Barocchi 5: 326–27 (Life of Pontormo). Vasari added that because of the two cartoons, Pontormo resolved to "imitate and follow" Michelangelo's style.

176 After this unhappy experience, the only cartoon that Michelangelo apparently intended for another artist's use is the so-called *Epiphany* or *Holy Family* for Condivi (London, British Museum, 1895-9-15-518+), c. 1550. Most scholars accept the attribution of the cartoon to Michelangelo, e.g., Hirst, *Michelangelo and his Drawings*, p. 77; but cf. Alexander Perrig, *Michelangelo's Drawings: The Science of Attribution*, trans. Michael Joyce (New Haven and London, 1991), pp. 86–93, figs. 95–98, for an attribution to Condivi. The cartoon is usually taken to be one of ten still

in Michelangelo's possession at his death (Perrig, p. 87). Another of these cartoons was the *Christ Taking Leave of his Mother*, now lost, but it is unknown whether Michelangelo made this work or the unfinished cartoon of the *Madonna and Child* (Florence, Casa Buonarroti, *Corpus* 239r) for himself or for another artist's use (as suggested by Hirst, p. 75n10).

177 One of Michelangelo's drawings (London, British Museum, 1859-6-25-553r) shows the two figures with no setting; Wilde, *Michelangelo and his Studio*, p. 93.

178 For this *Venus and Cupid*, formerly in the collection of Duke Alessandro and first documented in the inventory of the Guardaroba of Palazzo Vecchio dated 26 October 1553, see Philippe Costamagna, *Pontormo* (Milan, 1994), pp. 217–21. The painting remained in the Medici collections until 1563, when it was installed in the newly established Accademia del Disegno; Costamagna, p. 218. See also Tolnay, *Michelangelo*, vol. 3, pp. 108–09, 194–96; and for this and other versions of the composition, Angela Negro, *Venere e Amore di Michele di Ridolfo del Ghirlandaio: Il mito di una Venere di Michelangelo fra copie, repliche e pudiche vestizioni* (Rome, 2001).

179 According to Gaetano Milanesi, the bow and arrows evoke the wounds of carnal passion; roses signify the transitory joys that it procures; the mask of a smooth-faced youth refers to the deceptions of carnal pleasures, and the satyr's mask to the base instincts that sensual love arouses. See Milanesi in Vasari-Milanesi 6: 293.

180 These lines of Michelangelo's poem are cited by Milanesi in his commentary on the *Venus* in Vasari-Milanesi 6: 294, without identifying the sonnet; James Saslow very kindly did that for me. See Saslow, *Poetry of Michelangelo*, p. 236, no. 105, beginning "Non vider gli occhi miei cosa mortale," and written for Cavalieri, c. 1535–41.

181 See William Keach, "Cupid Disarmed, or Venus Wounded? An Ovidian Source for Michelangelo and Bronzino," *Journal of the Warburg and Courtauld Institutes* 41 (1978): 327–31, esp. p. 329, citing Ovid, *Metamorphoses* x (Venus' love for Adonis begins with Cupid's accidental wound); followed by Nelson, "Dante Portraits," p. 71, citing Dante's reference to Cupid's wounding Venus in *Purgatory* xxviii.64–66 – a text well known to Michelangelo – and also Bronzino's sonnet "Sopra una pittura di Venere," with similar imagery.

182 See Mendelsohn, *Paragoni*, p. 121.

183 Venus is unveiled in a copy by Giorgio Vasari in Hampton Court, one of "a very large number of copies" of Michelangelo's design, including two or three by Vasari himself. See John Shearman, *The Early Italian Pictures in the Collection of Her Majesty the Queen* (Cambridge, London, and New York, 1983), pp. 277–78, no. 302. Shearman accepts the attribution of the panel in Florence, Accademia, to Pontormo. Dolce's Aretino endorses such "modest" drapery in his description of Raphael's cartoon of *Roxana and Alexander*: "in order to maintain decency a rather soft little piece of drapery conceals those parts of her which should keep themselves hidden" (Roskill, *Dolce's "Aretino,"* pp. 168–69).

184 *Due lezzioni di Benedetto Varchi* (1549; modern 1550), in Barocchi, ed., *Trattati*, vol. 1, p. 48; cited by Nelson, "Dante Portraits," p. 71, and Mendelsohn, *Paragoni*, p. 121.

185 For the painting and Dolce's letter, see Rona Goffen, "Renaissance Dreams," *Renaissance Quarterly* 40 (1987): 292–93; and Goffen, *Titian's Women*, pp. 245–46.

186 The proximate cause was Titian's first, lost portrait of the emperor, completed in 1533; Charles declared him a Count Palatine and knight of the Holy Roman Empire. For the lost portrait, see Wethey, *Titian*, vol. 2, p. 21, and vol. 3, pp. 191–92, no. L3. Titian portrayed himself wearing the chain in his *Self-Portrait* (Berlin, Staatliche Museen); see Luba Freedman, *Titian's Independent Self-Portraits* (Florence, 1990), pp. 73–83.

187 Roskill, *Dolce's "Aretino,"* p. 108; my translation.

188 Leon Battista Alberti, *On Painting and On Sculpture: The Latin Texts of De pictura and De statua*, ed. Cecil Grayson (London, 1972), p. 61 (bk. 2: 25). Vasari, Hollanda, and Varchi, among others, take up the theme of the artist's dignity and the indignity of ignorant viewers; see Giorgio Vasari, *La vita di Michelangelo nelle redazioni del 1550 e del 1568*, ed. Paola Barocchi, 5 vols. (Milan and Naples, 1962), vol. 3, *Commento*, pp. 1104, 1107; for Antonio Mini and the *Leda* in France, ibid., pp. 1105–10, 1112–14.

189 For Dolce's use of *giostrare* to describe Titian's desire to excel, see Ruth Wedgwood Kennedy, "Apelles Redivivus," in *Essays in Memory of Karl Lehmann*, ed. Lucy Freeman Sandler (New York, 1964), p. 163; and p. 228 above for use of the word in relation to Sebastiano's competition with Raphael.

190 On this painting, see Nepi Scirè, "Recent Conservation," in *Titian*, ed. Biadene with Yakush, pp. 120–21, and Fiorella Spadavecchia, "*Saint John the Baptist*," in ibid., pp. 240–42; and Francesco Valcanover's catalog essay in Laclotte and Nepi Scirè, *Siècle de Titien*, p. 527. Michelangelo's style might have seemed particularly appropriate to Titian in the 1530s and 1540s, a period of economic crisis for Venetian commerce, exacerbated by famine in 1539–40; see Madlyn Kahr, "Titian's Old Testament Cycle," *Journal of the Warburg and Courtauld Institutes* 29 (1966): 200. In addition, Venice had been unwillingly at war with the Turks since 1536; the peace treaty of 1540 imposed humiliating conditions and a large indemnity on the Republic.

191 Vasari sent a copy of a Medici effigy to Aretino in summer 1538, for which Aretino thanked him in a letter dated 15 July 1538; Aretino, *Lettere, Libro primo*, ed. Erspamer, pp. 121–25, no. 63. Although Aretino mentioned both effigies, there was in fact only one figure, representing Giuliano; the copy was a clay model (see Erspamer in ibid., p. 121n1 and pp. 123nn4, 7).

192 Tom Nichols, *Tintoretto: Tradition and Identity* (London, 1999), pp. 52–56. See also Creighton Gilbert, "Tintoretto and Michelangelo's 'St Damian'," *Burlington Magazine* 103 (1961): 16–20.

193 Roskill, *Dolce's "Aretino,"* p. 190; my translation. The painting was then in the church of Santa Maria Maggiore in Venice.

194 Vasari-Barocchi 6: 160.

195 At the Scuola Grande di San Giovanni Evangelista, the *Vision of Saint John the Evangelist* was surrounded by four panels of the *Symbols of the Evangelists* and sixteen with cherub heads or masks; these smaller panels are now in the Gallerie dell'Accademia, Venice. The Santo Spirito in Isola ceiling paintings are usually dated 1542–44, but this chronology has been questioned by Joannides, "On Some Borrowings," pp. 33–34, with an incisive analysis of Titian's debts to Michelangelo. Titian's letter (Joannides, p. 33) does not settle the matter, however. Writing to Cardinal Alessandro Farnese on 11 December 1544, Titian referred to "my works" (*mie opere*) for the friars of Santo Spirito, against whom he had brought suit in relation to his high altarpiece of the *Pentecost*. Titian had previously painted the *Saint Mark Enthroned* for them, c. 1511 (now also Venice, Santa Maria della Salute), and the reference may therefore be to that work and to the *Pentecost* altarpiece then being adjudicated. But the phrasing also allows for reference to the ceiling, had it been completed by that date: the evidence is inconclusive.

For the letter, see Titian [Tiziano Vecellio], *Tiziano: Le lettere*, ed. Celso Fabbro (Cadore, 2nd ed. 1989), p. 78, no. 59; and for the lawsuit, Alessandra Sambo, "Tiziano davanti ai giudici ecclesiastici," in *Tiziano e Venezia: Convegno internazionale di studi, Venezia, 1976* (Vicenza, 1980), pp. 383–93. The two witnesses in that case allude to but do not name the "number of works" that Titian has done for their church (I am quoting Dom Donatus, in Sambo, p. 392). The plot thickens: Charles Hope has generously informed me of his discovery of documents relating to another legal action by Titian against Santo Spirito in late 1552, a suit for payment for unspecified work or works, which Hope suggests must be the ceiling. He believes that Titian received the commission for the ceiling after delivering the altarpiece for the church (commissioned in 1529) and that the ceiling was completed in 1552 – but that the brothers balked at payment, refusing to honor the commitment of a previous prior no longer in residence. For these various works, see the following essays in Biadene with Yakush, ed., *Titian: Silvia Gramigna Dian*, "Symbols of the Evangelists," pp. 274–78, no. 42b; Robert Echols, "Ceiling of the Scuola of Saint John the Evangelist," pp. 272–74, no. 42a; and Giovanna Nepi Scirè, "Ceiling of the Church of Santo Spirito in Isola," pp. 255–58. For the *Damned*, see n. 202 below. One could add to this list such works as the *Saint James* (Venice, San Lio), a work of the mid- to late 1540s; and the *Gloria* or *Adoration of the Trinity* (Madrid, Prado), 1551–54, which Charles v took with him to Juste when he abdicated in 1555. For these two works, see Wethey, *Titian*, vol. 1, p. 133, no. 103, and pp. 165–67, no. 149.

196 The description comes from Friedlaender, "Titian and Pordenone," p. 118, in reference to the Santo Spirito ceiling paintings but germane to all these works. For the near-total elimination of facial expression in the Santo Spirito cycle, see also Kahr, "Titian's Old Testament Cycle," p. 201. Both authors note other influences on Titian's Santo Spirito ceiling, including Correggio's vault in San Giovanni Evangelista, Parma. Goliath's pose is derived from the slain Aegisthus on an Orestes sarcophagus, according to Otto J. Brendel, "Borrowings from Ancient Art in Titian," *Art Bulletin* 37 (1955): 113–25, and fig. 11.

197 Greene, *Light in Troy*, pp. 41–42, discussing the relationship of Early Modern poets to their Latin predecessors.

198 As suggested by Hans Tietze and Erica Tietze-Conrat, *The Drawings of the Venetian Painters of the 15th and 16th Centuries*, Foreword by David Rosand, 2 vols. (New York, 1944; rpt. 1970), vol. 1, p. 325, no. 1962. Vasari recorded that he had prepared *disegni* for the three large paintings, at the behest of Jacopo Sansovino, who was directing the work at Santo Spirito; Vasari-Barocchi 6: 163 (Life of Titian). Vasari had gone to Venice at the invitation of his countryman, Aretino, "mio amicissimo," who commissioned him to design the production of a new comedy; ibid. 6: 382 (Life of Vasari); Aretino, *Lettere*, *Libro primo*, ed. Erspamer, p. 423n202, noting Aretino's influence on Vasari's historiography. For their collaboration on *La Talanta*, see Christopher Cairns, *Pietro Aretino and the Republic of Venice: Researches on Aretino and his Circle in Venice 1527–1556* (Florence, 1985), pp. 162–78; and Vasari's letter to Ottaviano de' Medici describing his setting for the production at the Sempiterni in 1542, in Vasari-Milanesi 8: 283–87, XXXI. In addition to commissioning Vasari's sets, Aretino ordered a portrait of his mother in the guise of the Annunciate Virgin; see Goffen, *Titian's Women*, p. 51. Presumably Aretino introduced Vasari to Titian; the biographer wrote that he was happy to go to Venice "because he very much wanted to see the works of Titian," among others; Vasari-Barocchi 6: 382 (Life of Vasari). Titian introduced him in turn to the nobleman Giovanni Corner – evidence of a cordial Venetian welcome. The introduction led to another commission, the ceiling for Palazzo Corner-Spinelli. See also Kahr, "Titian's Old Testament Cycle," pp. 193, 200.

199 Salviati's presence in Venice by 11 July 1539 is documented by Aretino's letter to Leone Leoni describing Salviati as "giovane glorioso"; Aretino, *Lettere*, *Libro secondo*, ed. Erspamer, pp. 248–49. Aretino commissioned a portrait of himself by Salviati as a gift for François I; see Iris H. Cheney, "Francesco Salviati's North Italian Journey," *Art Bulletin* 45 (1963): 338n8. In relation to the theme of the present book, note Salviati's evident fear of competition; see ibid., p. 337; and Cheney, "The Print as a Tool of Artistic Competition: Salviati and Michelangelo," in *Renaissance Papers 1985*, ed. Dale B.J. Randall and Joseph A. Porter (Durham, NC, 1985), pp. 87–95. In this essay, Cheney proposes that Salviati's design of the *Conversion of Saint Paul*, engraved after 1545 by Enea Vico, was "intended [. . .] to be compared to

Michelangelo's version of the subject in the Pauline Chapel" (p. 88). Born Francesco de' Rossi, Salviati trained in Baccio Bandinelli's studio, c. 1524–27, leaving with his fellow pupil Vasari to join the studio of Roberto Marone from 1527 to 1529. In 1531, Salviati was invited to Rome by Cardinal Giovanni Salviati (whose name he adopted). Vasari briefly joined him there in 1532; and the two were together again in Bologna in 1539 and thereafter in Venice. For their relationship, see Nigel Gauk-Roger, "Salviati, Francesco," in *Grove Dictionary of Art* (online). The purpose of Salviati's Venetian sojourn was to work on two ceiling commissions for Palazzo Grimani at Santa Maria Formosa, where much of the family's great collection of antiquities was housed. His patron was Giovanni Grimani (Patriarch of Aquileia from 1546 until his death in 1593). See Michael Hirst, "Three Ceiling Decorations by Francesco Salviati," *Zeitschrift für Kunstgeschichte* 26, Heft 1 (1963): 146–65; Marilyn Perry, "A Renaissance Showplace of Art: The Palazzo Grimani at Santa Maria Formosa, Venice," *Apollo* 113 (April 1981): 217–18; and Vasari-Barocchi 5: 518–19. Work in the Stanza di Apollo was completed on 17 August 1540; see Juergen Schulz, "Vasari at Venice," *Burlington Magazine* 103 (1961): 500.

200 For the problem of the narrative sequence, see Kahr, ibid., pp. 193, 195, agreeing with Hetzer's conclusion that *Isaac* was likely the central composition, "mediating in both colour and composition between the other two"; Theodor Hetzer, *Tizian, Geschichte seiner Farbe* (1935; rpt. Frankfurt, 1969), pp. 137–39.

201 For the Camera Picta (Camera degli Sposi), see Ronald Lightbown, *Mantegna: With a Complete Catalogue of the Paintings, Drawings and Prints* (Berkeley and Los Angeles, 1986), pp. 415–19, cat. 20. For Giulio's ceiling in relation to Titian's, see also Kahr, ibid., pp. 201–02.

202 In 1548 in Augsburg, Queen Mary commissioned a cycle of the *Damned*, consisting of *Tityus*, *Sisyphus*, and *Tantalus* (this last known from an engraving by Sanudo) for her summer residence, the palace of Binche in Flanders. A fourth "Damned," *Ixion*, was sent to Flanders in 1553. Cited by Dolce and Vasari, the paintings were seen at Binche by Calvete de Estrella in August 1549. In 1556, after the sack of the palace, the paintings were taken to Spain and are now in Madrid, Prado. For the *Dammed*, see Goffen, *Titian's Women*, pp. 250–53; Jesus Urrea, "Tityus," in Biadene with Yakush, eds., *Titian*, p. 284,

no. 44; and Wethey, *Titian*, vol. 3, pp. 156–60.

203 For Michelangelo's *Punishment of Tityus* and a copy of his *Rape of Ganymede* (the original is lost) in Windsor Castle, Royal Library, nos. 12771r and 13036 respectively, see Hirst, *Michelangelo and his Drawings*, p. 112; and Perrig, *Michelangelo's Drawings*, pp. 44–45. For Cavalieri's letter dated 1 January 1533, thanking Michelangelo for the gift of the drawings, see Barocchi and Ristori, *Carteggio* 3: 445–46.

204 According to Vasari-Barocchi 6: 381 (Life of Vasari).

205 For Vasari's letter to Leoni, dated Florence 20 July 1541, see Vasari-Milanesi 8: 283, xxix; it closes with greetings to Aretino, Sansovino, and Titian.

206 For Vasari's *Venus and Cupid* in Hampton Court, see Shearman, *Early Italian Pictures*, pp. 277–78, cat. 302.

207 Aretino, *Lettere, Libro secondo*, ed. Erspamer, pp. 12–14, no. 5. The ambassador was Gian Iacopo Leonardi, and the unnamed "youth" is identified as Vasari himself (then thirty-one) by Erspamer in ibid., p. 13n4. Undated, the letter was written after March 1547, according to Erspamer, p. 14n8; after 16 April 1542, according to the editors of Aretino, *Lettere sull'arte*, ed. Pertile and Camesasca, vol. 1, p. 247. Presumably Aretino meant his readers to recognize his unacknowledged reference to Plato's *Symposium* (180d–181e), wherein the two Venuses are distinguished. See Paul F. Watson, "Titian and Michelangelo: The *Danae* of 1545–1546," in *Collaboration in Italian Renaissance Art*, ed. Wendy Stedman Sheard and John T. Paoletti (New Haven, 1978), p. 246; Mary Pardo, "Artifice as Seduction in Titian," in *Sexuality and Gender in Early Modern Europe: Institutions, Texts, Images*, ed. James Grantham Turner (Cambridge and New York, 1993), p. 77; and Goffen, *Titian's Women*, pp. 237–38. On the appropriateness of varying degrees of masculinity and femininity in different nudes (Ganymede as opposed to Samson, for example), see Roskill, *Dolce's "Aretino,"* pp. 140–45.

208 See Aretino, *Lettere, Libro secondo*, ed. Erspamer, pp. 34–37, no. 18; and Barocchi and Ristori, *Carteggio* 4: 181–82, mxxi, and p. 182n2, explaining that Titian hoped for Michelangelo's intercession with the pope regarding an ecclesiastical benefice for the Venetian's son Pomponio, a cleric. Aretino had referred to the emperor's gifts of cups of gold in an earlier letter to the artist, 20

January 1538, asking for "a piece of those cartoons that you usually give to the fire." According to Erspamer in Aretino, ibid., p. 35n3, Aretino's hyberbolic praise of the *Last Judgment* is sarcastic. But such hyperbole, overblown by some standards, was a style shared by such authors as Vasari; see Patricia Rubin, "Raphael and the Rhetoric of Art," in *Renaissance Rhetoric*, ed. Peter Mack (London, 1994), pp. 165–82. When Aretino said that the *Last Judgment* made him cry, he must have been referring to copies of that work because he never saw the original.

209 Barocchi and Ristori, *Carteggio* 4: 87, CMLV. As the editors explain, the original is lost and the letter is known from its first publication in Aretino's *Primo libro de le lettere* (Venice, 1542), p. 512.

210 Aretino wrote to Michelangelo in November 1545 and published the letter, now addressed to Alessandro Corvino, with the date July 1547. See Aretino, *Lettere sull'arte*, ed. Pertile and Camesasca, vol. 2, pp. 175–77, CCCLXIV; Gaye, *Carteggio inedito*, vol. 2, p. 332; and Barocchi and Ristori, *Carteggio* 4: 215–17, MXLV. The letter is translated in Anthony Hughes, *Michelangelo* (London, 1997), pp. 250–51. For an analysis of Aretino's letters to Michelangelo, see Fidenzio Pertile, "Michelangiolo Buonarroti," in Aretino, ibid., vol. 3, pt. 2: pp. 378–86, esp. pp. 380ff.; and Bernadine Barnes, "Aretino, the Public, and the Censorship of Michelangelo's *Last Judgment*," in *Suspended License: Censorship and the Visual Arts*, ed. Elizabeth C. Childs (Seattle and London, 1997), pp. 59–84. Aretino's progression from veneration to condemnation was not consistent. For an earlier letter criticizing Michelangelo, 16 December 1537, addressed to Fausto Longiano, see Aretino, *Lettere*, ed. Erspamer, vol. 1, pp. 618–22, no. 300.

211 See Goffen, *Titian's Women*, pp. 215–25, 231–33. The story had been rarely represented before Titian, but it had been the subject of a play entitled *Danae* by Baldassare Taccone, staged by Leonardo da Vinci for the Sforza court, with an all-male cast. See Dalli Regoli, *Mito e scienza nella "Leda,"* p. 22 and n. 63.

212 Pigman, "Versions of Imitation," p. 26, referring to literary borrowings but equally relevant here.

213 At this time, Titian also produced individual portraits of the pope, of Cardinal Alessandro, and of the cardinal's son Pierluigi; he had previously (1542) painted

the pope's grandson Ranuccio. For Titian's portraits of the Farnese, see the following entries in Biadene with Yakush, ed., *Titian*: David Alan Brown, "Portrait of Ranuccio Farnese," p. 244; Paola Rossi, "Portrait of Pope Paul III," p. 246, and her "Portrait of Cardinal Alessandro Farnese," p. 270. See also Francesco Valcanover, "Tiziano Vecellio, dit Titien, *Portrait du pape Paul III Farnese*," in Laclotte and Nepi Scirè, *Siècle de Titien*, pp. 528–29; and Wethey, *Titian*, vol. 2, pp. 97–99, 122–26. The Municipio di Roma acknowledged Titian's success by granting him citizenship on 19 March 1546, shortly before his departure. Stopping in Florence *en route* back to Venice, Titian offered his services to Cosimo de' Medici, but the duke was unresponsive. On the artist's rivalry with Michelangelo in relation to patronage and gendered elements of style, see also Fredricka H. Jacobs, "Aretino and Michelangelo, Dolce and Titian: *Femmina, Masculo, Grazia*," *Art Bulletin* 82 (2000): 51–67.

214 The speaker is Aretino. I have slightly modified the translation in Roskill, *Dolce's "Aretino,"* pp. 110–11. For the prelate, see Clare Robertson, *"Il Gran Cardinale": Alessandro Farnese, Patron of the Arts* (New Haven and London, 1992).

215 Vasari-Barocchi 6: 164 (Life of Titian). For Florentine notions of *disegno*, see also Wolfgang Kemp, "Disegno: Beiträge zur Geschichte des Begrifs zwischen 1547 und 1607," *Marburger Jahrbuch für Kunstwissenschaft* 19 (1974): 219–40, and Fredrika H. Jacobs, "An Assessment of Contour Line: Vasari, Cellini and the *Paragone*," *Artibus et historiae* 9, 18 (1988): 139–50, explaining that not all Florentines defined line in quite the same way. For Venetian points of view, see Thomas Puttfarken, "The Dispute about *Disegno* and *Colorito* in Venice: Paolo Pino, Lodovico Dolce and Titian," *Kunst und Kunsttheorie 1400–1900* (*Wolfenbütteler Forschungen*, 48) (1991): 75–99; see also n. 164 above.

216 Vasari-Barocchi 6: 157. If Sebastiano actually said something of the sort, he might have been thinking of himself: after all, he had had precisely the advantages that he saw as lacking in Titian's early experience.

8 Bandinelli and Cellini

1 Vasari-Barocchi 6: 120.

2 Benedetto Varchi, *L'Ercolano, ovvero gli Alberi* (Venice, 1570), quoted in Eugenio

Battisti, "La critica a Michelangelo primo del
Vasari," *Rinascimento* 5 (1954): 124.

3 Benvenuto Cellini, *The Autobiography
of Benvenuto Cellini*, trans. George Bull
(London, rev. ed. 1998), pp. 317, 330, 338,
345, 367. In addition to this desire to kill,
Cellini described actual murders and
numerous other crimes, some real and others
imaginary (or desired?), judging from court
records; see Paolo L. Rossi, "The Writer and
the Man: Real Crimes and Mitigating
Circumstances. *Il caso Cellini*," in *Crime,
Society and the Law in Renaissance Italy*, ed.
Trevor Dean and K. J. P. Lowe (Cambridge
and New York, 1994), pp. 157–83. The
Autobiography cannot be taken as literal
reportage but as "a literary venture" (Rossi,
p. 158). Dictated in the 1550s, it is to be read
as an "*apologia*" for his art, as noted by
Michael Wayne Cole, "Benvenuto Cellini and
the Act of Sculpture," Ph.D. dissertation
(Princeton University, 1999), pp. 2–3. Cole,
pp. 3–4 and n. 10, lists among Cellini's other
writings – dating from the 1550s and
later – "two treatises on goldsmithing and
sculpture, a *paragone* exercise, a work of
architectural theory, an essay on pedagogy,
over 120 poems, and volumes of letters and
ricordi." On the rivalry between Cellini and
Bandinelli and their relationships with Duke
Cosimo, see Francesco Vossilla, "Baccio
Bandinelli e Benvenuto Cellini tra il 1540 e il
1560: Disputa su Firenze e su Roma," *Mit-
teilungen des Kunsthistorischen Institutes in
Florenz* 41, Heft 3 (1997): 254–313. See also
Donald Weinstein, "Benvenuto Cellini:
Inediti," *Rivista d'arte*, 4th ser., 6 (1990):
213–25, for six *suppliche* addressed by
Cellini to Cosimo and two letters from the
duke in response, all dating from 1546 to
1552; and p. 380 above.

4 See Louis Alexander Waldman, "Bandinelli
and the Opera di Santa Maria del Fiore:
Patronage, Privilege, and Pedagogy," in *Santa
Maria del Fiore: The Cathedral and its Sculp-
ture: Acts of the International Symposium
for the VII Centenary of the cathedral of Flo-
rence*, ed. Margaret Haines (Fiesole, 2001),
p. 232.

5 Born 12 November 1493 and baptized
Bartolomeo, he was known by his nickname,
Baccio (d. 7 February 1560). See James
Holderbaum, "The Birth Date and a
Destroyed Early Work of Baccio Bandinelli,"
in *Essays in the History of Art Presented
to Rudolf Wittkower*, ed. Douglas Fraser,
Howard Hibbard, and Milton J. Lewine
(London, 1967), pp. 93–97, esp. p. 94, for
the sculptor's birth record. See also Detlef

Heikamp, "In margine alla 'Vita di Baccio
Bandinelli' del Vasari," *Paragone*, n.s. 2, 191
(1966): 61n1 and *passim*; and cf. Charles
Avery, "Bandinelli, Baccio," *Grove Dictio-
nary of Art* (online), giving the birth date as
17 October 1488. For a survey of Baccio's
life and career, see Joachim Poeschke,
*Michelangelo and his World: Sculpture of the
Italian Renaissance*, trans. Russell Stockman
(New York, 1996), pp. 166–78. His father's
name meant that he was identified as "Baccio
di Michelangelo." On the name's significance
for Baccio's sense of himself in relation to
Michelangelo Buonarroti, see Kathleen Weil-
Garris, "Bandinelli and Michelangelo: A
Problem of Artistic Identity," in *Art the Ape
of Nature: Studies in Honor of H. W. Janson*,
ed. Moshe Barasch, Lucy Freeman Sandler,
and Patricia Egan (New York and Englewood
Cliffs, 1981), p. 230.

6 Without naming Bandinelli, Benedetto
Varchi summarizes Michelangelo's view of
him in the *Orazione funerale di M. Benedetto
Varchi fatta, e recitata da lui pubblicamente
nell'essequie di Michelagnolo Buonarroti
in Firenze, nella chiesa di San Lorenzo*
(Florence, 1564), p. 39: "a sculptor having
portrayed the Belvedere *Laocoön*, and boast-
ing that he had made his much more beauti-
ful than the ancient one, [and Michelangelo
was] asked whether this was true; he
answered that he did not know but that
whoever was following behind someone
could never pass ahead of him (*chi andava
dietro da Alcuno, mai passare innanzi non gli
poteva*)." Snide references to Baccio in letters
to Michelangelo may also be taken to reflect
his view of the younger man. Vasari's
libels against Baccio are enumerated in
Arduino Colasanti, "Il memoriale di
Baccio Bandinelli," *Repertorium für
Kunstwissenschaft* 28 (1905): 411–12. The
authenticity of the *Memoriale* is questioned
by Louis Alexander Waldman, however.
Considering historical inconsistencies, hand-
writing and usage in the unique manuscript
of the *Memoriale* among the *Carte Bandinelli*
in the Biblioteca Nazionale of Florence,
Waldman argues convincingly that the man-
uscript is the work of Baccio's grandson,
Baccio Bandinelli il Giovane. No *Urtext*
which the younger Baccio might have used is
known, and Waldman doubts that such an
original ever existed. Professor Waldman
most generously shared with me the text
of an unpublished lecture presented at the
Kunsthistorisches Institut in Florence in 1998
and other information, for which I am very
grateful. See Waldman, "Bandinelli and the

Opera di Santa Maria del Fiore," n. 4; and his *Rewriting the Past: The Memoriale Attributed to Baccio Bandinelli and the Documentary Pastiches of Baccio Bandinelli il Giovane*, forthcoming. Whoever wrote the *Memoriale*, I cite the text here as a reflection of Baccio's views, or at least views that might reasonably be attributed to him. Surely the work is accurate in recording the enmity with Vasari. Vasari's odium for Bandinelli transcended politics, in that both men were Medici dependents. For the historiography of Baccio's bad press, see Virginia L. Bush, "Bandinelli's *Hercules and Cacus* and Florentine Traditions," in *Studies in Italian Art and Architecture 15th through 18th Centuries*, ed. Henry A. Millon (Cambridge and Rome, 1980), pp. 164–65; and Holderbaum, "The Birth Date and a Destroyed Early Work of Baccio Bandinelli," p. 96.

7 Cellini, *Autobiography*, p. 1.

8 Ibid., pp. 317, 338. Cellini's reference to four Philistines is an exaggeration; see p. 361 above.

9 Vasari-Barocchi 5: 241.

10 For the letter from Venice, dated October 1545, see Pietro Aretino, *Lettere sull'arte di Pietro Aretino*, ed. Fidenzio Pertile and Ettore Camesasca, 3 vols. (Milan, 1957), vol. 2, p. 103, CCLXI. Because they had been friends in Rome, Aretino wrote, the least Baccio could do would be to send him four or five sketches; but it is his nature to be ungrateful.

11 Colasanti, "Memoriale di Baccio," p. 434 (the context is criticism of Baccio's work). Michelangelo is mentioned admiringly also on pp. 412, 425, 432, and 433. Michelangelo favored Baccio over Sansovino for the San Lorenzo façade project; see p. 445n173 above.

12 For Baccio's snowman, see Vasari-Barocchi 5: 240.

13 Ibid. For Baccio's procedures in making drawings, including his use of models in the poses of famous monuments – "art becomes real life and real life becomes art" – see Leonard Barkan, *Unearthing the Past: Archaeology and Aesthetics in the Making of Renaissance Culture* (New Haven and London, 1999), pp. 304–30, esp. p. 316 for the use of models, and pp. 319–30 for "The Rhetoric of Draughtsmanship"; see also pp. 271–89 for the interrelationships of Bandinelli ("Michelangelo's evil twin," p. 271), Cellini, and Vasari.

14 Vasari-Barocchi 5: 240 (Life of Bandinelli) and pp. 476–78 (Life of Giovan Francesco Rustici). In 1502 the Arte de' Mercanti had decided to replace the sculpture groups above the Baptistery doors. Andrea Sansovino was commissioned to do the marble statues of *Saint John Baptizing Christ* to be placed over the east door; the group was abandoned when he moved to Rome in 1505. In the winter of 1506–07 Rustici was given the commission for his three-figure bronze group to be placed over the north door. This was considered a most important commission because the Baptistery itself was "such a celebrated place and of such importance, and besides this, because of the competition of Andrea Contucci," that is, Andrea Sansovino (ibid. 5: 477). In the Life of Leonardo (ibid. 4: 37), Vasari reiterated the fact of Leonardo's advising Rustici. The last Baptistery group, the *Beheading of Saint John the Baptist* for the south door, was assigned to Vincenzo Danti in 1560. For the various groups, see John Pope-Hennessy, *Italian High Renaissance and Baroque Sculpture*, Part 3 of An Introduction to Italian Sculpture, 3 vols. (London, 1963), vol. 1, pp. 39–43.

15 Vasari-Barocchi 5: 477.

16 Pope-Hennessy, *Italian High Renaissance and Baroque Sculpture*, vol. 1, p. 40. See also Holderbaum, "Bandinelli," p. 93.

17 Vasari-Barocchi 5: 240. Vasari added that Baccio's *Head of a Woman* had been given by his father to Andrea Carnesecchi, who installed it over the garden doorway of his house in Via Larga.

18 Bush, "Bandinelli's *Hercules*," pp. 168–69, suggests that the statue was to represent *Hercules and Cacus*, which she and others identify as the subject of Michelangelo's pen sketch in Florence, Casa Buonarroti. Cf. Charles de Tolnay, *Michelangelo*, 5 vols. (Princeton, 1943–60), vol. 3: *The Medici Chapel*, pp. 101, 184, who suggests that Michelangelo was already thinking of a *Hercules and Antaeus*, his subject in 1525. For convincing confirmation of this, see now Paul Joannides, in *Master Drawings* (forthcoming), which was generously made available to me before publication. Joannides attributes a drawing of *Hercules and Antaeus* (Washington, National Gallery of Art), to Michelangelo c. 1505. For this and other reasons, Joannides concludes that *Hercules and Antaeus* was Michelangelo's subject in 1505 as it was in 1525; see p. 356 above.

19 See p. 119 above. For Florentine sculptures of Hercules, see Charles Seymour, Jr., *Michelangelo's David: A Search for Identity* (Pittsburgh, 1967), pp. 30–31, 37.

20 Vasari-Barocchi 5: 241.

21 Ibid. According to Vasari, others suggested that Baccio did it to have pieces of the cartoon for himself or perhaps to deprive other young masters of its lessons. Baccio's interest in the cartoon may have been heightened by plans – later abandoned – for a fresco in the *chiostrino* in the church of Santissima Annunziata for which he received payment on 1 March 1511 (modern 1512); John Shearman, "Rosso, Pontormo, Bandinelli, and Others at SS. Annunziata," *Burlington Magazine* 102 (1960): 155.

22 Vasari-Barocchi 5: 241. The *Leda* in Paris, Sorbonne, Collection du Rectorat, has been identified as Baccio's painting; Sylvie Béguin, "A propos du chef-d'oeuvre de Bronzino: La Déploration sur le Christ mort," in *Les Granvelle et l'Italie au XVIe siècle: Le mécénat d'une famille: Actes du Colloque international*, ed. Jacqueline Brunet and Gennaro Toscano (Besançon, 1996), p. 134.

23 Vasari-Barocchi 5: 242, 243.

24 Ibid., p. 243. Giuliano was appointed ruler of Florence in September 1512, succeeded in 1516 by his nephew, Lorenzo, Duke of Urbino, who died in 1519. Giovanni was elected pope 11 March 1513, taking the name Leo X. The *Saint Jerome* is lost.

25 Giovanni Poggi, ed., *Il Duomo di Firenze: Documenti sulla decorazione della chiesa e del campanile tratti dall'Archivio dell'Opera [1909]*, ed. Margaret Haines, 2 vols. (Florence, rpt. 1988), vol. 2, p. 150, parti X–XVII, no. 2172. See also ibid., pp. 151–52, nos. 2178–79. Completed in 1517, Baccio's *Saint Peter* was installed in the cathedral only in 1565. It echoes Michelangelo's *Saint Matthew* and also incorporates motifs from Donatello's *Saint Matthew* and campanile *Prophets*, as noted by Weil-Garris, "Bandinelli and Michelangelo," p. 230.

26 Vasari-Barocchi 6: 180 (Life of Jacopo Sansovino): "a concorrenzia." Vasari seems to have preferred Sansovino's *Apostle*, which he praised very warmly, pp. 179–80. The competitive element was implicitly recognized by Ammannati when he later opined that only Sansovino's *Saint James* and Bandinelli's *Saint Peter* were worthy of the cathedral; Bronzino shared this view. See Ammannati's letter, 8 October 1563, in Giovanni Gaye, *Carteggio inedito d'artisti dei secoli XIV.XV.XVI*, 3 vols. (Florence, 1840; rpt. Turin, 1968), vol. 3, pp. 118–20.

27 Vasari-Barocchi 6: 180 (Life of Jacopo Sansovino).

28 The lost *Hercules* was big but it was also a private commission. Moreover, between 1494, when Piero de' Medici fled Florence,

leaving his *Hercules* behind, and 1506, when it was installed in the Strozzi palace, the statue was presumably concealed from public view precisely because of its Medici associations. See p. 88 above.

29 For evocations of Rome in the decorations, see John Shearman, "The Florentine *Entrata* of Leo X, 1515," *Journal of the Warburg and Courtauld Institutes* 38 (1975): 136–54. Soderini's oration condemned the monarchic ambitions of the Medici, an attack related to contemporary debates about proper modern language, one side asserting the superiority of Dante's austerity and the other preferring the richer language of Petrarch and Boccaccio. See Francesco Vossilla, "Il colosso di Baccio," in Carlo Francini and Francesco Vossilla, *L'Ercole e Caco di Baccio Bandinelli* (Florence, 1999), p. 18.

30 Luca Landucci, *A Florentine Diary from 1450 to 1516 by Luca Landucci Continued by an Anonymous Writer till 1542 with Notes by Iodoco del Badia*, trans. Alice de Rosen Jervis (London and New York, 1927), p. 285, and pp. 279–85 for a description of the *Entrata* decorations.

31 Vasari-Barocchi 5: 243–44. For Baccio's life-long obsession with Michelangelo and with the *David*, see also Anna Forlani Tempesti, "Il Davide di Michelangelo nella tradizione grafica bandinelliana," *Antichità viva* 28, 2–3 (1989): 19, 20, and *passim*.

32 For David, Hercules, and the Medici, see Dale Kent, *Cosimo de' Medici and the Florentine Renaissance* (New Haven and London, 2000), pp. 281–87; and Nicolai Rubinstein, *The Palazzo Vecchio 1298–1532: Government, Architecture, and Imagery in the Civic Palace of the Florentine Republic* (Oxford, 1995), pp. 54–56. For the stucco *Hercules* and the hero's association with Florence, see Ilaria Ciseri, *L'ingresso trionfale di Leone X in Firenze nel 1515* (Florence, 1990), pp. 86–91.

33 It was 9.5 *braccia* according to Vasari-Barocchi 5: 243. See also Holderbaum, "Bandinelli," pp. 94–95 and n. 4: *David* is 4.10 meters high, *Hercules* approximately 5.21 meters.

34 For the trustworthiness of Vasari's visual evidence, see Holderbaum, ibid., p. 95.

35 Ibid., pp. 95, 96.

36 Ibid., p. 96, followed by Weil-Garris, "Bandinelli and Michelangelo," p. 231.

37 Bush, "Bandinelli's *Hercules*," p. 173.

38 Heemskerck lived in Rome from 1532 to 1536. As Virginia Bush has suggested, ibid., p. 174, Bandinelli's giant seems to be his

39 See also Weil-Garris, "Bandinelli and Michelangelo," p. 233.

response to the first version of Michelangelo's *Christ*, abandoned in 1516.

40 For the lost model of *David Severing the Head of Goliath*, see Karla Langedijk, "Baccio Bandinelli's Orpheus: A Political Message," *Mitteilungen des Kunsthistorischen Institutes in Florenz* 20, Heft 1 (1976): 33; for Baccio's presenting the model to the pope in Rome, see Vasari-Barocchi 5: 244.

41 Langedijk, "Bandinelli's Orpheus," pp. 43–46.

42 Ibid., p. 48, referring to Bronzino's portrait in Philadelphia Museum of Art, Johnson Collection, early 1540s. For Bronzino's use of a design by Baccio for two versions of the *Lamentation*, see Janet Cox-Rearick, "From Bandinelli to Bronzino: The Genesis of the *Lamentation* for the Chapel of Eleonora di Toledo," *Mitteilungen des Kunsthistorischen Institutes in Florenz* 33, Heft 1 (1989): 40, 70, 73–74; and Cox-Rearick, *Bronzino's Chapel of Eleonora in the Palazzo Vecchio* (Berkeley and Los Angeles, 1993), pp. 155–59.

43 The identification of the joints and praise for the statue are recorded in a letter by Cesare Trivulzio, written in June 1506; see Margarete Bieber, *Laocoön: The Influence of the Group since its Rediscovery* (Detroit, 1967), p. 12 (a translation of the letter); and Barkan, *Unearthing the Past*, pp. 2–17.

44 For Trivulzio's letter of June 1506, recording the judgment of Michelangelo and Giovanni Cristofano Romano, and for Sadoleto's poem, trans. H.S. Wilkinson, see Bieber, *Laocoön*, pp. 12–15. The lines quoted here are lines 5 and 6 of the poem.

45 Barocchi and Ristori, *Carteggio* 2: 214, CDLIV. The contemporary *Orpheus* (Florence, Palazzo Medici) "eulogizes" another classical icon, the *Apollo Belvedere*, as noted by Holderbaum, "Bandinelli," p. 97.

46 Vasari-Barocchi 5: 246; and Phyllis Pray Bober and Ruth Rubinstein, with Susan Woodford, *Renaissance Artists and Antique Sculpture: A Handbook of Sources* (London, 1986), p. 154. The wax replacement was lost when *Laocoön* was restored by Giovanni Montorsoli, whose restoration was replaced in turn when Laocoön's real arm was recovered in 1905. For this extraordinary discovery, see Ludovico Rebaudo, "I restauri del *Laocoonte*," in Salvatore Settis, *Laocoonte: Fama e stile* (Rome, 1999), pp. 256–58.

47 For the contest staged by Bramante, see Vasari-Barocchi 6: 178 (Life of Jacopo Sansovino), and for the presence of the competitors in Rome in winter 1507–08, see Mary Garrard, "The Early Sculpture of Jacopo Sansovino: Florence and Rome," Ph.D. dissertation (Johns Hopkins University, 1970), pp. 99–100. For Grimani's bronze, see Marilyn Perry, "Cardinal Domenico Grimani's Legacy of Ancient Art to Venice," *Journal of the Warburg and Courtauld Institutes* 41 (1978): 221–22, 242; and Bruce Boucher, *The Sculpture of Jacopo Sansovino*, 2 vols. (New Haven and London, 1991), vol. 1, pp. 9, 361 no. 83. Grimani was Sansovino's first Venetian "connection," and may have influenced the sculptor's decision to move to Venice after the Sack of Rome (Boucher, p. 9). For various Renaissance copies of *Laocoön*, see Bober and Rubinstein, *Renaissance Artists*, pp. 151–55.

48 Boucher, *Sansovino*, vol. 1, p. 9; vol. 2, pp. 314–15, 361–62, cat. 4, 84–85. Duke Cosimo's statuette is likely one of the three versions now in Florence, Bargello, representing the *Laocoön* before Montorsoli's restorations.

49 For Aretino's commission, see Boucher, ibid., vol. 2, pp. 35, 183, docs. 54–56, p. 361, cat. 84. Aretino's letter to Gonzaga (quoted by Boucher) gives the size as "perhaps one *braccio*," that is, about 58 cm., twice the size of the earlier bronzes. For the stucco in Francesco Sansovino's possession, see Boucher, pp. 361–62, cat. 85; and Vasari-Milanesi 7: 507. Both stuccoes are lost.

50 Vasari-Barocchi 5: 246. Vasari reported that Baccio's experience in restoring the *Laocoön*'s missing right arm with a replacement in wax, also at Giulio's behest, prepared the sculptor to undertake his copy of the whole. Work was suspended after Pope Leo's death in 1521, when Baccio accompanied Cardinal Giulio back to Florence during the reign of Hadrian VI (1522–23), and resumed when Giulio succeeded as Clement VII in 1523. Baccio's mention of his *Laocoön* is in Colasanti, "Memoriale di Baccio," p. 422, Memoria VII.

51 Barocchi and Ristori, *Carteggio* 2: 233, CDLXVII. The first part of the letter is discussed above, p. 256. In Venetian fashion, Sebastiano dropped a "c" from Baccio's name, which exacerbates the confusion with the word *bacio*, kiss. (Venetian dialect often drops one letter from doubles and sometimes compensates by doubling letters where Tuscan finds no need for repetition.)

52 Vasari-Barocchi 5: 246.

53 Barocchi and Ristori, *Carteggio* 2: 336, DCLV. Sellaio included an update on Sebastiano's *Raising of Lazarus*: "Sebastiano has almost finished – wonderful thing." Cavalcanti had commissioned Baccio's model at the behest of the papal datary, Baldassare Turini da Pescia, who in turn was acting on the instructions of Pope Leo. The funerary monument was to be the pontiff's gift to Henry VIII, at that time still a staunch ally of the church. See Margaret Mitchell, "Works of Art from Rome for Henry VIII: A Study of Anglo-Papal Relations as Reflected in Papal Gifts to the English King," *Journal of the Warburg and Courtauld Institutes* 34 (1971): 186–87, kindly brought to my attention by Paul Joannides.

54 Colasanti, "Memoriale di Baccio," pp. 433–34. The engraving of Baccio's design for the *Massacre of the Innocents*, 1525, enjoyed success throughout Europe. Both the *Massacre* and the *Martyrdom of Saint Lawrence* were also reproduced in maiolica, likewise enhancing Baccio's fame. See Vossilla, "Il colosso di Baccio," in Francini and Vossilla, *L'Ercole e Caco*, p. 19.

55 Vasari-Barocchi 5: 247.

56 Ibid., adding "that it is still found there today." The work is lost.

57 Gaye, *Carteggio inedito* 2: 464–65.

58 Colasanti, "Memoriale di Baccio," p. 429. The following discussion is derived from Weil-Garris, "Bandinelli and Michelangelo," p. 235.

59 Baccio's system of "mass production" failed near the end of his career, costing him such major commissions as the sculptural decoration of the Udienza in Palazzo Vecchio, which Cosimo then assigned to other masters. Whereas the duke withdrew support, however, Duchess Eleonora remained an enthusiastic patron, preferring Baccio to Cellini (who complained about this fact in his *Autobiography*).

60 See Weil-Garris, "Bandinelli and Michelangelo," p. 245nn27, 28.

61 Ibid., p. 246n33.

62 William E. Wallace, *Michelangelo at San Lorenzo: The Genius as Entrepreneur* (Cambridge and New York, 1994), ch. 2, on the Medici Chapel, and pp. 122–34, "Assigning Tasks."

63 Thus Vasari defended Michelangelo's solitude in the edition of 1568; Vasari-Barocchi 6: 109.

64 Ibid., p. 101. Leoni had made a portrait medal of him which "much pleased Michelangelo." Michelangelo's conception of *Hercules and Antaeus* is known from drawings, c. 1525–28, in London, British Museum (33r), and Oxford, Ashmolean Museum (BB 1712v; Parker 317r); see Johannes Wilde, *Michelangelo and his Studio: Italian Drawings in the Department of Prints and Drawings in the British Museum* (London, 1953; rpt. 1975), pp. 66–67; and W. E. Wallace, "Instruction and Originality in Michelangelo's Drawings," in *The Craft of Art: Originality and Industry in the Italian Renaissance and Baroque Workshop*, ed. Andrew Ladis and Carolyn Wood (Athens, GA, and London, 1995), p. 115. Paul Joannides now calls attention to two unpublished drawings of the same subject, arguing that this was Michelangelo's theme not only in 1524–25 but likely what he had in mind already in 1504, as Tolnay and now Joannides have argued (see n. 18 above).

65 Vasari-Barocchi 6: 62, "gara e concorrenza." Vasari mistakenly thought that the block had only recently been quarried; ibid. 5: 247 (Life of Bandinelli). See also Gaye, *Carteggio inedito*, vol. 2, pp. 2: 465–66, for a notation dated 20 July 1525 in Riccardiana 1854 (by the chronicler Giovanni Cambi). Reporting the transportation of the colossal block from Carrara to Florence, Cambi wrote that "the people desired that it be worked by" Michelangelo, and referred specifically to Hercules and Anteaus. "But because he was working on the Medici tombs, commissioned by Clement VII, the said pope planned that it [the colossus] be made by another Florentine sculptor, so that his tombs not remain unfinished." For Cambi's evidence, see also Martin Weinberger, *Michelangelo the Sculptor*, 2 vols. (London and New York, 1967), vol. 1, pp. 240–41.

66 Vasari-Barocchi 5: 248. According to Vasari, Buoninsegni's advice was motivated by hatred for Michelangelo after the artist refused to collude with him in defrauding the pope in relation to expenses for the San Lorenzo façade (an accusation confirmed by the *Carteggio*). Later, Buoninsegni conspired to delay the delivery of the marbles for the Medici Chapel, "to make you angry"; see the letter of Giovan Francesco Fattucci in Rome, 28 January 1525, to Michelangelo in Florence; Barocchi and Ristori, *Carteggio* 3: 130, DCLXXXVI.

67 Vasari-Barocchi 5: 249.

68 Ibid. 6: 62 (Life of Michelangelo) and 5: 248 (Life of Bandinelli), adding that Domenico Buoninsegni helped by "saying that Michelangelo wanted everything for himself." Once Michelangelo's friend, Buoninsegni was now his nemesis; ibid. 5: 247–48.

69 Vasari-Barocchi 5: 248 (Life of Bandinelli).

70 Barocchi and Ristori, *Carteggio* 3: 183, DCCXXVI; trans. in E.H. Ramsden, ed., *The Letters of Michelangelo*, 2 vols. (Stanford, 1963), vol. 1, pp. 163–64, no. 175. See also the letter dated 10 November and an undated letter of fall 1525, referring to efforts by Michelangelo's friends to gain him the commission and to his distress about losing it to Bandinelli; Barocchi and Ristori, *Carteggio* 3: 183–84, DCCXXVI.

71 Ibid. 3: 170, DCCXVII.

72 Ibid. Clement was referring to Lorenzo's prized collection of ancient vases; and he further explained that he wanted the relics to be displayed to the people. Fattucci added that the pope had commissioned him to "search for four porphyry columns" and that he had expressed interest in two beautiful columns of Asian granite.

73 Ibid., p. 171. Fattucci understood that the new giant was supposed to be a consolation prize or distraction. Vasari also referred to Bandinelli's models; Vasari-Barocchi 5: 248.

74 Barocchi and Ristori, *Carteggio* 3: 173–74, DCCXIX. At the end of the letter (p. 174) is a notation saying that this is a copy of Michelangelo's letter to Pope Clement made by Antonio Mini.

75 Ibid., p. 178, DCCXXII.

76 I have very slightly modified the translation of Ramsden, ed., *Letters*, vol. 1, pp. 164–65. For the Italian text, see Barocchi and Ristori, *Carteggio* 3: 188–91, DCCXXXIX–DCCXXX; the first is an incomplete autograph copy of the second, likewise autograph (ibid., p. 188).

77 Vasari-Barocchi 5: 247. Political savvy precluded his giving any credit to Soderini. For Vasari's use of "insegna" to describe *David* in the Life of Michelangelo, see chapter 4, n. 210 above.

78 For the argument that Clement was more interested in a beautiful depiction of *any* labor of Hercules, and Baccio in a chance to demonstrate his ability to represent dramatically intertwined bodies, see Vossilla, "Il colosso di Baccio," in Francini and Vossilla, *L'Ercole e Caco*, p. 22.

79 Weil-Garris, "Bandinelli and Michelangelo," pp. 230, 233; and n. 54 above.

80 For Baccio's use of small models in wax or in terracotta, see Vossilla, "Colosso di Baccio," in Francini and Vossilla, *L'Ercole e Caco*, pp. 22, 24.

81 Pope-Hennessy, *Italian High Renaissance and Baroque Sculpture: Catalogue*, p. 63.

82 The statue was restored in 1994; see Carlo Francini, "Restauro dell'Ercole e Caco in Piazza della Signoria," *Quaderni di restauro dell'Ufficio Belle Arti* 1 (1996): 33–37; and Francini, "L'Ercole e Caco dopo il restauro," in Francini and Vossilla, *L'Ercole e Caco*, pp. 57–62.

83 Baccio typically combined pieces when a single block precluded his following a particular model; see Francini, ibid., p. 58. On the ideal and the practice of one stone, see the references cited in n. 123 below. On the Renaissance monolith in competition with antiquity, see also Settis, *Laocoonte*, p. 49, noting that Giambologna's *Rape of the Sabines* is a monolith – and not coincidentally installed in the Loggia dei Lanzi.

84 Vasari-Barocchi 5: 263. For Baccio's practice in contradistinction to Michelangelo's, see Detlef Heikamp, "Baccio Bandinelli nel Duomo di Firenze," *Paragone*, N.S. 15, 175 (1964): 36. One of the separate pieces is the club, replaced in modern times with one made of aluminum. See Francini, "L'Ercole e Caco dopo il restauro," in Francini and Vossilla, *L'Ercole e Caco*, pp. 58–59, suggesting that the original club was made of bronze and likely gilded.

85 For the Medici alliance with France and political implications for Baccio's commission, see Vossilla, "Il colosso di Baccio," in Francini and Vossilla, ibid., pp. 10–11; and for the Sack and its consequences, the classic study by André Chastel, *The Sack of Rome, 1527* (Princeton, 1983).

86 Gaye, *Carteggio inedito*, vol. 2, p. 98; and Jeannine Alexandra O'Grody, "'*Un semplice modello*': Michelangelo and his Three-Dimensional Preparatory Works," Ph.D. dissertation (Case Western Reserve University, 1999), pp. 255–56.

87 Vasari-Barocchi 6: 62–63. Several bronze statuettes have been identified as records of Michelangelo's designs for the biblical hero with two Philistines; see Charles Avery, "After Michelangelo, *Samson Slaying Two Philistines*," in Pietro C. Marani, ed., *The Genius of the Sculptor in Michelangelo's Work*, exh. cat., 4/31 (Montreal, 1992), p. 264; Douglas Lewis, "Genius Disseminated: The Influence of Michelangelo's Works on Contemporary Sculpture," in ibid., pp. 181–82; Paul Joannides, "Michelangelo *bronzista*: Reflections on his Mettle," *Apollo* 145, N.S. 424 (June 1997): 14; and Eike D. Schmidt, "Die Überlieferung von Michelangelos verlorenem Samson-Modell," *Mitteilungen des Kunsthistorischen Institutes in Florenz* 40, Heft 1–2 (1996): 78–147, discussing copies of Michelangelo's lost model of *Samson and Two Philistines*.

88 In the absence of weapons – the terracotta model is missing all the hands and parts of arms – it is impossible to name the combatants. For the model, identified as either *Samson and the Philistine* or as *Hercules and Cacus* and generally dated mid- to late 1520s, see Lewis, "Genius Disseminated," in Marani, ed., *Genius of the Sculptor*, pp. 180–81 (Hercules); Poeschke, *Michelangelo*, pp. 114–16 (Samson); O'Grody, "'Un semplice modello'," pp. 250–61 (Hercules); and Pina Ragionieri, "Due lottatori," in Ragionieri, ed., *I bozzetti michelangioleschi della Casa Buonarroti* (Florence, 2000), pp. 42–46, suggesting a date c. 1530 and noting that the proportions of the group seem incompatible with those of the *Hercules and Cacus* block (p. 46). In part for this reason, Johannes Wilde argued that the model was unrelated to the colossus commission for the piazza and considered it a counterpart of the Palazzo Vecchio *Victory* planned for the Julius tomb; "Due modelli di Michelangelo ricomposti," *Dedalo* 8 (1928): 653–66; followed by Joannides, "Michelangelo *bronzista*," n. 21. Even if their conclusions are correct, the model might still stand as a proxy for what Michelangelo would have done in the piazza.

89 That Alessandro (1511–37) was a bastard and a Medici is undisputed; but his father's identity remains uncertain. He was either Lorenzo, Duke of Urbino, or Pope Clement. The "republican" Republic ended officially on 6 July 1531, with Baccio Valori installed as temporary governor. In keeping with the pope's treaty with Charles V, Alessandro was married to the emperor's illegitimate daughter, Margaret of Austria, and Lorenzo's daughter, Catherine, became the consort of the future Henri II. Tyrannical and heavy handed, Alessandro was assassinated by his cousin and boon-companion Lorenzo (Lorenzino) in January 1537 and succeeded by Cosimo.

90 Colasanti, "Memoriale di Baccio," pp. 422, 424. Baccio presented his gift in Genoa, where Charles and Clement met in October 1529 to make peace. Whereas the *Deposition* is also lost, it is known from drawings and a later cast by Antonio Susini (Paris, Louvre). The *Venus* may have existed only in the *Memoriale*.

91 For the knighthood and kinship with the "most ancient and most noble blood of the Bandinelli of Siena," see Colasanti, ibid., p. 423, and pp. 414–21 on the fictional family genealogy. Bandinelli was of course aware that Leo X had named Michelangelo Count

Palatine in 1515. For parallels with Michelangelo's social aspirations, see Weil-Garris, "Bandinelli and Michelangelo," p. 226.

92 Cellini, *Autobiography*, p. 9.

93 For the *Self-Portrait*, oil on canvas, see Philip Hendy, *Catalogue of the Exhibited Paintings and Drawings* (Boston, 1931), pp. 22–26. The painting must postdate October 1529, when Baccio became a knight of the Order of Santiago. The finished statue is very different from this drawing, which shows Cacus dead or at least with his head down at Hercules' feet, his limp right arm on the hero's left hip. The painting technique reflects Baccio's study with Rosso, as recorded by Vasari-Barocchi 5: 242. According to Weil-Garris, "Bandinelli and Michelangelo," p. 237, Baccio produced more self-portraits than any of his contemporaries, and "many of these were engraved, to be dispersed publicly in numerous copies"; Bandinelli resembled Michelangelo and seems to have emphasized this resemblance in his self-portraits (p. 248n44). A fifth independent sculpted self-portrait has been identified by Izabella Galicka and Hanna Sygietynska, "A Newly Discovered Self-Portrait by Baccio Bandinelli," *Burlington Magazine* 134 (1992): 805–07.

94 For paintings of drawings, see Rona Goffen, "Lotto's *Lucretia*," *Renaissance Quarterly* 52 (1999): 742–81; and for the importance of drawing to Baccio in relation to his rivalry with Michelangelo, see Wiemers, "'Und wo bliebt meine Zeichnung?' Zur Werkgenese im bildauerischen Oeuvre des Michelangelo-Rivalen Baccio Bandinelli," in *Michelangelo, Neue Beiträge: Akten des Michelangelo-Kolloquiums veranstaltet vom Kunsthistorischen Institut der Universität zu Köln im Italienischen Kulturinstitut Köln 7.–8. November 1996*, ed. Michael Rohlmann and Andreas Thielemann (Munich and Bonn, 2000), pp. 235–64.

95 For Baccio's draftsmanship, see Heikamp, "In margine alla 'Vita di Baccio'," p. 53; and Weil-Garris, "Bandinelli and Michelangelo," p. 227.

96 Clement was not always so merciful; many anti-Medici Florentines were exiled or put to death after the family's return to power. See Vossilla, "Il colosso di Baccio," in Francini and Vossilla, *L'Ercole e Caco*, p. 11. Bandinelli met the emperor again in 1536, supposedly presenting him with the *Venus* on that occasion; Colasanti, "Memoriale di Baccio," p. 424.

97 This and other deliciously vicious verses are published in Detlef Heikamp, "Antologia di

critici: Poesie in vitupero del Bandinelli," *Paragone*, N.S. 15, 175 (1964): 67 and *passim*.

98 See Vossilla, "Il colosso di Baccio," in Francini and Vossilla, *L'Ercole e Caco*, pp. 14–15. The confiscated land had belonged to an anti-Medici rebel who was also Baccio's personal enemy. Like Vasari, Condivi (naturally) praised Clement's patronage of Michelangelo, while recording that "Michelangelo was in the greatest fear because Duke Alessandro, young [. . .] ferocious, and vindictive, greatly loathed him." Had it not been for the pope's admiration for Michelangelo, Condivi claimed, p. 42, the duke would have done away with him.

99 Bush, "Bandinelli's *Hercules*," pp. 166–67, 169.

100 Peter Meller, "Physiognomical Theory in Renaissance Heroic Portraits," in *Studies in Western Art: Acts of the Twentieth International Congress of the History of Art*, vol. 2: *The Renaissance and Mannerism*, ed. Ida E. Rubin (Princeton, 1963), pp. 53–69, citing Verrocchio's *Colleoni* as an archetypal example of such militaristic leonine features. As master of Baccio's master, Rustici, Verrocchio was Baccio's professional grandfather, so to speak. Vasari recorded that Baccio made copies of works by Verrocchio and by Donatello; Vasari-Barocchi 5: 239. The characterization of Hercules is also indebted to Andrea Sansovino's giant terracotta *Porsenna*, c. 1520, of which only the head survives (Montepulciano, Palazzo Avignonesi); see Vossilla, "Il colosso di Baccio," in Francini and Vossilla, *L'Ercole e Caco*, pp. 32–33 and fig. 20.

101 In fact, Clement purged the city of his major political enemies, who were either banished or put to death after the Medici restoration. Like Vossilla and unlike Bush, I do not see any possibility of "clemency" in the *Hercules and Cacus*. See Vossilla, ibid., pp. 11, 29; and Bush, "Bandinelli's *Hercules*," pp. 179–82.

102 Kathleen Weil-Garris Brandt, "On Pedestals: Michelangelo's *David*, Bandinelli's *Hercules and Cacus* and the Sculpture of the Piazza della Signoria," *Römisches Jahrbuch für Kunstgeschichte* 20 (1983): 378–415, esp. pp. 379, 381 and fig. 4 for *David*'s pedestal, "the first extant Renaissance use for this purpose of a simple antique architectural socle form" (p. 381).

103 See Vossilla, "Il colosso di Baccio," in Francini and Vossilla, *L'Ercole e Caco*, p. 33; Carlo Francini, "Il piedestallo dell'*Ercole e Caco*," in ibid., pp. 49–53; and esp. Weil-Garris Brandt, "On Pedestals," pp. 393–406.

104 Atlantes or *termini*, symbolic of Eternity, were considered appropriate for monuments to victors.

105 This phrase neatly mocks Baccio's familial pretensions as well. For the text of Alfonso de' Pazzi's poem, "For Baccio Bandinelli, Sculptor," see Heikamp, "Antologia di critici," p. 66.

106 Weil-Garris Brandt, "On Pedestals," pp. 403–05.

107 For the duke's "compulsion" to imprison critics, see Vasari-Barocchi 5: 254; and for examples of such criticisms, Louis Waldman, " 'Miracol' novo et raro': Two Unpublished Contemporary Satires on Bandinelli's 'Hercules'," *Mitteilungen des Kunsthistorischen Institutes in Florenz* 38, Heft 2–3 (1994): 419–26. Note also the poems, both funny and devastating, that condemn Baccio's works for Florence cathedral, quoted in Heikamp, "Antologia di critici."

108 According to Bandinelli, Clement himself had wished him to design his tomb, a fact known to his executors, Cardinals Cibo, Medici, Ridolfi, and Salviati; Colasanti, "Memoriale di Baccio," p. 432.

109 For the statue and the project for the tomb, see Waldman, "Bandinelli and the Opera di Santa Maria del Fiore," pp. 223–24, and p. 231 *passim* for privileges granted to the sculptor by Cosimo.

110 Vasari-Barocchi 5: 269. Cellini entered the shop in 1513 and left two years later. Thus Michelangelo di Viviano was the "prelude to the rivalry between Benvenuto and Baccio" as the father of one and professional father of both men; see Weil-Garris, "Bandinelli and Michelangelo," p. 244n13.

111 Vasari-Barocchi 5: 269 (Life of Baccio). These events took place shortly after Cellini's return to Florence from France, where he had spent the years 1540–45 in the employ of François 1. Among his works for the king were the bronze relief of the *Nymph of Fontainebleau* (Paris, Louvre) and the spectacular gold salt cellar (Vienna, Kunsthistorisches Museum), both completed in 1543. For these and other French commissions, see Janet Cox-Rearick, *The Collection of Francis I: Royal Treasures* (New York, 1996), pp. 288–94, 298–302; Poeschke, *Michelangelo*, pp. 209–12; and John Pope-Hennessy, *Cellini* (New York, 1985), pp. 101–16, 133–46.

111 Cellini, *Autobiography*, p. 344.

112 Cellini's bronze and Bandinelli's marble are in Florence, Bargello; Cellini's marble, executed with assistance, is in San Francisco, de Young Museum; and Bandinelli's bronze is in

Florence, Palazzo Pitti. See Pope-Hennessy, *Cellini*, pp. 215–18.

113 Ibid., p. 217.

114 For the *Bindo Altoviti* (Boston, Isabella Steward Gardner Museum), completed c. 1551, see ibid., pp. 218–21, and Heikamp, "In margine alla 'Vita di Baccio'," p. 53. Cellini, *Autobiography*, p. 353, quoted Michelangelo's admiration for the portrait, which "pleases me as much and rather more than the antiques" in Altoviti's collection.

115 Poeschke, *Michelangelo*, p. 175 (Baccio) and p. 212 (Cellini); and Pope-Hennessy, *Cellini*, p. 218.

116 See Michael Cole, "Cellini's Blood," *Art Bulletin* 81 (1999): 214–35; Pope-Hennessy, *Cellini*, pp. 163–86; and for the chronology, Poeschke, *Michelangelo*, p. 214. Cellini's *Perseus* inspired sonnets of praise by Varchi and Bronzino, among others. For the latter's sonnet written on the occasion of the unveiling of *Perseus*, see Deborah Parker, *Bronzino: Renaissance Painter as Poet* (Cambridge and New York, 2000), pp. 88–91.

117 Ovid's phrase, "stone without blood" (*Metamorphoses* v.249), is quoted by Cole, "Cellini's Blood," p. 277; Cellini's alloy is approximately 95% copper and would thus originally have appeared redder than today (Cole, p. 234n69). See also John Shearman, *Only Connect . . . : Art and the Spectator in the Italian Renaissance* (Washington and Princeton, 1992), pp. 44–58, for the relation among *David*, *Hercules*, and *Perseus*.

118 Cellini, *Autobiography*, p. 385.

119 Ibid., p. 155, for the description of Vasari. Ammannati's first commission after his return from Rome was the Juno Fountain, for which he received payments from 1 March 1556 through January 1561; see Hildegard Utz, "A Note on the Chronology of Ammannati's Fountain of Juno," *Burlington Magazine* 114 (1972): 394; and Poeschke, *Michelangelo*, pp. 200–06, for this and for the Neptune Fountain. Cosimo rewarded the sculptor with the gift of one of Michelangelo's *River God* models, which Ammannati presented to the Florentine Academy in 1583, where it was used as a teaching model. See Rudolf Preimesberger, "Themes from Art Theory in the Early Works of Bernini," in *Gianlorenzo Bernini: New Aspects of His Art and Thought. A Commemorative Volume*, ed. Irving Lavin (University Park, PA, and London, 1985), p. 6.

120 For the description of the damage and historical information about the work, see David L. Bershad, "Recent Archival Discov-

eries concerning Michelangelo's 'Deposition' in the Florence Cathedral and a Hitherto Undocumented Work of Giuseppe Mazzuoli (1644–1725)," *Burlington Magazine* 120 (1978): 226, with the document recording the statue's transfer from Rome to Florence in 1674. See also Poeschke, *Michelangelo*, pp. 119–20. Michelangelo's death and his obsequies in Rome are described in letters from Diomede Leoni to the artist's nephew Lionardo in Florence; see Paola Barocchi and Giorgio Chiarini, *Michelangelo: Mostra di disegni, manoscritti e documenti* (Florence, 1964), pp. 202–03, nos. 109, 110, 20 June and 5 August 1564.

121 For the *Risen Christ*, see p. 92 above. Explaining the destruction of the *Pietà*, Vasari wrote that the block "had a lot of emery and was hard, often giving off sparks" when Michelangelo struck with the chisel; and in any case, "he was never contented with anything that he made," as proved by the fact that there are few finished works by him, most of them done in his youth (Vasari-Barocchi 6: 92). See also Weil-Garris, "Bandinelli and Michelangelo," p. 243.

122 Vasari-Barocchi 6: 80–81. The Toro Farnese (Naples, Museo Nazionale) – or the original of which it is a third-century copy – was described also by Pliny, *Natural History* XXXVI.33–34, noting that it was carved of one block of stone. For this work and Michelangelo, see Irving Lavin, "*Ex uno lapide*: The Renaissance Sculptor's *Tour de force*," in *Il Cortile delle statue: Der Statuenhof des Belvedere im Vatikan: Akten des Internationalen Kongresses zu Ehren von Richard Krautheimer*, ed. Matthias Winner, Bernard Andreae, and Carlo Pietrangeli (Mainz, 1998), pp. 203–05; and Lavin, "The Sculptor's 'Last Will and Testament'," *Allen Memorial Art Museum Bulletin* 35, 1–2 (1977–78): 22.

123 My translations. These texts are discussed in Lavin, "*Ex uno lapide*," p. 193. For the quoted passages, see Vasari-Barocchi 6: 114 (1550), 6: 77 (1568), explaining that the work had been meant for Michelangelo's tomb; ibid., pp. 92–93, for Vasari's explanation of how the statue came to be broken. Vasari also referred to the damage – and identified the "old man" in the *Pietà* as Michelangelo's self-portrait – in a letter to the sculptor's nephew, Lionardo, dated 18 March 1564. The statue had been acquired by Francesco Bandini, and Vasari hoped that it might be recovered: "It is a consideration that [. . .] Michelangelo, as I heard and also [. . .] M. Tomaso de' Cavalieri and many

others of his friends, that the *Pietà* with five figures which he broke, he was making for his sepulchre; [. . .] aside from the fact that it [the statue] was designed for himself, he portrayed himself there as an old man (*evvi un vecchio ch'egli ritrasse sè*)." See Vasari-Milanesi 8: 378, cxxv. Condivi also described Michelangelo's vandalism against the Vatican *Pietà* (pp. 51–52), praised for being carved from one block; see p. 104 above. See also Poeschke, *Michelangelo*, pp. 119–20; and William Wallace, "Michelangelo, Tiberio Calcagni, and the Florentine *Pietà*," *Artibus et historiae* 21, 42 (2000): 81, 83–84, and *passim*, for the challenge of carving a multifigure group from a single block and examples by other masters, including Andrea Sansovino and Francesco da Sangallo. As Wallace explains, p. 86, "Except for the *David*, the Florentine *Pietà* is the biggest marble that Michelangelo ever carved."

124 For Bandini and for Calcagni's work on the statue, see Wallace, "Michelangelo, Calcagni, and the *Pietà*," pp. 88–94.

125 These self-portraits are usually tondi with bust-length reliefs (like the ancient *imago clipeata*), as in the tombs of Filippo Lippi (d. 1469) by Filippino Lippi in the cathedral of Spoleto; of Antonio (d. 1498) and Piero (d. 1496) del Pollaiuolo in San Pietro in Vincoli, Rome; of Andrea Bregno (d. 1506) in Santa Maria sopra Minerva, also in Rome; and of Andrea Mantegna (d. 1506) in Sant'Andrea, Mantua. For these monuments and self-portraits in artists' tombs, see Anne Markham Schulz, *The Sculpture of Bernardo Rossellino and his Workshop* (Princeton, 1977), p. 40n38; and for artists' tombs in general, Lavin, "The Sculptor's 'Last Will'."

126 Michelangelo was not the first artist to adopt the guise of Nicodemus for a self-portrait. See Corine Schleif, "Nicodemus and Sculptors: Self-Reflexivity in Works by Adam Kraft and Tilman Riemenschneider," *Art Bulletin* 75 (1993): 599–626, esp. pp. 610–14, for such self-portraits in two works by Kraft in Nuremberg, the Schreyer-Landauer Epitaph in Saint Sebald, c. 1490, and the eucharistic tabernacle in Saint Lorenz, 1493–96; and in Riemenschneider's Maidbronn altarpiece in the Cistercian convent church near Würzburg, c. 1519–26. There is also at least one likely Italian precedent, a work well known to Michelangelo: Niccolò dell'Arca apparently represented himself as Nicodemus in the *Lamentation* made for Santa Maria della Vita in Bologna, c. 1485. See Schleif, p. 611; and Charles Seymour, Jr., *Sculpture*

in Italy: 1400–1500 (Harmondsworth, Baltimore, and Ringwood, 1966), p. 185. Nicodemus himself was credited as the sculptor of the *Volto Santo* Crucifix venerated in Lucca cathedral (Schleif, p. 608); Michelangelo surely knew this image too and was likely aware of its traditional attribution. For the possibility that Michelangelo was influenced by Nicodemism – that is, that he secretly embraced principles of the Protestant Reformation – see Jane Kristof, "Michelangelo as Nicodemus: *The Florence Pietà*," *Sixteenth Century Studies* 20 (1989): 163–82; and Valerie Shrimplin, "Michelangelo and Nicodemism: The Florence *Pietà*," *Art Bulletin* 71 (1989): 58–66.

127 Vasari mentioned the "clumsy pictures" made by painters unable to imitate Titian's late style; Vasari-Barocchi 6: 166.

128 Much has been made of Michelangelo's destruction of the leg, the fragment of which came into the possession of Daniele da Volterra. For psychological interpretations regarding the leg's placement and removal, see Leo Steinberg, "Michelangelo's Florentine *Pietà*: The Missing Leg," *Art Bulletin* 50 (1968): 343–50; Steinberg, "The Metaphors of Love and Birth in Michelangelo's *Pietàs*," in *Studies in Erotic Art*, ed. Theodore Bowie and Cornelia V. Christenson (New York and London, 1970), pp. 231–85; and Steinberg, "Animadversions: Michelangelo's Florentine *Pietà*: The Missing Leg Twenty Years After," *Art Bulletin* 71 (1989): 480–505.

129 Poeschke, *Michelangelo*, pp. 120–22; and more recently, an illuminating study by John Paoletti, "The Rondanini *Pietà*: Ambiguity Maintained through the Palimpsest," *Artibus et historiae* 21, 42 (2000): 53–80. The fragmentary forearm to Christ's right belongs to an earlier figure that Michelangelo began and abandoned, evidence of how "he tended to change his mind while carving"; see Wallace, "Michelangelo, Calcagni, and the *Pietà*," p. 87.

130 Michael Cole, "Benvenuto Cellini's Designs for his Tomb," *Burlington Magazine* 140 (1998): 800–01, 802. In his first known will, 10 August 1555, Cellini specified a marble tondo; in the codicil written the following month, he changed this to fresco and added that the wax model of the Crucifix was also to be displayed. Cellini further specified that he would make "by his own hand the said body of Christ crucified." When Cellini began to plan his tomb, "no sarcophagus as conspicuous as that of his instructions held

an artist's body" (Cole, p. 802); Raphael's plans had included a "prominent monument, but a hidden *arca*" (Cole, n. 25). The funerary monuments of Cellini, Bandinelli, and Michelangelo are considered together by Barkan, *Unearthing the Past*, pp. 334–38, noting that Bandinelli also began two paintings with Nicodemus (p. 335); and by Lavin, "The Sculptor's 'Last Will'," pp. 26–39, and "*Ex uno lapide*."

131 For the intended site, a pier adjacent to the Gondi Chapel, and the juxtaposition with Brunelleschi, see Cole, "Cellini's Tomb," p. 800; and Pope-Hennessy, *Cellini*, p. 256.

132 For the unfinished wooden *Crucifixion*, c. 1562, see O'Grody, "*Crocefisso*," in Ragionieri, *Bozzetti michelangioleschi*, pp. 64–67. I thank Paul Joannides for his incisive comments about this comparison.

133 According to the *Autobiography*, pp. 386–87, when Cellini installed the clamps to fix the Crucifix in place, the Dominicans caviled about his plans for a sarcophagus at the foot of the cross. He then approached the Servites of Santissima Annunziata, where his infant son, Jacopo Giovanni, had been buried in 1553. Meanwhile, learning that Bandinelli had obtained a site in the Pazzi Chapel of the same church for *his* tomb, Cellini began discussions with the church of Ognissanti, but revived the Annunziata proposal in his wills dated 23 April 1567, 28 March 1569, and 18 December 1570. See Pope-Hennessy, *Cellini*, pp. 257, 310n17; and Cole, "Cellini's Tomb," p. 802. Cellini probably initiated negotiations with the Annunziata in late 1559 (Cole, p. 803n31). That church is first mentioned in his will of 24 March 1561, whereas none of his wills after 1555 names Santa Maria Novella.

134 The two *suppliche* are translated and analyzed in Cole, "Cellini's Tomb," p. 801; my italics. That the Crucifix was to be Cosimo's has also been documented by Rossi, "Writer and the Man."

135 Cole, ibid., pp. 801–02, with the Italian in n. 18.

136 See ibid., p. 802, for this interpretation of Cosimo's reply to Cellini about the display of the Crucifix. In 1570 Cellini had not yet been paid either for the Crucifix or for the *Ganymede*, according to his letter to Cosimo dated 20 September; see Cole, "Cellini and Sculpture," p. 249n10. The Crucifix had been delivered to Cosimo's apartment in Palazzo Pitti in 1565, and Cellini submitted his bill for 1500 scudi in February 1566. Based on an assessment of the work by Ammannati, dated 16 September 1570 and

countersigned by Vincenzo de' Rossi, he was paid only 700 scudi. See Pope-Hennessy, *Cellini*, pp. 257, 310n19.

137 Cellini, *Autobiography*, pp. 386–87.

138 Colasanti, "Memoriale di Baccio," p. 443. I wonder whether this placement might reflect the original installation of Michelangelo's Vatican *Pietà*.

139 Bandinelli's contract with the Annunziata is dated 2 May 1559, but on 28 February 1558 he had already petitioned Duke Cosimo to be allowed to remove a tomb in the church in order to make room for his own *Pietà*. The earlier tomb honored "that soldier who died in a duel," and Bandinelli argued that "a sepulcher of one dead in enormous sin" should not be seen "*a paragone* [. . .] and to the right hand" of the altar of the Annunciation (a letter from Lelio Torelli to Cosimo I, 28 February 1559); Gaye, *Carteggio inedito*, vol. 3, p. 14. Meanwhile, Baccio negotiated with the church itself; Weil-Garris, "Bandinelli and Michelangelo," p. 250n55. On 13 November 1558 the friars rejected his first request as presumptuous: only popes can be buried in the middle of a church. They also rejected his request for a site to the right of the entrance, which would have involved destruction of Ammannati's Nari Monument and given Bandinelli a site sanctified by association with the miraculous image of the Annunciate Virgin to the left of the entrance. The friars and sculptor finally signed a contract on 2 May 1559; Colasanti, "Memoriale di Baccio," p. 413, and pp. 442–43, for references to the *Pietà* and Bandinelli's instructions to his sons about the chapel. The earlier dedication of the chapel to Saint James was relevant to Bandinelli as a knight of the Order of Santiago. For Bandinelli's testament, plans for his sepulcher, and dealings with the Annunziata, see also Gaye, vol. 2, pp. 283–84; Lavin, "The Sculptor's 'Last Will'," p. 19; Cole, "Cellini's Tomb," p. 803; and Weil-Garris, "Bandinelli and Michelangelo," pp. 238–42.

140 See Pope-Hennessy, *Cellini*, p. 310n17, explaining that the tomb project was first outlined in a will of 8 October 1565.

141 The composition resembles such paintings as the *Dead Christ with Joseph of Arimathaea* by Girolamo Savoldo (Cleveland Museum of Art) and such statues as the *Pietà* (Florence, Santa Croce) by Bandinelli himself, as explained by Lavin, "The Sculptor's 'Last Will'," p. 34.

142 Colasanti, "Memoriale di Baccio," p. 422. The *Pietà* seems to be a single block according to Weil-Garris, "Bandinelli and

Michelangelo," p. 243. For the paradigm of the single block in relation to this work, Cellini's *Crucifix*, and Michelangelo's *Pietà*, see also Barkan, *Unearthing the Past*, pp. 337–38.

143 For the lost *Saint John*, see Waldman, "Bandinelli and the Opera di Santa Maria del Fiore," pp. 238, 254, publishing documents of 1558 or 1559 and 1560. According to Colasanti, "Memoriale di Baccio," pp. 440, 443, the tomb was also to have included a *Saint Catherine of Siena*; but for doubts about the authenticity of this text, see n. 6 above.

144 His grief is restrained even if Bandinelli's self-portrait represents his role as a grieving father whose son Clemente (1534–54) has predeceased him, as suggested by Weil-Garris, "Bandinelli and Michelangelo," p. 242.

145 Weil-Garris, p. 241, compares the figure to God the Father in depictions of the Trinity and suggests that he represents Nicodemus as sculptor.

146 Colasanti, "Memoriale di Baccio," p. 433. Clemente probably began work on the *Pietà* in 1554 or 1555; Bandinelli then took over, continuing to work on it until his own death in 1560. See Weil-Garris, "Bandinelli and Michelangelo," p. 248n45. It is difficult to see why Baccio's grandson, identified by Louis Alexander Waldman as compiler of the *Memoriale* (see n. 6 above), would invent praise of his grandfather's bastard son: this particular, at least, seems an authentic record of Baccio's thoughts.

147 Colasanti, ibid.

148 For the inscription and translation, see Weil-Garris, "Bandinelli and Michelangelo," pp. 241, 250n56.

149 Bandinelli died on 7 February 1560, according to the modern calendar. Professor Bette Talvacchia has suggested to me that Bandinelli's wife, Jacopa Doni, may have been a kinswoman of Antonio Francesco Doni, described as "my great friend" in Colasanti, "Memoriale di Baccio," p. 423. Beside his Medici patrons, Doni was Baccio's principal contemporary admirer. Their friendship dated from as early as 1528; the sculptor is the protagonist of Doni's *Il disegno*, first published in Venice, 1549 (ed. Mario Pepe, Milan, 1970); and Doni also praised Bandinelli in *I marmi* (Venice, 1552). See Weil-Garris, "Bandinelli and Michelangelo," p. 243.

150 See Weil-Garris, ibid., p. 241, for Bandinelli's signature and *fabrefaciebat* to emphasize his skill and perhaps his authorship.

151 For Titian's *Pietà* as autobiography, see Rona Goffen, *Piety and Patronage in Renaissance Venice: Bellini, Titian, and the Franciscans* (New Haven and London, 1986), pp. 151–54, 246–48. For his "dialogue [. . .] with Michelangelo," see Erwin Panofsky, *Problems in Titian, Mostly Iconographic* (New York, 1969), pp. 25–26; and David Rosand, *Painting in Cinquecento Venice: Titian, Veronese, Tintoretto* (Cambridge and New York, rev. ed. 1997), pp. 57–61, esp. p. 59 for Michelangelo. For the history of the painting and its technique, see Giovanna Nepi Scirè, "Recent Conservation of Titian's Paintings in Venice," and "*Pietà*," in *Titian, Prince of Painters*, ed. Susanna Biadene with Mary Yakush, exh. cat., Venice, palazzo Ducale, and Washington, National Gallery of Art (Milan, 1990), pp. 128–29, 373–74.

152 For the letter of the Marquis of Ayamonte to Guzmán de Silva, see Nepi Scirè, "*Pietà*." For the painting's temporary display in the Frari before Titian's death, see Charles Hope, "A New Document about Titian's *Pietà*," in *Sight & Insight: Essays on Art and Culture in Honour of E.H. Gombrich at 85*, ed. John Onians (London, 1994), pp. 153–67. For a stylistic and iconographic consideration of the painting in the context of that church, see Goffen, *Piety and Patronage*, pp. 151–54.

153 The derivation from Venus was recognized by Fritz Saxl, *Lectures*, 2 vols. (London, 1957), vol. 1, p. 173 (an essay first published in 1935).

154 His identity has been disputed: Joseph of Arimathaea, Nicodemus, Job, or Jerome. See Rosand, *Painting in Cinquecento Venice*, p. 60 (Jerome); and for arguments regarding other possible identities, Goffen, *Piety and Patronage*, pp. 151, 247n54. For this and other self-portraits by Titian, in various guises and as himself, see Katherine T. Brown, *The Painter's Reflection: Self-Portraiture in Renaissance Venice 1458–1625* (Florence, 2000), pp. 77–87, 104–11, 168–78, 181–82; Luba Freedman, *Titian's Independent Self-Portraits* (Florence, 1990); and Zbynek Smetana, "Titian's Mirror: Self-Portrait and Self-Image in the Late Works," Ph.D. dissertation (Rutgers University, 1997).

155 "Dona Katta venir nostra pecata bene pixt. Sig[navit?] [natur?]. . . ." For this dialect inscription, read with the assistance of reflectography, and for the other inscriptions, see Nepi Scirè, "*Pietà*," in Biadene with Yakush, ed., *Titian*, p. 374.

Select Bibliography

Agosti, Giovanni, and Michael Hirst. "Michelangelo, Piero d'Argenta and the 'Stigmatisation of St. Francis'," *Burlington Magazine* 138 (1996): 683–84.

Alberti, Leon Battista. *On Painting and On Sculpture: The Latin Texts of De pictura and De statua*, ed. Cecil Grayson (London, 1972).

——. *Ten Books on Architecture*, trans. Cosimo Bartoli (Italian) and James Leoni (English), ed. Joseph Rykwert (London, 1965).

Albertini, Francesco. *Memoriale di molte statue et picture sono nella inclyta cipta di Florentia per mano di sculptori et pictori excellenti moderni et antiqui* (Florence, 1510; rpt. Letchworth, 1909).

Ames-Lewis, Francis, and Joanne Wright. *Drawing in the Italian Renaissance Workshop*, exh. cat., London, Victoria and Albert Museum (London, 1983).

Anderson, Jaynie. *Giorgione: The Painter of "Poetic Brevity"* (Paris and New York, 1997).

Arasse, Daniel. "Raffaello senza venustà e l'eredità della grazia," in *Studi su Raffaello: Atti del congresso internazionale di studi (Urbino–Firenze 1984)*, ed. Micaela Sambucco Hamoud and Maria Letizia Strocchi, 2 vols. (Urbino, 1987), vol. 1, pp. 703–14.

——. *Leonardo da Vinci: The Rhythm of the World*, trans. Rosetta Translations (New York, 1998).

Aretino, Pietro. *Lettere sull'arte di Pietro Aretino*, ed. Fidenzio Pertile and Ettore Camesasca, 3 vols. (Milan, 1957–60).

——. *Lettere, Libro primo*, ed. Francesco Erspamer (Parma, 1995).

——. *Lettere, Libro secondo*, ed. Francesco Erspamer (Parma, 1998).

Baldriga, Irene. "The First Version of Michelangelo's Christ for S. Maria sopra Minerva," *Burlington Magazine* 142 (2000): 740–45.

Bambach, Carmen C. *Drawing and Painting in the Italian Renaissance Workshop: Theory and Practice, 1300–1600* (Cambridge and New York, 1999).

——. "The Purchases of Cartoon Paper for Leonardo's *Battle of Anghiari* and Michelangelo's *Battle of Cascina*," *Villa I Tatti Studies* 8 (1999–2000): 105–33.

——. "A Leonardo Drawing for the Metropolitan Museum of Art: Studies for a Statue of *Hercules*," *Apollo* 153 (2001): 16–23.

Barbieri, Costanza. "Sebastiano del Piombo and Michelangelo in Rome: Problems of Style and Meaning in the Viterbo *Pietà*," Ph.D. dissertation (Rutgers University, New Brunswick, 1999).

Bardeschi Ciulich, Lucilla, and Paola Barocchi, eds. *I ricordi di Michelangelo* (Florence, 1970).

Barkan, Leonard. *Unearthing the Past: Archaeology and Aesthetics in the Making of Renaissance Culture* (New Haven and London, 1999).

Barocchi, Paola, ed. *Trattati d'arte del Cinquecento*, 3 vols. (Bari, 1960–62).

——, ed. *Scritti d'arte del Cinquecento*, 3 vols. (Milan and Naples, 1971–77).

——, ed. *Il giardino di San Marco: Maestri e compagni del giovane Michelangelo*, exh. cat., Florence, Casa Buonarroti (Milan, 1992).

—— and Giorgio Chiarini. *Michelangelo: Mostra di disegni, manoscritti e documenti* (Florence, 1964).

——, Katherine Loach Bramanti, and Renzo Ristori. *Il carteggio indiretto di Michelangelo*, 2 vols. (Florence, 1988–95).

—— and Renzo Ristori, eds. *Il carteggio di Michelangelo*, 5 vols. (Florence, 1965–83).

——. *See also* Vasari, Giorgio.

Battisti, Eugenio. "La critica a Michelangelo primo del Vasari," *Rinascimento* 5 (1954): 117–32.

——. "Il concetto d'imitazione nel Cinquecento da Raffaello a Michelangelo," *Commentari* 7 (1956): 86–104.

Bek, Lise. "Giovanni Santi's 'Disputa de la pictura': A Polemical Treatise," *Analecta Romana Instituti Danici* 5 (1969): 76–102.

Beltrami, Luca. *Documenti e memorie riguardanti la vita e le opere di Leonardo da Vinci* (Milan, 1919).

Bembo, Pietro. *Prose della volgar lingua: Gli asolani, Rime*, ed. Carlo Dionisotti (Turin, 1966).

Bertelli, Sergio. "Caen and Brera: From Marriage to Divorce," in *Raphael before Rome*, ed. James Beck (Washington, 1986), pp. 31–34.

Berti, Luciano, et al. *Il Tondo Doni di Michelangelo e il suo restauro*, Gli Uffizi, Studi e Ricerche 2 (Florence, 1984).

Biadene, Susanna, ed., with Mary Yakush. *Titian, Prince of Painters*, exh. cat., Venice, Palazzo Ducale, and Washington, National Gallery of Art (Milan, 1990).

Bieber, Margarete. *Laocoön: The Influence of the Group since its Rediscovery* (Detroit, 1967).

Billi, Antonio. *Il libro di Antonio Billi* (c. 1530), ed. Annamaria Ficarra (Naples, n.d.).

Bober, Phyllis Pray, and Ruth Rubinstein, with Susan Woodford. *Renaissance Artists and Antique Sculpture: A Handbook of Sources* (London, 1986).

Bolland, Andrea. "Art and Humanism in Early Renaissance Padua: Cennini, Vergerio and Petrarch on Imitation," *Renaissance Quarterly* 49 (1996): 469–87.

Boucher, Bruce. *The Sculpture of Jacopo Sansovino*, 2 vols. (New Haven and London, 1991).

Boudon, Marion. "Le relief d'*Ugolin* de Pierino da Vinci: Une réponse sculptée au problème du *paragone*," *Gazette des Beaux-Arts* 132 (1998): 1–18.

Brendel, Otto J. "Borrowings from Ancient Art in Titian," *Art Bulletin* 37 (1955): 113–25.

Brod, Harry. "Masculinity as Masquerade," in *The Masculine Masquerade: Masculinity and Representation*, ed. Andrew Perchuk and Helaine Posner (Cambridge, MA, and London, 1995), pp. 13–19.

Brown, C. Malcolm. " 'Lo insaciabile desiderio nostro de cose antique': New Documents on Isabella d'Este's Collection of Antiques," in *Cultural Aspects of the Italian Renaissance: Essays in Honour of Paul Oskar Kristeller*, ed. Cecil H. Clough (Manchester and New York, 1976), pp. 324–53.

Brown, Clifford M. "Little Known and Unpublished Documents concerning Andrea Mantegna, Bernardino Parentino, Pietro Lombardo, Leonardo da Vinci and Filippo Benintendi (Part Two)," *L'arte* 7–8 (1959): 194–206.

——, and Anna Maria Lorenzoni. *Isabella d'Este and Lorenzo da Pavia: Documents for the History of Art and Culture in Renaissance Mantua* (Geneva, 1982).

Brown, David Alan. *Leonardo da Vinci: Origins of a Genius* (New Haven and London, 1998).

Brucker, Gene. *The Civic World of Early Renaissance Florence* (Princeton, 1977).

Buddensieg, Tilmann. "Raffaels Grab," in *Munuscula discipulorum: Kunsthistorische Studien Hans Kauffmann zum 70. Geburtstag 1966*, ed. Buddensieg and Matthias Winner (Berlin, 1968), pp. 45–70.

Buonarroti, Michelangelo. *See* Barocchi, Paola, and Renzo Ristori; Gilbert, Creighton; Saslow, James.

Bury, Michael. "The 'Triumph of Christ' after Titian," *Burlington Magazine* 131 (1989): 188–97.

Bush, Virginia L. "Bandinelli's *Hercules and Cacus* and Florentine Traditions," in *Studies in Italian Art and Architecture 15th through 18th Centuries*, ed. Henry A. Millon (Cambridge and Rome, 1980), pp. 163–89.

Butterfield, Andrew. *The Sculptures of Andrea del Verrocchio* (New Haven and London, 1997).

Butters, Suzanne B. *The Triumph of Vulcan: Sculptors' Tools, Porphyry, and the Prince in Ducal Florence*, 2 vols. (Florence, 1996).

Cadogan, Jean K. "Michelangelo in the Workshop of Domenico Ghirlandaio," *Burlington Magazine* 135 (1993): 30–31.

——. *Domenico Ghirlandaio: Artist and Artisan* (New Haven and London, 2000).

Camesasca, Ettore, ed., with Giovanni M. Piazza. *Raffaello: Gli scritti. Lettere, firme, sonetti, saggi tecnici e teorici* (Milan, 1994).

Campori, Giuseppe. "Tiziano e gli Estensi," *Nuova antologia di scienze, lettere ed arti*, 1st ser., 27 (1874): 581–620.

——. "Tiziano e gli Estensi," in *Artisti degli Estensi: I pittori* (Modena, 1875).

Canuti, Fiorenzo. *Il Perugino*, 2 vols. (Siena, 1931).

Castiglione, Baldassar. *Il libro del cortegiano*, ed. Giulio Carnazzi, with introduction by Salvatore Battaglia (Milan, 1987).

Castiglione, Baldesar. *The Book of the Courtier*, trans. Charles S. Singleton (Garden City, NY, 1959).

Cavalcaselle, G. B., and J. A. Crowe. *Tiziano: La sua vita e i suoi tempi*, 2 vols. (Florence, 1877–78; rpt. 1974).

Cellini, Benvenuto. *La vita di Benvenuto Cellini scritta da lui medesimo*, ed. B. Bianchi (Florence, 1903).

——. *La vita*, ed. Carlo Cordié (Milan and Naples, 1960, rpt. 1996).

——. *The Autobiography of Benvenuto Cellini*, trans. George Bull (London, rev. ed. 1998).

Cennini, Cennino. *Il libro dell'arte*, ed. Franceso Brunello (Vicenza, 1982).

Chambers, D.S. *Patrons and Artists in the Italian Renaissance* (Columbia, SC, 1971).

Chastel, André. *The Sack of Rome, 1527* (Princeton, 1983).

——, et al. *Hommage à Raphaël: Raphaël dans les collections françaises*, exh. cat., Paris, Grand Palais (Paris, 1983).

Cheney, Iris. "The Print as a Tool of Artistic Competition: Salviati and Michelangelo," in *Renaissance Papers 1985*, ed. Dale B. J. Randall and Joseph A. Porter (Durham, NC, 1985), pp. 87–95.

Ciseri, Ilaria. *L'ingresso trionfale di Leone X in Firenze nel 1515* (Florence, 1990).

Clark, Kenneth, with Carlo Pedretti. *The Drawings of Leonardo da Vinci in the Collection of Her Majesty the Queen at Windsor Castle*, 3 vols. (London, 2nd ed. 1968).

Clayton, Martin. *Raphael and his Circle: Drawings from Windsor Castle*, exh. cat., London, Queen's Gallery (London, 1999).

Clements, Robert J. "Michelangelo and the Doctrine of Imitation," *Italica* 23 (1946): 90–99.

Cohen, Charles E. *The Art of Giovanni Antonio da Pordenone: Between Dialect and Language*, 2 vols. (Cambridge and New York, 1996).

Colasanti, Arduino. "Il memoriale di Baccio Bandinelli," *Repertorium für Kunstwissenschaft* 28 (1905): 406–43.

Cole, Michael [Wayne]. "Benvenuto Cellini's Designs for his Tomb," *Burlington Magazine* 140 (1998): 788–803.

——. "Benvenuto Cellini and the Act of Sculpture," Ph.D. dissertation (Princeton University, 1999).

——. "Cellini's Blood," *Art Bulletin* 81 (1999): 214–35.

Cole Ahl, Diane, ed. *Leonardo da Vinci's Sforza Monument Horse: The Art and the Engineering* (Bethlehem, PA, and London, 1995).

Condivi, Ascanio. *Vita di Michelagnolo Buonarroti* (Tabulae Artium 2), ed. Giovanni Nencioni (Florence, 1998).

Cordellier, Dominique. "Fragments de jeunesse: Deux feuilles inédites de Michel-Ange au Louvre," *Revue du Louvre* 41, 2 (1991): 43–55.

Costamagna, Philippe. *Pontormo* (Milan, 1994).

Cox-Rearick, Janet. "From Bandinelli to Bronzino: The Genesis of the *Lamentation* for the Chapel of Eleonora di Toledo," *Mitteilungen des Kunsthistorischen Institutes in Florenz* 33, Heft 1 (1989): 37–84.

——. *Bronzino's Chapel of Eleonora in the Palazzo Vecchio* (Berkeley and Los Angeles, 1993).

——. *The Collection of Francis I: Royal Treasures* (New York, 1996).

Cropper, Elizabeth. "On Beautiful Women, Parmigianino, Petrarchismo, and the Vernacular Style," *Art Bulletin* 58 (1976): 374–94.

——. "The Place of Beauty in the High Renaissance and its Displacement in the History of Art," in *Place and Displacement in the Renaissance*, ed. Alvin Vos (Binghamton, NY, 1995), pp. 159–205.

Dalli Regoli, Gigetta. *Mito e scienza nella "Leda" di Leonardo* (Vinci, 1991).

——, Romano Nanni, and Antonio Natali, ed. *Leonardo e il mito di Leda: Modelli, memorie e metamorfosi di un'invenzione*, exh. cat., Vinci, Palazzini Uzielli (Milan, 2001).

Davies, Martin. "Making Sense of Pliny in the Quattrocento," *Renaissance Studies* 9 (1995): 240–57.

De Vecchi, Pierluigi. *Lo Sposalizio della Vergine di Raffaello* (Florence, 1973).

——. *Raffaello: La mimesis, l'armonia e l'invenzione* (Florence, 1995).

——. *Lo Sposalizio della Vergine di Raffaello Sanzio* (Milan, 1996).

Delaney, Susan. "*L'Olive* and the Poetics of Rivalry," *Classical and Modern Literature* 14 (1993–94): 183–96.

Donato, Maria Monica. "Hercules and David in the Early Decoration of the Palazzo Vecchio: Manuscript Evidence," *Journal of the Warburg and Courtauld Institutes* 54 (1991): 83–95.

Draper, James David. *Bertoldo di Giovanni, Sculptor of the Medici Household: Critical Reappraisal and Catalogue Raisonné* (Columbia and London, 1992).

Dubos, Renée. *Giovanni Santi: Peintre et chroniqueur à Urbin, au XVe siècle* (Bordeaux, 1971).

Eisler, Colin. "The Madonna of the Steps: Problems of Date and Style," in *Stil und Überlieferung in der Kunst des Abendlandes*, vol. 2: *Michelangelo* (Berlin, 1967), pp. 115–21.

Ekserdjian, David. *Correggio* (New Haven and London, 1997).

Elam, Caroline. "Lorenzo de' Medici's Sculpture Garden," *Mitteilungen des Kunsthistorischen Institutes in Florenz* 36, Heft 1–2 (1992): 41–83.

——. "'Che ultima mano!': Tiberio Calcagni's *Postille* to Condivi's Life of Michelangelo," in Condivi, pp. XXIII–XLVI.

——. "'Che ultima mano!': Tiberio Calcagni's Marginal Annotations to Condivi's *Life of Michelangelo*," *Renaissance Quarterly* 61 (1998): 475–95.

Ettlinger, L. D. "Hercules Florentinus," *Mitteilungen des Kunsthistorischen Institutes in Florenz* 16 (1972): 119–42.

Even, Yael. "The Heroine as Hero in Michelangelo's Art," *Women's Art Journal* 11 (1990): 29–33.

Fabjan, Barbara, Pietro C. Marani, et al. *Leonardo: La dama con l'ermellino*, exh. cat., Kraków, Muzeum Narodowe in Krakowie (Milan, 1998).

Farago, Claire J. *Leonardo da Vinci's "Paragone": A Critical Interpretation with a New Edition of the Text in the Codex Urbinas* (Leiden, 1992).

Favaretto, Irene, and Giovanna Luisa Ravagnan, ed. *Lo statuario pubblico della Serenissima: Due secoli di collezionismo di antichità, 1597–1797* (Cittadella and Padua, 1997).

Fehl, Philipp. "Death and the Sculptor's Fame: Artists' Signatures on Renaissance Tombs in Rome," *Biuletyn historii sztuki* 59 (1997): 196–216.

Ferino Pagden, Sylvia. "Iconographic Demands and Artistic Achievements: The Genesis of Three Works by Raphael," in *Raffaello a Roma: Il convegno del 1983*, ed. Christoph Luitpold Frommel and Matthias Winner (Rome, 1986), pp. 13–27.

——. "From Cult Images to the Cult of Images: The Case of Raphael's Altarpieces," in *The Altarpiece in the Renaissance*, ed. Peter Humfrey and Martin Kemp (Cambridge and New York, 1990), pp. 165–89.

——, and Maria Antonietta Zancan. *Raffaello: Catalogo completo dei dipinti*, ed. Pietro C. Marani (Florence, 1989).

——, et al. *"La prima donna del mondo": Isabella d'Este, Fürsten und Mäzenatin der Renaissance*, exh. cat., Vienna, Kunsthistorisches Museum (Vienna, 1994).

Fermor, Sharon. "Movement and Gender in Sixteenth-Century Italian Painting," in *The Body Imaged: The Human Form and Visual Culture since the Renaissance*, ed. Kathleen Adler and Marcia Pointon (Cambridge, 1993), pp. 129–45.

——. *The Raphael Tapestry Cartoons: Narrative, Decoration, Design* (London, 1996).

Finucci, Valeria. "In the Name of the Brother: Male Rivalry and Social Order in Baldassare Castiglione's *Il libro del cortegiano*," *Exemplaria* 9 (1997): 91–116.

Forlani Tempesti, Anna. "Raffaello e il Tondo Doni," *Studi in onore di Luigi Grassi: Prospettiva* 33–36 (1983–84): 144–49.

——. *Raffaello e Michelangelo*, exh. cat., Florence, Casa Buonarroti (Florence, 1984).

——. "Il Davide di Michelangelo nella tradizione grafica bandinelliana," *Antichità viva* 28, 2–3 (1989): 19–25.

Forsyth, William H. *The Entombment of Christ: French Sculptures of the Fifteeth and Sixteenth Centuries* (Cambridge, MA, 1970).

Francini, Carlo. "Restauro dell'Ercole e Caco in Piazza della Signoria," *Quaderni di restauro dell'Ufficio Belle Arti* 1 (1996): 33–37.

——, and Francesco Vossilla. *L'Ercole e Caco di Baccio Bandinelli* (Florence, 1999).

Freedman, Luba. "'The Schiavona': Titian's Response to the Paragone between Painting and Sculpture," *Arte veneta* 41 (1987): 31–40.

——. "Raphael's Perception of the Mona Lisa," *Gazette des Beaux-Arts* 114 (1989): 169–82.

——. *Titian's Independent Self-Portraits* (Florence, 1990).

Frey, Karl [Carl], ed. *Il codice Magliabechiano* (Berlin, 1892).

——. *Die Dichtungen des Michelagniolo Buonarroti* (Berlin, 1897).

——. *Sammlung ausgewählter Briefe an Michelagniolo Buonarroti* (Berlin, 1899).

——. *Michelangelo Buonarroti: Sein Leben und seine Werke. Michelangelos Jugendjahre*, 2 vols. (Berlin, 1907).

——. "Studien zu Michelagniolo Buonarroti und zur Kunst seiner Zeit, III," *Jahrbuch der königlich preuszischen Kunstsammlungen*, Beiheft 13 (1909): 103–80.

Friedlaender, Walter. "Titian and Pordenone," *Art Bulletin* 47 (1965): 118–21.

Fritz, Michael P. *Giulio Romano et Raphaël: La vice-reine de Naples, ou la renaissance d'une beauté mythique*, trans. Claire Nydegger (Paris, 1997).

Frommel, Christoph Luitpold. "Jacopo Gallo als Förderer der Künste: Das Grabmal seines Vaters in S. Lorenzo in Damaso und Michelangelos erste römische Jahre," in *Kostinos: Festschrift für Erika Simon* (Mainz, 1992), pp. 450–60.

——, and Matthias Winner, ed. *Raffaello a Roma: Il convegno del 1983* (Rome, 1986).

Fusco, Laurie. "The Use of Sculptural Models by Painters in Fifteenth-Century Italy," *Art Bulletin* 64 (1982): 175–94.

Galicka, Izabella, and Hanna Sygietynska. "A Newly Discovered Self-Portrait by Baccio Bandinelli," *Burlington Magazine* 134 (1992): 805–07.

Gandelman, Claude. "The Semiotics of Signatures in Painting: A Peircian Analysis." *American Journal of Semiotics* 3, 3 (1985): 73–108.

Garrard, Mary D. "Leonardo da Vinci: Female Portraits, Female Nature," in *The Expanding Discourse: Feminism and Art History*, ed. Norma Broude and Mary D. Garrard (New York, 1992), pp. 59–86.

Garrison, James D. *Pietas from Vergil to Dryden* (University Park, PA, 1992).

Gauricus, Pomponius. *De sculptura* (Florence, 1504); ed. André Chastel and Robert Klein (Geneva, 1969).

Gaye, Giovanni. *Carteggio inedito d'artisti dei secoli XIV.XV.XVI*, 3 vols. (Florence, 1840; rpt. Turin, 1968).

Gelli, Giovanni Battista. *See* Mancini, Girolamo, ed.

Gere, J. A., and Nicholas Turner. *Drawings by Raphael from the Royal Library, the Ashmolean, the British Museum, Chatsworth and Other English Collections* (London, 1983).

Ghiberti, Lorenzo. *Lorenzo Ghibertis Denkwürdigkeiten (I Commentarii)*, ed. Julius von Schlosser, 2 vols. (Berlin, 1912).

Gilbert, Creighton [E.]. "Tintoretto and Michelangelo's 'St Damian'," *Burlington Magazine* 103 (1961): 16–20.

——. *Complete Poems and Selected Letters of Michelangelo*, ed. Robert N. Linscott (Princeton, 1963; rpt. 1980).

——. *Italian Art 1400–1500: Sources and Documents* (Englewood Cliffs, 1980).

——. "Some Findings on Early Works of Titian," *Art Bulletin* 62 (1980): 36–75.

——. *L'arte del Quattrocento nelle testimonianze coeve* (Florence and Vienna, 1988).

——. *Michelangelo On and Off the Sistine Ceiling: Selected Essays* (New York, 1994).

——. "What Did the Renaissance Patron Buy?," *Renaissance Quarterly* 51 (1998): 392–450.

Gilbert, Felix. *The Pope, His Banker, and Venice* (Cambridge, MA, and London, 1980).

Gilbert, Neal W. "Comment," *Journal of the History of Ideas* 48 (1987): 41–50.

Glasser, Hannelore. *Artists' Contracts of the Early Renaissance* (New York and London, 1965).

Gmelin, Hermann. "Das Prinzip der Imitatio in den romanischen Literaturen der Renaissance," *Römische Forschungen* 46 (1932): 83–360.

Goffen, Rona. "Friar Sixtus IV and the Sistine Chapel," *Renaissance Quarterly* 39 (1986): 218–62.

——. *Piety and Patronage in Renaissance Venice: Bellini, Titian, and the Franciscans* (New Haven and London, 1986).

——. *Spirituality in Conflict: Saint Francis and Giotto's Bardi Chapel* (University Park, PA, and London, 1988).

——. *Giovanni Bellini* (New Haven and London, 1989).

——. "Giovanni Bellini's *Nude with Mirror*," *Venezia Cinquecento* 1 (1991): 185–202.

——. *Titian's Women* (New Haven and London, 1997).

——. Review Essay: *Jacopo Bassano and His Public: Moralizing Pictures in an Age of Reform, ca. 1535–1600*, by B. Aikema (Princeton, 1996), and *The Art of Giovanni Antonio da Pordenone: Between Dialect and Language*, by C.E. Cohen, 2 vols. (Cambridge and New York, 1996), in *Art Bulletin* 80 (1998): 180–88.

——. "Crossing the Alps: Portraiture in Renaissance Venice," in *Renaissance Venice and the North: Crosscurrents in the Time of Dürer, Bellini, and Titian*, ed. Bernard Aikema, Beverly Louise Brown, and Giovanna Nepi Scirè, exh. cat., Venice, Palazzo Grassi (Milan, 1999), pp. 114–31.

——. "Lotto's *Lucretia*," *Renaissance Quarterly* 52 (1999): 742–81.

——. "Mary's Motherhood according to Leonardo and Michelangelo," *Artibus et historiae* 20 (1999): 35–69.

——. "Giovanni Bellini: Il Rinascimento visto da Rialto," in *Il colore ritrovato: Bellini a Venezia*, ed. Rona Goffen and Giovanna Nepi Scirè, exh. cat., Venice, Gallerie dell'Accademia (Milan, 2000), pp. 3–23.

——. "Signatures: Inscribing Identity in Italian Renaissance Art," *Viator* 32 (2001): 303–70.

——, ed. *Masaccio's "Trinity"* (Cambridge and New York, 1998).

——, and Giovanna Nepi Scirè, eds. *Il colore ritrovato: Bellini a Venezia*, exh. cat., Venice, Gallerie dell'Accademia (Milan, 2000).

Golzio, Vincenzo. *Raffaello nei documenti, nelle testimonianze dei contemporanei e nella letteratura del suo secolo* (Vatican City, 1936; rev. ed. Farnborough, 1971).

Gombrich, E. H. "The Early Medici as Patrons of Art," and "The Style *all'antica*: Imitation and Assimilation," in *Norm and Form: Studies in the Art of the Renaissance* (London, 1966), pp. 35–57 and 122–28.

Gould, Cecil. *Titian: The Studio of Alfonso d'Este and Titian's Bacchus and Ariadne* (London, 1969).

——. *The Sixteenth-Century Italian Schools*, National Gallery Catalogues (London, 1975; rpt. 1987).

Graeve, Mary Ann. "The Stone of Unction in Caravaggio's Painting for the Chiesa Nuova," *Art Bulletin* 40 (1958): 223–38.

Greene, Thomas M. *The Light in Troy: Imitation and Discovery in Renaissance Poetry* (New Haven and London, 1982).

Griffin, Alan H. F. "Unrequited Love: Polyphemus and Galatea in Ovid's *Metamorphoses*," *Greece and Rome* 30 (1983): 190–97.

Gronau, Georg. "Alfonso d'Este und Tizian," *Jahrbuch der kunsthistorischen Sammlungen in Wien*, n.s. 2 (1928): 233–46.

Hall, Marcia B. *Color and Meaning: Practice and Theory in Renaissance Painting* (Cambridge and New York, 1992).

Hayum, Andrée. "Michelangelo's *Doni Tondo*: Holy Family and Family Myth," *Studies in Iconology* 7–8 (1981–82): 209–51.

Hecht, Paul. "The *Paragone* Debate: Ten Illustrations and a Comment," *Simiolus* 14 (1984): 125–36.

Heikamp, Detlef. "Antologia di critici: Poesie in vitupero del Bandinelli," *Paragone*, n.s. 15, 175 (1964): 59–68.

——. "Baccio Bandinelli nel Duomo di Firenze," *Paragone*, N.S. 15, 175 (1964): 32–42.

——. "In margine alla 'Vita di Baccio Bandinelli' del Vasari," *Paragone*, N.S. 2, 191 (1966): 51–62.

Hetzer, Theodor. *Tizian: Geschichte seiner Farbe* (1935; rpt. Frankfurt, 1969).

Hibbard, Howard. *Michelangelo* (Cambridge and Philadelphia, 2nd ed. 1985).

Hirst, Michael. "The Chigi Chapel in S. Maria della Pace," *Journal of the Warburg and Courtauld Institutes* 24 (1961): 161–85.

——. "Michelangelo in Rome: An Altarpiece and the 'Bacchus'," *Burlington Magazine* 123 (1981): 581–93.

——. *Sebastiano del Piombo* (Oxford, 1981).

——. "Michelangelo, Carrara and the Marble for the Cardinal's Pietà," *Burlington Magazine* 127 (1985): 154–59.

——. *Michelangelo and his Drawings* (New Haven and London, 1988).

——. *Michelangelo Draftsman*, exh. cat., Washington, National Gallery of Art (Milan, 1988).

——. "Michelangelo in Florence: 'David' in 1503 and 'Hercules' in 1506," *Burlington Magazine* 142 (2000): 487–92.

——, and Jill Dunkerton. *Making and Meaning: The Young Michelangelo* (London, 1994).

Holderbaum, James. "A Bronze by Giovanni Bologna and a Painting by Bronzino," *Burlington Magazine* 98 (1956): 439–45.

——. "The Birth Date and a Destroyed Early Work of Baccio Bandinelli," in *Essays in the History of Art Presented to Rudolf Wittkower*, ed. Douglas Fraser, Howard Hibbard, and Milton J. Lewine (London, 1967), pp. 93–97.

Hollanda, Francisco de. *Four Dialogues on Painting*, trans. Aubrey F.G. Bell (Oxford and London, 1928).

Hood, William, and Charles Hope. "Titian's Vatican Altarpiece and the Pictures Underneath," *Art Bulletin* 59 (1977): 534–52.

Hope, Charles. "The 'Camerini d'Alabastro' of Alfonso d'Este," *Burlington Magazine* 113 (1971): 640–50, 712–21.

——. "The Camerino d'Alabastro: A Reconsideration of the Evidence," in *Bacchanals by Titian and Rubens*, ed. Görel Cavalli-Bjorkman (Stockholm, 1987), pp. 25–42.

——. "A New Document about Titian's *Pietà*," in *Sight & Insight: Essays on Art and Culture in Honour of E.H. Gombrich at 85*, ed. John Onians (London, 1994), pp. 153–67.

Howard, Deborah. "Bramante's Tempietto: Spanish Royal Patronage in Rome," *Apollo* 136 (October 1992): 211–17.

Hulse, Clark. *The Rule of Art: Literature and Painting in the Renaissance* (Chicago and London, 1990).

Humfrey, Peter. "Competitive Devotions: The Venetian *Scuole piccole* as Donors of Altarpieces in the Years around 1500," *Art Bulletin* 70 (1988): 401–23.

——. *Lorenzo Lotto* (New Haven and London, 1997).

Jacobs, Fredrika H. "An Assessment of Contour Line: Vasari, Cellini and the *Paragone*," *Artibus et historiae* 9, 18 (1988): 139–50.

——. "Aretino and Michelangelo, Dolce and Titian: *Femmina, Masculo, Grazia*," *Art Bulletin* 82 (2000): 51–67.

Janson, H. W. *The Sculpture of Donatello* (Princeton, 1963).

Joannides, Paul. "Michelangelo's Lost Hercules," *Burlington Magazine* 119 (1977): 550–54.

——. "A Supplement to Michelangelo's Lost Hercules," *Burlington Magazine* 123 (1981): 20–23.

——. "Two Bronze Statuettes and their Relation to Michelangelo," *Burlington Magazine* 124 (1982): 3–8.

——. *The Drawings of Raphael with a Complete Catalogue* (Berkeley and Los Angeles, 1983).

——. "Raphael and Giovanni Santi," in *Studi su Raffaello: Atti del congresso internazionale di studi (Urbino–Firenze) 1984*, ed. Micaela Sambucco Hamoud and Maria Letizia Strocchi, 2 vols. (Urbino, 1987), vol. 1, pp. 55–61.

——. "Leonardo da Vinci, Peter-Paul Rubens, Pierre-Nolasque Bergeret and the 'Fight for the Standard'," *Achademia Leonardi Vinci* 1 (1988): 76–86.

——. "On Some Borrowings and Non-Borrowings from Central Italian and Antique Art in the Work of Titian c. 1510–c. 1550," *Paragone*, N.S. 23, 487 (1990): 21–45.

——. *Michelangelo and his Influence: Drawings from Windsor Castle*, exh. cat., Washington, National Gallery of Art, and elsewhere (Cambridge, 1997).

——. "Michelangelo *bronzista*: Reflections on his Mettle," *Apollo* 145, N.S. 424 (June 1997): 11–20.

——. *Titian to 1518: The Assumption of Genius* (New Haven and London, 2001).

Jones, Roger, and Nicholas Penny. *Raphael* (New Haven and London, 1983).

Juřen, Vladimir. "Fecit faciebat," *Revue de l'art* 26 (1974): 27–30.

Kahr, Madlyn. "Titian's Old Testament Cycle," *Journal of the Warburg and Courtauld Institutes* 29 (1966): 193–205.

Kemp, Martin. "From 'Mimesis' to 'Fantasia': The Quattrocento Vocabulary of Creation, Inspiration and Genius in the Visual Arts," *Viator* 8 (1977): 347–98.

——. *Leonardo da Vinci: The Marvellous Works of Nature and Man* (London, 1981; rpt. 1989).

——. *Behind the Picture: Art and Evidence in the Italian Renaissance* (New Haven and London, 1997).

——, ed. *Leonardo on Painting*, trans. Martin Kemp and Margaret Walker (New Haven and London, 1989).

Kemp, Wolfgang. "Disegno: Beiträge zur Geschichte des Begrifs zwischen 1547 und 1607," *Marburger Jahrbuch für Kunstwissenschaft* 19 (1974): 219–40.

Kosegarten, Antje Middeldorf. "The Origins of Artistic Competitions in Italy (Forms of Competition between Artists before the Contest for the Florentine Baptistry Doors Won by Ghiberti in 1401)," in *Lorenzo Ghiberti nel suo tempo: Atti del convegno internazionale di studi*, 2 vols. (Florence, 1980), vol. 1, pp. 167–86.

Krautheimer, Richard, and Trude Krautheimer-Hess, *Lorenzo Ghiberti*, 2 vols. (Princeton, 1970).

Kristeller, Paul. *Andrea Mantegna* (London, New York, and Bombay, 1901).

Laclotte, Michel, and Giovanna Nepi Scirè, ed. *Le Siècle de Titien: L'Âge d'or de la peinture à Venise*, exh. cat., Paris, Grand Palais (Paris, 1993).

Land, Norman E. "Titian's *Martyrdom of St Peter Martyr* and the 'Limitations' of Ekphrastic Art Criticism," *Art History* 13 (1990): 293–317.

——. "*Narcissus pictor*," *Source* 16, 2 (1997): 10–15.

Landau, David, and Peter Parshall. *The Renaissance Print 1470–1550* (New Haven and London, 1994).

Landucci, Luca. *A Florentine Diary from 1450 to 1516 by Luca Landucci Continued by an Anonymous Writer till 1542 with Notes by Iodoco del Badia*, trans. Alice de Rosen Jervis (London and New York, 1927).

Langedijk, Karla. "Baccio Bandinelli's Orpheus: A Political Message," *Mitteilungen des Kunsthistorischen Institutes in Florenz* 20, Heft 1 (1976): 33–52.

Larson, John. "The Cleaning of Michelangelo's Taddei Tondo," *Burlington Magazine* 133 (1991): 844–46.

Lavin, Irving. "Michelangelo's Saint Peter's Pietà: The Virgin's Left Hand and Other New Photographs," *Art Bulletin* 48 (1966): 103–04.

——. "Bozzetti and Modelli: Notes on Sculptural Procedure from the Early Renaissance through Bernini," in *Stil und Uberlieferung in der Kunst des Abendlandes: Akten des 21. internationalen Kongresses für Kunstgeschichte in Bonn 1964*, vol. 3: *Theorien und Probleme* (Berlin, 1967), pp. 93–104.

——. "The Sculptor's 'Last Will and Testament'," *Allen Memorial Art Museum Bulletin* 35, 1–2 (1977–78): 4–39.

——. "David's Sling and Michelangelo's Bow: A Sign of Freedom," in *Past-Present: Essays on Historicism in Art from Donatello to Picasso* (Berkeley, Los Angeles, and Oxford, 1993), pp. 29–61.

——. "*Ex uno lapide*: The Renaissance Sculptor's *Tour de force*," in *Il Cortile delle statue: Der Statuenhof des Belvedere im Vatikan: Akten des internationalen Kongresses zu Ehren von Richard Krautheimer*, ed. Matthias Winner, Bernard Andreae, and Carlo Pietrangeli (Mainz, 1998), pp. 191–210.

——, et al. *Drawings by Gianlorenzo Bernini from the Museum der Bildenden Künste Leipzig, German Democratic Republic*, exh. cat., Princeton Art Museum (Princeton, 1981).

Lee, Rensselaer W. *Ut pictura poesis: The Humanistic Theory of Painting* (New York, 1967) [first published in *Art Bulletin*, 1940].

Levi d'Ancona, Mirella. "The *Doni Madonna* by Michelangelo: An Iconographic Study," *Art Bulletin* 50 (1968): 43–50.

Levine, Saul. "The Location of Michelangelo's *David*: The Meeting of January 25, 1504," *Art Bulletin* 65 (1974): 31–49.

Lewine, Carol F. *The Sistine Chapel Walls and the Roman Liturgy* (University Park, PA, 1993).

Lichtenstein, Jaqueline. *The Eloquence of Color: Rhetoric and Painting in the French Classical Style*, trans. Emily McVarish (Berkeley, 1993).

Liebert, Robert S. *Michelangelo: A Psychoanalytic Study of his Life and Images* (New Haven and London, 1983).

Lightbown, Ronald [W.]. "Michelangelo's Great Tondo: Its Origins and Setting," *Apollo*, n.s. 89 (January 1969): 22–31.

——. *Sandro Botticelli*. 2 vols. (Berkeley and Los Angeles, 1978).

——. *Mantegna: With a Complete Catalogue of the Paintings, Drawings and Prints* (Berkeley and Los Angeles, 1986).

——. *See also* Pope-Hennessy, John.

Lorenzi, Giovanni Battista. *Monumenti per servire alla storia del Palazzo Ducale di Venezia* (Venice, 1868).

Lotz, Wolfgang. *Architecture in Italy 1500–1600* (London, 1974; rpt. New Haven and London, 1995), with introduction by Deborah Howard.

Lucchesi, Laura, et al. *Il Crocifisso di Santo Spirito/The Crucifix of Santo Spirito* (Florence, 2000).

Lucchesi Ragni, Elena, and Giovanni Agosti, eds. *Il polittico Averoldi di Tiziano restaurato*, exh. cat., Brescia, Monastero di Santa Giulia (Brescia, 1991).

Luchs, Alison. "Michelangelo's Bologna Angel: 'Counterfeiting' the Tuscan Duecento?," *Burlington Magazine* 120 (1978): 222–25.

——. *Tullio Lombardo and Ideal Portrait Sculpture in Renaissance Venice, 1490–1530* (Cambridge and New York, 1995).

Mancini, Girolamo, ed. "Vite d'artisti di Giovanni Battista Gelli," *Archivio storico italiano*, 5th ser., 17 (1896): 32–62.

Mancusi-Ungaro, Harold R., Jr. *Michelangelo: The Bruges Madonna and the Piccolomini Altar* (New Haven and London, 1971).

Marani, Pietro C. *Leonardo da Vinci: The Complete Paintings*, trans. A. Lawrence Jenkins, with "Documentary Appendix" by Marani and Edoardo Villata (New York, 2000).

——, ed. *The Genius of the Sculptor in Michelangelo's Work*, exh. cat., Montreal Museum of Fine Arts (Montreal, 1992).

——. *See also* Nepi Scirè, Giovanna.

Martin, Andrew John. *Savoldos sogennantes "Bildnis des Gaston de Foix": Zum Problem des Paragone in der Kunst und Kunsttheorie der italienischen Renaissance* (Sigmaringen, 1995).

McLaughlin, M. L. "Humanist Concepts of Renaissance and Middle Ages in the Tre- and Quattrocento," *Renaissance Studies* 2 (1988): 131–42.

Meilman, Patricia. *Titian and the Altarpiece in Renaissance Venice* (Cambridge and New York, 2000).

Meller, Peter. "Physiognomical Theory in Renaissance Heroic Portraits," in *Studies in Western Art: Acts of the Twentieth International Congress of the History of Art*, vol. 2: *The Renaissance and Mannerism*, ed. Ida E. Rubin (Princeton, 1963), pp. 53–69.

Mendelsohn, Leatrice. *Paragoni: Benedetto Varchi's Due lezzioni and Cinquecento Art Theory* (Ann Arbor, 1982).

Meyer zur Capellen, Jürg. *Raphael in Florence*, trans. Stefan B. Polter (London, 1996).

——. *Raphael: A Critical Catalogue of his Paintings*, vol. 1: *The Beginnings in Umbria and Florence ca. 1500–1508*, ed. and trans. Stefan P. Polter (Münster, 2001).

Michelangelo. *See* Bardeschi Ciulich, Lucilla, and Paola Barocchi, ed.

Mignosi Tantillo, Almamaria. "Restauri alla Farnesina," *Bollettino d'arte*, 5th ser., 57 (1972): 33–43.

Milanesi, Gaetano, ed. *Le lettere di Michelangelo Buonarroti pubblicate coi ricordi ed i contratti artistici* (Osnabrück, 1875; rpt. 1976).

——. *See also* Vasari, Giorgio.

Millon, Henry A., and Craig Hugh Smyth. *Michelangelo Architect: The Facade of San Lorenzo and the Drum and Dome of St. Peter's*, exh. cat., Washington, National Gallery of Art (Milan, 1988).

Millon, Henry A., and Vittorio Magnago Lampugnani, ed. *The Renaissance from Brunelleschi to Michelangelo: The Representation of Architecture*, exh. cat., Venice, Palazzo Grassi, and Washington, National Gallery of Art (Milan, 1994).

Mommsen, Theodor E. "Petrarch's Conception of the 'Dark Ages'," *Speculum* 17 (1942): 226–42.

Morisani, Ottavio. "Art Historians and Art Critics–III: Cristoforo Landino," *Burlington Magazine* 95 (1953): 267–70.

Morozzi, Luisa. "La 'Battaglia di Cascina' di Michelangelo: Nuova ipotesi sulla data di commissione," *Prospettiva* 53–56 (1988–89): 320–24.

Möseneder, Karl. "Der junge Michelangelo und Schongauer," in *Italienische Frührenaissance und nordeuropäisches Spätmittelalter: Kunst der frühen Neuzeit im europäischen Zusammenhang*, ed. Joachim Poeschke (Munich, 1993), pp. 259–77.

Moskowitz, Anita Fiderer. *The Sculpture of Andrea and Nino Pisano* (Cambridge, 1986).

Mulazzani, Germano. "Raphael and Venice: Giovanni Bellini, Dürer, and Bosch," in *Raphael before Rome*, ed. James Beck (Washington, 1986), pp. 149–53.

Müller-Walde, Paul. "Beiträge zur Kenntnis des Leonardo da Vinci," *Jahrbuch der königlich preussischen Kunstsammlungen* 18 (1897): 92–169.

Musacchio, Jacqueline Marie. "Weasels and Pregnancy in Renaissance Italy," *Renaissance Studies* 15 (2001): 172–87.

Nagel, Alexander. "Michelangelo's London 'Entombment' and the Church of S. Agostino in Rome," *Burlington Magazine* 136 (1994): 164–67.

——. *Michelangelo and the Reform of Art* (Cambridge and New York, 2000).

Natali, Alessandro, et al. *L'officina della maniera: Varietà e fierezza nell'arte fiorentina del Cinquecento fra le due repubbliche 1494–1530*, exh. cat., Florence, Uffizi (Venice, 1996).

Nauert, Charles G., Jr. "Humanists, Scientists, and Pliny: Changing Approaches to a Classical Author," *American Historical Review* 84 (1979): 72–85.

Negro, Angela. *Venere e Amore di Michele di Ridolfo del Ghirlandaio: Il mito di una Venere di Michelangelo fra copie, repliche e pudiche vestizioni* (Rome, 2001).

Nelson, Jonathan. "Dante Portraits in Sixteenth Century Florence," *Gazette des Beaux-Arts* 120 (1992): 59–77.

Nepi Scirè, Giovanna. "Recent Conservation of Titian's Paintings in Venice," in *Titian, Prince of Painters*, ed. Susanna Biadene, with Mary Yakush, exh. cat., Venice, Palazzo Ducale, and Washington, National Gallery of Art (Milan, 1990), pp. 109–32.

——, Pietro C. Marani, et al. *Leonardo and Venice*, exh. cat., Venice, Palazzo Grassi (Milan, 1992).

——. See also Goffen, Rona; Laclotte, Michel.

Nesselrath, Arnold. *Raphael's School of Athens*, Recent Restorations of the Vatican Museums 1 (Vatican City, 1996).

——. "Lorenzo Lotto in the Stanza della Segnatura," *Burlington Magazine* 142 (2000): 3–12.

Oberhuber, Konrad. *Raphael: The Paintings* (Munich, London, and New York, 1999).

O'Grody, Jeannine Alexandra. "'*Un semplice modello*': Michelangelo and his Three-Dimensional Preparatory Works," Ph.D. dissertation (Case Western Reserve University, 1999).

Onians, John. "On How to Listen to High Renaissance Art," *Art History* 7 (1984): 411–36.

Pacteau, Francette. "The Impossible Referent: Representations of the Androgyne," in *Formations of Fantasy*, ed. Victor Burgin, James Donald, and Cora Kaplan (London and New York, 1986).

Panofsky, Erwin. *Problems in Titian, Mostly Iconographic* (New York, 1969).

Paoletti, John. "The Rondanini *Pietà*: Ambiguity Maintained through the Palimpsest," *Artibus et historiae* 21, 42 (2000): 53–80.

Pardo, Mary. "Paolo Pino's 'Dialogo di pittura': A Translation with Commentary," Ph.D. dissertation (University of Pittsburgh, 1984).

——. "Testo e contesti del 'Dialogo di pittura' di Paolo Pino," in *Paolo Pino teorico d'arte e artista: Il restauro della pala di Scorzè*, ed. Angelo Mazza (Scorzè, 1992), pp. 33–49.

——. "Artifice as Seduction in Titian," in *Sexuality and Gender in Early Modern Europe: Institutions, Texts, Images*, ed. James Grantham Turner (Cambridge and New York, 1993), pp. 55–89.

Parker, Deborah. *Bronzino: Renaissance Painter as Poet* (Cambridge and New York, 2000).

Parks, N. Randolph. "The Placement of Michelangelo's *David*: A Review of the Documents," *Art Bulletin* 57 (1975): 560–70.

Partridge, Loren, and Randolph Starn. *A Renaissance Likeness: Art and Culture in Raphael's Julius II* (Berkeley, Los Angeles, and London, 1980).

Passamani, Bruno, et al. *Giovanni Gerolamo Savoldo tra Foppa, Giorgione e Caravaggio*, exh. cat., Brescia, Monastero di Santa Giulia and Frankfurt, Schirn Kunsthalle (Milan, 1990).

Pedretti, Carlo. "L'Ercole di Leonardo," *L'arte* 57 (1958): 163–72.

——. *Leonardo: A Study in Chronology and Style* (Berkeley and Los Angeles, 1973).

——. *The Literary Works of Leonardo da Vinci, Compiled and Edited from the Original Manuscripts by Jean Paul Richter: Commentary*, 2 vols. (Berkeley and Los Angeles, 1977).

——. "The 'Angel in the Flesh'," *Achademia Leonardi Vinci* 4 (1991): 34–51.

Perrig, Alexander. *Michelangelo's Drawings: The Science of Attribution*, trans. Michael Joyce (New Haven and London, 1991).

Perry, Marilyn. "Cardinal Domenico Grimani's Legacy of Ancient Art to Venice," *Journal of the Warburg and Courtauld Institutes* 41 (1978): 215–44.

Petrarca, Francesco. *Rerum familiarium libri I–VIII*, trans. Aldo S. Bernardo (Albany, NY, 1975).

——. *Petrarch's Lyric Poems: The Rime sparse and Other Lyrics*, trans. and ed. Robert M. Durling (Cambridge, MA, and London, 1976).

Petrucci, Armando. *Public Lettering: Script, Power, and Culture*, trans. Linda Lappin (Chicago and London, 1993).

Philostratus the Elder and Philostratus the Younger. *Imagines*, trans. Arthur Fairbanks (Cambridge, MA, and London, 1979).

Pietrangeli, Carlo, Michael Hirst, et al. *The Sistine Chapel: A Glorious Restoration* (New York, 1994).

Pigman, G. W., III. "Versions of Imitation in the Renaissance," *Renaissance Quarterly* 33 (1980): 1–32.

Pino, Paolo. *Dialogo di pittura*, ed. Rodolfo Pallucchini and Anna Pallucchini (Venice, 1946).

——. "Dialogo di pittura," in *Trattati d'arte del Cinquecento fra manierismo e controriforma*, ed. Paola Barocchi (Bari, 1960), pp. 95–139.

Pliny. *Natural History*, trans. D.E. Eichholz (Cambridge, MA, and London, rpt. 1989).

——. *Natural History, Books XXXIII–XXXV*, trans. H. Rackham (Cambridge, MA, and London, rpt. 1995).

——. *Natural History, Preface and Books 1–2*, trans. H. Rackham (Cambridge, MA, and London, rpt. 1997).

Poeschke, Joachim. *Michelangelo and his World: Sculpture of the Italian Renaissance*, trans. Russell Stockman (New York, 1996).

Poggi, Giovanni, ed. *Il Duomo di Firenze: Documenti sulla decorazione della chiesa e del campanile tratti dall'Archivio dell'Opera* (1909), ed. Margaret Haines, 2 vols. (Florence, rpt. 1988).

Polverari, Michele, ed. *Tiziano: La pala Gozzi di Ancona. Il restauro e il nuovo allestimento espositivo*, exh. cat., Ancona, Pinacoteca Comunale (Bologna, 1988).

Pope-Hennessy, John. *Italian High Renaissance and Baroque Sculpture*, Part 3 of An Introduction to Italian Sculpture, 3 vols. (London, 1963).

——. *Italian Renaissance Sculpture*, Part 2 of An Introduction to Italian Sculpture (London and New York, rev. ed. 1971).

——. *Cellini* (New York, 1985).

——. *Donatello* (New York, 1993).

——, with Ronald Lightbown. *Catalogue of Italian Sculpture in the Victoria and Albert Museum*, 2 vols. (London, 1964).

Popham, A. E. *The Drawings of Leonardo da Vinci*, rev. ed. Martin Kemp (London, 1994).

Puttfarken, Thomas. "The Dispute about *Disegno* and *Colorito* in Venice: Paolo Pino, Lodovico Dolce and Titian," *Kunst und Kunsttheorie 1400–1900 (Wolfenbütteler Forschungen, 48)* (1991): 75–99.

Ragionieri, Pina, ed. *I bozzetti michelangioleschi della Casa Buonarroti* (Florence, 2000).

Ramsden, E. H., ed. *The Letters of Michelangelo*, 2 vols. (Stanford, 1963).

Rebhorn, Wayne A. "The Crisis of the Aristocracy in *Julius Caesar*," *Renaissance Quarterly* 43 (1990): 75–111.

Reilly, Patricia L. "The Taming of the Blue: Writing Out Color in Italian Renaissance Theory," in *The Expanding Discourse: Feminism and Art History*, ed. Norma Broude and Mary D. Garrard (New York, 1991), pp. 87–99.

Reiss, Sheryl E. "A Medieval Source for Michelangelo's Medici Madonna," *Zeitschrift für Kunstgeschichte* 50 (1987): 394–400.

Richter, Jean Paul, ed. *The Notebooks of Leonardo da Vinci*, 2 vols. (1883, rpt. New York, 1970).

Ridolfi, Carlo. *Le Maraviglie dell'arte ovvero le vite degli illustri pittori veneti e dello stato* (1648), ed. Detlev von Hadeln, 2 vols. (Berlin, 1914).

Riviere, Joan. "Womanliness as Masquerade" (1929), in *Formations of Fantasy*, ed. Victor Burgin, James Donald, and Cora Kaplan (London and New York, 1989), pp. 35–44.

Robertson, Charles. "Bramante, Michelangelo and the Sistine Ceiling," *Journal of the Warburg and Courtauld Institutes* 49 (1986): 91–105.

Rosand, David. *Painting in Cinquecento Venice: Titian, Veronese, Tintoretto* (Cambridge and New York, rev. ed. 1997).

——. "Raphael's *School of Athens* and the Artist of the Modern Manner," in *The World of Savonarola: Italian Élites and Perceptions of Crisis*, ed. Stella Fletcher and Christine Shaw (Aldershot, 2000), pp. 212–32.

——, and Michelangelo Muraro. *Titian and the Venetian Woodcut*, exh. cat., Washington, National Gallery of Art; Dallas Museum of Fine Arts; Detroit Institute of Arts (Washington, 1976).

Rosenberg, Charles M. "Alfonso I d'Este, Michelangelo and the Man Who Bought Pigs," in *Revaluing Renaissance Art*, ed. Gabriele Neher and Rupert Shepherd (Aldershot, 2000), pp. 89–100.

Roskill, Mark W. *Dolce's "Aretino" and Venetian Art Theory of the Cinquecento* (New York, 1968).

Rossi, Paolo L. "The Writer and the Man: Real Crimes and Mitigating Circumstances. *Il caso Cellini*," in *Crime, Society and the Law in Renaissance Italy*, ed. Trevor Dean and K. J. P. Lowe (Cambridge and New York, 1994), pp. 157–83.

Rowland, Ingrid D. "Render unto Caesar the things which are Caesar's: Humanism and the Arts in the Patronage of Agostino Chigi," *Renaissance Quarterly* 39 (1986): 673–730.

——. *The Culture of the High Renaissance: Ancients and Moderns in Sixteenth-Century Rome* (Cambridge and New York, 1998).

Rubin, Patricia [Lee]. "Il contributo di Raffaello allo sviluppo della pala d'altare rinascimentale," *Arte cristiana* 78 (1990): 169–82.

——. "Raphael and the Rhetoric of Art," in *Renaissance Rhetoric*, ed. Peter Mack (London, 1994), pp. 165–82.

——. *Giorgio Vasari: Art and History* (New Haven and London, 1995).

——, Alison Wright, and Nicholas Penny. *Renaissance Florence: The Arts of the 1470s*, exh. cat., London, National Gallery (London, 1999).

Rubinstein, Nicolai. *The Palazzo Vecchio 1298–1532: Government, Architecture, and Imagery in the Civic Palace of the Florentine Republic* (Oxford, 1995).

Rylands, Philip. *Palma Vecchio* (Cambridge, 1992).

Saccone, Eduardo. "*Grazia, Sprezzatura*, and *Affettazione* in Castiglione's *Book of the Courtier*," *Glyph: Johns Hopkins Textual Studies* 5 (1979): 34–54.

Salvini, Roberto. *Giotto bibliografia* (Rome, 1938; rpt. 1970).

Sambo, Alessandra. "Tiziano davanti ai giudici ecclesiastici," in *Tiziano e Venezia: Convegno internazionale di studi, Venezia, 1976* (Vicenza, 1980), pp. 383–93.

Sambucco Hamoud, Micaela, and Maria Letizia Strocchi, ed. *Studi su Raffaello: Atti del Congresso internazionale di studi (Urbino–Firenze 1984)*, 2 vols. (Urbino, 1987).

Santangelo, Giorgio, ed. *Le epistole "De imitatione" di Giovanfrancesco Pico della Mirandola e di Pietro Bembo* (Florence, 1954).

Sanuto, Marino [Marin Sanudo]. *I diarii di Marino Sanuto*, ed. Rinaldo Fulin et al., 58 vols. (Venice, 1879–1902).

Saslow, James M. *The Poetry of Michelangelo: An Annotated Translation* (New Haven and London, 1991).

Satkowski, Leon. *Giorgio Vasari: Architect and Courtier* (Princeton, 1993).

Saxl, Fritz. *Lectures*, 2 vols. (London, 1957).

Schapiro, Meyer. *Theory and Philosophy of Art: Style, Artist, and Society* (New York, 1994).

Schmidt, Eike D. "Die Überlieferung von Michelangelos verlorenem Samson-Modell," *Mitteilungen des Kunsthistorischen Institutes in Florenz* 40, Heft 1–2 (1996): 78–147.

Schneider, Laurie. "Raphael's Personality," *Source* 3, 2 (Winter 1984): 9–22.

Scott, Clive. "A Theme and a Form: Leda and the Swan and the Sonnet," *Modern Language Review* 74, 1 (1979): 1–12.

Settis, Salvatore. *Laocoonte: Fama e stile* (Rome, 1999).

Seymour, Charles, Jr. *Michelangelo's David: A Search for Identity* (Pittsburgh, 1967).

Shapley, Fern Rusk. *Catalogue of the Italian Paintings*, National Gallery of Art, 2 vols. (Washington, 1979).

Shearman, John. "Rosso, Pontormo, Bandinelli, and Others at SS. Annunziata," *Burlington Magazine* 102 (1960): 152–56.

——. "Leonardo's Color and Chiaroscuro," *Zeitschrift für Kunstgeschichte* 25 (1962): 13–47.

——. *Raphael's Cartoons in the Collection of Her Majesty the Queen and the Tapestries for the Sistine Chapel* (London, 1972).

——. "The Florentine *Entrata* of Leo X, 1515," *Journal of the Warburg and Courtauld Institutes* 38 (1975): 136–54.

——. "Raphael, Rome and the Codex Escurialensis," *Master Drawings* 15 (1977): 107–46.

——. *The Early Italian Pictures in the Collection of Her Majesty the Queen* (Cambridge, London, and New York, 1983).

——. "Alfonso d'Este's Camerino," in *"Il se rendit en Italie": Etudes offertes à André Chastel* (Rome and Paris, 1987), pp. 209–30.

——. *Only Connect . . . : Art and the Spectator in the Italian Renaissance* (Washington and Princeton, 1992).

——. "Castiglione's Portrait of Raphael," *Mitteilungen des Kunsthistorischen Institutes in Florenz* 38 (1994): 69–97.

Shell, Janice, and Grazioso Sironi. "Salaì and Leonardo's Legacy," *Burlington Magazine* 133 (1991): 95–108.

Shoemaker, Innis H., and Elizabeth Broun. *The Engravings of Marcantonio Raimondi*, exh. cat., Lawrence, Spencer Museum of Art, and Chapel Hill, Ackland Art Museum (Lawrence, 1981).

Smyth, Craig Hugh. "Venice and the Emergence of the High Renaissance in Florence: Observations and Questions," in *Florence and Venice: Comparisons and Relations*, vol. 1: *Quattrocento* (Florence, 1979), pp. 209–49.

Sohm, Philip. "Gendered Style in Italian Art Criticism from Michelangelo to Malvasia," *Renaissance Quarterly* 48 (1995): 759–808.

Steinberg, Leo. "Michelangelo's Florentine *Pietà*: The Missing Leg," *Art Bulletin* 50 (1968): 343–50.

——. "The Metaphors of Love and Birth in Michelangelo's *Pietàs*," in *Studies in Erotic Art*, ed. Theodore Bowie and Cornelia V. Christenson (New York and London, 1970), pp. 231–85.

——. "Animadversions: Michelangelo's Florentine *Pietà*: The Missing Leg Twenty Years After," *Art Bulletin* 71 (1989): 480–505.

——. "Who's Who in Michelangelo's *Creation of Adam*: A Chronology of the Picture's Reluctant Self-Revelation," *Art Bulletin* 74 (1992): 552–66.

Stewart, Andrew. *Art, Desire, and the Body in Ancient Greece* (Cambridge and New York, 1997).

Summers, David. "David's Scowl," in *Collaboration in Italian Renaissance Art*, ed. Wendy Stedman Sheard and John T. Paoletti (New Haven, 1978), pp. 113–24.

——. *Michelangelo and the Language of Art* (Princeton, 1981).

——. "Form and Gender," *New Literary History* 24 (1993): 244–71.

Symonds, John Addington. *The Life of Michelangelo Buonarroti*, 2 vols. (London, 1893).

Tafuri, Manfredo. "Raffaello, Jacopo Sansovino e la facciata di San Lorenzo a Firenze," *Annali di architettura* 2 (1990): 24–44.

Tassi, Roberto. *Tiziano: Il polittico Averoldi in San Nazaro* (Brescia, 1976).

Tempestini, Anchise. *Giovanni Bellini*, trans. Alexandra Bonfante-Warren and Jan Hyams (New York, London, and Paris, 1999).

Thoenes, Christof. "Galatea: Tentativi di avvicinamento," in *Raffaello a Roma: Il convegno del 1983*, ed. Christoph Luitpold Frommel and Matthias Winner (Rome, 1986), pp. 59–72.

Thornton, Dora. *The Scholar in his Study: Ownership and Experience in Renaissance Italy* (New Haven and London, 1997).

Tietze-Conrat, Erica. "Neglected Contemporary Sources Related to Michelangelo and Titian," *Art Bulletin* 25 (1943): 156–59.

——. "Again: Giovanni Bellini and Cornaro's Gazelle," *Gazette des Beaux-Arts*, 6th ser., 29 (1946): 187–90.

Tietze, Hans, and Erica Tietze-Conrat. *The Drawings of the Venetian Painters of the 15th and 16th Centuries*, Foreword by David Rosand, 2 vols. (New York, 1944; rpt. 1970).

Titian [Tiziano Vecellio]. *Tiziano: Le lettere*, ed. Celso Fabbro (Cadore, 2nd ed. 1989).

Tolnay, Charles de. *Michelangelo*, 5 vols. (Princeton, 1943–60), vol. 1: *The Youth of Michelangelo*; vol. 2: *The Sistine Ceiling*; vol. 3: *The Medici Chapel*; vol. 4: *The Tomb of Julius II*; vol. 5: *The Final Period*.

——. "L'Hercule de Michel-Ange à Fontainebleau," *Gazette des Beaux-Arts*, 6th ser., 64 (1962): 125–40.

——. *Corpus dei disegni di Michelangelo*, 4 vols. (Novara, 1975–80).

Traeger, Jörg. *Renaissance und Religion: Die Kunst des Glaubens im Zeitalter Raphaels* (Munich, 1997).

Turner, A. Richard. "Words and Pictures: The Birth and Death of Leonardo's Medusa," *Arte lombarda* 66 (1983): 103–11.

——. *Inventing Leonardo* (Berkeley and Los Angeles, 1992).

Varchi, Benedetto. *Orazione funerale di M. Benedetto Varchi fatta, e recitata da lui pubblicamente nell'essequie di Michelagnolo Buonarroti in Firenze, nella chiesa di San Lorenzo* (Florence, 1564).

——. *Opere*, 2 vols. (Trieste, 1859).

Varese, Ranieri. *Giovanni Santi* (Fiesole, 1994).

Vasari, Giorgio. *Le opere di Giorgio Vasari*, ed. Gaetano Milanesi, 9 vols. (Florence, 1906; rpt. 1973).

——. *Le vite de' più eccellenti pittori, scultori e architettori nelle redazioni del 1550 e 1568*, ed. Rosanna Bettarini and Paola Barocchi, 6 vols. (Florence, 1966–87).

——. *Le vite de' più eccellenti architetti, pittori, et scultori italiani insino a' tempi nostri nell'edizione per i tipi di Lorenzo Torrentino Firenze 1550*, ed. Luciano Bellosi and Aldo Rossi, introduction by Giovanni Previtali (Turin, 1986).

Verdon, Timothy. "'Amor ab Abspectu': Maria nel tondo Doni e l'Umanesimo cristiano," *Teologia nell'età di Giovanni Pico della Mirandola-Vivens homo: Rivista teologica fiorentina* 5, 2 (1994): 531–52.

Viatte, Françoise. *Léonard da Vinci: Isabelle d'Este* (Paris, 1999).

Vickers, Brian. *In Defence of Rhetoric* (Oxford, 1988).

Villata, Edoardo. "Il *San Giovani Battista* di Leonardo: Un'ipotesi per la cronologia e la committenza," *Raccolta vinciana* 27 (1997): 187–236.

Vossilla, Francesco. "Baccio Bandinelli e Benvenuto Cellini tra il 1540 e il 1560: Disputa su Firenze e su Roma," *Mitteilungen des Kunsthistorischen Institutes in Florenz* 41, Heft 3 (1997): 254–313.

——. *See also* Francini, Carlo.

Waal, H. van de. "The Linea summae tenuitatis of Apelles: Pliny's Phrase and its Interpretations," *Zeitschrift für Asthetik und allgemeine Kunstwissenschaft* 12 (1967): 5–32.

Waldman, Louis [Alexander]. "'Miracol' novo et raro': Two Unpublished Contemporary Satires on Bandinelli's 'Hercules'," *Mitteilungen des Kunsthistorischen Institutes in Florenz* 38, Heft 2–3 (1994): 419–26.

——. "Bandinelli and the Opera di Santa Maria del Fiore: Patronage, Privilege, and Pedagogy," in *Santa Maria del Fiore: The Cathedral and its Sculpture: Acts of the International Symposium for the VII Centenary of the Cathedral of Florence*, ed. Margaret Haines (Fiesole, 2001), pp. 221–56.

Wallace, William [E.]. "Michelangelo's Assistants in the Sistine Chapel," *Gazette des Beaux-Arts* 110 (1987): 203–16.

——. "Il 'Noli me tangere' di Michelangelo: Tra sacro e profano," *Arte cristiana* 56 (1988): 443–50.

——. "Michelangelo's Rome *Pietà*: Altarpiece or Grave Memorial?," in *Verrocchio and Late Quattrocento Italian Sculpture*, ed. Steven Bule, Alan Phipps Darr, and Fiorella Superbi Gioffredi (Florence, 1992), pp. 243–55.

——. *Michelangelo at San Lorenzo: The Genius as Entrepreneur* (Cambridge and New York, 1994).

——. "Instruction and Originality in Michelangelo's Drawings," in *The Craft of Art: Originality and Industry in the Italian Renaissance and Baroque Workshop*, ed. Andrew Ladis and Carolyn Wood (Athens, GA, and London, 1995), pp. 113–33.

——. *Michelangelo: The Complete Sculpture, Painting, Architecture* (Hong Kong, 1998).

——. "Friends and Relics at San Silvestro in Capite, Rome," *Sixteenth Century Journal* 30 (1999): 419–39.

——. "Michael Angelvs Bonarotvs Patritivs Florentinvs," in *Innovation and Tradition: Essays on Renaissance Art and Culture*, ed. Dag T. Andersson and Roy Eriksen (Rome, 2000), pp. 60–74.

——. "Michelangelo, Tiberio Calcagni, and the Florentine *Pietà*," *Artibus et historiae* 21, 42 (2000): 81–99.

——. "Michelangelo's *Leda*: The Diplomatic Context," *Renaissance Studies* 15 (2001): 473–99.

Wang, Aileen June. "Michelangelo's Signature," *Sixteenth Century Journal*, forthcoming.

Watson, Paul F. "Titian and Michelangelo: The *Danae* of 1545–1546," in *Collaboration in Italian Renaissance Art*, ed. Wendy Stedman Sheard and John T. Paoletti (New Haven, 1978), pp. 245–54.

Watts, Barbara J. "Artistic Competition, Hubris, and Humility: Sandro Botticelli's Response to *Visibile parlare*," *Dante Studies* 114 (1996): 41–78.

Webb, Ruth. "*Ekphrasis* Ancient and Modern: The Invention of a Genre," *Word and Image* 15 (1999): 7–18.

Weil-Garris, Kathleen. "Bandinelli and Michelangelo: A Problem of Artistic Identity," in *Art the Ape of Nature: Studies in Honor of H. W. Janson*, ed. Moshe Barasch, Lucy Freeman Sandler, and Patricia Egan (New York and Englewood Cliffs, 1981), pp. 223–51.

——. "On Pedestals: Michelangelo's *David*, Bandinelli's *Hercules and Cacus* and the Sculpture of the Piazza della Signoria," *Römisches Jahrbuch für Kunstgeschichte* 20 (1983): 378–415.

——. "Michelangelo's *Pietà* for the Cappella del Re di Francia," in *"Il se rendit en Italie": Etudes offertes à André Chastel* (Paris, 1987), pp. 77–108.

——. "'The Nurse of Settignano': Michelangelo's Beginnings as a Sculptor," in *The Genius of the Sculptor in Michelangelo's Work*, ed. Pietro C. Marani, exh. cat., Montreal Museum of Fine Arts (Montreal, 1992), pp. 21–43.

——, Cristina Acidini Luchinat, James David Draper, and Nicholas Penny, ed. *Giovinezza di Michelangelo*, exh. cat., Florence, Casa Buonarroti (Florence and Milan, 1999).

Weinstein, Donald. "Benvenuto Cellini: Inediti," *Rivista d'arte*, 4th ser., 6 (1990): 213–25.

Weiss, Roberto. *The Dawn of Humanism in Italy: An Inaugural Lecture* (New York, 1947; rpt. 1970).

Welch, Evelyn S. *Art and Authority in Renaissance Milan* (New Haven and London, 1995).

Wethey, Harold E. *The Paintings of Titian: Complete Edition*, 3 vols. (London, 1969–75), vol. 1: *The Religious Paintings*; vol. 2: *The Portraits*; vol. 3: *The Mythological and Historical Paintings*.

Wiemers, Michael. "'Und wo bliebt meine Zeichnung?' Zur Werkgenese im bildhauerischen Oeuvre des Michelangelo-Rivalen Baccio Bandinelli," in *Michelangelo, Neure Beiträge: Akten des Michelangelo-Kolloquiums veranstaltet vom Kunsthistorischen Institut der Universität zu Köln im Italienischen Kulturinstitut Köln 7.–8. November 1996*, ed. Michael Rohlmann and Andreas Thielemann (Munich and Bonn, 2000), pp. 235–64.

Wilde, Johannes. "The Hall of the Great Council of Florence," *Journal of the Warburg and Courtauld Institutes* 7 (1944): 65–81.

——. *Michelangelo and his Studio: Italian Drawings in the Department of Prints and Drawings in the British Museum* (London, 1953; rpt. 1975).

——. "Michelangelo and Leonardo," *Burlington Magazine* 95 (1953): 65–77.

——. *Michelangelo: Six Lectures* (Oxford, 1978).

Wind, Edgar. *Pagan Mysteries in the Renaissance* (New Haven and London, 1958).

Witt, Ronald G. *"In the Footsteps of the Ancients": The Origins of Humanism from Lovato to Bruni* (Leiden, 2000).

Wittkower, Rudolf. *Architectural Principles in the Age of Humanism* (New York, 1949; rpt. 1965).

——. *The Divine Michelangelo: The Florentine Academy's Homage on his Death in 1564: A Facsimile Edition of "Esequie del Divino Michelagnolo Buonarroti" Florence 1564* (Greenwich, CT, 1964).

——, and Margot Wittkower. *Born under Saturn: The Character and Conduct of Artists. A Documented History from Antiquity to the French Revolution* (London, 1963; rpt. New York, 1969).

Wohl, Helmut. *The Paintings of Domenico Veneziano: A Study in Florentine Art of the Early Renaissance* (New York and London, 1980).

Zimmermann, T. C. Price. "Paolo Giovio and the Evolution of Renaissance Art Criticism," in *Cultural Aspects of the Italian Renaissance: Essays in Honour of Paul Oskar Kristeller*, ed. Cecil H. Clough (Manchester, 1976), pp. 406–24.

——. *Paolo Giovio: The Historian and the Crisis of Sixteenth-Century Italy* (Princeton, 1995).

Zöllner, Frank. *Leonardo da Vinci Mona Lisa: Das Porträt der Lisa del Giocondo, Legende und Geschichte* (Frankfurt, 1994).

Photograph Credits

Scala/Art Resource, N.Y.: 1, 8, 18, 31, 34, 36, 49, 54, 55, 57, 59, 77, 83, 87, 95, 96, 97, 98, 101, 112, 122, 125, 128, 130, 131, 132, 135, 138, 142, 150, 151, 152, 155, 163, 165, 168, 191, 195, 196; Alinari/Art Resource, N.Y.: 2, 3, 9, 10, 23, 32, 33, 37, 38, 39, 40, 41, 42, 43, 44, 45, 46, 50, 52, 66, 79, 80, 90, 92, 93, 110, 114, 134, 137, 140, 171, 175, 176, 181, 182, 183, 186, 187, 189, 192, 193, 194, 201; Erich Lessing/Art Resource, N.Y.: 12, 88, 106, 119, 169; Artothek: 16; The Royal Collection © HM Queen Elizabeth II: 19, 20, 24, 65, 116, 141, 178; RMN/Art Resource, N.Y.: 21, 22, 28, 29, 56, 84, 85, 86; Foto Marburg/Art Resource, N.Y.: 30; Nicolò Orsi Battaglini/Art Resource, N.Y.: 60, 63; Photo © Aileen June Wang: 62; RMN/Art Resource N.Y., Photo © C. Jean: 67; Giraudon/Art Resource, N.Y.: 89, 124; © Photo RMN: 94, 100; Jörg P. Anders: 104; RMN/Art Resource, N.Y., Photo © Michele Bello: 108, 115; Photo by Paul Joannides: 126; Scala: 129; Cameraphoto: 158; Nimatallah/Art Resource, N.Y.: 199; © Patrimonio Nacional, Madrid: 200; © 2001, The Art Institute of Chicago. All Rights Reserved: page 340.

Index